# THE MAHARAJA OF
# JODHPUR'S
# GUNS

# THE MAHARAJA OF
# JODHPUR'S
# GUNS

## ROBERT ELGOOD

**Mehrangarh
Museum Trust**

**NIYOGI
BOOKS**

Jointly published by

**Mehrangarh Museum Trust**
Mehrangarh Fort, The Fort,
Jodhpur-342006, Rajasthan

NIYOGI BOOKS
Block D, Building No. 77,
Okhla Industrial Area, Phase-I,
New Delhi-110 020, INDIA
Tel: 91-11-26816301, 26818960
Email: niyogibooks@gmail.com
Website: www.niyogibooksindia.com

Text © Robert Elgood
Images of Jodhpur Collection © Mehrangarh Fort Museum
Photographs: Neil Greentree, unless otherwise mentioned

Editor: Martin Bryant and K.E. Priyamvada
Design: Sashi Bhushan Prasad

Endpapers: (front) The majestic Mehrangarh Fort, Jodhpur;
(rear) Jaswant Thada, the cenotaph of the royal family
of Jodhpur-Marwar, with Mehrangarh Fort in the background

ISBN: 978-93-89136-59-3
Publication: 2020

Printed at: Niyogi Offset Pvt. Ltd., New Delhi, India

# CONTENTS

The Indian Arms Act of 1878 regulated 'the manufacture, sale, possession and carrying of firearms'. It gave the British Government of India arbitrary power to forbid possession of arms, resulting in the disarmament of most of the population. During the First World War Mohandas Gandhi attacked this Act, writing in his *An Autobiography: The Story of My Experiments with Truth* (1925–9):

> Among the many misdeeds of the British rule in India, history will look back upon the Act depriving the whole nation of arms as the blackest. If we want the Arms Act to be repealed, if we want to learn the use of arms, here is a golden opportunity. If the middle classes render voluntary help to Government in the hour of its trial, distrust will disappear, and the ban on possessing arms will be withdrawn.

In 1959 the Union Government passed a law restricting ownership of guns for individual Indians. Section 45c. states that the Act does not apply in certain cases: 'Any weapon of an obsolete pattern or of antiquarian value or in disrepair which is not capable of being used as a firearm either with or without repair.' During Mrs Gandhi's premiership holes were drilled in the breeches of the historic guns in the Jodhpur Armoury illustrated in this book to render them unusable.

Arms still remaining in the princely armouries of India are rare survivors of successive government attempts to destroy them. As this book shows, these weapons have shaped the nation in war and peace over centuries and are a significant part of the national identity.

# FOREWORD

H. H. Maharaja of Jodhpur

It is widely believed that my clan, the warrior Rathores of Marwar, first met the firearm in AD 1527 at the historic Battle of Khanua, described early in this book in a victorious diarist's words. Unfortunately, we were only on the receiving end. Babur the Mughal, soon to be first Emperor, took my most esteemed ancestor Rao Maldev—then the heir-apparent—and his legendary cavalry completely by surprise; they were mowed down by a row of guns, match-lock and mortar, tethered together by chain. As the eminent historian, Sir Jadunath Sarkar, put it, 'The Rajputs had never seen anything like it before'. This was, in fact, the Rajput Confederacy's swansong, as they never quite learnt the lesson they could, and perhaps should, have; the Rathores particularly, preferring to the end the heady, reckless charge on horse with sword and lance—down to Haifa in 1918, considered by many as the last great cavalry action in military history.

Instruments of power and beauty, guns inevitably became valuable status symbols in the later Mughal Age, and my forbears built up quite a collection, generation after generation; a dazzling array of weapons in all sorts of precious metals and materials, in all shapes and sizes; some even to be used from a camel's back. Many of these, works of art really, have been on display at the Armoury in Mehrangarh Fort for some years, but it is for the first time now that our firearms have all been individually appraised and catalogued; exquisite craftsmanship captured photographically for all time by Neil Greentree, and Dr Robert Elgood in his expert commentary—a sumptuous work. We remain immensely grateful to him for it, coming as it does, so soon after his two-volume magnum opus—the inventory of Mehrangarh's formidable collection of swords, daggers and assorted weapons of war and artistry.

'Let them be, for they cannot fight without those toys of his!' disdained Maharaja Bijaya Singh in the summer of 1790, when scouts reported that the legendary French Maratha General De Boigne's cannon were stuck in the mud of a riverbed and easy for the taking. This was in keeping with the chivalric Rajput code of warfare. It was only in the 19th century, under the influence of the British, that firearms finally became favoured personal accessories—for sport not war. It was also soon to be the Golden Age of British gun-making and India's Maharajas indulged themselves on the hunting field. Though pig-sticking on horseback remained Jodhpur's 'national sport', it was the gun that travelled far and wide—from the blackbuck in Sardar Samand to the tiger in Bundi, from the imperial grouse at Gajner to the buffalo in East Africa. My grandfather, Maharaja Umaid Singh, was a great shikari and possessed some fine weapons; very few better than a coloured enamel Holland & Holland 12-bore shotgun, a present from my grandmother, made exactly a hundred years ago. It is no less than any Mughal artefact.

My father, Maharaja Hanwant Singh, took his passion for guns to a different dimension; setting up a gun factory in Mehrangarh Fort, and designing his own firearms. One of his famous inventions, a disguised .22 pen-pistol was recently auctioned as part of the Mountbatten Collection. How it got there—yet another fascinating story in this book!

These wonderful and historic pieces are all to be found within these pages. Magnificent, often eccentric; they were very much a part of our lives, once upon a time; if not quite revered as much as our Marwari horse and sacred sword, beloved and treasured none the less...

Gaj Singh II
Umaid Bhawan Palace

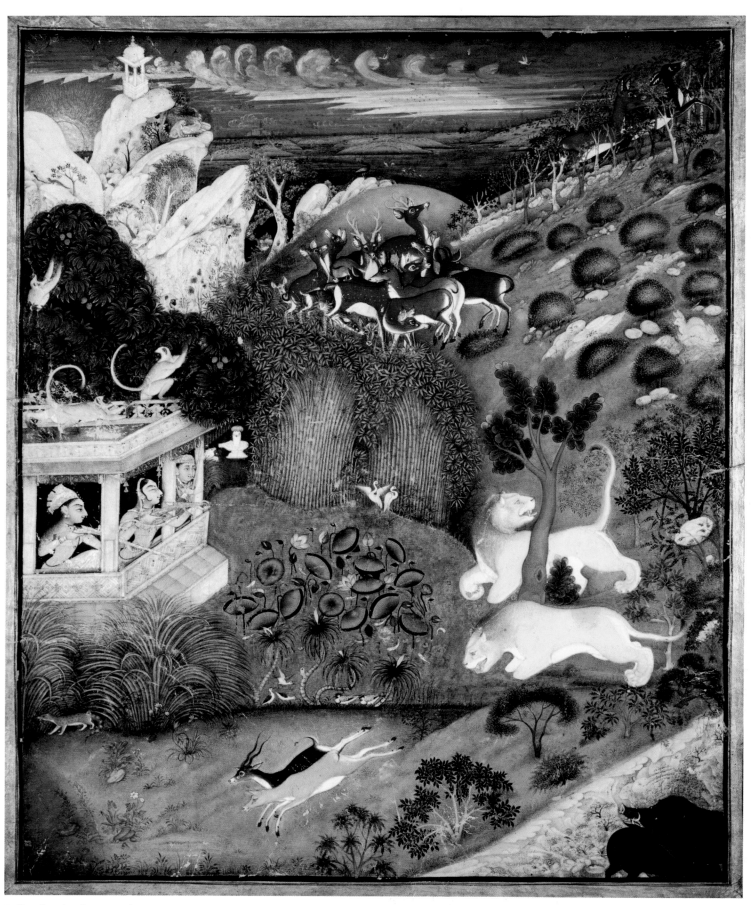

Ladies Shooting from a Pavilion, c. 1810. India, Rajasthan, Kota school, 19th century. The two ladies have ornate matchlocks decorated with paint, ivory and gilding. There are good examples of such women's guns in the reserve collection at City Palace, Jaipur. Ink, colour, and gold on paper; The Cleveland Museum of Art. Purchase from the J. H. Wade Fund 1955.48.

# ACKNOWLEDGEMENTS

There are many people I must thank for their kindness in helping me to write this book. The list begins with Bapji, H. H. the Maharaja of Jodhpur-Marwar, whose collection this is. I am enormously grateful to him, firstly for asking me to write this book and, secondly, for his support while doing so. Working in Jodhpur has been a pleasure and a privilege and I shall always think fondly of Rajasthan and its people.

I particularly want to thank Kr Karni Singh, Director of Mehrangarh, his father Thakur Nahar Singh Jasol, Dr Sunayana Rathore, Curator at Mehrangarh, and Bhanwar Singh Budhi. Also Dolly Mathur and Pushpendra Singh at the Maharaja's office, Umaid Bhavan, for their help and encouragement; and a particular thank you to Dr Mahendra Singh Tanwar and the people in the fort library.

Raj Kumar Kevi Singh, Monty and Mira – Rao Raja Mahendra Singh, The Rawat of Devgarh and his brother Hemant Singh. Kr Nirbhay Singh Deora.

Professor Chander Shekar of Delhi University, Assistant Professor Abhimanyu Singh Arha of the Dept. of History and Indian Culture, University of Rajasthan, Jaipur.

I am very grateful to Mark Murray Flutter at the Royal Armouries, Leeds who checked my work on modern guns and gave expert advice. Guy Wilson the retired Master of the Royal Armouries and David Williams at Bonhams also read the draft text and made valuable suggestions. Others I must thank include Natasha Bennett, curator of oriental arms at Leeds and Hyeok Hweon Kang who is writing a dissertation on Korean guns at Harvard. A number of curators, collectors and dealers have shown me objects that have assisted my research or discussed issues over the years. I particularly enjoyed discussing firearms with the late Claude Blair. Randolf Cooper. Ravi Reddy in San Diego; Philip Tom in Los Angeles, Lenny Lantsman, Peter Dekker in Amsterdam, Jim McDougal, Runjeet Singh, Jonathan Barrett and Peter Hawkins. I must also mention the kindness of David Penn regarding this publication.

I must thank Dr Nick Harlow at Purdey's and Douglas Pratt at Holland & Holland.

I was fortunate enough to spend a few hours with Rainer Daehnhardt at Belas, Portugal, discussing part of his incomparable collection of early guns and arms from the Portuguese empire. It is a great loss to the history of arms and armour that his collection and expert knowledge have not been adequately published. I must also thank Coronel Luis de Albuquerque, Director of the Military Museum of Lisbon. His museum contains one of the best collections of early cannons in the world including fine examples from India.

Many people working in museums across the world have kindly made pieces available for inspection or photographs available for publication. Similarly, the patient work of my editor Martin Bryant and publisher Bikash Niyogi must also be acknowledged. I am indebted to them all.

I am particularly grateful to Deborah Lee and her team who cleaned many of the guns in Jodhpur; and to the photographer, Neil Greentree, and his assistant Surendra Singh Jodha Kharia Khangar, for his excellent photos; and Anand and Bank Singh who sustained my work at the fort with innumerable cups of excellent masala chai.

Finally I must thank my wife Dr Hettie Elgood who made writing this book possible.

Dr Robert Elgood FSA
Oxfordshire

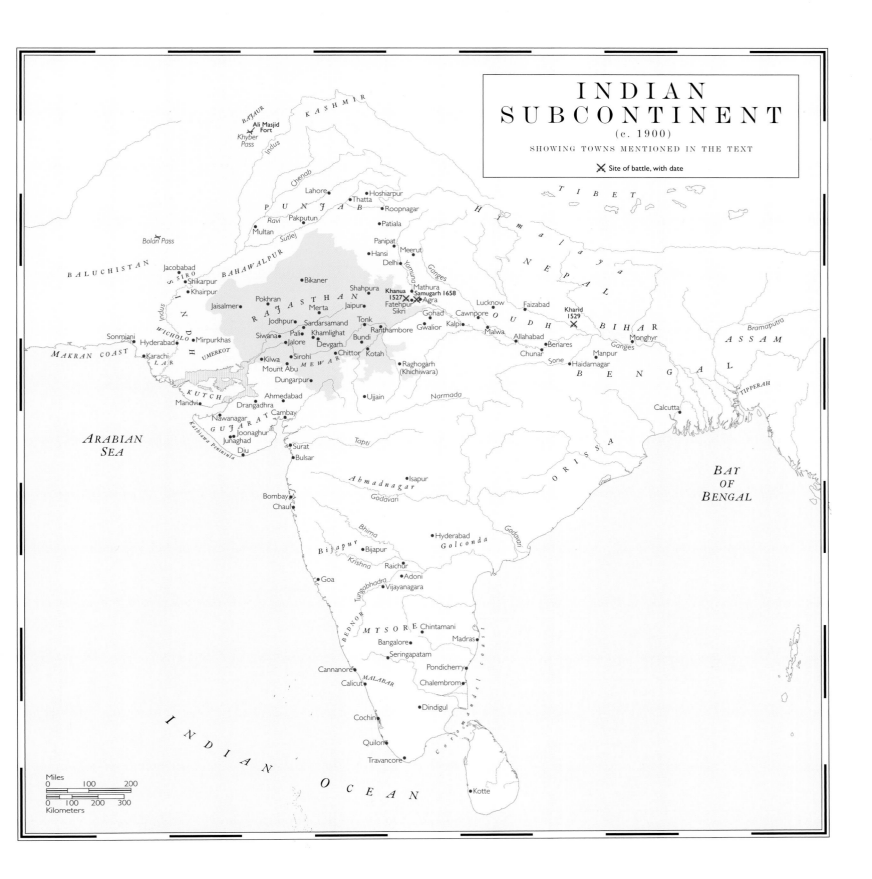

Rajasthan, in the Indian subcontinent

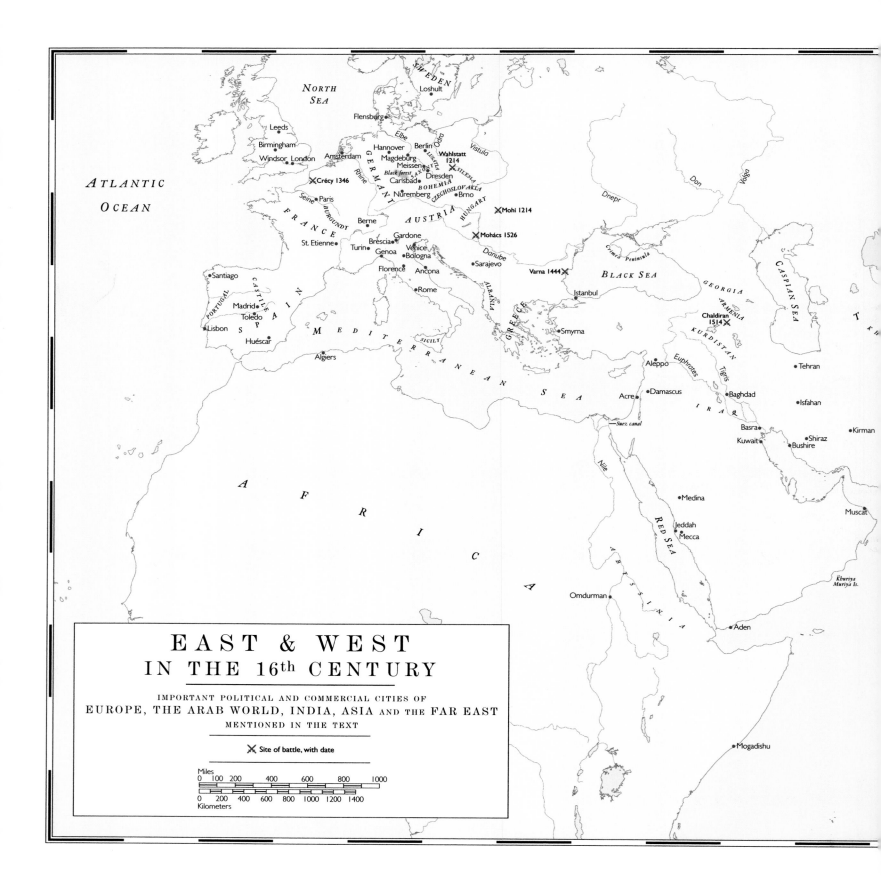

# EAST & WEST
## IN THE 16th CENTURY

IMPORTANT POLITICAL AND COMMERCIAL CITIES OF
EUROPE, THE ARAB WORLD, INDIA, ASIA AND THE FAR EAST
MENTIONED IN THE TEXT

✕ Site of battle, with date

Miles
0  100  200     400        600        800        1000

0    200   400   600   800  1000  1200  1400
Kilometers

East and West in the Sixteenth Century

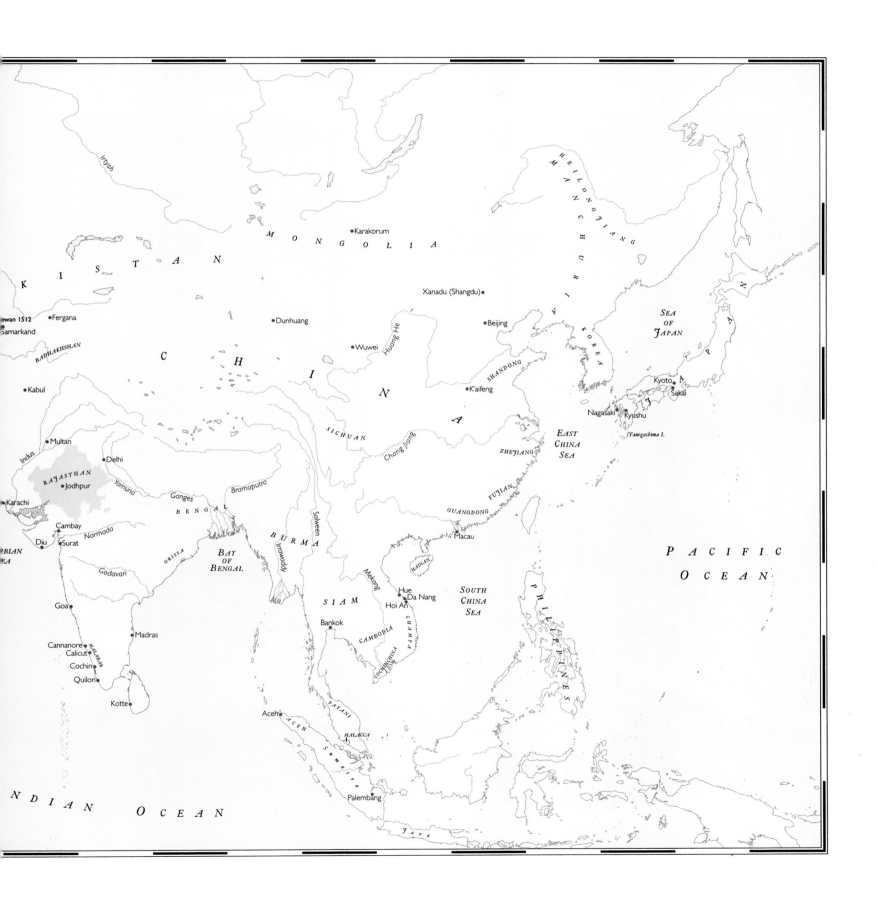

Irtysh

K I S T A N

ewan 1512
Samarkand

• Fergana

BADHAKHSHAN

• Kabul

C H I N A

M O N G O L I A

• Karakorum

Xanadu (Shangdu) •

• Dunhuang

• Wuwei

Huang He

• Beijing

SHANDONG

• K'aifeng

HEILONGJIANG

M A N C H U R I A

K O R E A

SEA
OF
JAPAN

J A P A N

Kyoto •
Sakai

Nagasaki •
Kyushu

Tanegashima I.

• Multan

Indus

• Delhi

RAJASTHAN

• Jodhpur

Yamuna

Ganges

Bramaputra

BENGAL

SICHUAN

Chang Jiang

ZHEJIANG

FUJIAN

EAST
CHINA
SEA

Karachi

Cambay
Normada
Diu
Surat

BIAN
SEA

Godavari

ORISSA

BAT
OF
BENGAL

BURMA

Irrawaddy

Salween

GUANGDONG

Macau

HAINAN

Goa •

Madras •

Cannanore •
Calicut •
Cochin •
Quilon •

MALABAR

Kotte •

SIAM

Bankok •

Mekong

CAMBODIA

COCHINCHINA

Hue
Da Nang
Hoi An

CHAMPA

SOUTH
CHINA
SEA

P A C I F I C

O C E A N

P H I L I P P I N E S

Aceh •

ACEH

Sumatra

PATANI

MALACCA

Palembang

Java

N D I A N      O C E A N

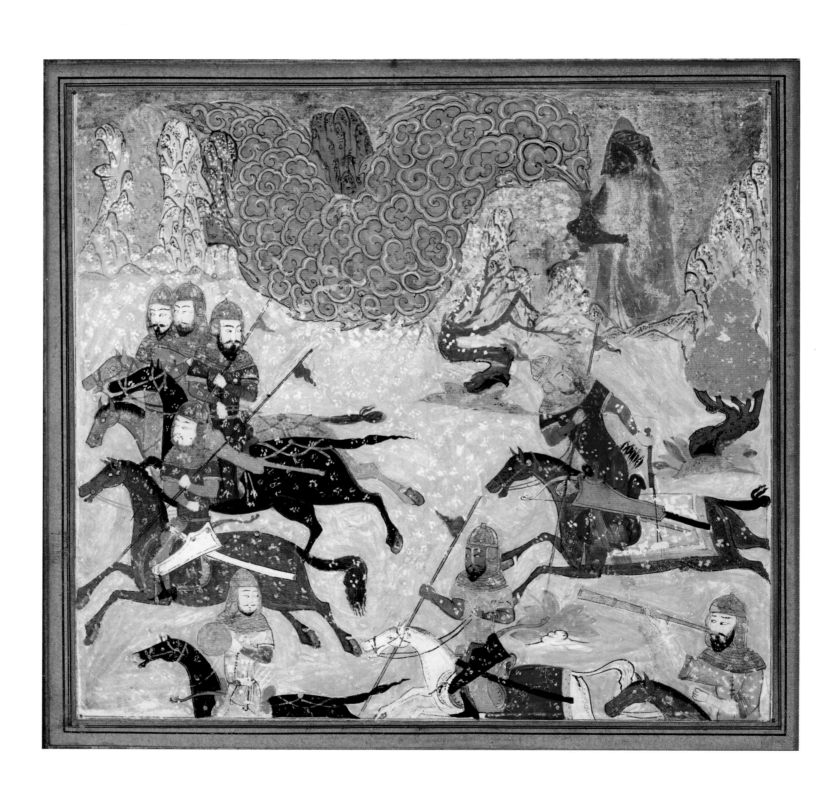

# 1 THE INVENTION OF GUNPOWDER WEAPONS AND THEIR ARRIVAL IN MEDIEVAL INDIA

The early history of gunpowder and firearms in India is complex, regional and often depends on questionable or ambiguous textual evidence. It is above all about the international transfer of technology and the local absorption and sometimes rejection of cultural influences that are a by-product of trade, war and intellectual enquiry. In 1880, Gustav Oppert (1836–1908), a German Sanskrit philologist, professor at the Presidency College, Madras, published a book: *On the Weapons, Army Organisation and Political Maxims of the Ancient Hindus*, which made sensational claims about very early Indian inventions, based on a translation of Valśampayana's *Nitiprakaśika* and the *Śukraniti*. Oppert did not attempt to date his text though he wrote that it 'belonged to the same period which produced the *Smriti* and the early epic literature' and indeed the *Śukraniti* is mentioned in the *Mahabharata*. These compilations, initially oral, developed between 800 BC and 400 AD, the dates being disputed. Most modern scholars conclude that the *Śukraniti* is of value in respect to the late medieval period but that the Sanskrit text used by Oppert has a later date, and that the inventions he claimed are interpolations. Oppert's argument was challenged by Partington,[1] Gode and by Iqtidar Alam Khan among many. His claims have been particularly popular with Hindu fundamentalists who see them as a rational explanation for the divine powers attributed to the Hindu pantheon, the Indian gods being considered historical figures. 'Of late the opinion has been gaining ground amongst scholars that his text was forged by a Pandit in the nineteenth century.'[2] There is no evidence to support a belief that Indians invented gunpowder, as has been argued, or used it for any purpose prior to the thirteenth century. Also untrue is the common assertion that Babur, the Central Asian invader who founded the Mughal Empire, introduced cannon and firearms to India in 1526.

Gunpowder, a mixture of saltpetre, sulphur and charcoal, is a Chinese invention, an inferior form of which is plausibly believed to have been assembled in the mid-ninth century[3] though earlier dates have been suggested. A mixture called *huo yao* or 'fire drug', similar to gunpowder, containing realgar,[4] saltpetre, sulphur and honey, was recorded in a Tang period list of dangerous elixirs. The document advised alchemists that when warmed the mixture was likely to set their beards or even the building on fire.[5] The earliest written formula for explosive powder using saltpetre, sulphur, charcoal and other substances is in a Song dynasty military handbook, the *Wujing Zongyao*, written between 1040 and 1044 AD.[6] Early Chinese 'gunpowder' burned better

than it exploded because it lacked sufficient saltpetre and the Chinese initially used it to create an infantry flamethrower (*fei huo ch'iang*, literally 'fireflying spear') projected from a paper or bamboo tube mounted on a spear pole: or as part of an incendiary bomb delivered by a catapult or arrow (*huo pao*): or as a rocket.[7]

The Mongols encountered these weapons in their wars with their Chin, Song and Tatar enemies in China in the first half of the thirteenth century and adopted them.[8] For example, the Mongols encountered the *fei-huo-ch'iang* at the siege of K'aifeng in 1232–3 AD.[9] A contemporary text states that it projected fire ten paces and none of the Mongols dared go near them. In 1215 Beijing fell to the Mongols who enslaved Chinese arms makers but K'aifeng is particularly important because there is a contemporary account written by a Jin official inside the town during the siege that provides contemporary information regarding military technology.[10] The defenders used trebuchets, catapults throwing explosive bombs with a fuse that had to be lit before the missile was lobbed. Sometimes the explosion occurred in the air or the bomb failed to go off but when it did it was capable of penetrating armour or setting the grass on fire. The Mongol besiegers were obliged to dig trenches and dugouts which they covered with their hide shields as protection. When the trenches reached the walls the defenders lowered these 'bombs' on chains and according to the account blew Mongols and shields to bits so no trace was left. The Mongols responded with their own trebuchets. The Jin infantry were armed with fire-lances (*huo ch'iang*), which had a tube fixed just below the blade containing a mixture of sulphur, charcoal, saltpetre, ground porcelain and iron filings. Each Jin foot soldier carried a small iron box containing smouldering material to light his fire-lance.[11]

This technology was carried west by the Mongols, taking with them captured Chinese technicians and craftsmen who eagerly transmitted their knowledge because the Mongol leaders spared them from execution because of their expertise. By 1218 AD Genghis Khan's China shared a frontier in the west with the Muslim Khwarazm-shah whose casual slaughter of Mongol envoys incited the initial Mongol invasion of the Muslim world. Once started, the Mongols fought their way westward with considerable speed. They were pastoral nomads, expert in the use of recurved bow, sword and horse. As they advanced across Muslim Asia they encountered hostile walled towns, which nullified their traditional manner of warfare, but they had experience of sieges in China and had the Chinese technicians to assist them. These Muslim towns held no attraction to nomads and had to be reduced as they could not be left behind to threaten the Mongol armies' lines of communication. Towns that resisted were sacked, the inhabitants slaughtered, terrifying the next town being called to surrender whose inhabitants had to make the fearful decision whether they opened the gates to these savage barbarians or relied on their walls to defy them. Fire was the obvious way to reduce these obstacles and the Mongols used it inventively. In one instance a town asked for time to consider the Mongol surrender terms and the commander agreed on condition that the town fed his army from the numerous pigeon lofts it possessed. The townspeople readily agreed. Then the Mongols tied burning brands to the feet of the pigeons and released them. The terrified birds flew back to their owners' lofts and soon the whole town was ablaze and easily stormed. This stratagem is first mentioned by Kautilya, the Indian adviser to the Mauryan emperor Chandragupta (r.c.321–c.297 BC) in his political treatise *Arthashastra*.[12]

By 1221 large Central Asian and eastern Persian Muslim towns like Samarkand, Bukhara, Merv and Nishapur were devastated, their populations massacred apart from 30,000 enslaved artisans and engineers.[13] The Mongols adopted other Chinese fire weapons such as the military

use of noxious smoke, used in battle against the Hungarians at Mohi in 1241 and the same month by another Mongol army against the Poles at Wahlstatt near Liegnitz. A formula for a 'poison smoke ball' or *tu-yao yen ch'iu* was known in the eleventh century. The formulae for these including gunpowder were popularly associated with shamans and wizards. A Sultanate *Shahnama* c.1430–5 shows Bazur the Turanian wizard with a bottle similar to those used for handguns from which he is conjuring darkness and snow to engulf an Iranian army.[14]

Chinese incendiary weapons incorporating gunpowder were used by the Mongols for siege warfare against Islamic states from the borders of China across Asia to Syria and eastern Turkey; and in the north of the Indian subcontinent, which suffered Mongol raids from 1221 to 1327. Baghdad, capital of the great Arab Abbasid dynasty, was captured in 1258. Gunpowder was also used for fireworks, which may account for the speed with which it was identified and adopted by the Muslims. In the thirteenth century the Arabs well understood the source of these new weapons as the names they gave them testify. Bottles containing incendiary material, fixed to arrows, were known in the Arab world as *siham khita'iyya*, Chinese style. Saltpetre, a vital ingredient of gunpowder, was referred to as *namak-i cini* or 'Chinese salt', while in Egypt it was called *milh al-ba'it* or 'Chinese snow' as early as 1225. These terms reached the Arabs bordering the eastern Mediterranean in advance of the Mongols themselves though whether via Arabs and Turks who served in Chinese armies, by Chinese or by Mongols is not known.

The period when contact between China and the Islamic world was at its greatest was between 1260 and 1368[15] when the Mongols ruled significant parts of both of these regions. Kublai Khan who established the Yuan dynasty came to the throne in 1260 and though his rule was in reality limited to China and Mongolia as Khagan, or Great Khan, his power stretched from the Pacific to the Black Sea and from Siberia to Afghanistan. A good example of the transfer of military technology can be seen when Kublai Khan summoned two Iraqi siege engineers, Ismail and Al al-Din from Mosul to destroy Song Chinese fortresses. The *hui-hui pao*, or Muslim trebuchet, was used by Kublai at the battle of Xiangyang to hurl explosive bombs. These machines were referred to as Frankish mangonels by the Ilkhanate[16] historian Rashid al-Din Hamadani, having been brought to the Levant by French or German Crusaders before 1242. The Mongol Hulagu used mangonels of this type to destroy the walls of Baghdad in 1258. Small excavated cannon survive which were also used in these wars against the southern Song. The destruction of the Song, and the Abbasids in Iraq, ushered in a period known as the Pax Mongolica, which made possible the circulation of ideas and goods across Eurasia to an unparalleled degree. Many Muslims emigrated to China; for example, Muslim soldiers settled in eastern Turkestan. Scholars have reappraised conditions in the Mongol Empire, seeing it as a period of peace and great achievement. Among many transfers of science and technology that it facilitated was that of gunpowder from the Chinese to the Arab world.[17]

In about 1280 AD, Hasan al-Rammah (Hasan the lancer) used the Arabic words *sahm al-khitai*, literally 'arrow from China' to mean a rocket in his *Kitab al-Furusiya wa'l-Munasab al-Harbiya* (Treatise on Horsemanship and Stratagems of War). Furusiya texts taught Arab equestrian military training. Hasan's text contains a great deal of evidence concerning the transmission to the Arab heartlands of Chinese gunpowder formulae and pyrotechnics. Thirteenth-century Arab names for these incendiary rockets include *sahm tuli* or 'long arrow', the *tayyar* or 'flying one' and the *al-majnun* or 'mad one'.[18] Military innovation inevitably passed from the Levant to the Muslim courts of India though the manner and timing of such transfers is rarely known.

There is a large and learned body of work on the development of gunpowder weapons in the Near East and the author offers a mise en scène in so far as it relates to India.

Military innovations are often created to counter a perceived threat. Given the potential of gunpowder it now seems banal that the most important early use for gunpowder-based battlefield weapons was to frighten the horses of enemy cavalry – no warrior can fight when his horse is out of control – a measure of how the Mongols and their enemies saw war. Furusiya documents were copied and dating them is often difficult. The early fourteenth-century *Nihayatal-Su'l wa-l-Umniyya fi Ta-lim A'mal al Furusiya* (Complete Instruction in the Practice of Military Arts) was written by Muhammad al Aqsara'i, probably in Damascus. Chapter 10 is entitled 'Ruses of War employing Fire and Smoke'. The Keir Collection has an undated fifteenth-century (?) furusiya text that includes an illustration showing troops, including one on horseback, evidently

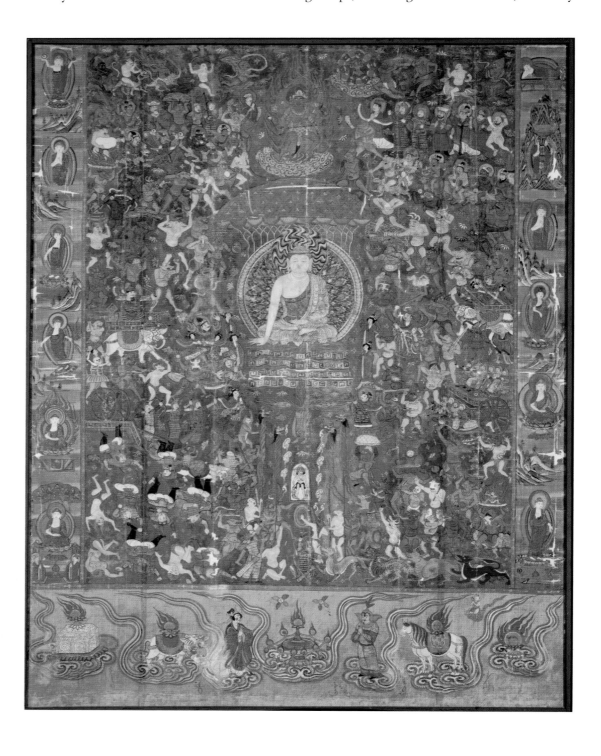

The earliest depiction of a firelance or *huo-ch'iang* on a painted Buddhist temple banner c. 950 AD from Dunhuang, a western Chinese frontier town on the Silk Road. The painting depicts the evil hosts of Mara the Tempter trying to interrupt the meditation of a bodhisattva.

Musée Guimet, Paris MG 17.655.

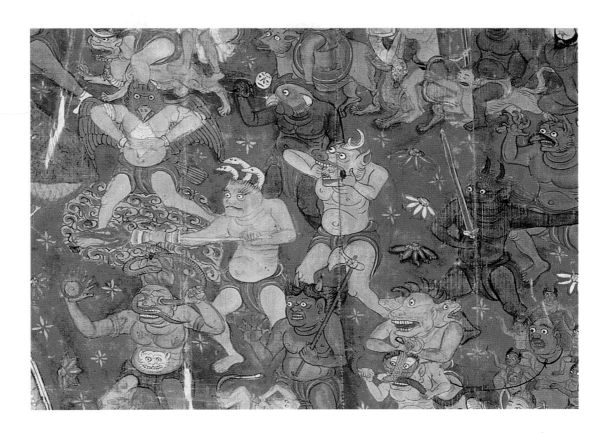

Detail of painting on the facing page. Fire and smoke billow from the firelance. Below is a demon with an incendiary grenade (*shou phao*).

Musée Guimet, Paris MG 17.655.

gunpowder specialists in fireproof asbestos cloth (the cloth probably from Badakhshan), covered from head to knee with squibs or firecrackers. A similar arrangement is depicted in the Egyptian manuscript *Kitab al-makhzun fi jami' al-funun* by Ibn Abi Khazzam, dated 1474.[19] These firecrackers exploded sequentially by means of a linked fuse. Another weapon designed to frighten horses, arguably the origin of the handgun,[20] was the fire-lance mentioned earlier. The earliest depiction of a fire-lance is on a Buddhist temple banner in a painting[21] of about 950 AD from Dunhuang, a western Chinese frontier town on the Silk Road. Even at that early date the weapon was en route for the west. The historian Iqtidar Alam Khan argues that Chinese fire-lances were probably adopted by the Mongols during Ogedei Khan's reign (1229–41 AD) who succeeded Genghis Khan: a belief supported in the *Jam'i al-tawarikh*.[22] This seems improbably late. In China the weapon attracted many names, most descriptive of the weapon's function. As late as the early twentieth century it was still used at sea to defend Chinese junks[23] from pirates. The fire-lance's limitation was that the projected flame had a short reach and was a short-lived deterrent. Enemy cavalry familiar with the weapon would appear to charge causing the infantry to light their fire-lances and would then halt until the flame had died before charging forward. However it was noted that a stone placed on top of the gunpowder in the tubular flame thrower would be shot out with some force when the mixture was lit. The weapon also shot pellets, a much easier projectile to source and load, in one instance compared to chickpeas. This weapon passed with the Mongols through Central Asia and Persia to the Arabs, who are said to have used it in 1280,[24] and on to Christian Europe.

The function and properties of the fire-lance are overshadowed by another incendiary weapon developed by the Byzantines circa 672 AD. 'Naft' is a word whose meaning transfers, originally the name for bitumen, used by the Byzantines to make what the Crusaders called 'Greek fire', a highly volatile flammable liquid mix of hydrocarbons distilled from petroleum and tar. This was directed at an enemy from a large syringe mounted on the prow of a ship, or in

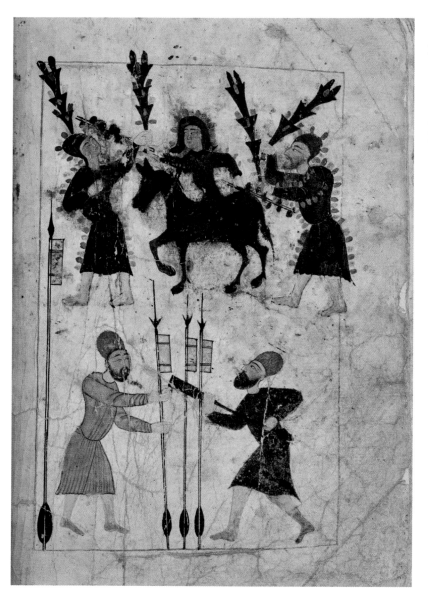

The upper figures are gunpowder specialists in fireproof asbestos cloth (usually from Badakhshan), covered from head to knee with squibs or firecrackers. There are four fire arrows with cylindrical powder containers, 'arrows of China' which the Arabs called *sahm tuli*. Note the man holding the handgun (lower right) which closely resembles the iron hand-bombard in the Musée de l'armée attributed to c. 1390–1410 AD. The date of this Mamluk *furusiyya* manuscript is uncertain, possibly c. 1460. Ink and colours on paper.

The Keir Collection of Islamic Art on loan to the Dallas Museum of Art made possible by Kosmos Energy, K.1.2014.107.A-EE.

clay pots as grenades, or as a bomb hurled by a mangonel. Knowledge of this weapon passed from Byzantium to the Arabs and on to China, which adopted the Persian word '*naft*' though each region had their own distinct formula.[25] A Chinese military handbook, the *Wujing Zongyao* (1040 and 1044 AD), contains the earliest Chinese depiction of a Greek fire flamethrower using a cylinder pump. Ayalon, historian of the Arab world, writes: 'Whenever the use of *naft* is mentioned before or during the days of the Crusades, it is immediately clear from the context that it is directed against some inflammable object for the purpose of burning it.'[26] Considerable confusion is caused by *naft* later meaning 'gunpowder' while also used as part of the name for various incendiary devices such as hand grenades – *qawarir an-naft or qudur an-naft* – which use naphtha. These inflammatory weapons were the responsibility of specialist units called *zarraqun* and *naffatun* and Ayalon notes an important distinction in the late Mamluk sources, that when these units take part in a battle the intention is to cause a fire; but when, using the same root, the word *nafiya* is used the meaning in all the sources is never inflammatory but rather relates to the troops using some form of gun. Ayalon notes that in Mamluk literature the Arabic word *naft*, meaning gunpowder, evolves to mean either gunpowder or firearms by about the 1360s.[27]

In most societies gunpowder was first used for making incendiary devices but the Chinese went on to produce copper and iron-barrelled guns called *khotun*. The earliest Chinese depiction of a hand cannon is found on a Dazu rock carving in Sichuan of 1128 AD, which shows a warrior firing a vase-shaped bombard that spits out flames and a cannonball. It closely resembles the first depiction of a cannon in England by Walter de Milemete in 1326. Early surviving examples include the Wuwei bronze cannon attributed to 1227[28] and the Heilongjiang cannon,[29] found in Manchuria, attributed to 1288, when Chinese troops under Chinese generals fought for the Mongols using gunpowder weapons. A bronze Chinese cannon dated to 1298 AD was excavated at Xanadu (Shangdu) in Mongolia where the Mongol Great Khans had their summer palace. There is a surviving Chinese bronze cannon of conventional form with an inscription showing it was made in the third year of the reign of Zhi Shun, equating to 1322 AD.[30] An excavated example is in Beijing dated 1351–2.

The Mongols were extremely tolerant of certain religions including Christianity[31] and welcomed travelling European monks, mainly Franciscans and Dominicans, anonymous men of education and enquiry who carried the gospel to the Mongol court. Christian Europe was hungry for scientific knowledge, often ancient Greek and Chinese in origin, transmitted through the Muslim world which the monks brought back to Europe. The *Liber Ignium* is a good example of this, tentatively attributed to Marcus Graecus, 'Mark the Greek', which is taken from the works of the contemporary Arab writer Najm al-Din Hasan al-Rammah whose

**BOTH ABOVE:**

Troops in flame retardant cloth suits, (al-qarqal, the term more commonly used for body armour), covered with fire crackers intended to panic enemy horses. The *Kitab al-makhzun fi jami' al-funun* by Ibn Abi Khazzam, Egypt dated 1474 is a treatise on military matters and includes an early description of firearms.

Oriental Institute, Russian Academy of Sciences, St Petersburg, No. C 686 [16].

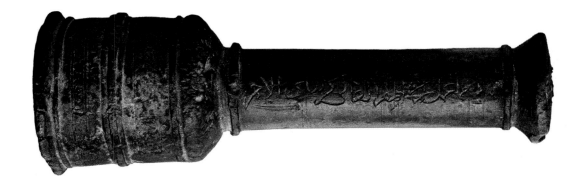

Mamluk hand cannon, late 15th century. An inscription on the breech states that this was made on the orders of Emir Kurtbay of Ahmar, Silahdar and Viceroy of Syria during the reign of Sultan al Nasir Muhammad (1496-8). This is believed to be the only surviving Mamluk handgun. The design which is illustrated in the accompanying furusiyya manuscripts shows how far the Mamluks were behind the Ottomans in firearms development.

Royal Armouries, Leeds XXVIF.245.

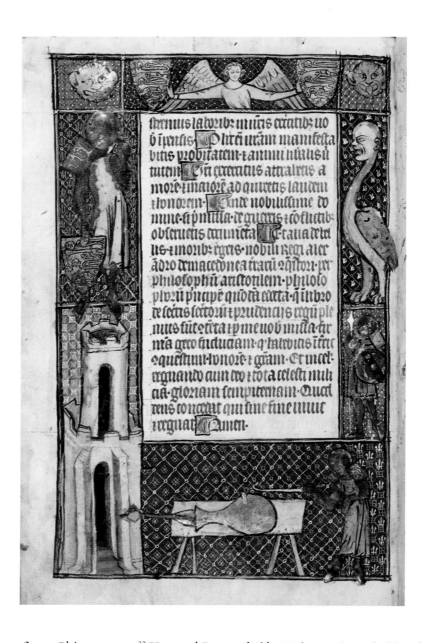

The earliest portrayal of a European pot-de-fer (cannon), taken from *De Nobilitatibus Sapientii Et Prudentiiis Regum*, a manuscript on kingship, written in 1326 by the English Scholar Walter de Milemete for Prince Edward, later King Edward III. The manuscript shows other siege weapons including a group of knights flying kite bombs laden with gunpowder over a city wall. Very similar guns were used by German knights at the siege of Cividale in Udine, north east Italy, in 1331.

Library of Christchurch, Oxford.

information reflects Chinese texts.[32] Hasan al Rammah (d.1294) mentions *ikrikh* and *warda*, two types of fuses in his work on *furusiya*. Monks like Albertus Magnus,[33] Roger Bacon,[34] William of Rubruck, who visited the Mongol Khan in 1254 AD at Karakorum,[35] and Berthold Swartz[36] were all associated with the development of gunpowder technology. Bacon and Rubruck knew firecrackers and it is a short step from firecrackers to a projectile use.

Much pre-Christian writing was lost when zealous early Christians led by the fathers of the Church such as St Augustine, St Martin, St Benedict, St Theophilus and St John Chrysostom systematically destroyed the culture of the classical world. Pagan temples and statues were smashed, an example being the Parthenon. Whole libraries were burned, such as the great Library at Alexandria that so impressed Julius Caesar. Christian thinking was similar to that of modern Salafi jihadist movements like al Qaeda and ISIL. At Palmyra ISIL continued the destruction started by the early Christians. In later centuries European intellectuals recognised the value of early Greek and Roman literature and tried to recover it. The principal places where Islamic science transferred to Christian Europe were Spain, particularly Toledo, and Sicily. Some of the earliest disputed references to the use of cannon in Europe occur in the Iberian peninsula, both areas having mixed Muslim and Christian populations. There are references to the Muslims

using cannon at the siege of Alicante in 1331 and the siege of Algeciras (1342–4). Christian belief in Muslim expertise is demonstrated by the king of Navarre's employment in 1367 of a Moor as *maestro de las guarniciones de artillería*.[37]

Putting definitive dates on technical transfers is difficult, firstly because the name often transfers from one object to a later different object;[38] and secondly, because witnesses are often not au fait with the gunpowder weapons they are seeing, resulting in ambiguous, sensational descriptions. Texts describe the explosion but fail to divulge the means of delivery – mangonel or cannon. What appears to be a cannon is described by Arab writers at the 1324 siege of Huéscar north-east of Granada where the Muslims used 'the great engine' which apparently shot a red-hot iron ball against the walls.[39] As late as the mid fifteenth century, Burgundian inventories of gunpower weapons list together culverins, a form of cannon, and culverin 'à main' or handguns.[40] It should also be noted that modern Western literature has conflated the cannon and the handgun seeing only a difference of scale but we are in fact looking for information on two separate weapons.

Arrow-shaped missiles fired from a tube appear in early Chinese references and are illustrated in the Ming dynasty text *Huolongjing*. When matchlocks were introduced into Tibet in the sixteenth century they had the Tibetan name *me mda*, literally 'fire arrow',[41] suggesting knowledge of the earlier Chinese weapon and the Gurkhas 'fired small arrows of iron out of their matchlocks' in the war of 1814–16.[42] The earliest European cannons fired metal arrows, as seen in the 1326 Milemete pictures from England and the Eltz arrows of 1331–3 from Germany, and the Rzewuski Arab manuscript. In 1338 an English vessel, the All Hallows Cog, was fitted with 'a certain iron instrument for firing quarrels[43] and lead pellets, with powder, for the defence of the ship'.[44] King Alfonso XI of Castile (1311–50) conquered the Muslim port of Algeciras in 1343 AD, according to the royal chronicler, 'by means of thunderclaps (*truenos*) great balls of iron and arrows so long and thick that a man could only with great effort raise them from the ground'.[45] The similarities at either end of the planet of vase-shaped cannon firing iron arrows cannot be regarded as chance. The spread of similar weapons across Europe at the date these guns were being depicted and other references suggests the technology was not new when the Council of Florence in 1326 ordered the manufacture of iron bullets and metal cannon '*pilas seu pallectas ferreas et canones de metallo*', 'missiles or iron bullets and metal cannon'.[46] Significantly no explanation of what these things are was given with the order. It should be noted that this was a time of abundant exchanges and communications between China and Italy and close ties between Italy and the Arab world. How much further advanced the Chinese were than Europe can be seen from the contemporary 'long range awe inspiring' cannon dated 1350 described in the *Huolongjing*.[47]

The fire-lance, known in Arabic as *makahil al-barud*, is mentioned in Hasan al-Rammah's manuscript of 1280 AD and is illustrated in the Rzewuski manuscript. The chronicler al-Wassaf (fl.1303–28) reported that the Il-Khanid ruler Muhammad Khudabanda Uljatu (AH 703–17/1304–17 AD), the Islamised descendant of the Mongol Hulagu, in 1313 AD assembled an army to fight the Mamluks with ballistae, flasks of naphtha, and pyrotechnists from China.[48] Al-Wassaf would have known naphtha, used in war for centuries by the Arabs, raising the question as to what role the 'pyrotechnicians from China' had if not to create the gunpowder mixtures for cannon and fire-lances? The fourteenth-century *Huolongjing* shows a gourd-shaped fire-lance discharging lead pellets and flames that has abandoned the spear blade altogether and is a handgun. In 1326 a document describes the same concept in Turin: 'for the making of

The Loshult gun was found by a farmer in a field in Sweden in 1861. This bronze, vase shaped gun, designed to shoot iron bolts or arrows, is thought to date from c. 1330-1350, the earliest surviving gun in Europe. Test firing in 2002 of a replica with various known early recipes for gunpowder and a variety of missiles gave an average range of 600 – 950 metres.

Length 12 ins. 31cm. Weight 9.050 kg. Bore at the muzzle 36mm reducing to 31mm.

National Historical Museum, Stockholm, inv.-no. 2891

Photo: Christer Åhlin, CC-BY-CA.

a certain instrument or device made by Friar Marcello for the projection of pellets of lead'.[49]

The fire-lance evolves into the handgun in Europe as in Asia while separately retained as a fire weapon; the dual nature of this weapon has obscured this development. Eurocentric arms historians used to claim that Europeans discovered gunpowder, now an untenable position, but a few still claim European invention of guns, apparently satisfied that the formulae picked up in foreign parts by mendicant monks had no practical application. The fire-lance provides the link by which deflagrating low-nitrate gunpowder as the basis of an incendiary evolved into explosive and propellant high-nitrate gunpowder in a handheld weapon. It is not entirely clear when this happened or where but the process constitutes a decisive step in the development and spread of handguns.

The author discussed this evolution of firearms with Claude Blair[50] who commented that the problem with the theory is the apparent absence of references to gunpowder projectile weapons being used in the Crusader wars of the Near East that ended in Syria with the fall of Acre in 1291 AD, or in Europe until much later. The absence of irrefutable evidence is not proof that something did not exist. Ayalon, the expert on early Arab guns and gunpowder, comments that the adoption for firearms 'was painful and slow': 'Particularly important is the fact that in Europe, generally speaking, [firearms] were adopted more efficiently than in the Muslim armies.'[51]

Proof that the fire-lance was regarded as an entirely separate weapon to cannon can be seen in Christian Europe where it became a weapon of the knights who gave it various names based on *tromba*, Latin for a trumpet.[52] To Italians it was *tromba da fuoco*, Turks called it *turonba* and Byzantine Greeks *troumpa*. In Europe as in the east the dual purpose of the weapon causes

Fourteenth-century European handgun. The iron barrel has iron straps binding it to the wooden tiller. The projecting spike was used to hook over a wall so that the user did not suffer from the recoil.

Bernisches Historisches Museum nr. 2193.

historians confusion. Early European firearms were often no more than a tube containing a solid division, one end being a gun barrel and the other end a socket to take a pole handle, an example being the 1298 Xanadu cannon. The precise date is somewhat arbitrary but by 1350 handheld cannon are part of the European battlefield and these were usually mounted on poles. The touch hole was central like a cannon and often the gun holder had an assistant to apply the match. An early example is in the Muzeum Wojska Polskiego, Warsaw.[53] Other early guns survive such as the early fourteenth-century Loshult gun, in the National Historical Museum, Stockholm, or the fourteenth-century example in the Historisches Museum, Berne,[54] a short cylinder attached to a tiller by two broad bands.[55] The Mongol fire-lance was originally intended to scare off enemy cavalry and this use is mentioned as late as the battle of Crécy in 1346 where, according to the contemporary Italian writer Giovanni Villani, the purpose of the five English ribauldequins[56] were to frighten the French cavalry and their Genoese crossbowmen:[57] but the use changed and by 1411 John the Good of Burgundy was reported to have 4,000 guns in his armoury.

The precise date when terms used to mean firework or flamethrower metamorphose into cannon or personal missile-projecting weapon that can be termed a handgun is difficult to assess and scholarly opinion divides on this issue.[58] In India as elsewhere facts are clouded by manuscripts with later interpolations and a tendency to transfer names of old weapons to new.[59] The debate centres on the scholar Muhammad Qasim Ferishta (c.1560–c.1620) whose history, the *Tarikh-i Ferishta*, was completed in 1606–7. This history cites earlier sources now lost to scholars and describes cannon and firearms (*top-o-tufak*) being used in 1366 when Bukka, the Vijayanagara ruler, attacked the Bahmanid kingdom in the Deccan making the strong castle of

Adoni his military base.[60] Ferishta says the Bahmanid army used cannon and firearms in this war for the first time and were victorious, capturing Adoni. He gives as his source for the claim Mulla Daud Bidari's *Tuhfatus Salatin*. The Mulla lived from 1397–1422. The historian Burton Stein wrote that the southern Indian state of Vijayanagara owed much of its success to its adoption of firearms.[61] Until 1347 when the Bahmanid state became independent the region had been part of the Delhi Sultanate with access to whatever gunpowder weapons the Tughluqid rulers of Delhi may have possessed. Muhammad b. Tughluq had close diplomatic relations with the Mamluks in Cairo where there are what Irwin describes as 'ambiguous references in Mamluk sources to the use of *makahil al-barud* [maybe handguns] and *madaafi* [maybe cannon]' in the 1340s and 1350s.[62] He also cites a reference to '*makahil al-barud*' (probably guns using gunpowder) in Al-'Umari's *al-Ta'rif bi'l-mustalah al-sharif* noting that this author died in 1349. The problem is that the technology changed faster than the terminology. Irwin states that there are numerous and unequivocal references to Mamluk use of cannon from the 1360s onwards, all of which makes the use of cannon by the Bahmanid state entirely plausible. Iqtidar Alam Khan provides evidence of pyrotechnics in Delhi in the last decade of the thirteenth century and gunpowder rockets (*hawai*) in Delhi sometime between 1357 and 1388,[63] which does not exclude the possible presence of cannon and firearms in Delhi at these dates.

Manucci (1638–1717 AD), an Italian traveller in India, wrote:

> The Emperor [Aurangzeb] has numerous artillery, and the pieces of cannon, which he makes use of in his armies, are for the most part older than any we have in Europe. Powder and cannon were certainly known in the Indies, long before the conquest of Tamerlane. 'Tis said the Chinese [the Mongols] who are supposed to be the first inventors, had cast some pieces of cannon at Delhi, at the time of their being masters there. This is a tradition of the country...[64]

Despite the lack of written evidence it is unlikely that Delhi failed to develop at the same pace as the rest of Asia and it would be surprising if the Bahmanids were not recipients of gunpowder technology from that source by 1366 AD. Scholars divide as to whether Ferishta's account is true or the introduction of later material; or merely the substitution of technical terms from his period that accurately or inaccurately reflect the original text.

Timur, ruler of Samarkand, portrayed himself as the restorer of the Mongol Empire of Genghis Khan. During his reign he is reputed to have killed about seventeen million people, perhaps 5 per cent of the world's population, a figure impossible to verify. In 1398 he invaded northern India and attacked the Delhi Sultanate. Timur's chronicler at this battle before Delhi, Nizam al-din Shami, describes the Tughluq army, which he says had 120 armoured war elephants forming the advance division in battle, their tusks reputedly poisoned. On their backs were 'structures' containing archers. Beside the elephants were *ra'd andazan* (throwers of explosive grenades) and *takhsh-afkanan* (either crossbowmen or rocketmen).[65] Timur countered the elephants by loading some of his camels with wood and combustibles that he set alight. The terrified camels trying to escape the flames on their backs were directed at the advancing elephants, which took fright and turned, trampling the advancing Tughluq troops, enabling Timur to win an easy victory. He then captured Delhi where, due to an incident, his troops subsequently massacred the population. The town did not recover for almost a century.

In late 1399 Timur began a war with the Ottoman Sultan Bayezid. The following year he captured Christian Armenia and Georgia and carried off more than 60,000 of the population as slaves. These two countries had excellent craftsmen in metal and good contacts with the Italian trading states, particularly Genoa and Venice, which had full access to gunpowder weapons. The Timurid armies next sacked Damascus and Aleppo. He then captured Baghdad and defeated and captured the Ottoman Sultan at the battle of Ankara in 1402, keeping him prisoner in a cage. It is believed that Serbian troops fighting on the Ottoman side at Ankara had some European-style handguns (*schiopetti*).[66] The Ottomans were perpetually at war with Christian Europe and as the fifteenth century progressed and cannon and firearms technology developed they had increasingly to adopt these military innovations. Timur then besieged the Christian Knights Hospitallers in their stronghold of Smyrna and decisively defeated them, executing the garrison. Christians invariably used advanced military technology to counter large Asiatic armies, particularly gunpowder weapons in fortifications but unfortunately the literary sources on the siege for both sides are late and uninformative. The extent to which Timur was opposed in these campaigns by armies equipped with cannon is not clear. Clavijo, the Spanish ambassador, wrote of his visit to Timur's capital, Samarkand, in 1404 shortly before Timur's death. Le Strange's 1929 translation is invariably cited:

> From Turkey he had brought their gunsmiths who make the arquebus, and all men of other crafts wheresoever he found them... Again he had gathered to settle here in Samarqand artillery men, both engineers and bombardiers, besides those who make the ropes by which these engines work.[67]

Clavijo's words in the original text are significantly different and suggest, rather improbably, that Timur had no interest in cannon.

> ...from Damascus he brought all the masters available to him, such as [those who make] cloths of silk of many kinds, likewise those [who] make bows which they shoot, and armourers and those who work in glass and porcelain, who are the best in the world; and from Turkey he brought crossbowers and other artisans, as many as he could find, like *alhanies*[68] and silversmiths and masons and all the trades as might be wished for, found in this city; and he brought others, masters of engines and artillerymen, among them [those] who made ropes for the engines and for this purpose cultivated hemp and flax which never before had been cultivated in this land.[69]

Timur's empire on his death in 1405 included Syria, Iraq, south-east Turkey, Iran and most of Asia to the Chinese border and he was preparing to attack China. Timur's empire was governed as an extreme military state and it is likely that most information relating to cannon and firearms technology would have been available in his capital of Samarkand though largely ignored.[70] The horse-riding aristocracy across Europe and the Arab, Persian, Indian and Asian worlds despised firearms. Matchlocks blackened the face and clothes of the people who used them. For Muslims they were therefore the weapon of slaves. The Ottomans had a regiment of such men, the Janissaries, Balkan and Anatolian youths, forcibly conscripted from Christian parents from the time of Murad I (1362–89) onwards and turned into fanatical Muslim infantry. They were initially armed with the recurved bow but from about 1440 onwards an ever-increasing

proportion of men were armed with handguns (*schiopetti*). The first literary use of the word *tufek*, Turkish for a gun, is said to be in 1465.[71]

Timur's Mongol Empire with a capital at Samarkand declined after his death in 1405 with the result that the trans-Asian trade routes lost their reputation for relative security, producing a shift to greater reliance on existing sea routes for the transfer of goods. Cambay, Surat, Mumbai, Goa, Cannanore, Calicut, Cochin and Quilon were major western Indian ports on the trade routes that linked Europe, the Ottoman and Arab world, south-east Asia and China. China had dealt with merchants from south Asia from before the rise of Islam but after Islam spread along the coast of western India trade with China was firmly in the hands of Arab, Persian, Indian and Chinese Muslim carriers. A Chinese map of the known world drawn by Zhou Qufei in 1178 AD refers to the Indian Ocean as the 'Eastern Sea of the Muslims'. 'It is impossible to be accurate about the history of the Muslims in the Indian Ocean without giving China its due.'[72] One would expect awareness of firearms technology to transfer along all these routes to the more important courts of western India. By the mid-thirteenth century if not earlier, the Mongols had adopted gunpowder and were using the *huo ch'iang*. According to the *Yuanshi* (History of Yuan), composed for the Ming in 1370, the Mongol Kublai Khan, founder of the Yuan dynasty, sent 20,000 to 30,000 south Chinese troops and cannon (*pao*) with them when they invaded Java in 1293.[73] Trade between Gujarat and China via Java and the Spice Islands was extensive and annual, making it most unlikely that gunpowder technology failed to transfer to Gujarat by 1366 from south-east Asia. The Moroccan geographer Ibn Battuta (1304–77 AD) visited several western Indian ports including Cambay and reports some Sultanate vessels but most came from Bahrain, Iraq, Oman and other distant places. At Calicut in 1341 he saw thirteen Chinese junks that dwarfed local craft. Western Indian ports were culturally and politically distinct from the Delhi Sultanate. Most followed the Shafi'i school of Islamic law, prevalent in Arabia, while Delhi followed the Hanafi school with its roots in Iraq. Gujarat is likely to have received information about this extraordinary new weapon from the Arab world, Mongol Delhi and China via south-east Asia with the last the most compelling in the fourteenth century.

As we have seen the Chinese invented firearms but their subsequent development and spread in southern and south-east Asia has been largely overlooked by historians of European and Islamic arms. Improved gunpowder weapons made an effectively contribution under the Song dynasty whose achievements, prior to their defeat by the Mongols in the late thirteenth century, were built on by their successors, the Ming whose first Emperor Zhu Yuanzhang (r.1368–98) drove the Mongol Yuan dynasty out of China by 1381. During this reign between 120,000 and 180,000 Chinese troops were armed with firearms.[74] The spread of military technology from Ming China into northern mainland south-east Asia had a considerable impact on the emergence of states there between 1390 and 1527.

The Vietnamese too had gunpowder weapons from the early fourteenth century. The rapid development of Viet military power enabled them to defeat the Cham people to their south and the Tai polities to their west. Che Bong Nga, king of the neighbouring state of Champa, died from a gunshot when he led an invading army into central Vietnam in 1390 AD. In 1407 the Ming conquered Đại Việt,[75] a domination that lasted until 1427. A Ming history (*Ming Shi*) states that the Chinese learnt the construction of 'divine cannon' from the Vietnamese after they invaded in 1407. Some units in the Ming (1368–1644) army used the *sanyanqiang* or 'three eyed gun' mounted on a pole, a direct descendant of the early fire-lance.[76] The Chinese recognised Vietnamese skills in the manufacture of firearms: 'During the Ming occupation of Vietnam, 1407–1427, the Chinese

took Vietnamese weapons specialists back to China to fabricate firearms. Ming chronicles report that during their occupation of Vietnam the Chinese acquired some artillery techniques from the Vietnamese, probably a reference to several types of fire lances which were initially developed in Vietnam.'[77] Another Vietnamese mentions that: 'Even high ranking Vietnamese prisoners were well treated by the Ming if they had knowledge of production techniques for firearms.'[78] According to Nguyen The Anh: 'Ho Nguyên Trung, son of Ho Quy Ly, the Vietnamese leader against the Ming forces, received special treatment from the Ming emperor after he was brought to China as a prisoner, because he was well versed in the production of firearms.'[79] Sun argues that this Asian 'Gunpowder Age' predates that of Europe and is key to the spread of firearms to south-east Asia and India in the late fourteenth and early fifteenth century.[80]

If Ferishta's claim is accepted it becomes highly probable that Vijayanagara had tufang in 1423 as he states. Niccolo de' Conti, an Italian merchant from Chioggia, reached India in 1419 and wrote that 'the natives of central India make use of balistae, and those machines we call bombardas, also other warlike implements adapted for besieging cities'.[81] Bukka I added Goa and Orissa to the Vijayanagara state and was therefore part of the international trade route from East to West: and it is believed that he sent an ambassador to China. They were geographically well placed to learn about guns from Chinese vessels arriving in their ports. Chinese vessels may have carried cannon in the thirteenth century and certainly did in the fourteenth century: a small Chinese vessel wrecked at Shandong had cannons dated 1377.[82] It is said that Chinese firearms were first used in naval battles in 1363. A decade later 'bowl-sized muzzle cannon' were being installed on warships, and in 1393 it was stipulated that each large vessel should be equipped with sixteen handguns, four 'bowl-sized muzzle cannon, twenty fire-lances (huoqiang), twenty rockets (huoqiang) and other firearms'.[83]

Modern research relating to the spread westwards of Chinese gunpowder technology suggests very different conclusions to the Muslim-centric perspective offered by Iqtidar Alam Khan. Sun has stressed the importance of the Ming's territorial expansion for the spread of cannon and handguns but gunpowder weapons undoubtedly reached Assam from China by land via upper and lower Burma,[84] and India by sea, prior to the arrival of the Portuguese. On coming to the throne the third Ming emperor, Zhu Di (r.1403–24), began a completely new Imperial initiative, the 'Xiafan Guanjun' or 'Foreign Expeditionary Armada'. Between 1405 and 1433 seven maritime expeditions under the eunuch Zheng He comprising several hundred vessels sailed westward along well-established trade routes in junks, some capable of carrying 1,000 tons of cargo, whose size vastly exceeded contemporary vessels elsewhere. These voyages went to Calicut, stopping at major ports en route, the fourth went on to Hormuz in the Persian Gulf and subsequent voyages went on to the Arab world and East Africa. The purpose of these voyages along known trade routes was to project Chinese power and to bring countries under Ming suzerainty. Because many of the states to be visited were Muslim, Zheng He and his senior commanders were deliberately selected because they were Muslims, as were many of the sailors. Most of the 30,000 on board were soldiers equipped with the most modern cannon and handguns.[85] The junks were referred to in Chinese sources as 'treasure ships' (baochuan) and 'jewel ships' (baoshi chuan) because they were under orders to obtain luxuries, particularly gems, for the Ming court.

The Chinese defeated the Semudera pretender Sekandar in northern Sumatra, destroyed Chen Zuyi's pirate fleet in Palembang and conquered Alekeshvara's kingdom in Sri Lanka in 1411. Zheng He took Alekeshvara to China, returning him to Sri Lanka a year later. During these voyages Calicut, described by the Chinese Admiral Ma Huan as 'the great country of the

western ocean', served as the rallying point from where parts of the fleet or individuals were dispatched to distant places. On the seventh voyage the Chinese went as far as Hormuz, Aden, Jeddah (and on to Mecca) and to Mogadishu. They brought envoys back to the Imperial court from most of the countries they had visited including Calicut and Quilon, who were feted and received presents from the emperor, and many countries became tributaries of the Ming emperor.

The commercial rise of the port of Malacca was arguably the most important development in fifteenth-century Indian Ocean commerce, made possible by the decline of the Javan state of Majapahit. Its rise coincided with the arrival of Chinese naval expeditions sent by the Yongle Emperor Zhi Di. Malacca sent envoys to China and became the port of preference for the Chinese where they traded with Javanese and Indians; the Indians, overwhelmingly Muslim, being predominantly from Gujarat, the Coromandel coast and Bengal. Many Javanese were Muslim and some Chinese converted.[86] In the Arab world Gujarati ships carried goods up the Red Sea to Cairo and Alexandria; and up the Persian Gulf to Basra and Baghdad. As a result Gujarat was in the forefront of adopting cannon and firearms and using them effectively. The Sultan of Gujarat took gunners and arquebus men from Gujarat to attack pirates at Bulsar in 1482.

'Maritime Southeast Asia became a sphere of Chinese influence as never before or even after'.[87] However, these voyages should not overshadow the more significant Ming overland expansion into south-east Asia and Yunnan. Sun suggests that the transfer of gunpowder technology was often caused by deserting or captured Ming soldiers but gifts of guns by the Ming, such as those used to exert influence over the Shan states of northern Burma, was also a factor. The south-east Asian states, like the Ottomans, were forced by military necessity to manufacture their own versions of the superior guns of their Chinese enemies.

Pyrotechnic recipes in the Orissan treatise *Kautuka-chintamani*, compiled for the Gajpati ruler Prataparudradeva (1497–1587) give gunpowder formulae of Chinese origin.[88] A Chinese cannon dated 1421 was left behind in Java. An Indian pilot who accompanied da Gama on his homeward voyage in 1499 told a Florentine noble that ships had arrived at Calicut eighty years earlier (i.e. 1419) with bombards, a clear reference to Chinese vessels. However consideration must be given to what this means in practice. The effectiveness of cannon at that time was extremely limited, the rate of fire extremely slow so that while their psychological effect when first used was considerable it is unsurprising that they were not highly regarded. While Europe and the Far East, particularly China and Vietnam, developed cannon and guns into aggressive, portable weapons, across much of India and south-east Asia they were more important as royal status symbols, fired to mark holidays and great events. As status symbols size became more important than function leading to enormous iron guns and mortars that were exceedingly difficult to move, militarily fairly useless but an essential symbol of a mighty ruler. The man in the crowd who celebrated the arrival of Vasco da Gama's ships at Calicut in 1498 by intermittently firing off his *espingarda* was acting true to form.[89] The major ports of Asia were busy international places crammed with ships of all nations. The first Portuguese sailor put ashore at Calicut by da Gama on his first arrival was taken to meet two North Africans who could speak Castilian and Genoese and who would certainly have known about firearms.[90]

The evolution of the handgun into a more effective weapon occurs in fifteenth-century Europe and owes much to the Hussites of Bohemia. In 1402 the priest Jan Hus began denouncing corruption in the Papacy and Christian Church and called for reform. His teaching was popular in Bohemia and suppressed by the Church. In 1414 Sigismund of Hungary convened a council to end the schism. Hus attended under safe conduct but was arrested and burned at the stake.

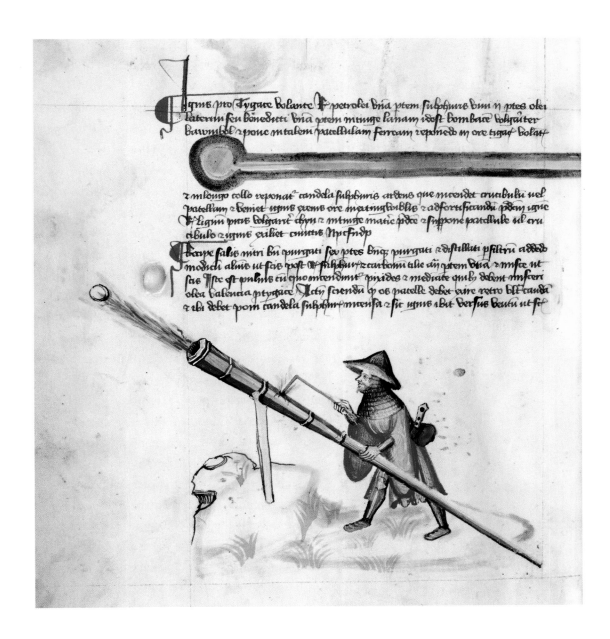

A large handgun mounted on a pole.

Konrad Kyeser, Bellifortis, 1405.

Niedersächsische Staats- und Universitätsbibliothek, Göttingen, 2° Cod. MS. Philos. 63 Cim., f, 104v.

The Czech nobility of Bohemia strongly protested and fighting broke out after Sigismund inherited the crown of Bohemia from his brother. Five anti-Hussite Crusades followed involving Germans, Danes, Poles, Lithuanians and the Papacy. The Hussites countered with raids against bordering countries, Silesia, Saxony, Lusatia, Meissen and Hungary, the Hussite Wars finally coming to an end in 1439. The Hussites were a popular movement involving many farmers, and the agricultural flail that they habitually worked with became one of the principal Hussite weapons.[91] German improvements to the corning of gunpowder[92] in the early fifteenth century improved the quality and reduced the price making hand cannons more accessible to the masses.

The Hussites' principal threat came from mounted knights so circa 1420 they developed the *vozová hradba* (Czech) or *wagenburg* (German) where large, specially constructed wagons were chained together in a circle. This tactic originated in the Chinese *dongwu che* or armoured cart of the fifth-century BC[93] and had literally rolled across Asia. Each Hussite wagon had crossbowmen, cannon (*houfnice*) and handgunners armed with *pišt'ala* in it and beneath it. The heavily armoured enemy knights were encouraged to attack these wagons and when they did so they, and particularly their horses, were shot leaving the dismounted men floundering and easily killed. Once the attack on the wagons failed the Hussite defenders would charge out and

complete their victory. Christians and Turks employed the *wagenburg* during the Hungarian War of 1443–4: as did the Crusaders under the Hungarian John Hunyadi at the battle of Varna in 1444, who were defeated by the Turks.

Skanderbeg, another innovatory Christian general, returned to Albania from Italy in 1443 and according to Marinus Barletius[94] at once added cannon and handguns to his army fighting the Turks. King Matthias Corvinus of Hungary had a standing mercenary army, the Feke Sereng (Black Army) that was extremely successful in the years 1458–94, conquering large parts of Austria and Bohemia and utterly defeating the Turks at the battle of Breadfield in Transylvania in 1479. The Feke Sereng's success was due to the fact that every fourth infantryman had an arquebus, an extremely high ratio of firearms at a time when most European armies armed only 10 per cent of the infantry with handguns.[95] King Matthias hired remnants of the Hussite army, Bohemians, Moravians, Czechs and Poles, and adopted their tactics, stationing his arquebus men behind carts or walls of pavises.[96]

A gun with a stock was first assembled in Germany where it was called a *hackenbuchse*. The German name was adopted across Europe, by the French as *hacquebute*, English *hakbut* and Spanish *hacabute*. It was used from about 1470 until the mid-sixteenth century[97] and gradually replaced the old hand cannon. A major improvement circa 1425 was the introduction of the serpentine, an S-shaped trigger that initially occupied a slot in the centre of the stock. When the trigger was pulled the arm containing the lighted match dipped and ignited the touch hole, still at this date in the centre of the barrel like a cannon. A matchlock in the Rainer Daehnhardt Collection of this type attributable to Nuremberg must date from the 1470s and certainly cannot be later than 1490.[98] Later the concept of the pan on the side of the barrel primed with powder made ignition more certain and the serpentine moved to the side of the barrel.[99] However, from habit pistols were fired tipped on their side with the pan uppermost so the ignition remained a vertical one. All the matchlocks used in the Islamic world are descended from either this Nuremberg design or snap matchlocks from Bohemia. One can see guns with the Bohemian lock being carried by Janissaries in a book illustration of c.1590.[100] Three thousand of these Bohemian guns were ordered by the court at Lisbon and many were taken by the Portuguese to Goa and further east where they were adopted in places like Japan.

King John II of Portugal became ruler in 1477 when his father retired to a monastery, and revived the exploration policy of his great-uncle, Prince Henry the Navigator. Cannon had been mounted on European ships since the fourteenth century where their primary purpose was to kill the enemy crew though ships are recorded firing on coastal fortifications. European ships' guns generally lacked the power or numbers to sink opposing vessels until late in the fifteenth century, such sinking that did occur being usually the result of fire. Sinking an enemy was not considered an option. King John is credited with introducing reinforced decks allowing ships to carry heavier guns (though small by land warfare terms) and in 1489 he introduced trained gunnery teams, further developing the concept of the broadside. His cousin Manuel I succeeded in 1495 and adopted the best central European gun technology and ordered the construction of bronze breechloading cannon of a weight not previously mounted in ships, the Portuguese favouring small ships.[101] By 1500 the Portuguese led the world in naval artillery having lured the best craftsmen, predominantly German, to Lisbon. The Portuguese Armada (navy) was the largest in Europe and was replacing its old wrought-iron cannon with more accurate bronze cannon. Heavy cannon mounted broadside were exceedingly difficult to muzzle-load and on ships the existing breechloading design was widely adopted.

THE INVENTION OF GUNPOWDER WEAPONS AND THEIR ARRIVAL IN MEDIEVAL INDIA    35

King Manuel sent Vasco da Gama to the Indian Ocean in 1498 where the Portuguese vessels and guns were unstoppable when confronting the technology available to the Muslims though da Gama found small numbers of European weapons in use. The need for Indian Ocean Muslim states to match the Portuguese in cannon and guns became even more acute after da Gama's second voyage to the Indian Ocean in 1502. He was sent 'to make war on Calicut and take vengeance on it' with ten large ships 'into which was put much beautiful artillery, with plenty of munitions and weapons, all in great abundance...'[102] Off the coast of Calicut in 1502 da Gama dramatically changed the perception and practice of naval warfare when he sank three Indian ships with only ten salvos, deliberately aimed at their waterlines. The Portuguese both outgunned any opposition and were capable of a rate of fire hitherto unknown though Correia mentions that the Portuguese were restrained from firing their cannons for lengthy periods because the recoil damaged their ships. Correia describes how the crew had 'loaded the guns with bags of powder which they had ready for this purpose made to measure, so that they could load again very speedily'.[103] He also mentions that 'the Moors also fired much artillery which they carried, but they were small guns...' With this action Portugal robbed the Muslims of their centuries-old hegemony over the richest and most important trade route in the world. Da Gama's cruelty and gratuitous violence, which included the burning on the high seas of a Muslim pilgrim ship full of defenceless men, women and children en route for Mecca, has forever stained his reputation.

Two Italians arrived the same year at Calicut where they established themselves as cannon-makers and then found they were not allowed to leave. They made between 400 and 500 cannon for the Zamorin of Calicut and trained local craftsmen in how to make arquebuses. The situation regarding gunpowder weapons was changing very fast. Faria y Souza says that the Zamorin's fleet carried 382 guns by 1503. Ludovico di Varthema (c.1470–1517), an Italian traveller from Bologna, found these fellow Italians stuck at Calicut in 1506 and plotted with the Portuguese to assist them to escape but they were betrayed by a slave and torn to pieces by a mob.

This was a time when firearms and cannon were rapidly improving in Europe, enabling the Portuguese to establish themselves in the Indian Ocean. Their efficient use of firearms forced the indigenous rulers to take greater account of guns, particularly the Mamluks. The fall of the Christian kingdoms in the Holy Land followed the coming to power of the Kurdish Ayyubids (1169–1250). Mamluks made up the core of the Ayyubid army, recruited from lands north of the Muslim states. Imported as adolescent slaves, generations of these future Mamluks at once began years of conversion to Islam and training as cavalry. This rigorous process made the furusiya hostile to anything that challenged their traditional skills with horse, bow, lance and sword on which their military and social superiority rested. As Muslim warrior converts they were bound to follow the sunna[104] of the Prophet Muhammad. The Mamluks were not blind to the firearms revolution sweeping across the Mediterranean countries. They adopted firearms some sixty years before the Ottomans[105] but with little enthusiasm, using them mainly but by no means exclusively in sieges where the horseman had no role. Archaeological evidence on this issue is unhelpful[106] but there are periodic references to guns reaching the Mamluks, such as the incident in 1451 when the French Levant trader Jacques Coeur[107] was accused in France of running guns illegally to the Mamluk Sultan Barsbay.[108] This sultan was strong enough to impose his will regarding the adoption of guns but conservatism permeated Mamluk society and efforts to introduce more effective firearm units by Sultan al-Nasir (r.1495–8), who was enthusiastic about firearms, was a prominent reason why he was disliked and assassinated.

Finally, in 1510 Sultan Qansuh al-Gawri formed a regiment of arquebusiers drawn from the lowest classes. The Mamluks contemptuously called the unit *al-'askar al-mulaffaq* meaning 'the false' or 'patched up army' and tried to close it down.[109]

In contrast, successive Ottoman sultans took an entirely pragmatic view. Having deliberately conquered the industrial centres in the Christian Balkans and converted the occupants to Islam, the Ottomans were far more open to technological innovation than the Mamluk elite and had an infinitely better industrial base to develop and manufacture guns[110] though even the Ottoman spahis despised guns. Firearms blackened the face and clothes and were not the considered the weapon of a gentleman. Neither society came near to competing with Christian Europe. The unique Mamluk social structure predestined the state to failure and firearms arrived after the state was already in economic decline. It has to be emphasised that the Mamluk distaste for gunpowder weapons inevitably had an effect on the Indian and south-east Asian Muslim world leaving it largely dependent on the firearms developed in the Far East. It is of course likely that Indian merchants brought gunpowder technology from the eastern Mediterranean though there is no direct evidence to support this.

Turkish-style firearms tactics on the battlefield won greater acceptance in the last five months of the Mamluk state but it was too late. The Cairene Ibn Ayas describes about thirty war carts being inspected by the sultan. The Mamluks' best firearms unit made up predominantly of black slaves was away fighting the Portuguese when the Ottomans invaded but the sultan put such arquebus men as he had into the carts at their final battle at Ridaniya in 1517. When the Janissaries armed with guns utterly defeated the Mamluks in 1517 the captive Amir Kurt Bay was brought before the victorious Ottoman Sultan Selim. Knowing he was to die Kurt Bay expressed his scorn at the Ottoman victory:

> …you have brought with you this contrivance artfully devised by the Christians of Europe when they were incapable of meeting the Muslim armies on the battlefield. The contrivance is that bullet (bunduq) which, even if a woman was to fire it, would hold up such and such number of men. Had we chosen to employ this weapon, you would not have proceeded us in its use. [A clear statement that the Arabs had knowledge of firearms before the Turks.] But we are the people who do not discard the sunna of our prophet Muhammed which is the jihād for the sake of Allah, with sword and lance. And woe to thee! How darest thou shoot at Muslims? A Maghribine brought this arquebus to Sultan al-Malik al-Ashraf Qansuh al Ghari [r.1501–1517 AD] and informed him that this arquebus had come from Venice[111] and that all the armies of the Ottomans and the West have already made use of it. The Mamluk Sultan ordered the Maghribine to train some of his Mamluks in the use of the arquebus, and that is what he did. Then these Mamluks were brought before the Sultan, and they fired their arquebuses in his presence. The Sultan was displeased with their firing and said to the Maghribine: 'We shall not abandon the sunna of our Prophet and follow the sunna of the Christians, for Allah had already said that if Allah helps you nobody will defeat you!' So the Maghribine went back to his country saying: 'Those now living will live to see the conquest of this Kingdom by this arquebus and that is what really happened.'[112]

This is the reason why the Arabs of Egypt and Syria had little to do with firearms, an attitude that persisted until the nineteenth century among Arabian tribes. As late as the early

nineteenth century the Egyptian ruler Muhammad 'Ali found it necessary to wipe out the Mamluks and settle the Bedouins in order to change the traditional military ethos, making possible Egypt's first modern army recruited from the fellahin. The Blunts, English travellers in northern Arabia in 1879, offered Faris, Shaikh of the northern Shammar, a modern rifle and pistol as a gift. He had enjoyed using these as a loan but declined: 'I am better as my fathers were, without firearms…'[113] This conservative attitude was mirrored by cavalry everywhere,[114] early evidence of which can be seen in the Christian reaction to the invention of the crossbow, which gave back to the low-born infantryman the possibility of some battlefield parity with the infinitely better equipped and trained knight. Significantly, the earliest references to the use of cannon in Europe show their introduction owed little to monarchs and everything to civic institutions, which presumably saw advantages in the technology without having any knightly interests to protect.[115]

In 1502 King Manuel I sent a new Portuguese fleet of twenty ships to India under da Gama with the aim of dominating the spice trade. Among the captains were the two Sodré brothers whose orders were to take their five ships on an independent patrol making war against Meccan ships. Da Gama went home in 1503 and the Sodrés ignored instructions, brutally attacking and looting Arab ships off Aden, killing all on board. They then took the fleet to the Khuriya Muriya Islands off the south coast of Oman to shelter from the monsoon and to repair the hull of one of the caravelas. They established friendly relations with the local Arabs who warned them that an impending storm from the north threatened their ships and that they needed to move them to the other side of the island. The smaller Portuguese vessels were moved but the brothers decided the large naus,[116] the *Esmeralda* and the *São Pedro* could trust their anchors. However, the storm tore the ships from their moorings and smashed them on the rocks, killing many of the crews including Vicente Sodré. The survivors salvaged what they could including seventeen cannon. Three remaining ships under Alvaro de Ataíde, da Gama's brother-in-law, were delivered to Alfonso de Albuquerque (c.1453–1515) and his cousin Francisco in India. King Manuel I had sent them to the Indian Ocean in 1503, Alfonso's first voyage to the region where he was to become famous as a great admiral, scourge of Muslims and creator of the Portuguese empire in the East. A letter from Francisco de Almeida, the first Portuguese Viceroy of India, dated 10 September 1508 describes how Malik Ayaz, Governor of Diu and bitter enemy of the Portuguese, had gone to the site of the shipwreck and retrieved many cannon including between fifty and sixty *berços*, two *bombardas grossas* and one *falcaõ*.[117] Malik Ayaz used these guns to inflict the first defeat of a Portuguese fleet in the Indian Ocean, off Chaul in 1508, killing their commander, the viceroy's son Lourenço de Almeida, who was struck by two cannonballs. Lourenço's ship was caught in fishing nets at low tide and immobilised and the entire crew were slaughtered. The viceroy at once took his revenge, defeating the joint Egyptian–Gujarati fleet off Diu in 1509.

Ottoman armies fighting Christian Europe were acknowledged leaders in gunpowder weapons throughout the Muslim world, a factor that gave them considerable prestige. In 1509 after the defeat near Diu, the Mamluk Sultan Kansawh al-Gauri applied for Ottoman assistance to build a new fleet to drive the Portuguese from the Indian Ocean. The Egyptian state was an Ottoman rival but the Portuguese threatened Muslim pilgrims, Jeddah and the holy cities of Mecca and Medina. In 1510 Albuquerque captured Goa from the Sultan of Bijapur. The Ottoman Sultan reacted the following year sending the Mamluks 300 *makahil sebkiyat* (arquebuses), 300 *kantars* of gunpowder, soldiers and materials to build ships. Firearms were also sent to the Gujaratis, the Sultan of Aceh in Sumatra, the khanates in the Crimea and Turkistan and Sultan Ahmed Gran

in Abyssinia. The Italian Manucci in India in the mid-seventeenth century reported that: 'The cannon of Aceh were particularly famed for their excellent workmanship and metal.'

Gujarati Muslim ship owners were determined to preserve their grip on Indian Ocean carrying trade and bitterly contested the Portuguese invasion. It was they who organised the defence of Malacca. In 1511 when the Portuguese captured Malacca they are said to have carried off 3,000 of the 5,000 guns supplied by Java,[118] China,[119] Siam and Burma. Albuquerque wrote that the biggest cannon in Malacca were sent from Calicut. Malacca had very strong trade links with Gujarat, Calicut, Mecca, Cairo, Alexandria and Venice long before its capture in 1511 where 'the gun founders were as good as those of Bohemia'.[120] Scholars have concluded that 'before the arrival of the Europeans the use and production of "modern weapons" were already fairly common over the Indonesian archipelago'.[121] One would expect some of the modern guns made in Malacca to be copies of Italian-supplied models. For centuries Venice had a major interest in the spice trade via Egypt (which the Portuguese were now diverting round the Cape of Good Hope) and were therefore happy to sell guns for use against the Portuguese.[122] The Portuguese Tomé Pires, an apothecary from Lisbon who travelled east to trade in drugs and spices, lived in Malacca from 1512 to 1515. He describes a regular trade in firearms from the Mediterranean to Malacca.[123]

The Ottoman sultans sent cannon and gun specialists abroad to promote Ottoman interests while others, many bearing the name Rumi, 'of Rum' meaning Istanbul, went of their own accord, offering their services for hire. For example the sultans of Gujarat employed Malik Ayaz before 1506–7, Khwaja Safar in 1507, Amir Mustafa Khan Rumi[124] and Jahangir Khan Qara Hasan in 1531. Barbosa, a Portuguese scrivener and Malayalam interpreter at Cannanore between 1500 and 1516, saw troops in Gujarat 'in wooden castles on the elephants' backs' armed with 'bows, arrows, arquebuses and other weapons'.[125] The Timurid ruler of Herat, Sultan Husayn Mirza used cannon at Hisar in Haryana, west of Delhi, in 1496. By contrast Babur used arquebuses at the siege of Bajaur on the Pakistan–Afghan border in 1519, which the defenders had never encountered before and found uproariously funny until casualties occurred which cleared the ramparts. Paes, a Portuguese visitor to Vijayanagara in south India in 1520, saw Indian troops with handguns 'and I was much astonished to find among them men who knew so well how to work these weapons'.[126] Vijayanagara used '*espingardas*' at Raichur the same year.[127]

When the Turkish Admiral Sidi Ali Reis brought his fleet to Gujarat in 1554 the ships had undergone two battles and a typhoon and their battered state made return to Turkey by sea impossible. Many of his troops took service with the Gujarati Sultan Ahmad. His captain of gunners, Ali Aga, and almost one hundred and fifty *tufeng-endaz* (arquebusiers) accompanied Reis overland to Istanbul, which they reached after two years travel.[128] At one point on the journey Reis writes that they were surrounded by 1,000 Rajputs but the *tufeng-endaz* positioned themselves behind couched camels and the Rajputs withdrew, evidence of the respect which the Rajputs accorded guns and arguably evidence of the Rajput lack of them. There is a late-sixteenth century depiction of a Turk using an Ottoman matchlock in the Ming Chinese manuscript *Shen qi pu*: and the superiority of the Turkish gun over the Portuguese is clearly stated.[129] In 1620 the Mughal Prince Khurram employed 1,000 Rumi *barq-andaz* or Turkish matchlock men in the Deccan.[130] Portuguese mercenaries were also much in demand.

German infantry armed with the arquebus became so dominant on European battlefields that the Ottoman army had to increase the number and quality of its own battlefield artillery and gun-carrying infantry to be able to contend on equal terms. To meet the increased demand for

guns and gunpowder Sultan Suleyman enlarged the state factories early in his reign. Production and import of firearms was an Ottoman state monopoly as is shown in a 1524 *kanun-name*, a secular law promulgated by the Ottoman Sultan to cover eventualities not met by Muslim Sharia (religious) law.[131] This text suggests considerable imports. The diffusion and development of Italian matchlocks was inevitable. Genoa and Venice supplied the Turks with arms and in the fifteenth century Florence and Ancona did too.[132] New Ottoman thinking in relation to cannon and firearms at this time can be seen at the battle of Mohács in 1526 when they brought 300 cannon to the battlefield, an unprecedented number, and the Janissaries first employed volley fire.[133] The ensuing Turkish victory gave them a large part of Hungary.

The artist Nicolas de Nicolay accompanied the French embassy under Baron d'Aramont[134] to Istanbul in 1551 where he drew a Janissary armed with a hackenbuchse or *tufek*, the lighted match held in his right hand, the surplus cord wrapped around his wrist. Accompanying the embassy of Ogier Ghiselin de Busbecq to Istanbul in 1555, Melchior Lorichs of Flensburg's woodcut also shows a Janissary who carries a *tufek*, but now with a serpentine on the side of the stock and also a tube sight,[135] which provide a date for the Janissary gun upgrade. European matchlocks used a bead front-sight and a standing back-sight with a notch from 1450 and the tube sight was introduced between 1525 and 1550. It occurs on Ottoman and European guns until the early seventeenth century. Another early sight found particularly on north German and Danish matchlocks from the late sixteenth and early seventeenth century comprised a long groove at the breech end of the barrel. Indian matchlocks copy this by having a top groove in the wooden breechblock behind the barrel, a detail still found in the nineteenth century. The Turks also adopted the comb peep sight, which they probably copied from the Protestant Dutch who were supplying Istanbul with shiploads of arms and munitions, the Turks being at war with their enemy Catholic Spain.

The quantity of guns being produced for European armies was remarkable, the market being international. For example, in 1570 Spain imported 6,000 arquebuses from the Netherlands and 20,000 from Italy.[136] For political reasons the Dutch and English in defiance of Spain and the Venetians supplied the Turks with cargoes of matchlocks at various times. Venetian sources report that Murad III (r.1574–95) re-equipped the Janissaries with new matchlocks, which may have been produced in Ottoman state workshops or have had a European origin. Central Asian tactics and technology were all acquired from the Ottoman Turks, guardians of the holy cities of Mecca and Medina and the most advanced Muslim military power, which had been acquired from their European wars. There is no evidence of the Ottomans themselves making any technological changes to improve the efficiency of their firearms, other than the adoption of damascus-twist barrels, a technique they acquired from their Muslim neighbours, though the perfection of the European serpentine lock has been credited to the Turks by some authors.[137] However, 'the Ottomans were able to maintain their firepower and logistical superiority against the Austrian Hapsburgs and Venetians until the very end of the seventeenth century'.[138]

In Central Asia a young prince, later known as Babur (1483–1531) meaning 'Tiger', a proud great-grandson of the Emperor Timur, was trying to recapture his father's kingdom of Fergana in modern Uzbekistan, which he had inherited in 1494 at the age of twelve. He tried several times to establish himself and each time his enemies drove him out before he could consolidate his rule. Babur had good relations with his Persian neighbours the Safavids and refused to acknowledge their enemy Ottoman Sultan Selim I as his suzerain. Because of this the Sultan

sent matchlocks (*tufek*) and cannon to Babur's rival, the Uzbek leader Ubaydullah Khan[139] who defeated Babur at the battle of Ghazdewan in 1512. The result of this battle convinced Babur that he had little chance of recapturing Fergana. However, his prospects improved in 1513 when the Ottoman Sultan planned a campaign against the Safavids and therefore sought to improve his relations with Babur with the aim of preventing Babur's army from uniting with the Persian forces. To effect the reconciliation the Sultan sent Babur Turkish firearms experts.

The Ottomans invaded Persia and at the battle of Chaldiran in 1514 the matchlock wielding elements of 12,000 Janissaries[140] defeated the Persian Shah Ismail Safavi's tribal horse archers whose Central Asian martial tradition so closely resembled that of the Rajputs. The Persian tribesmen lacking guns or cannon fought ferociously but to no avail. Despite this experience they continued to reject firearms.[141] Against their wishes Shah Ismail created a slave unit of matchlock men in preparation for a future war with the Ottomans.[142] Ottoman spies reported back to the Sublime Porte that the new Persian matchlocks were copied from captured Ottoman weapons.[143]

Babur's army of freebooters required loot or else they would disperse. Five times between 1518 and 1526 he led his small, battle-hardened army south over the mountains to India, his own goal being to capture the Punjab, formerly part of Timur's empire. The fifth time Babur had a force of 12,000 and boldly selected and prepared a defensive position with one flank protected by the town of Panipat, north of Delhi. Here he awaited Ibrahim Lodi, the most powerful ruler in north India, whose army was loosely estimated at between 50,000 and 100,000 men with 1,000 elephants. Babur's warriors had to win or die for there was no road home from defeat. Babur was assisted by two firearms experts, Ustad[144] 'Ali-Quli, an expert at making bronze mortars (*kazan*), and a Turk, Mustafa Rumi. Together they copied the Ottoman tactics at the battle at Chaldiran. At Panipat Babur massed his matchlock men and gunners in the Turkish manner and collected carts and lashed them together to provide a protective wall to prevent his forces being swamped by Ibrahim Lodi's huge army. Babur describes it as 'after the Anatolian manner',[145] the Turks themselves called it *tabur cengia* having learnt it from the Bohemians, Germans, Poles and Hungarians. Secure behind this cart wall, matchlock and cannon men worked their guns while Babur's horse archers rode out to prowl aggressively on the flanks of Ibrahim Lodi's army, raining down arrows, stinging them into attacking Babur's prepared position. Ibrahim's army had a core of professionals but mostly comprised untrained peasants. When Ibrahim Lodi was killed on the battlefield discipline disintegrated and his army fled. Babur was master of Ibrahim Lodi's fabulously wealthy north Indian empire.

Inevitably there was dissent in Babur's army over whether to take the loot and go home or stay and risk losing all. Men missed the cool, green, flower-strewn valleys of home but Babur marched on and took Agra, there distributing booty to his men, some of whom left. Several powerful armies were threatening his new empire. The most dangerous was led by Sangram Singh, better known as Rana Sanga, ruler of Mewar, the most important warrior in Rajasthan, famous for his reckless courage and eighty wounds including the loss of an eye and an arm. Rana Sanga united warriors from the most powerful Rajput clans and threatened to seize Agra and expel Babur from Hindustan so Babur marched against him. At Khanua as at Panipat, Babur chose his position and concentrated his guns and matchlock men. An account written after the battle for Babur admits his debt to Ottoman tactics: 'Obeying the cautions of prudence, we imitated the *ghazi*s of Rum by posting matchlockmen (*tufanchian*) and cannoneers (*ra'dandazan*) along the line of carts which were chained to one another in front of us...'[146]

These were no ordinary carts. The *Baburnama* says that Mustafa Rumi, Babur's Turkish artillery expert, had 'the carts (araba) made in the Rumi way, very strong and suitable'.[147] 'Suitable' because unlike Panipat where Babur commandeered local carts, these were the Chinese *dongwu che* type, armoured with thick wood,[148] now garrisoned by men with *tufenk* (matchlocks) and possibly archers too. There were not enough of these armoured carts to cover the entire front of the army, probably because the Rumi carts took time to make, so where there were gaps 'Khurasani and Hindustani spademen and miners were made to dig a ditch'. In addition, 'ropes of raw hide on wooden tripods' were set up, devices intended to neutralise cavalry. The heavy wooden tripods were on wheels so they could move as the army advanced. The *Baburnama* says it took 'twenty to twenty five days before these appliances and materials were fully ready'. The East India Company official and historian of Rajasthan James Tod (1782–1835) suggests that during this time Babur was in negotiations with Rana Sanga concerning a frontier between them. These discussions were probably to gain time to complete his preparations as the negotiator deserted to Babur during the battle. The Rajputs won the initial skirmishes and a Muslim astrologer made pessimistic forecasts. Morale among Babur's troops sank. Babur countered by declaring the war jihad and renouncing wine, a move followed by three hundred of his *beg*s and household. The battle was hard fought, the Rajputs charged with great bravery, but Babur's position held and his guns were decisive. 'From the centre our dear eldest son, Muhammad Humayun, Mustapha Rumi brought forward the caissons, and with matchlocks and mortars broke not only the ranks of the infidel army but their hearts as well.'[149] Rana Sanga, wounded again, was carried off the battlefield unconscious, dying in his fortress of Chittor in January 1528, reputedly poisoned by his own nobles who regarded a renewal of the campaign against Babur as suicidal. The battle of Khanua consolidated Mughal control over the Lodi empire.

Babur valued his matchlock men, awarding presentation daggers to Haji Muhammad and Buhlul, the best shots (*pahlawan*), on 18 December 1528.[150] Guns and carts became a standard part of Babur's army. In September 1528 Abu'l Fazl mentions a messenger sent ahead ordering troops to muster 'before the fighting apparatus, culverin, cart and matchlock, was ready'.[151] In October 1528 Abu'l Fazl reports that the Lodi treasuries captured at Delhi and Agra had been expended. Babur ordered that all stipendiaries (*wajhdar*) should contribute 30 per cent of their salary to the Diwan 'to be used for war-material and appliances, for equipment, for powder, and for the pay of gunners and matchlock men'.[152]

Given the trading connections between Bengal and China one would expect to find cannon in the former at an early date by Indian standards. Babur fought Nusrat Shah, the Sultan of Bengal on 4 May 1529 at Kharid and commented on the Bengalis' efficiency with cannon though he considered their aim was bad. Babur did not introduce firearms to India though many of his adversaries may not have encountered them before; it was the professionalism with which he used them on the battlefield that was novel.

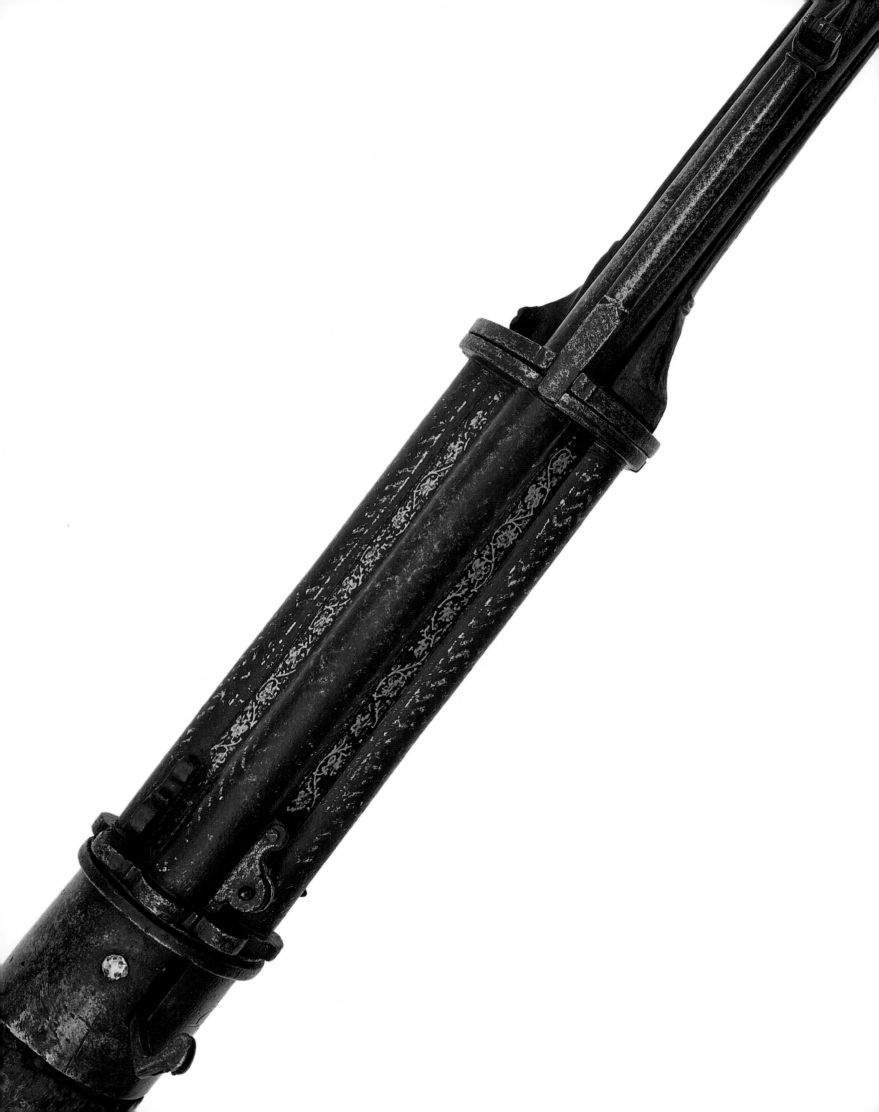

# 2 MATCHLOCK GUNS WITH REVOLVING MECHANISMS IN THE PORTUGUESE EASTERN EMPIRE

The 1843 Jodhpur Armoury Inventory lists four multishot guns as a group: '3 no. *banduks* firing four shots (*chargoliya*, literally four balls) with painted stocks. Gold work on one barrel, the other two plain. 1 no. six shot *banduk* with painted butt.' Two of these guns are still in Jodhpur:

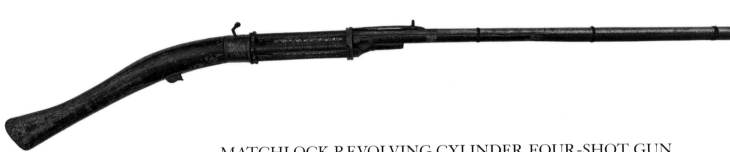

FRM/76/291

## MATCHLOCK REVOLVING CYLINDER FOUR-SHOT GUN
The Portuguese Arsenal, Goa
Second half of the seventeenth century

OVERALL LENGTH: 146 CM
BARREL LENGTH: 99 CM
CYLINDER LENGTH: 16.8 CM

### DESCRIPTION
Four-shot revolving cylinder matchlock gun. Cylindrical steel smooth-bore barrel with brass bead foresight, the surface undecorated. Provision for a ramrod mounted beneath the barrel in the European manner. Hand-turned iron cylinder with four chambers, covered with gold false-damascened chevrons and a meandering creeper (*lata*) with flowers. A flat steel spring locks the cylinder in line with the barrel and supports a rear sight. Frizzen pans with hand-operated covers. Iron serpent, trigger and nails used in the construction. Curved wooden stock painted black over a rose-coloured ground (the forestock is a modern restoration). Armoury mark SK 40.

FACING PAGE:
Detail showing chambers, sprung stay and rudimentary sight that locks the cylinder in alignment with the barrel.

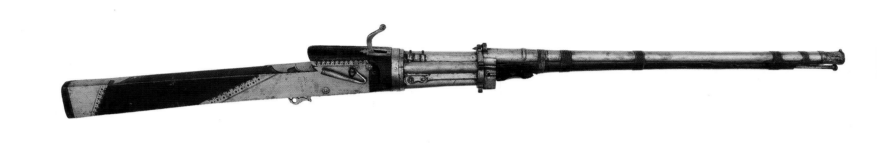

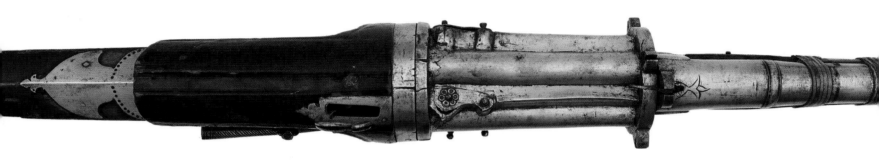

FRM/76/15
Four-shot revolving cylinder
matchlock gun
The Portuguese Arsenal, Goa
Latter part of the seventeenth
century with eighteenth- or
nineteenth-century alterations

ABOVE:
Detail showing more robust
construction of this later gun
and simplified stay. The flower
engraved at the base of the barrel
is a devotional gesture to the
Goddess, suggesting that the gun
had a Hindu owner. This gun
would have been owned by a ruler
and as the personification of God
on earth they are married to Shri
Devi, the Goddess.

# FOUR-SHOT REVOLVING CYLINDER MATCHLOCK GUN

OVERALL LENGTH: 125 CM
BARREL LENGTH: 58.5 CM
CYLINDER LENGTH: 13 CM

## DESCRIPTION

Four-shot revolving cylinder matchlock gun. Conventional Indian wooden full-stock in two parts except for the breech section, made circular to match the circular steel plates of the cylinder. The four chambers rotate on a central rod. The stop aligning each barrel is a simple swivel on top of the barrel that drops into one of four slots on the cylinder. This also serves as a rear sight.

## COMMENT

This gun was re-stocked during its working life. The decorative steel plates, trigger, match-shield tube and serpentine are all from this later period as is the gold work on the muzzle, frizzens and rivet heads. Armoury mark SK 36.

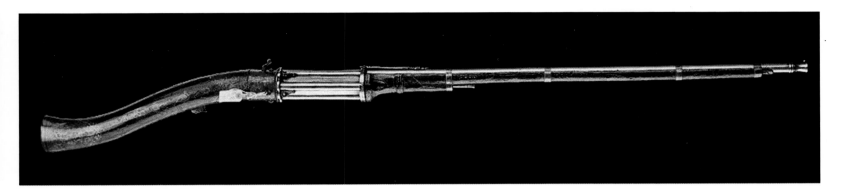

Four-shot *banduk* with painted butt
listed in the 1843 Inventory. It bears
the Jodhpur armoury mark SK 12.
Latter half of the seventeenth century.
Overall length: 142cm, revolving drum
15.5cm, barrel 80cm. The same private
collection owns SK 11, another four-
shot *banduk* from Jodhpur.
Private collection.

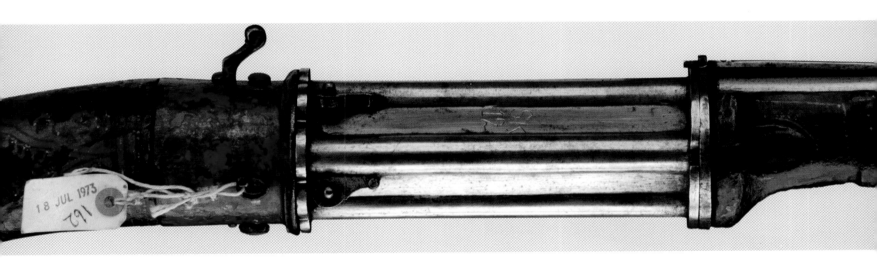

Detail of SK12 above.

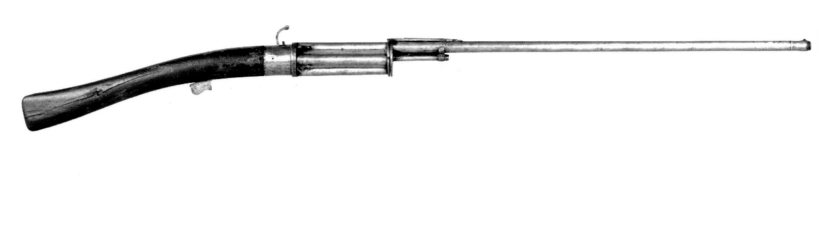

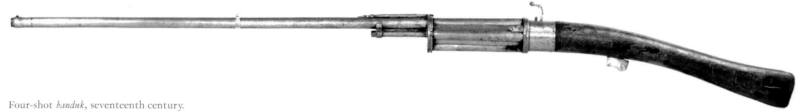

Four-shot *banduk*, seventeenth century.
It bears the Jodhpur armoury mark SK
11. Overall length: 1334mm, barrel
690cm. Private collection.

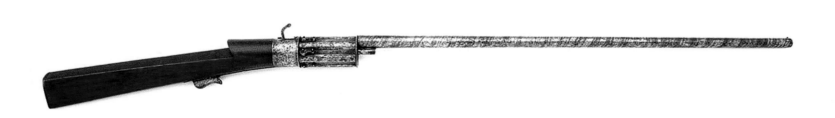

Six-shot *banduk*, eighteenth century. Overall
length: 1365mm. Barrel length 819mm.
Private collection.

# A BRIEF HISTORY OF EARLY REVOLVING GUNS

The mechanism used in these Goan revolving matchlocks originates in Europe. Many European gunmakers in the first half of the sixteenth century trained as blacksmiths, made tower clocks for their towns, the most technically demanding skill of the late Middle Ages, and went on to make arquebuses. The Swiss Kaspar Brunner is a good example, making the famous astronomical clock at Berne before becoming Master at the Berne Arsenal. In 1541 he was invited to Nuremberg to be Master of the Arsenal there. Nuremberg was the largest city in the Holy Roman Empire, famous for its metalwork, particularly armour, edged weapons, clocks and locks. Nuremberg, Augsburg and Pilsen in Bohemia were at the forefront of gunmaking in the fifteenth and sixteenth centuries. The Veronese soldier Giovanni Matteo Cicogna wrote in *Il primo libro del tratto militare* published in Venice in 1567 that: 'Arquebuses of different types are being produced in various parts of the world, the very best in Germany and Bohemia, reason for their outstanding fame. Also in Nuremberg they are producing many kinds of large, small and even tiny arquebuses with wheel-lock mechanisms as well as snap matchlock mechanisms.'[1]

Kaspar Brunner wrote a text on guns but in the sixteenth century the Gunmaker's Guild kept their techniques secret and he limited circulation to Nuremberg's councillors. Familiarity with clock mechanisms led to the concept of the wheel-lock ignition mechanism, an obvious advance over the matchlock assuming that skilled craftsmen were present to maintain the system in good working order, which was not the case in the Muslim world. A wheel-lock pistol in the Royal Armoury, Madrid, inscribed 1530, is the earliest surviving dated example but Leonardo da Vinci made wheel-lock mechanism drawings in his *Codex Madrid* in the mid-1490s and two subsequent drawings of the mechanism attributed to 1508 in his Codex Atlanticus and he is often said to be the inventor of the system. Drawings by an unknown German inventor in a book dated 1505 offer an alternative possibility. Wheel-locks reached India with Europeans but were never adopted by Indians (and very rarely by Turks) because they were too mechanically complex, difficult to maintain and speed of ignition had to be set against unreliability. With the

Snap-matchlock, Styria, c. 1525. This is the oldest gun in the Landeszeughaus. The barrel (15.7 cal.) is circular with octagonal sections at the breech and muzzle. It is stamped with two crescents, the mark of the Mürzzuschlag maker Peter Hofkircher. (1490-1557) who began working as a gunmaker c. 1524. The stock, probably contemporary, has Gothic features. Arne Hoff dates the mechanism to pre 1500. The brass lock plate is still very small and the cock-spring and sear-spring with press button trigger are still external. A stud which is part of the sear-spring protrudes through the lock plate and holds the heal of the cock in rest position. When the button trigger is pressed the stud moves with it releasing the cock. See Hoff 1969, vol. I, S.14f. My thanks to Guy Wilson for bringing this to my attention and for his image.

Inv. Nr. G 156. Styrian Armoury - Universalmuseum Joanneum GmbH

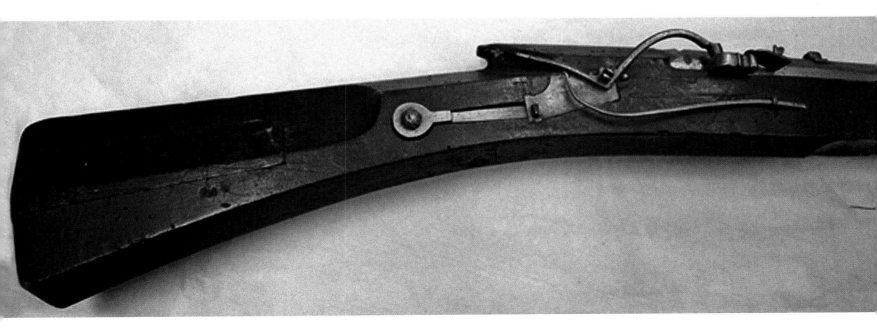

matchlock it was merely necessary to blow on the lighted end of the match to remove the ash before firing.

Nuremberg and Augsburg were major trading towns on the road between Italy and northern Europe and their products were exported and copied; consistency of design cannot easily be maintained and the attribution of dates is exceedingly difficult. The Turks obtained matchlocks from many differents sources, most captured or traded. Woodcuts show both Nuremberg and Bohemian matchlocks being carried by Ottoman soldiers. Nuremberg guns appear to have been copied by the Turks because the Iranians, who had hitherto despised firearms, copied these Turkish guns after they were defeated by the massed firearms of the Janissaries at the battle of Chaldiran in 1514.[2] The Nuremberg design then passed to Muslim states across northern India. The Bohemian arquebuses used a button on the side of the lock-plate that served as a trigger. Bohemian guns were recognised in Europe as being the best and Portugal bought 3,000, some later used for the conquest of Goa and taken by them further east as the Portuguese empire expanded.[3] Matchlocks found across the Muslim world, reflecting whoever brought firearms to different countries in the early seventeenth century, are the prototypes of most guns east of Turkey in the sixteenth century.[4] India, with the partial exception of Portuguese Goa used the Nuremberg design. In 1510 the Portuguese admiral Albuquerque captured Goa. Gaspar Correia in his *Lendas da India* says that the Goan Arsenal was filled with 'a great number of metal guns, and a large quantity of gunpowder, saltpetre and utensils used in the making of these, and an enormous quantity of all kinds of weapons', 'which the Turks had brought from the defeat of Dom Lourenço at Chaul' in 1508.[5] Did 'utensils' include European tools enabling the Goans to make screw breech plugs: because uniquely in India they acquired this skill shortly before Albuquerque seized the town. Goan metalworkers copied Turkish or European guns during the rule of the Muslim Adil Shahs and it was a fully functioning arsenal that the Portuguese took over and expanded. Albuquerque records his admiration for the skill of Goanese cannon makers and gunsmiths in letters to King Manuel I of Portugal: 'I also send your Highness a Goan master gunsmith; they make guns as good as the Bohemians and also equipped with screwed in breech plugs'.[6]

The earliest metal screws used for furniture-making occur in fifteenth-century Europe but these were handmade with a file until the eighteenth century. The screw breech plug was a European feature invented in the later half of the fifteenth century, replacing cast or forged one-piece barrels. It is not found on Indian matchlocks where the plug was welded in place until the nineteenth century because they lacked the ability to cut threads. Thévenot who travelled in India for thirteen months between 1666 and 1667 derided Indian attempts at fashioning screw threads:

> The Indians of Delhi cannot make a screw as our locksmiths do: all they do is fasten to each of the two pieces that are to enter into one another some iron, copper or silver wire, turned screw-wise, without any other art than of soldering the wire to the pieces…[7]

Abu'l Fazl, circa 1590, describes how the breech was closed in Hindustan: 'When a barrel is completed lengthways, before the transverse bottom piece is fixed to it, they engrave on it the quantity of its iron and the length, both being expressed in numerals.' At a later stage 'they are taken out and closed, by the order of His Majesty, with a transverse bottom piece'.[8]

A consequence of Muslim efforts to drive the Portuguese from the Indian Ocean was changes to weapons and warfare in the subcontinent and south-east Asia. The Ottoman Sultan

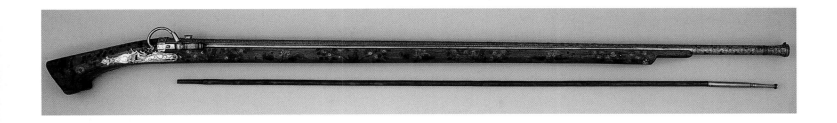

Mid-sixteenth century Goan matchlock, given by Francesco I de' Medici, Grand-Duke of Tuscany to Elector Christian I of Saxony in 1587. Watered steel barrel, niello and damascened brass; wooden stock, carved, painted and varnished; iron pan and pan cover, lock plate; serpentine and mountings nielloed silver. Overall length 164,2 cm; barrel 136,6 cm; bore 14 mm; weight 6320 g; Inv.no. G 1116 © Rüstkammer, Staatliche Kunstsammlungen Dresden. Photo: Carola Finkenwirth

Selim I negotiated with Sultan Muzaffar II of Gujarat concerning a joint attack on Goa but died in 1520. His son Sulaiman continued this policy. An enormous Turkish bronze cannon in the Tower of London, one of a number sent to India in the Turkish expedition of 1538, bears an inscription that expresses this policy:

> Sultan Sulaiman ibn Salim Khan, may his victory be great, Sultan of the Arabs and non-Arabs, ordered this gun to be made in the way of God to vanquish the foes of the State and the Faith, the infidels who enter the land of India, Portugal the accursed; in Cairo the preserve [of God] the year 937 (AD 1530–1).[9]

The Turkish governor of Egypt sent a fleet into the Indian Ocean to fight the Portuguese in 1537–8, which was defeated. Some of these Turks may have found their way to south-east Asia where the Portuguese encountered Muslim armies led by Turks. Fernão Mendes Pinto says that the Sultan of Aceh sent four ships to Egypt laden with pepper in 1538, which returned with several hundred Turkish soldiers. Aceh probably received the most modern firearms at that time if they did not already possess them. Aceh again sent envoys to the Ottoman court at Istanbul in 1563 seeking aid against the Portuguese and the Sultan responded, sending gunsmiths and artillerymen, probably in 1564 and certainly in 1568.[10] The Sultan of Aceh wrote to the Ottoman sultan: 'The eight artillerymen whom you have sent previously arrived here and are as precious as mountains of jewels to us.'[11] The Muslim Deccani states of Golconda, Bijapur and Ahmadnagar defeated Vijayanagara in 1565, a Portuguese ally, and proceeded to attack Goa. Golconda allied with Aceh against the Portuguese in 1590, sending arms and men.

In his list of the arms available to the Portuguese in India in 1525, commissioned by Governor de Menezes, mention is made of the need for *espingarda*s 'that may be proved there [in Portugal] because those that came in the year 1524 have in great part burst'.[12] Attempting to make Goa less reliant on guns supplied from Portugal and equipped to face any attack, a later viceroy ordered the manufacture of so many firearms in the 1540s that the arsenal, one of the biggest in the world, was renamed 'House of Ten Thousand Guns'. A mid-sixteenth century Goan-made gun is listed in the Dresden Rustkammer inventory of 1606.[13] From Goa the Portuguese supplied weapons to Indian, south-east Asian and to Far Eastern non-Muslim rulers they hoped to influence[14] but they rejected the Mughal Emperor Jalal-ud-din Akbar's request for cannon from Goa or Chaul, transmitted through the Jesuit Jerome Xavier.[15] Individual Portuguese sold their personal guns privately, as occurred in Japan. Because Japanese copper was very plentiful, Japanese and Korean gun locks were made of copper alloy while the Dresden gun and most European and European-inspired locks were made of iron or steel.

Gunpowder weapons are thought to have reached Japan from China by about 1270 AD. The Japanese called these teppo (鉄砲) literally 'iron cannon'. The Japanese adopted Chinese

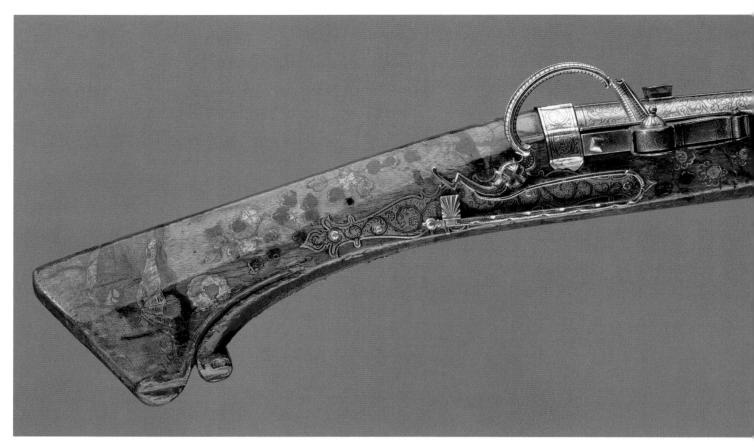

Detail showing lock and stock
© Rüstkammer, Staatliche Kunstsammlungen Dresden
photo: Elke Estel/ Hans-Peter Klut

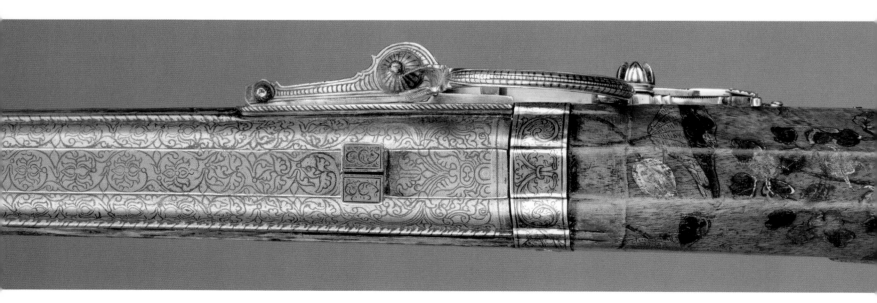

Detail showing rear sight, similar to those found on later Indian matchlocks. The chamber does not swell in the manner of other Indian barrels indicating the superior gunpowder used in Europe and by the Portuguese in India. However, the inlaid design on the barrel is a forerunner of the simpler designs on many of the later guns in this group. The distinctive domed cover is also used on later South Indian guns.

© Rüstkammer, Staatliche Kunstsammlungen Dresden,
photo: Elke Estel/ Hans-Peter Klut

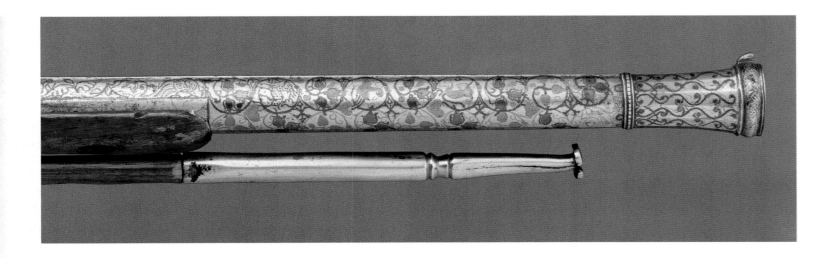

Detail showing barrel
© Rüstkammer, Staatliche
Kunstsammlungen Dresden, photo:
Elke Estel/ Hans-Peter Klut

gunpowder bombs but cannon were not much used in Japanese warfare until the sixteenth century. In 1543 a storm at sea drove a junk with Portuguese passengers to take shelter at the Japanese island of Tanegashima. The islanders were very impressed by the Portuguese snap matchlocks and the local lord, Tanegashima Tokitaka, bought two and put his swordsmith to work making more. The matchlocks brought by chance to Japan had a serpentine that snaps forward and may well have been Venetian[16] or Venetian copies made in Malacca. The swordsmith was unable to make the screw breech plug, an unknown technique in Japan, and it was not until the following year when the Portuguese returned with a gunsmith who showed how this was done that the first Japanese gun was successfully completed, a fact confirmed by Japanese sources. They immediately made large numbers of snap matchlocks with forward falling serpentines and these guns, known by the name of the island, were copied for three centuries by the Japanese without any effort to improve the late fifteenth century lock mechanism. Guns continued to be made in Kyushu but in the late sixteenth century Kyoto and the port of Sakai[17] became important production centres. The arms historian Hyeok Kweon Kang said that: 'The Chinese received the screw in breech design directly from the Japanese by 1548, and left drawings of screwed breech plugs in military manuals. These texts were taken to Korea by 1595, helping Korean gunsmiths to build their first breech plugs. The Korean word for the screw breech came from these Chinese texts, but it seems that they learned to make them from Japanese prisoners-of-war working in Korean arsenals at the time.'[18]

A drawing shows a three-barrel *ladenbüchsen* or hook gun, made for the Emperor Maximilian I, c.1500–10, but this required the user to apply a match by hand to each barrel.[19] European guns with hand-revolved multiple barrels though rare became increasingly common[20] and by the last third of the century the multishot revolving cylinder matchlock with a single barrel existed. Two German eight-shot revolvers made in Nuremberg survive, one c.1580[21] and another dated 1597 bearing the spur stamp of the maker Hans Stopler.[22] Sophisticated guns of this kind made splendid gifts between Hapsburg rulers. In Portugal there are several guns with revolving cylinders, even with superimposed charges in the revolving cylinders, from the second half of the sixteenth century. These had to have hand-operated sliding or pivoting covers over the pans to keep the priming powder in place, a detail previously introduced on wheel-locks. Lisbon guns with this mechanism were taken to Portugal's overseas possessions.

A revolving three-barrel pistol in the Doge's Palace Museum, Venice,[23] almost certainly the '*schioppo da serpe con tre cane*' listed in the 1548 inventory, has an identical pan cover to

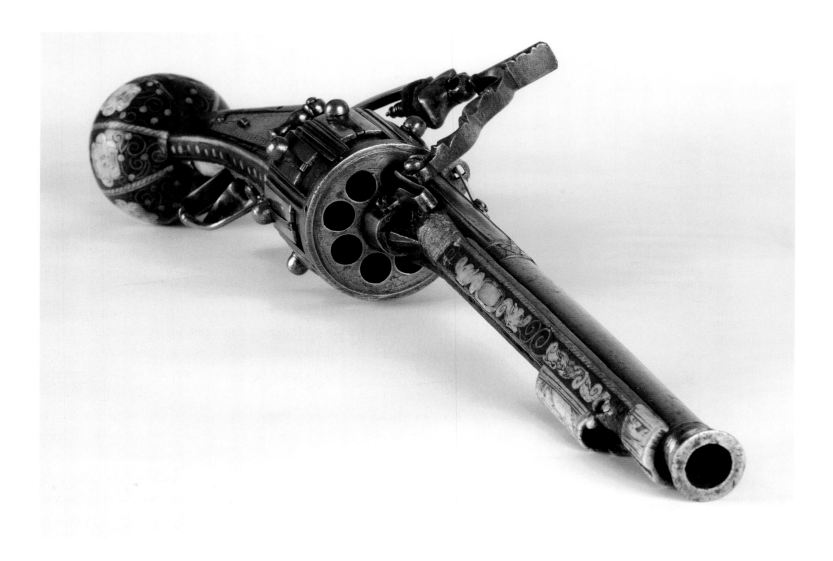

Nüremburg eight–shot revolver dated 1597 bearing the spur workshop stamp of Hans Stopler. Maihaugen Museum, Lillehammer, Norway.
Camilla Damgård, Maihaugen

the early Asian–Portuguese four-barrel pistol or *tapancha* attributed to late sixteenth- or early seventeenth-century Goa in Jaipur.[24] A four-barrel gun of this type from Goa in the Royal Scottish Museum, Edinburgh has muzzles of late sixteenth-century form and dates from the beginning of the seventeenth century if not earlier.[25]

In 1557 the Chinese authorities finally allowed the Portuguese to settle in Macau in return for an annual payment, creating a triangular trade between China, Japan and Europe. The Portuguese viceroy in Goa sent a gift of arms made in Goa to the Emperor of Japan in April 1588. This included two double-handed swords, two complete suits of armour, two horses with saddles and garnitures and two pistols, all richly decorated with gold. One would expect the pistols to be fine examples, which makes it likely they were the Anselmo flintlock.[26] There is a revolving three-barrel Japanese gun in the Smithsonian Institute, Washington attributed to the early seventeenth century.[27] The *Shen qi Pu*, a Ming Chinese gunnery manual from 1598 describes and illustrates several revolving matchlock models; some with one lock mechanism and two or three-barrels, others with multiple sets and combinations.[28] Where did these designs originate?

The European system of revolving barrels was in due course replaced by a revolving cylinder though this made the barrel less gas tight, adversely affecting the gun's power. Lieutenant Rice, author of *Tiger Shooting* (1857), tried an antique Goan revolving gun on the corpse of a tiger and judged the result only likely to enrage the animal rather than kill it.

Fath Allah Shirazi, described in the *Akbarnama* as 'the Learned of the Age', was an intellectual Sayyid who was enticed to leave Persia for the court of Ali Adil Shah in the Deccan. On Adil Shah's death in 1578, the Mughal Emperor Akbar invited him to assist Todarmal, the Finance Minister, with land revenue reform in the empire, awarding him the title Amir al Mulk. Best known for all aspects of natural philosophy, particularly mechanics, Abu'l Fazl said of him: 'If the books of antiquity should be lost, the Amir will restore them.' He was one of Akbar's favourites, portrayed in a contemporary text as 'a worldly man' of giant strength who often ditched science 'to accompany Akbar hunting with a gun on his shoulder and a powder bag at his waistband'. He is said to have introduced improvements to Akbar's firearms[29] but Abu'l Fazl, with whom Fath Allah Shirazi was on excellent terms (Fath Allah taught Abu'l Fazl's son), tactfully attributes these to the emperor in his matchlocks chapter in the *A'in-i Akbari*: 'Guns are now made in such a manner that they can be fired off, without a match, by a slight movement of the cock.' This description does not match the snap matchlock or the European wheel-lock system and furthermore Indian guns mounted with a wheel-lock mechanism are virtually unknown. This is a reference to a Portuguese Anselmo flintlock mechanism.[30] The flintlock was a Portuguese invention, created in the Royal Arsenal at Lisbon by a German gunmaker between 1530 and 1550, some forty years before it was copied by French gunsmiths.[31]

Akbar also had a multishot gun said to be the work of Shirazi but it is likely to have come from the Portuguese and to have had a revolving system. Superimposed loads, where the barrel is loaded twice with one charge lying above the other with the intention of firing two separate shots, do not give 'multishot' results being usually limited to two. Akbar met Portuguese merchants at Cambay during the siege of Surat in 1572 and the following year Abu'l Fazl records that he met others who showed him European products. Akbar was so eager to own European items that he sent Hajji Habibullah Kashi to Goa with instructions to bring back 'choice articles' and any master craftsmen who would accept his generous terms. One can only speculate on the likely influence of all this on Mughal gunmaking. Fath Allah Shirazi died in Kashmir in 1589, and surviving multishot Goan matchlocks with Indian stocks all date from after Akbar's death in 1605.

Most of the Indian-made seventeenth-century revolving multishot guns under consideration are from the same workshop, almost certainly in Goa. Arguments have been put to the author that these guns were made in Portuguese Sri Lanka, the Portuguese having arrived there in 1505. Barbosa wrote ten years later that when the Portuguese first reached Sri Lanka they found that: '…the natives of this island, as well Moors as Heathen, are… extremely luxurious and pay no attention to matters of weapons, nor do they possess them…'[32] However, the Sinhalese had at least one cannon though it appears it wasn't used for war. Father Fernao de Queyroz S. J.[33] (d.1688) relates that when arrangements were made for the first Portuguese envoy to visit the King of Kotte, the king recalled that the Chinese had invaded his country in 1411. Knowing that his capital was not far from the coast and dangerously exposed to an invader, the king arranged for the envoy's Sinhalese guides to take him marching hither and thither through the toughest country available for three days to give the envoy the impression that the city was far distant. The envoy was taken across the same river in various different places but was not fooled because a cannon in the city was fired at intervals to give the inhabitants the time and the envoy recognised the repeated sound. Diogo do Couto (1542–1616) explains: '…at that time there was not a single firelock in the whole island, and after we entered it with the continual use of war that we made on them, they became so dextrous as they are today and

came to cast the best and handsomest artillery in the world and to make the finest firelocks and better than ours…'[34] Pyard, a French traveller in 1605, described Sri Lankan-made guns as the finest in India, even superior to those of France.

There is no good reason why guns with this mechanism could not be made in other Portuguese bases but the fact that most examples are found in Indian armouries suggests they were made in India. Sri Lanka adopted the miquelet at an early date, one of the few places east of Persia to do so. If these guns, copied from European examples, were made in Sri Lanka they would presumably have used miquelet locks. Early Sri Lankan guns have trigger guards, further evidence of European influence though the Sri Lankans added spiritually protective decoration to their guns as they did to other arms.

All the revolving cylinder guns are small bore, particularly when compared with standard Indian barrels. Most have similar inlaid silver decoration on the barrel, which is not an Indian design, presumably added under Portuguese supervision. Also supportive of an Indian origin for these guns are their Indian painted stocks, which are the standard sixteenth- and seventeenth-century finish for these guns. The *A'in* describes Akbar's guns being one of nine colours and the *Hamza Nama* shows plain and floral painted stocks. Payag's painting of Shah Jahan with his matchlock (c.1630–45) in the *Nasir al-Din Shah Album*[35] shows floral painting on the stock (See Illus p. 76). The mid-sixteenth century Goan matchlock in Dresden has a painted stock. The revolving cylinder guns were probably made to present to important Mughal courtiers and were status symbols as they were in Europe. King Louis XIII of France (1610–43) had matchlock revolvers in his *cabinet d'armes* and two fine guns using this system made c.1620.[36]

A fine example of these Indo-Portuguese guns with gold inlay is in the Lisbon Military Museum, part of the R. Daehnhardt Collection. He describes it as a four-shot rotating cylinder gun from the third quarter of the seventeenth century with a *de patiba* flintlock. Another of the same date with the same type of lock has three rotating barrels taking superimposed loads giving six shots in total.[37]

One of these Indian guns is in Albert Hall Museum, Jaipur,[38] attributed to 'Bikaner, seventeenth century'. This gun has a large Bosnian-Turkish barrel with a dragon muzzle dating from the second half of the seventeenth century,[39] probably captured by the Portuguese from one of the many Balkan mercenaries in Algiers and shipped to Goa for disposal. The dragon muzzle is found on early sixteenth-century German and Italian barrels though usually given an Italian provenance. The mechanism is similar but a later evolution of the Jaipur pistol. The silver decoration on the Albert Hall gun dates from the late nineteenth century when it was common on talwar hilts as, probably, does the painted stock, suggesting the gun was decorated in the late nineteenth century for display purposes.

There is another of these guns in the armoury in Bikaner[40] but the barrel is missing. It is similar to the Jaipur pistol, with an identical trigger. Another six-chamber gun is in the Wallace Collection which has a pure Goan stock with clumsy bone inlay but the ramrod arrangements are European. It has a pan cover with a turned iron 'peg' to assist opening. The peg is identical to those found on European matchlock pan covers from the period 1520–1560 through to tricker locks (also called a trigger lock, a matchlock mechanism that uses a trigger) of the 1690s. This detail may not solve the date of the gun but it does show an entirely European design detail. This gun was originally placed in the Wallace Collection's European Armoury before the arms historian A. V. B. Norman reassigned it to 'India, probably seventeenth century' in 1964.[41]

Another six-shot example was in the C. G. Vokes Collection with a Devanagari inscription and a Samvat date equivalent to 1689 AD.[42] The Victoria and Albert Museum Reserve Collection has one with the owner's name in Devanagari: 'Shree 108 Prathi Singh Samvat 1745'. The Samvat date corresponds to 1688 AD. 'Prathi' is a mistaken reading, being feminine and meaning 'blessed'. Another name has not been read, probably the maker, the translation problem due to a Portuguese name being rendered in Devanagari. The use of a carbine would be consistent with European gun development but alien to the Indian matchlock tradition until the latter half of the eighteenth century. '108' is added to a Hindu ruler's name as a mark of profound respect, here proving the royal ownership of the gun and underlining its importance. Since it is unlikely that a ruler would be presented with an archaic gun the royal connection makes it likely that the date relates closely to when the gun was made.

A Goan example with a later Turkish stock inset with circular ivory rondels and brass studs is in the Askeri Muzesi, Istanbul, mistakenly catalogued as Turkish.[43] Another sold in auction, has a four-shot revolving chamber and a 12-mm calibre barrel.[44]

To sum up, there are enough of these guns to suggest that there was a workshop producing them and Goa is the most likely place in India with the technical expertise and production facilities to produce a run of such guns over perhaps half a century since they are clearly of differing dates. Dating is complicated by the possibility that some of these guns may not have the original stocks. There is general consensus that they were made in the seventeenth century but nothing more specific has been argued though there are dates on two that place the guns in the late seventeenth century. Two revolving matchlocks of this Goan type were consigned to Czerny's auction house in Italy in 2015 and offer the possibility of fresh evidence to date this group of guns. The French vendor came from a family with a history of colonial service in Indochina and these guns have Far Eastern features. These two guns differ little and were made in the same workshop. Both are now owned by American collectors.[45]

Weight: 13 lb 12 oz
Bore diameter: 0.47
Barrel length: 35¾ in.
Internal chamber length: 7 in (from mouth to touch hole)
Chamber tubes, each with a wall thickness of about 3/16 in.
Cylinder length: 8 in. (external)

DESCRIPTION

Single-barrel, manually rotated, cylinder gun with five chambers. Like the Goan guns a thick leaf spring screwed to the top of the barrel acts as a stay, its extremity engaging notches cut into the raised front rim of the cylinder, aligning chamber and barrel. However, these guns differ from the usual Goan cylinder having a metal jacket over the cluster of chambers that is braised to the disc at either end of the cylinder. The jacket creates a good surface for decoration. Any assumption that this is a modified Goan gun is not sustained because the gun cylinders are longer than all the Goan examples and unlike the Goan examples, the cylinders taper slightly towards the muzzle.

The lock is an eastern copy of a late seventeenth-century northern European trigger lock. The trigger lock was introduced in European matchlocks in the late sixteenth century. The simple sear-lever matchlock was too easily fired accidentally by the slight

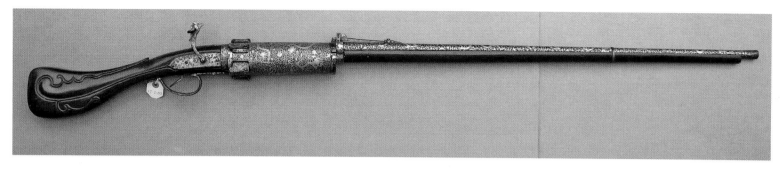

A five-shot version of the 'Goan' cylinder gun probably made in Indochina, one of two very similar guns originally from the same workshop, now in private collections in the USA. These guns have local copies of late seventeenth century northern European trigger locks.

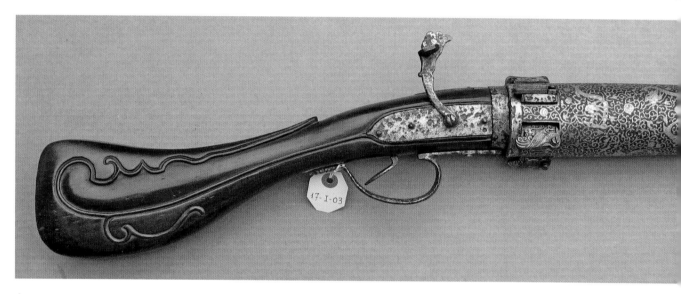

The Far Eastern stock made of huali wood.

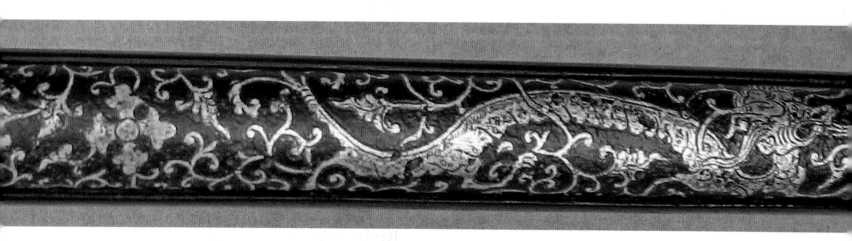

Decoration on the barrel. Note the Cross of Avis which appears on both Far Eastern guns.
17-1-03ca bbl

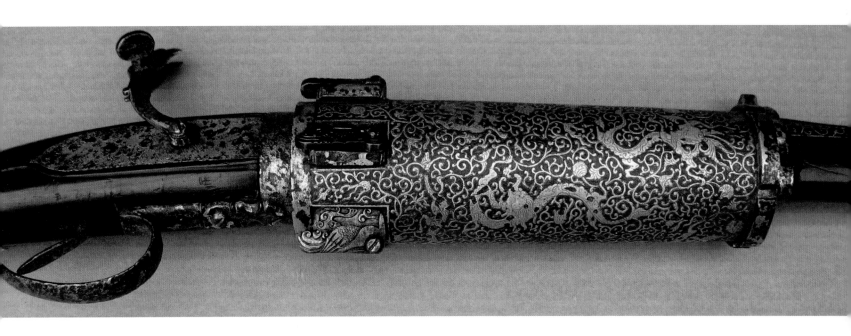

The cylinder has seventeenth century Far Eastern dragons and arabesques. The pan covers have a carefully executed but stylised chiselled design that has not been identified.

depression of the lever that hung under the stock, which had been derived from crossbows. The trigger system remedied this, the trigger acting on the right-angled end of the sear, the trigger now being protected by a trigger guard. In the second half of the seventeenth century the trigger lock matchlocks had lock plates like those found on flintlocks. The lock plates on the guns being examined have never been decorated in the manner of the cylinder and barrel with Ming-style Chinese dragons, an omission that suggests that the lock was fitted well after the gold and silver decoration was added. The two revolving matchlocks under discussion are wrapped in an iron sleeve, a Far Eastern detail, like the barrels of the 'three eyed gun'.

Both have stocks made of valuable *huali* or *huanghuali* wood known as fragrant rosewood (*Dalbergia odorifera*), common in the southern Chinese regions of Fujian, Hainan, Zhejiang and Guangdong.[46] Huali wood was used extensively for making furniture in the late Ming and early Qing dynasties.

Our research into the origins of these two handguns starts from the Indochina provenance.

Following Vasco da Gama's discovery of the route to Asia at the end of the fifteenth century, the Portuguese reached the Vietnamese coast and settled in Da Nang[47] in 1517. Fernão Mendes Pinto states that commercial relations were established by 1540 between Patani, Cambodia and Cochinchina and the Portuguese. The Portuguese were followed by Dutch, British and French trading vessels. In seventeenth-century Vietnam the port city of Hoi An (Faifó) nineteen miles from Da Nang, was the most important international centre in Vietnam with a wealthy Japanese population. The port had strong connections with China and among other commodities imported cannon from Macau and sulphur, saltpetre, lead, copper and silver from Japan. As early as 1596 Chen Yan demonstrated to the Ming court the superiority of barbarian matchlocks (*niaochong*), which had twice the range of Chinese matchlocks.[48]

In 1622 the Dutch attacked Macau and the Portuguese began to improve their defences, sending deputies to Goa seeking a garrison of 300 soldiers. Dom Francisco de Mascarenhas, the first Governor of Macau,[49] established a foundry at Chunambeiro, next to the Bom Parto Fort, and contracted with two 'Chinas' to cast cannon.

Francisco Dias Bocarro, described as the first Portuguese gun founder in Goa, retired in 1587 and was succeeded by his son Pedro Dias as master. His son, Manuel Tavares Bocarro, greatest of this family of cannon-casters, worked as an assistant at the Caza da Fundição (Foundry House) before being sent to Macau in 1623. In 1626 the Macau foundry was freed from management by 'two Castilians' and Manuel took charge of what became 'the main source of supply for the Portuguese forts and fleets in India' where iron and bronze cannon were manufactured.[50] Manuel's cannons were all dedicated to saints.[51] The chronicler António Bocarro described Macau in 1635: 'This place has one of the world's best cannon foundries, whether of bronze, which has been here a long time, or of iron, which was done by order of the Viceroy Count of Linares. It's where artillery for the whole State (of India) is continually cast, at a very reasonable price.' Macau cannon owed their superiority to the import of high quality Japanese copper.

Macau also supplied the Ming dynasty with large cannon (by Chinese standards), the first four being sent in 1621 on the recommendation of Chinese Christian converts. The Ming called these 'red barbarian', *hongyi* cannon. In 1623 four Portuguese gunners from Macau and European cannon were sent to reinforce garrisons beyond the Great Wall. A further 200 gunners from Macau under Goncalves Texeira and Antonio del Capo were hired by the Chinese in 1630. The Ming dynasty had used firearms to drive out the Mongol Yuan dynasty and under the Ming firearms developed, giving them a great advantage over their neighbours. The Ming became increasingly reliant on Portuguese military assistance[52] but their successors the Qing (1644–1912) had no such advantage as the Burmese and Vietnamese were also able to acquire European guns.

A Jesuit delegation left Macau for Vietnam on 29 December 1621 and reached Faifó on the 5 January 1622 from where they went to Hue for an audience with the king.

> On the third day, the king came to visit us dressed in our manner in garments we had taken as gifts. We visited the orchard and the armoury, which is not very heavy but is well equipped. He told us about a house in the middle of a field where cannons are used for target practice. He ordered the practice to start and many hit the target afterwards with a gun manufactured in Lisbon.[53]

Vietnam was ruled by two competing families, the Nguyen lords in the south and the Trinh lords in the more populous north. In the civil war that began in 1627 the larger Trinh army was unable to defeat the Nguyen army to the south because the latter had acquired Portuguese artillery which they used very ably. The Portuguese missionary Christoforo Borri wrote in 1620 that the Nguyen acquired excellent modern Portuguese and Dutch cannon from shipwrecks, which encouraged them to challenge the powerful Trinh. He also wrote that their skill with these cannon surpassed the Europeans so that European ships kept their distance from Cochin vessels.[206] There was a gun foundry at Hue, the Annamite capital, in 1615 where an area of the town was called 'casting quarter'; eighty workmen are recorded in 1631, a large industry. An Indo-Portuguese, João da Cruz (1610?–82),[55] believed to have been born in India,[56] worked at this foundry and cast cannon for the Nguyên lord Hien Virong (r.1648–87). This ruler was noted for his interest in weaponry and Laneau who visited in 1683 was assured by a minister that the king 'highly praised the cannons made in India'. What the king meant by India in this context is not clear. The Nguyen sent 3,000 kg of copper to the Portuguese foundry at Macau to cast cannon in 1651, suggesting that they lacked local capacity to fulfil the order where da Cruz worked.[57] Manuel Bocarro was Captain General of Macau from 1657 to 1664.

Two cannon outside the Ministry of Defence, Bangkok are inscribed: 'For King and Great Lord of Cochinchina, of Champa and of Cambodia, Ioão da Crus fecit 1667' (and 1670 respectively). Borri comments that visitors to Vietnam were obliged to supply arms to gain trade concessions.[58] This was particularly the case with the Nguyen who relied on their guns and cannon to repulse the more numerical northerners. In practice the Portuguese backed the south and the Dutch the north.[59] João da Cruz became Master of the Royal Foundry and his son Clemente succeeded him.[60] Seven Trinh offensives between 1627 and 1672 failed, after which Vietnam was effectively divided into two parts. Seventeenth-century travellers all mention the excellence of the Nguyen army. Alexander de Rhodes mentions 600 matchlock men and many war elephants.[61] Borri, resident in Cochinchina 1616–21, says the Nguyen imported a large quantity of Japanese swords, known for their quality.[62] The Tokugawa shoguns suppressed trade between Nagasaki and Macau in 1639 because they objected to the activities of Spanish missionaries but the Macanese and Japanese merchants made alternative arrangements, much to the benefit of the port of Faifó. Macau cannon were superior to cannon elsewhere including Europe because of their access to Japanese copper, considered better quality than European, together with the skilled casting of Manuel Bocarro.[63]

In 1640 the Guerra da Restauraçã began, Portugal's war of independence from Spain. When the news reached Macau in 1641, 200 cannon were sent to Portugal as a present for King John IV.[64] A Portuguese galleon, the *Sacramento*, sank in 1647 while sailing from Goa to Lisbon with a cargo of bronze Bocarro cannon cast in Macau.[65]

In 1750 the French merchant Pierre Poivre reported that the Nguyen court had some 1,200 bronze cannon of various calibres, some bearing the Portuguese or Spanish coat of arms while locally made cannon resembled dragons, sphinxes, and leopards. Early Portuguese records relating to cannon in Sri Lanka refer to Nags, Camels, Falcons, Lions, Serpents, Basilisks, Savages, Culverins, Bombards, Pedreiros, Spheres, Roqueiros, Passamuros, Mortars and Berços.[66] Pre-Portuguese Malacca cannon appear to have been highly ornamented bronze culverins, introduced from Gujarat and China.[67] The Malacca Sultanate was a tributary state of the Ming dynasty and as a result of the Portuguese seizing the state the latter were barred from establishing relations with China for many years. Malacca's importance lay in the fact that seaborne trade between China and India passed through these straits. The town contained merchant communities of Arabs, Persians, Turks, Birmanese, Bengalis, Siamese, and others. Dutch superiority at sea forced the Portuguese to abandon their slow, lightly armed 'Great Ships' in favour of smaller, fast sailing galliots. In 1641 the Dutch took Malacca from the Portuguese. Dutch control of the straits reduced contact between Goa and Portuguese territory in the Far East. The Dutch also gained control of Malacca's famous gunmaking workshops. Conflict with the Dutch induced King Charles II of England in 1663 to send 100 made-to-order English military flintlock muskets to the Sultan of Bantam, Abulfatah Agung, who was fighting the Dutch in Java.[68]

Many people commented on the Vietnamese skill with metal:

> The Vietnamese craftsmen's manual dexterity, skill, and perseverance were favourable traits for the development of technology. They managed to obtain important achievements through very simple means and extraordinary patience. Great adapters rather than creative artists, they were capable of imitating very closely the most curious things ever fabricated provided they could have the proper materials. In his

Phủ Biên Tạp Lục (*Frontier Chronicles*; 1776) Lê Quý Đôn spoke admiringly of the family members of an artisan, Nguyn Vn Tú, working for the Nguyn lords who had been a student of the Dutch. Apparently they were all capable of manufacturing very sophisticated cog-wheeled clocks and telescopes.[69]

The two guns with Vietnamese stocks under consideration have gold scrolls and dragons on a silver ground. The work is not of Imperial Chinese standard. In the midst of this decoration along the barrel at intervals are a degenerate version of the cross potent.[70] There are three Portuguese Military Orders in the seventeenth century, each with a version of the cross as their emblem, all active in the Portuguese empire. The Order of Santiago cross motif has a long spear blade as the lowest arm, removing it as a contender.

It is suggested that the device on the gun barrels is the cross of Avis, a Portuguese military order founded in 1146, whose members followed Benedictine rule. After the Muslims were expelled from the Iberian Peninsula the Military Orders found a new purpose with the expansion of the Portuguese empire. Pope Alexander VI permitted the knights to renounce celibacy in 1502 and in 1551 Pope Julius III authorised them to own and dispose of personal property and they were formally secularised in 1789.[71]

The third, the Military Order of Christ (Ordem Militar de Cristo) was the most prestigious and powerful, formerly the Knights Templar Order. Pope Clement V proscribed the Order by papal bull in 1312 but the Portuguese king, Denis I, refused to join in the Europe-wide annihilation of the knights and in 1317 established the Military Order of Christ in recognition of their assistance in the Reconquista. Denis negotiated with Pope Clement's successor, John XXII, and gained recognition for the Order and their right to inherit Templar assets. In Portugal the Order became immensely rich as a result of the Portuguese discoveries in the east and the New World. King Henry 'the Navigator' was a Master of the Order as was Vasco da Gama, the two Cabrals, Bartolomeu Dias, Francisco de Almeida and many other noted Portuguese involved in the voyages. Many Portuguese ships at this time were owned by the Order and displayed the cross of their Order on the mainsail. Volkov states that João da Cruz was a knight of the Order, working closely with the Jesuits who filled various scientific posts at the Nguyen court. Domingo Fernández Navarrete (1610?–89), wrote in 1676: 'There is at present in Cochinchina, a half-Black of Portuguese Breed, who in my time was made Knight of the Order of Christ; he is an able Officer, an excellent Founder,[72] and very curious at making Chain-Bullets, and other warlike instruments.'

The two guns under consideration were modified in Dutch style, probably by a Vietnamese craftsman in the late seventeenth century because the replacement Vietnamese-made lock is based on the northern European trigger-lock of that date.[73] The lock-plate is a fair copy as is the match-holder but the trigger is extremely poor and the stock distinctly Vietnamese.

A startling entry in the 1843 Jodhpur inventory reads: '1 no. *banduk* Jodhpuri *beeshwar chute*', literally: '1 Jodhpur gun twenty fire'. The day, month and year when the armourer checked it in the Armoury is recorded and one cannot doubt the gun existed though now missing. What was it? This gun fires too many shots to be a revolving matchlock and the listing is totally inconsistent with a *shatghri* or *arghun* with multiple fixed matchlock barrels fired simultaneously by a tray of loose powder.

Throughout the seventeenth century European gunmakers sought to create a practical multi-shot breech-loading system. There was the Wender magazine system and the Kalthoff system which was the basis of magazine guns made by Dutch gunmakers such as Jan Flock, Cornelis Kant, Michael Dortlo, Harman Barne, Caspar and Pieter Kalthoff, Hendrik Bartmans and Cornelis Coster.[74] Guillaume Kalthoff of Solingen received a patent issued in 1640 by King Louis III of France to make muskets and pistols that could shoot eight to ten rounds by one loading. The following year Pieter Kalthoff received a patent from the States General giving him the exclusive right to make a rifle which could shoot twenty-nine rounds from one loading. Six months later Bartmans received a patent for a rifle firing thirty rounds from a single loading. Mid-seventeenth-century guns made by the Florentine Lorenzoni and by Cookson and other gunmakers in England who copied the Lorenzoni system fired up to nine balls.[75] In the late seventeenth century, a Chinese firearms expert, Daizi, manufactured various firearms of the latest model for the Kangxi emperor. Three are specifically attributed: a large artillery gun (冲天炮) and two repeater muskets. Of the latter, there is a 'coiled intestine gun' and a 'repeating gun' (連珠火銃). There is a specimen of the 'repeating gun' in the Palace Museum and scholars attributed it to England (英格兰). The 'coiled intestine gun' was brought by the Dutch embassy of 1686. When Emperor Kangxi received the gift he allegedly responded that China already had such a gun and ordered Daizi to quickly make ten more and send them back with the Dutch.[76] European gunsmiths emigrated to the colonies and trained local people, resulting in indigenous European-style guns[77] but there is no evidence of Indians making magazine guns until the late eighteenth century.

The missing Jodhpur gun may have been made to the design of the eighteenth-century gunmaker Chalembrom. The French East India Company made Pondicherry their principal Indian base in 1674. In 1761 during the Seven Years' War the British captured it but the Treaty of Paris ending the war in 1763 returned it. The British successfully besieged the town during the Wars of the French Revolution and again returned it to France in 1814. A flintlock magazine musket made in Pondicherry c.1785 (?) has the steel barrel inlaid 'Chalembrom' in gold and the lock inlaid 'APondicherry' in European script.[78] Another in the Musée de l'Armée, Paris, bears the inscription 'Fait Par Chelembrom Pondichery 1785'. 'Chalembrom' is clearly the gunmaker's name, working in Pondicherry. It is however worth noting that 'Chalembron' is an eighteenth-century European misspelling of Chidambaram, the former Chola capital, forty miles from Pondicherry.[79] The artist Carel Frederik Reimer[80] in 1774 labelled a watercolour as 'De grote Pagode te Chalembrom' (The Great Pagoda at Chalembrom). The town was fought over several times during the wars between the British and French in the eighteenth century. Any local Indian would have spelt the name correctly though it is possible that an Indian craftsman might have been given the name by Europeans to denote his place of origin. Chalembrom has been assumed to be a Frenchman because he worked in French Pondicherry but the name is not typically French and does not appear on the lists of gunmakers in France. Possibly the name was an assumed one. His early life is undocumented but solely on the basis of his distinctive guns he is presumed to have served his apprenticeship in France where Jean Bouillet of St Etienne (1707–76), *arquebusier du roi*, made several repeating guns of this type including one firing twenty-four bullets from a single barrel which he presented to the king in 1767.[81] French and Indian gunsmiths later made Chalembrom-style repeaters in various places across India for Haidar Ali, his son Tipu Sultan of Mysore, for the Nizam of Hyderabad and for Claude Martin at Lucknow, any one of whom may have caused the Jodhpur gun to be made.

This gun is a good example of how Western technology spread across the subcontinent in the second half of the eighteenth century.

In 1750 the mercenary captain Haidar Ali and his Bidar peons (irregular infantry) captured a portion of the assassinated Nizam Nasir Jang's treasure, enabling him to recruit additional troops including French deserters. Five years later he was appointed Faujdar of Dindigul and further enlarged his army 'employing French engineers to organize his regular artillery, arsenal and laboratory'.[82] In this Haidar Ali was remarkably shrewd. Indo-Persian literature does not provide many instances of interest in Western scientific thought until the mid-eighteenth century[83] and his actions laid the foundation of much that his son was to create at Mysore. In 1763 Haidar seized the kingdom of Bednur[84] in Karnataka, making Bednur his capital but renaming it Haidarnagar. Here he employed 'skilful armourers, carpenters and other workmen from the arsenal at Pondicherry, collected at much expense and trouble by the French'.[85] Haidar made great efforts with his army including giving money to a missionary, Father Swartz, to create an orphanage. He supplied the boys with small wooden muskets and recruited them when old enough. In 1782 Haidar died of cancer, leaving a letter of instruction to his son Tipu: 'It is by the aid of the French that you could conquer the British armies which are better trained than the Indian. The Europeans have surer tactics; always use against them their own weapons.'

Tipu continued his father's work at Haidarnagar, modernising Mysore's military establishment, engaging thirty or thirty-two French experts to foster mechanical knowledge.[86] The French helped Tipu design a machine powered by bullocks to bore cannon.[87] Haidar had ensured that his son was well educated, both on the battlefield and academically. Tipu set his European prisoners to translate Western books, had a fine library, and wrote a manual on the handgun – *Risalah dar Adab-i Tufang*.[88]

A Chalembrom repeater gun made for Tipu dated AH 1200/1785 AD recently appeared in a UK auction.[89] This silver mounted 20 bore, complete with bayonet housed in the stock, fired twenty-one shots. It was made by Sayyid Da'ud in the Haidarnagar workshop and, significantly, the lock is in the French style. In 1785 the French in Pondicherry wrote a military and economic review of Tipu's Mysore that noted that Seringapatam produced ten muskets per day and that Bangalore and Nagar had cannon foundries and made artillery ammunition. Cossigny, French Governor in Pondicherry, refers in a letter dated 5 July 1786 to a musket supplied by 'Tipu Sultan's workers', presented to him by Tipu which he considers as good as anything produced in Europe.[90] Cossigny wrote that 'Nagar' was the centre of Tipu's munitions industry. A pair of Mysore pistols sent by Tipu to King Louis XVI were considered excellent by French experts. In 1786 Tipu made changes in his military regulations; changed the words of command from French (due to his father Haidar Ali's use of French mercenary instructors) to Persian and Turkish; and changed the names of Mysore firearms.

Tipu also had a *karkhanajat* or workshop and an arsenal at Chintamani, a small town in Mysore with iron and steel production.[91] A similar 25 bore gun to the one above was in the Wigington Collection, made in 'the joy finding fortress of Chintamani' as an inscription under the pan tells us, in AH 1217/1788 AD.[92] The British captured both fortresses at Chintamani in 1791 from Tipu but they were returned at the end of the war and more of these guns were made. A repeating flintlock gun in the Royal Collection, Windsor is signed on the breech in translation: 'Made in the Fortress of Chintamani' with the date AH 1212/1797 AD.[93] Another of these guns with the same inscription and date is in the Royal Armouries, Leeds.[94]

A flintlock repeating musket from the Midmar Castle Collection was sold at auction, the provenance provided being the armoury of the Nizam of Hyderabad.[95] The catalogue suggests that this gun marked with initials HIDR was made under the direction of General Raymond, Controller of Ordnance for Nizam Ali Khan c.1780. In fact, Michel Joachim Marie Raymond joined the service of the Nizam of Hyderabad in 1786 and set up a number of gun foundries making cannon and muskets. Raymond was very popular, known as Musa Rahim to Muslims and Musa Ram to Hindus. He died in 1798. A very rare pair of Chalembrom pistols made in his workshops for the Nizam are illustrated on page 246.[96]

Some of the Pondicherry gunsmiths who presumably worked with Chalembrom later worked for Claude Martin (1735–1800)[97] in Lucknow because he made a magazine gun there using this system. The gun is in the Royal Armouries, Leeds, and is signed 'Lucknow Arsenal Major Claude Martin'. Martin began at the arsenal as a captain in the Bengal army, rising in rank periodically as the inscriptions on his guns show, becoming major on 11 September 1779.[98] Martin was a common soldier in the French governor's bodyguard in Pondicherry in 1755 and deserted in 1760 during the British siege. He joined a battalion of foreign troops in the service of the British East India Company in the Bengal army, many of them French deserters from Pondicherry.[99] In 1664 they deserted to the Nawab of Oudh and some established themselves as gunsmiths but Martin loyally remained with the British. The Nawab's arsenal was then at Faizabad, which was visited by the Compte de Modave in 1773 who noted that the guns and bayonets manufactured there were 'almost as well as in our workshops in Europe'.[100] Martin spent time in Monghyr, famous for arms manufacture before joining Nawab Shuja-ud-daula at Faizabad. The Nawab's successor, his son Asaf-ud-daula, moved the court to Lucknow but the British who dominated Oudh forced the new ruler to dismiss all Frenchmen in his employment. The new court attracted people from India, Europe and the Middle East and under the Nawab a fashion developed for European luxury goods. Oudh was closed to goods supplied by East India Company officials, which aided merchants like Martin. In 1776 Martin was appointed superintendent of the Nawab's arsenal in Lucknow. He had his pick of the now unemployed French gunsmiths from the Nawab's arsenal at Faizabad, most of whom he knew from when they all lived in Pondicherry.

The Chalembrom repeater system was an eighteenth-century complicated novelty, made in small numbers for rulers. The system did not continue into the nineteenth century but the search for a simple, reliable multishot gun remained.

Firearms with revolving mechanisms attracted the attention of the American Colonel Samuel Colt who began designing revolvers in 1830 at the age of sixteen. The flintlock revolvers of Elisha Collier of Boston Massachusetts greatly influenced him but Colt had the advantage of designing weapons using the newly invented percussion cap. In London in 1835 he patented his first revolver, number 6909. Returning to America in 1836 he applied for a patent for a 'revolving gun', the Colt Paterson. The Paterson factory, New Jersey was forced to close but he subsequently interested the Texas Rangers in his revolver and then the United States Army and his success was assured. The Colt mechanism was single-action where the hammer had to be pulled back using the thumb. Colt wrote in 1855:

> The author had been aware since the year 1835 of the existence of ancient examples of repeating fire-arms, but it has only been on the occasion of his present visit to Europe in 1851 that he has been able to devote any attention to their chronological history, as

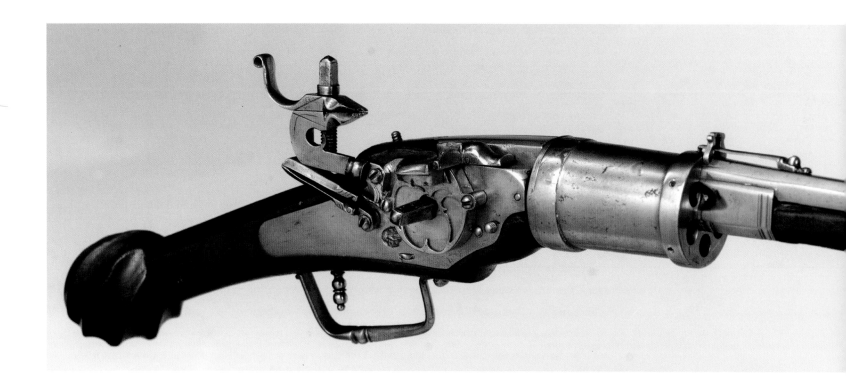

A six-shot wheellock revolving pistol,
made by Paul Dübler in Germany c.
1600, examined by Colonel Colt in
London in 1851.
Royal Armouries, Leeds XII.1078

exhibited in the specimens existing in the museums and private collections, to which he
has recently obtained access…The earliest specimen which the Author has been able to
discover is a matchlock gun now in the armoury of the Tower of London, supposed to be
of the fifteenth century.[101] It has a revolving breech with four chambers, mounted on an
arbor parallel with, and welded to, the barrel. The hinder end of the arbor is attached to
the gun-stock by a transverse pin, or nail. Notches are made in a flange, at the fore-end
of the breech, to receive the end of a spring, fixed to the stock, and extending across the
breech, for the purposes of locking it, when a chamber is brought up into line with the
barrel. The antiquity of this arm is evident, from the match-lock contrivance for igniting
the charge, and the fittings, and mounting indicate an Eastern origin. Each charge-
chamber is provided with a priming-pan, with a swing cover, which, before firing, would
require to be pushed aside by the finger, to present the priming-powder to the match.
A repetition of the fire is effected by throwing back the match-holder, and turning the
breech by hand, to bring up another loaded chamber.[102]

It is unfortunate that Colt only saw such a poor version of the Goan type. The dating of this gun
with four chambers by the Royal Armouries has ranged from fifteenth century when Colonel
Colt saw it to Richardson's reasonable 'probably 17th century'[103] to the present day assessment
of 1801–30. This last is far too late though the crudeness of the work and the many differences
suggests that the gun is possibly a provincial copy of the Goan original.

Goan guns drew their design from Europe. A six-shot drum mechanism pistol made by Paul
Dübler in Germany (c.1600) has a stay on the top of the barrel that is remarkably similar
to the Indian group. This pistol was examined by Colonel Colt during his London visit.[104]
Colt owned a more sophisticated six-shot snaphaunce revolving carbine made by the English
gunsmith John Dafte with a spring catch on top of the barrel that holds the cylinder in place,
again very similar to the Goan guns. Dafte was apprenticed in 1660 and was made free of the

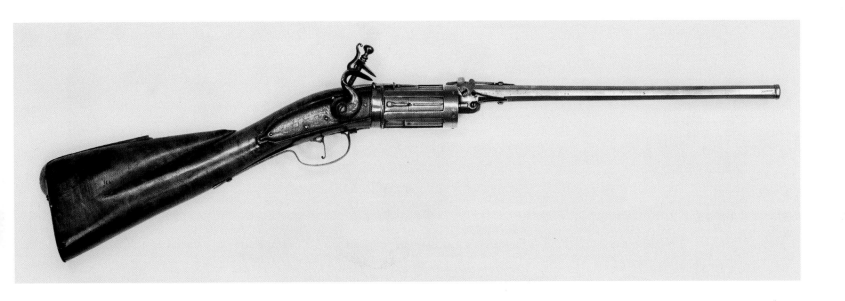

Six–shot snaphaunce revolving gun made by the London gunmaker John Dafte in the latter half of the seventeenth century.
14 3/8 in. (36.6 cm),
barrel length; 46 calibre.
Wadsworth Atheneum Museum of Art, Hartford, CT
The Elizabeth Hart Jarvis Colt Collection, 1905.1022.
Photography credit: Allen Phillips/Wadsworth Atheneum

London Gunmakers Company in 1668, becoming Master in 1694. He died in 1696. Dafte's gun is now in the Wadsworth Atheneum, Hartford, Connecticut,[105] where it is attributed to 1680–90. The Atheneum also has a Goan four-chamber cylinder gun, given a copy of a Brescian fluted mid-seventeenth century stock by an Indian craftsman.[106] A cylinder four-shot gun of this type was made by Georg Ernst Peter who was recorded at Carlsbad c.1690–1725.[107] Another cylinder four-shot sporting gun by the same maker c.1725 was modified by the English silversmith Edward Bate with silver marks for 1774 and 1775 showing that the gun continued in use at this late date.[108] Colt's first revolving cylinder rifles were manufactured at Hartford by Anson Chase and W. Rouse in 1832. Tranter, Adams, Webley, Harding and Daw subsequently made similar guns all suffering from a lack of power and accuracy due to the escape of gas uncomfortably close to the face. Like the Goan matchlocks they only worked effectively with small bore barrels and even then these were unsatisfactory compared to a muzzle-loader.

The matchlock with revolving cylinder had a long use life, particularly in India. One with five chambers, the touch holes with sliding covers, was captured during the fighting at Lucknow in 1858.[109] It was described as 'very old'. Mrs Gardner, on a sporting tour of India in 1898 with her husband, wrote: 'The armoury [at Lahore] has some curious old weapons. Amongst the firearms is a curious matchlock, some 150 years old, with four revolving chambers. So the revolver was not invented in America!'[110]

To sum up. These Indo-Portuguese revolving chambered multishot guns were first made in the Goan Arsenal. They have the Portuguese patilha lock (familiar to many collectors as the miquelet lock) and most date from the second half of the seventeenth century. The large arsenal in Colombo had the technical ability to make them but there is no evidence to suggest that they did. Surviving examples have all been found in India with two exceptions. The two 'Vietnamese' versions of this system differ from the Goan guns in detail and for that reason appear to be copies. There is no way of telling if these were initially matchlocks but there is no reason why these should not have been made in Vietnam in the late seventeenth century, their date of construction being governed by the presence of the trigger lock suggesting Dutch influence.

# 3    THE INDIAN MATCHLOCK

Even small numbers of matchlocks gave great military advantage in regional warfare in Asia in the early sixteenth century. Much is made of the consequences for firearms development due to the Portuguese arrival in India and further east but the role of the Turks in the development of firearms in this vast region is scarcely mentioned though they too in the same period became an Indian Ocean power with particular interests in pilgrim traffic, the spice trade and jihad. Ayalon's first recorded use of a handgun (as opposed to a cannon) in Egypt is 1490.[1] In the Indian Ocean the Mamluks looked to the Turks for cannon and guns with which to fight jihad against the Portuguese. Alliances made by the Turks explain why some places between India and China have Ottoman-style gun locks and others Portuguese. These two styles of gun replaced such gun design influence as the Chinese had disseminated in the East though archaic firearms continued in use among the poorest people into the early twentieth century. In 2004 the arms historian Iqtidar Alam Khan wrote: 'Contemporary evidence can be cited to prove the wide use of a primitive type of gunpowder-based artillery in the whole of India as early as the middle of the fifteenth century. But similar evidence for the handguns is not strong.'[2]

The matchlock mechanism used in India until the twentieth century was first created in Nuremberg in the fifteenth century and copied by the Turks. After the Persian defeat at Chaldiran in 1514 the Persians copied captured Turkish guns. Ottoman gunstocks closely copied late fifteenth-century European guns, depicted in the *Codex Monacensis* of c.1500. Apart from stock similarities, the chamber end of Indian barrels is invariably marked on the exterior by a raised band or astragal, an early Ottoman detail, intended to reinforce the chamber, which was made of thicker metal than the rest of the barrel. The comb back-sight with a sighting notch or hole also derived from Ottoman barrels as is the decoration of some muzzles. These sights offered the shooter's right eye some slight protection from exploding barrels. The Mughal emperors appear to have either had access to European guns or copied European designs from at least Humayun's reign (1530–40 and 1555–6) because his *Memoirs* describe him owning a double-barrelled gun in 1539.[3]

The historian Saxena suggests that cannon and matchlocks were adopted in Rajasthan following the battle of Khanua in 1527.[4] Until the Rajputs established trusted relations with the Mughals it is hard to guess where they might have obtained cannon and guns and any such adoption was negligible and without military consequences. Very few were available in north

India until later in the sixteenth century. The Mughal *Hamza Nama* from the 1560s depicts armies but very few guns. *A Leviathan Attacks Hamza and His Men*, painted circa 1567, shows two ships, one with a cannon barrel protruding from the forecastle, fighting off a sea monster.[5] Among the passengers we see a crossbowman, three archers and two matchlock men. Their gunstocks have a pronounced step below the breech, a standard feature of Persian and Indian matchlocks until late in the sixteenth century. Significantly, one gun has been drawn showing a serpentine, the S-shaped trigger mechanism that guides the lighted match to the touch hole. From Abu'l Fazl we learn that the Emperor Akbar ordered guns to be made with two lengths of wrought-iron barrels, *banduk*, the full sized barrel of about 170 cm long (66 ins); and the shorter *damanak*, 113 cm (41 ins) approximately.[6]

It has been claimed that Babur's use of firearms ended outdated methods of warfare in India.[7] Not as far as the Rajputs were concerned. Maharana Vikramaditya (r.1531–7) attempted to arm infantry with guns at Mewar and forfeited the support of his aristocracy. Fifty years after Mughal guns defeated the Rajputs the Rana of Udaipur appears not to have brought firearms to the battle of Haldigatti in 1576. Badayuni, present at the battle, makes no mention of them on either side but one of the Rana's elephants was injured by a bullet. The Rajputs are often said to have fully adopted Mughal culture by the late sixteenth century but their attitude to guns and cannon certainly differed from that of the Mughals. For centuries Hindu kingly tradition had extolled the importance of becoming a *chakravartin*, a great ruler dominating by force of arms neighbouring lesser kings. It was unthinkable by Rajput warriors that this status could be achieved using gunpowder weapons. The Rajputs never lost their virile belief that war was matter of individual combat for personal glory. They largely ignored other societies' tactical development of firearms, which diminished the individual's ability to show his skill with edged weapons and his courage. A warrior should fight his enemy up close and the Rathores had such contempt for firearms that a wound from a sword received double the compensation paid to a similar wound from a gun.[8] The seventeenth-century Iranian traveller in India 'Abdullah Sani[9] who attended Shah Jahan's court expressed surprise at the large numbers of Rajputs and Afghans serving in the Mughal army. However Jodhpur paintings rarely show Rajputs of status with guns until the second half of the eighteenth century. Hunting scenes show bows being used though there are many literary references to Rajputs using guns. The fame of Rani Durgavati (d.1564), queen of Gondwana, reached Akbar's court. 'She was a good shot with gun and arrow and continually went a-hunting…It was her custom that whenever she heard that a tiger had made his appearance she would not drink water till she had shot him.'[10]

In contrast to Rajput disdain, Akbar was very interested in guns. Abu'l Fazl tells us Akbar 'introduces all sorts of new methods and studies their applicability to practical purposes. Thus a plated armour was brought before His Majesty, and set up as a target; but no bullet was so powerful as to make an impression on it.'[11] More of these were ordered. Since rulers and generals were expected to direct battles from the vantage point of a howdah on the back of the largest elephant available where they made excellent targets one can see why this might appeal to him. Abu'l Fazl acknowledges the importance to Akbar of guns, saying he is responsible for various gun inventions: 'With the exception of Turkey, there is perhaps no country which in its guns has more means of securing the government than this.'[12] He further says: 'His Majesty looks upon the care bestowed on the efficiency of this branch as one of the higher objects of a king, and therefore devotes to it much of his time. Daroghas and clever clerks are appointed to

FACING PAGE:
An invention attributed to the Mughal Emperor Akbar, illustrated in an eighteenth century copy of the sixteenth century *A'in-i Akbari*. Abu'l Fazl records that *banduk* barrels used to be polished by hand but His Majesty has invented a wheel (barghu) turned by an ox which polishes the bores of sixteen matchlock barrels in a very short time.
©British Library Board.
Add.5645, ff. 60v-61

keep the whole in proper order.'[13] The *Padshahnama* refers in 1636 to 'Bahadur Beg, supervisor of the Imperial matchlocks'. Matchlocks 'are in particular favour with His Majesty, who stands unrivalled in their manufacture, and as a marksman'.[14] 'Many masters are to be found among gunmakers at court'[15] including Ustad Kabir and Husayn. 'It is impossible to count every gun; besides clever workmen continually make new ones, especially *gajnals* and *narnals*.'[16]

The Portuguese priest Francis Henriques, a member of the first Jesuit mission to Jalal-ud-din Akbar in 1580 wrote from Fatehpur Sikri: 'Akbar knows a little of all trades, and sometimes loves to practise them before his people, either as a carpenter, or as a blacksmith, or as an armourer, filing'.[17] Henriques's companion, Father Monserrate, confirmed this in his *Commentary*:

> Zelaldinus [Latin for Jalal-ud-din] is so devoted to building that he sometimes quarries stone himself along with the other workmen. Nor does he shrink from watching and even himself practising for the sake of amusement the craft of an ordinary artisan. For this purpose he has built a workshop near the palace where also are studios and work rooms for the finer and more reputable arts, such as painting, goldsmith work, tapestry-making, carpet and curtain making, and the manufacture of arms. Hither he very frequently comes and relaxes his mind with watching those who practise their arts.[18]

Many early Turkish gun barrels were made of bronze but wrought iron gradually replaced these. In 1556 Janissaries sent to further Ottoman interests in Central Asia had their iron-barrelled arquebuses seized by the Khan of Bukhara who gave them inferior copper-barrel arquebuses in return.[19] Early Indian gun barrels were made of sheet of iron rolled into a tube with the two edges brought together and braised. 'They also take cylindrical pieces of iron, and pierce them when hot with an iron pin. Three or four such pieces make one gun.'[20] Joining three or four pieces of metal to make a gun barrel sounds particularly hazardous but it should be remembered that in Mughal India as in Ottoman Turkey it was common to make cannon in two parts and since guns were seen as small cannon the same practice applied. The powder chamber required very much thicker walls than the rest of the barrel and was made separately. The two parts were then joined, the joint reinforced by an astragal.

Barrel-making in Hindustan improved when they were made by twisting a ribbon of iron round a mandrel. In the next stage the metal was heated and the mandrel held vertically and hammered to weld the edges. 'Numerous accidents' were caused by barrels exploding. Abu'l Fazl tells as that Akbar tested new guns personally and put the experience to good use.

> His Majesty has invented an excellent method of construction. They flatten iron, and twist it round obliquely in form of a roll, so that the folds get longer at every twist; they then join the folds, not edge to edge, but so as to allow them to lie one over the other, and heat them gradually in the fire.[21]

The overlap described by Abu'l Fazl as Akbar's invention was already used for joining the cannon which were cast in two parts, the powder chamber (*daru-khana*) and the stone chamber (*tash-awi*). Ottoman cannon were made with a screw thread to join the parts but the Indians lacked the technical knowledge to make this. The result of Akbar's new gun-barrel-making technique was that: 'Matchlocks are now made so strong that they do not burst, though let off when filled to the top.'[22] His system may have made barrels stronger but it also made them a great deal heavier, which was unimportant to him as he was extremely strong. There were still

casualties however. Maharana Hamir Singh severely wounded his hand when his gun exploded during a hunt in 1778. He died from the infected wound six months later.

In 1567–8 Akbar was still trying to bring the Rajputs to heel and he besieged Chittor, the great Mewar fortress where an incident took place that tells us much about guns and contemporary attitudes.

> At this time H.M. perceived that a person clothed in a hazar mikhi (cuirass of a thousand nails) which is a mark of chieftainship amongst (Rajputs) came to the breach and superintended the (repairs). It was not known who he was. H.M. took his gun Sangram, which is one of the special guns, and aimed it at him. To Shuja'at Khan and Rajah Bagwant Das he said that, from the pleasure and lightness of hand such as he experienced when he had hit a beast of prey, he inferred that he had hit the man...[23]

The man Akbar sniped was Jaimal Rathore, a Mertia Rathore, the fort commander. The next day the women all committed jauhar, immolating themselves in a large fire to preserve their honour, and the warriors sallied out to die fighting. An unsupported story claims Jaimal Rathore's thigh was smashed by Akbar's bullet. The wound was mortal. Not wanting the shame of dying in bed he was put on a horse and rode out seeking death in battle, leading the Rajputs out of the fort which they might otherwise have held successfully.

Akbar named this gun Sangram or 'Battle' and used it all his life. His son Jahangir later called it 'one of the rare guns of the age'. Abu'l Fazl records:

> An order has been given to the writers to write down the game killed by His Majesty with the particular guns used. Thus it was found that with the gun which has the name of Sangram, 1,019 animals have been killed. This gun is the first of His Majesty's private guns, and is used during the Farvardin month[24] of the present era.

Akbar established a Records Office in 1574 to keep note of events and details of his life but Abu'l Fazl's account suggests that earlier he kept a Game Book. In a single month over the thirty years that elapsed before the *A'in-i Akbari* was written, Akbar shot an annual average of almost thirty-four animals with this gun alone. His son wrote in the *Jahangirnama*: 'With it he hit three to four thousand birds and beasts.'[25] Others would have been killed using sword, lance and bow. But the number of animals shot by the emperor was greater than this suggests because Akbar did not limit himself to a single gun each month. Abu'l Fazl explains: 'His Majesty has selected out of several thousand guns, one hundred and five as khasa [household] guns'. In addition to the twelve guns 'chosen in honour of the twelve months' there were guns for the week and for certain days in a most complicated cyclical routine. Nor was this empty ritual. Abu'l Fazl states that: 'His Majesty practises often'.[26] Jahangir simply said of his father: 'In marksmanship he had no equal or peer.'[27]

Abu'l Fazl wrote of the large numbers of guns being made for Akbar and clearly the Mughals were the major producer in Hindustan but Lord Egerton's 1896 catalogue of Indian arms attributes no guns to them, merely recognising some pan-Indian regional differences in form and surface decoration.[28] The Mughals led the development of firearms in Hindustan and it must be assumed that Mughal or strictly speaking Persian technology provided the means by which barrels were made in the sixteenth century. Babur's armourer was Ghiasu'd-din[29] and Mughal

armourers mentioned in successor reigns are all Muslim. Did the Rajputs obtain their barrels from Mughal workshops, import them or make them themselves? How should we distinguish Mughal guns from those of their allies the Rajputs? If the seventeenth- and eighteenth-century guns in the various Rajput armouries are all Rajput-made one is left asking where to find the missing Mughal guns? It would be surprising if the guns the Rajputs obtained were not Mughal in origin. Saxena says that 'in the beginning guns and cannon were mostly procured from Agra and Delhi'.[30] Lahore with its Persian and latterly Sikh craftsmen became increasingly important. The Rathores have a fine collection of cannon at Mehrangarh Fort but they are all acquired rather than made locally and a high proportion are European in origin.[31] The 1853 arms inventory shows that Jodhpur used two technical terms relating to gun barrels: simple twist construction known as *pechdar*; and *jauhardar* by which was meant forms of damascus,[32] terms likely to reflect earlier practice. Most of the seventeenth- and eighteenth-century barrels in Jodhpur are *pechdar* though many late seventeenth- or early eighteenth-century damascus matchlock barrels combine this with *jauhardar*. Judged by the evidence provided by Rajput sword construction in the sixteenth and seventeenth centuries the more sophisticated barrels were Mughal in origin.[33] Damascus pattern is a technique associated with Muslim craftsmen but these, including arms makers, were well integrated into the Hindu states. A good heavy gun barrel is fairly indestructible and the collection shows that they were very frequently re-used. Quality gun barrels acquired at the height of Mughal power in the seventeenth and first half of the eighteenth centuries may well have met most of the Rajput aristocracy's needs in later years.

Mughal adoption of Hindu aesthetics made the assimilation of Mughal decoration easy for Hindus. For example, the column bases in the Red Fort in Delhi comprise pots with columns rising out of them, which are decorated with a ring of lanceolate leaves. Those in the Bhadon Pavilion or in the Diwan-i Khass are good examples, both dating from 1639–48. These are certainly not acanthus and Koch says these are 'reminiscent of lotus petals'[34] but the carved marble shows a leaf, one that resembles the Indian willow, (*Salix tetrasperma*, in Sanskrit *vanjula*).[35] This pot and leaf design has no precedent in Islamic architecture and the *kumbha* or pot decorated with leaves is an auspicious Hindu symbol. The same leaf design decorates the muzzles of matchlocks found in Rajput armouries from approximately the date of these buildings onwards though the design varies and in time becomes stylised. The original form is found on European barrels, which are adopted but given an Indian interpretation, becoming a shared Muslim/Hindu design: but there are symbols that indicate a purely Hindu gun like the trisula that appears on barrels in the City Palace, Jaipur, a specific order by a Jaipur Maharaja.[36]

The changing acceptability of firearms is indicated by Mughal rulers permitting their portraits to be painted holding guns. A sketch by Balchand shows Shah Jahan as a prince using a matchlock c.1620. More important is the painting of Shah Jahan by Payag, Balchand's older brother, c.1630–45. The *Padshahnama* shows retainers holding matchlocks at a 1628 darbar though the painting recording the event is attributed to 1640, commissioned by Shah Jahan, an example of how from the Mongol period onwards paintings were used to emphasise royal continuity and legitimacy. All the guns have match arms, sinew binds stock and barrel, and curved metal rests, necessary because of the length and weight of barrel, are fixed to forestocks. The stock ends are slightly convex and lack heel plates. All these court guns are decorated with an emerald flanked by two rubies, set at intervals in line up the length of the stock, suggesting they are royal guns.[37] The Venetians led the use of ebony for princely furniture which predated the European discovery of the sea route to India. The *studiolo* (cabinet of curiosities) of

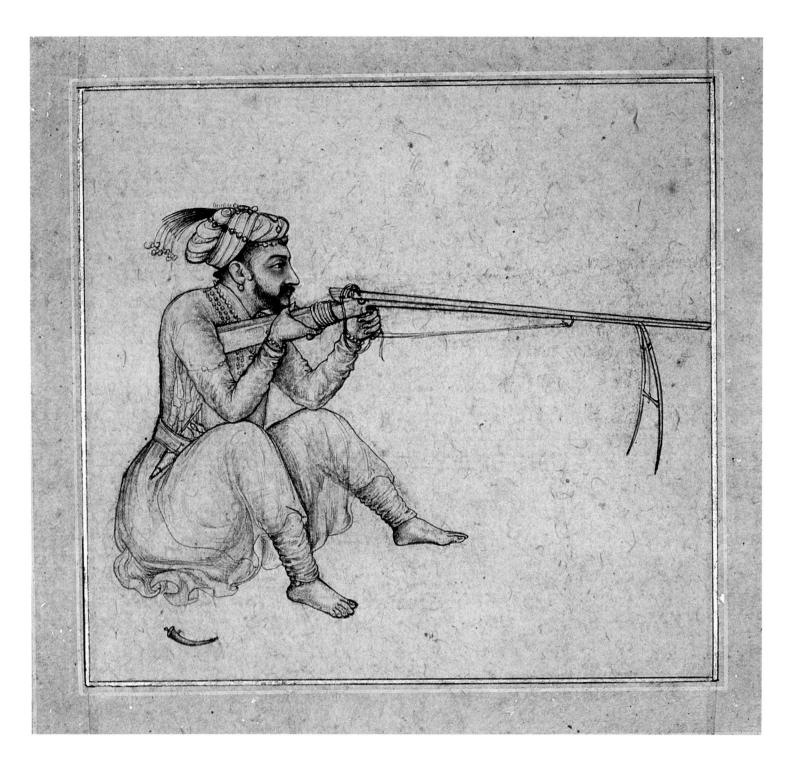

Prince Khurram, later Shah Jahan (b. 1592), firing a matchlock. His mother was a Marwar Princess, Jagat Gosaini. Drawing, c. 1620, attributed to Balchand. Note the European form of the priming flask on the ground. Chester Beatty, M.S. 11A, NO. IV

Francesco de' Medici (1541–87) in Palazzo Vecchio was decorated with ebony set with a variety of precious stones, a design concept derived from India which Francesco pioneered. Craftsmen journeyed from Munich, Prague and elsewhere to Florence to establish workshops making goods in Eastern taste, part of a deliberate Medici policy to establish luxury trades in the city.[38]

Another *Padshahnama* painting shows the Mughals capturing the Bengal port of Hoogly from the Portuguese in 1632. The Indians hold the stocks of their matchlocks under the armpit rather than to the shoulder.[39] Presumably this was intended to keep the face as far away from the breech as possible because of the danger of barrels exploding but it can hardly have helped accuracy. Perhaps this was one reason why the infantry in Akbar's time though very numerous were not regarded as important. Many were in state service in some humble capacity, came from a wide variety of castes and occupations, and were pressed into armed

Maharana Amar Singh II smoking a hookah, c. 1704. He holds a small matchlock with a gilt barrel and a painted stock studded with jewels. The barrel and stock are almost in a straight line. Note the pricker for unclogging the vent, suspended from a chain. His powder flask in the form of a nautilus shell is also jewelled and he has a blackbuck horn priming flask with an ivory nozzle in his belt. In contrast his katar and talwar are plain metal.
Dimensions: 9 1/16 in. x 7 1/16 in. (23 cm x 17.9 cm)
Edwin Binney 3rd Collection. The San Diego Museum of Art. Accession Number: 1990.614

service without training when the need arose. Pay depended on their caste and the arms they owned. In the sixteenth century the Mughals called them *piyadagam*, *paik* and *ahsham*. They were equipped with a motley collection of spears, swords and bows and the number of guns among them increased slowly. Bernier says an Indian bowman could fire six arrows in the space of time it took a matchlock man to fire twice. Acquiring a matchlock gave a man status, which enabled him to progress up the military hierarchy where he might become a *silehaposh*. Units of *silehaposh* were of mixed origin and in Rajasthan often included Nagas. Paid a modest wage they provided escorts to rulers and were guards on city ramparts. Some were provided with arms by the state. Bhils too were recruited in Rajasthan, men noted for their skill with a bow. In the eighteenth century the Rajputs increasingly recruited Purbias, people from eastern India, particularly Bihar, as matchlock men. They were referred to as

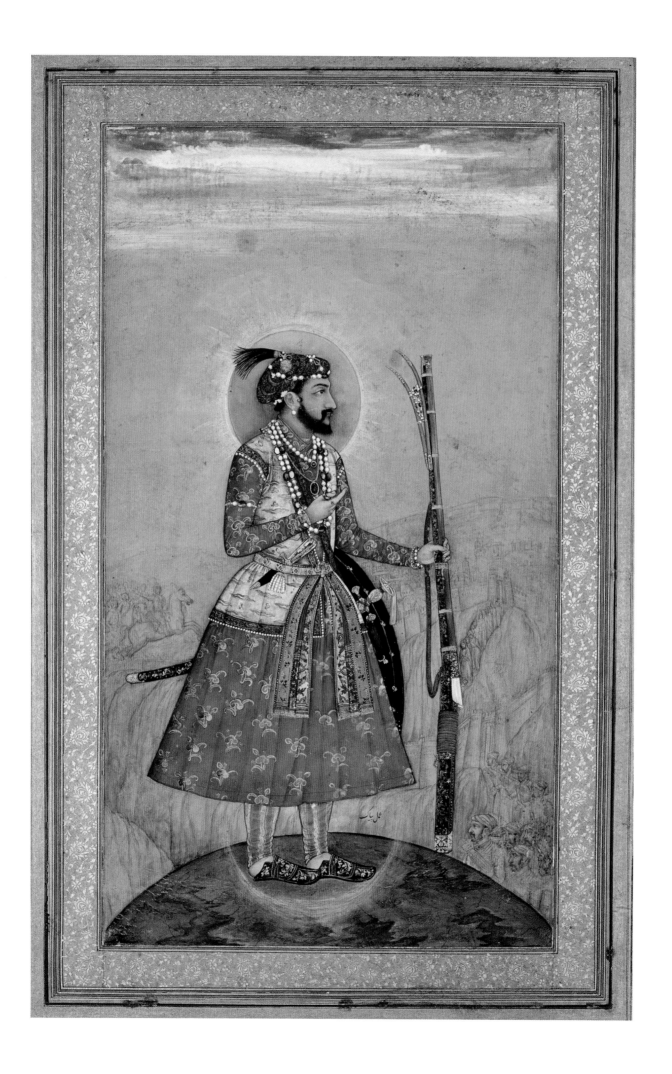

Biradaris, the units each known by the name of their leader. Brigades of mercenaries for hire were a prominent feature of the north Indian military labour market from at least the fifteenth century.[40] Successive Mughal emperors kept *bandukchis* under their control, attached to and paid by the Royal household rather than giving power to their nobles; but with time favoured nobles like the Kachwahas of Amber were permitted to recruit as a privilege. Mirza Raja Jai Singh had both ordinary matchlock men (*dakhil banduk*) and mounted matchlock men (*sawar banduk*) in 1663.[41] Mounted *barq-andaz*, some of them of Ottoman origin, served in the Mughal army attempting to suppress Durga Das's revolt in support of Ajit Singh, which started in 1679. The opportunities and Mughal rules relating to the recruitment of matchlock men were arbitrary and became less regulated as Mughal power declined.

The Turks replaced their matchlocks with the miquelet lock, developed in the Iberian peninsula on the back of Portuguese designs by about 1580[42] and this lock was adopted across the Mediterranean region. The Turks used this until the late nineteenth century but Indians never used it, other than guns produced under Portuguese instruction in Goa and other Portuguese possessions. These have miquelet locks, often dog locks, in Sri Lanka mounted on the left hand side of the gun, a peculiarity never satisfactorily explained. Gun barrels made in the Ottoman Balkans found a market in India though the extent of this trade is hard to assess. Evilya Celebi (1611–82), a Turkish official whose *Seyahatname* details journeys in the Ottoman Empire, described Sarajevo in Bosnia as 'an emporium of wares from India…'. Sarajevo's famous gun barrels were exported across the Ottoman Empire and as far as India.[43] Two major gunmaking towns in Albania, Prizren[44] and Tetovo[45] also sent gun barrels to India though probably few before the seventeenth century. The success of this trade was no doubt helped by the Turks of high status who came to serve the Mughals such as the Ottoman governor of Basra, Amir Husain Pasha, who abandoned Sultan Mehmed and arrived in Delhi in 1669 where he was liberally welcomed by Aurangzeb, eventually becoming subadar of Malwa. In 1715 when Maharaja Ajit Singh of Marwar's daughter Indra Kunwar married the Emperor Farrukh Siyar, the maharaja's rise in status was indicated by his purchase of matchlocks worth one lakh, a large order, the supplier unknown.

The Ottoman army encountered European dragoons in the Cretan War (1645–69) who fired from horseback using fusils, flintlock muskets that were lighter and more convenient than the contemporary matchlock, a new approach to warfare that Rumi mercenaries brought to India. The *Mirat-i-Ahmadi* describes Rathore horsemen armed with matchlocks and incendiary bombs advancing to take the town gates of Ahmadabad in 1729. Horsemen armed with matchlocks increasingly became a feature of Indian battlefields from the latter part of the seventeenth century. To facilitate this matchlocks became shorter and lighter.

The nineteenth-century writer Irvine argued that in India until the mid-eighteenth century the bow was considered a far more reliable weapon than firearms.[46] Too much credence in the apparent technical superiority of the matchlock over the bow has encouraged the assumption that firearms were swiftly adopted. True it was easier to train a matchlock man than a bowman but the theoretical advantages of the gun was often negated on the battlefield by it not working or poor powder or a shortage of bullets, all very common in India when responsibility was individual until the development of a competent commissariat and a conscientious and honest supervisory structure. This applies to Indians and Europeans. There are accounts of small units of British soldiers being hastily sent up country in 1857 with half their muskets defective or lacking flint, powder or shot.

FACING PAGE:
Shah Jahan with his matchlock,
painted by Payag, c. 1630-45
Nasir al-Din Shah Album.
Chester Beatty 7B 28

The Rajput view on this would probably admit the use of guns as a necessary evil but favour the bow until the mid-eighteenth century. The Rajputs are a conservative people and the bow won approval because it was used by familiar heroes in classic literature. Bhishma, 'Terrible', a prominent warrior in the *Mahabharata*, displays Rajput virtues as a man of courage, honour, loyalty and chivalrous behaviour, which all warriors would be taught since childhood to emulate. The Rathores deliberately sought death in battle as a sacrifice to the Goddess and Bhishma was gloriously pierced by so many arrows in battle that he fell from his chariot. His dying body was held off the ground by the arrow shafts protruding from his body. Lying on this couch of arrows he managed to delay his death for fifty-eight days until the sun started its northern course because Rajputs believed that the passage to warrior heaven is easier during this period.

In Hinduism, dharma, a Vedic concept, changes its meaning over the centuries and cannot be expressed in a single word but 'order', 'model,' 'custom,' 'duty' and 'law' have been used concerning it. Hinduism personifies dharma as a deified Rishi (enlightened person) personifying goodness and duty. His son is Yudhishthira – 'firm in battle'. Dharma expresses the obligation of correct behaviour in all aspects of daily life integrated with religious duties so that individual responsibilities and cosmic order (Rta) can harmoniously align. Rajput dharma adds to this philosophical concept a unique social and religious code of its own that is the core of group identity and behaviour patterns. Individual Rajputs acknowledge rigidly shared sanctified rules, declaimed by court poets (Charans) and enforced by group pressure that gloried in and maintained tradition. Rajput dharma created an exclusive, tightly united, conservative group that was unsympathetic to the use of guns.

The Rajputs were taught that the bow was a part of Rajput dharma and that warriors should practise with it every day, either hunting, or shooting at a baked earth target. It took years of practice to become a good archer. The bow in question was not the great self bows used by the indigenous peoples that are depicted in the hands of many of India's warrior gods. It was the *kaman Turki, chahar kham* ('four curved') recurved bow, used in Central Asia from the third millennium BC that came to India at the time of the Scythian invasions.[47] Made of horn, sinew and wood, painted and lacquered to make the bow waterproof and attractive, such bows, the work of skilled craftsmen, were vulnerable to the climate and often had to be replaced. For Rajputs and Muslims the bow was a status symbol. New Indian dynasties, seeking to burnish their kshatriya credentials, noted this and sometimes used the bow and quiver in their accession ceremonies. Guru Har Gobind, the sixth Sikh Guru, put on a quiver and held a bow in his ceremony in 1606.[48] The same recurved bow was used by Indian Muslims. The Prophet, himself an archer, had urged the faithful to practise with the bow so for Muslims archery was a spiritual exercise. For these reasons the bow remained popular. Irvine heard stories of British troops killed with arrows in the Mutiny. The British at that time thought the bow archaic but Indians took a different view and it was commonly included among the weapons in the howdah of princes out hunting until very late in the nineteenth century, for use as well as the symbol of a gentleman. James Tod, who knew the people well, wrote in 1830: 'The Rajput who still curses those vile guns which render of comparative little value the lance of many a gallant soldier, and he still prefers falling with dignity from his steed to descending to an equality with his mercenary antagonists.'[49]

The transition from matchlock to flintlock in the eighteenth century was gradual and largely due to European military commanders appointed by Indian rulers. The eighteenth-century European wars between the British and French were also fought in India where defeat resulted

FACING PAGE:
A Mewati carrying a matchlock. These mercenaries, also called Meos, lived south-west of Delhi. Colonel James Skinner (1778-1841) commissioned Delhi artists, the most prominent being Ghulam Ali Khan, to create the *Tashrih al-aqvam*, an account of the occupations of castes and tribes at Hansi, Hissar District, eighty-five miles north-west of Delhi c. 1825.
MS, British Library,
Add no. 27255, f. 70b.

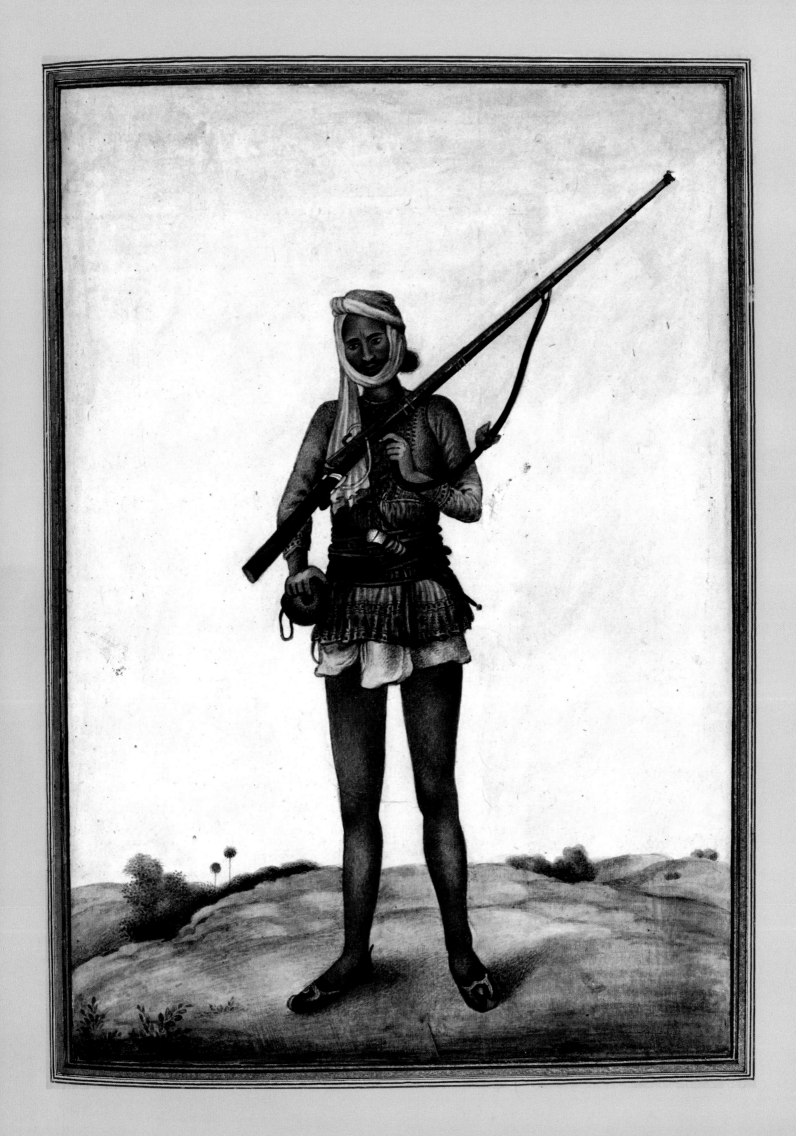

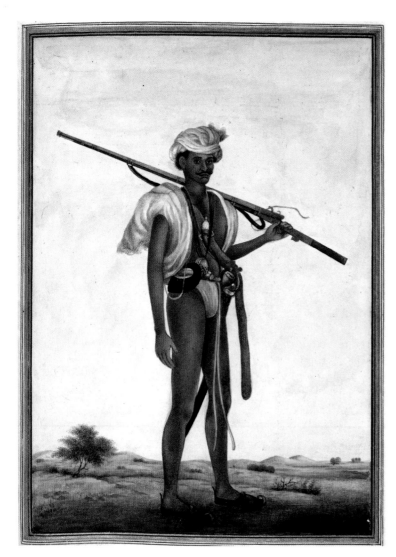

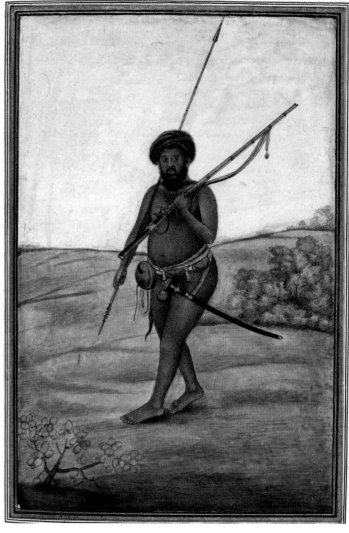

in disbanded French soldiers seeking employment, training and equipping local armies in the European manner. The Maratha sardar's 'regular' infantry were increasingly armed with flintlocks, but they also recruited Kolis and Bhils armed with matchlocks as auxiliary troops. A Scottish mercenary, Colonel George Sangster, was employed by the mercenary General de Boigne to create an arsenal at Agra in 1790. 'Sangster, who had trained as a gun-founder and manufacturer before coming to India, cast excellent cannon and made muskets as good as the European models for ten rupees each.'[50] It was customary for European mercenaries to equip their troops with arms and ammunition. De Boigne's campo included Najibs, Pathans, Rohillas and high-caste Hindus and these gave up their matchlocks and were equipped with Sangster's flintlocks. He eventually created five arsenals run by *daroghas*, at Mathura, Delhi, Gwalior, Kalpi and Gohad. Indian troops used their flintlocks in idiosyncratic ways as Fitzclarence noted in 1817:

> As we approached…I was thrown upon the qui vive by the flash of a gun or pistol in that direction; but, from no report reaching me, I was convinced it had originated in that most unsoldierly trick so common among the native cavalry of India, of flashing in the pan of their pistols to light their pipe.[51]

In 1796 a European observer noted that the matchlocks of the irregular infantry at Oudh 'carried further and infinitely truer than the firelocks (flintlocks) of those days'.[52] Fitzclarence

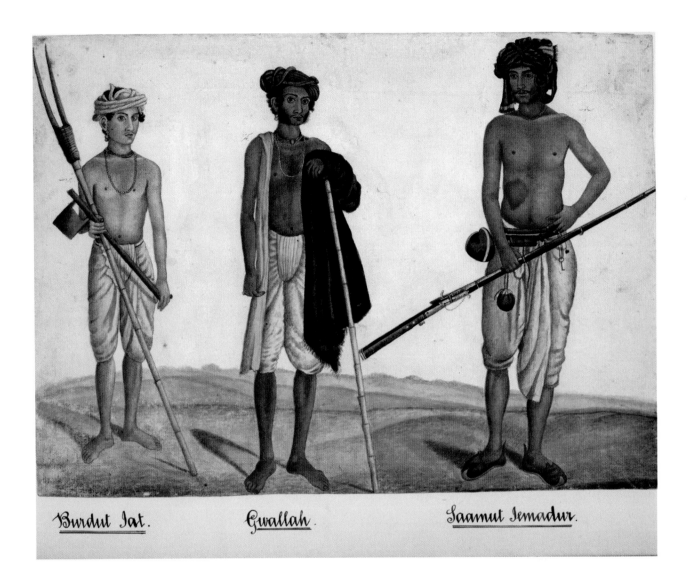

Burdut Jat.    Gwallah.    Saamut Jemadur.

Sanat Jamadar with a matchlock.
Frazer Album, Hansi, c. 1815-16.
British Library ADD Or .1277

in 1818 wrote that: '…the matchlock is the weapon of this country' and: 'the flintlock…is far from being general, and I may even say is never employed by the natives: though the Terlinga, armed and disciplined after our manner, in the service of Scindiah and Holkar, make use of it. Some good flintlocks are however, made at Lahore'.[53] However, in the early nineteenth century Lahore also continued making matchlocks,[54] popular in Rajasthan and, 'like the locally produced examples, they are often highly finished and inlaid with mother-of-pearl and gold: those of Bundi are the best'.[55] Tod noted that matchlocks, swords and other arms were manufactured at Pali and Jodhpur.[56]

Egerton, an experienced arms collector in India from 1858, reports that Kotah and Bundi made famous matchlocks.[57] This probably reflects the arms market created by Kotah's prime minister, Zalim Singh, who in the latter part of the eighteenth century hired large numbers of mercenaries to defend the state against the Marathas. These troops included two brigades led by Firangis who had become Indian in all but name, brigades of Dadhu Panthi Naga ascetics, individual Marathas and a great many Pathans. In the late eighteenth century many Pathans were in Rohilla service in the Rampur region but after the British helped the Nawab of Oudh to defeat the Rohillas in 1774 there was a general reshaping of north Indian military employment and the Pathans moved west of the Ganges and found employment in Kotah, Jodhpur and indeed all the Rajput states.[58] These troops brought their arms with them but needed the support the bazaar gave them until Zalim Khan, probably acting with the advice of

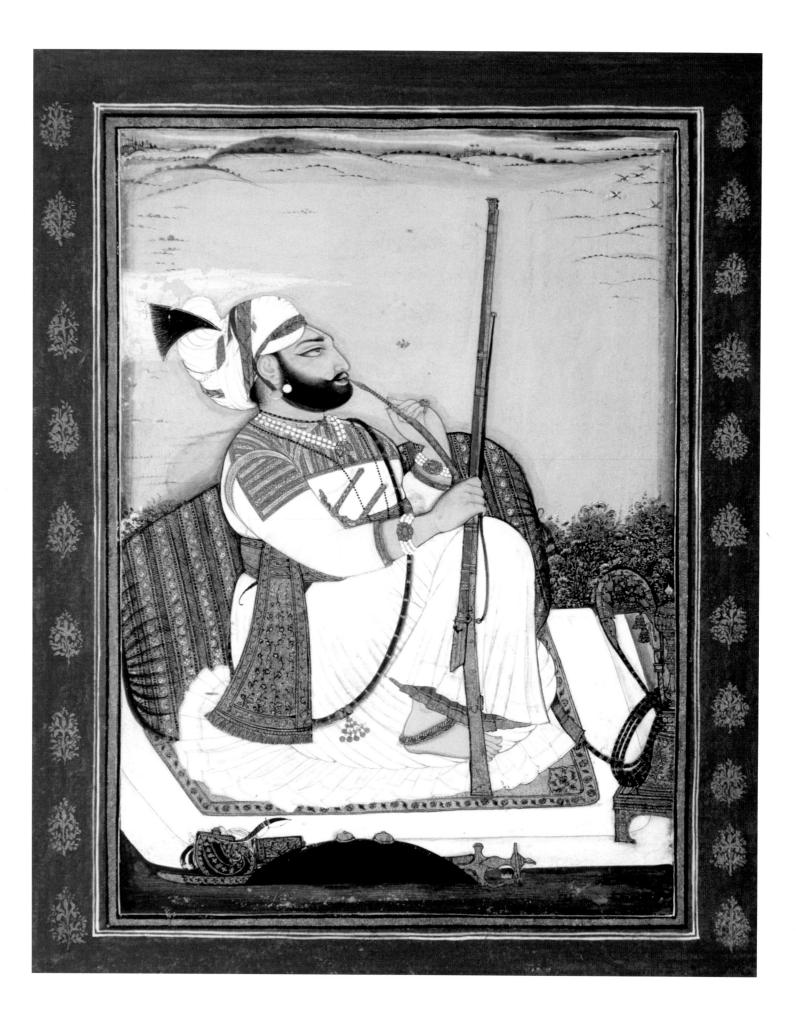

French officers, introduced central control on all aspects including equipment towards the end of the eighteenth century. The Pushtun Amir Khan, deeply involved in Rajput affairs, ended as Nawab of Tonk in 1806, a good example of a mercenary's rise to power. He was born in Sambhal in Rohilkhand in 1767 and started as a leader with ten men. By 1814 he commanded 30,000 horse and foot and a well-run train of artillery.[59] Nineteenth-century inventories give the origin of guns, showing that at that date the Rajputs made gun barrels and also imported them, but these are generally hunting guns. A distinction needs to be made between the needs of the aristocracy, the mercenary, and the peasant who sought cheap guns to defend his mud-walled village from marauding Pindaris, Marathas, dacoits, wild animals, rapacious landlords and tax collectors.

The Rajputs had no military necessity to adopt new technology because from 1818 the British were treaty-bound to protect the Rajput states. Rajputs acquired European hunting guns if they had good contacts but paintings rarely show maharajas using them and they were rare until the 1840s. One sees relatively few in the state armouries until the nineteenth-century military examples come into use.[60] Sometimes one finds whole rooms of racked nineteenth-century British military weapons in forts, as though a regiment had handed in their arms and marched away. From the Indian point of view the complex flintlock mechanism had to be kept clean, lubricated and was hard to repair. The matchlock had few moving parts, was cheap to produce, easy to maintain and repair and used a locally grown match. Gun flint is not found in India and had to be imported from Europe. Agates used as a substitute were extremely hard and damaged the frizzen. A variety of sizes was required and these needed reversing in the jaw of the cock when they became worn after a small number of shots, usually using a knife edge as a screwdriver. The flintlock was an unreliable weapon. It is suggested that even in good weather it misfired 15 per cent of the time and in damp or wet weather the rate rose significantly. European flintlock mechanisms were not used to upgrade Rajput matchlocks. This is surprising since their neighbours the Sindhis when given European guns as presents usually discarded all but the English lock which they fitted to their *jezails*. Sometimes they copied these, Sindhi lock-plates spuriously signed Parker after the noted London maker being particularly common. In this they were possibly influenced by Persian attitudes to Western guns, Persian metalworkers being technically competent and happy to copy Western gunlocks in the nineteenth century. Iqtidar Alam Khan wrote that 'the inability of the Indians to copy cast-iron cannon and adopt more efficient flintlocks as standard military muskets were perhaps the two most conspicuous failures in the field of firearms during the seventeenth century'.[61] The present author does not agree. Earlier adoption of the flintlock by Indians would have changed little if anything, the gap between the efficacy of the two systems being not so great, particularly in an Indian context. Failure came from the mismanagement of existing resources, people and the Indian philosophy of war rather than from technology.

FACING PAGE:
Rawat Gokul Das seated with a matchlock. Painted by Bagta at Devgarh in southern Rajasthan and dated VS. 1864, (1807AD). The magnificent paintings at Devgarh show guns that the family still own. Written on the back of each paintings are details about what each depicts. The design of the light gun he holds suggest it was made in Lahore. Dimensions: 10 5/8 in. x 8 3/8 in. (27 cm x 21.3 cm) Edwin Binney 3rd Collection. The San Diego Museum of Art. Accession Number: 1990.661

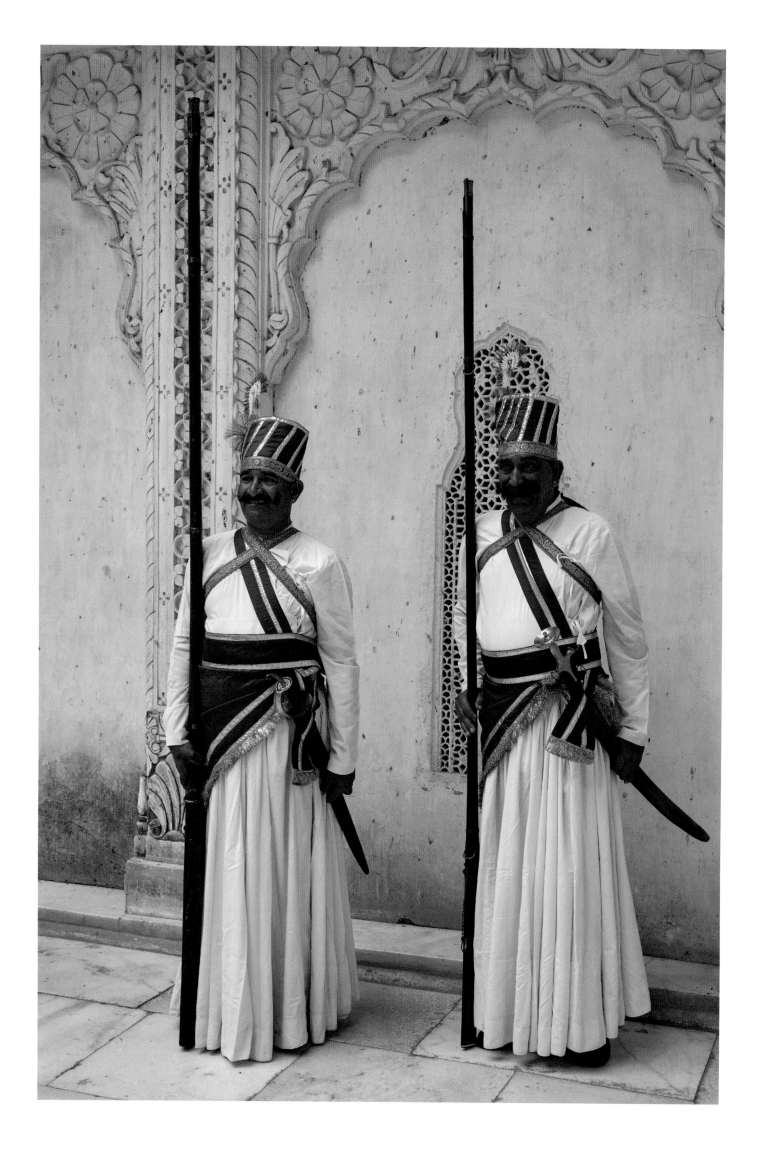

<div style="text-align: center">

# 4 CATALOGUE

</div>

## LAMCHAR

*Lamchar*, literally 'big and long', is the Jodhpur name for a tall matchlock gun such as the large-calibre, ten-foot long, two-man, matchlock rampart guns in the armoury. These seventeenth- and early eighteenth-century guns probably derive from *metris tüfengi*, Turkish trench guns used mainly in sieges that fired an 80 mm (3.1 in) ball, a very heavy version of the Turkish shishana. The Turks took the concept from the *doppelhaken* (German), the *archebuse à chevalet* (France) or the *arcabuz de muralla* (Spanish). Abu'l Fazl wrote: 'for long guns the weight of a ball does not exceed twenty-five *tank*s, and for small ones fifteen' remarking that only the emperor dares to fire the heavy ball.[1] A *tank* is a Mughal gem weight. Thackston prints an excellent table of weights and measures taken from the *Jahangirnama*.[2] Unfortunately there is inconsistency in the text over the precise values so Thackston compares these with those given by the seventeenth-century jeweller Tavernier who visited the Mughal court. Thackston concludes that 1 *tank* = 4.25 grams. Rounding up, Akbar's bullets were 3.75 ounces; he was an extremely strong man. The standard Mughal bullet in the 1580s was 2.25 ounces. Contrast these with the British army Brown Bess military flintlock musket, in service in various forms from 1722–1838 with a bullet of about an ounce. The calibre remained at .75 but bullets collected on battlefields show they were often cast undersize at .69 because of the problems black powder fouling in the barrel caused when loading. Excavated evidence suggesting a bullet variation of 22.2 (0.783 oz) to 30.65 grams (1.0811 oz).

The very large Mughal lead bullets caused an unlikely death. Prince Danyal, third son of the Emperor Akbar and brother of Jahangir, was very fond of hunting. His favourite gun was engraved with a verse he composed: 'Yearning to fall prey to you, the soul is refreshed. For everyone hit by your bullet it is one shot and it's the funeral bier.' The last line '*yaka-u-janaza*' being the name he gave to the gun.

While Subadar of the Deccan he became an alcoholic and his father appointed guardians to prevent him receiving wine and spirits. However the prince arranged with his friends that when hunting they would smuggle 'double distilled spirits' to him concealed in the prince's gun barrel and in the entrails of cows hidden under their clothes. He became ill and died in 1605, aged thirty-two.[3] Black powder causes heavy fouling, is corrosive and hydroscopic which

FACING PAGE:
Bhoor Singh (left) and Bhanwar Singh Jaloda (right), demonstrate the length of the seventeenth-century *lamchar*s in Mehrangarh Fort armoury.

FOLLOWING PAGES:
Bhoor Singh (front) and Bhanwar Singh Jaloda (back), guards at Mehrangarh Fort, demonstrate the size of a late seventeenth-or early eighteenth-century *lamchar* from the armoury (FRM/76/8). These were often used without any rest other than a wall or a companion.

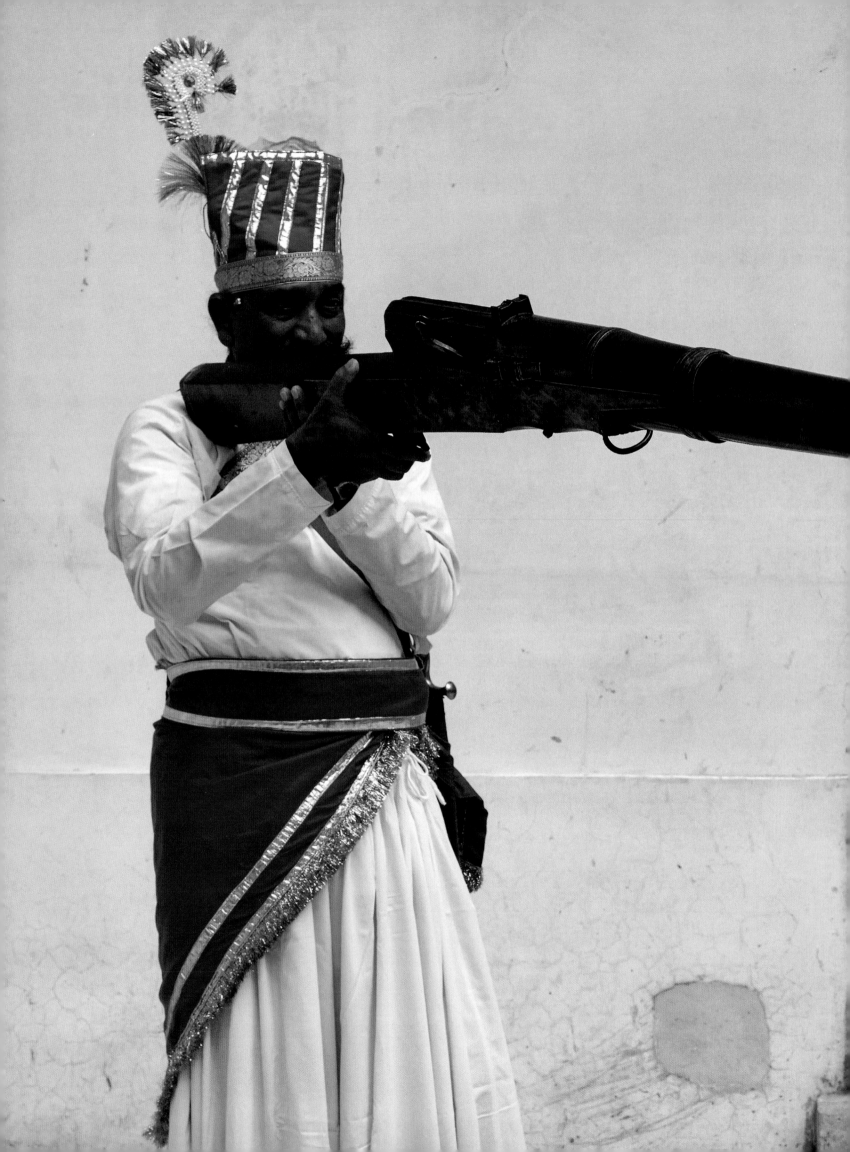

RIGHT:
A young Mughal prince carrying a matchlock, early seventeenth century. Al Sabah Collection. Inv. no. LNS 362 MS

FACING PAGE:
Akbar's siege of Ranthambhor in 1569. Painted c. 1590-95 by Miskina and Bhura. Amongst the small calibre guns directed at the fort are breech-loading small cannons and conventional style large matchlocks, all mounted on stands. V&A IS.2:74-1896.

causes rust. Prince Danyal's symptoms are consistent with lead poisoning brought about by the alcohol dissolving the residue of lead deposited in the gun barrels by the passage of bullets.[4]

*Lamchar* are large versions of conventional matchlocks but for use they were mounted on stands, illustrated in the *Akbarnama* paintings of the Mughal siege of the Rajput fort of Ranthambhor in 1569. These stands originated in Europe; Leonardo da Vinci made a design for one at the end of the fifteenth century.[5] From the beginning the form and decoration of European cannons and guns exercise considerable influence on Indian guns though tiger and lion heads decorate cannon that bear Sher Shah's name date from the 1540s. The different muzzle endings on matchlocks and the other barrel details are mostly found on early cannons and these designs continued until the mid-eighteenth century, in some instances through to

the nineteenth century. The standard matchlock muzzle in Jodhpur has an astragal followed by a concave form flaring at the extreme end, identical to Brescian matchlock muzzles from the 1570s.[6]

There is a clear difference between the shape of the stock of Mughal matchlocks in the 1560s and the late sixteenth century. From then through the seventeenth century there is no distinction and dating is a problem, particularly as barrels were re-used. The distinction between a mounted gun and a personal weapon is not clear cut. An individual's gun at this time was about as tall as the user, demonstrably so in *A Young Mughal Prince Carrying a Matchlock* in the Al Sabah Collection. This portrait is attributed on stylistic grounds to the early seventeenth century and an inscription names the future Emperor Jahangir (1569–1627). Like a modern hunter the prince wears green and brown when shooting game. His gun is carefully depicted, taller than its owner, with a plain wooden stock. The gun barrel, secured to the stock by bindings, appears decorated for its full length. If chiselled as the painting suggests this follows contemporary fashion on European gun barrels. Abu'l Fazl mentions that after Akbar has checked the strength of each gun barrel being made by loading it for a third of its length and firing it, and then checking that each gun barrel shoots straight: 'in the presence of His Majesty (it is) handed over to a filer. He adorns the barrel in various ways, according to orders, when it is taken to the harem'.[7]

This strongly suggests that the Emperor selected raised filed patterns for his gun barrels.

A further point of interest is the fact that each barrel is thick enough to be capable of taking such chiselling. From this we can infer that early Mughal barrels were particularly heavy. (This can be seen on gun FRM/76/269 on page 95). The block behind the breech in the painting is clearly made of a different wood, the usual choice being ebony, which is both tough and decorative. Such matchlocks, used throughout the seventeenth century, are represented at Jodhpur in this chapter. Lake, an East India Company man in early nineteenth-century Madras, is surely mistaken when he called all large guns 'ginjals'. In his opinion they were the same as *jezails*. 'Long matchlocks, of various calibres, used as wall-pieces by the natives of India, which are commonly fixed like swivels, and carry iron balls not exceeding a pound in weight. In the field they are sometimes carried on the backs of camels.'[8]

The very large gun with a stock was reinvented by Herman Maurice, Compte de Saxe (1696–1750), Marshal of France, who called his gun of this type an 'amusette' in his *Reveries, or Memoirs upon the Art of War*. He mentions: 'A piece of ordnance of my own invention which carries above 4000 paces with extreme velocity.'[9] Although considered a small cannon the amusette had a stock like a musket. 'It is worked by two or three men; and carries a half-pound ball'. Experiments were carried out with various calibres by the French and British. The Compte de Saxe intended the gun to be used on the battlefield to harass the enemy at extreme range when forming up. The Nizams of Hyderabad who had French and British military advisers at various times used similar flintlock guns c.1790, made by Furlong of Shadwell, London, with barrels 193cms (6.33 ft) long.[10] The British army abandoned amusettes in 1795.

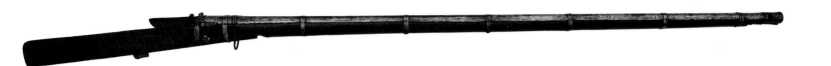

FRM/76/265

LAMCHAR. MATCHLOCK GUN
Mughal
Seventeenth century

OVERALL LENGTH: 240.5 CM
BARREL LENGTH: 184.5 CM
WEIGHT: 11.22 KG

DESCRIPTION
Smoothbore matchlock gun with round barrel, double astragals at the enlarged breech and muzzle. Nagari inscription on the breech: Jo. Sau. 13 [These letters are an abbreviation and a number.] Muzzle with chiselled open and shut lotus design. Groove rear-sight but no foresight. Plain iron ramrod, trigger, sling swivel and eight flat barrel bands. Shisham stock with fluted breechblock. Armoury mark SK 54.

COMMENT
The gun is in original condition. The curved end to the butt without a heel plate is found on early guns. Note also the nearly straight form of the stock. The double astragal can be seen on a barrel illustrated in a Mughal miniature of c.1585.[11]

Crude muzzle showing an early example of the standard matchlock design.

Close up showing the enlarged powder chamber.

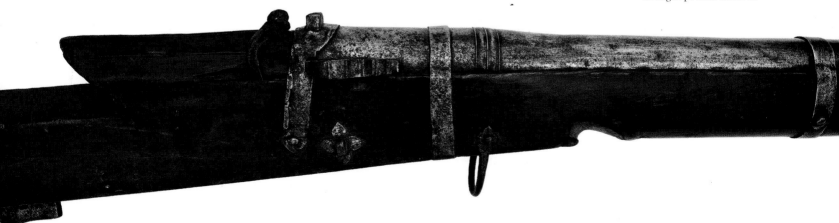

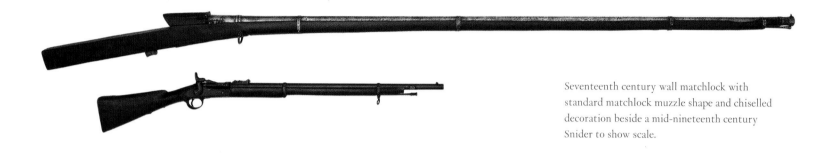

Seventeenth century wall matchlock with
standard matchlock muzzle shape and chiselled
decoration beside a mid-nineteenth century
Snider to show scale.

FRM/76/9

# LAMCHAR
Mughal or Rajput
Seventeenth century

OVERALL LENGTH: 266 CM
BARREL LENGTH: 211 CM
BREECH LENGTH: 10.4 CM
WEIGHT: 11.28 KG

## DESCRIPTION
Smoothbore undecorated barrel with double astragals at the breech marking the end of
the powder chamber and another below the muzzle; which is chiselled with a raised open
and closed lotuses with a lattice pattern base. Iron peg foresight and groove rear-sight.
Ramrod with facetted tip, iron trigger, serpentine, sling swivel and four flat iron barrel
bands. Shisham stock.

## COMMENT
Flat iron barrel bands with overlapping ends pinned with a rivet are sufficiently common
to be considered original. The Snider-Enfield (FRM/76/23) shows comparative lengths.

Typical early back–sight with
raised 'ears' on the corners.

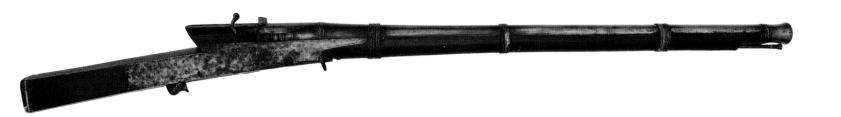

FRM/76/8

Seventeenth or early eighteenth-century heavy Mughal matchlock. Note the early form of sights, with four raised sections. This detail does not feature after approximately the mid-eighteenth century though it is found after that date when a barrel is reused.

## LAMCHAR
Mughal
Late seventeenth or early eighteenth century

OVERALL LENGTH: 239 CM
BARREL LENGTH: 165.6 CM
BREECH LENGTH: 18.2 CM
WEIGHT: 41.82 KG

### DESCRIPTION
Smoothbore cannon barrel with groove rear-sight with raised ears. Iron ramrod with fluted tip. Iron trigger and serpentine, the match shield tube missing though the fixing bolt remains in the side-plate. Shisham stock with fluted block behind the barrel. One sinew whipping from the use-life of the gun, the other two new. The understock is incised to suggest the metal side-plate with serrated decorative edge found on standard matchlocks. The iron sling swivel reflects conventional matchlocks though it seems improbable that anyone would carry the gun on a sling.

### COMMENT
The topmost flute behind the breech serves as a sight line as there is no foresight.

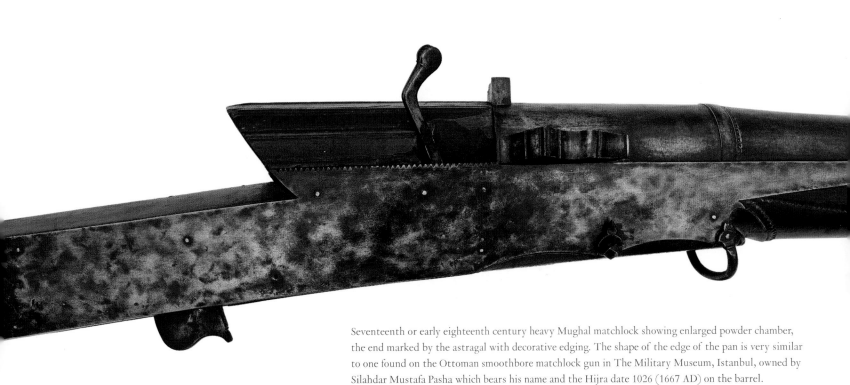

Seventeenth or early eighteenth century heavy Mughal matchlock showing enlarged powder chamber, the end marked by the astragal with decorative edging. The shape of the edge of the pan is very similar to one found on the Ottoman smoothbore matchlock gun in The Military Museum, Istanbul, owned by Silahdar Mustafa Pasha which bears his name and the Hijra date 1026 (1667 AD) on the barrel.

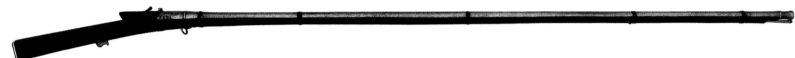

Late seventeenth century matchlock. These are guns with good accuracy and relatively high muzzle velocity because of the length of barrel which makes the most of the low quality black powder.

FRM/76/266

## LAMCHAR
Mughal or Rajput
Late seventeenth or early eighteenth century

OVERALL LENGTH: 247 CM
BARREL LENGTH: 200 CM

### DESCRIPTION
Smoothbore matchlock with enlarged breech chamber, round damascus-twist barrel with single astragals at the breech and muzzle. The concave muzzle section is undecorated and there is a groove rear-sight but no foresight. Simple iron ramrod, trigger and two iron slings. Five sinew barrel bindings.

Shisham full-stock with part of the heel-plate missing. Integral fluted block behind the barrel. Armoury number SK 54.

### COMMENT
The form is generally seventeenth century but the gun is finer than the earlier versions and the rear-sight has lost half of the raised ears that was normal in the earlier guns.

Top view showing changing rear–sight.

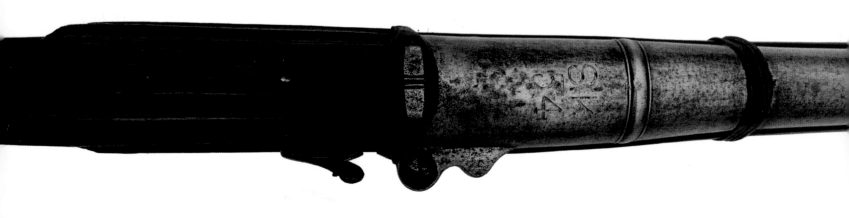

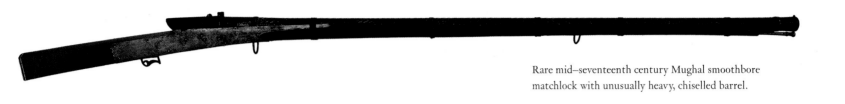

Rare mid–seventeenth century Mughal smoothbore
matchlock with unusually heavy, chiselled barrel.

Barrel with sophisticated chevron
chiselling, gilding and rear–sight.

FRM/76/269

## LAMCHAR
Mughal
1640s

OVERALL LENGTH: 202 CM
BARREL LENGTH: 149 CM

### DESCRIPTION
Large, unusually heavy, smoothbore barrel with concave muzzle and similar-shaped iron ramrod tip. The barrel is chiselled throughout its length with a raised 'V' pattern, covered with gold leaf and has a toothed margin just above the line of the stock. The gold false damascening at the breech is now indistinct.

The groove sight has raised ears in the seventeenth-century manner. The iron side-plate terminates with a simple decorative edge and this and the trigger are of similar date. Shisham stock with fluted ebony block behind the barrel and layered wood and bone butt-plate. Armoury mark SK 46.

### COMMENT
Indian chiselled barrels probably derive from sixteenth century European wheel-locks. The author has not seen a comparable 'V' pattern barrel but the design occurs in north Indian architecture: for example on *chadar* (stone water shoots) at Humayun's tomb, at the Red Fort, Delhi and on the facade of buildings such as Jahangiri Mahal, Agra Fort (1570s): or the corner colonnette in the Kanch Mahal, Sikandra (first quarter of the seventeenth century). It can also be seen as a textile pattern in a *Padshahnama* painting of 1633.[12] The barrel's very unusual weight and length suggests an early date and the quality suggests an important owner. Early seventeenth-century European barrels are common and it would be odd if Indian barrels of the same date have not survived. This barrel appears to have had a long use life because the pan cover is a late addition. This barrel is totally unlike the chiselled shikar barrels of the nineteenth and twentieth centuries.

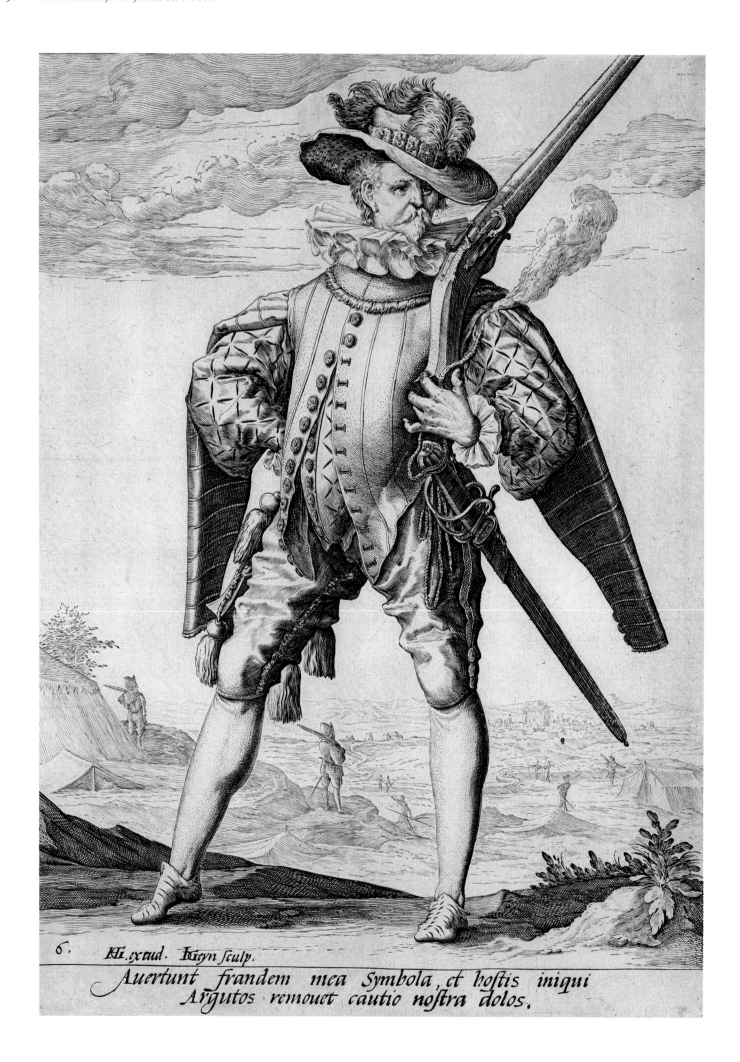

6.    HG. exud.    Geyn sculp.

Auertunt frandem mea Symbola, et hostis iniqui
Argutos remouet cautio nostra dolos.

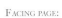

FACING PAGE:
'A Musketeer' by Jacques de Gheyn,
1587. Edwin Binney 3rd Collection.
The San Diego Museum of Art.
Accession Number: 1990.146

RIGHT:
'Portrait of the Portuguese Admiral
D'Albuquerque.' Artist Unknown,
attributed to c. 1615. This Mughal
portrait of a swaggering musketeer
is copied from a 1587 print by
Jacques de Gheyn. The series title is
'Uniforms of an Infantry Regiment
which shows Rudolf II, Holy Roman
Emperor' Guards regiment. Edwin
Binney 3rd Collection. The San
Diego Museum of Art. Accession
Number: 1990.303

Side view of seventeenth century heavy Mughal matchlock beside a 54 bore Robert Adams' Model 1851 self-cocking revolver.

FRM/76/22

## LAMCHAR
Mughal
Seventeenth century

OVERALL LENGTH: 231CM
BARREL LENGTH: 157 CM
BREECH LENGTH: 17 CM
WEIGHT: 31.31 KG

### DESCRIPTION
Smoothbore cannon barrel with groove rear-sight and no foresight. Steel ramrod with fluted tip. Iron trigger, serpentine and match shield tube. Shisham stock with ebony fluted block behind the barrel. Three sinew whipping barrel bands survive from the use-life of the gun. The understock is incised to suggest the metal plate with serrated decorative edge found on conventional matchlocks.

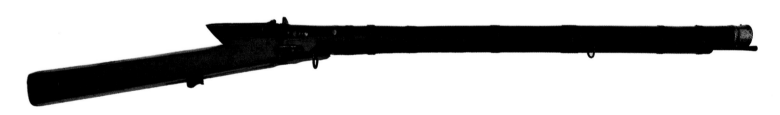

FRM/76/70

## LAMCHAR
Mughal
Barrel seventeenth century, the gun later refurbished

OVERALL LENGTH: 167 CM
BARREL LENGTH: 108 CM
WEIGHT: 12.40 KG

### DESCRIPTION
Smoothbore barrel with punched rings, all but the muzzle and an astragal at the breech chemically blackened, the barrel with peg foresight and square groove rear-sight with raised ears. Hammered steel ramrod with tapering tip. Iron trigger, serpentine and match shield tube. Twin sling swivels. One iron barrel band in situ together with six sinew whippings from the working period of the gun. Shisham stock and fluted ebony block behind the barrel. Armoury mark SK 15

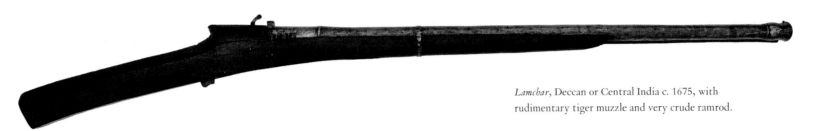

*Lamchar*, Deccan or Central India c. 1675, with rudimentary tiger muzzle and very crude ramrod.

FRM/76/72

# LAMCHAR
Deccan or Central India
c.1675

OVERALL LENGTH: 233 CM
BARREL LENGTH: 157 CM
WEIGHT: 75.71 KG

DESCRIPTION

Smoothbore gun, damascus barrel with bajra stippling, lion head muzzle with inlaid brass eyes, peg foresight and square groove rear-sight. Hammered iron ramrod with swollen tip, iron trigger and serpentine, one iron barrel band in situ.

Shisham stock, possibly a replacement, with fore section missing from the splice joint, later separate block of unusually plain form behind the barrel. The butt is incised to suggest the presence of a butt-plate.

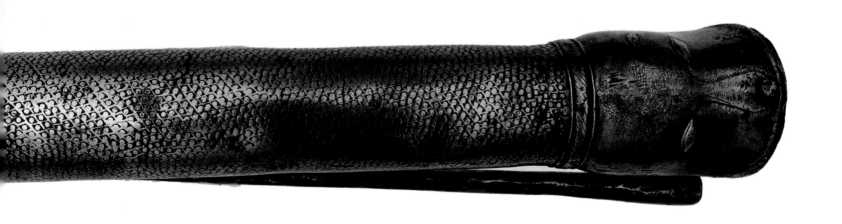

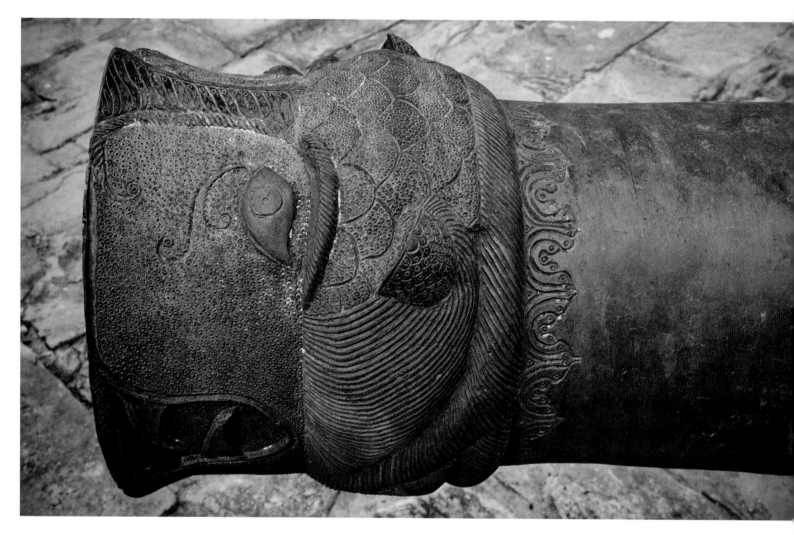

Cannon at Mehrangarh c. 1675. Lion
headed muzzles are found on both cannon
and handguns. The incised decoration at
the neck is also found on gun FRM/76/22.

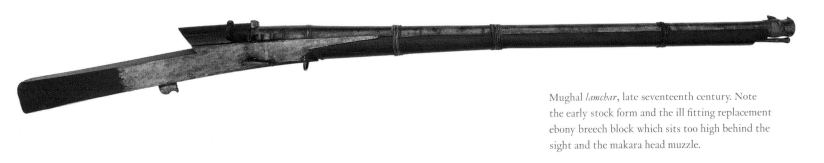

Mughal *lamchar*, late seventeenth century. Note the early stock form and the ill fitting replacement ebony breech block which sits too high behind the sight and the makara head muzzle.

FRM/76/74

## LAMCHAR
Mughal
Late seventeenth century barrel and metal parts

OVERALL LENGTH: 243 CM
BARREL LENGTH: 170.5 CM
WEIGHT: 31.735 KG

DESCRIPTION
Smoothbore gun with makara head muzzle with inlaid brass eyes, crest foresight and square groove rear-sight with raised ears. Iron ramrod with fluted tip, iron trigger, serpentine and match shield tube.

Shisham stock with replaced forestock, block behind the breech and renewed sinew whipping. The original understock is incised to suggest the metal plate with serrated decorative edge commonly found on matchlocks. The iron sling swivels were presumably used to secure these guns to a pack animal.

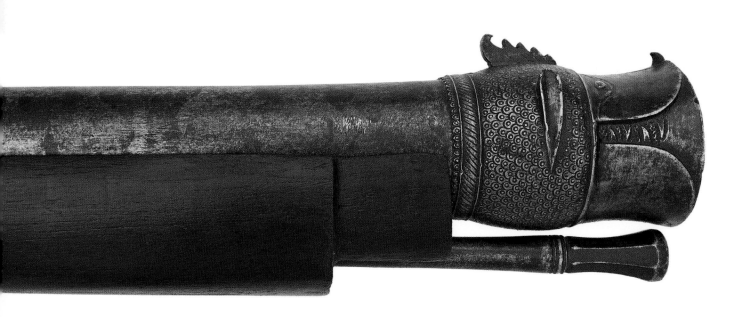

# SWIVEL GUNS OR SHUTURNAL

Swivel gun refers to the method of mounting a gun, usually a small cannon with the trunnions in an iron yoke, turning on an iron pivot. Blunderbusses, heavy muskets and matchlocks sometimes replaced the cannon. These are also termed wall pieces or rampart guns. In Europe the French and British made them during the first half of the eighteenth century. In the East demi cannon and heavy guns were mounted on camel saddle pommels. For practical reasons camel guns are considerably shorter than swivels.

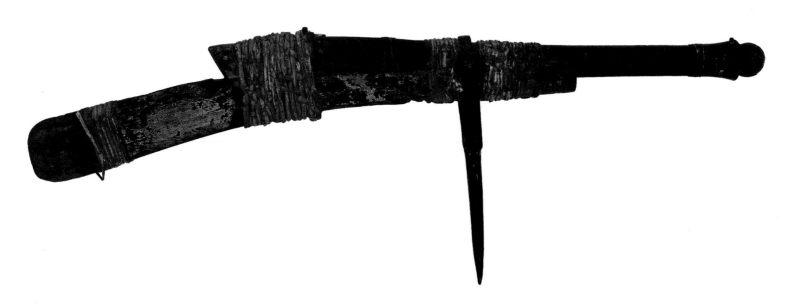

FRM/76/75

## CAMEL GUN, JUJARBA
Eighteenth century

OVERALL LENGTH: 122 CM
BARREL LENGTH: 75 CM

### DESCRIPTION
Cannon barrel with enlarged chamber, marked by an astragal, tapering slightly to another astragal at the muzzle, the latter with a toothed border. The muzzle has the same concave shape as matchlocks and a peg foresight. Groove rear-sight. There is a large incised lotus flower at the breech. The gun is fired from a touch hole on the top. Sinew whipping clamps barrel to wooden stock and reinforces the butt. An iron band round the barrel is attached to a Y-shaped swivel with pivot. A cannon ball has been soldered to the muzzle.

Camel gun drawn by John Lockwood Kipling for *Beast and Man in India*. London and New York, MacMillan and Co, 1891, 1st edition, p.285. This is the indigenous gun, mounted on the pommel.

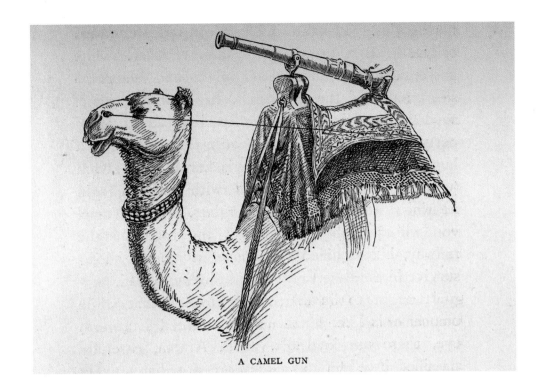

A CAMEL GUN

2nd edition, fig. 13.24, p.255. This later image shows an Imperial trooper. The posed rider holds the modern gun with one hand and a lighted match with the other. The gun is mounted on a swivel positioned so that when the camel is couched the rider can shelter behind the animal. Note the 'arghun' with twenty-four barrels mounted on the camel saddle on the ground. (British Library)

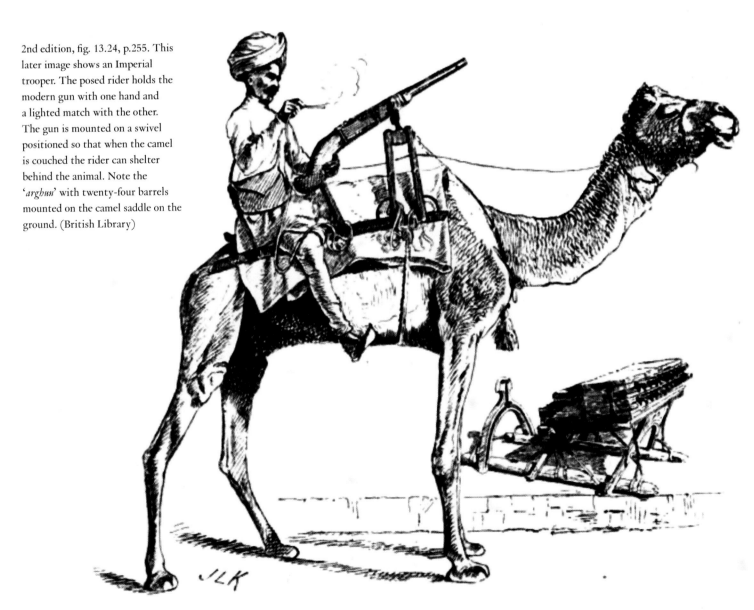

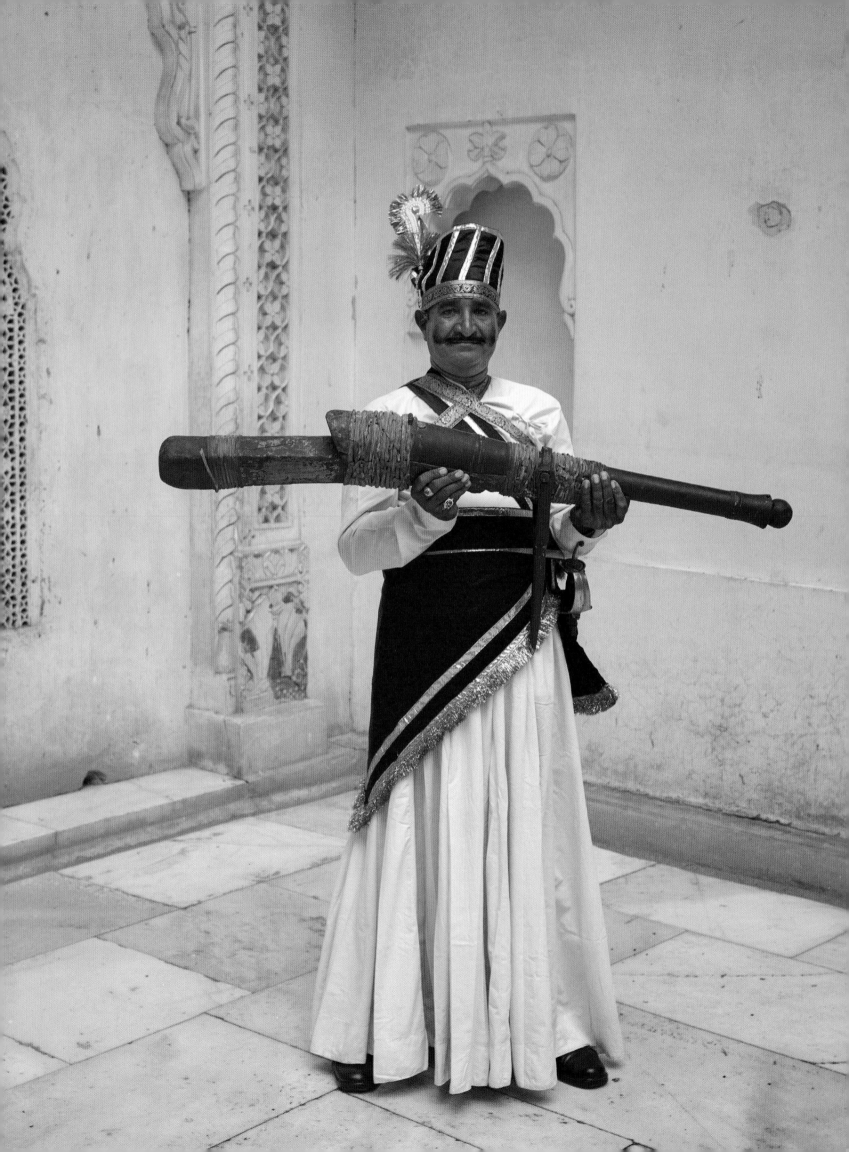

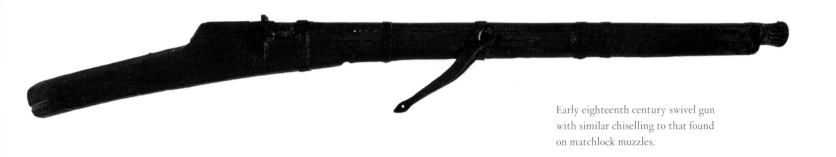

Early eighteenth century swivel gun with similar chiselling to that found on matchlock muzzles.

FRM/76/10

## SWIVEL GUN
Rajput
Early eighteenth century

OVERALL LENGTH: 183.5 CM
BARREL LENGTH: 126 CM
BREECH LENGTH: 11 CM
WEIGHT: 22.70 KG

### DESCRIPTION
Smoothbore barrel with undecorated round barrel with astragals at the breech marking the end of the powder chamber and another just short of the muzzle, which is chiselled with a raised design of closed lotuses with a lattice pattern base. Iron peg foresight and groove rear-sight without ears. No provision for ramrod. Crude shisham stock without provision for trigger or serpentine. Iron sling swivel. Seven flat iron barrel bands. The muzzle has a wooden plug to keep out dust.

FACING PAGE:
Bhoor Singh, one of the fort guards, holds the camel gun.

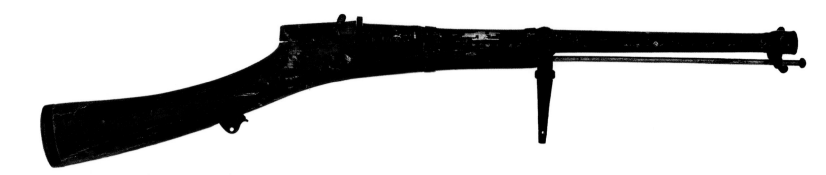

FRM/76/12

SHUTURNAL

Afghan or north Indian

Early eighteenth-century barrel; with nineteenth-century modifications

OVERALL LENGTH: 127 CM
BARREL LENGTH: 74 CM

DESCRIPTION

Cannon barrel with lion-head muzzle and swivel stand. The gun has a rear-sight with raised ears; and a nineteenth-century stirrup ramrod of the type found on military handguns. Wooden stock may be original but has been cut down.

# SEVENTEENTH- EIGHTEENTH- AND NINTEENTH-CENTURY BANDUK

When examining matchlocks it is necessary to consider separately the likely date of the barrel, stock, bindings/barrel bands and surface decoration which rarely all date from the same period.

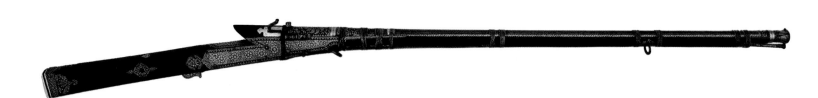

FRM/76/1

MATCHLOCK

Barrel second quarter of the eighteenth century
Koft work c.1870–80

OVERALL LENGTH: 150 CM
BARREL LENGTH: 101CM

DESCRIPTION

Smoothbore matchlock with 'bajra' barrel. Standard concave muzzle with raised lotus design decorated with gold but the finish is more elaborate than the seventeenth-century design. The breech, separated from the rest of the barrel by a double astragal, is covered with chiselled flowers and leaves in a raised design with contrasting blackened silver ground. There is a similar apron at the muzzle. Copper-bead foresight and flat-topped groove rear-sight.

Figured shisham stock with ivory layered butt-cap and iron side-plates bearing gold flower heads. The pierced floral panels match those on another late nineteenth-century gun, FRM/76/2. Fluted wooden block behind the barrel, the central flute with single metal strip decorated with gold meander pattern, the serpentine aperture strengthened with a silver plate. Iron ramrod with flared head, iron slings and match shield tube. The iron trigger is decorated with false-damascened gold flowers on a blackened, cross-hatched ground matching other work on the gun. Sinew barrel whipping held in place by raised fences circling the upper barrel. Armoury mark SK 28.

COMMENT

Chiselled iron flowers are discussed elsewhere.[13] This ornate example has degenerated from the simple mid-seventeenth-century specimens. The gold flowers on the stock-plates are a later addition, similar to those found on a *susan patta* hilt in Mehrangarh Armoury dated vs 1934/1877 AD.[14] The silver half-barrel bands and guide for the match arm are from this period.

Barrel, second quarter of the eighteenth century with later goldwork. View of the breech showing chiselled flowers on a contrasting black ground

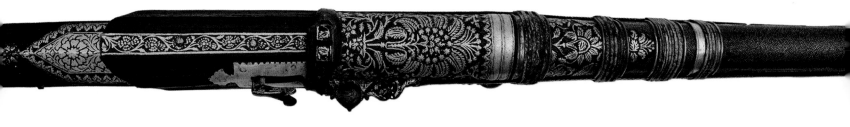

There are two type of matted finish for Rajput gun barrels, bijr meaning seed, a fine pattern, and bajra meaning millet, a larger stipple.

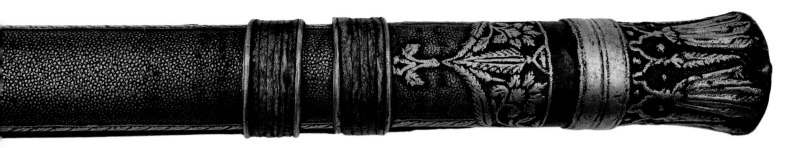

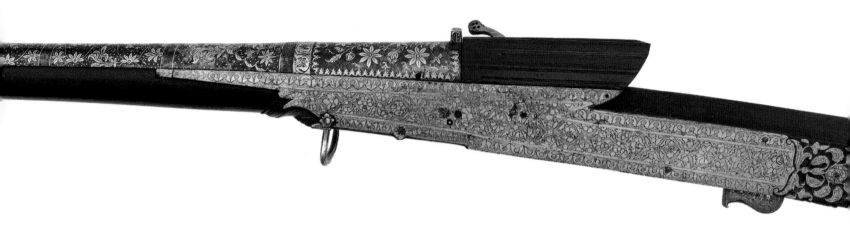

FRM/76/2

MATCHLOCK
Gun, nineteenth century
Koft work second half of the nineteenth century

OVERALL LENGTH: 180 CM
BARREL LENGTH: 129 CM

DESCRIPTION
Smoothbore matchlock, the heat-blackened barrel inlaid with panels of gold flowers with a dot pattern background. Standard concave muzzle with open and closed lotus design, gold inlaid instead of chiselled. The copper-bead foresight is missing, flat-topped groove rear-sight. Finely figured shisham stock with iron butt-cap and side-plates covered with gold flowers on a dulled gold ground. Fluted wooden block behind the barrel.

Iron ramrod head crudely decorated with gold; iron trigger with a crude silver inlaid repeat pattern, which does not match other work on the gun. The barrel bands and slings are silver, the latter renewed in 2016. The match shield tube is missing. Armoury mark SK 40.

COMMENT
The gold decoration on the barrel can be found on second half of the nineteenth-century talwar hilts in Alwar and City Palace, Jaipur. Note the retention of the spaces along the barrel for barrel bands, too narrow for sinew whipping. This gun acknowledges traditional design but does not adopt the expense of it.

Top view: The gaps in the pattern for barrel–bands are inadequate to take sinew whipping which dates the koft work. This damascened pattern is common on tulwar hilts from the second half of the nineteenth century. The silver barrel band is modern.

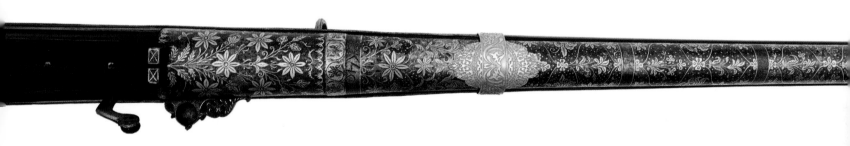

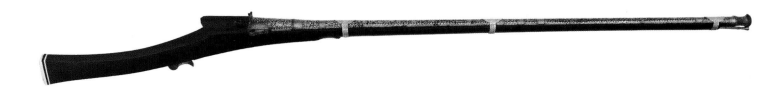

FRM/76/3

## MATCHLOCK
Central India, Bundelkhand or Indore.
Late eighteenth century with nineteenth century decoration to the barrel.

OVERALL LENGTH: 177 CM
BARREL LENGTH: 124 CM

### DESCRIPTION
Smoothbore matchlock, the barrel decorated with false-damascened gold flowers. Lotus muzzle shape and butterfly rear-sight. No iron side-plates. Figured shisham stock with fluted block behind the barrel; and layered ivory butt-plate. Iron ramrod, the baluster head with gold band. The iron trigger has a remnant of sheet silver, a design unmatched elsewhere on the gun. The barrel bands were renewed in 2016. Armoury mark SK 26.

### COMMENT
This central India gun is from a different aesthetic tradition from Rajput guns. The butt curves up in a distinctive manner. Egerton records that the muzzles of matchlocks in Bundelkhand are lotus-shaped.[15] The bare steel bands interrupting the barrel's gold decoration indicate the position of bindings but the potential position adjacent to the muzzle cannot work as it would impede the use of the ramrod, suggesting the gold work was added after the use-life of the gun. A painting by Bijna of 'Kunwar Dhan Singh on his dappled horse in 1808 AD' in the Edward Binney Collection shows this butt shape is from Datia and Orcha in Bundelkhand.[16] These states had close ties with the Mughals from the time of Jahangir.

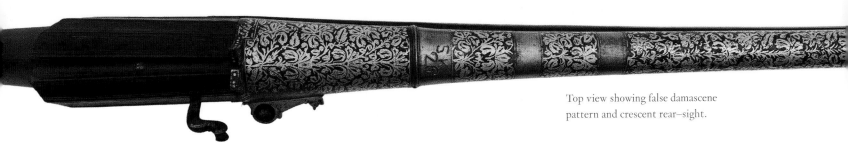

Top view showing false damascene pattern and crescent rear–sight.

Typical central Indian muzzle.

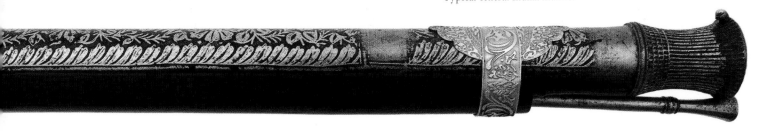

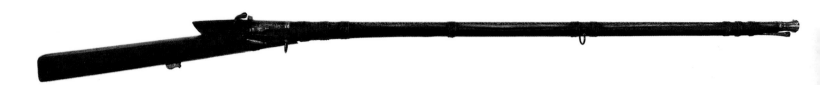

FRM/76/40

# MATCHLOCK
Mughal or Rajput
Second half of the seventeenth century

OVERALL LENGTH: 196 CM
BARREL LENGTH: 143
WEIGHT: 5.76 KG

### DESCRIPTION
Smoothbore barrel decorated with chiselled flowers divided by a raised frame all covered with silver, contrasted with a stippled black ground. The muzzle has a leaf pattern in relief, probably once silvered. Groove rear-sight with raised ears; copper-bead foresight. Original iron ramrod, plain iron mounts including sling swivels, chain with pricker and match shield tube. Plain shisham stock with fluted block behind the breech. Nine sinew bindings secure the barrel to the stock.

### COMMENT
The sophistication of the Shah Jahan floral barrel contrasts with the simplicity of the stock, iron mounts and sinew barrel bands. The barrel's length indicates its seventeenth-century date. Armoury mark SK 3. Jaipur City Palace has a similar chiselled barrel. The Inventory records it was made in Narwar.[17] A scabbard with flowers down its full length in fairly similar manner can be seen in a 1645 miniature in the *Padshahnama*.[18]

View from above showing seventeenth-century rear-sight, swollen powder chamber with double astragal, and chiselled flowers extending along the barrel. Neat rows of flowers are common on Mughal artefacts from the reign of Shah Jahan, particularly architecture, painting and textiles.

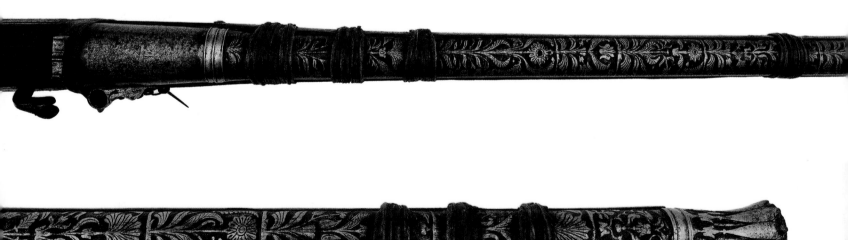

Chiselled barrel and unusual muzzle decoration.

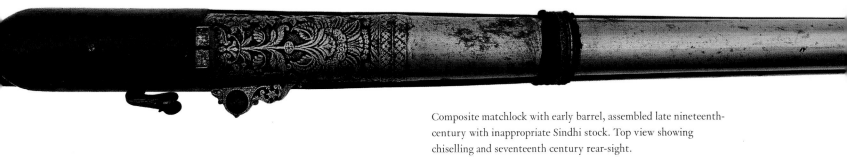

Composite matchlock with early barrel, assembled late nineteenth-century with inappropriate Sindhi stock. Top view showing chiselling and seventeenth century rear-sight.

FRM/76/44

## MATCHLOCK
Barrel and trigger late seventeenth or first half of the eighteenth century
Stock late nineteenth century

OVERALL LENGTH: 172 CM
BARREL LENGTH: 130 CM

### DESCRIPTION

Damascus barrel with deeply chiselled flower at the breech, originally contrasted against a gold ground, now missing. The remainder of the barrel had a diamond pattern created from punched dots, eroded by abrasive cleaning. There are twin astragals and the muzzle is in the form of a makara head with a copper foresight. In vs 1910/1853 ad Maharao Ram Singh of Kotah gave weapons to Maharaja Takhat Singh of Jodhpur including: '1 Delhi gun with gold work on the barrel and muzzle in the shape of a crocodile'.[19]

Ramrod with flared faceting. The solid iron trigger is decorated with false-damascened gold flowers in the manner found on seventeenth-century dagger fortes.

### COMMENT

The shisham stock is devoid of decoration, missing its butt-plate and inferior to the other parts of this gun, which appears to have been assembled from disparate parts in the late nineteenth century, perhaps to allow the excellent barrel to be displayed. For similar floral chiselling see Elgood, 2017, ch. 8.

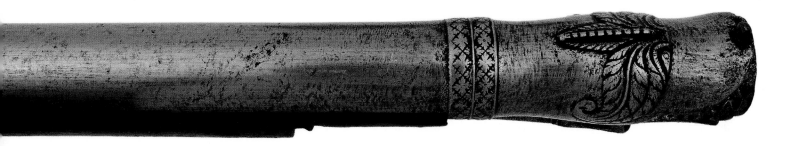

Detail showing makara muzzle.

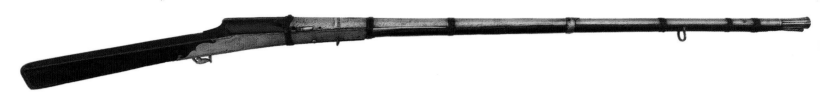

FRM/97/249

# MATCHLOCK
Jaipur
Late seventeenth or early eighteenth century

OVERALL LENGTH: 145.5 CM
BARREL LENGTH: 96 CM

## DESCRIPTION

Matchlock smoothbore gun made for a boy or a woman, probably the former. Smoothbore barrel decorated with magnificent mechanical 'orange segment' damask and trisula (trident) chiselled in relief. Groove rear-sight with raised ears. Long ribbed swelling muzzle. Simple iron ramrod with swollen tip, pierced iron trigger. Simple iron mounts with stamped and incised border. The barrel is secured to the plain shisham full-stock with sinew bindings and one earlier steel band. Armoury mark SK 22.

## COMMENT

The orange segment pattern can be seen on a pistol barrel in City Palace, Jaipur.[20] The damask pattern and the trisula and raised rib on the barrel are commonly found on barrels in Jaipur. A matching barrel with orange segment watering and trisula is published by Fiegiel attributed to 1700.[21] The quality of these barrels suggest they were made for a Maharaja. The sighting rib rises as the central tine of Shiva's trident. The eleventh-century *Kamikagama* states that the three tines represent the three *guna*s, *sattva* (purity), *rajas* (energy) and *tamas* (inertia or lethargy), which are natural forces in the theory of creation and evolution. The central tine representing energy speeds the bullet down the barrel. According to Hindu Samkhya philosophy all matter contains these three gunas in various proportions. Samkhya in Sanskrit means 'relating to numbers' calculation, counting, numerical enumeration or rational examination. The school's strong reliance on reason would be particularly attractive to Maharaja Sawai Jai Singh II (r.1699–1743) the mathematician and astronomer, who ruled Amber and built Jaipur on rational principles. He was under strong military pressure from the Marathas at the time these barrels are thought to have been made. For a gun from the same workshop see ARM/76/41. FRM/97/232

Top of the gun showing Shiva's trident with central sighting line and 'orange segment' damask barrel.

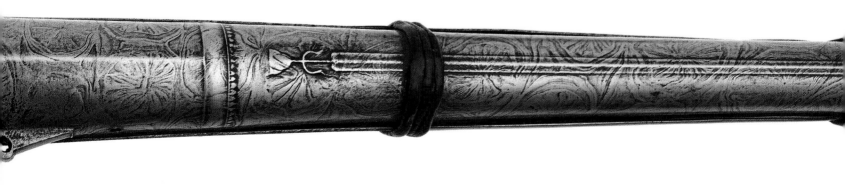

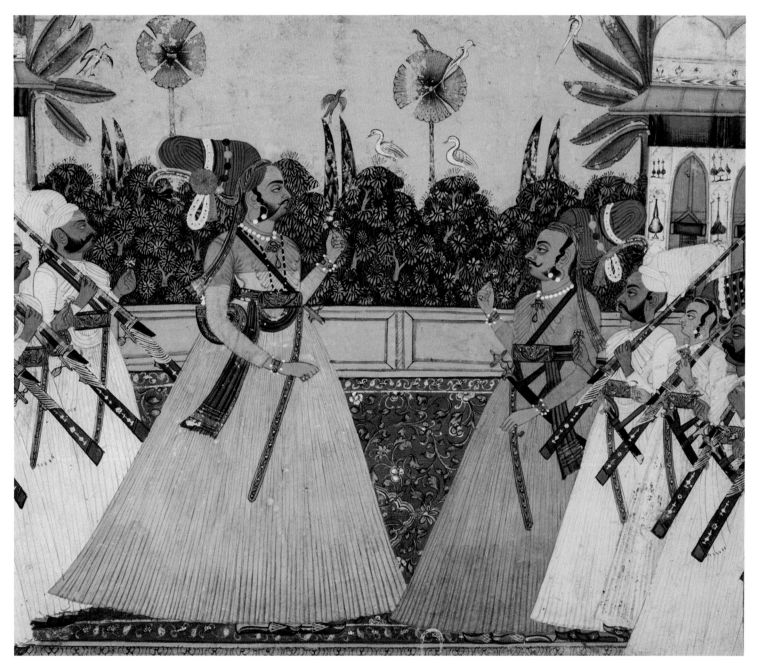

Hari Singh of Chandawal and Hindu Singh of Patiakot with courtiers. Jodhpur, c. 1760-70. Note the
distinctive inlaid ivory in the stocks, the uniformly wound match and the whipping securing the barrels
to the stocks. The uniformity shows a short-lived court style enforced by the Maharaja's chamberlain. The
inlay is distinct from the earlier examples from Jaipur in this catalogue such as FRM/76/41 and 232 which
are Mughal in inspiration. 23 x 26.5 cm. National Museum, New Delhi, no. 65.135.

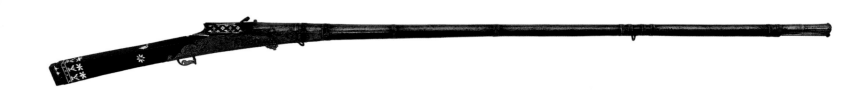

FRM/76/41

## MATCHLOCK
Jaipur
Late seventeenth or early eighteenth century

OVERALL LENGTH: 180 CM
BARREL LENGTH: 134 CM

### DESCRIPTION
Smoothbore barrel decorated with mechanical 'orange segment' damask, raised sighting rib with two parallel tines. Groove rear-sight with raised ears. Long ribbed swelling muzzle. Simple iron ramrod with mushroom tip, pierced iron trigger. Simple iron mounts with rudimentary stamped and incised border. Silver chain and iron pan cover. No armoury number. Shisham stock, the block behind the breech and the butt inlaid with ivory flowers and borders. Sinew bindings.

The block behind the breech and the butt inlaid with ivory flowers and borders.

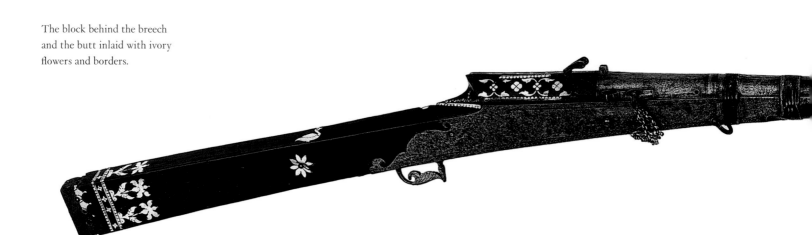

Watered steel barrel showing muzzle and ramrod.
The muzzle design below the astragal is first seen on
Bohemian half-arquebuses which were imported into
Portugal in large numbers and shipped east.  This is the
type of gun that the Portuguese took to Goa and on to
the Far East, whose lock was copied by the Goans, the
Japanese, the Sri Lankans and Malayans. This muzzle
detail was copied until the nineteenth-century.

Top of gun showing ivory inlay,
rear-sight and watered steel breech.

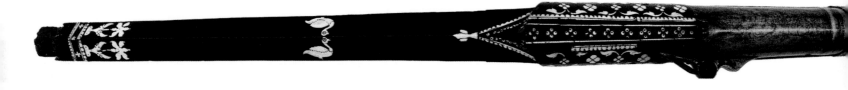

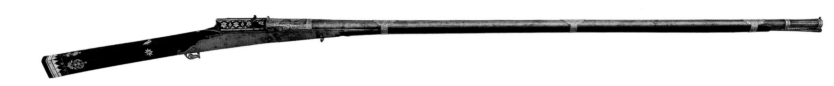

FRM/97/232

## MATCHLOCK
Jaipur
Late seventeenth or early eighteenth century with nineteenth-century gold koft work.

OVERALL LENGTH: 173.5 CM
BARREL LENGTH: 122 CM
WEIGHT: 3.48 KG

### DESCRIPTION
Matchlock with watered-steel barrel, the zigzag pattern a tour de force of barrel-making. Sighting rib in the form of an elongated trisula above a raised gold small trisula. Nineteenth-century gold decoration at the breech and muzzle. The muzzle section is long and slightly flared. Copper-bead foresight and small groove rear-sight with raised ears. Iron ramrod with tapering head and false damascening. Pierced iron trigger. Modern barrel bands.

Plain shisham stock inlaid with fine ivory flowers and abstract motifs on the butt and block behind the barrel. The hole drilled in the back of the block serves as a match shield tube. Armoury mark SK 6.

### COMMENT
Egerton illustrates a matchlock '*toradar*' with watered-steel barrel and ivory inlay belonging to this group, no. 422 in his chapter on decoration, a gift to the South Kensington Museum by the 'Rajah of Jaipur'.

View from above showing trisula on the watered steel barrel, original ivory inlay and nineteenth century gold decoration.

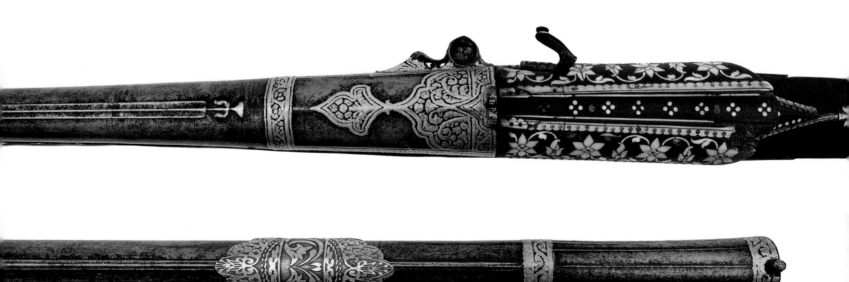

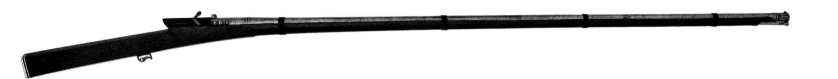

FRM/76/45

## MATCHLOCK, TODEDAR BANDUK
Rajput
Late seventeenth or eighteenth century

OVERALL LENGTH: 180 CM
BARREL LENGTH: 134 CM
WEIGHT 5.77 KG

DESCRIPTION
Smoothbore, damascus-twist barrel. Groove rear-sight and copper-bead foresight. Raised chiselled pattern of closed lotuses at the muzzle. Iron ramrod with faceted tip, pierced iron trigger. Shisham block behind the breech. Bone butt-plate. The barrel is secured to the stock with four sinew bindings. Armoury mark SK 55.

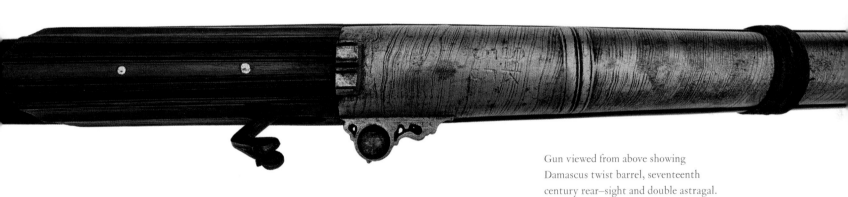

Gun viewed from above showing Damascus twist barrel, seventeenth century rear–sight and double astragal.

Muzzle details.

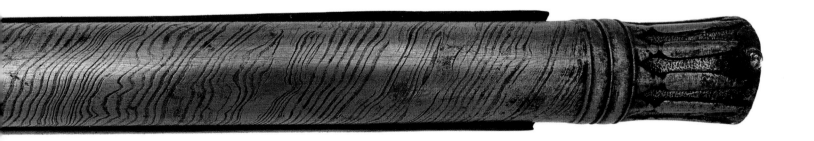

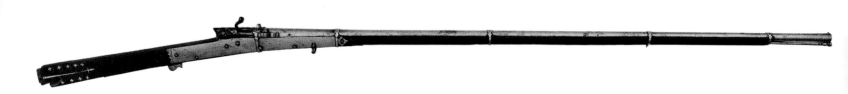

FRM/97/279

## MATCHLOCK
Mughal
First half of the eighteenth century with nineteenth-century Punjabi brasswork

OVERALL LENGTH: 185 CM
BARREL LENGTH: 132 CM

### DESCRIPTION
Smoothbore damascus-twist barrel with slightly flared muzzle, copper-bead foresight and groove rear-sight. Unusual pan and cover, a nineteenth-century alteration.

Shisham stock with bone inlay at the stock and on the block behind the breech. The barrel is secured to the stock with five brass bands and there is inset brass stringing and rondels behind the breech, all nineteenth-century Punjabi type. Iron side-plate with mechanical damask pattern, plain iron trigger, sling mount and iron ramrod with turned end.

### COMMENT
Detail showing early twist barrel and later Punjabi brass barrel–bands, wide powder pan and odd circular pan cover.

The inlaid bone design on the stock is a degenerate stylised form of Mughal plant stem with subsidiary stems leading to flower heads. The design can be seen in Shah Jahan textiles and rugs, the later chiefly made in Lahore. The gun shows work at two stages in its use-life.

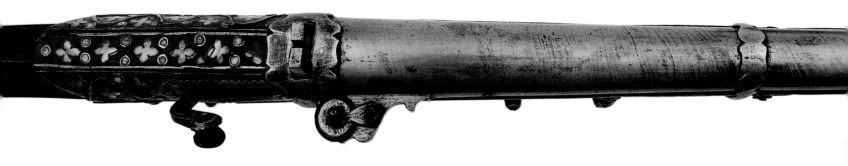

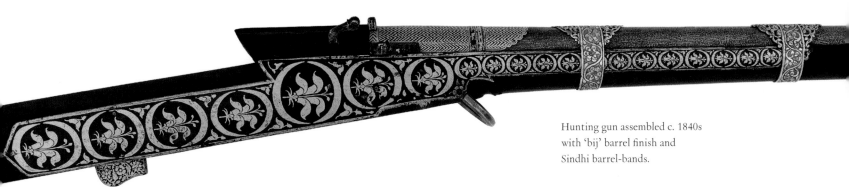

Hunting gun assembled c. 1840s
with 'bij' barrel finish and
Sindhi barrel-bands.

FRM/76/4

# MATCHLOCK
Barrel c.1740

OVERALL LENGTH: 164 CM
BARREL LENGTH: 130 CM

## DESCRIPTION

Smoothbore matchlock with 'bij' matted barrel. Conventional muzzle with gold decorated
raised open and closed lotus design. The breech, separated from the rest of the barrel by a
double astragal, has a gold chevron pattern, matched at the muzzle. Copper-bead foresight
and groove rear-sight with raised ears.

Finely figured shisham stock with iron butt-cap and side-plates, all bearing gold flower
heads within circular frames on a black ground. Fluted wooden block behind the barrel.
Iron ramrod with baluster head. The iron trigger has false-damascened gold flowers on a
blackened, cross-hatched ground, unmatched on the gun. The silver barrel bands and slings
are Sindhi. Metal match shield tube missing. Armoury mark SK 1.

## COMMENT

The basic elements of this large, unusual gun probably date from the mid-eighteenth
century. The iron butt-cap, worn from use, is not a Rajput design. Egerton shows a similar
detail on a gun he attributes to the Marathas.[22] The unusual gold flower pattern in its round
frame has no obvious parallel. The gun was arguably improved to its current form in the
1840s but does not follow the usual Takhat Singh design. The barrel bands suggest that a
Sindhi silversmith relocated to Jodhpur with the Sindhi Mirs who found sanctuary with the
Rathores after the British seized their country in 1843. Egerton shows similar bands on a
Jodhpur gun in 1880.

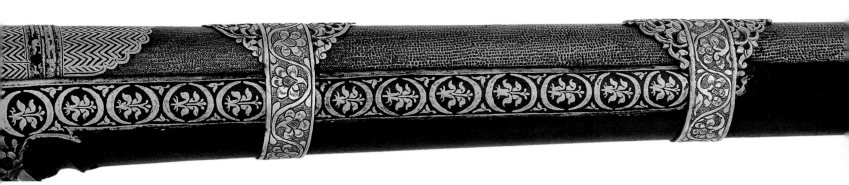

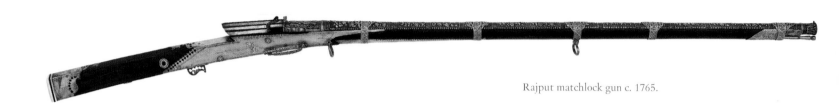

Rajput matchlock gun c. 1765.

FRM/76/5

## MATCHLOCK
Rajput
Third quarter of the eighteenth century with nineteenth-century
barrel bands and silver work

OVERALL LENGTH: 161 CM
BARREL LENGTH: 111 CM

DESCRIPTION
Smoothbore matchlock with ring-matted 'bajra' barrel. The standard concave-shaped
muzzle has raised open and closed lotus design decorated with gold. A male tiger, chiselled
in relief, crouches on a bed of flowers at the breech. An astragal separates the remainder
of the barrel, which is inlaid with silver flowers in relief, some with birds in the spandrels.
Copper-bead foresight and groove rear-sight.

Figured shisham stock with twin ivory butt-plates sandwiching a layer of wood. Fluted
block behind the barrel, the flutes filled with silver strip, a feature seen in Rajput miniatures
of c.1765. The barrel bands and mounts are silver, the match shield tube with an incised
floral pattern. Iron ramrod with baluster head: pierced iron trigger with applied gold leaf.
Armoury mark SK 36.

COMMENT
This hunting gun has fourteen breaks for sinew bindings in the floral pattern on the
nineteenth-century barrel: multiple bindings are illustrated in miniature paintings. The
silver barrel bands are nineteenth-century replacements as are the other silver mounts.

Top view showing chiselled
tiger and inlaid silver flowers.

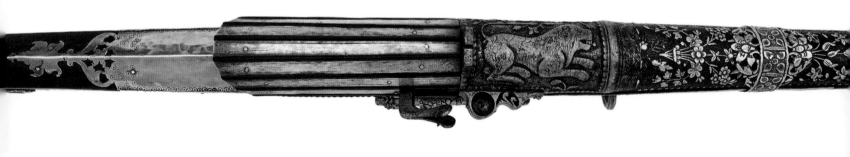

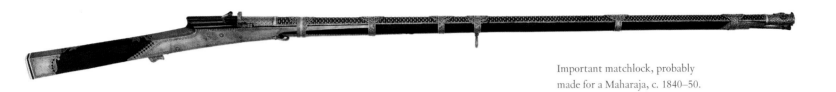

Important matchlock, probably
made for a Maharaja, c. 1840–50.

FRM/76/6

## MATCHLOCK

Barrel first half of the eighteenth century with nineteenth-century embellishments. The gun was probably modified and assembled for Takhat Singh.

OVERALL LENGTH: 184 CM
BARREL LENGTH: 133 CM

### DESCRIPTION

Smoothbore matchlock, the barrel chiselled with raised tiger stripes and dots, a version of a common design of Iranian-Turkish origin, highlighted in gold against a matt-black ground. The makara head is decorated with gold false damascening en suite with the barrel. Copper-bead foresight and groove rear-sight with raised ears. The breech has a gold reticulated pattern with flowerheads and an astragal. Figured shisham stock with twin ivory butt-plates sandwiching a layer of wood. The flutings on the block behind the barrel are filled with silver strip, a design that begins in the 1760s but remained popular into the nineteenth century. The barrel bands and mounts are silver, the match shield tube missing. Iron ramrod with baluster head decorated with gold chevrons. The iron trigger is decorated with false-damascened gold flowers on a black ground. Armoury mark SK 43.

Detail showing makara muzzle.

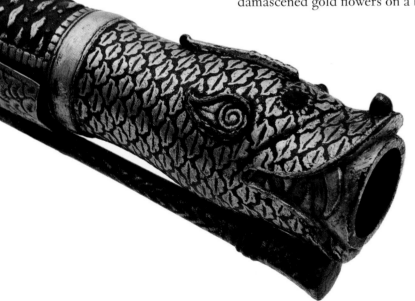

### COMMENT

This is a tour de force of the barrel-maker's art, clearly a royal order. The makara muzzle is sometimes found on seventeenth-century Turkish and Indian matchlocks and cannon muzzles and here is from the original barrel design. The author knows of inscribed barrels with dates c.1800 in private collections with makara muzzles but this proves little. The absence of breaks in the pattern for barrel bindings suggests the *Chintamani* decoration is nineteenth century. The silver mounts are from that date as are the Talpur-style[23] barrel bands, the gun probably assembled for Maharaja Takhat Singh in the 1840s.

Top view of gun.

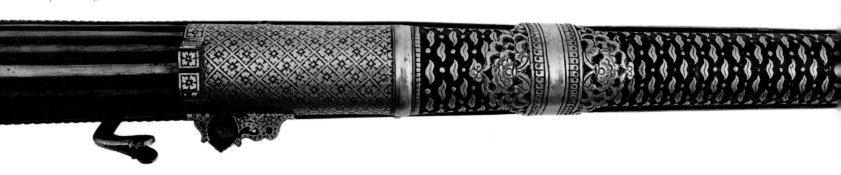

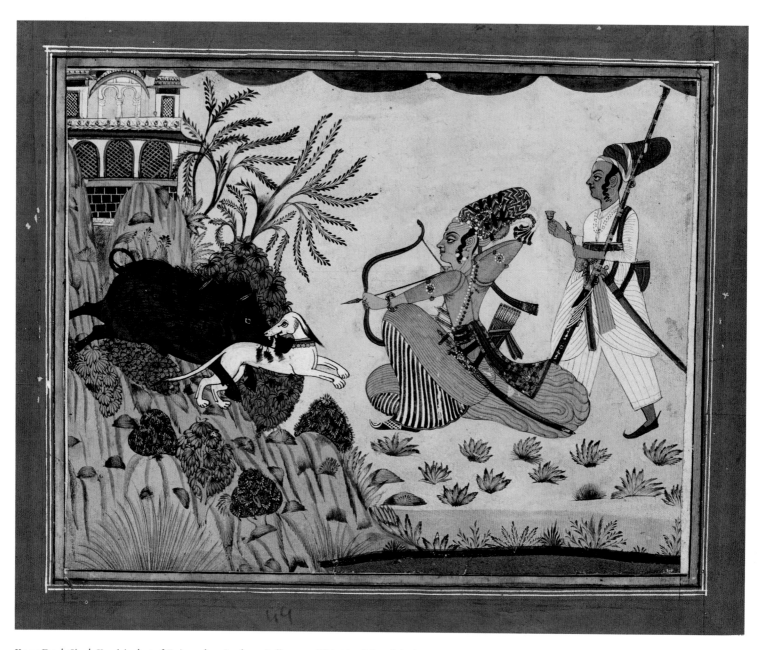

Kamr Fateh Singh Kesrisinghot of Raipur shooting boar. Jodhpur, c. 1750–60. Although he has a gun available, he prefers to shoot the boar with his bow. RJS 4701 Mehrangarh Museum Trust and His Highness Maharaja GajSinghji II of Jodhpur–Marwar

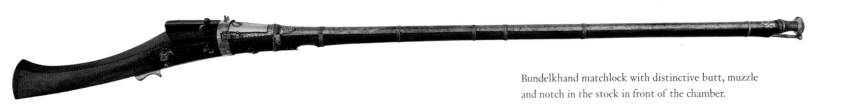

Bundelkhand matchlock with distinctive butt, muzzle
and notch in the stock in front of the chamber.

FRM/76/94

# MATCHLOCK
Bundelkhand or Indore
Late eighteenth century with nineteenth-century koftgari decoration

OVERALL LENGTH: 170 CM
BARREL LENGTH: 121.5 CM

DESCRIPTION
Smoothbore barrel with mushroom-shaped gold muzzle. Breech with applied gold panel
with gold false-damascened flower and foliage design. Bij finished barrel.

Curved stock with turned-up butt, ebony block behind the barrel and ebony butt-plate.
There are metal side-plates below the breech which are varnished to blend with and
reinforce the stock. Silver chain with pricker, probably added in Jodhpur. The wire securing
the barrel is also a late addition. No armoury number.

Breech detail showing distinctive
Bundelkhand rear-sight.

COMMENT
For a very similar gun see Elgood 1995, p.154.

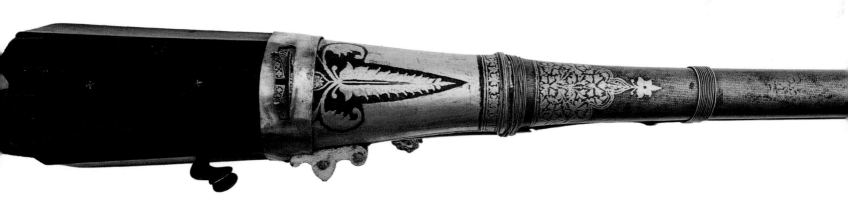

Muzzle detail.

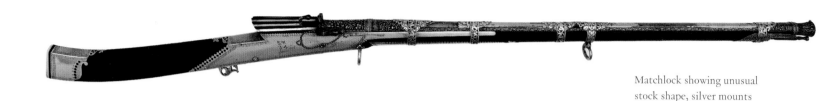

Matchlock showing unusual stock shape, silver mounts and chiselled barrel.

FRM/76/97

# MATCHLOCK GUN
Mid-eighteenth century barrel
Remainder probably 1840s

OVERALL LENGTH: 141 CM
BARREL LENGTH: 90.5 CM

## DESCRIPTION
Smoothbore barrel with lotus muzzle, decorated with unusually elaborate raised lotus design. Groove sight with raised ears. Breech with raised flower and foliage design and double astragal, all gilt. The barrel has a gold meander pattern running above the stock. All the gold work has a blackened ground and the barrel was silvered. Shisham stock of unusual form with turned-up butt. Layered ivory and wood butt-cap. Ebony block behind the breech with inset silver stripes. Silver mounts including silver chain with pricker. Armoury mark SK 34.

## COMMENT
The short barrel has complex chiselled decoration, the grooved sight has minimal projecting ears. These facts suggest the barrel is mid-eighteenth century, made for a youth or a woman. The frizzen pan cover is unusual in its construction, a clumsy form not found in the first half of the eighteenth century. The barrel was selected as part of a gun assembled for Takhat Singh. The silver work is typical of his reign. The shape of the stock is unusual, for another less curved see FRM/253. This may represent some regional design, for example central Indian stocks turn up. Alternatively it is possible that the man who commissioned this oddity had become used to shooting with a European stock and wanted to replicate it on an otherwise standard Indian matchlock. This gun illustrates an important decorative point. The chiselled area of raised flowers at the breech has a silvered ground that is now black. In construction silver sheet is applied to the entire decorative area. The raised areas then have gold applied. To make it adhere the gold is heated. This causes the silver to go black. The old Jodhpur craftsman with whom the author discussed this was adamant that the black contrast to the gold was the intended finish and the silver ground should be left black.

Detail of muzzle, barrel band and unusual ramrod design.

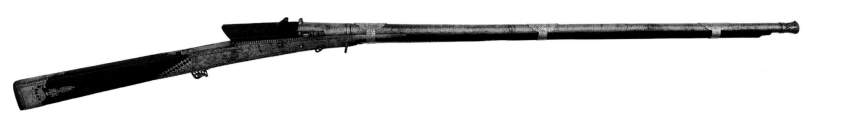

FRM/76/101

## MATCHLOCK MADE FOR A YOUTH OR A WOMAN
Jaipur
Mid-eighteenth century

OVERALL LENGTH: 134 CM
BARREL LENGTH: 85 CM
WEIGHT: 2.28 KG

### DESCRIPTION
Smoothbore damascus-twist barrel, the muzzle with raised lotus design. Groove rear-sight with raised ears and copper-bead foresight. Shisham stock with fluted ebony block behind the barrel. Wooden butt-plate. Steel fittings. Modern silver barrel bands.

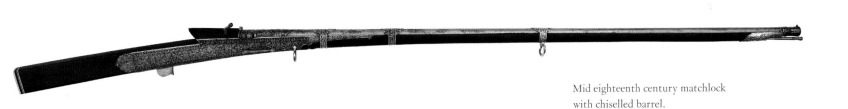

Mid eighteenth century matchlock with chiselled barrel.

FRM/97/223

## MATCHLOCK
Mid-eighteenth century

OVERALL LENGTH: 190 CM
BARREL LENGTH: 137 CM

### DESCRIPTION
Smoothbore matchlock with concave-shaped muzzle with open and closed lotus flowers. The breech is decorated with a flower in high relief, originally silvered with heat-blacked ground, now both lost. Flat-topped rear groove sight. Plain iron trigger (probably not original), ramrod with baluster finial. Silver barrel bands and match shield tube from the Takhat Singh period. Plain shisham stock with layered ivory butt. Armoury mark SK 19.

FRM/97/223

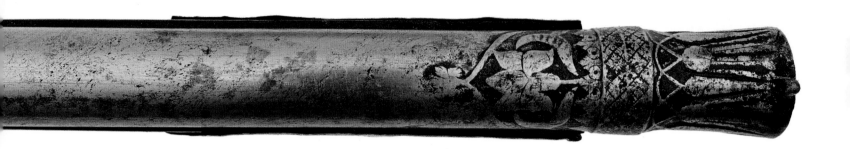

Detail showing the muzzle.

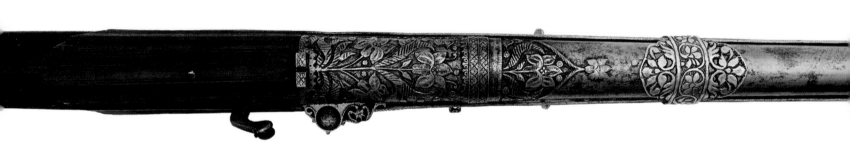

Detail showing the barrel.

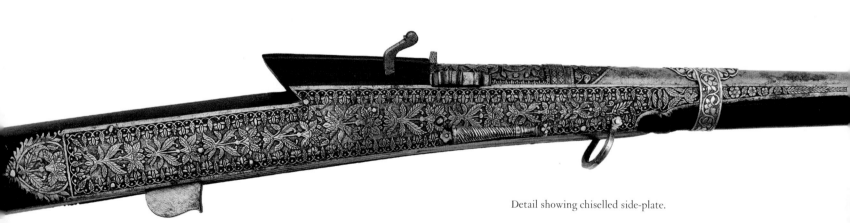

Detail showing chiselled side-plate.

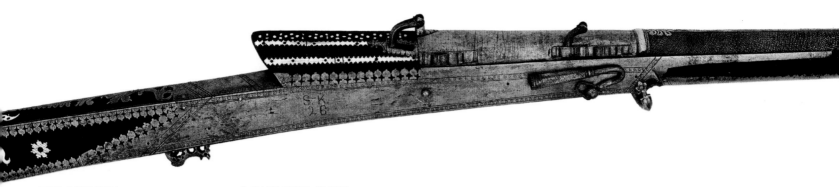

FRM/97/224

Very rare superimposed matchlock gun. The single trigger depresses each of the two arms at the same time, both reaching their respective pans at the same moment. To fire two successive shots the match would have been placed in the front position and after firing brought back to the second arm.

View from above showing twist construction elongated breech and stippled lower barrel with sighting rib.

## MATCHLOCK
Mughal, late seventeenth or early eighteenth century

OVERALL LENGTH: 155 CM
BARREL LENGTH: 105 CM

### DESCRIPTION
Smoothbore with damascus-twist barrel with a 'hogs back' sighting rib[24] and raised gilt motifs in a Sindhi style which is presumably Mughal in origin. The barrel is also remarkable for having two serpentines and pans for superimposed loads. Both would fire simultaneously when the single trigger is depressed if both had a lighted match. However, the practice was to place the match in the front jaws, fire and then move it to the back jaws for the second shot. The position of the astragal is unusually distant from the breech end, suggesting the thickened powder chamber wall extends abnormally far along the barrel, to give space for the double powder charge. The barrel is secured by sinew whipping, probably original. Shisham full-stock, the block behind the breech inlaid with ivory. There are inlaid ivory motifs including stylised birds and a tree on the butt, motifs also seen on Jaipur guns which emulated Mughal designs. Iron mounts with stamped, fretted and incised decoration, secured to the stock with iron nails. Pierced trigger (the forepart broken). Iron ramrod with vase-shaped end. Iron sling swivels and match shield tube with a chevron pattern. Armoury mark SK 26.

### COMMENT
Firing guns with this system must have been an exciting event and many probably burst. There was another matchlock with double serpentines and pans in the Tonk Armoury, illustrated by Hendley[25] and another is in the Daehnhardt Collection, Lisbon. In both cases the stock is inlaid with ivory in this manner and the muzzle is not the usual Rajput concave shape. Barrels with similar-shaped muzzles found in Muscat were taken there by Sindhi merchants from Thatta or mercenaries from Gwadar, the Omani enclave on the Makran coast of Baluchistan. See the barrel on FRM98.

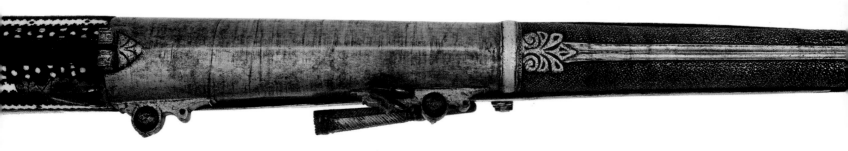

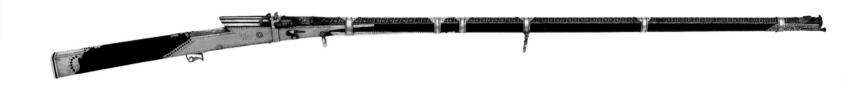

FRM/97/225

## MATCHLOCK
Mid-eighteenth century barrel, the date of the chiselling unknown

OVERALL LENGTH: 174 CM
BARREL LENGTH: 123 CM

### DESCRIPTION
Smoothbore barrel chiselled the full length with meandering lotuses framed between a spiral ribbon of steel for its full length. The barrel has been heat-blacked and the raised decorative elements were silvered, producing a barrel of great magnificence. At the breech is a false-damascened gold portrait of Durga, holding a sword and trident and riding on a lion, surrounded by flowers.

The muzzle is in the form of a makara. Square groove rear-sight with a copper-bead foresight. Ordinary iron ramrod, possibly a replacement. Pierced iron trigger and gilt iron pricker (now broken). Silver barrel bands, and fittings. The barrel band with the rear-sight passing through it is typically nineteenth century.

Shisham full-stock with fluted block behind the breech inset with silver; and layered bone and wood butt-cap. Armoury mark SK 15.

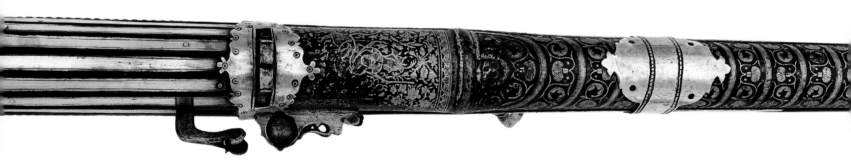

View from above showing gold depiction of
Durga. Note also the matching silver mounts.

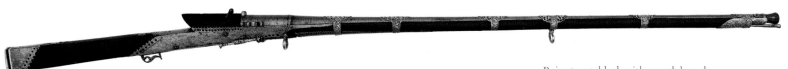

Rajput matchlock with superb barrel.

FRM/97/226

## MATCHLOCK
Mughal barrel c.1700
Nineteenth-century Sindhi silver mounts

OVERALL LENGTH: 174 CM
BARREL LENGTH: 123 CM

DESCRIPTION

Smoothbore barrel with an exceptional damascus-pattern barrel, the breech with magnificent contrasting strands forming a damascus-twist ribbon. Below the astragal that marks the end of the powder chamber the damascus forms a series of meandering twists, (Fiegiel calls this 'X pattern') running its length until the astragal before the muzzle. Fiegiel suggests the barrel was made by: 'Longitudinally welding alternative segments of on edge laminate and a deeply ground twisted laminate. When welding was completed, the barrel was heated segmentally and twisted to produce the wave pattern.'[26] Fiegiel does not speculate where these ornate barrels were made but it is likely that the work was done by a Muslim master barrel-maker. The muzzle is the standard concave shape with a raised lotus flower design, decorated with gold wash. Rear groove sight with ears, bead-sight missing. Iron mounts with stamped, fretted and incised decoration, secured to the stock with iron nails with flowerhead brass washers. The side-plates have a strong mechanical damascus pattern. Pierced and chiselled trigger and steel ramrod with vase-shaped end. Silver sling swivels, silver match shield tube pierced and engraved with Matsya,[27] with a silver chain with a vent cover and pricker. Five embossed and pierced silver barrel bands of Sindhi form. Shisham full-stock with fluted block behind the breech and layered ivory butt-cap. Armoury mark SK 13.

COMMENT

One of the finest barrels known to the author. The work should be considered parallel to the best Persian watered-steel shamshir blade construction. The longitudinal pattern is discussed under gun FRM/97/224. The gun was probably assembled in its present form for Maharaja Man Singh (r.1803–43).

Detail showing both types of Damascus pattern and the early rear-sight.

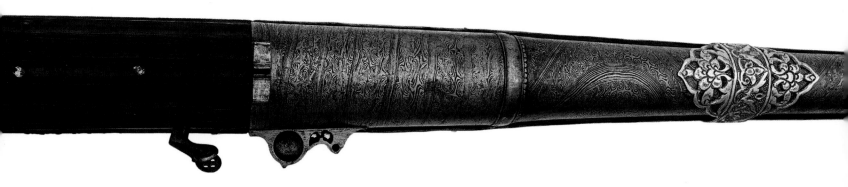

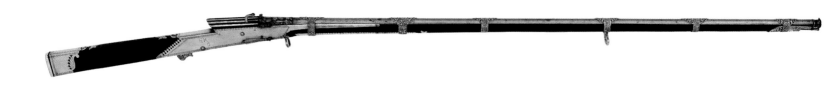

FRM/97/228

## MATCHLOCK
Barrel last quarter of the eighteenth century
Re-mounted in the nineteenth century

OVERALL LENGTH: 193 CM
BARREL LENGTH: 140 CM

### DESCRIPTION
Smoothbore matchlock with ring-matted 'bajra' barrel. The muzzle is the standard concave shape with raised open and closed lotus design decorated with gold. The breech, separated from the rest of the barrel by an astragal, has a heat-blackened ground with false-damascened two-colour gold Cyprus trees, rocks and flowers. Copper-bead foresight and eared groove rear-sight. Finely figured shisham stock with twin ivory butt-plates sandwiching a layer of wood. Fluted block behind the barrel, the flutes filled with silver strip. Ramrod with baluster head, a section of gold damascened chevron pattern to a raised ring, beyond which the rammer has a carefully drawn leaf pattern in gold, possibly the ashoka leaf. The trigger is decorated en suite with the breech. The barrel bands and mounts are silver, the match shield tube with an incised chevron pattern echoing the koft work on the ramrod. Armoury mark SK 5.

### COMMENT
Two-colour gold decoration indicates quality, a style quite common on Jaipur pieces. The barrel and trigger may have been part of a gift to Takhat Singh from Maharaja Sawai Ram Singh II of Jaipur (1835–80) who married four daughters of the Jodhpur maharaja. The greater part of the gun is Jodhpur work.[28]

Detail showing two colour gold decoration at the breech, a design found on daggers in Jaipur.

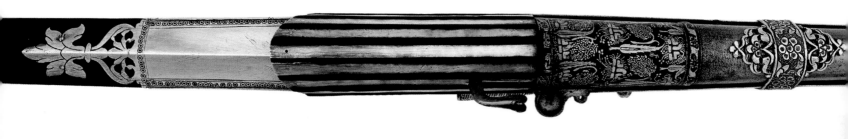

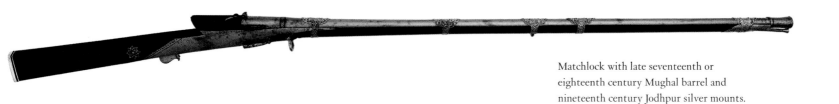

Matchlock with late seventeenth or
eighteenth century Mughal barrel and
nineteenth century Jodhpur silver mounts.

FRM/97/ 229

## MATCHLOCK

Mughal barrel, first quarter of the eighteenth century, remounted on a gun upgraded for
Maharaja Man Singh (1803–43).

OVERALL LENGTH: 177 CM
BARREL LENGTH: 125 CM

### DESCRIPTION

Smoothbore damascus-twist matchlock barrel with unusually elongated concave muzzle
section. The barrel has false damascene borders at the muzzle and breech. Adjacent to the
muzzle is an incised Persian inscription: Rokan Neror Roktan Remi, possibly the maker's
name in Urdu. Groove rear-sight, foresight missing. Steel ramrod with spiral-cut section
below the baluster end. Silver mounts added during the first half of the nineteenth century:
pierced silver match shield tube chiselled with flowers and figure with fishtail feet, Matsya,
Vishnu's first incarnation.[29] Shisham stock with fluted block behind the breech. Ivory and
wood layered butt-plate.

Detail showing twist barrel with
nineteenth century barrel band
and renewed pan.

### COMMENT

The barrel bands are of the form found on Jodhpur royal guns from the first half of the
nineteenth century.

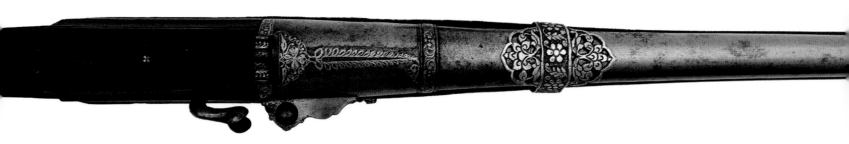

Muzzle showing Damascus steel
pattern, non Rajput form of muzzle,
and Persian inscription.

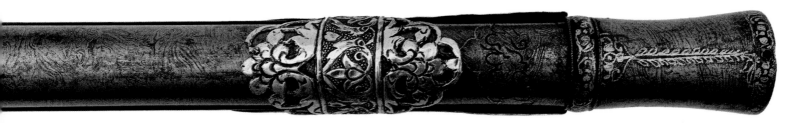

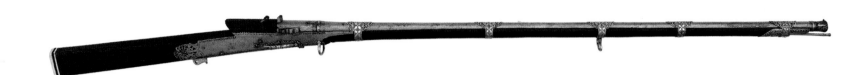

FRM/97/233

## MATCHLOCK
Mid-eighteenth century matchlock

OVERALL LENGTH: 174 CM
BARREL LENGTH: 124 CM

### DESCRIPTION
Matchlock barrel with zigzag pattern, enlarging at the chamber. Muzzle of standard concave form with raised open and closed lotuses, formerly gold decorated. Copper-bead foresight and eared groove rear-sight. Iron ramrod with baluster head and plain trigger. Vent cover and cleaner on silver chains, tubular match shield and silver sling swivels. Five embossed silver barrel bands.

Plain shisham full-stock with layered ivory butt-plate. Fluted block behind the barrel. Armoury mark SK 6.

### COMMENT
Watered-steel barrel but the chevron pattern, which appears to be a tour de force of barrel-making, is in fact etched on the surface. The same pattern enhanced with silver is common on steel axe hafts.

Acid etched chevron pattern barrel.

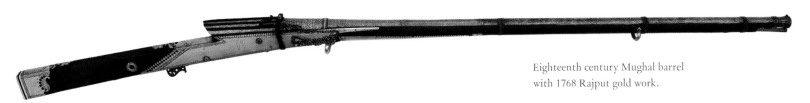

Eighteenth century Mughal barrel
with 1768 Rajput gold work.

FRM/97/237

## MATCHLOCK
Eighteenth-century Mughal barrel
Inscription dated vs 1825/1768 AD

OVERALL LENGTH: 154 CM
BARREL LENGTH: 102 CM

### DESCRIPTION
Matchlock gun with three-stage barrel, the mid-section faceted, covered with gold false damascene bands of flowers and chevrons. The muzzle has a poorly incised closed lotus flower design. A chiselled raised saw-edged ring decorates the muzzle; eared groove rear-sight and copper foresight. Marwari inscription at the breech with the date:

> *Shri Mahadev ji sada saath mhara reve Shri Prithvi Singhji vasta banduk 1 Mehbuyusan (`ma+ha+bu+yu+sa+na) ree tatha raa. Sa. Vaa. Sa. (?) Samvat 1825 ra Kati sud 7.*
> May the blessings of Lord Mahadev always remain with us, one mehbusuyan *bandook* (gun) for Shri Prithvi Singh ji; and ra. sa. va. sa. (?); dated Kati sud 7th, vikram samvat 1825. (VS 1825 / 1768 AD)

Iron ramrod. Four sinew bindings, two within silver channels with beaded edges. Striped shisham full-stock with layered ivory and wood butt-plate. The fluted block behind the barrel has silver strips with a stamped pattern. The hole through the cheek of the stock with silver flower head surround is to anchor the unlit end of the match before it was wound round the stock. The same silver design occurs on dagger and katar scabbards and is nineteenth-century. The inlaid silver mounts have stamped and pierced borders and floral terminals. Replaced iron vent cover and pricker on silver chains, and silver sling swivels. Pierced iron trigger. Armoury mark SK 27.

### COMMENT
The gold decoration and inscription on the barrel was added during the use-life of the gun. Blocks with inlaid silver strip can be seen in Rajput paintings from c.1765 well into the nineteenth century. Old guns remained in use.

Detail of breech showing inscription and decoration.

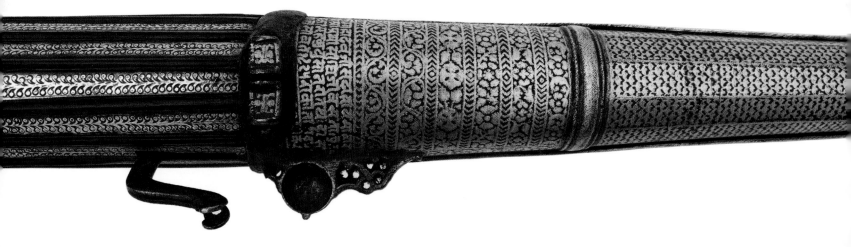

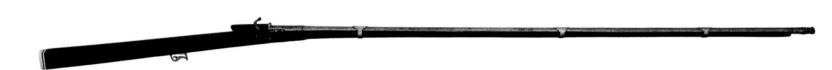

FRM/97/238

## WOMAN'S MATCHLOCK
Late seventeenth or early eighteenth century
Possibly Jaipur with nineteenth-century Punjabi barrel bands

OVERALL LENGTH: 147 CM
BARREL LENGTH: 104 CM
WEIGHT: 0.93 KG

### DESCRIPTION
Smoothbore barrel, probably damascus-twist, with concave drum muzzle with raised open and closed lotus design and copper-bead foresight. Early form of groove rear-sight with raised ears. Simple gold wash at the muzzle and the double astragal at the breech.

Very straight shisham stock with fluted ebony block behind the breech, three brass barrel bands and layered ivory butt-plate (replaced). Armoury mark SK 33.

### COMMENT
Triggers of this design are found on Jaipur guns. See ARM/76/41, 249 etc. Brass barrel bands of this form are Punjabi from the first half of the nineteenth century. Nineteenth-century Sikh triggers are often distinctively minimal, usually so cut away as to have more air than metal.

After the defeat of the Sikh kingdom Dr Login was sent to catalogue the Sikh treasures including arms and armour. A matchlock (*toradar*) dating from the first half of the nineteenth century, selected as having been owned 'by the late Maharajas and sirdars etc of the Punjab', was sent to London and is now in the Royal Armouries, Leeds.[30] It has brass barrel bands of this type.

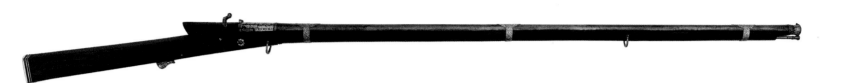

FRM/76/239

# MATCHLOCK
Eighteenth-century gun

Overall length: 183 cm
Barrel length: 104 cm

## DESCRIPTION
Smoothbore barrel covered with very fine silver criss-cross lines creating tiny diamond-shaped fields, each of which is embellished with a central silver dot. Concave muzzle with raised open and closed lotus design and copper-bead foresight. Grooved rear-sight with ears. Simple gold wash at the muzzle and gold damascened floral panel on blackened ground at the breech. The match arm and the trigger are decorated with false damascening. Pan cover missing.

Shisham stock with fluted block behind the breech and layered ivory butt-plate. Three modern barrel bands.

## COMMENT
Compare this barrel with 76/254 by the same craftsman. The gun though plain is very rich in appearance and quality.

Detail showing barrel decoration. The barrel band is modern, added to secure the barrel to the stock.

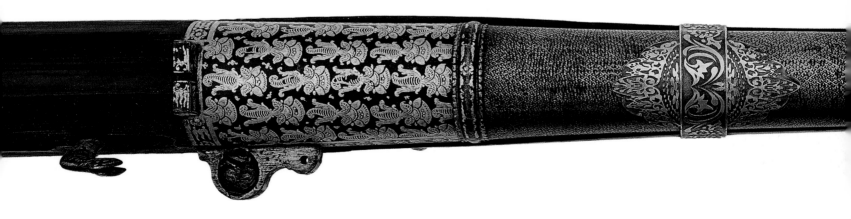

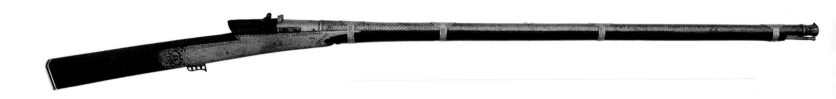

FRM/76/241

# MATCHLOCK
Mughal or Rajput
Barrel late seventeenth or early eighteenth century

OVERALL LENGTH: 167.5 CM
BARREL LENGTH: 117 CM
WEIGHT: 4.8 KG

DESCRIPTION

Matchlock smoothbore gun, the *pechdar* barrel decorated with inlaid brass 'cobra scales', *kalindar jadea*, a later addition. Concave muzzle with later crudely engraved lotus buds. Eared grooved rear-sight and copper peg foresight. Simple iron ramrod with turned and faceted tip, pierced iron trigger. Simple iron mounts with rudimentary stamped and incised border and pierced floral work inlaid on the stock. The barrel is secured to the plain shisham full-stock with modern silver barrel bands. Armoury mark SK 33.

COMMENT

This barrel has *kalindar* decoration. In Rajasthan the cobra is divine, considered a gentle, unaggressive snake. It is worshipped in the villages at the feast of *nag panchmi* in the bright half of the month[31] of Savan (July/August), harvest time. Milk is left at their shrines. The Gwalior royal families have a legend of the snake protecting the badly wounded clan leader lying on a battlefield when his enemies where searching for him to kill him and other princely families have similar traditions. In Mehrangarh a cobra used to sun itself on the library windowsill and another co-exists very amicably with the fort director's children sharing their sandpit. It would be considered very poor behaviour to harm one.[32] Several seventeenth-century barrels in the Daehnhardt Collection have the snake scale pattern and one unique late sixteenth or early seventeenth-century barrel has a muzzle in the realistically sculpted form of a striking cobra.

Top view showing the snake scales. The barrel band is modern.

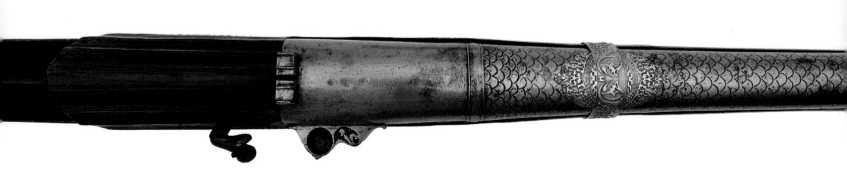

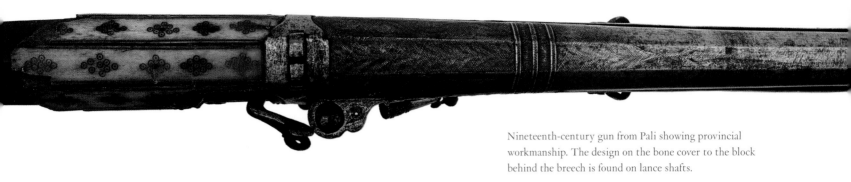

Nineteenth-century gun from Pali showing provincial workmanship. The design on the bone cover to the block behind the breech is found on lance shafts.

FRM/97/250

## MATCHLOCK
Pali
c.1820

OVERALL LENGTH: 186.5 CM
BARREL LENGTH: 136 CM

### DESCRIPTION
Smoothbore faceted damascus barrel, iron bead foresight and simple square grooved rear-sight. The breech is cross-hatched for false damascening, now missing. The match arm and the trigger are decorated with false damascening, an unusual attention to detail.

Shisham stock with renewed forestock in sagwan[33] with bone-plates behind the breech, decorated like the Pali lances. The butt has an ebony plate but not the standard square-edged form; it is rounded. There was a fashion for butts of this shape that coincides with the Pindaris and may be connected to them. Five modern barrel bands and one original iron band that passes on either side of the rear-sight, a popular provincial nineteenth-century style. Jodhpur Armoury mark SK 34.

### COMMENT
Pali is a small industrial town in Marwar, south of Jodhpur. This is an unsophisticated gun, the underside poorly finished and the modest silver decoration indicating a cheap object. The long barrel is very old fashioned, possibly necessary because of the low standard of provincial gunpowder available at that time.

Distinctive iron strap on underside of gun.

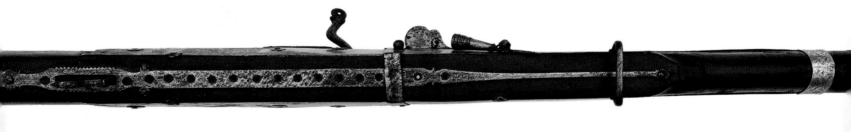

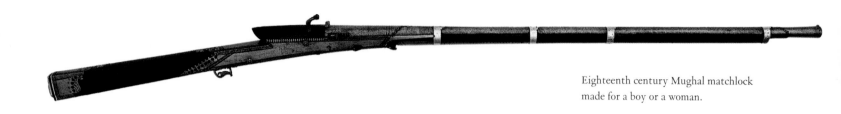

Eighteenth century Mughal matchlock
made for a boy or a woman.

FRM/76/119

# MATCHLOCK
Mughal barrel
Eighteenth century

OVERALL LENGTH: 136 CM
BARREL LENGTH: 87 CM

## DESCRIPTION
Matchlock rifle made for a boy or a woman. Damascus barrel with raised aprons at the breech
and flared muzzle, raised sight line, grooved rear-sight and inset copper-bead foresight.
Plain silver barrel bands. Layered butt-cap. Iron mounts with stamped, fretted and incised
decoration, secured to the stock with iron nails with flowerhead brass washers. Pierced and
chiselled trigger and duck's head match holder. One rope twist swivel for a sling, the second
missing. Armoury mark SK. 15

## COMMENT
This elegant barrel is unusual in a number of ways. The tang is not a Rajput element nor is
the duck's head match holder. All point to Mughal ownership.

Detail showing barrel with
sighting rib, apron and tang.

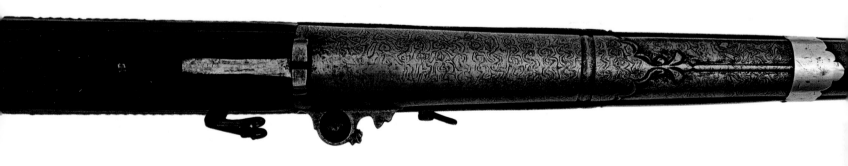

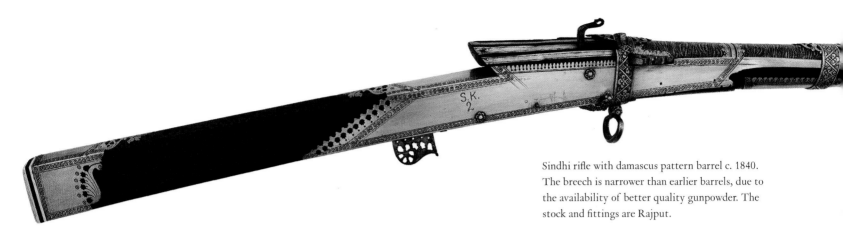

Sindhi rifle with damascus pattern barrel c. 1840. The breech is narrower than earlier barrels, due to the availability of better quality gunpowder. The stock and fittings are Rajput.

FRM/76/102

## MATCHLOCK RIFLE
Sindh
c.1840s

OVERALL LENGTH: 163 CM
BARREL LENGTH: 111 CM

### DESCRIPTION
Sindhi rifled damascus-twist barrel with iron foresight and grooved back-sight, mounted on a Jodhpur matchlock. Steel ramrod, the upper section decorated with a gold chevron pattern. Pierced steel trigger with gold false damascening. Gold pan. Shisham stock, the fluted block behind the breech with silver mounts. Ivory and wood butt-plate. Silver fittings, barrel bands including one wrapped round the rear-sight, sling swivels, silver chains with pricker and cover. Armoury mark SK 2

### COMMENT
This high-quality rifle combines Jodhpur and Sindhi characteristics. The fine damascus-twist barrel was made by a Sindhi gunsmith though we do not know if it was made in Sindh or Jodhpur. Many Sindhi armourers must have been forced to seek new homes following the defeat of their Talpur clients by the British in 1843. Members of the Talpur royal family settled in Jodhpur which borders Sindh and these states are linked by a major trade route. In 1780 Marwar captured the district of Umerkot over which it had a claim but later lost it to the Talpurs of Sindh. In 1843 after the British seized Sindh Jodhpur applied to them to have Umerkot restored to them but the British considered the fort a valuable frontier post and kept it. The barrel is decorated with gold bands in a style attributable on the basis of dated guns to 1845–50. The style is not that found on Sindh guns and this work was added in Jodhpur. A particularly fine gold-mounted Sindh rifle in Jodhpur has an inscription in Marwari to Maharaja Takhat Singh dated vs 1903/1846 ad. All the gold mounts were added in Jodhpur for the Maharaja, the designs identical to those on his matchlocks.

Detail of muzzle with typical Sindhi gold decoration.

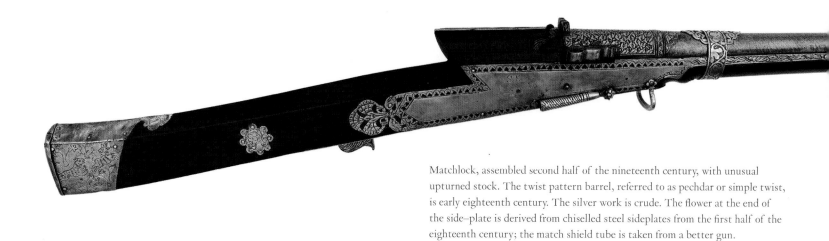

Matchlock, assembled second half of the nineteenth century, with unusual upturned stock. The twist pattern barrel, referred to as pechdar or simple twist, is early eighteenth century. The silver work is crude. The flower at the end of the side–plate is derived from chiselled steel sideplates from the first half of the eighteenth century; the match shield tube is taken from a better gun.

FRM/97/253

# MATCHLOCK
Barrel early eighteenth century
The remainder of the gun second half of the nineteenth century

OVERALL LENGTH: 172 CM
BARREL LENGTH: 123 CM

### DESCRIPTION
Smoothbore pechdar barrel, the breech section separated by an astragal. Concave muzzle, decorated with false-damascened gold flowers, en suite with koft work at the breech, barrel tang and trigger. Steel ramrod with cup-shaped head.

Shisham full-stock with lightly fluted block behind the barrel. Unusual butt, the last section turned up, possibly reflecting European influence.

Silver furniture, the butt cover incised with vignettes of animals and a hunter. Five silver barrel bands, silver suspension rings for a sling, silver match shield tube attached to the side-plate. Silver chain with attachments missing. Armoury mark SK 16.

### COMMENT
The silver side-plate, barrel bands and butt-cap are very crudely made. The gold decoration is nineteenth century.

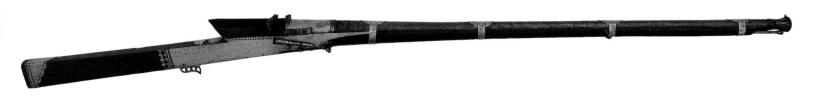

FRM/76/254

# MATCHLOCK
Rajput, stock and barrel mid-nineteenth century

OVERALL LENGTH: 158 CM
BARREL LENGTH: 104.5 CM

### DESCRIPTION
Smoothbore barrel covered with very fine silver criss-cross lines creating tiny diamond-shapes, each a quarter of an inch long, embellished with a central silver dot. The barrel at either end was originally gilt. The muzzle has a raised lotus and leaf design and a copper-bead sight. Grooved rear-sight with ears. The pan has no cover. Modern silver barrel bands.

Plain shisham stock with fluted ebony block behind the breech: with conventional steel side and butt-plates, match shield tube and twin swivels.

### COMMENT
The inlay on the barrel is so fine that at first glance it appears cross-hatched and burnished. With contrasting gold muzzle and breech it must have been princely. In contrast the stock and fittings are inferior, suggesting the parts are a marriage.

Detail of the inlaid silver barrel decoration.
The barrel–bands are modern.

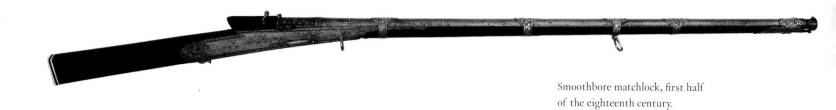

Smoothbore matchlock, first half
of the eighteenth century.

FRM/97/255

## MATCHLOCK
Rajput, first half of the eighteenth century

OVERALL LENGTH: 177 CM
BARREL LENGTH: 125 CM

DESCRIPTION
Matchlock gun with double astragal at the end of the breech and spiral damascus pattern.
The breech has been deeply chiselled with a large flower. The concave muzzle has the usual
raised lotus pattern and copper-bead foresight.

Undecorated shisham full-stock with twin bone butt-plates. Fluted block behind the barrel.

Iron mounts decorated with a large flower en suite with the barrel. Unusual iron ramrod
with capstan tip, below which is a square section before the standard cylinder. Plain
iron trigger.

Five nineteenth-century silver barrel bands, one with a ring for a sling. The silver chain,
vent cover and cleaner are missing but the silver match tube remains.

Close up of breech. Note the
damascus twist barrel.

Seventeenth or early eighteenth century
Mughal matchlock with twist barrel showing
enlarged powder chamber and rear-sight.

FRM/97/257

## MATCHLOCK
Mughal, first half of the eighteenth century

OVERALL LENGTH: 159 CM
BARREL LENGTH: 107 CM

DESCRIPTION
Matchlock with bold spiral-twist pattern, greatly enlarged powder chamber and astragals. The concave muzzle has an incised open lotus flower pattern and an iron foresight. Grooved rear-sight with ears.

Undecorated shisham full-stock with ivory and wood butt-plate. Fluted block behind the barrel. Simple iron ramrod, plain iron trigger, single iron sling at the breech, the other missing, steel chain with iron pricker. Armoury mark SK 5.

COMMENT
The gun is in original condition apart from its missing sinew barrel bindings.

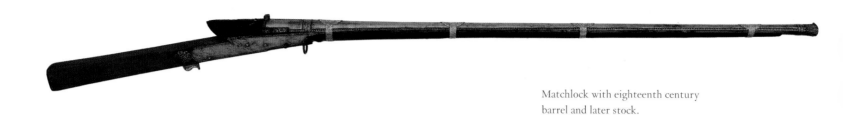

Matchlock with eighteenth century
barrel and later stock.

FRM/76/258

## MATCHLOCK
Barrel, trigger and side-plates first half of the eighteenth century

OVERALL LENGTH: 173 CM
BARREL LENGTH: 123 CM

### DESCRIPTION
Smoothbore damascus-twist barrel (now polished bright) with raised sighting ridge, the breech and muzzle section separated by a double astragal. Concave muzzle, with false-damascened gold en suite with the koft work at the breech and trigger. The rear-sight has the raised ears typical of seventeenth-century barrels but the top of each half is curved rather than flat, suggesting the barrel was not made in Rajasthan. The toothed border running the length of the barrel above the stock is present on another early barrel (FRM/76/269).

The chiselled steel oval on the side of the stock can also be seen on FRM/76/233. It is similar to the chiselled breeches found on FRM/76/304 and FRM/76/44.

### COMMENT
Lack of provision for a ramrod suggests the stock is a replacement added when the gun was prepared for display. The stock is Kashmir walnut (the spliced fore-end wood differs, something the original owner would probably not have tolerated). Fluted ebony block behind the barrel probably taken from an earlier gun. Modern silver barrel bands. The flower rivet heads are also found on Indo-Persian shields. Raised sighting ridges are common on Sindhi barrels as are convex rear-sights, suggesting the barrel is from north-west India.

View from above showing sights and double
astragal. The barrel–bands are modern.

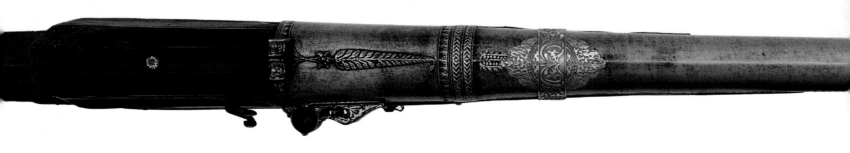

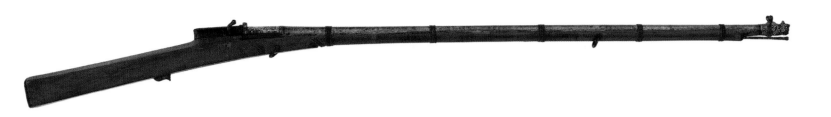

FRM/97/261

## MATCHLOCK
Bihar?
Late eighteenth century

OVERALL LENGTH: 181 CM
BARREL LENGTH: 130 CM

### DESCRIPTION
Matchlock gun, the damascus barrel with rhinoceros-head muzzle, the horn forming the foresight. The goddess Durga is depicted in gold false damascening on the breech. The barrel and stock are bound with sinew whipping. Undecorated wooden full-stock, possibly teak. Unusually thin shisham block behind the barrel with flattened ridge section. Plain iron trigger and sling swivels, iron ramrod. Iron sling at the breech (the other missing), steel chain and simple iron pricker. Armoury mark SK 5.

### COMMENT
The grooved rear-sight has a very unusual thin iron tang that anchors the breech to the adjacent stock. The wood not used in Rajasthan. A matchlock with teak stock inlaid with ivory is in the Jaipur Armoury, attributed to Manpur in Bihar, north-eastern India,[34] a town known for making railway sleepers.

Muzzle detail. Guns with rhinos heads were popular. Note the thin piece of metal linking the breech to the wooden block behind it.

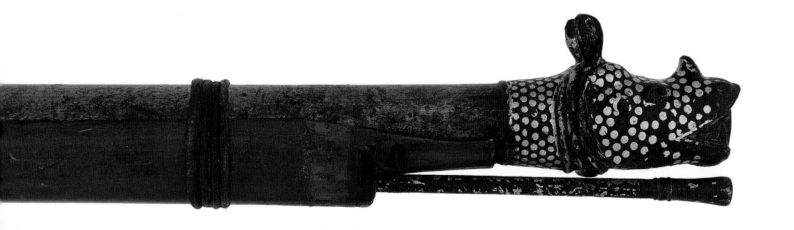

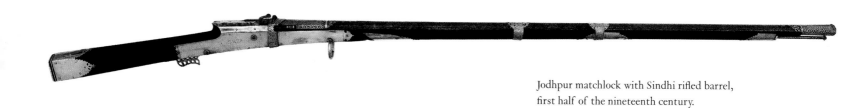

Jodhpur matchlock with Sindhi rifled barrel,
first half of the nineteenth century.

ARM/76/822

## MATCHLOCK RIFLE

OVERALL LENGTH: 172 CM
BARREL LENGTH: 122 CM

### DESCRIPTION
Rifled damascus-twist barrel from Sindh, with thick gold damascening at the breach and
muzzle. Rounded grooved rear-sight and copper-bead foresight. Three gold barrel bands,
gilt silver swivel for sling, gilt steel trigger with pierced decoration, gold decorated ramrod,
gilt match holder and silver mounts. Shisham stock with ivory and wood butt-plate.
Armoury mark SK 38.

### COMMENT
The barrel dates from the first half of the nineteenth century but the gun was assembled
late in the century. The silver work is below the quality made for Takhat Singh and the
parts do not match his fittings which have a good deal of uniformity. The rough edges
suggest the gun was never made for use and was assembled to display the superb barrel at
a Delhi durbar.

The Jodhpur maker of this gun has not made use of
the barrel tang, a detail that does not appear on Hindu
matchlock barrels, preferring the clumsy barrel band that
passes on either side of the typical Sindhi convex groove
sight. The pan which has been added in Jodhpur is the
wide form from the late nineteenth century.

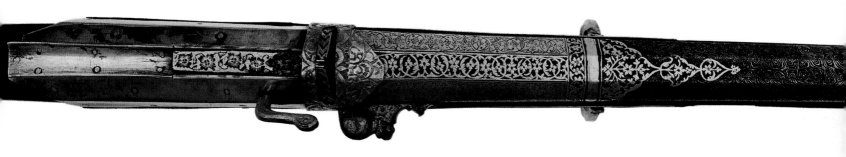

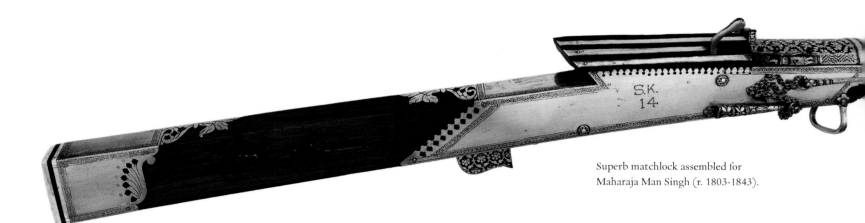

Superb matchlock assembled for
Maharaja Man Singh (r. 1803-1843).

ARM/76/846

## MATCHLOCK
Jodhpur
Early eighteenth-century barrel, the gun probably assembled for
Maharaja Man Singh (r.1803–43).

OVERALL LENGTH: 194 CM
BARREL LENGTH: 140 CM

### DESCRIPTION
Smoothbore 'bij' barrel with concave muzzle with gilt raised lotus design. Gilt double astragals at the breech and muzzle. Eared rear-sight and copper-bead foresight. The breech has a gold jali design of leaves enclosing carnation heads. The plain iron trigger is decorated en suite. Pan with hinged cover. Shisham stock, the fluted block behind the breech with silver strips. Silver side-plates, butt-plates, silver chain with pricker. Matsya, the half-man, half-fish incarnation of Vishnu, is engraved on the match shield, also found on ARM/76/229 and 226. The presence of Matsya here requires explanation. At the end of the last Hindu era when the world was engulfed by water an Asura snatched the sacred *Veda*s from Brahma's hands and vanished into the sea. Matsya helped Vishnu to retrieve the Vedas. Many maharajas believe themselves to be incarnations of Vishnu. Matsya helped Vishnu to retrieve the *Veda*s. This story would have particular appeal to Maharaja Man Singh (1803–43) who was a religious scholar who collected religious manuscripts and built the Pushtak Prakash, or library, in Mehrangarh to house these and his own writings. Furthermore, Matsya inhabits water, the safest place to put a lighted match when keeping it distant from gunpowder when loading.

Detail showing 'bij' (seed)
pattern barrel, Sindhi style
barrel-band and Rajput muzzle.

### COMMENT
Superb eighteenth-century barrel, deliberately dulled for hunting. The mounts and barrel bands are typically first half of the nineteenth century.

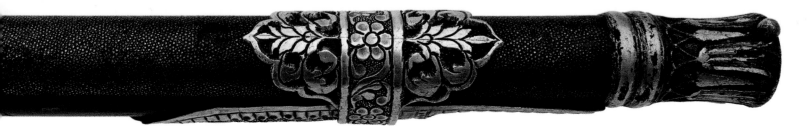

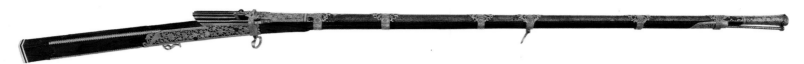

Gun assembled and decorated for Maharaja
Takhat Singh in the mid nineteenth century
incorporating an earlier Sindhi barrel.

UBP/2017/18

## MATCHLOCK

Sindhi barrel early nineteenth century. The gun was assembled and decorated for Maharaja
Takhat Singh in mid-century and remains in H. H. the Maharaja's personal collection.

OVERALL LENGTH: 169 CM
BARREL LENGTH: 117 CM

DESCRIPTION
Sindhi damascus-twist rifle barrel with eight grooves, c.1830, with a flat sighting rib. Gold
Jodhpur mounts and Sindhi gold decoration on the barrel. Silver bead foresight and grooved
back-sight with sloping shoulders, mounted on a Jodhpuri stock made of rosewood.

Stamped and pierced sheet gold decorated with flowers and parrots laid over green velvet,
Jodhpur work. The author has seen a tulwar scabbard made en suite. Six gold barrel bands
of a different design. The looped sling carriers are of different design and are Sindhi style.
The fore-sling-carry is a Sindh type, the rear one Rajput.

Steel ramrod with mushroom head terminal, decorated with gold. Gilt steel pierced trigger
and serpentine. No armoury mark.

COMMENT
The gun has lost large portions of its pierced gold decoration.

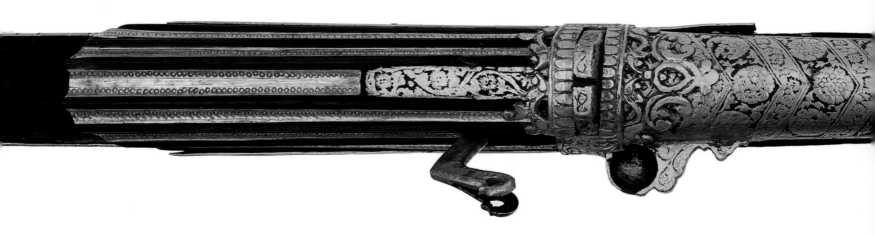

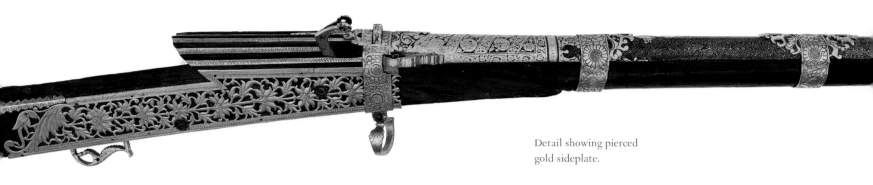

Detail showing pierced
gold sideplate.

Detail showing watered
pattern and muzzle.

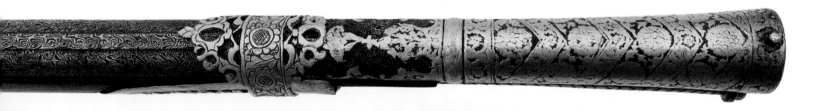

Detail showing the top of the gun.

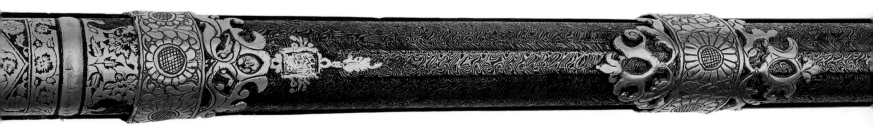

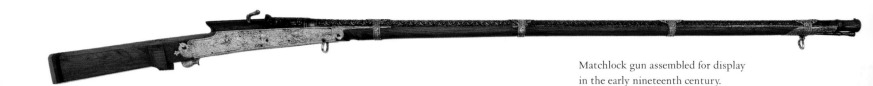

Matchlock gun assembled for display
in the early nineteenth century.

UBP/2017/19

## MATCHLOCK GUN

Eighteenth-century barrel, remounted in the early twentieth century when the remainder
of the gun was made.

OVERALL LENGTH: 176 CM
BARREL LENGTH: 129 CM

### DESCRIPTION

Smoothbore barrel with long, slightly concave, muzzle decorated with elaborate raised
lotus design. Barrel with raised flower and foliage design for its entire length. The muzzle
bears an incised maker's name, *Ustad Hari Singh K…?*

Kashmir walnut stock with unusual square-edged protuberances on the butt, possibly to
emulate European rifles. Layered wood butt-cap. The sides of the stock have iron plates
incised with flowers and peacock heads with applied gold sheet, which is adhering badly.
Other mounts include a chain of late form with a gilt pricker, silver barrel bands that
have been reused from an earlier gun and gilded, and a gilt trigger contemporary with the
gun's assembly.

### COMMENT

The barrel itself is late seventeenth or early eighteenth century, the back-sight of early
type, but there are no gaps in the chiselled design for the sinew bindings. The addition of
a maker's name on objects becomes common towards the end of the nineteenth century.
The chiselling on the barrel and the shape of the polished area on which the inscription
appears is twentieth-century work. This gun and number UBP/2017/20 (not illustrated),
which have a Persian inscription at the muzzle (Rokan neror Alian ebri), are a decorative
pair, likely to have been a gift to an earlier maharaja. They remain in the present Maharaja's
personal possession.

Detail of the barrel, pan cover
and barrel band.

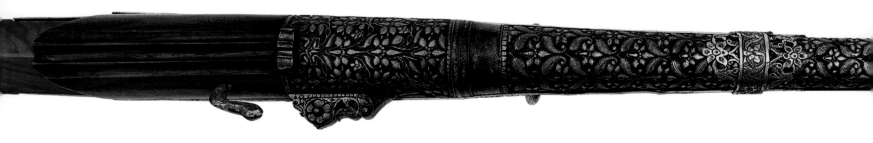

UBP/2017/19

Detail showing barrel band,
muzzle and inscription.

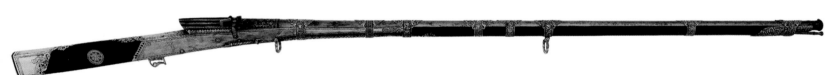

Jodhpur matchlock c. 1843.

UBP/2017/21

## MATCHLOCK GUN

Second half of the eighteenth-century barrel remounted for Maharaja Takhat Singh, the remainder of the gun from his reign.

OVERALL LENGTH: 184 CM
BARREL LENGTH: 133 CM

### DESCRIPTION

Smoothbore barrel with concave muzzle with unusually elaborate raised lotus design. Breech with gold flower and foliage design, on blackened, cross-hatched ground. The barrel had a ring-matted design, now polished off, and was probably silvered. Silver mounts include eight barrel bands, chain with pricker.

Shisham stock with layered ivory and wood butt-cap. Armoury mark SK 11.[35]

### COMMENT

The amount of applied silver and particularly the circular silver decoration on the stock is what one would expect on a Sindhi gun rather than one from Jodhpur.

# THE SINDHI JEZAIL

Mehrangarh Armoury has a particularly fine selection of guns and swords from neighbouring Sindh, now one of the four provinces of Pakistan. Sindh derives from Sindhu, Sanskrit 'river', a reference to the Indus, which has served as highway, carrying trade goods through Afghanistan, Pakistan and Sindh to the Arabian Sea.[36] The region borders Baluchistan in the west, Punjab to the north, and the two modern Indian states of Gujarat and Rajasthan. The future Emperor Akbar was born in Sindh at Umerkot and the Mughal's representative ruled from Thatta in southern Sindh. Nadir Shah's invasion of India and sack of Delhi in 1739 so weakened the Mughals that the Kalhoras who ruled northern Sindh were able to seize the rest of the province and Thatta, a major trading centre under the Mughals, went into terminal decline. The Kalhora, who brought the Talpurs from Baluchistan as mercenaries, came to fear their power and ambitions and assassinated their leaders, causing the very revolt that they feared. From the 1780s three Talpur brothers ruled Sindh as three states. Geographically and politically Sindh can be divided into Siro, the upper region centred on Jacobabad, Wicholo, the central region round Hyderabad, and Lar, the southern region centred on Karachi with Talpur courts at Khairpur, Mirpurkhas and Hyderabad. The British provoked war against the latter two on trumped-up charges in 1843, defeating them at the battle of Miani. Among the booty taken by the British at Hyderabad were '167 gold matchlocks'. These *jezail*s are a heavy rifle, used in Sindh, North-West Frontier region and Afghanistan.

Lieutenant Leech wrote that some Sindhi fighting practices emulate those of the Rajputs who they greatly admire: 'When a man is brave and a good swordsman they call him a Rajpoot, and all discipline troops they call Tilingees,[37] whom they have a great dread of.'[38] Like the Rajputs their prowess in battle was recorded by a caste of poets: 'The Marces are said to be invulnerable…water is said to run out of the muzzles of matchlocks fired at them.' The Sindhis had little idea of military manoeuvring and used to ride to battle and dismount, 'and after one or two shots from their matchlocks, on which they don't much depend, they throw them away, and rush on with a shout of ailee ailee, well drugged with opium.'[39] Like the Rajputs and Arabs they often tied themselves to each other before going into battle so no one could run away. The Sindhi army comprised distinct regional elements, which may explain variations in Sindhi gun stocks:

> The main strength of the Sindhian army consists in the Baloch [Baluch] tribes; another division is that of the Pathoors, including Jokhyas, Homrys, Karmotee, Balochies, and Jathas of the Jatee Purguna and some Hindustanys, about 400 between the four; Rohillas about 50…[40]

Leech remarks that the Jokhyas are very bad marksmen. 'I have seen thirteen of them with the advantage of a rest fire fifteen rounds with English powder at a bottle, put up at sixty feet, without hitting it once.'[41] He also says: 'The Mirs in time of peace had no more standing army, than is sufficient to guard their persons, and treasury, and to collect the revenues under the kardars, and a few troops to look after the forts.'[42] And: 'In time of war the chiefs receive presents of guns and swords and the troops receive lead and powder.' Leech goes on:

> A soldier is obliged to come into the field with his musket, sword, and shield, and the cavalry with horses, and as everyone is armed, there is no armoury to keep up. The guns and swords are

FACING PAGE:
'A Baluchi Soldier and Hindu Trader of Sindh'.
Frontispiece to: *Personal Observations on Sindh* by Thomas Postans, 1843.
British Library.

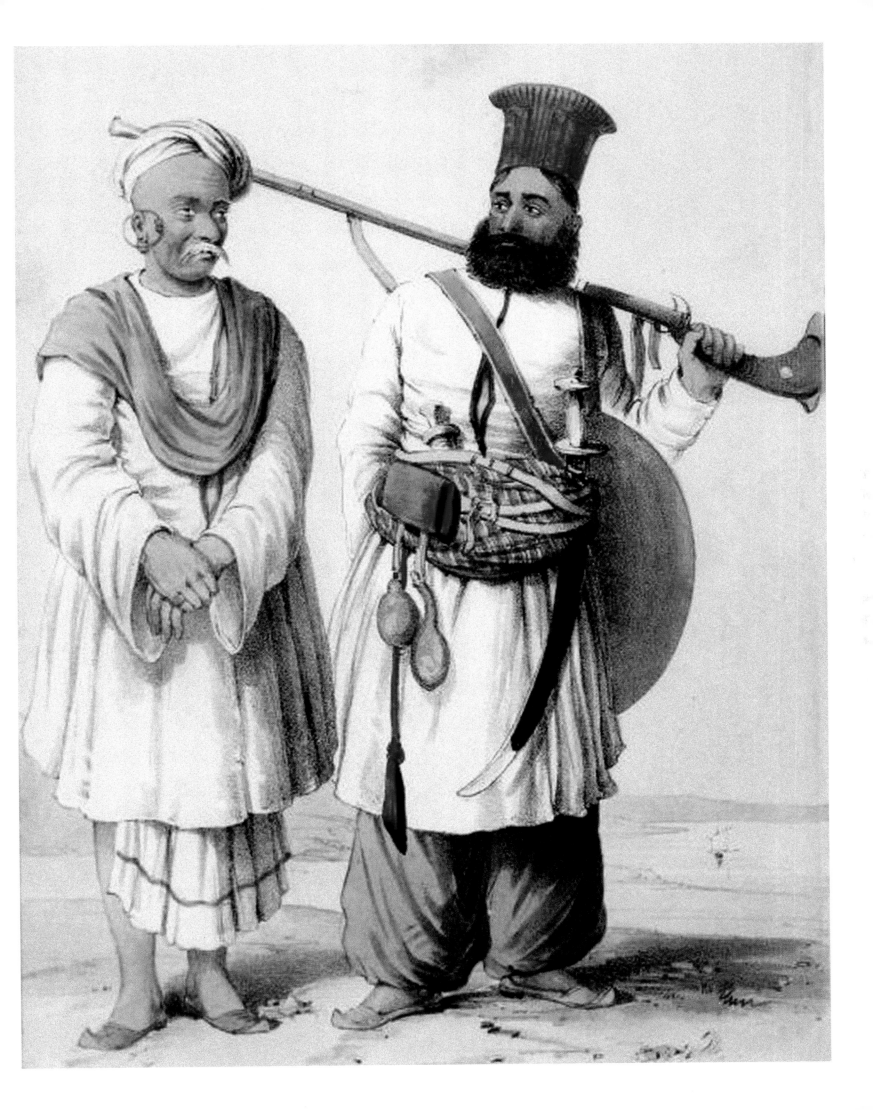

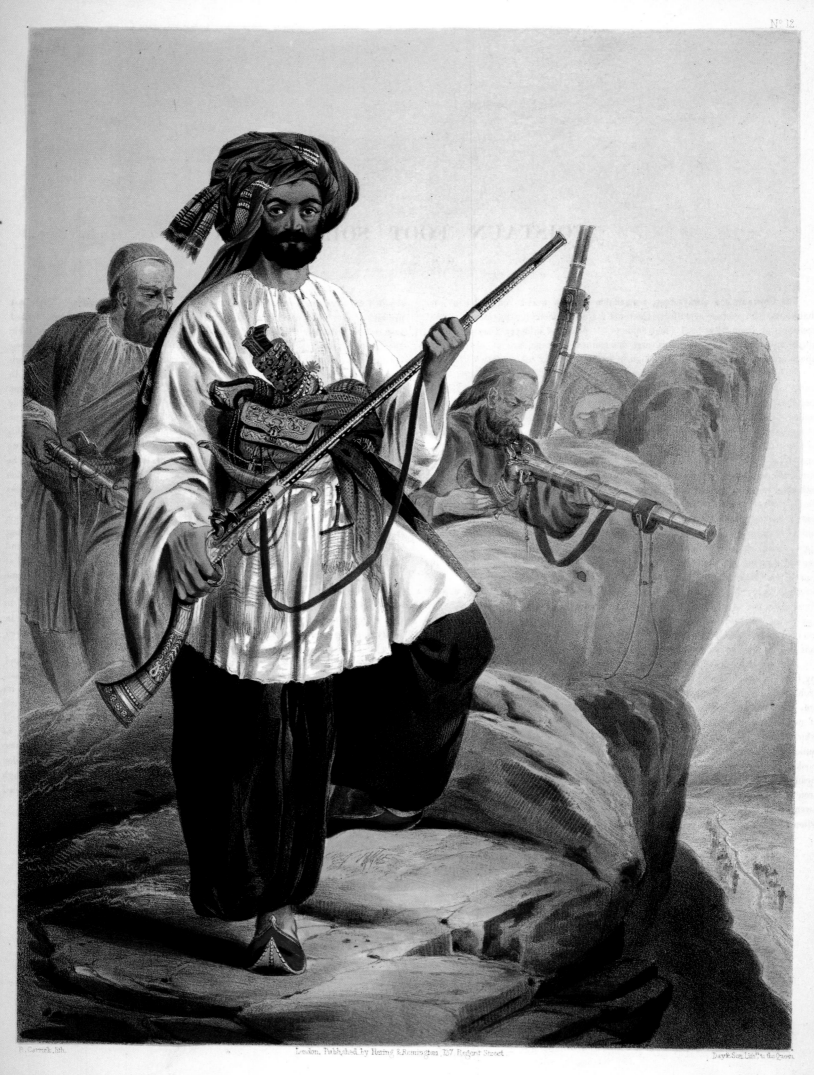

E. Carrick, lith.　　　London, Published by Hering & Remington, 137 Regent Street.　　　Day & Son, Lith.rs to the Queen.

KO-I-STAUN FOOT SOLDIERY IN SUMMER COSTUME.

mostly manufactured in Hyderabad, the prices of a good matchlock is from 10 to 30 Rupees, and for swords 6 Rupees.[43]

Sindh court guns have some of the best damascus barrels ever made, either Persian or locally made in Persian style, often bearing the owner's name in gold. There is no evidence of this luxury product until the Talpurs took over the state in the 1780s and pre-nineteenth century Sindhi guns are unknown or unrecognised. Silver mounts are common, gold rarer, usually on royal guns. Sindhi guns are rifled and have barrel tangs, details not usually found on north Indian Hindu guns. Persian enamellers worked at the Talpur courts, the local Multan enamel being far cruder, but both types of enamel decorated guns.[44] Thomas Postans records nineteen Hindu dealers in enamel in Shikarpur in 1840–41 and seventeen dealers in metals.[45] The latter received metal from Marwar. He writes that the Hindus carry on all the trade, the Muslims all artisan work. The town exported shields to Khurasan through the Bolan Pass but there is no mention of the manufacture, import or export of weapons.[46]

John Malcolm describes the manufacture of guns, pistols, swords and military equipment at Shiraz in a dispatch following his mission to Persia in 1801 and these would have found a market in Sindh. Kirman was famous for making excellent guns as another early nineteenth-century traveller, Pottinger, mentions, adding that they were heavily taxed there.[47] He describes their principal export markets as Khurasan, Kabul, Balkh and Bukhara. Kabul was described at that time as the gate to Sindh. Moorcroft who travelled this region in the first half of the nineteenth century wrote that: 'In Persia, Kabul, the Punjab and Sindh, the same general principles prevail but the matchlocks of the last are held deservedly in high esteem.'[48] The Marwaris (Indian merchants), dominated trade in Kirman and Shiraz and brought these fine barrels to Sindh on the caravan route to Rajasthan. Postan describes Sindhi guns in 1841:

The arms of Sindh are very superior to those of most parts of India, particularly the matchlock barrels, which are twisted in the Damascus style. The nobles and chiefs procure many from Persia and Constantinople, and these are highly prized, but nearly as good can be made in the country. They are inlaid with gold, and very highly finished. Some very good imitations of European flintlock are to be met with: our guns and rifles, indeed, are only prized for this portion of their work; the barrels are considered too slight, and incapable of sustaining the heavy charge which the Sindhian always gives his piece. The European lock is attached to the Eastern barrel: the best of Joe Manton's and Purdey's guns and rifles, of which sufficient to stock a shop have at various times been presented to the Sindhian chiefs by the British government, share this mutilating fate. The Sindh matchlock is a heavy unwieldy arm; the stock much too light for the great weight of the barrel, and curiously shaped. One of the Amirs used our improved percussion rifles, but he was an exception to the general rule, the prejudice being generally decidedly in favour of the native weapon.[49]

FACING PAGE:
A foot soldier from Kohistan, Persian 'mountainous land', now within the Khyber Pakhtunkhwa Province in Pakistan. He is in summer costume armed with a *jezail* during the first Anglo-Afghan War of 1839-42. The Afghans loved to decorated their rifles, in this picture with brass and silver. Rattray describes one decorated with human teeth. He also has a flintlock pistol, a Khyber knife and a brass priming flask. The gun is pared down to the minimum to reduce weight.
James Rattray, *Afghaunistan*, plate 11.

Initially Sindhi guns were matchlock but later guns have English locks or local copies of English flintlocks,[50] particularly after the disastrous British retreat from Kabul when the Afghans captured large numbers of British-made guns. The *jezail* had a better range than the British army Brown Bess musket but the lock mechanism on the Brown Bess was admired and stripped out and used on court and tribal *jezail*s. All travellers mention the Sindhi Mirs love of hunting:[51] 'in hunting the Ameers use long muskets, inlaid with gold and jewels, to which the locks of the

guns presented by the English are fixed, though they do not esteem them as they ought.'[52] Alexander Henry Boileau was given a Sindhi *jezail*:

> On quitting Ahmudpoor the Khan produced his own pet rifle with which he had killed many a deer, and sent it me as a further token of his goodwill. The barrel was of Sindh manufacture, composed of thirteen pistol barrels beaten up and welded together, the muzzle being wrought into the figure of an alligator's head: the stock is of a very dark wood, very short, exceedingly thin in the grasp, and spreading out into a very broad but thin butt. A large coil of slow match is wound neatly about the stock just behind the breech of the gun, and is covered by a chintz cloth, round which are cast several folds of coloured tape, and an additional leather strap to keep the whole coil secure. A leather sling lies under the barrel: a little flap, primed with wax, secures the pan from damp, and additional protection is afforded to the priming by an exceedingly neat kind of lock-cover, which appears to be formed of horse-hair stitched in between thin leather, and bound with green morocco or kid skin, being entirely the work of Buhawul Khan's own hands. The whole of the mountings of this curious rifle are of silver, and a powder-flask of black leather (exactly the shape of a chemist's retort), stamped with embossed patterns and mounted with silver, accompanied the gift, as also a powder measure of buffalo horn and a bullet mould: on both of the latter were engraved the words 'Kilan walee', denoting that it belonged to the large gun, though it's ball is not near so large as that of a carbine. A double barrelled percussion fowling piece, with a few other articles including a brace of pistols, sent by Lieutenant Trevelyan, remained with the Khan as a slight memorial of our visit to the Indus and its neighbourhood.[53]

Many European travellers who wrote reports for the British East India Company on Sindh's military potential ignored small arms production, focusing on Sindhi artillery which everywhere was in a deplorable state, much unusable.

In the seventeenth and eighteenth century, Thatta, the Mughal capital, was Sindh's major manufacturing town but during the nineteenth century trade moved to Hyderabad, the Mirs capital from 1782. 'The principal manufactures of Sindh…Pakputun, 120 miles N.E. of Buhawulpur. Very good fire-arms are made by Buhawul Khan's workmen, [at Ahmedpur] though not equal to those of Khyrpoor [Khairpur] and Hyderabad.'[54] Khairpur corresponds to Siro and Hyderabad to Lar, the southern region. To this list should be added the guns produced in Lahore for sale in Sindh. Iron and steel was shipped from Mandvi to Lakhpat. Pottinger writing in 1816 gives matchlocks, spears and swords and embroidered clothes as the principal manufactures of Hyderabad but until the nineteenth century it was not a major place of trade like Karachi or Shikarpur. Sindh was well integrated into the Indian Ocean economy and a significant community of Sindhi merchants, mostly Bhatias from Thatta, traded in Muscat with consequences for a particular type of gun barrel;[55] and merchants, mostly from Shikarpur, Thatta and Sukkur traded with the Persian Gulf, particularly dominating the pearl market. Commercially the Gulf had strong connections to Basra and, via the Tigris and Euphrates, with Baghdad and important trading cities to the north such as Aleppo. Caravans carried goods from Tehran, Isfahan and Shiraz reached Bushire to be shipped to India. Afghan merchants are recorded by Lieutenant Gordon in 1841 at the port of Sonmiani (a coastal town 83 km north-west of Karachi) importing 80 rupees of percussion caps, a 'fowling-piece' worth 125 rupees, pistols worth 45 rupees and 40 rupees worth of gunpowder from Bombay.[56]

Speculation in Malwa opium was one of the major sources of capital accumulation in India between 1770 and 1870. The East India Company, itself a major exporter of opium cultivated in British India, harassed Malwa opium exports transiting through British territory, hoping by this to dominate the trade with China. As a result a trade route developed about 1819 that avoided British territory. Malwa opium, much of it from Ujjain, was carried to Pali in Mewar and then across the Thar Desert by camel via Jaisalmer and Umerkot to Karachi in Sindh from where it was shipped to the Portuguese Indian port of Damao which sent it on to Macau. British efforts to interdict this traffic which included treaties with the Rajput States all failed. The effect of this was to integrate Sindh into the central India trading area. In the years before the British annexation of Sindh vast profits were made in the opium business. A British report in 1837 said that Malwa opium was by far the biggest component of the export trade from Karachi. The occupation of Sindh enabled the British to close down the Mewar route and redirect Malwa opium through Bombay, something they had sought to do for twenty years. Art history has seen Sindh and Rajasthan as two very distinct cultural areas but commercially they were rather closer than perhaps has been realised.[57]

Some Sindhis from Hyderabad settled in exile in Jodhpur after the British annexation of Sindh in 1843. It seems possible that their influence changed the decoration of Jodhpur matchlocks, though the process may have started earlier during Maharaja Man Singh's period: the evidence remains unsatisfactory. Presumably Sindhi guns in the Jodhpur armoury came as gifts, others as the result of the 1780 war when Marwar captured the frontier district of Umerkot,[58] later lost to the Talpurs. Sindhi guns themselves pose problems, grouped here into two forms of stock, the very large and thin, flat, fishtail type used at Hyderabad; and a considerably smaller stock version. There are very few stocks of intermediate size. Both stock forms have been treated as Sindhi in the past and they may be regional variations or an evolving shape. Arms production in Hyderabad disappeared after the overthrow of the Mirs in 1843.[59] Postans writing in 1843 says there is only one decent workman left and 'the best workmen and artificers, finding plenty of employment under milder governments, emigrated to Bombay and other places'.[60]

Can the reduction of the butt on Sindhi guns be explained as moving to a form that might be used by Jodhpuris as well as Sindhis? Probably not as the magnificent Sindhi guns in the armoury do not feature in Marwar paintings. A Jodhpur painting c.1810 shows an army on the march, which includes camels carrying two men, each with a very long gun in a bag, unusually wide at the stocks.[61] Guns were usually carried covered in red cloth gunbags, in this instance too wide for conventional Indian matchlock butts, and it is likely they contain Sindhi *jezails*. 1843 was the date Takhat Singh came to the throne. Sindhi guns are very ostentatious. Did they influence Jodhpur matchlocks, which had been rather sober and less opulent? While the two stock types share certain silver designs the small type cover much of the wood of the stock with silver in a very different manner to those from Hyderabad. Whether this indicates changing fashion or the products of different parts of Sindh or evolution over years is not known. There are Sindhi decorative details that become common on Jodhpur matchlocks about 1843. When the traditional Rajput sinew bindings holding barrel and stock together became passé in the late eighteenth and nineteenth centuries the Rajputs adopted Sindhi-style silver barrel bands. One associates rifled damascus barrels with Sindh but there are smoothbore damascus barrels possibly made for the Rajput market. (See FRM90). One of these 'small butt' 'Sindhi' matchlocks with gold mounts, 'used for sporting purposes', was presented by 'the Rajah of Jodhpur' to the India Museum, London in 1851.[62]

Sindhi merchants began to appreciate that Sindhi crafts including arms appealed to Europeans in Bombay as early as the 1840s and they began selling 'Sindwork' there.[63] In about 1860 some Hyderabadi merchants or 'Sindworkies' took the bold decision to set up tourist shops in Egypt. The Suez Canal opened in 1869 and the Sindhis sold large amounts of curios to travellers passing through Egypt on the way home to Europe. This initiated a large international trading network in ethnic goods, which over the next few decades required more stock than Sindh itself could produce so that by the 1870s they were obliged to turn to the Punjab, Kashmir, Benares and even to China and Japan for produce to sell. One consequence was 'Japonisme', which swept Europe and America at regular intervals between the 1860s and the 1920s.[64] The traditional centres of arms manufacturing in the Punjab and Jaipur found new markets for traditional products, which were sold by this remarkably energetic international sales network.

# SINDHI JEZAILS WITH LARGE STOCKS

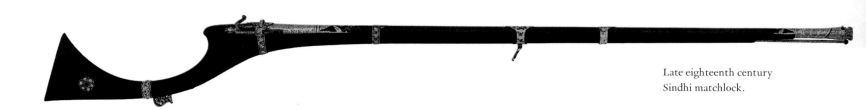

Late eighteenth century
Sindhi matchlock.

FRM/97/208

## JEZAIL
Sindh
Latter part of the eighteenth century

OVERALL LENGTH: 155 CM
BARREL LENGTH: 120 CM

DESCRIPTION
Matchlock, the watered-steel damascus-twist barrel has a sighting rib and eight-groove rifling. Steel ramrod. The barrel is decorated at the muzzle with a gold damascened tiger head with paste eyes; and at the muzzle and breech with gold aftabi flower patterns. There are two inscriptions in excellent gold Persian nastaliq:

*Sircar Mir Fath 'Ali Khan Talpur.*
*Amal Hajji Mir Khan.*

The barrel bears a square sunken gold panel with a raised inscription in fine naskh script: Amir ul Mu'minin Haidar.

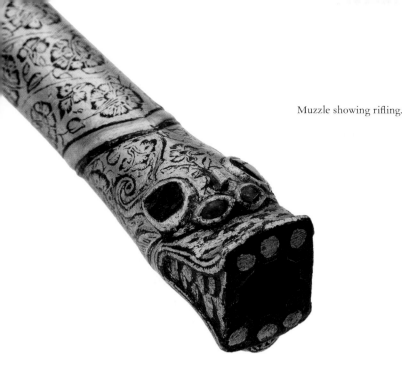

Muzzle showing rifling.

View of the muzzle and ramrod.

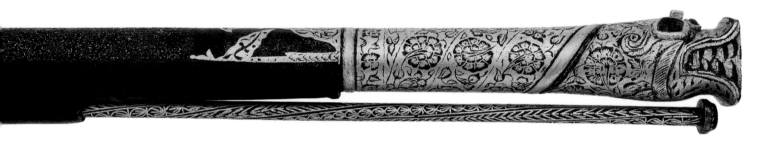

View from above.

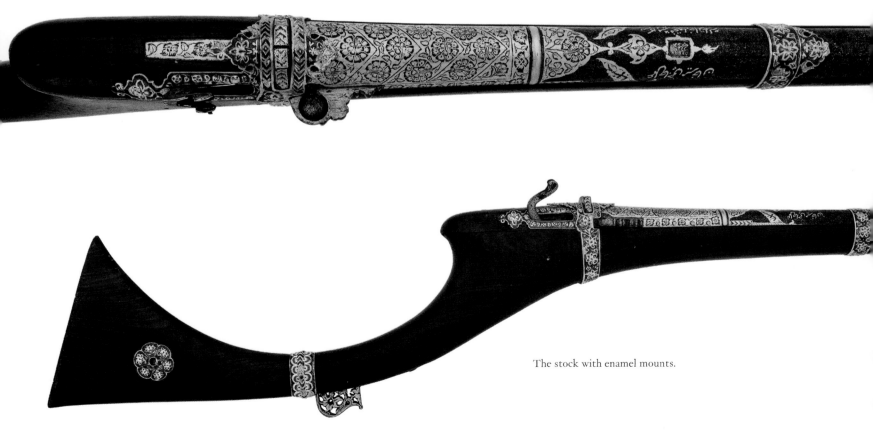

The stock with enamel mounts.

Wooden full-stock with gold and champlevé enamel, predominantly green with blue, white and yellow flowers. There are three barrel bands, one with a gold and enamel swivel.

COMMENT

Hajji Mir Khan, maker of this barrel, also made the barrel on a flintlock Sindhi gun, now in the Victoria and Albert Museum.[65] The museum attribution of c.1830 rests in part on the lock signed 'John Manton and Son, Patent' with the serial number '7787' which dates the lock to 1820. The V&A barrel also bears the owner's name, Mir Murad 'Ali Khan Talpur, of the ruling house of Hyderabad who died in 1834. The V&A might therefore reasonably redate their barrel closer to 1820 as the maker was working for the Talpurs in the late eighteenth century.

Jodhpur's Sindhi matchlock with its pierced trigger and high quality enamel is rare. A European-style trigger can be found on a Sindhi flintlock musketoon dated ah 1213/1799 AD[66] and on that basis the traditional trigger, which can also be found on other Sindhi guns with royal barrels, may date from the eighteenth century. Another clue regarding date are the enamel mounts, certainly Persian rather than Multan work. James Burnes visited the court in 1819 and mentioned that two Persian enamellers worked there[67] exemplified by the Persian enamel on two guns in the Khalili Collection,[68] a style that lasts well into the mid-century. The enamel on the Jodhpur gun is certainly different, more sensitive and earlier. Persian enamel is rare until the Qajar period so comparative material is scarce. However, there are similarities in terms of palette and handling of flower heads with a dagger and sheath in the Hermitage, which is attributed to the late eighteenth century or early nineteenth century.[69] Unfortunately the butt-plate, which would be the principal enamelled section, is missing. However, Mir Fath 'Ali Khan Talpur, eldest son of the Hyderabad royal house, died in 1801. Another barrel by this maker is in the Khalili Collection, with the owner's name 'Sarkar Mir Muhammad Nasir Khan Talpur', son of Murad 'Ali Khan Talpur.[70]

Amir ul Mu'minin is the title adopted by the Caliphs who succeeded the Prophet Muhammad and means Leader of the Faithful. Haidar, a common male name, in its various spellings all indicate some characteristic of a lion. In this instance it means brave. It is often a reference to the Prophet's son-in-law 'Ali, 'the victorious lion of Islam'. The inscription on this gun refers to 'Ali's title and his role at the heart of Shi'ism. The words on the barrel are devotional, highly appropriate for the Talpur ruler.

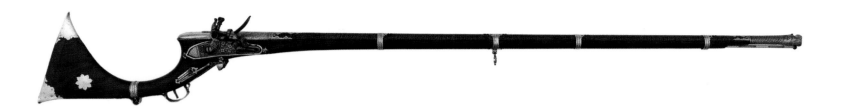

UBP/2017/22

# FLINTLOCK GUN
Hyderabad, Sindh
c.1830

OVERALL LENGTH: 167 CM
BARREL LENGTH: 127 CM

## DESCRIPTION

Sindhi rifled damascus-twist barrel c.1830 with lion-head muzzle with kundan-set Nishapur turquoises. Chiselling and koft work at the muzzle and breech and the invocation 'Ali! Copper foresight and grooved back-sight. Shisham stock with four original barrel bands.

European flintlock mechanism c.1830, the plate, frizzen and cock with added Sindhi chiselled flowers and gold border. Steel ramrod decorated with bands of gold. Silver trigger, trigger-guard and mounts.

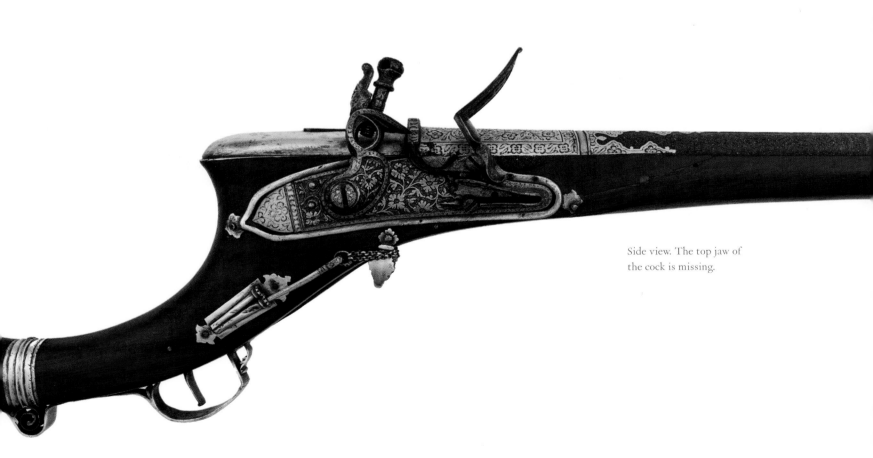

Side view. The top jaw of the cock is missing.

View of the muzzle

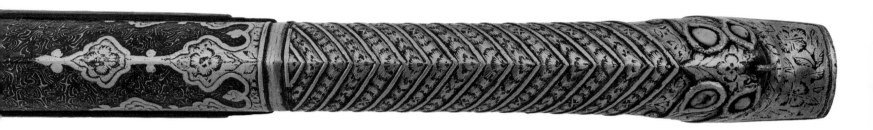

View of the breech.

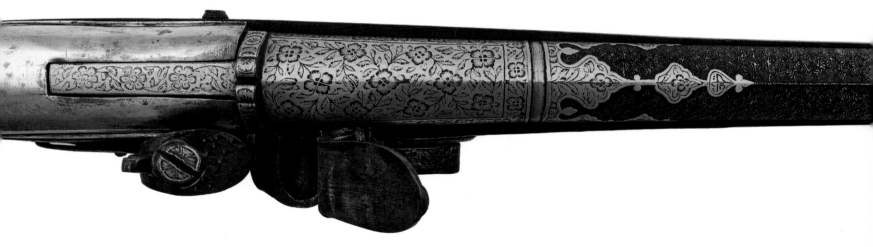

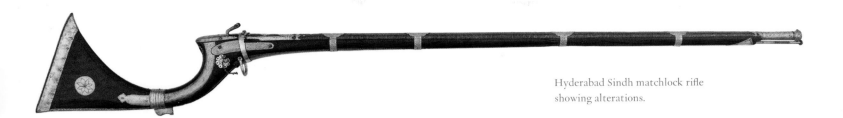

Hyderabad Sindh matchlock rifle
showing alterations.

FRM/76/283

# JEZAIL
Hyderabad Sindh
c.1835

OVERALL LENGTH: 163 CM
BARREL LENGTH: 118 CM
WEIGHT: 4.05 KG

## DESCRIPTION
Matchlock eight-groove rifle, the damascus-twist barrel with three raised lines for its full length. Muzzle and breech with gold aftabi flower patterns and the invocation 'Ali! There are vignettes of a tiger, rhino and deer, all quarries of the hunter-owner of this gun. Steel ramrod with mushroom head. Wooden full-stock with brass mounts secured with copper nails. Similar work covers the block behind the barrel, a replacement during the working life of the gun. One silver barrel band remains at the breech. The others are modern, added in 2016.

## COMMENT
The magnificent barrel shows the owner could afford the best but later appears to have fallen on hard times, probably as an exile after 1843. The lock and mounts were removed, possibly to pay debts.

Detail showing patterned steel barrel
and contemporary koft work.

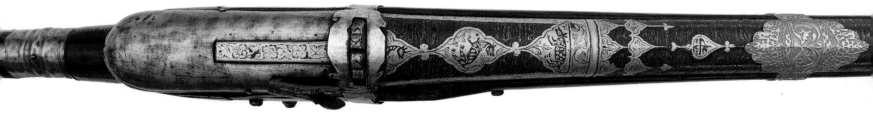

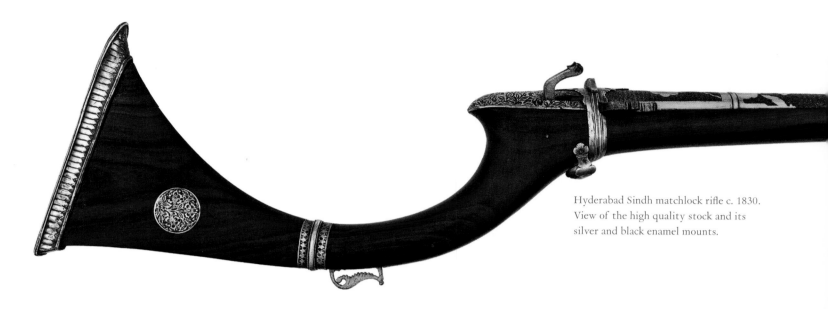

Hyderabad Sindh matchlock rifle c. 1830.
View of the high quality stock and its
silver and black enamel mounts.

UBP/2017/17

# JEZAIL
Hyderabad, Sindh
c.1830

OVERALL LENGTH: 162 CM
BARREL LENGTH: 119 CM

## DESCRIPTION
Matchlock, damascus-twist barrel with sighting rib and eight-groove rifling, the breech
and muzzle decorated with gold panels and borders and a gold damascened lion head with
cabochon ruby eyes and green glass ears. The gun has acquired a replacement Jodhpur
trigger. Shisham full-stock with silver and black enamel mounts. Five silver barrel bands,
one with a sling swivel. Jodhpur armoury mark SK 8.

## COMMENT
For a similar Sindhi twist 'hogs back' barrel, the gun decorated with black enamel on silver
mounts, see Antique Arms, Armour and Modern Sporting Guns, Bonhams, Knightsbridge
23 and 24 May 2018, lot 82. All the barrels in this group have an identical cartouche with an
invocation to 'Ali! There are black enamel talwars and khanjars relating to this gun.

View of the muzzle and the magnificent
Damascus steel pattern.

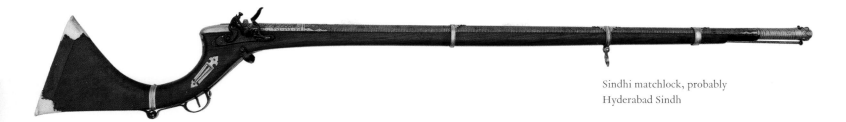

Sindhi matchlock, probably
Hyderabad Sindh

FRM/76/7

## SINDH GUN
1830 with later additions

OVERALL LENGTH: 160 CM
BARREL LENGTH: 116 CM

### DESCRIPTION
Sindhi damascus-twist rifled barrel c.1830 with tiger-head muzzle (there are raised tiger stripes on the neck) with kundan set foiled garnets. There is further chiselling and koft work at the breech. Elongated copper foresight and grooved back-sight with rounded top, mounted on a late nineteenth-century, Jodhpur-made, shisham stock.

English flintlock mechanism, the plate signed Theo Richards. Theophilus Richards senior was a Birmingham gunmaker, the son of a gunmaker, with premises in the High Street, who was sufficiently prominent for Lord Nelson to visit his shop in 1802. He died in 1828.[71] His son of the same name is thought to have worked until 1833. The lock and sling swivel have been chemically blackened when the gun was assembled.

Iron ramrod decorated with a gold pattern when the stock was made. Steel trigger of European form, Anglo-Indian trigger-guard with gold false damascening. Silver copies of Sindhi barrel bands and sling swivels. No armoury mark.

### COMMENT
This gun was assembled to exhibit the barrel, probably for one of the Delhi durbars. A gun with a very similar muzzle is in the collection of H. H. Mir Mohammad Ali Khan Talpur, Hyderabad, catalogued as 'Hyderabad Vicholo, mid 19th century'.[72] Vicholo means the middle of the country, which is often spoken of as being divided into three, Siro the head, Vicholo and Lar, the descent or lower section.

Tiger's head muzzle with low quality garnet eyes and ears. Note the original Sindhi ramrod, typical of the 1830s, gold reticulated floral pattern of seventeenth-century type.

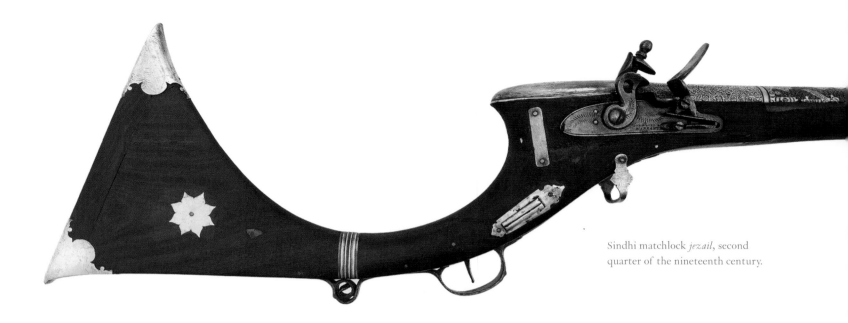

Sindhi matchlock *jezail*, second quarter of the nineteenth century.

FRM/97/251

# SINDH MATCHLOCK

OVERALL LENGTH: 154.4 CMS
BARREL LENGTH: 117.3 CMS

## DESCRIPTION
Matchlock rifle, watered-steel damascus-twist barrel with sighting line and eight-groove rifling. The foresight is missing and the grooved rear-sight has the normal curved top. The barrel is decorated at the muzzle and breech with gold aftabi flowers in a chevron pattern and a gold Persian invocation in nastaliq: 'Ali! Shisham full-stock with multiple repairs; and an Indian-made English-style flintlock mechanism inscribed 'John Lord and…, warranted'. Silver furniture and mushroom head ramrod. Armoury mark SK 3.

## COMMENT
The ramrod is not original and some silver mounts on the stock are replacements. Fine barrel, the remainder of the gun of lesser quality.

View of the muzzle.

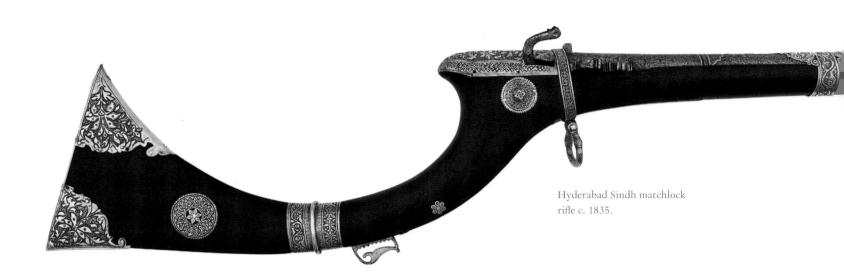

Hyderabad Sindh matchlock
rifle c. 1835.

FRM/76/284

# JEZAIL
Sindh
c.1835

OVERALL LENGTH: 158 CM
BARREL LENGTH: 116.5 CM

## DESCRIPTION
Matchlock rifle, the damascus-twist barrel has a raised sighting line for its full length and six-groove rifling. Steel ramrod with mushroom head. The barrel is decorated at the muzzle with a makara head with the remains of red wax eyes. Muzzle and breech have renewed gold decoration, clumsily executed.

Wooden full-stock with silver mounts.

## COMMENT
The silver work is considerably later than the barrel, which has later gold work.

Muzzle detail. The gold and silver
decoration is unusual and late.

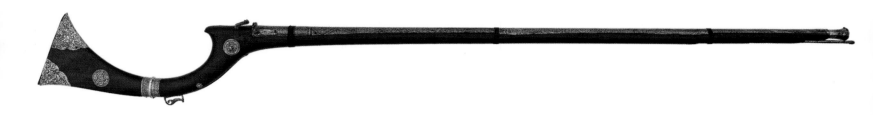

FRM/97/288

JEZAIL
Sindh
Nineteenth century

OVERALL LENGTH: 160.5 CM
BARREL LENGTH: 119 CM

DESCRIPTION
Rifled barrel with very rare wave-pattern damascening, decorated at the muzzle and breech with a gold flower. See gun number FRM/97/226 for an earlier example and discussion of this intricate pattern. The trigger is iron and an unusual design. The shisham full-stock has typical late Sindhi silver mounts. This weapon lacks the pan and forestock cap.

Detail showing barrel
pattern and muzzle.

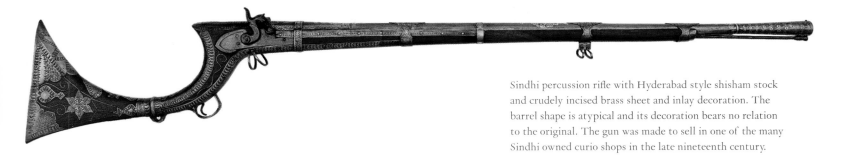

Sindhi percussion rifle with Hyderabad style shisham stock and crudely incised brass sheet and inlay decoration. The barrel shape is atypical and its decoration bears no relation to the original. The gun was made to sell in one of the many Sindhi owned curio shops in the late nineteenth century.

FRM/76/120

# SINDH PERCUSSION RIFLE
c.1880

OVERALL LENGTH: 122 CM
BARREL LENGTH: 93.25 CM

## DESCRIPTION
Round, burnished-steel barrel with six-groove rifling and flared muzzle. Better barrels had eight grooves. The breech, mid-section and muzzle have crude silver decoration applied to a cross-hatched ground, work that is certainly late nineteenth century. Indian percussion lock in European style that does not function. Shisham stock with brass furniture and inlay with crude punched and chiselled decoration. Unusually the gun has a small cavity in the underside of the stock with a sliding cover to store a small number of percussion caps.

## COMMENT
Made for the European decorative market, the brass decoration on the stock is similar to inlaid Hoshiarpur (Punjab) tables and Kashmiri boxes sold by Sindhi merchants in curio shops from the 1840s. For an example of work of this kind see FRM120.

Detail of the inlay decoration on the stock.

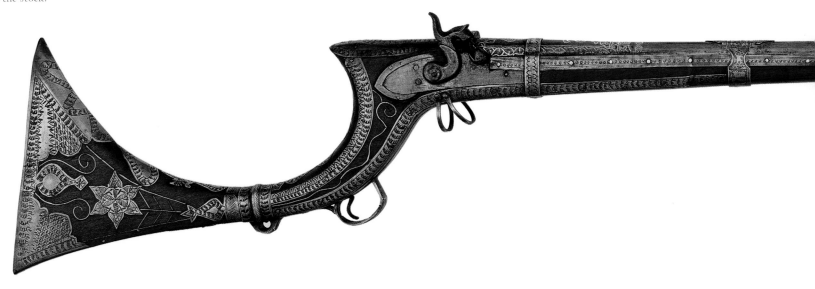

# SMALLER SINDHI STOCKS

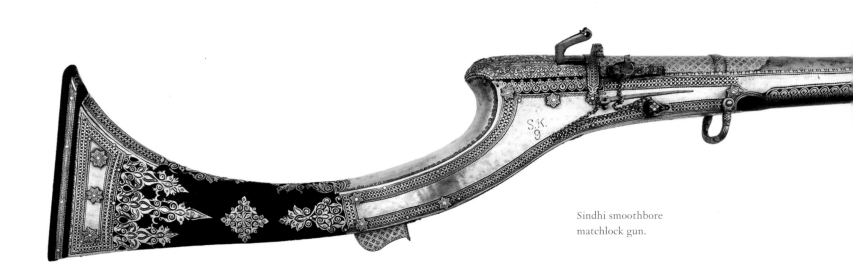

Sindhi smoothbore
matchlock gun.

FRM/76/90

## SMOOTHBORE MATCHLOCK GUN, 1840S

OVERALL LENGTH: 180 CM
BARREL LENGTH: 132 CM

### DESCRIPTION
Smoothbore round barrel with chiselled mihrab-shaped aprons and koft work at the breech
and muzzle, the pattern repeated on the trigger. Copper-bead foresight and grooved back-
sight with sloping shoulders, mounted on a stock made of shisham. Elaborate stamped and
pierced silver sheet decoration with barrel bands en suite.

Silver pricker and detachable pan cover on chains. Plain steel ramrod with faceted head
decorated with crude chevrons. Armoury mark SK 9.

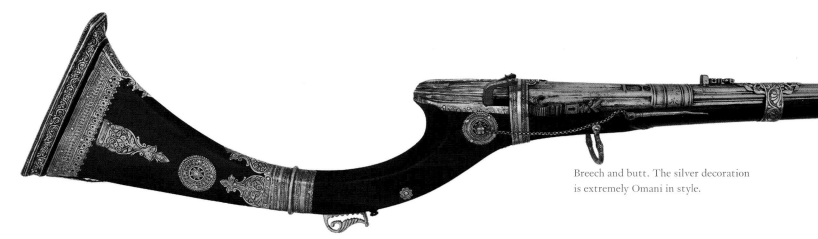

Breech and butt. The silver decoration
is extremely Omani in style.

## SMOOTHBORE MATCHLOCK GUN

OVERALL LENGTH: 167 CM
BARREL LENGTH: 123 CM

### DESCRIPTION

Smoothbore barrel of Makran type.[73] This example has a multi-fluted breech (resembling
the wooden block behind the breech on Rajput guns). The triple mihrab recesses take gold
tablets on which to write the maker or owner's name or devotional text, a Persian gun
feature. Above this is an applied rear-sight, a late, simple version of the type. The end of
the chamber normally finds a half-round astragal is marked by a broad band of metal. The
pan is highly elaborate and stylised. The ribbed barrel flares slightly at the muzzle where
there is an elongated brass foresight. Stock of striped shisham with elaborate stamped
and pierced silver-sheet decoration with barrel bands en suite. Silver pricker on a chain.
Pierced gilt iron trigger and serpentine. Plain steel ramrod with turned head like vertebra.
Armoury mark SK 4.

### COMMENT

Barrels of this form are found in Oman and parts of the Omani empire, which included
Zanzibar and the Makran coast of what is now Pakistan.[74] Yemeni histories state that the
*banduk* first appeared in the Yemen in 1515 and that the Turks took it to the Hadhramaut
but local rulers played off each power against the other and Portuguese matchlock men
were involved in 1538–9.[75] European guns reached the Arabs of Southern Arabia in the
early sixteenth century due to the intervention of the Portuguese and the Ottomans in
local politics. Brescian guns were exported to the region and the Arabs always considered
el-Lazzary to be the best available, named after Lazzarino Cominazzi (c.1580–1641). His
extended family were seventeenth-century barrel makers from Gardone near Brescia and
these early *schioppetti*[76] provided the distinctive design that became unique to Oman. The
Portuguese allied with the Safavids giving them guns to use against their mutual enemy,
the Ottoman Turks. The Arabs were very conservative and kept the form of one of the first
barrels that reached them. This gun is possibly from the workshop that made ARM/76/90.

View of the muzzle
and ramrod.

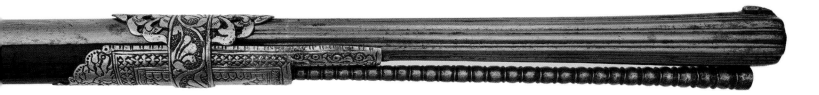

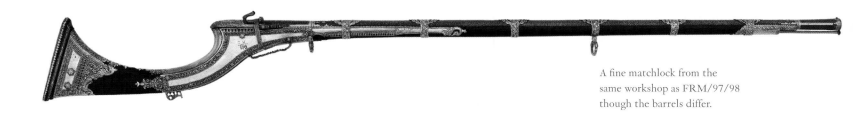

A fine matchlock from the same workshop as FRM/97/98 though the barrels differ.

FRM/97/93

## JEZAIL C. 1840

OVERALL LENGTH: 169 CM
BARREL LENGTH: 123 CM

### DESCRIPTION

Rifled damascus-twist barrel with eight grooves, c.1840. The barrel has a flat sighting rib for the greater part of its length. There is chiselling and koft work at the breech and muzzle. Copper-bead foresight and grooved back-sight with sloping shoulders, mounted on a stock made of shisham.

Stamped and pierced silver-sheet decoration with barrel bands of a different design, possibly nineteenth-century replacements. The looped sling carries, still known in the modern Indian army as 'secling currie', have well-formed makara heads. Silver match holder and pricker on a chain. Plain steel ramrod with mushroom head terminal. Gilt pierced steel trigger and serpentine. Armoury mark SK 46.

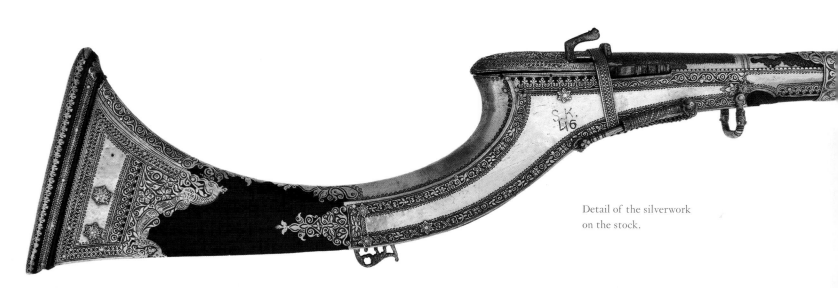

Detail of the silverwork on the stock.

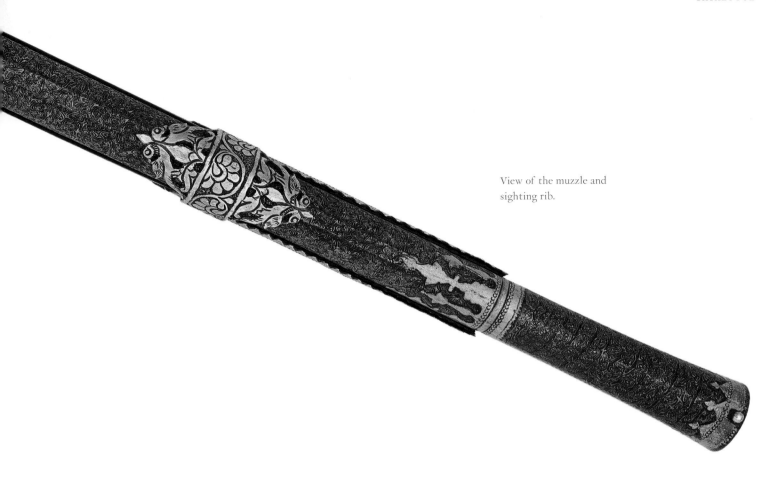

View of the muzzle and
sighting rib.

View of twist pattern barrel
and silverwork.

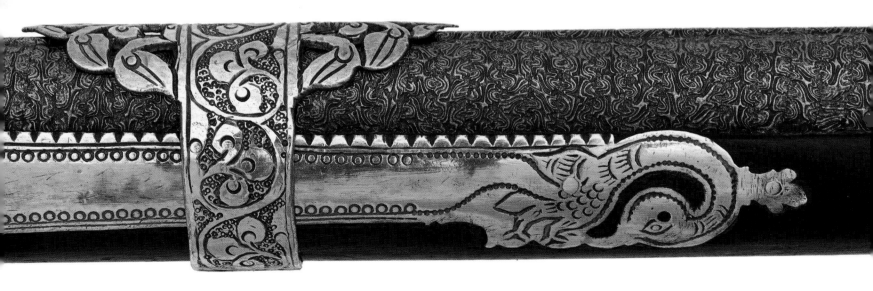

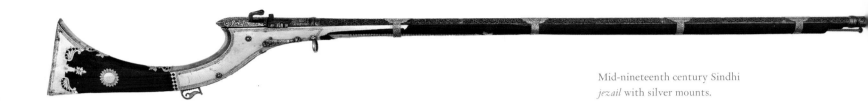

Mid-nineteenth century Sindhi *jezail* with silver mounts.

FRM/76/282

## JEZAIL
Sindh
Nineteenth century

OVERALL LENGTH: 165.3 CM
BARREL LENGTH: 116.5 CM
WEIGHT: 4.13 KG

### DESCRIPTION
Matchlock gun, smoothbore barrel chiselled with a jali pattern with inset flowers. The muzzle and breech has mid-nineteenth-century false-damascened gold flower patterns. Square rear-sight and copper-bead foresight. Pierced gilt trigger and serpentine with gold decoration.

The shisham full-stock and silver-sheet decoration on the butt is typically Sindhi and dates from c.1840. Steel ramrod with mushroom head. Modern silver barrel bands added in 2016 to stabilise the gun.

### COMMENT
The barrel is unusual in form and is Mughal not Sindhi. It appears to be early eighteenth century. The gun appears to be assembled from parts in the mid-nineteenth century. The match cover and side-plate is very Rajput.

Early eighteenth century Mughal barrel with chiselled decoration. The breech has nineteenth century false damascened flowers and the embossed silver cover behind the rear sight is nineteenth century Sindhi silver work.

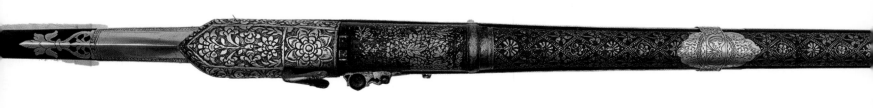

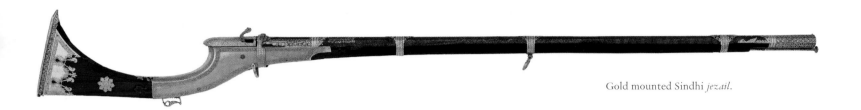

Gold mounted Sindhi *jezail*.

FRM/97/209

# JEZAIL
Sindh
Nineteenth century

OVERALL LENGTH: 166 CM
BARREL LENGTH: 120 CM

## DESCRIPTION
Matchlock rifle, the eight-sided watered-steel damascus barrel has eight-groove rifling. Steel ramrod. The barrel is decorated at the muzzle and breech with gold damascening. There are two inscriptions at the breech. Marwari inscription:

> *Sri 108 sri Maharaja diraj sri Takhat Singhji son chamkay samat VS1903 [1846] ra soni kisan ram*
> In the year vs 1903 [1846], on the orders of Shri Shri 108 Maharajadhiraj Shri Takhat Singhji, gold was polished by the goldsmith Kishan Ram.

On the other side of the barrel in Persian naskh mixed with nastaliq: *Sircar Mir Mahmud Khan Talpur.*

Wooden full-stock decorated with gold sheet at the stock (some parts missing) and three gold barrel bands, one with swivel.

Detail showing the stock and buttplate.

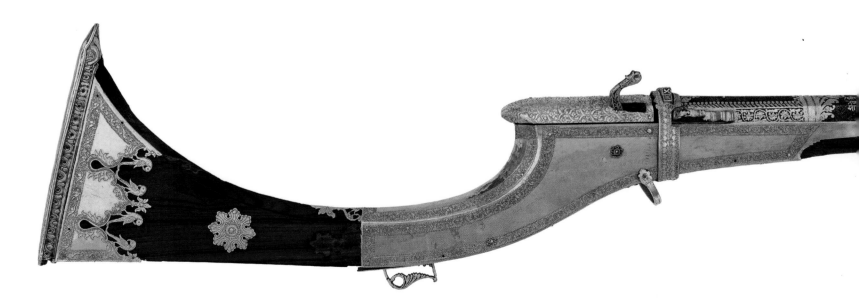

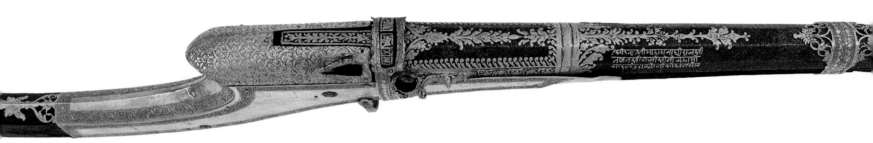

Persian inscription giving the name of the owner: Sircar Mahmud Khan Talpur. Note the very fine damascus twist barrel: and the typical nineteenth century gold inlay – in particular the border at the breech with its distinctive fringe of gold commas. Unfortunately parts of the applied gold have been pilfered. The front barrel band is original, very finely worked. The rear barrel band and the metal strip parallel with the barrel are very crude modern replacements. Marwari inscription explained in the description

## COMMENT

Sindh was divided into seven distinct districts ruled by members of one family (Chauyari rule). Mir Mahmud was the ruler of one of these. He was the son of Mir Bahram Khan, (assassinated 1774–5). Both his older brothers, Mir Bijar Khan and Mir Sobdar Khan, were assassinated by the Kalhoras, the former in 1781 and the latter in 1774. When Mir Fateh Ali Khan died in 1801 the status of principal ruler passed to his brother, Mir Ghulam Khan (d.1811) but this succession was challenged by Mir Thara Khan, founder of the Mirpur line. Mir Ghulam Khan asked his uncle, Mir Mahmud Khan, the owner of the gun under consideration, to lead the army against Mir Thara Khan, which he did with conspicuous success, defeating him in 1803 near Wangi. In 1833 Mir Murad Ali died, the last ruler of the first Chauyari. Mir Mahmud Khan served on the ruling Council.

This gun was one of a number of gold guns captured by the British when they defeated the Talpurs in 1843 and given to Maharaja Takhat Singh of Jodhpur. He received others because he gave an identical gun to the East India Company, now in the Victoria and Albert Museum.[77] Another is in the Maharaja Sawai Man Singh II Museum in City Palace, Jaipur.[78] The barrel has two Devanagari inscriptions, the first giving the Rajput owner's clan, title and name: Devrajot, Thakur Nath Singh; and the second the maker, Lohar Bavdi.

The inscription on the barrel to Mir Mahmud Khan Talpur is authentic but does not guarantee that the stock and gold mounts were also his as the barrel may have been reused though there is nothing to indicate this. It dates the barrel to the early nineteenth century or earlier still if it was inherited by him though the absence of the inlaid name of any earlier Talpur suggests Mir Mahmud was the first owner. The Marwari inscription concerning polishing ordered by the Maharaja in 1846 suggests the gun arrived complete with goldwork despite the fact that the peacock design on the butt looks very Rajput.

Detail showing muzzle and damascus twist barrel.

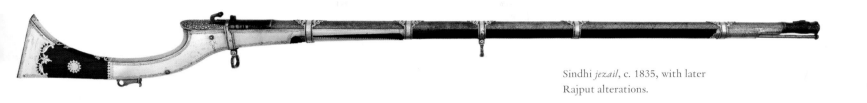

*Sindhi jezail*, c. 1835, with later
Rajput alterations.

FRM/97/285

## JEZAIL
Barrel c.1800
Gun c.1840

OVERALL LENGTH: 160.5 CM
BARREL LENGTH: 119 CM

### DESCRIPTION
Matchlock with smoothbore barrel, decorated at the muzzle with a makara head with
cabochon ruby eyes and the vestigial remains of gold damascene flowers which match those
at the breech. The barrel is decorated with ring-matting with emphasised lattice pattern,
the only example of this design in the armoury. The trigger is brass and an unusual design,
probably not Sindhi. The shisham full-stock has typical Sindhi silver mounts. Armoury
mark SK. 6

### COMMENT
There is a gun with a makara muzzle matching the one under consideration in a private
British collection, inscribed with a Hijra date equivalent to 1800; and there is another in
the Toor Collection. The barrel type is not commonly found on Sindhi guns and the lattice
decoration is Rajput, intended to look like damascus steel. The five silver barrel bands too
appear to be nineteenth-century Rajput rather that low-quality Sindhi. There are four new
nail heads anchoring the silver sheet to the stock above the trigger. These details all point to
the conclusion that the gun has been restored in the second half of the nineteenth century.

The barrel is ring matted, Rajput work
intended to look like damascus steel.
The barrel bands are also probably a
Rajput copy of Sindhi type.

# BALUCHISTAN MATCHLOCK

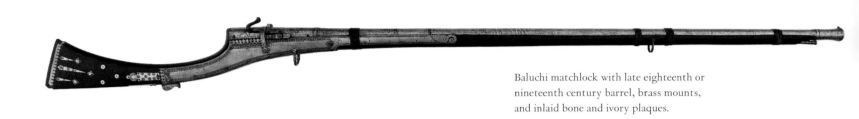

Baluchi matchlock with late eighteenth or
nineteenth century barrel, brass mounts,
and inlaid bone and ivory plaques.

FRM/97/89

## MATCHLOCK
Baluchistan
Nineteenth century

OVERALL LENGTH: 163 CM
BARREL LENGTH: 129 CM

### DESCRIPTION
Smoothbore matchlock with twist steel barrel. The muzzle is without decoration but
flares slightly. The breech is separated from the rest of the barrel by an astragal. Copper-
bead foresight and grooved rear-sight. Sinew barrel bands. Shisham stock with inlaid
ivory plaques. Stamped brass mounts, the match shield tube missing; iron trigger.
Armoury mark SK 36.

Detail of the stock with inlaid bone
and ivory plaques.

### COMMENT
The brass stylised head with scales on the forestock is a motif found on Sindhi guns.

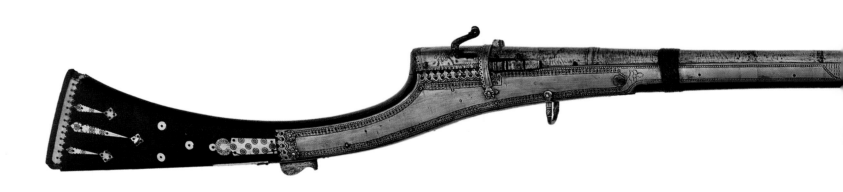

# MATCHLOCK BARRELS

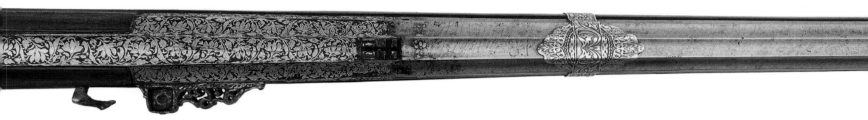

**FRM/76/281**

Seventeenth century very heavy fluted smoothbore barrel with a barrel tang and unusual square pan, probably a Turkish or Persian barrel, the gold decoration added at a Mughal or Deccani Muslim court. The barrel band is modern.

## SEVENTEENTH CENTURY BARREL
Probably Mughal or Deccani Muslim courts

OVERALL LENGTH: 175.2 CM
BARREL LENGTH: 131 CM
WEIGHT: 5.4 KG

### DESCRIPTION
Matchlock gun, smoothbore, damascus-twist barrel with ten concave flutes. Muzzle and breech have false-damascened gold flower patterns. Panel back-sight and copper-bead foresight. Iron trigger and serpentine with gold decoration. The square pan is unique in an Indian context and the tang is unusual. Shisham full-stock with thin brass butt-plate. Steel ramrod with collar and flared head. Modern silver barrel bands added in 2016 to hold the gun together.

### COMMENT
The 1900s stock was made to display this very heavy[79] fluted barrel, an impressive piece of metalwork made for someone important. Hindu barrels do not usually have a tang, suggesting it was made for a Muslim. There are no astragals and the powder chamber does not widen as early Indian barrels do, suggesting the design is an import. Wide fluting of this type can be found on early Bohemian matchlocks, though rarely for the full length, but German target barrels are usually rifled. A sixteenth-century Turkish barrel at Dresden has a wide concave sighting channel but this is unusual.[80] The Emperor Akbar's overlapping ribbon twist construction would have produced unusually heavy barrels. Fluting would remove metal while maintaining strength. Sindhi barrels are rifled and the decorative flutes and square pan are unknown on Sindhi barrels. The back- or panel-sight was introduced as early as 1500 in Europe and was copied by the Turks, appearing on seventeenth-century Albanian barrels. The Mughal or Deccani gold work on the barrel is early seventeenth century, on the ramrod nineteenth century. This appears to be a Turkish or Persian barrel where the twist pattern, Persian in origin, is the common barrel construction.

Muzzle.

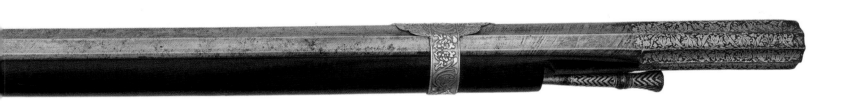

Breech showing chiselled flower which is rooted in an auspicious lota, ring-matted bajra barrel and groove rear sight with ears. Rajput or Mughal, first half of the eighteenth century.

FRM/97/304

## GUN BARREL
Rajput or Mughal
c.1725–50

BARREL LENGTH: 128 CM
WEIGHT: 3.23 KG

### DESCRIPTION
Smoothbore barrel with ring-matted silvered 'bajra' barrel, the muzzle flared with raised lotus and leaf design and copper-bead sight. Grooved rear-sight with ears. The pan has no cover at this date. Chiselled flower in relief at the breech.

### COMMENT
Other barrels with similar chiselled decoration are in the armoury.[81] The barrel FRM/76/310 retains the silver leaf applied to the chiselled flower.

The bajra design is Rajput, intended to replicate a damascus barrel, part of the Rajput desire to adopt Persian culture.

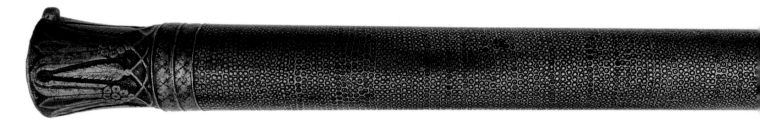

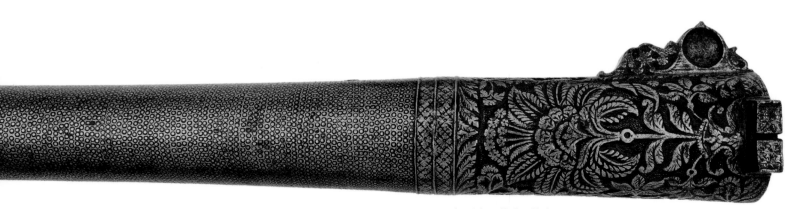

Muzzle with well chiselled
alternate tree and flower design.

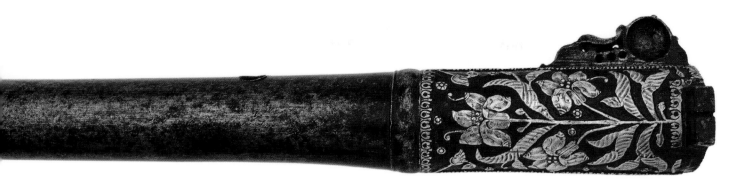

View of the breech showing the chiselled and silvered flower with contrasting black ground. The silvered border next to the astragal and the back sight is commonly found on early north Indian gun and cannon barrels. Note the way the barrel flares to create a large powder chamber.

FRM/97/310

# MATCHLOCK BARREL
Mughal or Rajput
c.1700

BARREL LENGTH: 127 CM

## DESCRIPTION
Round, smoothbore damascus-twist barrel with raised chiselled flowers at the muzzle and breech. Grooved back sight with ears.

## COMMENT
This barrel retains the silver leaf applied to the chiselled flowers. A miniature painting attributed to Bhavanidas, *Shah Jahan Enthroned on a Terrace*, Mughal 1707–12, shows a figure in the foreground wearing a sword and katar with gold decoration and contrasting black ground.[82] The 'horseshoe' repeat motif that forms a decorative ribbon framing the floral design is often found on guns and cannon of this period. See p. 100.

View of the muzzle.

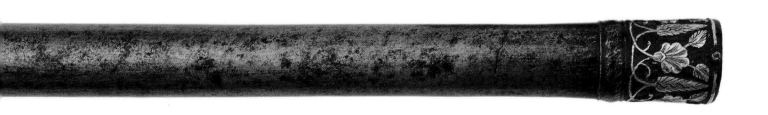

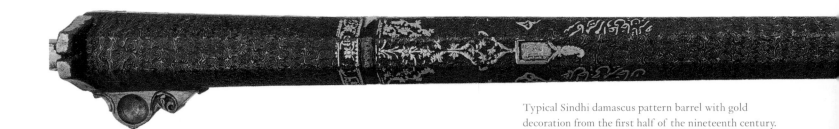

Typical Sindhi damascus pattern barrel with gold decoration from the first half of the nineteenth century.

FRM/97/ 311

# GUN BARREL
Talpurs of Sindh
Early nineteenth century

BARREL LENGTH: 114 CM
WEIGHT: 2.8 KG

## DESCRIPTION
Damascus-twist matchlock barrel with swamped muzzle, foresight and eight-groove rifling. The breech and muzzle are decorated with gold flowers. Two Persian gold nastaliq inscriptions at the breech refer to the owner and the barrel-maker:

> *Sircar Mir Ali Murad Khan Talpur.*
> *Amal Hajji Mir Khan.*

An inlaid gold tablet has illegible raised calligraphy, usually 'Ya 'Ali'.

## COMMENT
Mir Ali Murad Khan Talpur, known as Aadil-i Jang, was the second ruler of Upper Sindh from 1842 until 1894. After the British conquest of Sindh in 1843 the British eroded his power and territory. Lieutenant Lewis Pelly wrote sympathetically about the Mir's straightened circumstances and altered position in a report on Khairpur for the Bombay Government in 1854.[83] For details of Hajji Mir Khan see FRM/97/208.

Detail of the steel pattern.

Section of barrel showing the use
of multiple strands with differing
compositions to produce the pattern.

FRM/97/313

# MATCHLOCK BARREL CONVERTED TO PERCUSSION
Talpurs of Sindh
Early nineteenth century

OVERALL LENGTH OF BARREL: 103 CM
OVERALL LENGTH INCLUDING TANG 108 CM
WEIGHT: 2.30 KG

## DESCRIPTION
Damascus-twist 'hogs back' barrel with eight-groove rifling and swamped muzzle. Square-topped grooved rear-sight with shoulders, no foresight. The breech and muzzle are decorated with chiselled Persian cartouches in relief. The damascened gold flowers are a later addition. There is a short barrel tang.

Detail of the repeat pattern.

Muzzle detail showing twist
pattern and gold damascening.

FRM/97/316

## MATCHLOCK BARREL
Mughal
Mid to late eighteenth century

BARREL LENGTH: 125 CM
WEIGHT: 2.46 KG

### DESCRIPTION
Damascus-twist smoothbore matchlock barrel with flared muzzle. Grooved rear-sight
with ears and copper-bead foresight. The muzzle and breech are decorated with gold false
damascening, flowers and parrots. The barrel was originally heat-blackened, probably for
its full length but this now only survives adjacent to the koft work.

### COMMENT
The large gold flowers follow the chiselled designs of earlier guns. Note the double astragal,
now part of the gold decoration.

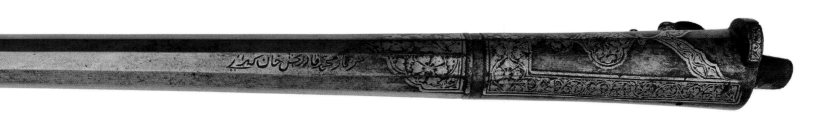

FRM/97/319

Three stage Sindhi barrel with
breech plug, the breech inscribed:
*Sarkar Mohammad Ghader Bakhsh
Khan Kehrani.*

## GUN BARREL
Late eighteenth century

BARREL LENGTH: 117 CM
WEIGHT: 3.33 KG

### DESCRIPTION
Short, heavy, smoothbore damascus-steel three-stage barrel with flared muzzle. Foresight
missing. Half-moon grooved rear-sight. Plug welded into the back of the breech. The gold
floral false damascening at the breech probably dates from the late eighteenth or early
nineteenth century. There is a Persian inscription on the side of the barrel: *Sarkar Mohammad
Ghader Bakhsh Khan Kehrani*

### COMMENT
Kehrani Sarnon Ka Tala is a village south-east of Barmer in Marwar. The three-stage barrel
with a faceted central section is unusual but the rear-sight is typically Sindhi. The barrel
dates from the late eighteenth century.

'Hogsback' damascus twist barrel,
made by a Sindhi barrel maker.

FRM/97/320

## GUN BARREL
Sindh
Early nineteenth century

BARREL LENGTH: 102.5 CM
WEIGHT: 1.9 KG

### DESCRIPTION
Damascus-twist, 'hogs back', matchlock barrel with Rajput concave muzzle and eight-groove rifling. The breech and muzzle are decorated with aftabi gold flowers. Small cartouche with chiselled Persian invocation to 'Ali at the breech.

### COMMENT
The Rajput-style muzzle suggests this small high quality barrel was commissioned from a Sindhi barrel-maker for a Rajput prince or one of the royal women, all of whom enjoyed hunting.

The muzzle has the standard
Rajput shape and decoration.

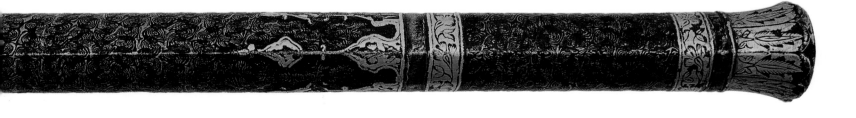

Very short Sindhi damascus twist
barrel with Rajput false damascening.

FRM/97/321

# GUN BARREL
Sindh
Second half of the eighteenth century

BARREL LENGTH: 90 CM
WEIGHT: 2.44 KG

## DESCRIPTION
Rifled damascus-twist barrel with added Jodhpur gold decoration which includes flowers
and parrots. There is a breech plug, a sign of quality but the rifling is very shallow and not
to a good standard. The damascus pattern is unusually complex.

## COMMENT
The barrel is made by wrapping six structurally diverse strands of mechanical damascus
steel round a mandrel and heat-fusing them.

View of the muzzle, the gold work contrasting
superbly with the damascus pattern.

FRM/97/324

## GUN BARREL
Mughal or Rajput
Late seventeenth century

BARREL LENGTH: 116 CM
WEIGHT: 2.71 KG

### DESCRIPTION
Smoothbore matchlock barrel with chiselled flowers in relief in separate panels, the flowers silvered against a heat-blackened ground. Gold bands at the breech, near the muzzle and before the rear-sight. Square grooved rear-sight with raised ears, bead foresight missing. There is a slot under the breech, which would originally have held a lug for fixing the barrel in the stock.

### COMMENT
The barrel was probably made for a royal wife and one would expect the stock that once accompanied this to be painted and set with precious stones.

Late seventeenth century Mughal or Rajput smoothbore barrel decorated with silver flowers, made for a royal wife.

# INDIAN BLUNDERBUSSES

The word blunderbuss derives from German 'dunder' meaning thunder or Dutch 'donderbus', 'thunderpipe'. It developed in continental Europe in the first half of the seventeenth century. The traveller Pietro della Valle describes how the ruler of Calicut examined a Portuguese soldier's flintlock blunderbuss (*bollomarti*) in 1624. This was new to the king who tried to buy it but the soldier would not sell.[84] Fifty years later when the Abbé Carre travelled north from Mumbai he had an escort of slaves armed by the Portuguese with 'matchlocks, javelins, and some sort of a blunderbuss, so large and bulky that its balls must have weighed at least two pounds'.[85] Fryer, in Goa in 1675, calls it a '*bocca mortis*' or 'mouth of death'.[86] He and his companions used them to drive off Malabar pirates, described as in use throughout India, having 'a barrel three spans (44 in) in length and a flintlock. They throw a ball of two or three ounces, and at the end of a street against a crowd they are as effective as a swivel gun.' Initial belief in enormously wide muzzles to maximise the spread of bullets was replaced in the mid-eighteenth century by shorter guns with far less flare though the muzzle was sometimes made to look bigger and more intimidating by bulking metal externally. Short forms of blunderbuss were used across the Muslim world until the late nineteenth century. The Indo-Persian *sher-bacha*, literally 'tiger cub', an allusion to the fierce properties of the gun, was made in Persia and northern India in the eighteenth and nineteenth centuries. The *Akbar-ul-Muhabbat* describes 10,000 men in Ahmad Shah Abdali's army in 1760 armed with sher-bachas of Kabul.[411] In the late nineteenth century Baden Powell carefully distinguishes between the sher-bacha and 'a short and somewhat wide mouthed piece' which he terms a *karabin*.

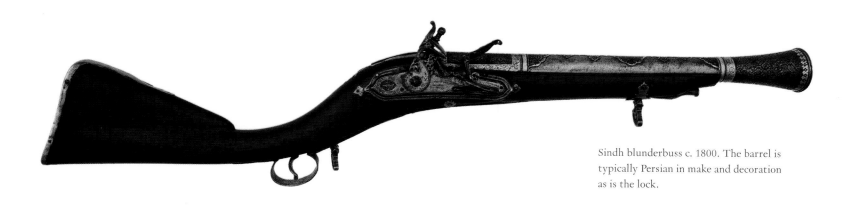

Sindh blunderbuss c. 1800. The barrel is typically Persian in make and decoration as is the lock.

FRM/76/81

## BLUNDERBUSS. KARABIN
Sindh
Last quarter of the eighteenth or early nineteenth century

OVERALL LENGTH: 78 CM
BARREL LENGTH: 37 CM

DESCRIPTION

Flintlock blunderbuss. The rosewood stock combines hooked Sindhi camel gun stock form and a comb, suggesting European influence. There were a number who worked in Sindh. Persian barrel with closely chiselled floral fore-end and breech, the central section with chiselled floral cartouches, the steel contrasted at intervals with gold sheet with an aftabi floral pattern. The lock is of European form made in Sindh. It bears a stamped Persian mark on the lock-plate:

خدا بخشنده آهنگری ار،بهر ره کار کی مک درک چوحمد سنانے
*Khuda bokhshanda-i hangar; bahar kare ke kard chu(n) Muhammad senani*
'*God forgive the iron smith for whatever he has made by Muhammad senani (the spearmaker).*'

The trigger-guard, ramrod throat and suspension rings are made of silver.

COMMENT

A similar gun is in the Tareq Rajab Museum, Kuwait, dated 1799. See Elgood, 1995, p.168.

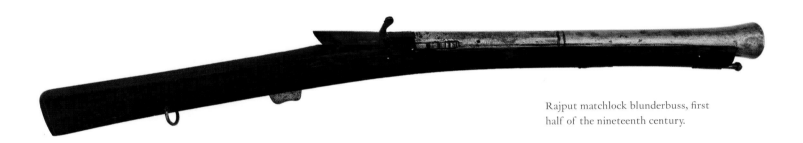

Rajput matchlock blunderbuss, first half of the nineteenth century.

FRM/97/362

MATCHLOCK BLUNDERBUSS
Rajasthan
First half of the nineteenth century

OVERALL LENGTH: 91.5 CM
BARREL LENGTH: 44 CM
MUZZLE INTERNAL WIDTH: 3.8 CM

DESCRIPTION

Heavy two-stage barrel with tang in the European manner. The pan was never fitted with a hinged cover. Iron ramrod and pipes and plain iron trigger. Rear sling swivel. Plain shisham stock.

COMMENT

This was made for a chowkidar or watchman.

# MATCHLOCK PISTOLS AND COMBINATION WEAPONS

FRM /76/80

Combination ankus and
matchlock. Rajput, late
seventeenth or early
eighteenth century.

## ANKUS WITH MATCHLOCK
Rajput
Late seventeenth or early eighteenth century

OVERALL LENGTH: 84.8 CM
WEIGHT: 2.88 KG

### DESCRIPTION
The iron haft of the ankus is a gun barrel with trigger and
serpentine, the muzzle with standard lotus design, below which
is attached a solid turned steel spike. The barrel is decorated with
incised and originally silver inlayed bands and peacocks. The grip
ends with a large faceted knop. Large hook with makara terminal.

FACING PAGE:
Warrior with 2 guns and other weapons.
Raoraja Umaid Singh of Bundi (r.1749-
1770 and 1773-1804).

RJS 3982 Mehrangarh Museum Trust
and His Highness Maharaja Gaj Singhji
II of Jodhpur–Marwar

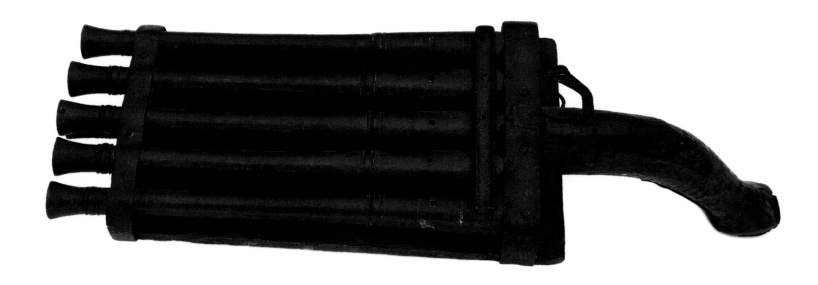

An eighteenth-century multi-barrel pistol. The barrels are not splayed so all shots strike close together and almost simultaneously when the powder in the tray is ignited.

FRM/76/78

## MATCHLOCK MULTI-BARREL PISTOL. PANJTOP OR SHER KA BACHE.
Eighteenth century

OVERALL LENGTH: 48 CM
BARREL LENGTH: 28 CM

### DESCRIPTION
Five smoothbore pistol barrels mounted in line with shared ignition, a tray containing loose gunpowder.

### COMMENT
The barrels are mounted on a square of wood with a ring at each corner for securing the weapon to a stand or tripod. The Akbarnama shows examples at the siege of Ranthambhor in 1569.[88] The concept is the same as the shatghri, a cart with gun barrels mounted in a row, fired simultaneously from a powder train. See also *arghun*. The holes drilled in each barrel are required by modern Indian legislation.

# POWDER FLASKS

**TEMP 1**

Seventeenth-century Mughal serpentine ivory priming flask, made in sections, assembled with ivory pegs and part painted. There is an angel or peri with wings flying out of the makara mouth spout. Similar ivory flask spouts with angels are in the Salar Jung Museum, Hyderabad and the Museum Reitberg, Zurich.

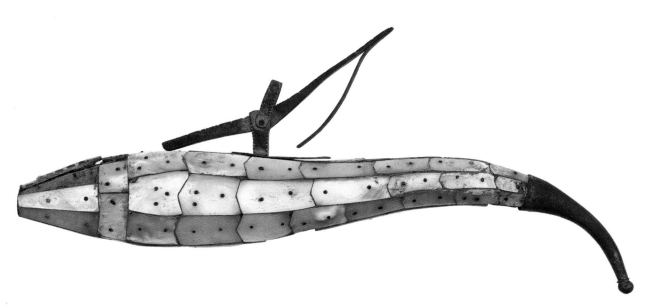

**TEMP 3**

Seventeenth-century Gujarati fish-shaped mother-of-pearl priming flask pinned to wooden core with brass nails. The brass spring is damaged and there is a brass finial. Overall length: 25 cm

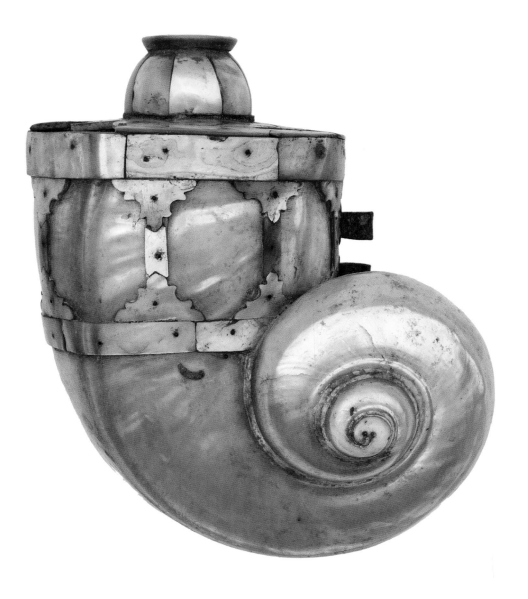

**FRM/76/122**

Nautilus shell powder flask with applied arcading, from
Gujarat; eighteenth century. The rectangles are pinned
on with brass pins. See Elgood, 2017, vol.II, p.861.

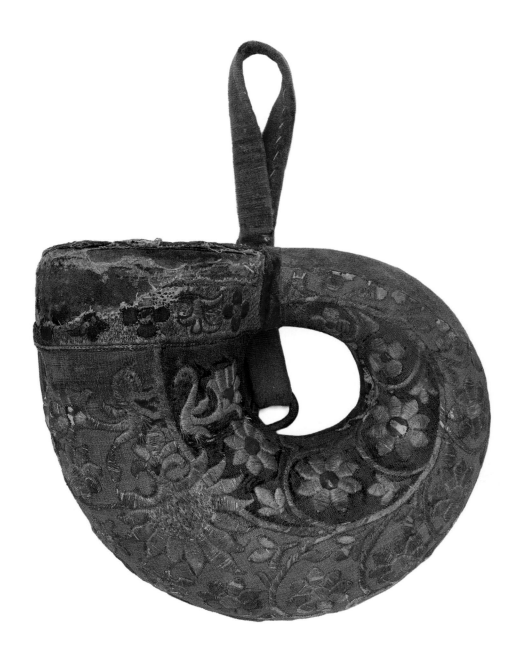

TEMP 4

Rare Mughal or Rajput powder flask with embroidered velvet applied to a wooden core, mid eighteenth century.

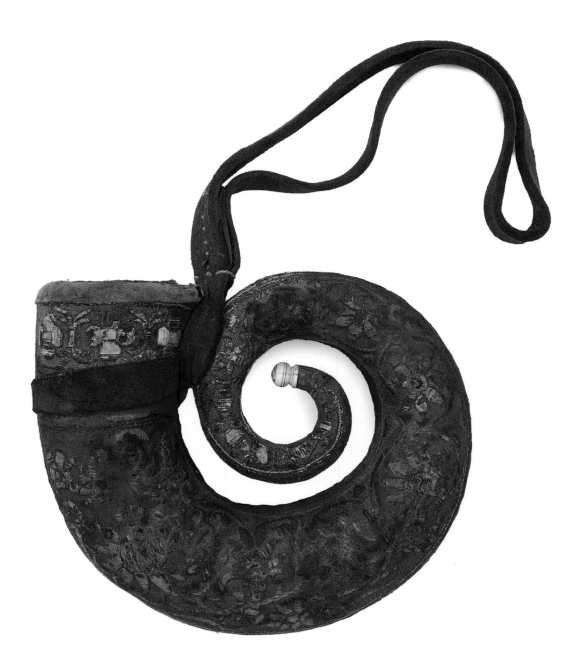

TEMP 5

Rare eighteenth-century Mughal or Rajput
powder flask with embroidered velvet applied
to a wooden core with ivory button.

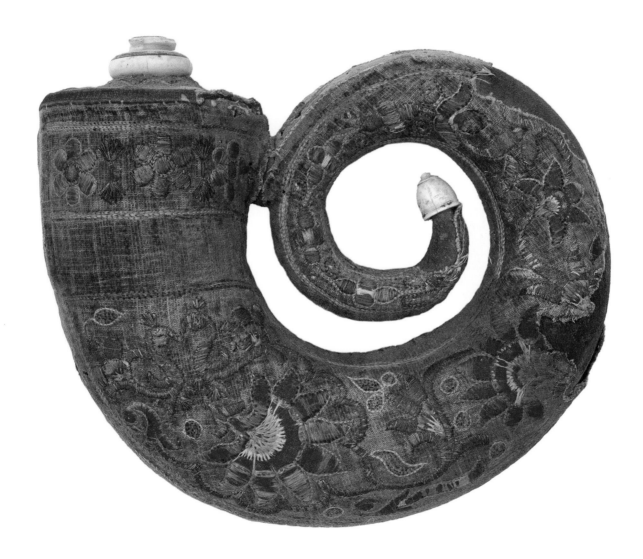

FRM127

Rare Mughal or Rajput powder flask with
embroidered velvet applied to a wooden
core with ivory button c.1760.

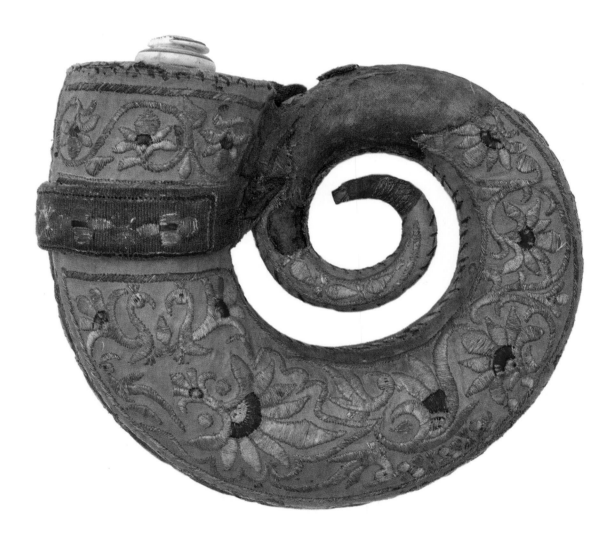

**FRM129**

Rare Mughal or Rajput velvet powder flask
decorated with stumpwork, with gilt thread
confronting peacocks and floral meander, c.1760.

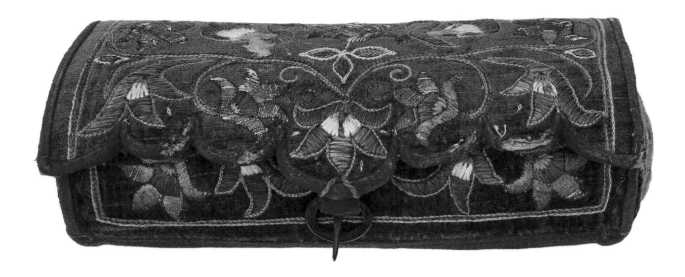

TEMP 6

Rare Mughal or Rajput belt pouch, the flap
with scalloped edge and metal buckle c.1760.

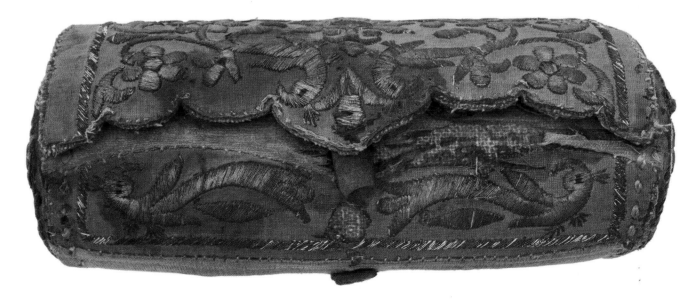

FRM126

Rare Mughal or Rajput belt pouch, the flap
with scalloped edge and metal buckle c.1760.

TEMP 7

Rare velvet purse decorated with
stumpwork, with gilt thread confronting
peacocks, mid-eighteenth century

FRM128

Embroidered velvet cover
for an axe head c.1760.

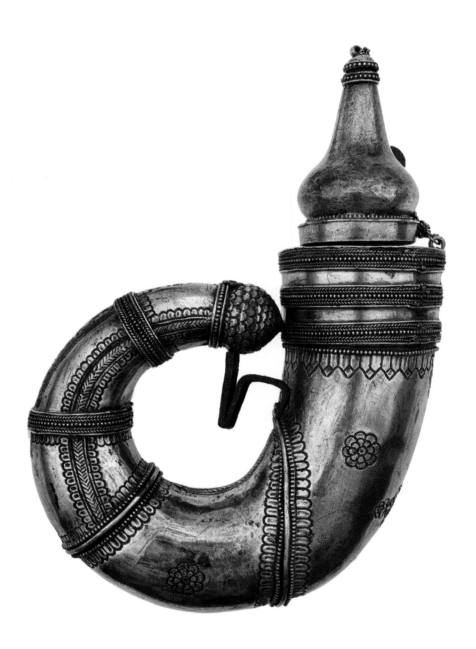

**TEMP 2**

Silver powder flask of horn shape made in Hyderabad, Deccan, in the late eighteenth or nineteenth century for an Arab mercenary serving in India. A related flask was bought by the Royal Armouries at the Great Exhibition, London, in 1851.

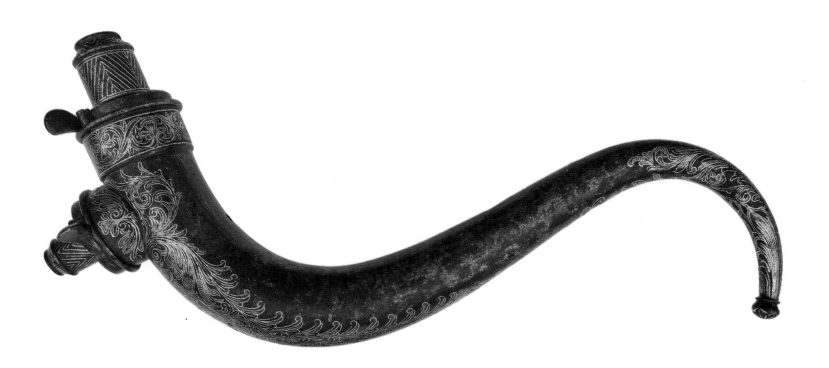

FRM/76/103

Serpentine blued-steel priming flask with gold
decoration, based on the earlier animal horn flasks,
with two spring-operated dispensers for different
sized muzzles. Indian mid-nineteenth century.

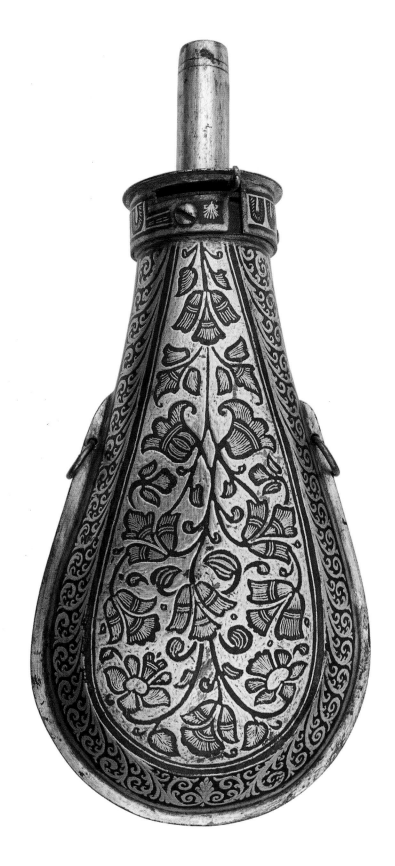

FRM/76/189

Sirohi powder flask, late nineteenth century,
the design based on an English flask with false-
damascened silver and gold floral decoration
with chemically blackened stalks.

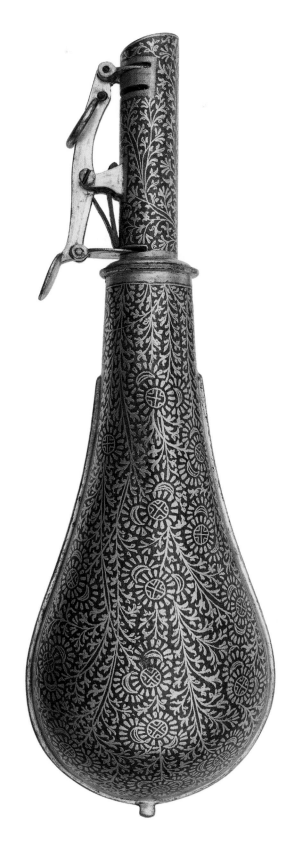

FRM/76/190

Punjabi shot flask, late nineteenth century, the
design based on an English original by G & J. W.
Hawksley or James Dixon and Sons, Sheffield.

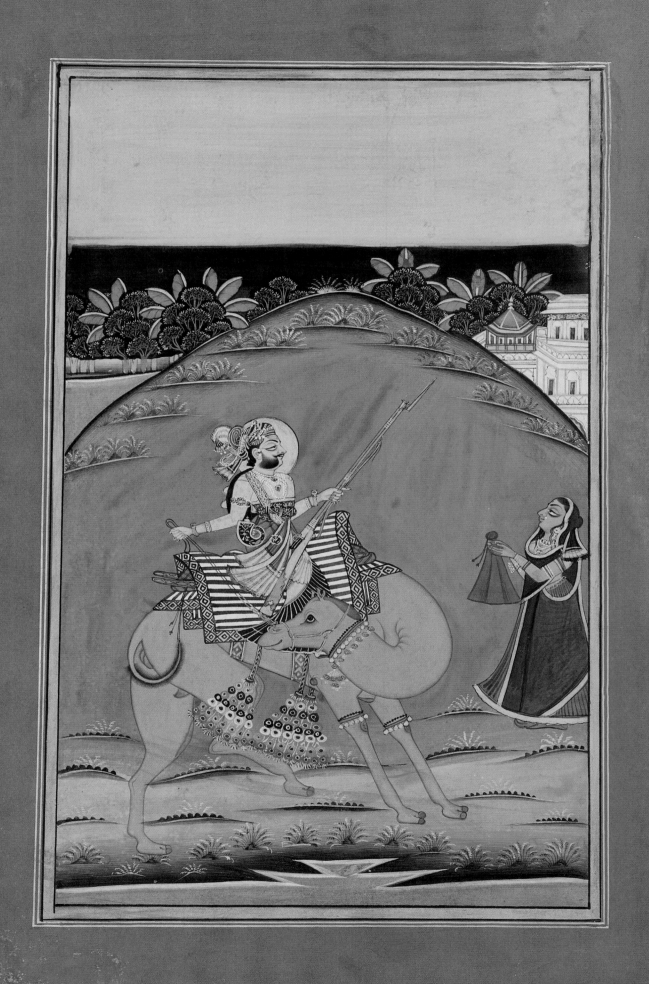

# MINIATURE CANNON

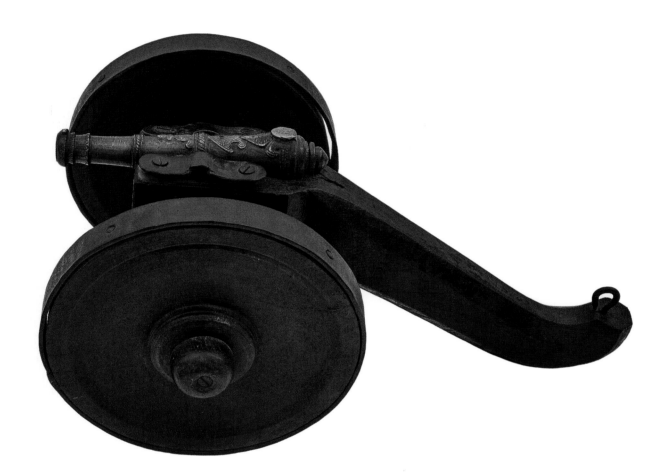

ARM/76/366

## MINIATURE CANNON, LATE NINETEENTH OR TWENTIETH CENTURY

OVERALL LENGTH: 40 CM
BARREL LENGTH: 18.5 CM
WHEEL HEIGHT: 21 CM

### DESCRIPTION
Cast brass cannon barrel capable of being fired. The breech is sealed by a lead tamp which bears the Jodhpur *cheel*. Black-painted wooden carriage with solid wheels with iron rims. The wooden parts are held together by wood screws. There are hooks for a limber to accompany this gun, which suggest the gun is a child's toy rather than a saluting cannon.

ARM/76/372

# WINCHESTER CANNON

OVERALL LENGTH: 43 CM
BARREL LENGTH: 31 CM

## DESCRIPTION
10-bore breech-loading cannon with blued-steel barrel and cast-iron carriage painted black. The top of the barrel is marked 'Not for Ball' and 'Manufactured by the Winchester Repeating Arms Co. New Haven, Conn. USA Patented August 20, 1901 10 GA'. The Winchester proof mark was stamped on every gun they made but is often illegible on cannon.

## COMMENT
The 10-bore breech-loading Winchester Cannon, designed by Charles H. Griffith was granted patent 681,021 on 20 August 1901. The 1903 Winchester Catalog described it as: 'a low-priced breech-loading cannon possessing safety, simplicity of construction, and ease of manipulation… satisfactory for the Fourth of July and other celebrations, and for saluting.' Today they remain popular for starting yacht races.

The Mughal Emperor Humayun in 1535 ordered that his leaving the Diwan should be announced by a matchlock (*tufang*) being fired[89] and the practice spread to other occasions of significance. The armoury has a dozen of these cannon for firing salutes. Household files record arrangements for visits by prominent people entitled to gun salutes:

B313/9941 Saluting guns, 1939–40. Visit by the British Resident to Jodhpur. 'A salute of guns should be fired from the Fort Battery as usual on the departure of His Highness the Maharaja Saheb Bahadur.'

In June 1940 the Maharaja ordered that because of the war the normal salute of fifteen guns should not be fired on the occasion of Shri Maharaj Kumar Sahib's birthday. However, for the Dasara Festival 'a single gun should be fired at the departure of Sawari, fifty one at the time Rawan falls down; and a single gun when Sawari returns to the fort'.

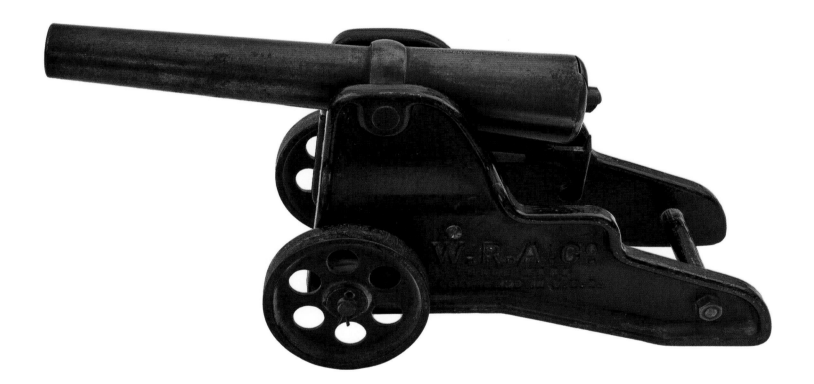

10 bore breech-loading
cannon manufactured by the
Winchester Repeating Arms
Co. New Haven, Conn.

# BRITISH MILITARY GUNS

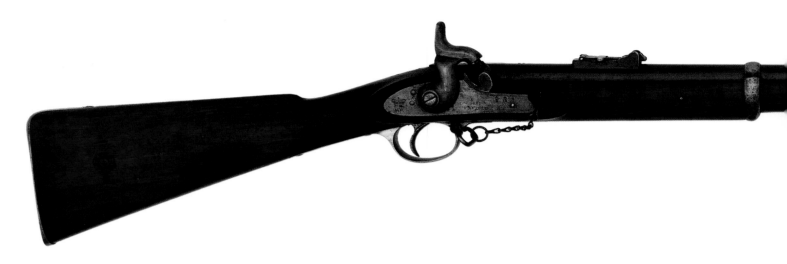

FRM/76/117

## ENFIELD PATTERN 1853, 4TH MODEL PERCUSSION GUN
Dated 1861 on the lock-plate, with chained nipple protector.

OVERALL LENGTH: 137 CM
BARREL LENGTH: 99 CM / 39 INS
CALIBRE: .577

### DESCRIPTION
The Pattern 1853 (P53) is a three-band rifle-musket with a 39-inch barrel. The majority of this model were not issued but kept in store, later the model most selected for conversion to Snider's breech-loading system.

### COMMENT
In 1853 the British War Department approved the retirement of smoothbore muskets used by generations of soldiers, the last being the 1842 model, in favour of a general-issue rifled barrel. The Enfield Pattern 1853 rifle-musket was a .577-calibre muzzle-loader. The 39-inch barrel has three-groove rifling with a 1:78 twist. It was secured to the stock by three iron bands, so these rifles are often called 'three band Enfields'. The 4th Model is distinguished by the use of Baddley's patent barrel bands in which the clamping screw is recessed to avoid catching on clothing. The front band does not use a recessed screw as it carried a sling swivel. The Enfield had a 1,000-yard adjustable rear-sight with steps set for 100 yards, which indicates its range.

The British Army were first issued with the Enfield Pattern 1853 in 1855 during the Crimean War. At that time there were British regular army regiments and East India Company Regiments in India and the Royal Service units received the gun in Bombay and Madras before sailing to the Anglo-Persian War, fought between November 1856 and April 1857. The East India Company bought 10,000 Pattern 1853 rifles in 1856.[90]

Enfield Pattern 1853, 4th Model
percussion gun dated 1861 on the lock–
plate, with chained nipple–protector.

The gun was noted for its accuracy and had a rate of fire of little more than three shots a minute. The length of barrel remained unchanged from earlier smoothbores because the infantry practice of firing in three ranks remained and it was necessary for the muzzle of the rear rank man to project beyond the front rank. For defence against cavalry it was also necessary for the bayonets of the regiment formed in a hollow square to project adequately. There is no separate bayonet lug on the barrel, the sight acting as such.

The 1st Battalion, HM 60th Rifles was the only unit of either the Royal or East India Company's armies to have been issued with a complete set of Pattern 1853 Enfield rifles before the mutiny broke out on 10 May 1857.[91] The regiment received their rifles at Meerut where the sepoys saw that the loading drill required the soldier to tear open the cartridge with his teeth and the rumour spread that the paper-wrapped cartridge containing powder and ball were greased with beef tallow and lard, grossly polluting to the Hindu and Muslim sepoys. Muslim and Hindu troops rose in defence of religion; disaffected landlords and peasants joined them for a variety of disparate regional reasons. The uprising is notable for the extent to which those fighting the British lacked a common purpose beyond dissatisfaction with some aspect of the status quo.

After this bloody engagement was over a smoothbore version with the .656 calibre of the Enfield Pattern 1853 known as the 'Musket Smoothbore, Indian Pattern 1858' was issued to Indian troops. The cartridge did not require greasing as the barrel was smoothbore but the gun was very much less accurate. Another feature was the replacement of the variable distance back-sight found on the superior Enfield with fashioned non-adjustable block back-sight like a matchlock. The thinner walls of the Pattern 1858 were known to burst occasionally and the barrel flexed during bayonet practice so a new pattern with thicker barrel walls was introduced in May 1859 that remedied these problems.

In its various forms the Enfield was used across the British Empire with approximately one and a half million produced until 1867 when many were converted to the Snider breech-loading system.

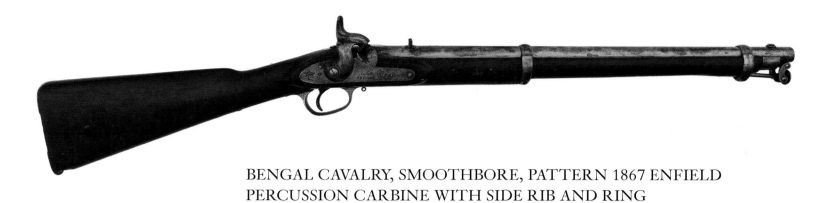

## BENGAL CAVALRY, SMOOTHBORE, PATTERN 1867 ENFIELD PERCUSSION CARBINE WITH SIDE RIB AND RING

FRM/97/220

OVERALL LENGTH: 93 CM
BARREL LENGTH: 53 CM / 21 IN

DESCRIPTION

Lock-plate with crowned VR: 1858–67: Enfield: I over broad arrow: crown over arrow. Brass trigger-guard, brass cap to the fore stock and butt-plate in two parts with a blank space between them. Stamps on barrel including Armoury mark 715. There is no bayonet lug.

COMMENT

One of a series of arms, popularly known as 'Indian Enfields', which were introduced to rearm native regiments in India after the Mutiny. This cavalry model Enfield was made in 1857. In 1867 for Indian service the rifling was removed making the barrel smoothbore and the Enfield ladder rear-sight was replaced by a block back-sight. The lack of rifling meant that the cartridge could be loaded without grease, the original catalyst for the Mutiny since the cartridge had to be bitten open and the grease was reputed to be polluting to Muslim and Hindu. With these modifications the gun, less accurate as a result of the changes, was issued to Indian troops.

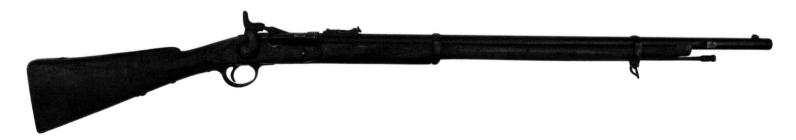

FRM/76/23

## ENFIELD SNIDER, SHORT, 1871 WITH SNIDER BREECH CONVERSION

The lock-plate stamped with a crowned V.R behind the hammer, crown and broad arrow above 1871 Enfield; and SR 4.

These .577-calibre, two-band Snider Short rifles were conversions of the Enfield pattern 1860 Short rifle, in this case with a Mark III action, as can be seen marked on the knoxform. The Mark III designation was allocated to identify the breech action employed, this example being the final design.

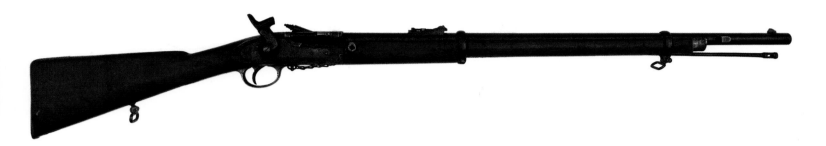

FRM/76/53

TRADE PATTERN SNIDER, THE LOCK DATED 1875,
SIGNED WARD AND SONS LONDON.

BARREL LENGTH: 77 CM / 30½ INS

DESCRIPTION

The Snider–Enfield was produced in a variety of forms. This is the Short Rifle with two iron barrel bands, the type issued to sergeants of line regiments and rifle units. It has five-groove rifling with a single turn over 48 inches. The action carries the Snider trademark, an S pierced by an arrow, found only on commercially made rifles, making this a Trade Pattern Snider–Enfield, many of which were sold to members of Volunteer military units. Although marked 'London', Ward and Sons (1859–1900) were in fact Birmingham gunmakers specialising in trade guns for the Empire. The barrel is incised with Pratap Singhji's name.

COMMENT

By the mid-nineteenth century the advantages of breech-loading over muzzle-loading guns were obvious. A man could fire three shots with a breech-loader in the time it took to load a muzzle-loader. Furthermore, many of the troops wounded in the Crimean War received bullets in their right arm due to it being exposed in the trenches when loading their muzzle-loaders with a ramrod. European armies began to search for a suitable conversion mechanism for their muzzle-loaders, in the case of the British Army, the Enfield rifle, introduced in 1851. The British government formed a committee of experienced officers who recommended the change in principle on 11 July 1864 but made no suggestion regarding the form to be adopted. Secretary of State Earl de Gray accepted this and asked the Ordnance Committee to find an efficient system that cost no more than one pound per gun. Gunmakers were invited to submit designs and seven were chosen for consideration. An American, Jacob Snider (1811–1866) produced the best design and the Snider became the British Army's first breech-loader. The conversion removed very little wood from the stock so strength was maintained. The original Enfield barrel, furniture, hammer and lock were retained. Two and a half inches was cut from the breech of the Enfield barrel, replaced by a section of half barrel fitted with a pivoting longitudinal block. When lifted the breech was exposed and as it slid back it engaged the rim of the cartridge, ejecting it. The mechanism reused the hammer, which struck a firing pin set in a hinged block at an angle that struck the percussion cap at the base of the cartridge.

The pattern 1853 Enfield with the Enfield .577 calibre bullet, converted to Snider–Enfield, was probably the most common of the various Sniders adopted by the British Army in 1866. An iron plug in the base of the lead bullet expanded it to fit the rifling tightly. Weighing 480

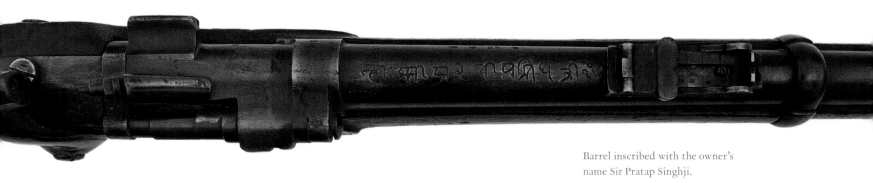

Barrel inscribed with the owner's
name Sir Pratap Singhji.

FRM/76/53

grains it was a knock-down bullet but fouling was a serious problem. Paper cartridges used by all European armies were simply not strong enough and there was a tendency for hot gas to leak towards the soldier's face and even to blow open the block. A modification was invented, a locking latch at the breech, known as the Bolted or Improved breech. Enfield carried out the work but the demand was huge and they were assisted by the London Small Arms Company and the Birmingham Small Arms Company.

In 1866–7 Colonel Edward Boxer of the Woolwich Arsenal designed a brass cartridge which contained the bullet, powder and cap, had the additional advantage of being waterproof and sealed the breech when fired. The user could now safely hold the gun close to his face improving accuracy and the rate of fire increased from three or four shots a minute to eight or nine. The Boxer cartridge combined with the Snider breech produced extraordinary results. The flatter trajectory gave the gun a range of over 1,000 yards, three times that of the Prussian army's Dreyse and twice as far as the French Chassepot.

Four thousand Sniders were sent to India for the Indian Army troops engaged in the Abyssinian campaign of 1867–8 against the Emperor Tewodros. Their first major test was the battle of Aroghee in 1868 where Snider volley fire at 250 yards was employed:

> 'Three hundred blue barrels came up together and three hundred hammers clicked back to full cock. The burst of fire ran down the line with a noise like a great tearing of canvas and a wide gap appeared abruptly in the centre of the Abyssinian line as the storm of fire hit it. Hundreds went down at the first discharge and the whole line reeled. Theodore's[Tewodros's] fighting men, used only to muzzle-loaders, apparently anticipated a decent interval while the slow ritual of powder and ball, rod and cap was obeyed, but it was not granted them.'[92]

The Martini–Henry rifle replacement first appeared in 1871 but the Dominions kept their Sniders for years, particularly India where memories of the Mutiny were strong and it was thought undesirable to give the sepoys a more modern rifle. Indian troops used Sniders in the opening battle of the Second Anglo-Afghan War (1878–1880), an engagement at the fort of Ali Masjid, the narrowest point in the Khyber Pass.

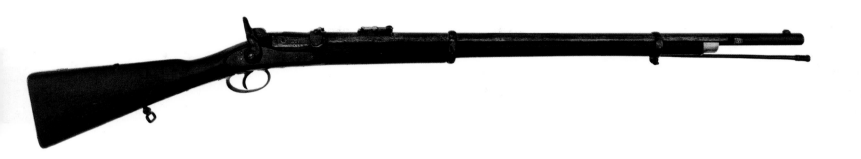

FRM/76/213

## A RARE ALBINI-BRAENDLIN PATENT BREECH-LOADING CENTRE-FIRE RIFLE

OVERALL LENGTH: 123 CM
BARREL LENGTH: 85 CM

DESCRIPTION
Lock-plate signed W. Powell & Son 1870

Brass trigger-guard, butt-plate with trap, and fore-stock cap. The barrel is stamped '450' in two places, at the side of the breech and above this on the hinged breechblock. Below the rear-sight are four stamps including the Birmingham proof mark and the number '25' (the bore).

The top of the breech is stamped 'Albini Braendlin Patent'. The rifle has a hinged forward lifting action allowing the insertion of a bullet. This combines with the hammer to lock and fire the rifle. When fired the hammer strikes the pin within the breechblock, locking it into position. Pulling the hammer back withdraws the striker from the breechblock allowing the latter to be lifted using a small knob on the side of the block (the knob missing).

Calibrated folding back-sight. There is a bayonet lug on the side of the barrel below the muzzle stamped '298'. One sling swivel is missing. The steel ramrod is not original, belonging to a Snider. There are old brass repairs to the stock at the breech.

COMMENT
The rifle was designed by an Italian officer, Augusto Albini, in 1865 who had it manufactured by Francis Braendlin, a Birmingham gunmaker. This system could be used to convert muzzle-loaders or for new weapons. The Albini-Braendlin system was granted a provisional British patent, No. 460, on 20 February 1867. As a single shot 11 mm breech-loading, centre-fire rifle it was used by the Belgium Army from 1867 until 1918.

Braendlin manufactured these rifles, sold by Holland & Holland, the first recorded in the Number Books is no.1289 ordered in 1867.[93] Holland & Holland sold 500 Enfield breech-loading rifles using the Albini-Braendlin system to the State of South Australia, (M1867), for the South Australia infantry, the only Australian military unit to use them. The lock is marked '1867'

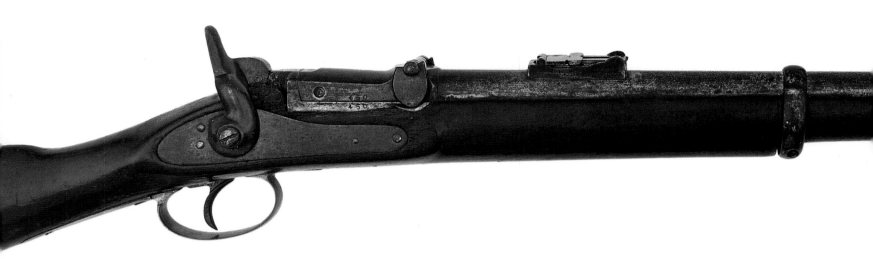

Detail of a rare Albini-Braendlin Patent breech-loading centre-fire rifle, 1870.

and on the breech is stamped 'Braendlin-Albini / Patent / No 2250 and barrel H HOLLAND 98 New Bond Street'. These are almost identical to the M1868 Italian Naval Albini-Braendlin except that Holland & Holland reverse the maker's names putting 'Braendlin-Albini Patent' on the breech as well as 'H. Holland, New Bond Street'. The Italian version also has brass furniture. The Jodhpur gun has brass butt-plate, trigger-guard, fore-stock cap and side-plate screw head cups but the barrel bands are steel.

Braendlin Armoury Co., was at 1–3 Lower Lovejoy St, Birmingham (1871–89) where William Tranter was Augustus Braendlin's landlord. The firm was also at 63 Cornhill, London (1885–95) and at 13 & 14 Abchurch Lane (1896–8).[94] Braendlin made guns for other makers to put their own names on and their mark was a very small stamped cross pennants with the letter 'B'. They were licensed to make Martinis under British Patents 1868 and 1870.

William Powell founded his business in 1802 in the High Street, Birmingham. He died in 1848 and his son, William Powell II, succeeded him. The firm is still in existence and is noted for the excellence of its handmade shotguns.

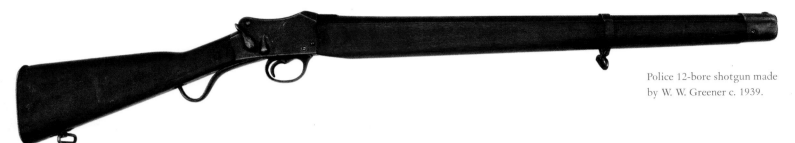

Police 12-bore shotgun made
by W. W. Greener c. 1939.

## POLICE 12-BORE SHOTGUN.

UBP/2017/4

OVERALL LENGTH: 106 CM
BARREL LENGTH: 65.5 CM

Martini action, the side of the breech stamped 'Greener Police gun Mark III/12' (Repeated on the flat of the barrel). The reverse side: 'W. W. Greener. Maker Patent No. 463628 / 35'.

'STAMPED 1816' (obscured, perhaps Roman III) before the trigger-guard. Many marks at the side of the breech. 'P 802: 2 ¾" choke: Nitro Proof: Crowned BP: Crowned BV over a crown: Diamond with 12 G: Crown over entwined GR: 12'. Wooden full-stock with single iron barrel band with swivel, the other swivel screwed to the underside of the stock. The gun has post 1925 Birmingham proof marks and was probably made in the late 1930s.

### COMMENT

W. W. Greener was the second generation of a noted Birmingham gun-making family. His father, William, had worked for Manton, arguably the best gunmaker in Britain in the early nineteenth century. By 1900 Greener owned the largest sporting gun factory in Britain employing 450 craftsmen. The Greener Police gun mark 1 was introduced in 1921 for riot control by police forces in the British Empire, large numbers being sent to Egypt. The design brief was for a robust, single-shot gun that could also serve as a club. The result was a full-stock reinforced at the muzzle and butt that totally protected the barrel. It was without rifling so that in the event of a mutiny by the police, the regular army would outgun the mutineers. The Martini action fired special 12-bore 2¾ in case cartridges loaded with shot. To make it impossible to use stolen guns it had proprietary ammunition but criminals wrapped 12-bore cartridges in paper to fit so a modified gun was produced, the Mark III, which used a bottleneck-shaped cartridge that did not fit any other gun. Furthermore, a modified trident-shaped striker with longer outer tines struck all cartridge bases except the specially made Greener cartridge, stopping the central tine from hitting the detonator. Greener marketed the gun until the mid-1970s.

In June 1942 SOE (Special Operations Executive – known as Force 136 in India) required a powerful shotgun that could be used by irregular forces behind Japanese lines with more striking power than the ordinary 12-bore shotgun. With a shotgun in his hands rather than a rifle, an untrained partisan would have far more chance of hitting his target. SOE discovered that Messrs. Greener & Co. manufactured a gun that met their requirements but at that time Greeners were under contract to the Egyptian government to supply the Egyptian Police. The Egyptian government and the War Office reached an agreement and some 2,800 shotguns plus cartridges were diverted from the Egyptian contract to India. It is likely this gun was one of these.[95]

# EUROPEAN CIVILIAN GUNS

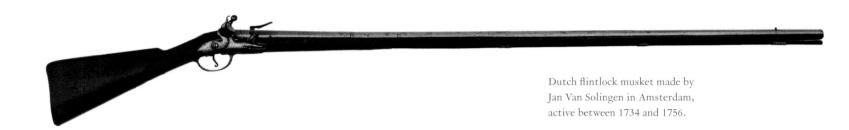

Dutch flintlock musket made by
Jan Van Solingen in Amsterdam,
active between 1734 and 1756.

FRM/76/38

## FLINTLOCK MUSKET
Dutch second quarter of the eighteenth century

OVERALL LENGTH: 167 CM
BARREL LENGTH: 127 CM
WEIGHT: 4.1 KG

### DESCRIPTION
Three-stage smoothbore barrel separated by astragals, the upper two stages round, the last faceted with traces of an incised border at the breech. Dark mahogany stock with chequered grip. Curved lock-plate engraved with a winged putto holding a horn, signed 'Jan Van Solingen, Amsterdam'. Iron trigger-guard, ramrod pipes and butt-plate. The ramrod lacks its metal tip. Armoury mark SK 12.

### COMMENT
The gun is original in all respects except for the ramrod, a replacement from the gun's working life. The Van Solingen family were well-known gunsmiths. Jan, son of Jacob, is recorded as working between 1734 and 1756.[96] A blunderbuss made by him is in a Dutch museum. The gun is likely to have been brought to India by a Dutch merchant working for the Vereenigde Oost-Indische Compagnie (VOC), much the biggest of the European companies trading in Asia.

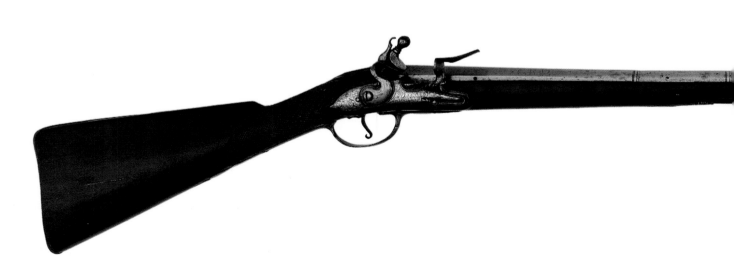

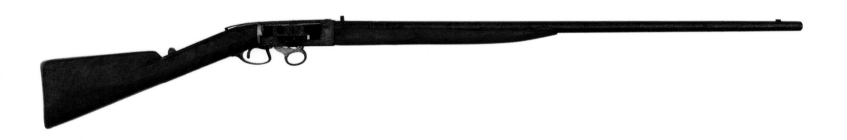

FRM/76/39

## AN ENGLISH COPY OF A COCHRAN UNDER-HAMMER 'TURRET GUN'

OVERALL LENGTH: 135.5 CM
BARREL LENGTH: 80.5 CM

### DESCRIPTION

Smoothbore percussion sporting gun with seven-shot revolving drum magazine, retaining much of the original case-hardening. The gun bears no maker's name, merely a crowned GP London proof mark on the barrel. A second mark is too eroded to read, probably crowned 'V', the companion London view mark. The drum is removed by a catch on the small of the butt which releases the lever hinged behind the rear-sight. The individual chambers are aligned with the barrel by a sprung lever with a pin which copies the design found on FRM/76/291.

### COMMENT

John Webster Cochran (1814–74) of New York City registered 25 patents for handguns[97] between 1834 and 1876, this system on the 28 April 1837, US Patent 188. His guns were made by C. B. Allen of Springfield, Massachusetts.

Because Samuel Colt had patents for cylinder revolvers other inventors were forced to design alternative multishot systems that tended to have problems. Turret guns and pistols are rare because a particular hazard was that while one chamber was aligned with the barrel another ominously faced the shooter and in the case of accidental chain ignition this was fatal. Parry W. Porter designed a vertical turret gun that had some success but the drum prevented aiming along the barrel. Cochran designed two successive versions of his rifle and gun under examination matches. On Cochran's guns the rear catch holding the top strap doubles as the rear-sight. In the present gun it serves no such purpose. Cochran's guns are marked 'Cochran's Patent' and 'C.B. Allen / Springfield / Mass' but the present gun is without markings.

It seems that Cochran's patent (no.7286) was filed in Britain by the patent agent Moses Poole in 1837, shortly after Cochran had filed his American patent. A cased turret pistol made in 1839 by James Wilkinson & Sons, No. 27 Pall Mall, London[98] was in the Keith Neil Collection.

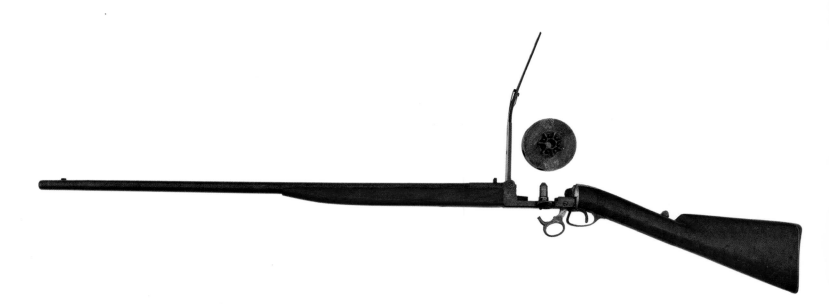

That year Wilkinson made a turret rifle for the Marquis of Breadalbane, subsequently owned by Lord Egerton, the oriental arms collector, now in the Royal Armouries, Leeds.[99] Wilkinson is recorded as only making nineteen Cochran turret guns, two of which were unfinished, the last dated 1844. Wilkinson examples have octagonal barrels and a triggerguard that encompasses both the trigger and the under-hammer.

Later turret designs include Système Noel with a double-action side hammer, the Genhart, patented in France in 1844 with an underhammer. The concept was rescued from obscurity by the very successful Lewis gun, an American-designed, gas-operated, light machine gun with a revolving drum magazine.

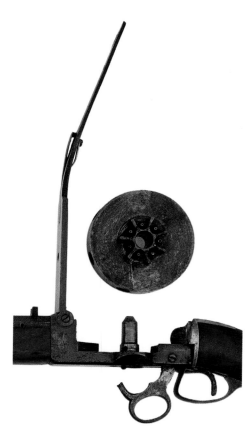

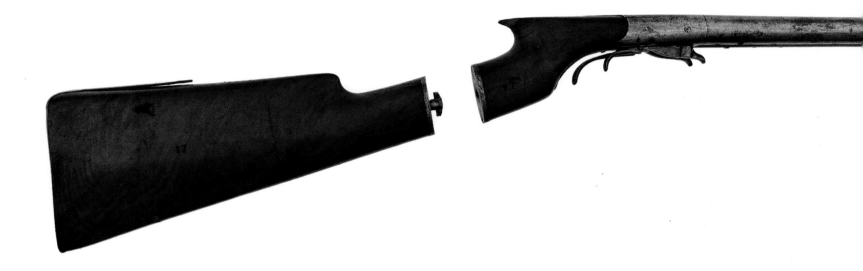

FRM/76/113

## AN UNUSUAL DOUBLE-BARRELLED UNDER-HAMMER PERCUSSION SIX-GROOVE RIFLED GUN WITH DETACHABLE WALNUT STOCK

OVERALL LENGTH: 117.5 CM
BARREL LENGTH: 81.5 CM

The gun has a 'take-down' stock and is probably one of a pair as it has the number '2' on the under rib, but this could also be its serial number. Both barrels are stamped with 'post 1813' Birmingham proof marks. The barrel tang is engraved with 'Reid's Patent'. Stepped triggers, bead fore-sight, no rear-sight. Ramrod missing. The stock is stamped '17'.

### COMMENT

Under-hammer guns first appeared in the flintlock era[100] but are very rare. They are associated with American rather than English gunmakers and a take-down version is even more unusual. They were called 'buggy' rifles in America because they were frequently carried in a boot affixed to the side of a horse-drawn buggy. Five countries experimented with under-hammer guns for military use: England, France, Denmark, Norway and the United States. Only England rejected the system.

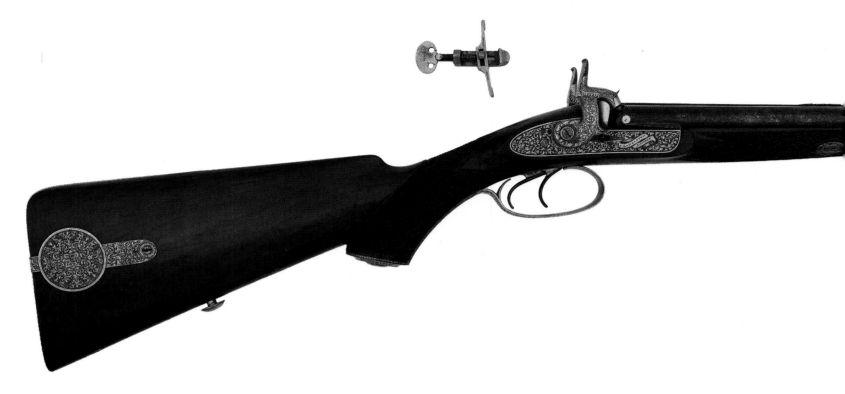

UBP/2017/5

## 49-BORE D/B LANCASTER SPORTING PERCUSSION RIFLE C.1850

OVERALL LENGTH: 110 CM
BARREL LENGTH: 69 CM

The locks signed on the plate: 'C Lancaster London'.
Damascus barrels inscribed: 'Charles Lancaster. 151 New Bond St. London' and 'Patent smoothbore rifle'.

Rib marked I of a pair of guns. Hammers with safety catches. Leaf sights to 300 yards; platinum plug.

Mahogany butt with chequering, chiselled gilt mounts, patch box in the butt, cap box in the small of the butt; inlaid silver escutcheon plate with the Jodhpur *cheel* and initials H. S. The case is missing but a spring vice remains.

COMMENT
The English gunmaker Charles William Lancaster (1820–78) worked for Joseph Manton before setting up on his own. He is recorded at 151 New Bond Street, London between 1847 and 1854. His experiments with ballistics resulted in his conclusion that an oval bore was the most efficient for rifles and cannon and he constructed a 68-pounder cannon at Birmingham which the War Office sent for successful trials at Shoeburyness. Lancaster's famous oval bore barrels were patented in 1850.

Maharaja Takhat Singhji ordered a pair of rifled 20-bore percussion howdah pistols from Charles Lancaster in 1862, presumably as a gift because they are inscribed in gold Devanagari on the barrel with the name of his eldest son, Kanwar (Prince) Shri Jaswant Singhji.[101] In the years 1861–2 Takhat Singh ordered no less than fourteen firearms from Lancaster.

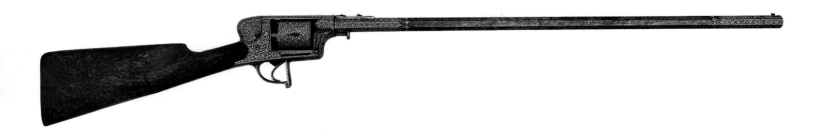

UBP/2017/1

REVOLVER CARBINE BY DEANE ADAMS & DEANE 30 KING WILLIAM ST. LONDON BRIDGE C.1855.

Adams Patent
Serial No. 10232 R

OVERALL LENGTH: 134 CM
BARREL LENGTH: 81 CM

Octagonal smoothbore barrel. Rear sight inscribed 'Shrapnel's 1834 Patent sight no. 88'. Five-shot cylinder with serial number. Fitted with hammer shroud. Replaced burr walnut stock.

COMMENT

On 22 August 1851, Adams applied and then later was granted a British patent for a new revolver. He was manager at the London gun manufacturer George and John Deane. Impressed by his design and orders, including the East India Company for their cavalry, they made him a partner, the new firm being Messrs. Deane, Adams and Deane. The company was dissolved in August 1856.

The .436 Deane Adams was a five-shot percussion revolver with a spurless hammer. The double-action system cocked the gun when the trigger was pulled, a far faster system than the single-action revolvers like Colts which required the hammer to be pulled back to cock them. The new pistol was the first to be made with a solid frame. It was exhibited until 15 October 1851 at London's Great Exhibition, which attracted six million visitors, equivalent to a third of the population of Britain. The exhibition's patron, Prince Albert, consort to Queen Victoria, became patron of the new firm, featuring on their trade label.

Samuel Colt also exhibited, demonstrating his new Colt Navy as well as earlier Walker and Dragoon pistols. The Adams was more expensive than Colt's gun and had serious deficiencies. The long trigger-pull made it less accurate, the percussion nipples were not case-hardened and sometimes burst, and the lack of a shield behind the cylinder resulted in some blowback causing powder burns to the shooter's hand. The Ordnance Board bought 14,000 Colts for the British Army and 9,500 for the navy, enabling Colt to build a London factory with innovatory

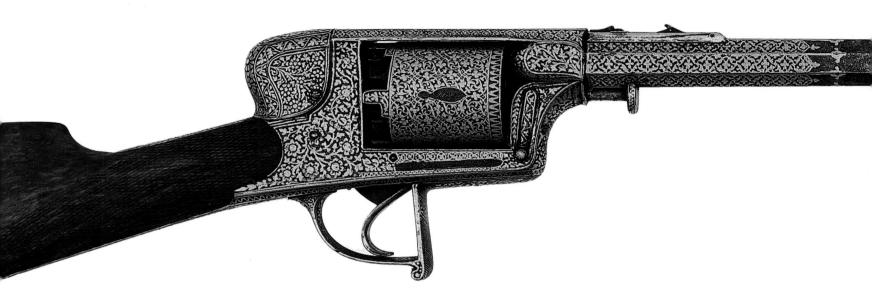

mass-production assembly lines that amazed everyone including the novelist Charles Dickens who described them in the 27 May 1854 edition of his *Household Words*.

An 'Improved frame' model of 1854 corrected the initial problems effecting the Deane Adams and British officers bought the gun privately for use in the Crimean War. In 1855, Lieutenant Frederick Beaumont, a Crimean veteran, further improved the gun by linking the trigger to a spurred hammer permitting single- and double-action fire. Double action (when pulling the trigger first cocks the gun and releases the hammer to fire) was faster than single-action Colts but less accurate. Rapid fire made the Adams revolver ideal for close combat where accuracy was not a factor while the large cartridge size (.442 calibre as compared with Colt's .36 calibre) ensured knock-down. The 'Improved' Deane Adams was so popular in 1856 it put Colt's London factory out of business. In the fierce close-quarter fighting of the Indian Mutiny of 1857–8 the Adams revolver became the pistol of the British Army.

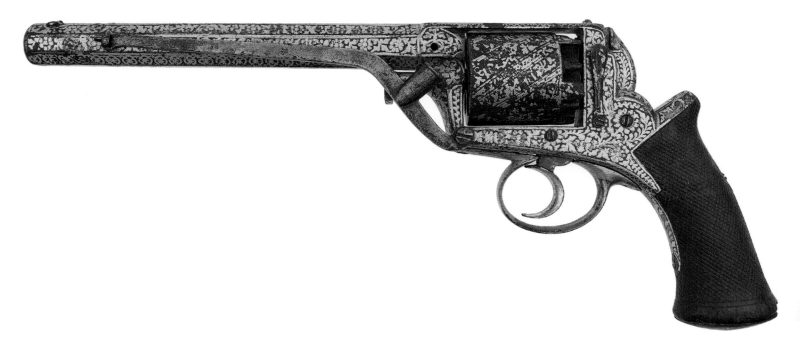

FRM/76/86

# NINETEENTH- AND TWENTIETH-CENTURY EUROPEAN AND AMERICAN PISTOLS

## 54 BORE ROBERT ADAMS MODEL 1851 FIVE SHOT SELF-COCKING PERCUSSION REVOLVER, FITTED WITH A TRANTER TYPE 'L' FRAME RAMMER, INTRODUCED IN 1853

### COMMENT

William Tranter, eldest son of a blacksmith, was apprenticed to the Birmingham gunsmith firm of Hollis Bros. in 1830 at the age of fourteen. Nine years later a modest inheritance allowed him to buy another Birmingham firm of gunsmiths and he went into partnership for five years with Hollis. By 1853 Tranter had made over 8,000 Adams revolvers under licence and he began experimenting with James Kerr to modify the design. Tranter's first model featured a detachable rammer. The second model rammer was secured by a keyed peg and a hook on the barrel as in this instance.

The gold decoration added in India includes the name of the owner – Sir Pratap Singhji (1845– 1922), Regent and Chief Minister at Jodhpur.

The gold decoration includes the name of the owner – Sir Pratap Singhji (1845–1922), Regent and Chief Minister at Jodhpur.

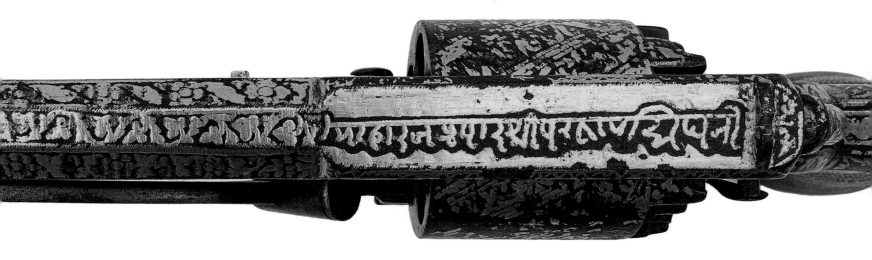

UBP/2017/25

## CASED COLT SELF-LOADING PISTOL. CALIBRE .45 IN ACP

### INSCRIBED
Government Model C117138
Patented Apr 20,1897, Sept.9,1902
Dec 19,1905, Feb. 14, 1911, Aug 19, 1913.
COLT'S PT.F.A. MFG.CO.
Hartford, CT. U.S.A.

In autograph script on the ivory grip: 'with love to dear Hanwant - Umaid Singh 1943'.

Red baize case stamped in gold on the underside of the lid: 'R. B. Rodda & Co.', the British royal coat of arms and: 'By Appointment London and Calcutta.' Gilt metal and ivory handled tools and a gilt oil bottle stamped: 'R.B. Rodda & Co. London and Calcutta.'

### COMMENT
The letter 'C' before the serial number indicates a commercial sale. This is a commercial Colt Government Model 1911 pistol made in 1919. Colt factory records show it was shipped in August that year to Colt's best engraver, William H. Gough in Philadelphia. It is engraved with Gough's distinctive flower and vine design and fitted with the ivory grips for which he was famous.

Cased Colt self-loading pistol,
calibre .32 in (ACP) no.
450761, made in 1924.

Cased Colt self-loading pistol,
calibre .32 in (ACP) no.
450761, made in 1924.

R. B. Rodda was a British gunmaker/retailer in the early nineteenth century, trading from 36 Piccadilly in the late 1840s. When Brown, his partner, died in 1847 he renamed the firm R. B. Rodda and Co. In 1850 he opened a shop at 5½ Tank Square, Calcutta.[103] Rodda also maintained a factory in Birmingham in the 1860s.[104] Their guns bear the London and Calcutta addresses on adjacent barrels but most if not all were made in Birmingham.[105] R. B. Rodda emigrated to America in 1857 where he died shortly afterwards. The firm was sold to the brother of his son-in-law but maintained the name. Rodda and Co became gunmakers to the Viceroy in 1880.

On 26 August 1914, the month that war broke out in Europe, Rodda and Co were sensationally robbed of 50 Mauser pistols and 46,000 rounds of ammunition, part of a large consignment being conveyed from Customs to the company's godown in Vansittart Row, Calcutta. Jatindra Nath Mukherjee led the secret Jugantar section of the Anushilan Samiti, a Bengali revolutionary organisation seeking to violently overthrow the British Raj. They attempted to suborn the 10th Jat Regiment garrisoned in Fort William, Calcutta and robbed rich Bengalis to obtain funds. Mukherjee was an educated patriot, a disciple of Swami Vivekananda who believed that a politically independent India was essential for the spiritual advancement of humanity. In 1911 Mukherjee and Naren Bhattacharya met the German Crown Prince Wilhelm[106] who was visiting India, who promised to supply them with arms and ammunition for a pan-Indian rising planned for February 1915 once the anticipated war between Germany and Britain had broken out. Rodda and Co had an Indian employee who unknown to them was a member of the Anushilan Samiti. He tipped off the Jugantar members about the imminent arrival of the arms. On 26 August the employee was sent to supervise collection of the consignment at the docks. 202 boxes were loaded onto seven bullock carts, the last cart with ten boxes being driven and escorted by disguised revolutionaries. As the convoy threaded its way through the busy streets it was a simple matter for the last cart to peel off. These pistols were used in most of the nationalist attacks in Bengal during the war.

In 1914 the Indian Independence Committee or Berlin Committee worked closely with the Jugantar, which, supported by the German government, shipped a cargo of arms from California to Bengal via the Far East. The British learned of the plan. While the navy cordoned off the coast the police raided revolutionary safe houses, finding a clue that led them to where Mukherjee and four companions were hiding in the mofussil. The five were hunted by armed police and soldiers across country before making a stand. Their Mausers were no match for the rifles of the authorities and they were captured after a fight in which one died and two were seriously wounded. Mukherjee died in hospital in September 1915. Among those who paid tribute to him was Charles Tegart, Police Commissioner of Bengal: 'Though I had to do my duty, I have great admiration for him. He died in open fight.'

Many of the pistols owned by H. H. Maharaja Umaid Singhji (1903–47) listed below were tested in the U. S. Military trials of January 1907 which brought together some outstanding guns. The US Army wanted a new .45 automatic with good stopping power after the inadequate performance of the .38 Colt single-action army revolver in combat during the Philippine–American War of 1899–1902 and subsequently against Filipino guerrillas fighting for independence which lasted until 1913. The famous Peacemaker M1873, 'The Gun that Won the West', was immensely popular and is still being made today as an American icon but was even then technically outdated. As a temporary measure in 1902 the military adopted the new Colt double-action .45 but what they wanted was a semi-automatic. Pistols were submitted for trial by Colt, Savage, Luger in 7.65 mm and Grant-Hammond (whose pistol later became the very successful High Standard .22 calibre automatic). The US Army decided that only the Savage and the Colt offered what they wanted and ran comparison tests in which the Savage excelled the Colt in many respects. It won the velocity test (819 feet per second), held eight cartridges in a magazine that could be expelled by the pistol hand and sat well in the hand. It avoided flat springs, had only thirty-four parts, nine fewer than the Colt, and was easily assembled and disassembled though some of the judges thought it had excessive recoil.

In May 1907 the army asked for 200 examples of each gun with modifications. Colt could afford to supply these at $25 a pistol but Savage was a small concern and could not, and was forced to withdraw. Luger, which had come third in the tests, offered to replace Savage but then discovered what it would cost the company to re-tool their factory to produce 200 of the .45 Lugers, and retired from the trials. Savage then found the money and agreed to supply their pistol at a cost of $65 each and began working on the Savage .45-calibre Model 1907 Military Contract, at the same time also making a commercial .32 version. Modifications followed on both guns but the final test was won by Colt though the Savage performed well.[102]

UBP/2017/27                    CASED COLT SELF-LOADING PISTOL, CALIBRE .32 IN (ACP) NO. 450761

DESCRIPTION
Colt Model 1903 Pocket Hammerless .32 in., ACP, designed by John Browning. The magazine
holds eight rounds.
Overall length: 6¾ ins
Barrel length: 3¾ ins
Weight: 24 ounces
Muzzle velocity 950 ft/sec

On the side of the gun: 'Colt's PT. F.A. MFG CO. HARTFORD. CT. U.S.A. Patented APR
20.1897. Dec. 22. 1903.'

Small V containing a flower on the front side of the trigger-guard; the number 51 on the reverse.
The magazine is marked Cal. 32 Colt. Factory-fitted mother-of-pearl grips with an inset Colt
prancing horse medallions.

COMMENT
The Colt Model 1903 was produced until 1945. Humphrey Bogart used one in his films
*Casablanca*, *Key Largo* and *The Big Sleep*. Bonnie and Clyde, Al Capone, Willie Sutton and John
Dillinger all used them. During the Second World War these small, easily concealed pistols
were issued to the American OSS (Office of Strategic Services, precursor of the CIA) for
covert use. Between 1940 and 1942, 8,359 of these .32 pistols were sent to England, many
issued to SOE.[107] They were also issued to General Officers of the United States Army from
the 1940s to 1972.

This pistol was shipped from the Colt factory in July 1924 to the Winchester Repeating Arms
Co. who exported it to Bombay. The wooden case bears the inset coat of arms of the Jodhpur
royal family and a silver presentation plaque records that the pistol was a gift from the present
Maharaja to his son Yuvraj Shivraj Singhji on his 21st birthday in 1996. A heraldic *cheel* is
engraved on the breech.

UBP/2017/28                          SAVAGE MODEL 1907 SELF-LOADING PISTOL IN CASE

DESCRIPTION

Inscribed on top flat: 'Savage Arms Company Utica N.Y. U.S.A. Cal .32. Patented November 21. 1905 – 7.65 mm.'

Weight: 19 ounces

Overall length: 6.5 ins

Barrel length: 3.75 ins

Mother-of-pearl grips inset with circular plaque bearing an eagle's head: and an oval plaque with an English-style crown and initials U. S. (Maharaja Umaid Singhji). The pistol has factory engraving and according to the 1909 Savage Arms Catalogue cost $55. On the reverse grip a circular inset silver disc shows the Savage Company logo, an American Indian in profile.

The wooden box has an inset disc bearing the Rathore coat of arms and a plaque: 'Presented by H. H. Maharaja Gajsingh of Jodhpur to Yuvraj Shivraj Singh on his 21st Birthday, 1996.' The lid bears a trade label: 'R. B. Rodda & Co. Gunmakers By Appointment Gunmakers to His Excellency the Viceroy & Governor General of India. Dalhousie Square, Calcutta.'

COMMENT

Arthur Savage founded the Savage Repeating Arms Company in Utica, New York, in 1894, renaming it the Savage Arms Company in 1897. The Company manufactured 209,791 Model 1907 pistols between 1908 and 1920, the highest serial number observed being 245,750. Savage made three models of the .32 calibre, 1907, 1915 and 1917 with twenty-five variations of the basic pistol including with nickel, silver and gold plating; three standards of engraving; with or without pearl grips.[108] The 1905 date on the pistol relates to when the patent was awarded to Albert Searle but the pistol is in fact the Model 1907. These pistols were known by the slogan '10 quick shots'.

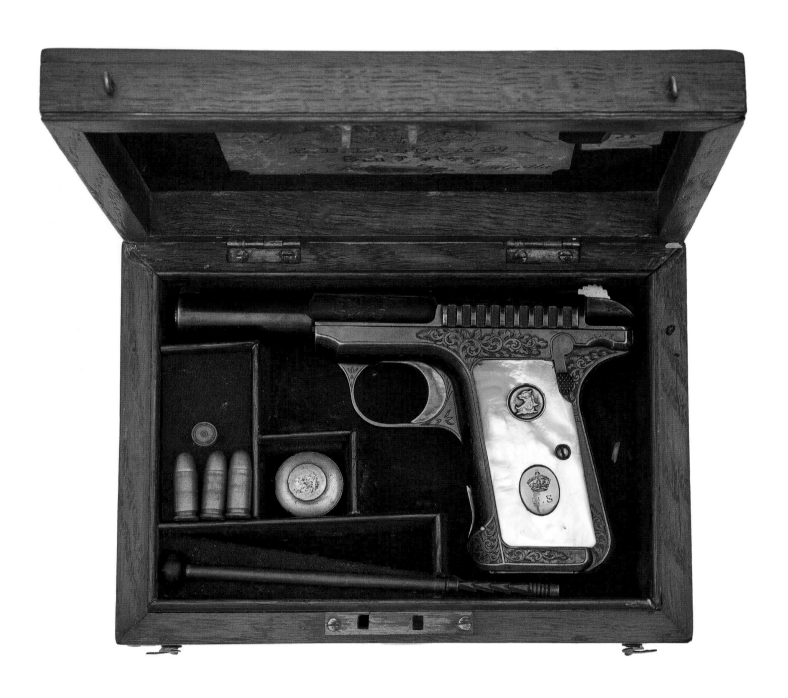

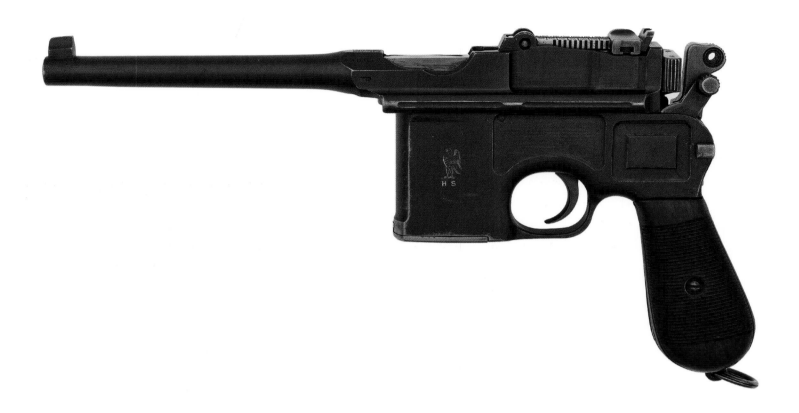

UBP/2017/32

## A 7.62 MM (.30 CALIBRE) 'C96' SELF-LOADING MAUSER PISTOL NO. 360042: WITH DETACHABLE WOODEN STOCK/HOLSTER

### DESCRIPTION
This version was manufactured between 1915 and 1921.
Barrel length: 5.5 ins
Weight: 2.5 lbs

Circular barrel with blade foresight and box magazine. On the back of the hammer: N superimposed over S for Neues Sicherung (New Safety) introduced by Mauser in 1915. This is the 'small ring' model. The gun number and German proof mark, a double crown with a U beneath it, is given three times on component parts. Elsewhere 'Waffenfabrik Mauser Oberndorf A. Necker'. Below the barrel is 5 (twice), B and V. The trigger-guard bears an Imperial German crowned eagle with spread wings. The Jodhpur *cheel* with H. S. (Maharaja Hanwant Singhji) is engraved on either side of the magazine.

The wooden shoulder stock served as a holster and telescopic sights were sometimes mounted, particularly in the Boer War. The pistol with its high velocity cartridge was effective at up to 160 to 220 yards and had better range and penetration than any other pistol until the invention of the .357 Magnum cartridge in 1935.

### COMMENT
The Germans called this the *Kuhfusspistole* or 'Cow's foot pistol' but in Britain and America it was known as the 'Broomhandle'. Mauser supplied the C96 to Westley Richards in Britain for

resale. Many British officers bought them including Winston Churchill who used one at the battle of Omdurman in 1898 and in the Boer War (1899–1902). At Omdurman the 400 men of Churchill's regiment, the 21st Lancers, charged a distant line of Dervishes only to find that they numbered 2,500 warriors. Churchill shot three Dervishes with his Mauser at close range and survived.

The diary of the Rajput aristocrat Amar Singh for 12 October 1900 describes Jodhpur Lancer officers armed with Mauser pistols serving in China under Sir Pratap Singh, part of the British Empire contingent fighting the Boxers. H. H. Maharaja Ganga Singhji of Bikaner visited Sir Pratap who presented him with two Mauser pistols.[109]

This small ring hammer version of the Model 1896 (C96 – Construktion 96) Mauser pistol, one of the more common versions, was used by the German Army during the First World War. It is in the present Maharaja's personal collection and was owned by his father. An order for ammunition by his grandfather Maharaja Umaid Singhji survives in the household papers in a letter dated 19 February 1949 from Manton and Co. Ltd, Gunmakers, 43 Old Court House St., Calcutta regarding a Jodhpur State Armoury order for 300 .30-calibre Mauser pistol cartridges.

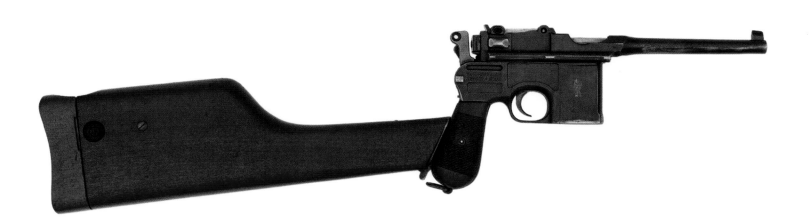

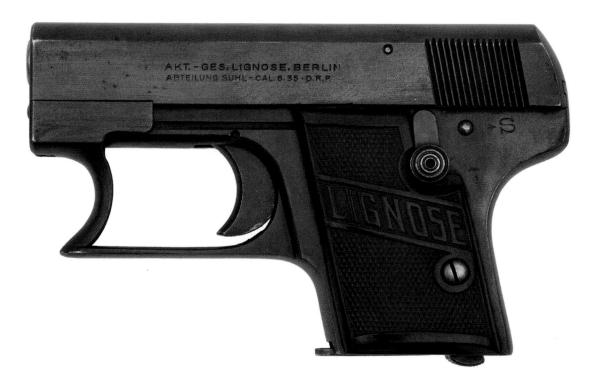

UBP/2017/33

## LIGNOSE SELF-LOADING PISTOL, CAL. 6.35-D.R.P. NO. 26331

DESCRIPTION
Overall length: 4.6 ins/11.7 cm
Barrel length: 2.1 ins/5.3 cm
Weight: 1.1 lbs (0.51)

Small pistol, inscribed Lignose on the Bakelite grips. German nitro proof of a crowned monogram NJ on the inner barrel: the crowned N is repeated elsewhere on the gun. The side of the gun is inscribed:

AKT.-GES.LIGNOSE, BERLIN
ABTEILUNG SUHL-CAL.6.35- D.R.P.

Leather holster with press stud and belt loops.

COMMENT
This .25 ACP (6.35 mm) German pistol, known as the 'Lignose Einhand', (German 'one hand'), was manufactured after the First World War by Aktiengesellschaft Lignose, Berlin Abteilung Suhl. The mechanism uses the blowback principle but features an unusual one-hand cocking trigger-guard designed by Witold Chylewski. He filed a patent in 1912 and obtained it in 1919. The pistol was made by Bergmann starting in 1912 but in 1921 the factory was taken over though production of the Lignose Einhand continued. This is the Model 2A with a six-round detachable box magazine. Model 3A has a nine-round detachable box magazine.

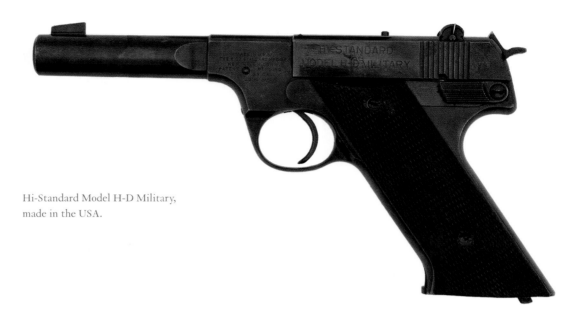

Hi-Standard Model H-D Military,
made in the USA.

UBP/2017/26

## SELF-LOADING TARGET PISTOL

DESCRIPTION
Inscribed on the side:

> Hi-Standard Model H-D Military
> Made in U.S.A. The High Standard MFG.Co.
> New Haven.Conn.
> Patent Pending .22 Cal. Long Rifle

In a wooden box with green baize-lined box with trade label – 'Colt's Patent Fire-Arms Manufacturing Co., 14, Pall Mall, London SW.'

COMMENT
The firearms designer Lucius Diem worked for both Colt and Winchester before founding the Hartford Arms and Equipment Company, producing a nine-shot .22 Long Rifle pistol called Model 1925. Diem's company went into liquidation in 1932 and was bought by Swedish firearms designer Carl Gustav Swebilius who began making inexpensive .22 calibre Model A and Model B semi-automatic pistols based on Diem's original. In 1940 they made their most successful pistol, the H-D, which continued in production until 1955. This single-action blowback pistol has a ten-round magazine, exposed hammer and the appearance of a Luger. Weighing a solid 40 ounces, it was cheap, reliable, strong and accurate and quickly became popular with target shooters. The American War Department liked its price and performance and ordered 34,000 H-Ds for military pistol training. Between October 1943 and March 1944 the Office of Strategic Services (OSS), the American wartime intelligence service, predecessor of the CIA, also ordered 2,600 H-Ds with silencers designed by Electric Bell Laboratories for use in covert operations. Each shot gave off a mere 20Db. These IMS (Military Silent) versions are all between serial numbers 114,000 and 117,000. The H-D Military is very similar to the H-D. It was introduced in 1945 and manufactured until 1950. It takes the .22 Long Rifle cartridge and has either a 4.5-inch or 6.75-inch barrel, adjustable sights and chequered walnut grips.

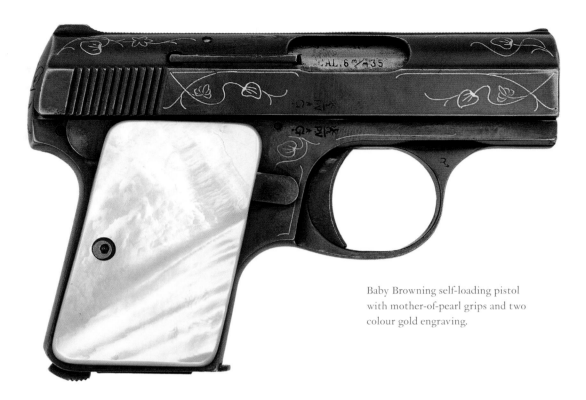

Baby Browning self-loading pistol
with mother-of-pearl grips and two
colour gold engraving.

UBP/2017/31

## CASED BABY BROWNING SELF-LOADING PISTOL
Made by Fabrique Nationale d'Armes de Guerre, Herstal,
Belgique Browning's Patent Depose. Serial no. 45731

### DESCRIPTION
Inner barrel: Belgian proof mark of a crowned oval with initials E over LG (Liege). 6.35 mm calibre. Five-point star over letter G (the Liege inspectors stamp used by inspector Josef Charlier (working 1928–59). Horse over PV (the Belgian nitro proof mark used for all arms after 1903). This example was probably made c.1938. The frame and slide of this example has two-colour inset gold line engraving depicting floral motifs. One pearl grip engraved with a *cheel*, the initials H. S. (Maharaja Hanwant Singhji); and personal inscription. Presentation box with silver catch and hinges.

### COMMENT
FN is a Belgium company started before the First World War, which had a German majority takeover from 1896–1914. During both world wars the company was sequestered and under German control. This pistol is the 6.35 mm FN Baby Browning model, a redesigned version of the Model 1906 'Vest Pocket Model', which was also known as the Model 1905 in America, the first manufacturing year. The Baby Browning was effectively a new pistol, by Dieudonné Saive, FN's chief designer, introduced by FN in 1931.

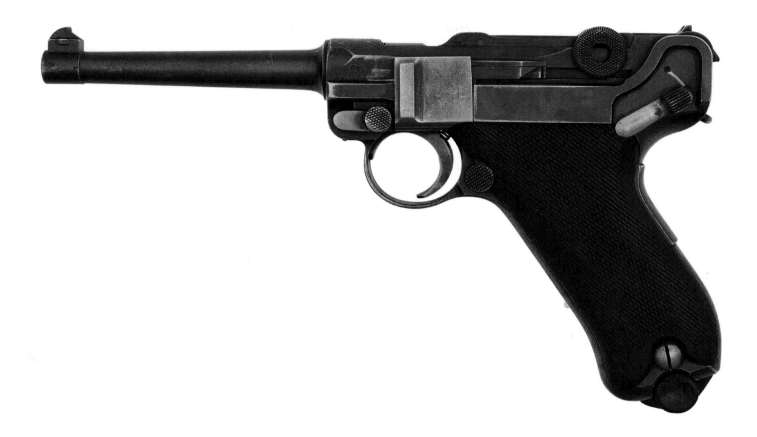

UBP/2017/35

# LUGER P08 SELF-LOADING PISTOL, SERIAL NO. 62914

### DESCRIPTION
Under the barrel: proof mark of Crowned N; 62914. The wooden magazine filler is numbered 4333. On the back of the gun below the rear-sight is number 14. Monogram DWM on top flat above the chamber. Engraved with the Jodhpur *cheel* and initials H. S. on the breech of the barrel.

### COMMENT
The P08 was introduced using the 7.65 mm Parabellum cartridge but the German Army adopted a modified P08 using 9 x 19 mm Parabellum ammunition. The Pistole Parabellum is a toggle-locked recoil-operated self-loading pistol designed by George Luger as an improvement of the Borchardt semi-automatic pistol. It was manufactured as the Parabellum Automatic Pistol, Borchardt-Luger System by the German arms manufacturer Deutsche Waffen und Munitionsfabriken (DWM), one of four Luger pistol manufacturers, the others being Mauser, Simpson & Co, and the state arsenal at Erfut. It was also produced under licence by several nations from 1898–1948 and was the pistol of choice as a military sidearm for more nations than any other contemporary weapon.

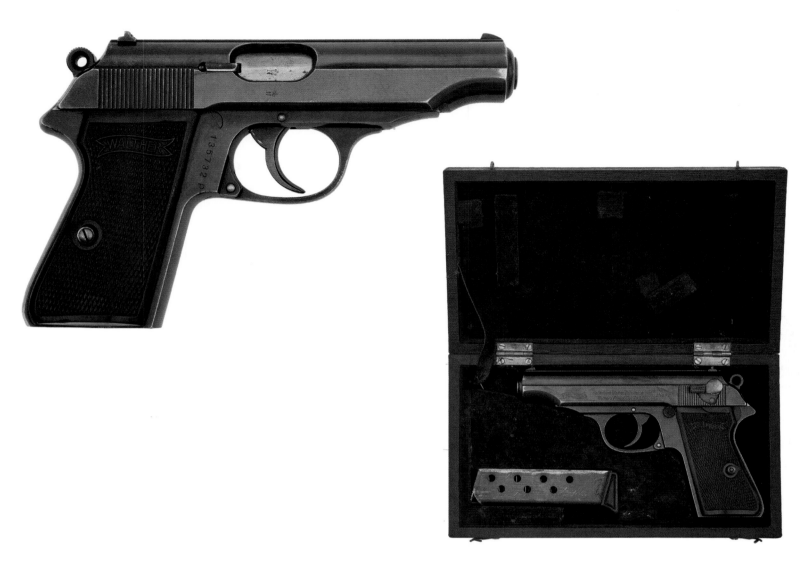

UBP/2017/30

## WALTHER MODEL PP SELF-LOADING PISTOL NO.135732 P IN FITTED CASE

### DESCRIPTION

Walther's Patent Cal. 7.65 mm pistol. Inscribed 'Walthers' in a banner and 'Waffenfabrik Walther, Zella-Mahlis (Thür.) Walther's Patent Cal. 7,65 m/m Mod. PP'.
Round barrel 3¾ ins

The pistol has a 60-degree safety lever, a side magazine release, black plastic chequered grips and blue finish. The serial number appears beside the trigger. Crowned N (the German nitro proof mark) stamped on the barrel chamber and slide.

### COMMENT

Walther started manufacture of the PP model in 1929. This example was made before 1938 when German proof marks changed from the crowned N to eagle over N. The SS used these pistols during the Second World War and these have special markings.[110] Pistols lacking proof marks are thought to have been looted by American troops who captured the factory in Zella-Mehlis in April 1945.

# LATE NINETEENTH- AND TWENTIETH-CENTURY AIR PISTOLS

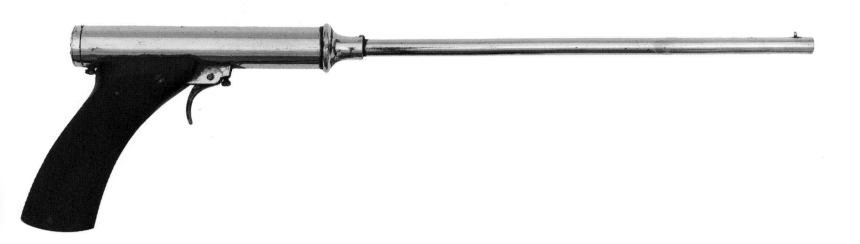

UBP/2017/37

## BUSSEY AIR PISTOL
Embossed Bussey Patentee Brevete London
Crown O stamped indistinctly under the grip

### COMMENT

George Bussey (1829–89) was born in Ripon in Yorkshire and was apprenticed to a saddler in Richmond. In 1851 he moved to London. London Directories for 1855 classify him as a guncase maker at 173 High Holborn. He described himself as a gunmaker from 1870 to 1889. On 9 February 1876 he applied and on 8 August 1876 patented his design for the only mass-produced British-made airguns in the last quarter of the nineteenth century. His company G. G. Bussey & Co. made air weapons from 1870 to 1914. In the official catalogue of the 1878 Exposition Universelle at Paris under 'Classe 40. Armes Portatives. Chasse' we find: 'Bussey, George Gibson; Fabricant breveté; Museum Works, Rye Lane, Peckham, London. Bouteilles brevetées, en verre et en faience, pour vins, spiritueux, sauces, parfums. Armes à vent brevetées.'

Both the rifle and pistol appear similar to the Quackenbush Model 1 air rifle but there is no similarity in construction. Although a number of Bussey's rifles survive, there are only a handful of these extremely rare pistols. Bussey realised that his business could not compete regarding price or design with American airguns made by Quackenbush[111] and the Quackenbush-designed air pistol manufactured by the Pope brothers, which was commercially endorsed by General Sheridan, who in 1864 during the American Civil War defeated Confederate forces in the Shenandoah Valley; he became General-in-Chief of the US Army in 1883. During the 1880s Bussey concentrated on manufacturing English sporting goods and games. He registered patents relating to cricket bats, tennis, badminton and squash racquets, Bussey golf clubs and a small billiard table that converted into a dining-room table by adding mahogany leaves.[112]

UBP/2017/29

## A RARE GERMAN EISENWERKE GAGGENAU 'MF' AIR PISTOL WITHOUT MARKINGS
Made between 1878 and 1900.

### DESCRIPTION
They are normally signed on the left side of the octagonal breech 'Brevet s. g. d. g.' and 'Patent' on the other side. It comes with two cocking handles, which also serve as spring removing tools; and a dart.

These guns have a cast-iron barrel and butt made in one piece and are nickel-plated. The spring and air chamber is in the butt and the gun is cocked by pulling on the button at the base of the butt. They also shoot .177 pellets.

### COMMENT
In 1683 Margrave Ludwig Wilhelm of Baden leased the newly built Gaggenauer hammer mill (Eisenschmelze, Hammerwerk und Nagelschmiede) to Captain Adam Ernst von der Dekhen who began production of wrought-iron and nails. A succession of owners with varying degrees of success followed but by 1848 the business had forty employees. In 1852 the first foundry with cupola (*kupolofen*) was established in the Murg Valley, followed in 1858 by a rolling mill operated by Murg's hydropower plant. The workshops made agricultural machinery such as ploughs and harrows from the raw material in the valley.

In 1873 Franz Korwan and Michael Flurscheim bought the ironworks and renamed it Korwan and Flürscheim ironworks Gaggenau at Rastatt (Korwan und Flürscheim Eisenwerke Gaggenau bei Rastatt). They diversified into new iron products, bridges, railings, gas regulators, shot blasters and paint mills. Franz Korwan died within a year but the company thrived under Flürscheim's direction. He established very progressive social facilities for the workforce and their families including health insurance, a fire brigade, a gymnastics club, a school for apprentices, workers' housing, a savings bank, a provident fund and a trade association.

Michael Flürscheim designed the Eisenwerke Gaggenau 'MF' air pistol. Production started on 3 July 1878 and on 18 February 1879 a patent was granted, no.3690 titled 'Neuerungen an Luftpistolen' or 'Improvements to Air Pistols'.[113]

In 1880 Theodor Bergmann, a manufacturer from Konstanz, joined the company and it further diversified and developed an enamel factory, stamping shop, nickel-plating, book-printing, carpentry and art foundry. One new product was Badenia bicycles. By this time it has 150 employees and in 1884 Bergmann became a partner and developed the company's gun business.[114] The company changed its name to: 'Eisenwerke Gaggenau, Flürscheim und Bergmann'. Two years later the company produced its own steam-driven car. In 1894 it was decided to limit the wide range of manufactured goods and weapons production ceased though it resumed during the Second World War until most of the factories were destroyed by Allied bombing in 1944. Today Gaggenau is internationally known as a manufacturer of built-in kitchen appliances.

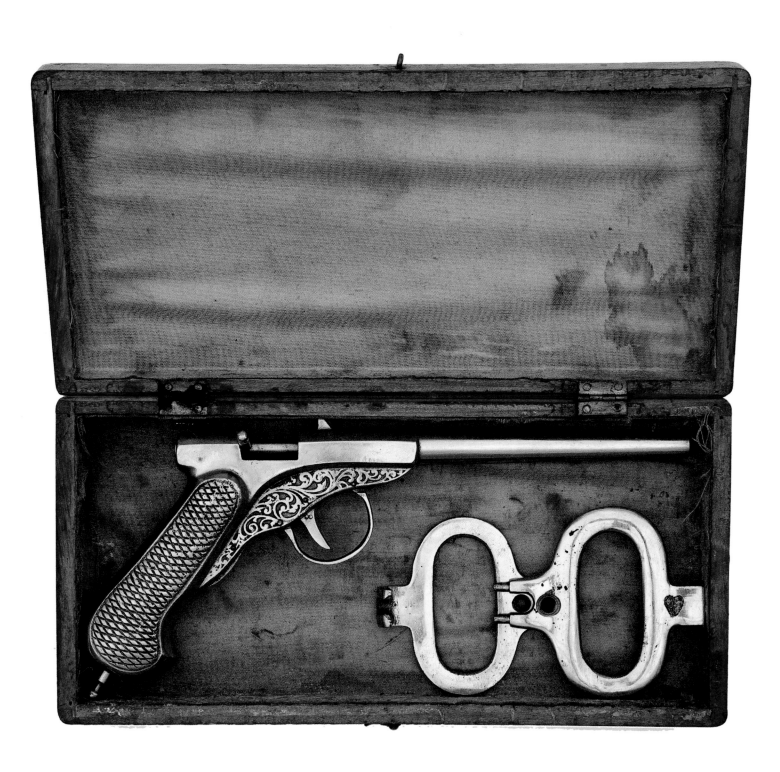

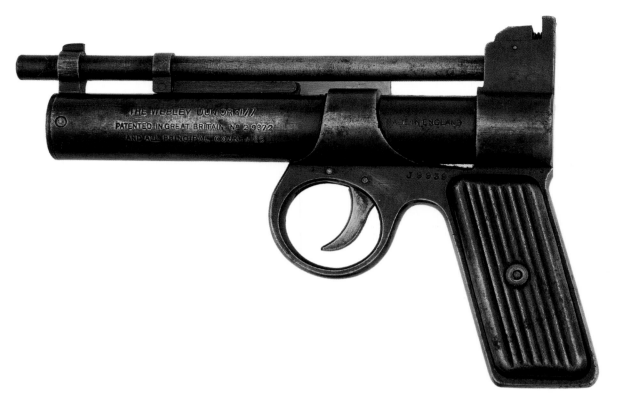

UBP/2017/36

# THE WEBLEY JUNIOR AIR PISTOL
# BY WEBLEY & SCOTT LTD

## DESCRIPTION
On the side of the barrel:

> Webley & Scott Ltd Birmingham
> The Webley Junior .177
> Patented in Great Britain No. 219872 and all principal countries
> Made in England
> Serial number: J9939

Overall length: 22 cm
Barrel length: 15 cm
Calibre: .177
Muzzle energy: 7 joules

## COMMENT
Webley was founded by William Davies who made bullet moulds in the late eighteenth century. In 1834 the company was taken over by his son-in-law Philip Webley and Philip's brother James began making percussion sporting guns. The company became famous in mid-century for single and double-action pistols. Webley made air pistols from 1924. Webley Junior pistols made prior to the Second World War have a serial number starting with the letter J. (The Webley Senior starts with an S). The Junior was designed in 1929 by Webley employees Douglas Johnstone and John Fearn. It uses a spring piston.439 The gun being examined is the Junior Mark 1 with slanted tin plate grip, one of the last before the introduction of the Junior New Model in 1936.

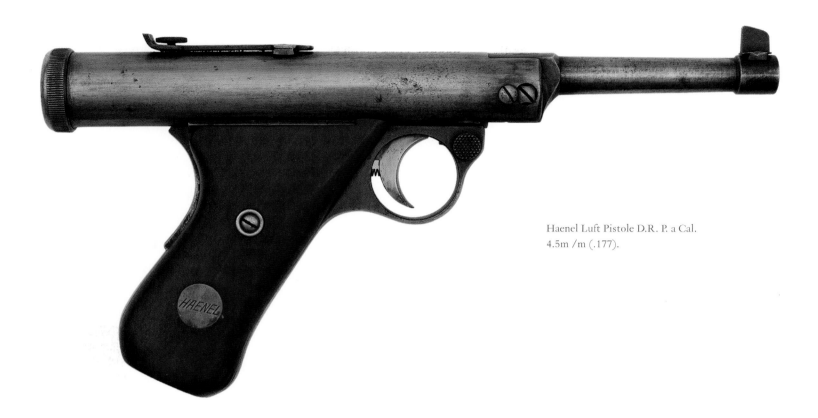

Haenel Luft Pistole D.R. P. a Cal.
4.5m /m (.177).

UBP/2017/34

## HAENEL AIR PISTOL

### DESCRIPTION
Inscribed on the side of the barrel: 'Cal. 4.5m /m (.177).' Under the barrel: 'Made in Germany'.
On top of the breech: 'Haenel Luft Pistole D.R.P.a'
Chiselled *cheel* over initials H. S. (Maharaja Hanwant Singhji).

### COMMENT
The Model 28 single-shot pistol was designed by Hugo Schmeisser in 1927 but production only
started in 1933. About 25,000 were made. It features a rifled barrel with barleycorn front sight
and notch rear-sight on an adjustable leaf. Owners of these guns suggest it shoots at between
250 and 270 fps. Also made was the 28R (Repeater).

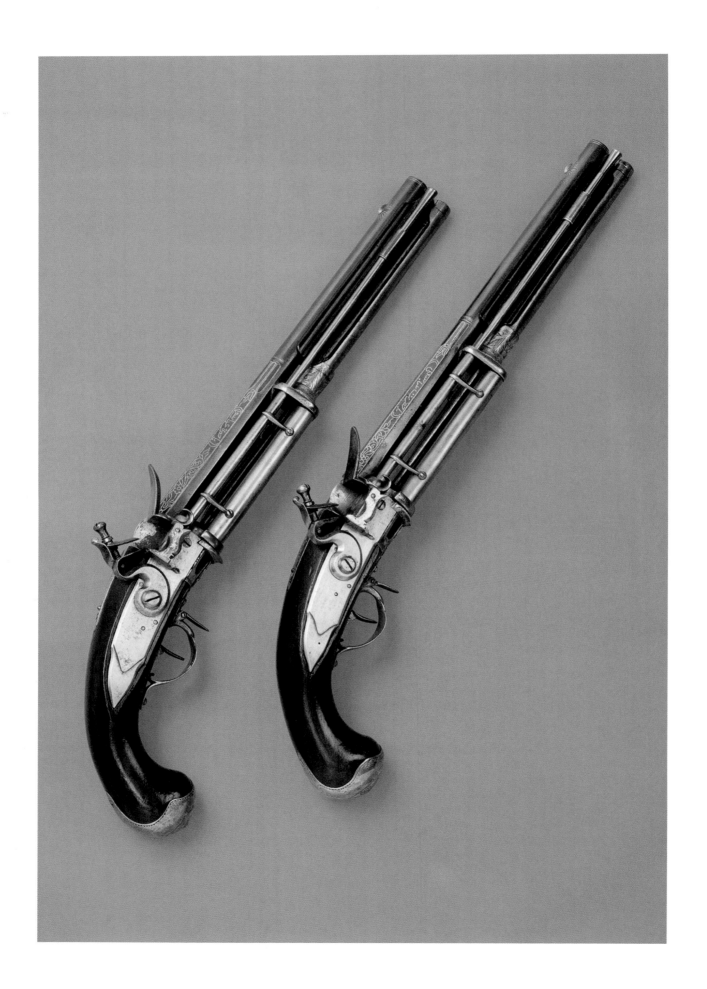

# 5 ADVANCES IN SPORTING GUNS IN INDIA IN THE NINETEENTH CENTURY

FACING PAGE:
A very rare pair of Chalembrom pistols, formerly Visser collection. The barrels are inscribed:
*Kār Chalebrom sanat 1214*,
'Work of Chalembrom Panshari 1214' (1799–1800 AD). The receiver is inscribed: 'Sarkar Sikandar Jah Bahadur', the future Asaf Jah III of Hyderabad prior to his accession in 1803.
The Chalembrom guns exemplify the increasing sophistication of firearms demanded by princely India; and also the ability of Indian gunmakers to produce these unaided. The earliest Chalembrom guns were made by Indian gunsmiths working under French supervision in Pondicherry. These guns made excellent gifts to rulers and were soon copied in Tipu Sultan's various arms workshops. The Indian rulers used French mercenaries to establish arsenals largely staffed by Indian craftsmen. For example, Marie Raymond from Sérignac in Gascony arrived in Pondicherry as a merchant in 1775 and served as a soldier under General Bussy. He entered the Nizam's service in 1785, creating an elite French corps; and was appointed *Amar-e-Jinsi*, (Controller of Ordnance) in 1796 when he built the *Top ka Sancha* in Hyderabad. Sir John Malcolm describes visiting Raymond's foundries in his *Political History of India*, 1798: 'they cast excellent cannon and made serviceable muskets'. A Chalembrom gun in the National Rifle Association Museum, Fairfax, Virginia dated 1214 AH, 1799–1800 AD, was also made for the Nizam. By kind permission of Peter Finer Ltd.

Miniature paintings showing maharajas hunting with European guns are comparatively rare until the mid-nineteenth century. Flintlocks, known in India by their Persian name, *chakmaki bunduk* or to the Sikhs as *banduk du kala*[1] were often given as gifts by officials and private individuals to prominent Indians. Some Indian rulers employed gunsmiths to make copies of European guns. Tipu Sultan in Mysore, the Nizams of Hyderabad and the Nawabs of Oude all retained Frenchmen and Indian craftsmen trained by French gunsmiths in India. In the nineteenth century the Indian princes began ordering arms directly from the best European gunmakers. Fane in Oudh records in 1836:

> The son of the Nawab came afterwards to see the Commander-in-Chief's guns, one of which, on the tube principle, he seemed very much pleased with, and said he should order out some of the same kind. He is an excellent shot, and three or four years ago he took it into his head he wanted guns, and immediately wrote to Joe Manton, ordering him to send ten guns; for which he enclosed an order for ten thousand rupees, or a thousand pounds.[2]

Joseph Manton (d.1835) patented the tube or pill lock in 1816, an improvement on Alexander Forsyth's 1807 'scent bottle' lock, which initiated the use of fulminates of mercury to detonate a gun. In India a percussion-cap gun was called a *topidar*, 'top' meaning 'hat', a reference to the shape of the percussion cap. By 1830 the percussion gun primed with a copper cap was firmly established in England and among the English in India but all social levels of Indians continued to use the matchlock. The era of the flintlock was over in Britain where old flint guns were converted to cap, either by having a plug screwed to the side of the breech by the vent, or by having a new breech fitted. The flint cock was removed and replaced with a percussion hammer. The new mechanism removed the time lapse between pulling the trigger and ignition. It also ended misfires and most problems with rain and damp that had so affected flint guns. Forward-action locks where the mainspring was in front of the hammer were thought to work faster than back-action. The hammer required a particularly powerful spring because otherwise the ignition of the larger-bore guns could blow back, lifting the hammer off the nipple, sending parts of the percussion cap into the face of the shooter. The best English stocks in the nineteenth century were made of Turkish walnut, English walnut being much less figured. In the 1820s and 1830s

there was a brief fashion for birdseye maple, imported from the northern United States and Canada, which was discouraged by the trade because the grain was difficult to work. Maple stocks were often made darker using stain or flame. Greener wrote that the best Birmingham gun mounts were made of swaff iron, the inferior ones of cast iron.[3]

These European percussion guns were still muzzle-loaded with a set measure of black powder. The stock was thumped on the ground to ensure that the powder reached the end of the breech. A felt wad was pushed down the barrel with a ramrod until it sat on the powder. The bullet or shot followed next. The gun was then put on half cock and the copper cap fitted. It was now ready, only requiring the hammer to be pulled to full cock before firing.

It was dangerous to reload a muzzle-loading gun because any smouldering residue in the barrel might ignite the powder being poured down the barrel which in turn could ignite the substantial quantity of powder in the flask from which it was being poured, turning the container into a bomb. The Europeans invented versions of fire-proof flasks with nozzles that closed off the main container but the safe method was to decant the powder from the flask into a small measure and tip this into the barrel. The Turks all did this but there is no Indian equivalent and accidents in India must have been common.[4] It was always dangerous to reload a matchlock because of the risk of the lighted match igniting spilt powder grains. Close proximity to other matchlock men was also potentially dangerous. Indian matchlocks usually have small conical match holders riveted to the side of the breech. These are to push the end of the lighted match into when loading the gun. Some matchlocks that lack this safety device have a small hole in the back of the wooden block behind the barrel that serves the same purpose.

In the early percussion era a popular medium-sized European rifle for shooting deer was often a 16 bore with an ounce ball and 1½ or 2 drams of powder. The usual killing range was about 100 yards. Big game rifles from 12 to 4 bore used 2½ to 3 drams of powder in the case of the smaller gun up to 6 to 8 drams for a 4 bore. The hunter's need for a second shot, particularly when confronting dangerous large animals, made a double-barrel gun desirable. Gunmakers overcame the difficulty of having a single sight serving both barrels by making barrels converge towards the muzzle. In the 1830s and 1840s the double-barrelled rifle became the standard huntsman's weapon though large bore single-barrel guns were still often carried by a bearer. Demand for double rifles reached their peak in the 1870s when they were used for stalking in the Highlands as well as for big game. Hunters in India and Africa needed a gun with the capacity to floor their dangerous quarry and initially they achieved sufficient shock by using very large charges of powder and a heavy ball fired from a smoothbore, accurate only as far as about fifty yards. The smoothbore was necessary because rifling stripped the soft lead bullets at velocities well below 1,400 feet per second. The limited range was a problem, overcome when the two-groove rifle was invented, firing bullets hardened with pewter with two lugs that fitted the grooves. However it was seen that the hardened round or conical bullet passed through the body, which dissipated its shock effect on the target and expended its energy in the ground beyond. For better effect a belted lead ball was introduced which spread on impact which staggered the charging animal and usually gave the hunter time for a second aimed shot. The thick cloud of black smoke from the first shot had to clear before the hunter could see if his target was still charging at him.[5] It was not uncommon for the second shot to despatch the quarry a few feet away. Samuel Baker, one of the best-known shots of his day who hunted big game in Ceylon, recommended a double-barrelled 10-bore rifle weighing 15 lbs carrying a charge of 10 grams of coarse grain no. 6 powder.

James Purdey was apprenticed in London in 1798, working with the celebrated gunsmith Joseph Manton, and opened his own gunsmith's business in 1814. He experimented making double-barrel rifles and his son James developed this interest.[6] The latter created smaller-bore, two-groove rifles of 40 and 50 bore (.500 and .450), using 4 and 4½ drams of powder respectively. His work in the 1850s with larger powder charges giving higher muzzle velocities of 1,600 feet per second or faster resulted in him calling these rifles 'express trains' then newly introduced on the railways, because of their bullets' flat trajectory, heavy weight and high speed. The 'Express' was introduced by James Purdey the younger in 1852 and in time 'Express' came into general use as the name for small-bore rifles of this type. Purdey supplied guns and rifles to many Indian princes. It was a worker at Purdey, Frederick Beesley, who designed the self-opening hammerless gun of the 1880s, an advance followed ten years later by the inclusion of ejectors. An unlikely consequence of the disappearance of external hammers was the Crystal Indicator patented by William Scott in 1875.[7] This was a small circular window set in the side of the lock-plate that allowed anxious sportsmen to check that their gun was indeed cocked.

Stub-twist barrels were originally made in Birmingham from old horseshoe nails forged into a ribbon, it being believed that the pounding these got on the road purified the iron. Later the Birmingham barrel-makers imported old nails from Europe, which were better iron than the English nails. By the early nineteenth century it became customary to add steel scrap to the process, Swedish steel[8] being highly regarded. The ribbons were then heated red hot and wound round a mandril, then brought up to welding heat, part welded by banging the rod down to bring the edges into contact, a process known in England as 'jumping'. The barrel was then put on a hardened mandril and short sections were heated and hammered to complete the welding. Afterwards the barrel was cooled and then hammered to condense and harden the metal.[9] Stub-twist barrels made in this manner had light steel and darker iron colour, which could be brought out as a pattern when the barrel was browned. Birmingham coal and steel made it cheaper for the barrels to be made there and for London makers to import them rather than making them themselves.

The origin of 'damascus-twist' barrels is unknown but the technique was probably Persian. Barrel construction changed at the Mughal court in the latter part of the sixteenth century. The best smiths in the Islamic world were Persian and Persian culture permeated the Mughal and Deccani courts. Damascus-twist barrels remained the standard Persian construction into the twentieth century. In the nineteenth century British makers began making damascus-twist barrels in the manner used in India and the Middle East and these gradually replaced stub-twist barrels between 1815 and 1865. Birmingham forgers made ribbon by welding iron and steel rods together alternately, six iron rods with six mild steel rods. The resultant bar was fixed at one end and wound using a wheel until 12 to 14 twists to the inch was obtained, all equal. Three of these rods were placed together, the central rod placed in reverse so the pattern ran counter to the other two. These rods were then hammered into one at white heat. The ribbon was then rolled out, thicker at the breech, thinner at the muzzle. The end of this metal ribbon was fixed to a tapering mandril and the barrel coil was created, the partial weld created by a tap on the end of the hot barrel. The process then followed that of stub barrels. After that the barrels were filed and bored to size and browning applied to the barrel to bring out the pattern.

In 1851 Wilkinson showed a variety of patterns at the Great Exhibition in London. Intricate damascus barrels were made in France, Austria, Italy, the German states and Belgium. Belgium barrel makers were also noted for common iron barrels with a thin applied veneer of watered-steel.

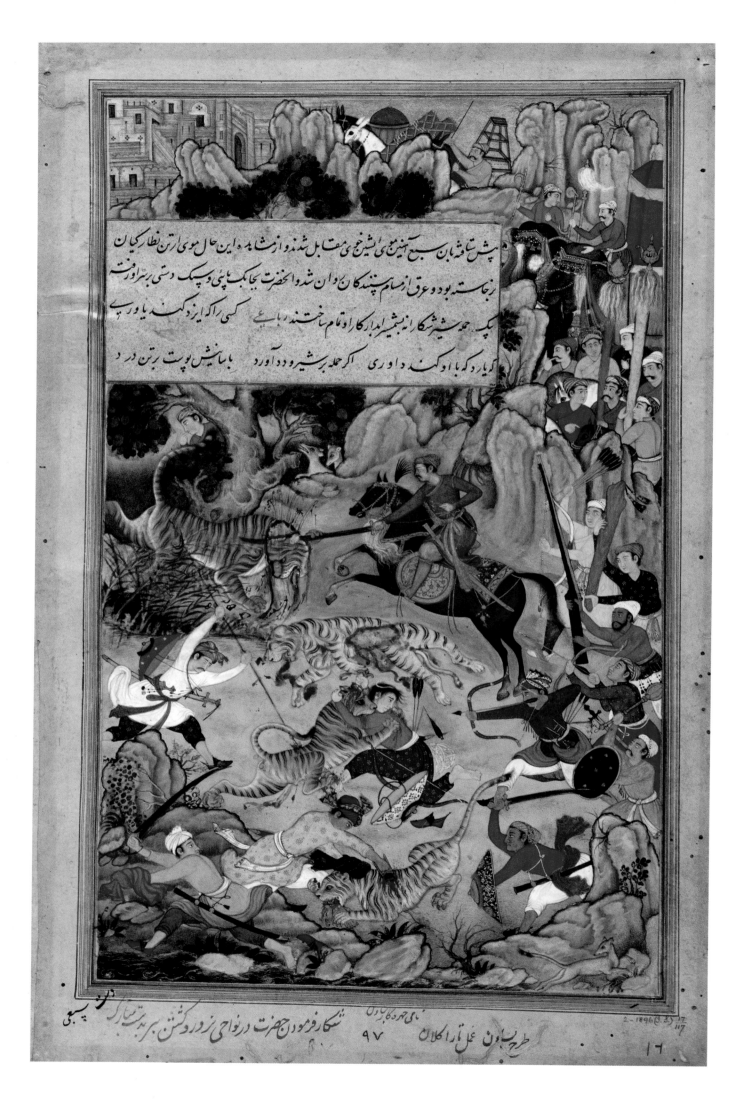

# 6 HUNTING WITH SPEAR AND GUN IN RAJASTHAN

## PIG-STICKING

Since time began the aristocratic Indian hunter rode down his quarry on his horse and speared it with his lance. Indian sangfroid in such matters set standards that visitors from other nations were obliged to follow. In the late eighteenth century, Colonel James Skinner (1778–1841), who raised the cavalry regiment Skinner's Horse at Hansi in 1803, hunted tigers on horseback with a lance as did his contemporary General Lake. Lake shot a large tiger with a flintlock pistol just as it was about to spring on Major Naire by whom it had been speared.[1] Alwar, a princely state in eastern Rajasthan, was famous for releasing caged panthers and hunting them on horseback with a lance, a form of coursing that continued into the twentieth century.[2] The Indian servants perched on top of the cage had an anxious moment when they opened the door to let the panther out in case it went for them but generally it was off like a rocket. Amar Singh describes one such occasion where the servants were given a small spear to protect themselves.

Captain R. S. S. Baden-Powell, later better known as the founder of the Boy Scout movement, wrote *Pigsticking or Hog Hunting* in 1889.[3] He argued that this was the most ancient sport in the world. Its modern Indian form begins in the early nineteenth century as a substitute for bear sticking which had been a popular sport in Bengal in the eighteenth century. There are three types of bear in India, red and black bears in the Himalayas and the sloth bear in the rest of the peninsula. The bear was hunted by mounted sportsmen armed with a short, heavy, broad-bladed spear, which was thrown. When bears became scarce, hogs were substituted.

It was the custom to get up a sweepstake before the hunt, won by the person who first threw his spear so it stuck in the pig's body. To identify who owned the winning spear coloured ribbon was tied to it. In those days the actual death or escape of the pig was not an important consideration. The wild boar of India, *Sus indicus*, is of low and powerful build weighing up to 300 pounds, covered in bristles that change colour according to age. Sportsmen measured height off the ground to establish the worth of their quarry, anything over 36 inches being rare. The male is armed with two tushes on the lower jaw, tapering, sharp and pointing upwards, and two shorter and thicker in the upper jaw, also curling upwards. With his small red, deep-set eyes he has a wicked appearance that faithfully reflects his true nature. Barren sows were ferocious and fair game for the hunters but to spear a fertile sow was as unacceptable as shooting a fox and the Calcutta Tent Club for one imposed a fine of a dozen bottles of champagne for anyone who did so.

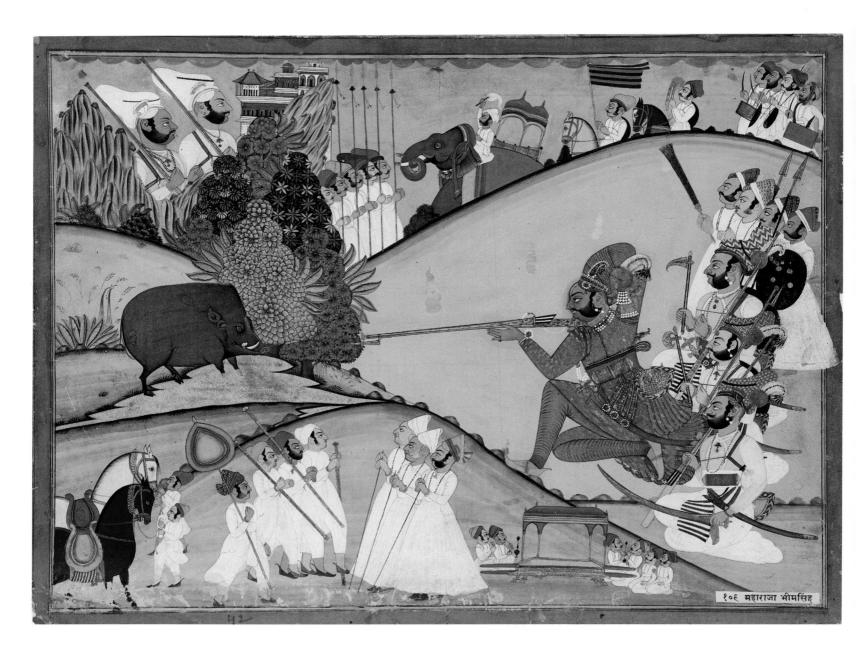

१०६ महाराजा भीमसिंह

Kunwar Bhim Singh hunting boar. VS
1847 Jyestha. (1790 AD). Amar Das, one
of the principal Jodhpur painters during
Bhim Singh's reign (1793-1803) and
his successor Man Singh, experimented
with portraiture and composition.
Note the decorative silver stripes set in
the ebony block behind the barrel. See
FRM/97/237, p. 133 for an example.
RJS 2051 Mehrangarh Museum
Trust and His Highness Maharaja Gaj
Singhji II of Jodhpur–Marwar

Modern pig-sticking involved mounted hunters in groups of three or four posted
at intervals beside cover, which was driven by beaters. Hogs usually made 'forms' for
themselves out of clumps of grass, lying up all day. When a boar broke cover, if it was a
suitable age the nearest party galloped after it, each man trying to win the honour of being
the first to spear it. The spear was kept in the hand and all the riders combined to overcome
the beast as it went very fast over broken ground. In India men were required to be good
horsemen and pig-sticking, like polo, was excellent training. It took a man all over the area
for which he was responsible and could not be equalled as training for cavalry. Most people
who knew fox hunting regarded pig-sticking as a far superior sport. The horses too became
very knowledgeable and adept, some even darting forward at the appropriate time without
any impulse from the rider when an opportunity to place a spear offered itself. Williamson
witnessed a horse that had 'lost its rider, yet followed with the highest glee, and amused itself
with leaping over the hog, backwards and forwards, keeping him in perpetual state of alarm,
thereby impeding his progress, and giving time for the others possessing less speed to finish
the chase.'[4]

Wild boar were very numerous in Jodhpur and in order to control numbers they were often shot until the latter part of the nineteenth century when the Regent, Sir Pratap Singh, encouraged pig-sticking and other sports. The sporting Mrs Gardner, an Edwardian belle, writes:

> Formerly the wild boars were shot in the hills they inhabit and no attempt was made to drive them on to ridable ground. Now large sums are spent in preserving and feeding them and they are enticed into the best riding country. At first grain was laid at the foot of the hills, and the pigs came down during the night to feed. Then it was placed further off, until little by little the sounders were induced to search for food in the middle of the plain. The riders start long before daybreak, and conceal themselves behind clumps of bushes, well out in the open. As the dawn breaks, the old boars are seen trotting quietly back to the hills, and are generally ridden down and speared before they reach them. They are very savage, especially in the hot season, when they will frequently attack men without provocation. It takes very little to make an old boar show fight, and when he does he is the pluckiest animal in creation. He will wriggle himself up the spear to get at you, and if the spear breaks, his long tushes are sharp as a razor and slash like an Indian sword.[5]

Mrs Gardner writes in a letter from Jodhpur on the 27 February 1893:

> Alan went out pig-sticking with Major Beatson, the officer in charge of the Imperial Service Troops. They started about three o'clock in the early morning and rode to a valley about ten miles off, where they duly waited for the boars. Directly it got light enough to see, sounder after sounder cantered past on their way home; and sometimes two or three gigantic boars would be seen hastening back in different directions, to reach the hills before sunrise.
>
> They got several capital gallops, and altogether killed six fine boars. One was an enormous fellow, and after he had been slightly speared went into some thorn bushes and kept turning round facing the horses, so they could not get at him. At last, with a grunt of defiance, he charged out, and, breaking Alan's spear, cut his horse badly above the hock. Alan was riding a very nice little Australian mare, who curiously enough, was badly cut by a charging boar the last time she was ridden, and had been laid up from the wound for three months. Major Beatson also had his horse severely cut by another boar, although it was so badly speared that it died shortly afterwards.
>
> In the afternoon we went out after the little Indian gazelle (chinkara). Several herds were grazing in the ravines within a mile or two of our house. They were very shy, but we managed to shoot two bucks with good heads.[6]

Sir Pratap who was fearless and Spartan in spirit describes an incident when hunting boar at Khema-ka-kua in 1894 with General Roberts, then commander-in-chief in India and General White. Roberts thrust at a boar with his spear but missed as it jinked. Sir Pratap attempted to turn the boar back towards his guests. His horse at full gallop jumped a bush and he saw before him a ditch on the other side into which horse and rider fell as he threw away his spear. Seeing him on the ground the boar turned and drove its tusks into his thigh. Sir Pratap seized the boar's head with one hand while pulling it over onto its back by its ear with the other hand. He

then sat on its belly and finished it with the jambiyya he habitually carried in his riding boot. When Roberts rode up Sir Pratap assured him he was unhurt but the blood running down his leg was visible to all.[7]

Another guest of Sir Pratap Singhji at Jodhpur was the Prince of Wales, the future King Edward VIII, who stayed for two days pig-sticking in November 1921. One of the prince's companions described the prince's first experience of this dangerous sport when the spears in parties of four rode out:

> The boar was at bay and I saw him charge one of the Jodhpur sirdars broadside on, who narrowly missed being knocked over. Shortly after the boar charged H. R. H., who met him coolly with the point of his spear, but the shock bowled over the Prince's pony, and I was afraid there was going to be trouble, but we managed to divert the boar's attention while H. R. H. got up and re-mounted. Fortunately, neither he nor his horse was hurt, and after some more exciting moments the boar was at last killed.[8]

It was on this occasion that Sir Pratap admonished the prince in his famous fractured English for a dangerous piece of riding due to his lack of experience of the sport: 'I know you Prince of Wales, horse know you Prince of Wales, but pig not know you Prince of Wales!'

Hogs take up residence in odd places as two nineteenth-century accounts demonstrate. A boar occupied the Memorial Gardens at Cawnpore. A group of Englishmen closed all the gates in the railings and tackled it on foot, an exceedingly dangerous game. The boar, after three profitless circuits of the garden seeking to escape, charged the leading man, a Mr Kingscote. His spear went clean through the boar and the impact made him take three graceful backward somersaults. Fortunately the boar was then distracted by Kingscote's hat, which it despatched before being despatched in turn. Another instance in Cawnpore involved an urgent appeal to a sitting magistrate to drive a boar out of a private house. The boar, resisting all persuasion to vacate the premises, was busily destroying the furniture. The court adjourned. Outside the house the magistrate found an excited crowd while within the sound of breaking chattels could be heard. The crowd shrank very rapidly when he ordered the front door to be thrown open. Out sprang a large boar, which the magistrate speared. In Jodhpur in 2011 H. H. Maharaja Gaj Singh created a substantial wild plant and desert rock garden below the fort. He was addressing a good crowd at the opening when a fine boar appeared behind him, in full view of the crowd. Everyone watched with interest as the maharaja, completely unaware he had competition, continued to the end of his speech. The boar prudently decided not to tangle with Pushpendra Singhji, the maharaja's ADC. It continues to inhabit the garden, probably believing that this habitat had been created for its benefit, which in a way is true. It has never caused any trouble though people sauntering through the garden occasionally encounter it on the paths, which adds a certain excitement to the contemplation of botany.

## SHOOTING

A love of hunting permeates the court histories of the various Mughal rulers and conveys the era very well. In December 1610 a lion the Mughal Emperor Jahangir had just shot and wounded charged him. He was knocked to the ground by his companions trying to escape and Jahangir later recalled that two or three stepped on his chest as they fled. The lion seized the unfortunate man who carried the tripod (*sih-payah*) on which the emperor rested his gun barrel and mauled

him. Prince Khurram, the future Shah Jahan and others stepped forward and drove it off with swords and sticks. The contemporary *Jahangirnama* tells the story and thirty years later it was illustrated by Balchand in the *Padshanama*.[9] In the 1640 painting the emperor holds a gun almost as tall as he is, very straight with little lay-off for the stock. The barrel is dark metal, consistent with Persian watered-steel, and there is gold decoration at the breech and muzzle.

A *Jahangirnama* entry in 1618 describes how the Emperor Jahangir heard of the presence of four lions and set out on elephants with the ladies of the harem to shoot them. Nur Jahan obtained his permission to shoot and despatched all four. Greatly impressed Jahangir scattered a thousand gold coins (*ashrafis*) over her head and gave her a pair of pearls and a valuable diamond, remarking: 'Until now such marksmanship had not been seen from atop an elephant and from inside a howdah she had fired six-shots, not one of which missed...'[10] Jahangir apologizes in the *Jahangirnama* for shooting a lioness: 'Although it is a rule with me not to hunt anything but males...'[11] He also says: 'I am an avid hunter of everything that can be hit with a gun, and I have shot eighteen antelope in one day.'[12] This was probably achieved by having all the game driven into an enclosure, a *qamargha* hunt. Jahangir describes an occasion on 30 December 1611 in Samugarh when he noted the many antelopes in the vicinity and had them rounded up into an area of land a kos[13] and a half surrounded by a *saraparda* (a cloth wall):

> I entered the qamargha with the women of the harem and hunted as much as I wanted. A few were captured alive, and some were shot with gun and bullet and killed. On Sunday and Thursday on which days I do not shoot animals, they were caught in traps. During these seven days 917 antelopes, male and female, were hunted.[14]

The texts explains that 276 antelopes were killed and eaten by people at the court and the rest were released.

On his return to France from India, François Bernier (1620–88), personal physician to Prince Dara Shikoh, the elder son of the Emperor Shah Jahan, wrote *Travels in the Mughal Empire*, his reminiscences of the Mughal court. He was particularly informative about the emperor's extravagant hunting arrangements. Bernier explains that no hunting was permitted on Imperial lands, which were consequently well stocked with animals. 'Of all the diversions of the field the hunting of lion is not only the most perilous, but is particularly royal; for, except by special permission, the King and Princes are the only persons who engage in the sport.'[15] One sees this rule applied in a painting of 1635 from the previous reign when Shah Jahan shoots a lion from an elephant. No one else possesses a gun.[16] The ruler's power over fierce animals was part of his mystique. Fights between elephants were very popular at Indian courts, regarded at the Mughal court as symbolising conflict for dynastic succession. For centuries elephants were symbols of royalty and also military power because of their role on the battlefield. Indians and Britons enjoyed fights staged between animals involving tigers, buffaloes, bears, rams, cocks, mongoose and snake but these gradually ceased over the nineteenth century. However the great Mughal hunts, either on horseback or using elephants, served as a model for local rulers who became increasingly autonomous and needed to emphasise their status as the Mughal Empire splintered. An account from 1778 says:

> The Vizier, Asoph Ul Doulah, (Nawab Asaf-ud-Daula of Awadh, 1775–1797) always sets out upon his annual hunting party as soon as the cold season is well set in; that is,

Aurangzeb hunting lions, c. 1670-80. The hunted animals are surrounded by nets, the Emperor himself is well protected by a wall of spearmen riding buffaloes and his companions possess considerable fire power. This is a royal display, far removed from the personally dangerous hunting practices of the earlier Mughal Emperors. In the distance is the Emperor's hunting camp, a city of tents. Chester Beatty Library, Dublin, 11A.28

about the beginning of December; and he stays out till the heats, about the beginning of March, force him back again. During this time, he generally makes a circuit of country from four to six hundred miles...[17]

And:

The arms he carries with him are a vast number of matchlocks – a great many English pieces of various kinds – pistols (of which he is very fond),[18] a great number, perhaps forty or fifty pairs – bows and arrows – besides swords, sabres, and daggers innumerable. One or more of all these different kinds of arms he generally has upon the elephant with him, and a great many more are carried in readiness by his attendants.[19]

The vizier used to amuse himself by shooting from his palace window at the pots of water being carried on the heads of people passing to and from the river. Johnson, a visiting Englishman, said he was a good shot but the Vizier apparently remarked that it 'was of little consequence if he killed anyone having plenty of subjects in his country'.[20] The vizier had a collection of 1,500 double-barrel guns and a passion for Manton guns.[21] Johnson had a double-barrel Probin,[22] which he refused to sell though offered a large sum.

Asaf-ud-Daula's successor travelled every March, April and May in much the same way: 'All the court, great part of his army, and seraglio, accompanied him, a guard only being left for the protection of his capital. About ten thousand cavalry, nearly the same number of infantry, thirty or forty pieces of artillery, and from seven to eight hundred elephants attended.'[23] To this must be added an army of servants, camp followers and all the requirements of a town on the move.[24]

Early in the morning his Highness left his Palace at Lucknow, with a number of noisy instruments playing before him; as soon as he was clear of the city and suburbs, a line was formed with the Nawab Vizier in the centre, generally on an elephant elegantly caparisoned, with two spare elephants, one on each side of him. The one on his left bore his state howdah empty; the other on his right, carried his spare guns and ammunition also in a howdah, in which two men were placed to load the guns, and give them to his Highness when required, and to take back others that had been discharged. Several guns were kept ready loaded with ball and shot, on each side of the two elephants. I believe that I am within bounds, when I say that he took with him from forty to fifty double barrel guns, besides a number of single barrel long guns, rifles, and pistols. Behind him were several beautiful led horses handsomely caparisoned.[25]

Such a journey was an excellent way for a ruler to see conditions in his country for himself, dispense justice, exercise the army and be seen by his subjects in the most impressive and powerful manner possible. Besides these considerations, hunting was a pleasure with a severely practical aspect, the removal of animals that preyed on the population or depleted their crops.

Most hunting was conducted in a simpler manner. The French traveller Jacquemont describes how his friends William Fraser and Colonel James Skinner decided to hunt lions for amusement near Hansi in 1815. They considered using an elephant and howdah unexciting so

Aurangzeb shooting nilgai, attributed
to Hashim, Mughal 1660.
Chester Beatty Library, Dublin.
MS. 11, NO. 27.

they improved the odds for the lions by agreeing to use matchlocks and to hunt from horseback.
Frazer alone accounted for eighty-four lions, wiping them out in the area 'but lost a number
of horses in the process'. What the three of them thought about shooting from an elephant is
described by Jacquemont in a letter home in 1830:

As for lions and tigers, that is the most harmless of sports (for gentlemen that is to say),
since they are not hunted on horseback, but only from an elephant. Every huntsman is
perched up like a witness in an English court of justice, in a very high box strapped to
the animal's back. He has a small park of artillery at hand, comprising a pair of guns and
a pair of pistols. It sometimes happens, though rarely, that when the tiger is brought to
bay it leaps on the head of the elephant; but that is nothing to do with the likes of us:
it is the business of the mahout, who is paid twenty five francs a month to put up with
this sort of accident.[26]

Men frequently shot from a *machan*, a seat roughly rigged in a tree over a kill which Indian women never used. Rajput women often shot from a *jharokha*, an enclosed projecting balcony, or else established tented enclosures in the jungle where they could maintain purdah but still hunt, often on horseback. Indian States had very well equipped hunting lodges where one could sit on a chair on the roof terrace and shoot game driven passed.

Johnson wrote in 1821:

> In many parts of India, animals of prey are numerous, and in other parts those only are found which destroy vegetation; wherever either or both are found, it is absolutely necessary that the farmers or villagers should have some contrivance for their destruction, in order to preserve themselves, their cattle...[27]

Even today in India one can see nilgai[28] heading for cultivated fields as dusk falls. Farmers must guard their crops overnight or have them stripped bare. There are many miniature paintings of Mughal emperors shooting nilgai, which were a source of food for the court. Indian hunting arrangements were copied by British ICS officials who recognised the administrative benefits of touring their region. This was strikingly different to the ambitions of nineteenth-century European hunters who arrived in India wanting trophies to hang on the wall in their homes, side by side with Oriental arms, all of which suggested their owner's affluence and masculinity. The great country houses of Britain added exotic foreign trophies to the stags' heads that adorned their draughty halls. Stuffed animal heads from India and Africa were very much on display at the Great Exhibition of 1851. The Mutiny of 1857–8 showed the interests of the Indian princes and British Indian administrators lay together and in time aristocratic Britons and Indians found they shared many of the same values. Baden-Powell epitomises the sense of duty, patriotism, honour, love of natural history, dangerous military and hunting exploits and male fraternity that has its counterpart in Maharaja Sir Pratap Singhji, the great warrior sportsman, three times Regent at Jodhpur, who the Victorians idolised as a great sportsman and the epitome of Rajput chivalry. Both shared a passion for pig-sticking, a very dangerous sport. The martial ranks of Indian society had always hunted, regarding it as excellent training for war, and the upper-class British shared this tradition, many of the most avid hunters being military men.

Leopards have a reputation for being supremely dangerous because they are cunning as well as courageous. Leopard and panther are the same species, panthers being merely cases of melanism. Black panthers are found all over India but are more common in the south. Panther skin was sought by sadhus as prayer carpets. Some animals challenge panthers such as the langur monkey, a deep *hoo! hoo!* call, as do peafowl, barking deer and chital. Leopards spend a lot of time up trees, climbing so well that they catch and eat a lot of monkeys. Very frequently leopards kill domestic cattle and a constant battle is fought against such depredation. In the 1850s Pratap Singh regularly went hunting with his father Maharaja Takhat Singh. When Pratap was nine they came upon a recently killed sheep and spread out to beat the hill for the predator. Pratap Singh saw the bloated panther sleeping in the shade of a slab of rock. He intended to shoot it but when he reached the rock decided it would be exciting to kill it with his talwar. He had half-drawn his sword when the panther awoke and raised its head. Abandoning the sword Pratap Singh raised his gun, which the panther seized in its jaws. Pratap pulled the trigger and the panther died instantly. Though he scolded his son for his foolhardy behaviour the maharaja

328 MAHARAJA GAJ SINGH OF (BIKANER) HUNTING

र महाराजा गजसिंह शिकार में

Maharaja Gaj Singhji of Bikaner goes hunting. Eighteenth century, no date. Note the three matchlocks with painted stocks and prong supports for the muzzles. (r.1745-1787).
RJS 2037 Mehrangarh Museum Trust and His Highness Maharaja Gaj Singhji II of Jodhpur–Marwar

was delighted, narrating the story with pride to his sardars, calling him *Banka Bahadur* (Urdu and Marwari: ever victorious champion).

Pratap's knowledge and liking for animals was only exceeded by his daring. As a small boy he wrestled with one of the monkeys on the fort wall. It is said that one hot day he deliberately crept into a pitch-black cave where a tiger was known to be lying up and lit a match. When the startled tiger sprang at him he blew out the match and dived flat so the tiger passed over him. In the 1880s Sir Pratap established a school at Jodhpur for the sons of thakurs and jagirdars. He took a close interest in the boys' education and was particularly keen to inculcate in them a proper Rajput spirit of manliness and courage. With this objective he introduced a fully grown panther into the school, which the boys were expected to wrestle. The panther was muzzled and thick leather gloves were fitted over its feet but even so 'it was capable of giving a very good account of itself in a rough and tumble'.[29]

The opening of the Suez Canal made India far more accessible to Britons and great play was made of the hunting and sporting aspects of the visits by the Duke of Edinburgh in 1869 and by the Prince of Wales in 1875–6. This period coincided with great improvements to firearms.

To read Frederick George Aflalo's majestic *The Sportsman's Book for India*, published in 1904, is to enter another world, now epitomised by faded sepia photos of Indians and Europeans proudly showing off their hunting trophies and the innumerable stuffed heads that line the walls of the princely palaces and regimental messes of India and Pakistan. Aflalo's book is dedicated to 'His Excellency General Viscount Kitchener of Khartoum G. C. B.', commander-in chief of the magnificent Indian Army at the high point of its Anglo-Indian existence. Nearly a century had elapsed since Captain Williamson of the Bengal Army had written *Oriental Field Sports*, dedicated to 'His Majesty King George III', telling Britons of the sporting possibilities offered by India. Hundreds of books published subsequently had told of individual sportsman's adventures but, as Aflalo remarked from his home in Bournemouth where he edited expert contributions, 'there has not up to the present been any one manual essaying to offer sound practical information on any and every outdoor pastime that may in that country fall to the lot of the official, military, or civilian, planter or even bird of passage.'

Sport was an obsession in India and Aflalo's book describes this from the British perspective – shooting, fishing, sports and games involving horses such as pig-sticking, polo and hunting with hounds. The final section considers minor sports and games such as cricket, football, golf, hockey, tennis, yachting, gymkhanas and, somewhat surprisingly, cheetah hunting. 'This sport, popular with the native princes, is a form of coursing where cheetahs that have been starved for twenty four hours to make them keen are released to run down deer.' These Asiatic cheetah, slightly smaller than the African example, were imported from Iran though they were once common in the Arabian Peninsula, the Near East, the Caspian, and the subcontinent.[30] Three of Tipu's cheetahs with their keepers were sent to King George III in 1799. The Prince of Wales visiting India in 1921–2 was introduced to cheetah coursing but he and his companions found it cruel and un-British.[31] Aflalo captures the spirit of the age when he wrote that it was 'a sport little known to Europeans, who prefer, as a rule, to take an active, rather than a passive, part in the pursuit of game of any description.' The robust energy and adventurous nature of Britons of that time is epitomised by the fact that one of Aflalo's authors sent in his manuscript from a hunting camp many thousands of feet up in the Himalayas; while the author of the section on pig-sticking was unable to keep to his deadline because of a pig-sticking accident!

As far as shooting is concerned Aflalo's book marks almost the end of an era as some of his contributors are astute enough to recognise. Lieutenant General Sir Montagu Gerard remarked that tigers (and bears and in some areas panthers) are now found in comparatively limited areas and are practically extinct in districts where they abounded half a century ago. He blamed the advent of the railways and increased cultivation, together with improved firearms and said their survival was solely because they were protected by physical conditions or strictly preserved by native chiefs.[32] Game has everywhere been reduced and in some places exterminated. Aflalo himself remarks that 'if the India of today may still claim to be reckoned very high among the sporting countries of the world, its opportunities forty years ago must have been fourfold'.

Elephant shooting is omitted from Aflalo's book because the sport was practically confined to such jungles as Mysore and Travancore where the maharajas from time to time permitted distinguished visitors to shoot. There were elephants in other parts of India but in those parts under direct British rule the elephant was preserved though rogue elephants and those destroying crops were still shot. The earliest 'Act to prevent the indiscriminate destruction of wild elephants' was at Madras in 1873. Other regional Acts followed, culminating in the Elephant Preservation Act no. VI, 1879, which applied to all of British India.[33] By 1904 Aflalo

FACING PAGE:
Akbar hunting with cheetahs.
From an *Akbar-nama* painted by
Basawan and Dharam Das.

۱۲

could write that the elephant was preserved in all British territory. Other maharajas like the Maharaja of Kashmir took note and limited the number of licences issued for specific game.

In the latter part of the nineteenth century Colonel Cuthbert Larking[34] described the preparations for his first shooting expedition in India.

> All of us, except Lauder, were quite new to big-game shooting; so that we drank in his anecdotes of former shikars with the greatest avidity, and he sent us off to bed dreaming of tigers, panthers, and other quarry. Next day we devoted ourselves to overhauling our kits and seeing that everything was in order. My battery consisted of a .500 Express, by Holland and Holland, a No. 10 smoothbore, by Moorson, and a pair of No. 12 smoothbores, by Boss. I had ball-cartridges made for all my smoothbores, and provided myself with an immense amount of ammunition from Rodda and Sons, of Calcutta. On an expedition like this, it is always as well to have a great deal more ammunition than is really required, for so many accidents may happen to it, carried about as it is on coolies' heads, or in rough bullock-bandies, through the jungle, and, as we should probably be between two and three hundred miles away from our base, it would have been very annoying to run short. Doctor Lauder, who managed the whole expedition, made a most excellent bandobast,[35] and seemed to have provided every luxury he could think of – such as champagne, hock, claret, sherry, two hundred dozen of soda water, pâté de foie gras, liqueurs, and other similar things too numerous to mention. His Highness the Nizam kindly lent Paget and myself two of his staunch elephants, which, with the Vikar's three, had already gone on some days. The Vikar had also sent on eleven riding horses, three camels, seventy-two bullock-bandies, twenty sowars, and a like number of Rohillas, two complete sets of camp tents and cooks, and had arranged that we were to have a post backwards and forwards every two or three days, though sometimes this would entail a ride of from one hundred and fifty to two hundred miles for the sowars who carried it. We calculated that our party, including soldiers, servants, and followers, would number about two hundred and fifty men, a large body to move in a country with no roads, and where most of the provisions had to be carried about with us.[36]

Larking commented on the fact that people starting for the first time on a shooting expedition were inclined to take a quantity of useless things and he therefore listed the things he regarded as necessary. A good supply of flannel shirts, then a couple of shikari suits, made by a native darzi…Two pairs of sambur leather boots, with cotton soles, are useful for walking in the jungle: they prevent one slipping on the smooth rocks, and also deaden the crackling sound as one treads over the dry leaves. A couple of pairs of leather gauntlets, with air holes in the back, will save the hands from a good many scratches while riding through the thorny jungle; and a belt carrying a small pocket hatchet and saw, to clear the front on a tree, or to cut tempting-looking walking sticks, will be found handy. Two solar-topes, and a pad to go down the back, are also absolutely necessary.[37]

Obtaining the loan of an elephant from an Indian prince required considerable diplomacy and largely depended on the prince's estimation as to the status of the sportsman. Tiger shikar for sport by the more important sportsmen was usually conducted from the back of an elephant with a large number of village beaters whose task was to drive the tiger towards the waiting guns. The power of a tiger is illustrated by a Rajput story of a tiger that broke

Maharaja Man Singh of Marwar and his court enjoy an elephant fight. Early nineteenth-century. RJS2075 Mehrangarh Museum Trust and His Highness Maharaja Gaj Singhji II of Jodhpur–Marwar

through a line of beaters, leaping over one man. A forepaw hit the beater on the top of his head and decapitated him. The tiger vanished and though the head was searched for it could not be found. Later it was discovered that the force of the tiger's blow had pushed the head into the man's thoracic cavity.

For centuries tigers were very numerous and considered dangerous vermin. The French seventeenth-century traveller Thevenot wrote: 'Though the Road (between Agra and Delhi) I have been speaking of be tolerable, yet it hath many inconveniencies. One may meet with Tygres, Panthers and Lions upon it…'[38] This was no exaggeration. Johnson recalled how early in the nineteenth century, British officers were allotted money to keep open a road and to cut the jungle back on either side for fifty yards 'without which, it would have been dangerous in the extreme for any small body of people to have traversed that road, the tigers being so numerous'.[39] The East India Company (EIC) introduced rewards for killing tigers in the eighteenth century and there were also rewards for killing panthers and leopards which lasted into the twentieth century. One of the most celebrated victims of a tiger attack was the son of General Sir Hector Munro who in 1792 was carried off while picnicking with friends. Williamson wrote in 1808 of the dangers to travellers of tigers, adding that:

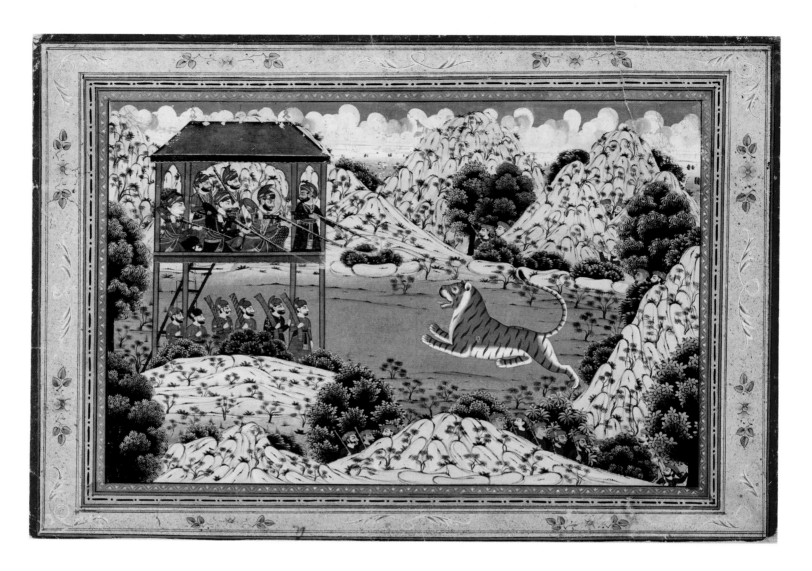

Hunters on a *machan* shooting tigers. The guns are held well away from the face and body without any use of the shoulder or proper sighting. Maharana Swaroop Singh of Udaipur, b. 1815, ruled 1842-1861. RJS 3988 Mehrangarh Museum Trust and His Highness Maharaja Gaj Singhji II of Jodhpur–Marwar

The death of a tiger is a matter of too much importance to be treated with indifference. The Honourable East India Company, with a view to prevent interruption to the common course of business, and to remove any obstacle to general and safe communication, bestow a donation of ten rupees, equal to twenty-five shillings, for every tiger killed within their provinces. The Europeans at the several stations situated where the depredations of tigers are frequent, generally double the reward.[40]

In the second half of the nineteenth century it was estimated that tigers killed 1,600 people a year in India[41] and considerable numbers of cattle. Jim Corbett mentions a man-eating tiger that had killed about 200 people in Nepal before moving to Kumaon where it killed a further 234 people, one a week over four years, before it was shot. The removal of tigers was a duty as well as a privilege of rank which Indian princes and British administrators across India took on with delight tempered with respect. The usual practice was to sit up over the corpse in a *machan* and shoot the tiger or leopard when it returned to its kill. The perils of travel in India were described by the experienced Hugo James who wrote in 1854: 'In traversing a district covered with jungle, travellers should be careful to have fire-arms by them; in fact, no one ought to move in India without pistols. If men do not attack you, possibly a tiger or some other denizen of the forest will suddenly pay you an unwelcome visit.'[42] His advice to coarse fishermen in India was also novel:

The Terai abounds with every species of game, whilst fishermen can enjoy their peculiarly English pastime, either with or without the fly. This is rarely employed with success in the Bengal rivers, as the fish seldom rise to an artificial bait. In some of the hill streams noble specimens of trout leap over falls and rocks with wonderful agility. Hook one of these gentlemen, and I will trouble you to land him in a moment. Here let me inform those who are fond of piscatory amusements, and who purpose going to India, that it is advisable to furnish themselves with a good set of tackle previous to leaving England, as otherwise they may find some difficulty in obtaining it. The angler should always take the precaution of having by his side a double barrel gun, loaded with ball; very dangerous encounters have occurred quite unexpectedly, particularly when the banks of the river are covered with thick jungle. Tigers have been known to spring unawares upon their totally unprepared victim, thus monopolizing the sport. Perhaps the more harmless deer may visit your fishing ground, in order to quench his thirst: shoot him, my dear sir; do not remain too long admiring his symmetry, his branching antlers, and elegant movements; he will be off as soon as he perceives your vicinity, and you will be minus a delicious addition to your jungle larder.[43]

Nicholson, an ICS man, made it a rule that if ever a tiger was seen he was to be informed at once. Public business was at once abandoned for the hunt, common practice across India, but Nicholson's chosen means of killing tigers was unique. He liked to ride his terrified horse in circles ever closer to the tiger until he could lean from the saddle and kill it with a sword. The God-fearing Nicholson who ruled with Bible and sword was one of the bravest of the brave, so much admired that some Indians worshipped him as a god. He was so troubled by these disciples wanting to touch him that he had to issue orders that anyone who did so would be flogged which greatly added to his allure. The tiger was regarded with grim admiration, hunting a game where the best men matched their wits and courage with that of their quarry. In Bengal, a collector at Tipperah was killed by a tiger, which he thought he had shot dead the previous day.[44] Villagers argued that once reduced to reasonable numbers the damage tigers did to their cattle was more than compensated for by the tigers keeping down wild pigs which otherwise ruined their crops. However coexisting with tigers brought problems as events in the late nineteenth century at a remote railway station demonstrate:

The smaller railway stations only boast as a rule two baboos – the station master and the telegraph clerk....a telegram was received by the traffic superintendent at Calcutta, from the baboo at some distant little station.

'Calcutta Mail due, tiger at points. What shall do? Waiting orders.'

Then a minute later came a frantic appeal – 'Tiger in station! Baboo on roof! Wire instructions!'[45]

In 1899 Lieutenant Colonel Archibald Adams claimed that 'the tiger is still to be found in many parts of Marwar and Sirohi although he is yearly becoming scarcer, and must shortly follow the fate of the lion and cease to belong to the fauna of these jungles.[46] In the Maharaja of Jodhpur's copy of Aflalo's *The Sportsman's Book of India*, published in 1904, was written: 'In Kathiawar, the

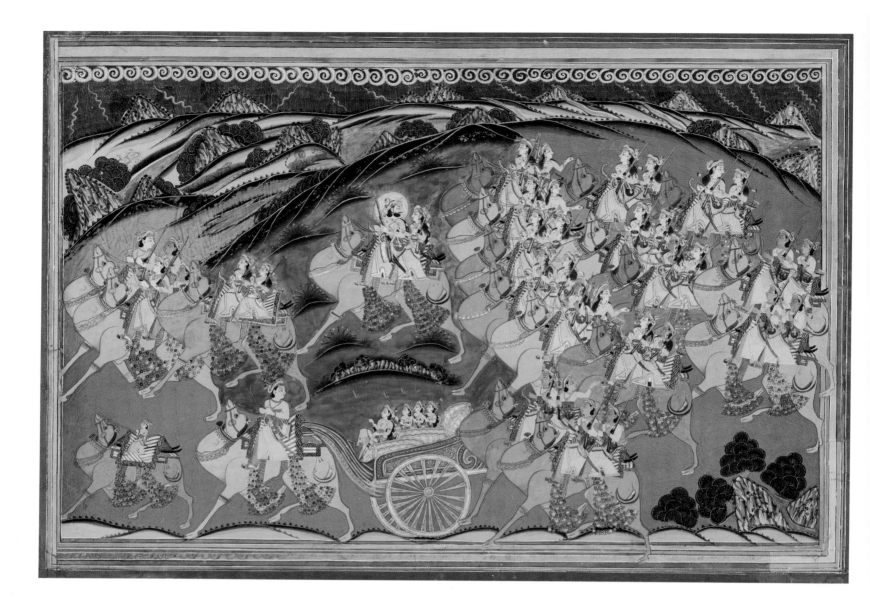

last home of the Indian lion, which, but for the nawabs of Joonaghur, would now be extinct, the tiger is absolutely unknown, as it likewise is in Bikaner, Jodhpore and other more or less desert tracts.' The word 'Jodhpore' is firmly underlined and in the margin Maharaja Umaid Singhji has written a crisp 'No!'.

In the north from the Terai down to the Bramaputra, jungle often consisted of enormous stretches of giant reeds, in some places eighteen-feet high, intersected by streams and quicksand where nothing could be achieved on foot. Local guides were essential and the probable success of the sportsman was directly related to the number of elephants he had in his party. A party of half-a-dozen guns would require about fifty howdah and pad elephants, the former for riding and the latter for carrying supplies. These could not be simply hired but had to be begged or borrowed and much depended on contacts and importance. In 1876, when the Prince of Wales was the guest of the Nepalese prime minister in the Terai, the latter assembled 500 elephants to ensure good sport. A line would be formed, the pad elephants interspersed with the howdah elephants, which would advance, beating the jungle. This sort of shooting required neither woodcraft nor even fine shooting as one often fired at a patch of moving grass. Men took their wives, cold drinks, sunshades and dressed without concern for camouflage. Sir Montagu Gerard, with his experience of tackling tigers on foot, was

unimpressed, remarking that 'there is not the smallest risk incurred to any save possibly the mahouts or people on the pad elephants', describing it as 'altogether a thoroughly Oriental rather than English form of sport' though decidedly interesting because of the great variety of game that might be flushed from cover.[47]

In contrast to this sybaritic form of hunting, in many parts of India the tiger was pursued on foot so physical fitness was essential. A two-month shooting leave involved walking three or four hundred miles as reports arrived of tigers killing cattle, forcing the hunter to zig-zag across the region, moving camp ten or a dozen miles several times a week. In central and southern India, except in reserves, there was often only a pair of tigers or perhaps a family of three, four or five tigers in an area of two or three hundred square miles. Good local shikaris would know where there was water where tigers might lie up in hot weather in March, April and May when water is scarce. At this season the gun barrel could become so hot as to blister the hand. An experienced man knew his bearer might not be close at hand in the jungle with the .577, which was heavy to carry on a long march on a hot day: many carried a .500 as a second gun on a sling over the left shoulder, butt first, in case they suddenly needed it. A large mature tiger weighed between 400 and 450 pounds and in scrubland could charge at up to twenty paces a second. In the Indian jungle game is seldom seen beyond fifty or sixty yards and a tiger's brain, the optimum target, is a mere two-inch square. If the tiger was wounded it became the personal responsibility of the hunter to track and kill it, the most dangerous game in the world. Often the hunter became the hunted. The hunter needed iron nerves and the ability to read the warning bell of a sambur, the bark of a karkar or muntjac, the alarm call of monkeys and birds to tell him where the tiger was. Corbett describes tracking a tiger through thick scrub where he noted that the grass on which the tiger had briefly lain was just springing back up, which he judged meant that he was within a minute of it without knowing precisely where it was. For this a gun was needed to suit the game being hunted and the strength of the user. In India a heavy rifle with good stopping power was preferred for big game while in Africa lighter rifles were used. One cannot better the advice given by Gerard, a tiger hunter of great experience, who suggested that the useful all-round weapon in 1904 was something between the .500 Express of the past and the modern .265 Mannlicher.

> It is a very different story indeed when you are selecting a rifle intended specifically for tiger shooting under all conditions, one whose stopping power you must, when following up a wounded beast on foot, entrust your life. As to the best for this purpose, opinions differ widely, but one can unhesitatingly say, that, no matter what calibre you may adopt, a double barrelled weapon is alone admissible, and that your rifle should be absolutely flush sighted, and the stock have exactly the same length and 'cast off' as the shot gun to which you are accustomed. It is scant satisfaction to know that you can hit an egg with it at a measure of 150 yards, when there is a trajectory of about six inches at some unrecorded intermediate point. What you do want to be assured of is that, if only you hold straight, you can hit a charging animal by a snap shot through bushes or grass, within anything from three score to a dozen yards of you.[48]

Corbett gives an example of this when circling round a fallen tree which he believed hid a wounded leopard. He made the radius of the first circle about twenty-five yards and was part way round when his attention was drawn to his dog which had halted.

There were a succession of deep-throated, angry grunts, and the leopard made straight for us. All I could see was the undergrowth being violently agitated in a direct line towards us, and I only just had time to swing half right and bring the rifle up, when the head and shoulders of the leopard appeared out of the bushes a few feet away. The leopard's spring and my shot were simultaneous, and side stepping and leaning back as far as I could, I fired the second barrel from my hip into his side as he passed me.[49]

Corbett recalls that in all the dangerous times he had hunted with his dog this was the only occasion when it fled, reappearing late in a shamefaced manner.

Rifle makers will not realize that shots in an Indian jungle are fired under very different conditions from those which obtain in a Highland deer forest; and that the ticklish shots are just those at close quarters. The hollow rib with the foresight perched on a raised lump of metal at the muzzle is also an abomination, and suitable only for pot shots. All quick work must be dependent upon one's familiarity with a shot gun, and you should be able to chuck up and pull with your rifle at a galloping chance between trees as quickly as if firing at a woodcock in covert.[50]

Gerard was utterly against sights, which he regarded as a distraction when taking a snapshot, a wide V cut in the rib being all he allowed; and he disliked bottle cartridges because they required a thicker breech which made a man shoot high. Anything that diverged the line of fire from the line of sight was unacceptable.

For sporting purposes one does not want folding sights for any number of yards – 150, 200, or 250. What you require to know is at what range the bullet will have fallen an inch or so below the line of sight, and up to which you can aim as with a shot gun. It is beginning from this point, whether it be 75, 90 or 100 yards, that you want the first raised sight. In the case of a tiger one only fires at above a hundred yards under very exceptional circumstances, such as at an already wounded animal crossing over open ground.[51]

Gerard was not a supporter of small bores.

These with the Jeffrey's[52] or the Dum-Dum[53] bullet may be very deadly and they are extremely handy; but they have not the necessary knock down blow and the stopping power of a heavier bullet. It is just the difference between a rapier and a sledge-hammer. I have seen a tiger, shot practically through the heart with a 450 Express bullet, gallop 300 yards before falling. Indeed the man who fired at it, believed he had missed clean, as the animal did not even wince at the shot. For similar reasons, a solid bullet should be eschewed for such soft-skin beasts as tigers, panthers and bears. Broadside shots are the rule and a solid bullet passes through a tiger and wastes as much as half of its energy on the ground beyond; whereas either a shell or an Express bullet expends the whole force of its momentum on the animal itself.[54]

Initially Gerard used a 10-bore with 7 drams and a Calvert shell of 2¼ oz before asking Dickson of Edinburgh to build him a .577. It weighed 11 lbs., used 200 grains of black powder, and a

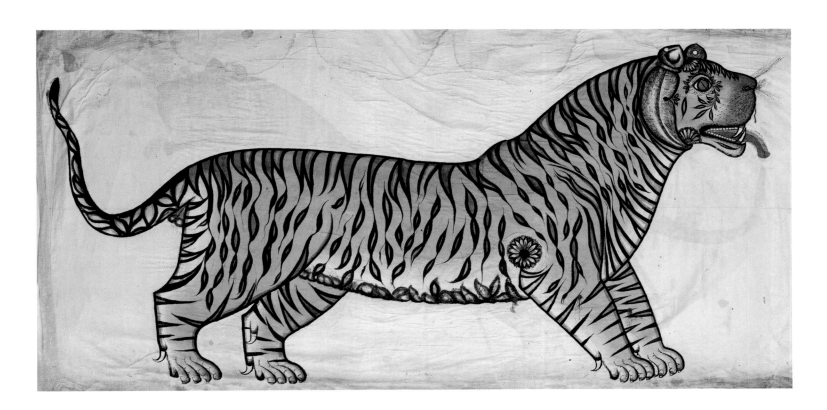

Shooting a tiger was a royal event and the hunter usually offered his quarry to the Goddess as an act of devotion. In some Rajput States, possibly all of them, it was customary to order a painting of the animal with the date and place of the kill recorded on the reverse. I am grateful to Nahar Singhji, Rawat of Devgarh for showing me three examples in the palace, one of which is dated 1849. Black dots often mark where the bullets struck the animal but lotuses, symbol of the goddess serve this purpose at Devgarh. Such paintings were gradually replaced by photographs.

540-grain hollow-tip bullet and was flush-sighted.

Gerard says: 'The securing of records becomes increasingly difficult as the game decreases in numbers...because the finest trophy was always selected to be shot leaving only lesser heads with limited chance to breed and grow.'[55] It was announced that Lord Hardinge, viceroy between 1910 and 1916, had shot a tiger in Gwalior with the record length of 11 feet 5½ inches. Lord Reading, a successor viceroy from 1921–25, followed this by shooting a tiger of 11 feet 5 inches, also in Gwalior. A lively correspondence followed this news in the *Field*.[56] A naturalist, Mr Dunbar-Brander, pointed out that Maharaja Scindia had himself shot between 700 and 800 tigers and been present at the killing of about 1,400 of these beasts but remarkably these record tigers only turned up to be shot by viceroys. Some hard questions were put regarding the method of measurement. One explanation, unknown at that time, was the existence of a special tape measure that was passed among the maharajas which generously stretched feet and inches. For the maharajas, hosting the viceroy and ensuring his happiness was politically important for the well-being of their states and the visits were very carefully managed. To ensure the viceroy got his tiger it was not unknown for the animal to be laced with opium so that it was doped at the time it was shot. Secondary marksmen were also occasionally used to ensure a satisfactory outcome.

Captain H. E. Gregory-Smith, the viceroy's ADC, repudiated the insinuation in the *Field*[57] and various gentlemen present when both these two tigers were shot swore that their measurements were accurate. Gregory-Smith stated that Lord Reading's tiger was measured 'as best we could' by three people and that it was lying 'in a dried up water course surrounded by rocks'. For this reason the body could not be measured between pegs. Lord Hardinge's tiger was measured by twenty-five people, also 'round curves'. Eighteen gentlemen signed a certificate headed by the maharaja as to the accuracy of the result. However, Lord Hardinge's troubles grew as the length of his tiger shrank. Mr Dunbar-Brander had an encyclopaedic knowledge on the subject and had published *Wild Animals in Central India* that very year. He was determined

to win his argument and in the same issue rejected this distinguished evidence. He pointed out that tiger skins generally stretch by about 1 foot 4½ inches in length once skinned, making them larger than life and cited an extreme example that had stretched by three feet.[58] Lord Hardinge's tiger skin defied normal practice by shrinking to 11 feet 4 inches!

Another letter to the *Field* facetiously suggested that vice-regal tigers should be regarded as a sub-species and be given the name *Felis tigris superbus*. The debate continued with great courtesy but overwhelming dissatisfaction regarding the measurement of the two vice-regal tigers. Measuring 'round the curves' was repudiated by some and the prevailing view was that, excluding tigers shot a century earlier when large animals abounded but actual results were not properly recorded, an 11-foot tiger was yet to be shot. It was publicly asserted by a correspondent that steel tapes existed which had twelve sections of 12 inches marked which had an actual length of 10 feet 6 inches but this was thought to be a mischievous intervention.

The Prince of Wales, later King Edward VIII, and his staff shot thirty tigers in 1921–2, five of which fell to the prince. He also shot two of the ten rhinoceroses killed by the party. The remainder of his bag was modest – 2 blackbuck, 1 chinkara, 1 sambur and one hamadryad.[59] He also shot much small game – grouse, ducks, demoiselle cranes etc. None of the larger animals were record specimens. The rifles and guns taken to India by the Prince of Wales are interesting and on the evidence of loans made to him in India he was poorly advised in London.

1. 400 bore express double-barrelled rifle, No. 21906, by J. Purdey & Sons, London. Barrels made of Sir Joseph Whitworth's fluid-pressed steel,[60] taking 47 grains low-pressure cordite, and 230 grains bullet.
2. 400 bore express double-barrelled rifle, by J. Purdey and Sons, London, taking 3 inch case, 47 grains low pressure cordite, and 230 grains nickel base bullet.
3. 280 bore single-barrel high-velocity magazine rifle, by Chas. Lancaster, No. 13097, taking 52 grains powder and 160 grains hollow bullet.
4. 450 bore rifle, supplied by H. H. the Maharana of Udaipur.
5. 470 bore rifle, supplied by H. H. the Maharana of Udaipur.

The prince borrowed a .470 bore double-barrel rifle by George Gibb to shoot a rhino. He also took two 16-bore double-barrel guns by J. Purdey and Sons, made of Whitworth's fluid-pressed steel.[61]

Having the Prince of Wales to stay was a great deal more than a social coup. Offering shooting of one form or another was a common means of influencing the administrative decisions of the officials of the British Raj, considered morally acceptable by all concerned. Maharajas did it on a grand scale. A former Rawat of Devgarh arranged the re-siting of a railway station to Khamlighat to his satisfaction by giving the engineer responsible a tiger shoot. Sport was a major part of the deep British love of India, an activity that brought them into close contact with the people, the country and its wildlife. Alfred Lyall, Eton and Haileybury, who arrived in 1856, delighted in his escape from 'frigid and formal' England must speak for many: 'I have only one chair of my own and but three teacups but I have two horses and four guns…'[62] These are values any Rajput would have shared. Lyall was made agent to the Governor General of Rajasthan and lived in the self-contained English community on Mount Abu which he regretted:

The people who live here regularly can think very little of the deserts about Jodpur whence I have come, where the cattle are dying from want of forage and they are praying to all their gods for a little rain, where you may see gaunt hard-looking men come riding in across the sands on camels with their matchlocks and water-skins slung beside them.[63]

In the 1890s Thakur Mangal Singh of Pokhran, a remote desert place 85 miles to the east of Jaisalmer, wanted wells built for his people which they badly needed. An Englishman, Mr Irons, newly arrived from England, had the means to deliver wells so the Thakur wrote to him offering him some hunting, hoping to ingratiate himself. After all, he reasoned, the sahibs are mad sportsmen. Much to the thakur's surprise and delight Mr Irons wrote back accepting the kind invitation, remarking that he had always wanted to shoot a bear. And there lay the problem. Pokhran was desert and was totally unsuitable country for bears, in fact there wasn't a bear living wild for miles…The thakur pondered this difficulty with his advisers and shikar men. Then he sent a trusted agent on a special errand 110 miles south to Jodhpur. This man took himself to Sojati Gate where he knew the men with dancing bears congregated at the end of the day. There he chose a fine shaggy sloth bear with all his teeth whose dancing suggested the beast was in robust health, hired the previous owner to look after it, and the party set out for Pokhran in a camel cart.

The Thakur inspected the bear in his stables where it frightened the horses and ate quantities of special food that had to be brought a long distance. It was a relief when the day of the hunt finally dawned. The thakur and his guest set out after an early breakfast and drove into the desert with the usual entourage of staff and servants. The thakur was an honest man and found conversation about the day's hunting prospects rather difficult but Mr Irons who was new to such things found the whole expedition hugely exciting. 'My chief shikar tells me this is a promising spot,' said the thakur, halting the cars at the foot of a massive dune which he viewed apprehensively. The thakur wished he had given orders for the bear to be driven before the guns at some comfortable hunting lodge where it could have been shot from a chair on the roof but everyone knew that strenuous exercise was an essential part of British sport. After some milling around, Mr Irons, a bearer, the thakur and a small party set out to walk with scouts out in front, supposedly scouring the ground for tracks.

The bear was sitting in the sand on the reverse slope, several dunes to the north. It didn't much like the desert, disliked walking up hill in the sand, and was generally being difficult. The thakur's best tracker was on the ridge keeping his eyes skinned for the hunting party while the bear's former owner and some of the thakur's men tried to placate it. A party of beaters made up the numbers. The day grew warmer by the minute. In due course the hunting party were seen trudging wearily over the adjacent dune. The bear's collar was slipped off and everyone tried to persuade it to walk over the ridge. The bear thought little of this but in the end it was pushed and cajoled to just below the top where it would go no further. It was a very puzzled bear by this time. The thakur and his guest were getting nearer. The beaters were a little afraid of the bear but this was an emergency. Keeping well below the ridge they seized their sticks and old metal pots and began to drum and yell and caper. The bear was startled and ran over the crest and then reacted instinctively in the manner that it had learnt pleased its master. It began to dance…

Mr Irons had his sights on the bear but, green as he was, even he could not mistake a dancing bear. He lowered his rifle and looked hard at the thakur. 'A very fine bear,' said the Thakur with

authority, 'just what you wanted!' Iron's remembered his request, remembered some fellows at the club who had nudged each other when he said he was going to Pokhran to shoot a bear, put two and two together and began to laugh. The thakur laughed with him, at first with relief and then the two of them fell about laughing together, the entire party joined in, and up on the ridge the bear danced happily, the laughter confirming to it that all was well.[64]

In the Shikarkhana (hunting) department at Jodhpur there are miscellaneous files dating from 1938–9[65] show the loss of two balam or pig spears, sundry purchases and wages and a high mortality among the goats bought by the department, mostly due to ill health or cold rather than by service as decoys.[66] British officers in India received two months leave a year and it was generally spent hunting. Permissions were granted, for example, to Brigadier Duncan 'to shoot crocodile and duck at Hemawas during the X'mas week'. The Indian recruiting officer in Ajmer writes to his friend the Rao Raja to say that he will be stuck in a village after work for twenty-four hours and could he have His Highness's permission to pass the time by shooting 'one or two blackbuck in the Jodhpur State Reserve on the Bikaner border?' The maharaja responded to appeals from villagers who signed their letters with thumb prints, authorising them to drive away pigs from their crops using blanks, 'the licence to cease whenever the Maharaja does shikar in the area'. Another letter: 'pigs and deer are very troublesome to the cultivators' in an area where hunting was reserved and there are other similar appeals. The preservation of game, the desire of the ruler who wanted hunting reserves, was a trial to farmers. Other appeals were more dramatic. A telegram dated 16 July 1940 reads: 'Complaints received by Superintendent Shikarkhana that two Bageras (panthers) are troubling people near Jalore one at Mayla Bas village Vethoo and another at Toskhavj Ki Baori stop Superintendent requests that His Highness orders for shooting may be obtained and communicated.'[67]

The Superintendent Shikarkhana responded the same day by telegram: 'Your telegram His Highness orders being obtained will communicate when received'.

At the same time the Comptroller of Household to H. H. The Maharaja Sahib Bahadur Jodhpur seeks instruction from Rao Raja Hanutsinghji Sahib. The file lacks a response but the next telegram dated 1 August 1940 has dramatic news: 'One panther cought [sic] alive at village Mayalabas District Siwana by villagers when it entered in one house kindly convey orders for it. Ramsingh'.

On 12 August the next telegram on file to the villagers reads: 'Kanwar Bijeysinghji and Harisinghji coming for panther shooting under His Highness orders at Jalore stop will stay at rest house Jalore Station Please render necessary assistance. Controller Stables'.

Another telegram from the Superintendent Shikarkhana demands: 'Please wire immediately whether panthers have started coming during morning hours'.

The Controller of Stable meanwhile instructs the Jamadar Shikarkhana Jalore to supply goats and render all possible help with shikar arrangements. At the same time the Comptroller of Household swings into action recording that all arrangements are chargeable to the Civil List of His Highness. One would like to know how long the panther lived in the villager's home but at this point the file ends…While this incident appears minor it is worth recalling the case of two leopards which between them killed 525 people.[68]

The author heard a good story when staying at Kilwa with the thakur and his family. A leopard had killed a cow and the villagers had called in their thakur to save their herds from future loss. He positioned himself against a large rock where he had a good field of fire. As the sun went down the mosquitoes came out in great numbers and made life miserable. It was far

too early for the leopard to come, it would be lying up somewhere enjoying the evening sun just as he was…so he lit a cigarette to pass the time. The smoke rose driving away the flies and he sat contentedly, rifle across his knees. His reverie was broken by a little cough. Looking up he saw the leopard looking down at him, sitting on the rock a few feet above him, wreathed in his cigarette smoke.

The last lions were shot in Marwar near Jaswantpura in 1872 when Colonel Hayland bagged four of them. Maharaja Ganga Singh of Bikaner, a keen hunter, shot a lion at Junagarh as late as May 1941. Today they thrive in the wild in the Forest of Gir in Gujarat the sole remaining sanctuary for the Asiatic lion (*Panthera leo persica*) which once flourished across North Africa, northern Greece and south-west Asia.[69] The lions were reduced to twenty due to trophy hunting and the viceroy brought their imminent demise to the attention of the Nawabs of Junaghad. Their survival is due to the work of this royal family, in particular Nawab Muhammad Mahabat Khan III and his father. In 1965 the Nawab's former hunting grounds became part of a National Park and Wildlife Sanctuary and at the last count there are 523 lions. The Gir lions rarely attack people though they live in close proximity to them but they do occasionally attack livestock owned by villagers or the maaldharis, semi-nomadic tribesmen who live in the park. The lions are sometimes poisoned in retaliation or poached but the Asian lion is now safe from extinction, a triumph for conservation.[70]

In India the indigenous hunter was transformed by the end of the nineteenth century into a poacher by the creation of game and forest laws, administrative action and the separation of human and animal habitats.[71] Privileged sportsmen were permitted to shoot in the restricted forest areas where conservation created a high animal regeneration rate that more than outpaced shooting requirements. Restricted access to hunting reserves were closely linked to class and the development of a code that broke with the indiscriminate slaughter of animals of the first half of the nineteenth century and broke also with the historic reasons for hunting. In pig-sticking only boars were speared, though clearly sows ravaged crops as much as the males. The right to kill 'was in a sense legitimated by [the hunters] understanding of the quarry, its environment and its anatomy, and his knowledge of firearms and ballistics added an extra scientific dimension.'[72] Hunting was virile, calling for courage and judgement, and reflected the traditional values of the ruling classes. It has usually been the case that those interested in hunting have also been instrumental in preserving game but the Rajput relationship with tigers was historically more complex than that suggests. The Rajputs as the premier warrior caste of India identified with tigers as can be seen in a Charan[73] verse describing a tiger and tigress about to be attacked by hunters. The tiger is unafraid and his mate admires his fine *keshari*[74] coat: 'Rajputs wear this colour for the *johar*[75] but tigers wear it all the time.' Rajputs were taught to be slow to anger but formidable when roused. To fight and take life was a Rajput birthright, a privilege of caste.[76] The Rajput belief that warrior traits are passed through blood from one generation to the next has no scientific basis but culturally it holds good in much the same way that a good regiment embodies martial tradition and inspires a code of conduct. Shooting tigers fulfilled a cultural requirement rooted in centuries of conspicuous bravery by Rajputs.

Some maharajas shot hundreds of tigers. Despite this the princes as a whole cared deeply about preserving game and did a good conservation job. For example, Sir Laxman Singhji, the Maharawal of Dungarpur (1908–89) re-introduced tigers in his state reserves in the 1930s.[77] Donald Field, the British Political Officer at Udaipur, who was a keen hunter had wiped out all the tigers in the area. Field apologised and obtained a breeding pair from Gwalior, which

The Sardarsamand Farm and Dam was formerly owned by the Maharaja's of Jodhpur who maintained it as a reserve. It is bio-diverse and the Rajasthan Government Forest Department has recommended that this area be declared a protected reserve as it is home to endangered species like blackbuck, chinkara and migratory birds.

the maharawal named Bokha and Bokhi. Bokha lived four years under the close supervision of the maharawal. When his teeth were all gone and he could no longer fend for himself and had to be shot, Laxman Singhji commissioned a memorial to him behind the palace. Strict game laws were applied but this did not mean the end of all hunting and in the period 1928–50 forty-eight tigers were shot in Dungarpur. This programme is nevertheless counted a great success and it is undoubtedly due to the maharawal that Dungarpur State had twenty-five tigers at the time of Independence in 1947. Laxman Singhji loved hunting. Towards the end of his life he had to have a pacemaker fitted. He could shoot from the left and right shoulder with equal dexterity so prior to the operation he tried out each side to see which of his eyes offered the best vision so that the pacemaker could be fitted in the other side and his hunting could continue.

Although a keen hunter, Maharaja Umaid Singhji was greatly interested in wildlife and conservation and made generous donations of 500 rupees to the Bombay Natural History Society.[78] Shooting and conservation were not then considered mutually exclusive. The eminent academic Bernard Ellison F.R.G.S, C.M.Z.S., F.L.S. clearly saw nothing incongruous about writing an article about the Prince of Wales's shooting trip to India in 1921–2 in the *Journal of the Bombay Natural History Society*. The article appears alongside learned articles, many written by British officers, on Indian dragonflies, 'New and little known Indian Bombyliidæ, Orthoptera from S. W. Asia' and 'The snare of the Giant Wood Spider'. Ellison was the author of *The Prince of Wales's Sport in India* where he describes himself on the frontispiece of his book as 'Formerly Curator of the Bombay Natural History Society and Naturalist to the Shoots'. The prevailing system appears to have been effective because in 1947 at the time of Independence a government statistic put the total number of tigers in India at 47,000. Others estimated 70,000.[79] Pressures due to increasing population make direct comparison unreasonable but the World Wildlife Fund and Global Tiger Forum estimated the number of wild tigers in 2016 at 3,890. This is a catastrophic failure though after years of decline the number is believed to be rising. India's sporting princes had a deep-rooted understanding of the land, the requirements of people and animals and did a better job dealing with poaching and protecting habitat than modern Indian governments. However well-informed and conservation-minded the hunters were, public attitude hardened and by 1961 when Queen Elizabeth II and Prince Philip made a state visit to India and Nepal there was worldwide outrage when the latter shot a tiger. The event was a defining moment for big-game hunting in India. After 1976 it became illegal to shoot a tiger other than a man-eater for which a permit is required.

Modern India mixes new and old in its own unique fashion. Some years ago Raj Kumar Devi Singhji of Jodhpur had to shoot a man-eating leopard that had killed eleven people. He and a friend set themselves up shortly before dusk, sitting on the ground not far from the few mangled bits of flesh and clothing of the leopard's last victim, an old woman who had been gathering firewood. A goat was tethered by the remains. Shikaris sometimes rub very hot raw chillies on a goat's mouth to make it bleat and attract the leopard; or attach a fish hook with a line to the goat's ear to pull when it goes quiet.[80] The sun was sinking, the wonderful gold haze of evening when cows are driven back to villages and people get married because it is an auspicious time of day. Much to their surprise a villager hurried up to the goat and put his mobile phone on the ground by it. He then came over to the raj kumar and gave him a scrap of paper with the phone number, explaining that if the goat went to sleep and stopped bleating they should wake it up with a phone call...

The night grew darker and darker and the hours crawled by. Suddenly they heard a scuffle and could just make out a leopard with the goat's head in its mouth. The shot was instinctive, the leopard vanished. Both men thought it hit but the night was too dark to follow any marks. For several hours they waited, wondering if the leopard would return. Then a car came for them. As they walked across to it their torch revealed the dead leopard.

Today elderly Rajputs point to the stuffed heads of the animals displayed in their homes that they shot, often as teenagers when their fathers introduced them to hunting in the time-honoured manner of fathers and sons and acknowledge that what was normal is now unsustainable. The interest in wildlife remains and some have replaced the gun with the camera. The Rawat at Devgarh takes superb photos of leopards from a hide close to a cloth decoy with a wire frame containing a recording of a goat bleating. The decoy is carried off by the leopard on occasion.

Leopards never lose their fear of humans and if they become man-eaters they usually kill at night. Man-eating tigers by contrast have lost their fear of humans and kill by day when people are freely available. Mumbai is a densely populated city of 21-million people, the ninth most crowded city on the planet. Adjacent to Mumbai, the Sanjay Gandhi Game Park suffers from illegal building, which has encroached on the forty-square-mile reserve, home to about thirty-five leopards. The leopards, protected by law and untroubled by predators, have flourished and are far too numerous for the habitat. They frequently enter the Mumbai suburbs at night hunting for dogs to which they are very partial but they have also carried off a number of people every year, predominantly children.[81]

There are Raj stories of leopards taking dogs that were sleeping at the foot of their owner's bed and accounts of leopards entering tents and private houses in India are common. In earlier times leopards and tigers used to get in through the thatched roof or when a door was left open. One such incident was reported in the newspapers very recently. The leopard severely injured seven people in the house before being shot with a tranquilliser dart and released back into the wild, a better result than its victims received. Maintaining a balance between the needs of people and wild animals with finite land available for each remains exceedingly difficult and will require management including selective culling if the correct balance between species is to be maintained. The successes like the Forest of Gir point the way.

The Sardarsamand Farm and Dam owned by the Maharajas of Jodhpur was one of the first mechanised farms in India. A large part was left undisturbed as a habitat for wild animals, plants and birds. After Independence ceiling laws were introduced limiting landholding for individuals and Maharaja Gaj Singhji, seeking to hold together the large reserve at Sardarsamand, gave it to the local people. This gift was challenged in the courts by the State Government who took over this land and then leased mining rights. The National Green Tribunal intervened and non eco-friendly activities were restricted. The area is now bio-diverse and the Rajasthan Government Forest Department has recommended that this area be declared a protected reserve as it is home to endangered species like blackbuck, chinkara and migratory birds. Maharaja Umaid Singhji would surely have thoroughly approved of such an outcome.

His Highness
Maharajah Sahib
Shri Umaid Singhji
of Jodhpur's
(Marwar)
Sikar Diary

~~23. Jan.~~ 1926.
19.th May 1926.

---

His Highness
The Maharajah
of Jodhpur

A Khukari for
merry Smith
One Hollands
375. D.B.

Reward
Mahadeo
To ticket Bedan
on araminigas
Jodhpur
B & H.

One leather
close box for self
on safari

70-B: Super Speed Camera

Jam Beshen is getting too uppish

To send Capt merry Smith the
plans of the boddies
with the sliding roofs

asked
When I Beshen to coppy my
diary and send it to Jodhpur
he said that it was
a Bloody nuecence

---

| A | E | I |
|---|---|---|
| His Highness | E W Hayward | Moti Lal Compounder |
| **B** | **F** | **J** |
| Maharaj Ajit Singh | Rahim Khan | |
| **C** | **G** | **K** |
| Kanwar Beshen Singh | G Santan | |
| **D** | **H** | **L** |
| T. Ram Singh | Moti Lal | Fresh Khana and Kitchen |

# 7

# PAGES TRANSCRIBED FROM THE 1926 HUNTING DIARY OF H.H. MAHARAJA UMAID SINGHJI

Among the papers at Umaid Bhavan is a nondescript brown paper notepad labelled *His Highness Maharajah Sahib Shri Umaid Singhji of Jodhpur's Shikar Diary – 19th May 1926*. Like many diaries this one starts with good intentions but ends abruptly after three accounts written by Umaid Singhji in which he records hunting incidents that year. As an informal record of an Indian ruler and enthusiastic hunter the document could hardly be bettered.

## HIS HIGHNESS MAHARAJAH SAHIB SHRI UMAID SINGHJI OF JODHPUR'S (MARWAR) SIKAR DIARY. 19TH MAY 1926

*January 7th started to January 23rd; 16 days hunting. That leaves 8 days of January and 7 days of February. 15 days in all for elephant hunting. That leaves from 8th of February to the 5th of March for other game (16 days) 1926.*

### ADVENTURES WITH A ROGUE ELEPHANT

*I have been close to death on more than one occasion, but never so close as the time I lay between the fore legs of a rogue elephant.*

*It was in the summer of 1926 that we went down the Seajore Ghat to Arnakati in the foothills of Ooty. On arriving at the place we engaged two trackers and bought five buffalo calves for bait for the tiger, sending two out the same evening. For two days we had no kills and we spent the time taking walks in the jungle for chital and other game. The third day the tracker brought 'khabar' of a good bison nearby, so we started at once and after tracking for about 10 miles we lost the tracks. There was nothing to be done but go home.*

*So after having a little rest and some food we started home and divided into two parties Guman Singh and Capt Ambar going one way and Ajit, Pirthi and myself going the other. After walking for about two miles, we walked straight into a herd of bison feeding. There were fine animals altogether and only 30 yards from us. No sooner had we spotted them when they got our wind and off they went down the hillside, and we saw there was no bull among them. We were just about to advance when there was a tremendous crash in front of us and a bull bison came charging down the path and about 15 yards from where we stood.*

*We fired and the animal swerved off to the right and went down the hillside as fast as he could go. We did not think we had hit him, but on going to the spot where he had swerved off we found blood and as it was*

FACING PAGE:

The initial pages of Umaid Singhji's hunting diary, 1926

*getting dark by then we decided to look him up in the morning. On arriving home we were informed by the man who took the bait out that he had been charged by a rogue elephant. None of us took any notice of this. We asked the forest guard if there was a rogue elephant and he said that there was no rogue in the neighbourhood. The next morning we started at dawn and found the bison dead. We were all standing around the dead bison when a man came and reported that the tiger had killed the bait and that he was lying up close by. We lost no time in arranging the beat and sat in likely places along a dried water course.*

*The beat started and came closer and closer but the tiger did not come. After the beat was over we tracked the tiger and found that he had slipped out before we arrived and had moved up the hill. We beat another bit of the jungle little higher up, but the tiger had gone for good. So we turned home very tired and disappointed. We were just about halfway down the hill when we saw a huge elephant walk across a clearing in the jungle and disappear on the opposite side. We had gone about three miles further and were walking along an old elephant path when the tracker in front of me stopped and pointed, I saw about 80 yards in front the elephant come and stand on the path.*

*He was a magnificent sight, standing with his head raised and ears cocked forward. He had scented and heard us but had not seen us as we were just behind a big tree. He stood like this for quite two minutes feeling the air for any scent when two beaters came talking around the bend in the path. That was enough for him. With a trumpet that was heard three miles away he charged down the path. And now we made the worst mistake we could have made of running instead of standing behind the tree, for the elephant had not seen us and would have gone behind the two beaters, but as soon as we moved he caught sight of me at any rate and swinging round charged behind me. I was not aware of this at the time and was running from bush to bush. Just then I dropped my hat and was just going pick it up when I heard a shout 'Look out!' and on turning round I saw the elephant about 25 feet away with his trunk straight out in front of him. Getting round a small bush, I fired and noticed he drew his trunk in, but this did not have any effect on his pace and before I could fire again I felt the rifle knocked out of my hand and I fell backwards. As he went past he caught me with his leg and sent me sailing through the air for about 10 paces and when I opened my eyes again, I saw him kneeling over me with one of his tusks through my braces and shirt and into the ground, having pinned me down. The shot I had fired had broken his trunk and dazed him. All this happened in a moment. Ajit and Pirthi, who were just behind me, fired point blank into his ear. On receiving the shots the elephant got up and stood over me swinging from side to side. I was jammed in between his four legs and managed to crawl out and ran down a nulla. No sooner had I crawled out when he fell to the ground. Ajit and Pirthi had fired four shots and the tracker had run away with the cartridge bag and there we were without any more cartridges and the elephant was struggling to get up. All the shots were soft nose and had just stunned the elephant but had not penetrated to the brain.*

*The elephant slowly got up and we thought that the game was up, we were only a few paces from him. But all his fighting was knocked out of him by now and he was very glad to get away. By this time the tracker with the cartridges bag had returned and after reloading Ajit and Pirthi followed the elephant. They had gone about a quarter of a mile when they saw him sitting down in a thick bush. As the elephant saw them coming he tried to get up but Ajit put a bullet in his brain and he rolled over, never to rise again. He was a very big elephant and measured 9'.6" at the shoulder and the tusks were 6'.8" and 6'.5" and weighed 52 lbs each.*

*I was helped back to the little forest hut by two of our servants who had come as beaters and after having my head bandaged up and an ounce of brandy I felt quite alright again, except that I could not move my arms as they had been badly bruised in the fall.*

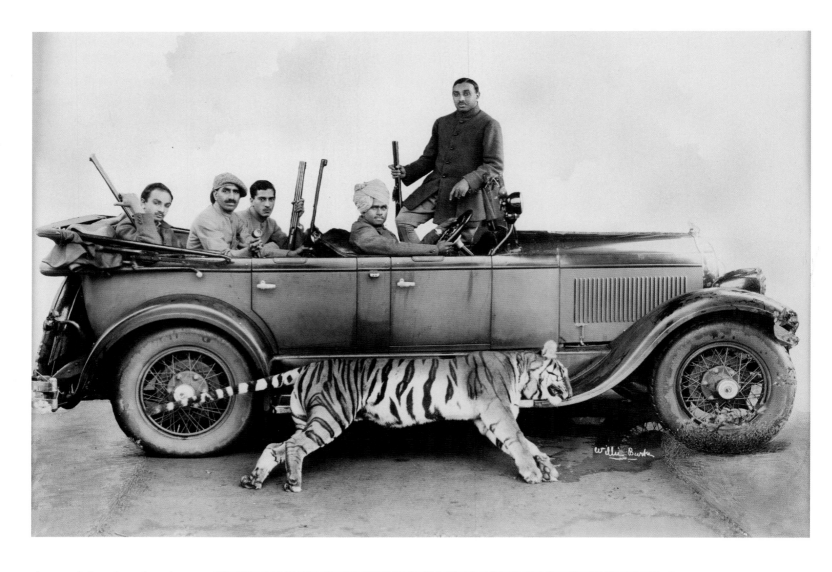

Photograph from the Maharaja's private albums.

## CLOSE QUARTERS WITH A PANTHER

*I was out inspecting a new railway line at Samdari and one evening we had nothing to do so we decided to go out for a drive to a bund about 12 miles from the station called Mali ka Bund. On our way back we were driving past some small hill at the foot of which was a small village. I looked up and there I saw against the skyline the head and shoulders of a panther sitting watching the village cattle coming home in the evening. He seemed to take no notice of the car and he looked huge in the light of the setting sun. We stopped and had a good look at him through our glasses. I had at the time a Purdeys light 400 rifle with me so I offered it to some of my friends with me, but they all refused. So I decided to try and stalk him from behind and have a shot.*

*Jodh Singh, the motor driver, who was armed with a stout jack-knife and I started to walk round the hill. When we got behind the hill we found that it was not as easy as it looked and the rocks were very steep and slippery, so I took my boots off and started to climb. The rocks were very sharp and hot and by the time I had gone halfway my silk socks had big holes in them. With great difficulty we reached the top and I was just going to get up on a big rock and look down on the panther, which I thought was further down the hill side when I felt my coat pulled from behind and on looking round I saw Jodh Singh pointing to the panther just behind the rock.*

*What had happened was that when walking round the hill I had forgotten to mark the exact place the panther was sitting and instead of climbing the bigger hill and getting above the panther, I climbed the hill*

he was sitting on. There was nothing to be done now. We were on one side of the rock and the panther on the other. The sun was just going down and there was no time to waste. So cocking my rifle I put the barrels over the rock and then I slowly stood up. No sooner had I got my head above the rock when I heard a growl and saw him spring at me. He was too close to allow me to put the rifle to the shoulder so, pointing the rifle at him, I pulled the trigger. 'Thank God' I had hit him for he rolled over backwards. I gave him the left to make quite sure and then a most funny feeling went through my body. I felt a cold shiver down my back.

On walking up to the panther I found that the hair around his left eye were all burnt with the charge of the powder from the rifle and that I had some spots of blood on the barrel of my rifle. The first shot had hit him just below the left eye and had smashed the head. He was a good size animal measuring 7'.1" round the curves and had a very nice winter coat.

## MY RIFLE MISFIRING AT A CHARGING PANTHER

I received a telegram one day from the headman of Minwrie that a panther was doing damage to their cattle and had even taken to killing camels. I sent a man out at once to enquire if it was true and if so to try and locate the panther. I heard a few days later from my man that he had seen the panther and that it was a very big one. A day or two later, after having made all the arrangements, we motored down the Pali-Earaupura road about 47 miles and then turned right and went cross-country along cart tracks for 18 miles and arrived at the village at about 4 pm.

After a wash and a cup of tea, we motored out about two miles from the village and leaving the cars in a small nulla walked for half a mile and came to the place the panther had killed a goat the night before. As there were very few trees in which 'machans' can be tied, we used 'odies', that is a cage made of thin wire netting with thorns all around it, the wire being there to keep snakes out. After I had sat in the 'odi' and made myself comfortable, a fresh goat was tied as there was nothing left of the previous goat. When everything was ready the men walked away and sat by the cars, taking the other goat, as we always keep two in case of accident with them and put it on one of the cars.

I sat for about two hours when I heard footsteps coming and soon saw the men coming towards me as it was a moonlit night. On coming up they told me that as they were sitting between the two cars they heard the goat get very excited and try to jump out and on looking up they saw the panther just about to jump in the car at the goat. On seeing the men the panther made off towards the village that there was not much chance of him coming my way. I was rather glad to get out of the 'odi' as the evening was getting quite cold and I only had a pullover on and no coat.

On getting back to the village we saw our lorry lying but no servants and, on going close, we found them all hiding inside the lorry. On seeing us they told us that two panthers have been fighting quite close by them and took no notice of the noise they made with the horn in the lorry. So they got frightened and hid in the lorry. On hearing this we all jumped into Ajit's car, a great big Chrysler. Ajit was driving, I was sitting beside him and at the back were about five others jammed in together, and we all drove off in search of the two panthers. Just as we got on the other side of the little tank we saw two eyes in the distance and we all got wildly excited. Ajit forgot that he was driving and ran the old car right on a great big boulder and there we stuck and the panther disappeared over a small rise.

We all got out and after about a quarter of an hour, we got going again after having left half the engine behind in the dark. No sooner had we got over the rise when we saw the panther again. He was walking slowly towards the hills. On seeing the car he started to trot, but soon gave that up and stood beneath a small tree looking at us. This was our chance, so telling Ajit to stop I took a careful lead on his shoulder and fired. I must have pulled in the excitement for the bullet hit the animal just behind the shoulder. No sooner was he hit than he rolled over and getting up he came straight at the car. I waited till he was about 30 yards when I

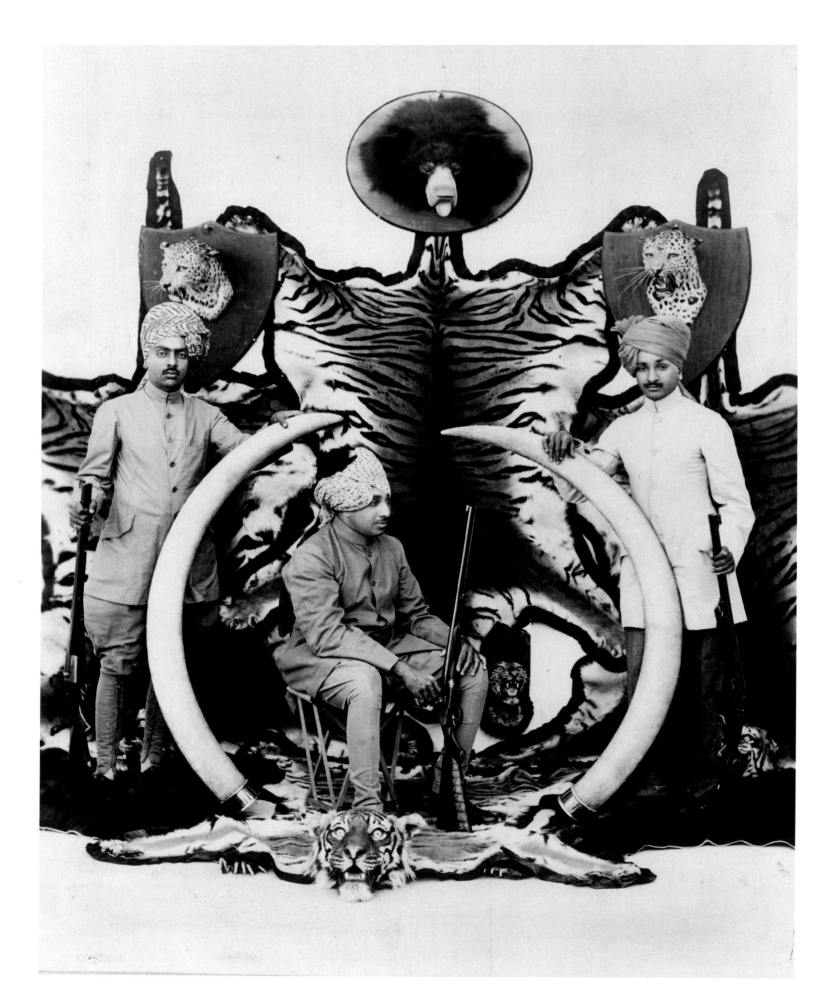

*fired again, but all I heard was a click, the rifle had misfired. There was no time to reload and the men in the back were much too jammed in to be able to stand up and shoot.*

*It now rested with Ajit to dash the car to one side in the hope that the panther would pass to one side but the car refused to move and stopped, having broken something when it ran over the big rock. There was nothing to be done now and we all sat waiting for the panther, but as he got to about 25 yards he slowly turned to the left and rolled over dead.*

*After connecting the petrol pipe, which had got disconnected in the bumping we had, we picked up the panther and went back to the tank. We were measuring the panther and all standing round, while the driver was reversing the car alongside the lorry, when the headlights shone across the water, which was about 150 yards across and then we saw a pair of eyes shining like two small lights on the far side, so thinking it was the other panther the servants had told us of, we lost no time in getting into the car and driving off.*

*On getting there we found a hyena drinking. I put a bullet through his shoulder and he dropped. We stopped alongside it and Karan Singh and Ajit got off to pick it up and put it on the mudguard. Just as Karan got hold of the four legs the hyena suddenly raised its head and had a snap at Karan's hand and just missed it by inches. By this time I put another bullet in its neck and that finished him. We had put the hyena on the mudguard and Ajit was turning the car around when we saw, about 25 yards away and in a bush, the other panther hiding.*

*As soon as the lights of the car fell on the beast he got up and ran and we saw that it was a pantheress. But all the same we gave it the chase. She ran straight towards the village and although only a few yards in front of the other car, I could not fire on account of the village and so we went on and eventually she jumped a hedge into a large field and I thought that was the end as I could not see a way to take the car in. I was looking around when I felt a great bump and on looking in front again I could not see anything but dust flying. When the dust had blown aside I realised that Ajit had taken the hedge, which was about 4 feet high, full on at about 20 miles an hour and that we were now inside the field. We saw the panther standing behind a bush, just the head and the shoulders showing, about 50 yards away. With headlights full on it was an easy mark and I put a bullet through the neck and she dropped on the spot.*

*After picking it up we were drawing back to the tank when a panther cub about the size of a small pie dog ran across our car. This was too much for my brother and off we went chasing this thing. The grass was about a foot high so it made the going very blind. We had not gone more than two hundred yards when we all gave a tremendous shout and I shut my eyes. We stopped with a great jerk with one wheel over the edge of an old disused well. This was too much for me and pushing Ajit out of the driving seat I drove the car back to the tank and so to dinner.*

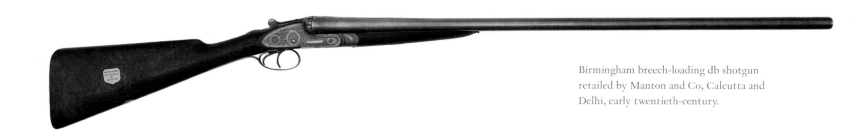

Birmingham breech-loading db shotgun
retailed by Manton and Co, Calcutta and
Delhi, early twentieth-century.

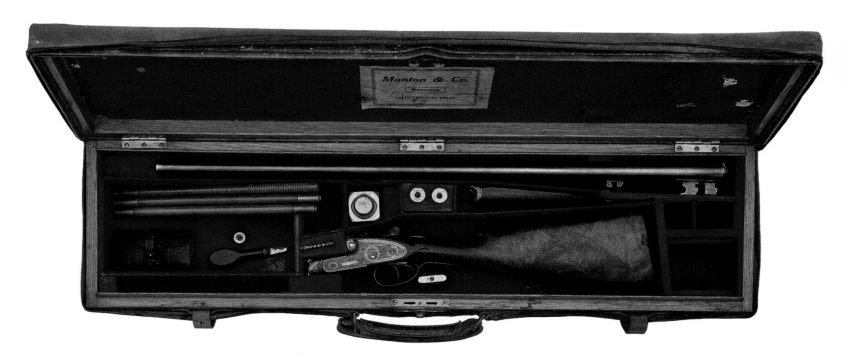

Birmingham breech-loading db shotgun retailed
by Manton and Co, Calcutta and Delhi, early
twentieth century. The gun in its travelling case.

# 8 CATALOGUE – MAHARAJA UMAID SINGHJI'S SPORTING GUNS

UBP/2017/7

## BREECH-LOADING DB SHOTGUN RETAILED BY MANTON AND CO.

Made after 1904 in Birmingham
Overall length: 123.5 cm
Barrel length: 81 cm / 32 ins
Gun number 1
Trigger-guard bears the number 8260

### DESCRIPTION

Let into the stock is a gold shield inscribed: 'His Highness the Maharaja of Jodhpore'; and the underside bears the Rathore crest. 32-inch smoothbore barrels, the rib inlaid in gold: 'Manton & Co. Gun makers, London and Calcutta, by appointment to H.E. the Viceroy.' '1' indicates it was one of a pair. The number 2 gun is UBP/2017/11. Maker's marks and stamps are on the underside of the barrel including no. 86799.
Original wooden case with dust cover including assorted fittings.
Label: 'Manton and Co. Gunmakers. Calcutta and Delhi.'

### COMMENT

Webley action with third bite, made in Birmingham. The gun is chambered for three-inch shotgun cartridges.

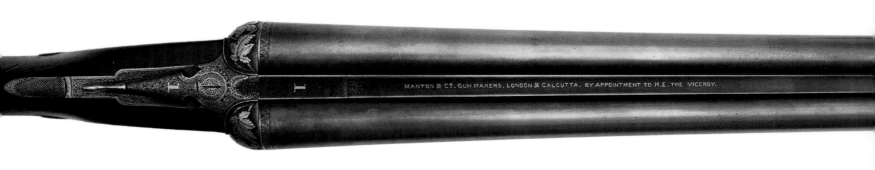

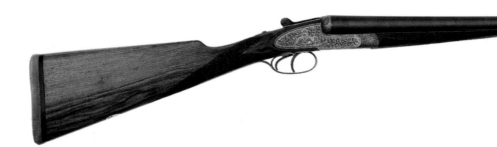

Holland & Holland Royal hammerless Ejector 12 bore d/b shotgun no. 25052. The gun was made in 1906 for a Mr Bowey and subsequently owned by H.H. Maharaja Umaid Singhji of Jodhpur.

UBP/2017/9

## CASED HOLLAND & HOLLAND 12 BORE D/B SHOTGUN NO. 25052 BUILT IN 1906.

Barrel length: 71 cm / 28 ins
Overall length: 114 cm

### DESCRIPTION

Gun no. 2. Inscribed Holland & Holland on either side. Inscribed under the action in front of the trigger-guard: 'Royal Hammerless Ejector'. Crowned V in two places on the action and on the barrels. Set into the stock, an English crown above U.S. (Maharaja Umaid Singhji) in polychrome enamel. S. W. Silver and Co recoil pad. The barrels are stamped on top, 1st barrel: 'Holland & Holland'; 2nd barrel: '98 New Bond Street, London.' The barrels are chiselled with arabesques and these are partially inlaid with gold. The case lid bears the Holland & Holland London label and contains ivory and gilt accoutrements. Holland & Holland records state that this gun was built in 1906 for a Mr Bowey, unfortunately no other information is recorded.

### COMMENT

Henry Holland began working on the first hammerless action of the guns that would become known as 'Royals' in the 1880s and the design though improved is still in production today though it only reached the present form in the mid-1890s. Hollands introduced the first 'Royal hammerless ejector' on the market in 1894. A characteristic of these guns from the 1890s is the classic bold foliate scroll engraving known as 'Royal Engraving'.

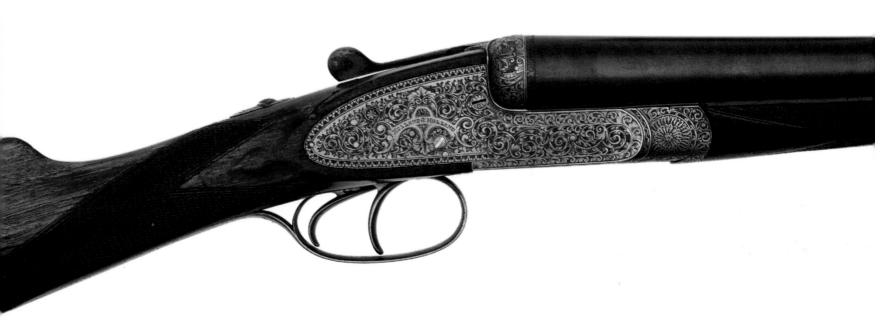

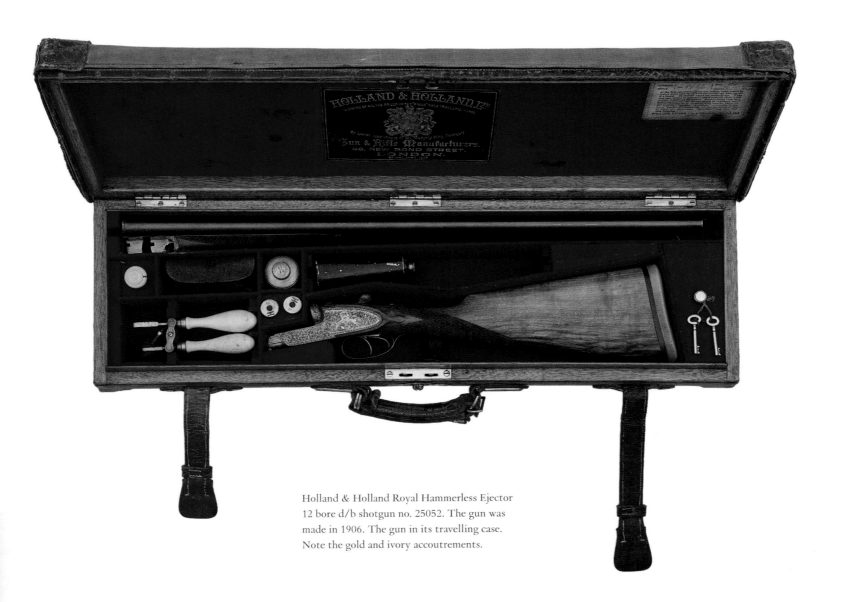

Holland & Holland Royal Hammerless Ejector
12 bore d/b shotgun no. 25052. The gun was
made in 1906. The gun in its travelling case.
Note the gold and ivory accoutrements.

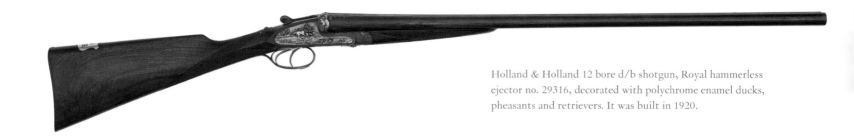

Holland & Holland 12 bore d/b shotgun, Royal hammerless
ejector no. 29316, decorated with polychrome enamel ducks,
pheasants and retrievers. It was built in 1920.

UBP/2017/10

## CASED HOLLAND & HOLLAND 12-BORE D/B SHOTGUN NO. 29316 WITH POLYCHROME ENAMEL DUCKS AND PHEASANTS ON EITHER SIDE, BUILT IN 1920.

Overall length: 119 cm

Barrel length: 76 cm / 30 in

### DESCRIPTION

Under the action in front of the trigger-guard is an en-suite round cloisonné enamel plaque depicting a retriever carrying a pheasant. Let into the stock, an English crown above U.S. in polychrome enamel for Umaid Singhji, the Maharaja. Crowned V in two places on the action and on the barrels. The barrels are stamped on top, 1st barrel: 'Holland & Holland'; 2nd barrel: '98 New Bond Street, London'. The case contains ivory and gilt accoutrements.

### COMMENT

Holland & Holland records state that this Royal Hammerless ejector was built in 1920 for a Mr. Matan. A Holland & Holland double rifle in .500/.465 Nitro Express exists with similar enamel from the same workshop. The case lid bears the Holland & Holland London label but also a secondary label: 'Manton & Co. Gunmakers Calcutta and Delhi.'

Detail showing the
underside of the gun.

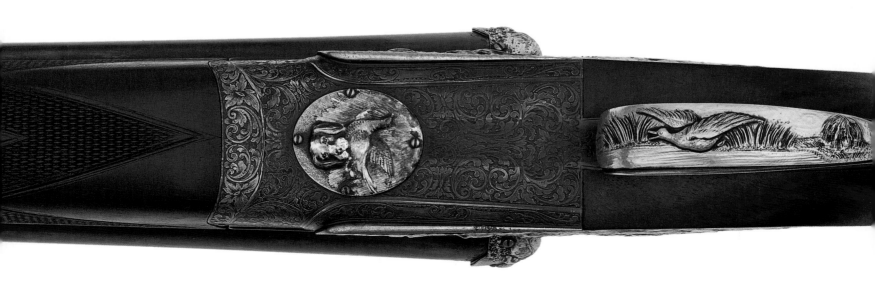

Detail showing H.H. Maharaja Umaid
Singhji's initials and crown on a gold plaque.

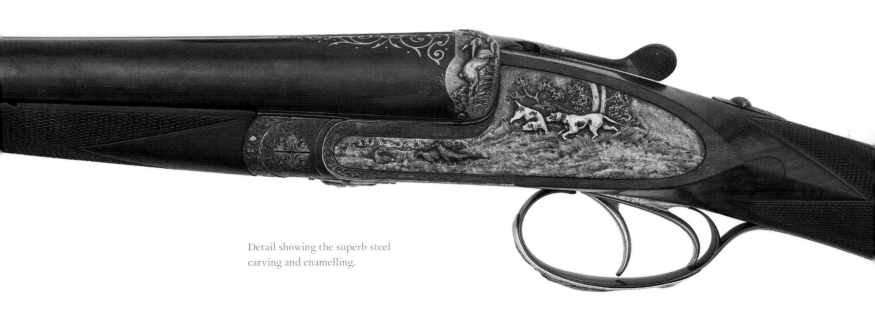

Detail showing the superb steel
carving and enamelling.

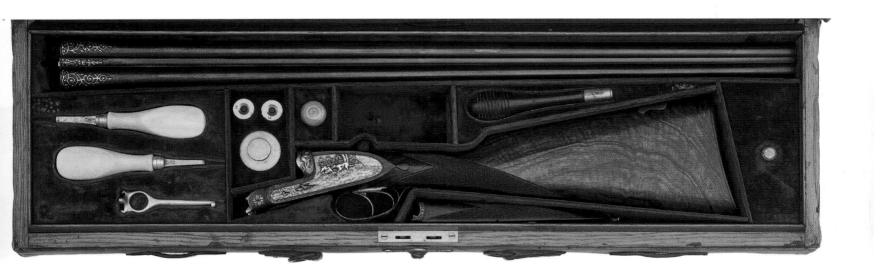

Holland & Holland 12 bore d/b shotgun,
Royal hammerless ejector no. 29316, built in
1920. The gun in its travelling case. Note the
gold and ivory accoutrements.

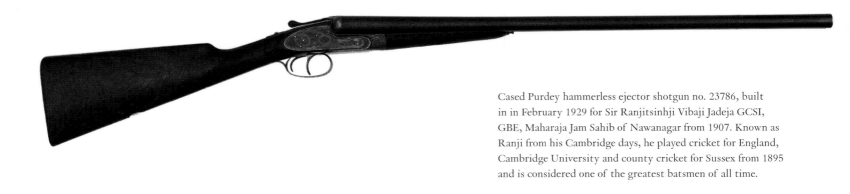

Cased Purdey hammerless ejector shotgun no. 23786, built
in in February 1929 for Sir Ranjitsinhji Vibaji Jadeja GCSI,
GBE, Maharaja Jam Sahib of Nawanagar from 1907. Known as
Ranji from his Cambridge days, he played cricket for England,
Cambridge University and county cricket for Sussex from 1895
and is considered one of the greatest batsmen of all time.

UBP/2017/14

## CASED PURDEY HAMMERLESS EJECTOR SHOTGUN NO. 23786, BUILT IN 1929.

Barrel length: 68.5 cm / 27 ins
Overall length: 110 cm

### DESCRIPTION

Crowned V proof marks in two places under the barrel. The gun is numbered '2' of a pair. The rib is inscribed: 'J Purdey and Sons. Audley House. South Audley Street, London.' Made of Sir Joseph Whitworth's Fluid Pressed Steel. Under the barrels are the loop numbers 58853 and 4. The fore-end-iron is stamped with the actioner's initials FH, the gun's number, and no. 2. Let into the stock is an Indian-made oval gold plaque, poorly engraved with a *cheel*'s head, replacing the lion motif of Nawanagar described on the original Purdey order.

Label in case: 'James Purdey & Sons, Ltd., Gun and Rifle Makers To H. M. the King & H. R. H. the Prince of Wales. Audley House. South Audley Street, London.' The case has a canvas outer cover.

### COMMENT

This gun was completed in February 1929 for Sir Ranjitsinhji Vibaji Jadeja GCSI, GBE, Maharaja Jam Sahib of Nawanagar from 1907. Known as Ranji from his Cambridge days, he was born in 1872 and played cricket for England, Cambridge University and county cricket for Sussex from 1895 and is considered one of the greatest batsmen of all time. In his first match at

Lords against the MCC he scored 77 not out and 150 in his second innings and took six wickets. He made his Test Match debut in 1896 against Australia and was famous for innovatory stroke play, inventing the leg glance, initially considered eccentric.[1] Wisden made him one of five cricketers of the year and wrote: 'If the word genius can with any propriety be employed in connection with cricket, it surely applies to the young Indian's batting.' After his death the Board of Control for Cricket in India (BCCI) established the Ranji Trophy in 1934, donated by Maharaja Bhupinder Singh of Patiala, which remains India's premier domestic cricket trophy. As a sportsman he had a very considerable cultural and political impact on cricket and the Empire. Purdey's records show this pair of guns were ordered with cross-eyed stocks because Ranji had lost his right eye. On 31 August 1915 he was shooting grouse on the Yorkshire Moors near Langdale End when one of the other guests accidently shot him in the eye which had to be removed by a surgeon. When Ranji died in April 1933 he had no sons but had adopted an heir who succeeded him, his nephew Digvijaysinhji Ranjitsinhji.[2] He asked Purdey's in 1934 to restock Ranji's guns as straight. The new ruler continued to buy guns from Purdey's, suggesting that the gun being considered here was given by him to Maharaja Umaid Singhji of Jodhpur (r.1918–48) as a gift. Maharaja Takhat Singh of Jodhpur had married a Nawanagar princess in the nineteenth century and Ranji was a friend of Takhat Singh's son, Pratap Singh, the Regent of Jodhpur, resulting in a close relationship between the two families. Gun number 1 also appears to have been given away as Purdey records show that it was owned by another Indian ruler.

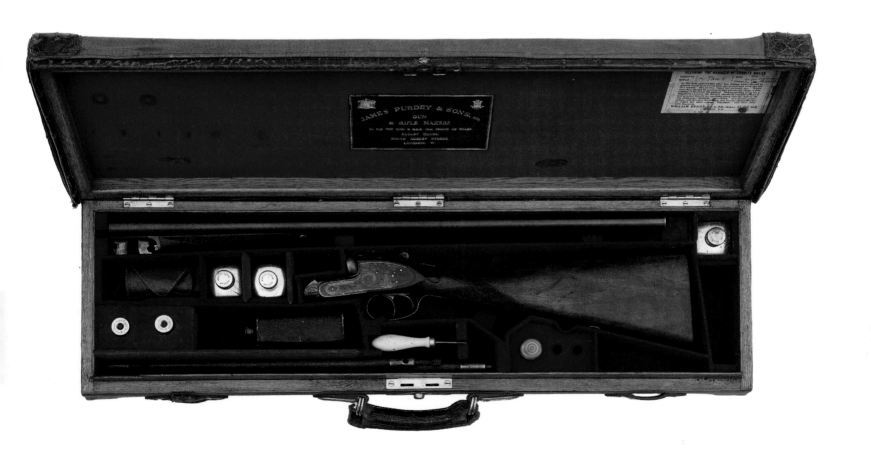

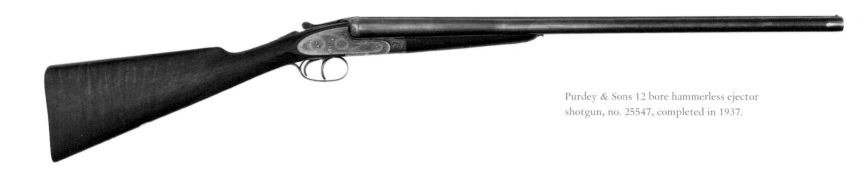

Purdey & Sons 12 bore hammerless ejector
shotgun, no. 25547, completed in 1937.

UBP/2017/15

## CASED J. PURDEY & SONS 12-BORE HAMMERLESS EJECTOR SHOTGUN, NO. 25547, BUILT IN 1937

Barrel length: 25 ins
Stock length: 14 in

### DESCRIPTION
Signed on top of the barrels: 'J. Purdey & Sons. Audley House. South Audley Street, London.'
Crowned V proof mark in two places under the barrel. Under the barrels are the loop numbers
63539 and 40.

Let in to the underside of the stock is a gold plaque incised with a *cheel* and the letters 'H. S.'
(Maharaja Hanwant Singhji). Label in case: 'James Purdey & Sons, Ltd., Gun and Rifle Makers.
Audley House. South Audley Street, London.' The case has a canvas outer cover.

### COMMENT
This gun, order number 2227, was made in 1938 and is a number 3 gun, built to match gun
numbers 25401/2, completed by Purdey's in 1937.

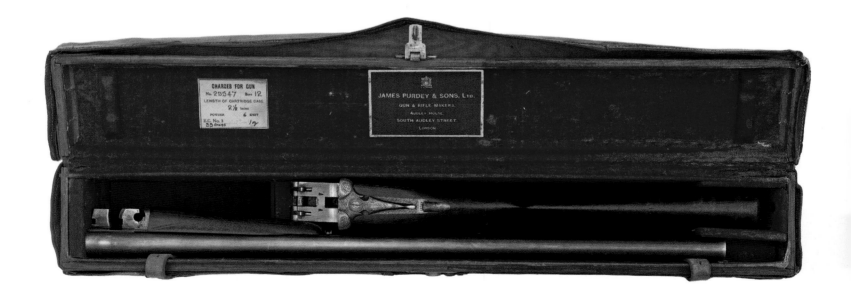

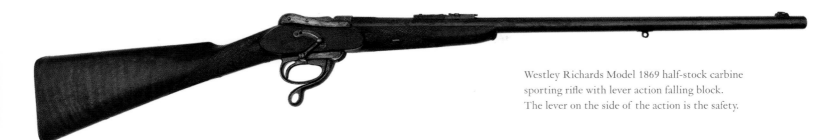

Westley Richards Model 1869 half-stock carbine
sporting rifle with lever action falling block.
The lever on the side of the action is the safety.

FRM/97/325

## WESTLEY RICHARDS MODEL 1869 HALF-STOCK CARBINE SPORTING RIFLE WITH LEVER ACTION FALLING BLOCK

Overall length: 109 cm

Barrel length: 66.5 cm

Weight 6 lbs

### DESCRIPTION

On the side of the breech: 'Westley Richards Patent 170 New Bond St London.' On the flat above the breech: 'Rifle 2 ¼ case; and 0444'. Barrel inscribed 'Henry's Patent Rifling Barrel'; other stamps include a Birmingham proof mark. Walnut half-stock with chequering and buffalo horn fore-stock cap. Rear sling swivel missing. Sighted to 800 yards.

### COMMENT

Westley Richards began making guns in 1812 in Birmingham and opened a shop in Bond Street in 1815. The firm invented the falling-block action in 1868. (Patent no.1931 of 12 June 1868.) This is therefore the first that Westley Richards marketed, Model 1869 sporting rifle chambered for the .450 No.1 Carbine cartridge with 2¼ in case. The falling-block design predates the Martini and also has an internal hammer and firing pin.On 15 November 1860, Alexander Henry took out Patent No.2802 Rifled Firearms. 'Henry's Patent Rifling' used a soft lead bullet that expanded to fill every part of the bore, which had seven shallow grooves with initially a 1 in 30 twist. Later a 1 in 22 inches (560 mm) twist was made. Most Henry rifles were .451 bore. The accuracy of the rifle became legendary, leading to massive sales in the 1860s. This was the era of the Volunteer Movement in Britain with many shooting competitions in which the Henry excelled. In the 1860s the British government conducted trials to find a replacement for the .577 Snider. His breech mechanism was rejected in favour of the Martini but his barrel was selected. The Martini–Henry rifle entered service in the British army in 1871, gradually replacing the Snider–Enfield, and continued until replaced by the .303 Lee–Metford in 1888. The new nitro powders had made Henry's expanding lead bullet obsolete.

Detail showing the receiver and breech block and the famous Henry barrel.

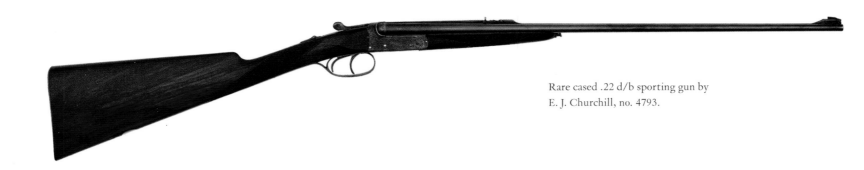

Rare cased .22 d/b sporting gun by
E. J. Churchill, no. 4793.

UBP/2017/16

# EXTREMELY RARE CASED .22 D/B SPORTING GUN BY E. J. CHURCHILL, NO. 4793.

Overall length: 95.5 cm

Barrel length: 55.5 cm / 21⅞ ins

## DESCRIPTION

The action is signed E. J. Churchill on either side. Within two crowned Vs and the gun number. In front of the trigger-guard is inlaid .22 in gold, repeated on top of the barrel. Forestock with gun number only. Rifled d/b stamped on top: 'E. J. Churchill (Gun Makers) Ltd. Orange St Gunworks Leicester Square, London.' Let in to the underside of the stock is a gold plaque incised with a *cheel* and the letters H. S. (Maharaja Hanwant Singhji).

The case has a canvas dust cover. It has two labels: 'E. J. Churchill (Gun Makers) Ltd. Orange St Gunworks Leicester Square, London.' The 'V.C.' Guncase Sole Makers E. J. Churchill (Gun Makers) Ltd. B. C. M. / XXV London, Eng.

Detail of .22 d/b sporting gun
by E. J. Churchill, no. 4793.

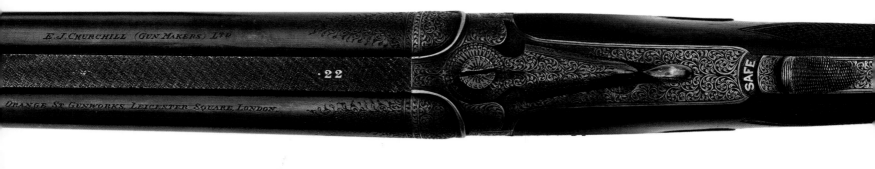

Rare .22 d/b sporting gun by E. J. Churchill, no. 4793 in its travelling case.

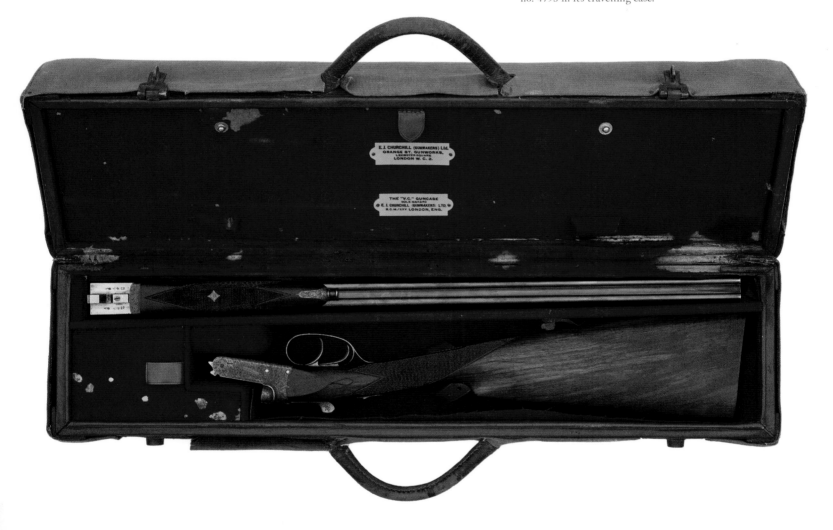

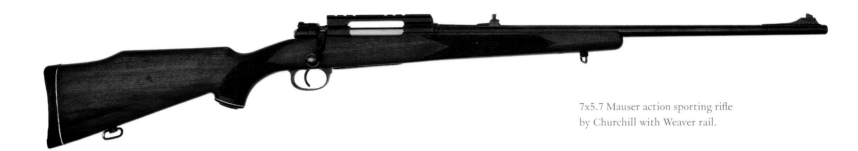

7x5.7 Mauser action sporting rifle
by Churchill with Weaver rail.

UBP/2017/2

## BOLT-ACTION SPORTING GUN. ON THE TOP MID-SECTION OF BARREL – 'CHURCHILL (GUNMAKERS) LTD. 7 BURY STREET, LONDON SW1. ENGLAND'

Overall length: 114.5 cm
Barrel length: 62.5 cm

### DESCRIPTION
On the side of the barrel behind the rear-sight: '80271 Made in England.' On other side is the London Nitro proof mark of an armoured bent arm holding a scimitar above NP.

7 X 5.7 18.5 TONS

9348 stamped in front of the trigger–guard.

### COMMENT
Edwin John Churchill established his gunmaking workshop in London in 1891. Although best known for their shotguns, Churchill also sold Mauser actioned rifles. This rifle is chambered for the 7 x 57 mm Mauser cartridge, a popular cartridge particularly for European hunters going to India and Africa. The gun is fitted with a Weaver telescopic sight rail. William Ralph Weaver (1905–75) was the founder of W. R. Weaver and Co. that made telescopic sights. From this developed the military standard Picatinny rail in the mid-1990s.

7x5.7 Mauser action sporting rifle
by Churchill with Weaver rail.

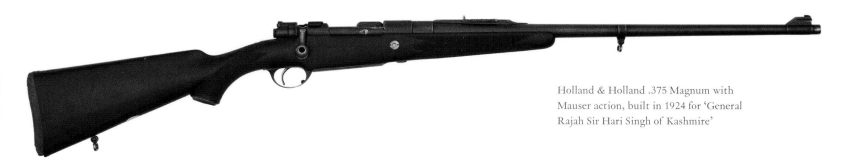

Holland & Holland .375 Magnum with
Mauser action, built in 1924 for 'General
Rajah Sir Hari Singh of Kashmire'

UBP/2017/12

## .375 MAGNUM

Overall length: 116 cm
Barrel length: 65 cm

### DESCRIPTION

Inscribed on top of the barrel 'Holland & Holland. 98 New Bond Street, London' built in 1924.
On the trigger-guard: 672; on the bolt lever: 349.

Built with a half-pistol grip stock, cheek rest and a Mauser action. In case with label and some
accoutrements.

### COMMENT

Holland & Holland records state that this rifle, with a 24-inch barrel with a detachable stock
and a scope, was built as a .375 at Holland & Holland in 1924 for 'General Rajah Sir Hari Singh
of Kashmire'. The .375 magnum round was designed by Holland & Holland in 1912 specifically
for big game in Africa and India. It is still made today and is known for its reliable ballistic
performance, flat trajectory and moderate recoil. The underside of the butt has an inset gold
plaque with the Jodhpur *cheel* and the initials H. S. (Maharaja Hanwant Singhji).
Maharaja Hari Singhji (1895–1961) was a Suryavanchi Rajput who came to the *gaddi* in 1925 and
was the last royal ruler of Jammu and Kashmir. At the time of Partition in 1947 the Maharaja
had to decide personally whether his Muslim majority state should join India or Pakistan or
remain independent. He opted for India, a decision that led to the first Indo-Pakistan War.

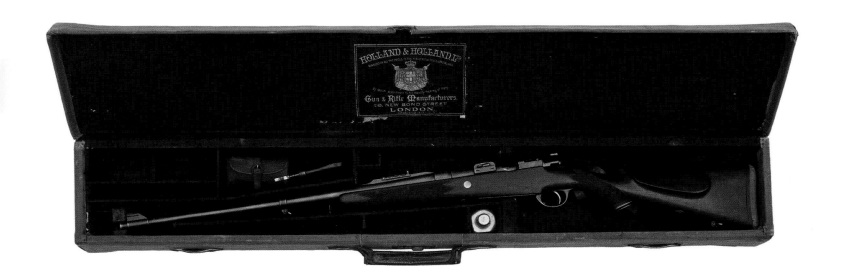

PRIVATE COLLECTION 1

Three-barrel German 'Drilling' sporting gun by Adolf Loesche, Hannover, no. 16139, with an alternative set of shotgun barrels. The gun is stamped with proof marks for 1929. The gun was owned by H.H. Maharaja Umaid Singhji who gave it away as a present.

THREE-BARREL GERMAN 'DRILLING' SPORTING GUN BY ADOLF LOESCHE, HANNOVER, NO.16139, WITH AN ALTERNATIVE SET OF SHOTGUN BARRELS. THE GUN IS STAMPED WITH PROOF MARKS FOR 1929.

Overall length: 114 cm

Barrel length: 70 cm

DESCRIPTION

Both side-by-side shotgun barrels with ejector, marked at the breech: 'Prima Fluss Stahl.' Under the barrel: Crowned N (German nitro proof mark); '2.2 g Sch.P 32 gBl'. The mark designates proof loads for service loads for shotguns. Here 2.2 grams of Schultze powder with 32 grams of lead shot. The rifled barrel: '2.2 g GBP/ St.m.G' (the mark designating proof loads for smokeless proof of rifles. Here 2.2 grams of Gewehr-blattchen powder and Stahlmantelgeschoss steel jacketed bullet. The three-barrel set has provision for a telescopic sight. On the barrel release lever: 'D. R. G. M. No. 252511 Justav Kerstens, VERSCHLUSS.' Cross bolt locking. Hinged compartment for four bullets in the base of the butt. Horn trigger-guard. Twin triggers, the rear one for the under barrel. The thumb push above the small of the butt cocks the front trigger and raises the back-sight for use with the rifle barrel. Safety catch on the side of the stock above the trigger. Formerly owned by Maharaja Umaid Singhji, now in a private collection.

COMMENT

In 1873 Adolf Loesche began selling guns at Koelner Str.13, Magdeburg, and was succeeded by his son Gustav in 1905. By 1916 Waffen-Loesche, Magdeburg is recorded at Wilhelmstrasse 13 having acquired the bankrupt Stendebach & Co of Suhl. A retail office at Grosse Packhofstrasse 21, in Hannover opened in 1919 but in 1926 the Suhl branch closed. The Berlin branch with A. Helmuthauser is recorded working from 1925–41. Drillings are associated with Germany and middle Europe, the provision of two shotgun barrels and a single rifle barrel allows the hunter to take both winged and ground game, specifically boar. Hunting of this nature took place in the great European forests such as the Black Forest or the Thuringian Forest.

Detail showing the three barrel construction

Remington Model 30 Express
bolt action sporting rifle with
telescopic sight, made in 1940.

UBP/2017/13

REMINGTON MODEL 30 EXPRESS BOLT-ACTION SPORTING RIFLE WITH
TELESCOPIC SIGHT, MADE IN 1940.
Overall length: 108 cm
Barrel length: 58 cm

DESCRIPTION

Inscribed on the top of the barrel: 'Remington Arms Co. Inc. Remington. Ilion Works Ilion.
N.Y. Made in U.S.A.' Stamped on the side of the barrel above the breech: 'Springfield 30 Cal.
1906 Express 29218.' On the barrel right side above the breech: 24 over a rectangle containing
the letters R.E.P. (Remington English Proof). A shamrock. A four-pointed star with one point
elongated. The date code 'O.J.' for July 1940, the year of manufacture.

COMMENT

Based on the Enfield P17 built by Remington in the First World War for the British government
(.303 in) and the American government (.30 in – 1906 Springfield. aka .30-06), this rifle was
repurposed as a sporting rifle model in 1921, chambered in the Springfield .30-06 cartridge
(1906) and called by Remington the Model 30 Express. The scope is an American Burris 3
x 9 telescopic sight with Weaver mounts, each stamped: 'Weaver USA'. The Burris Optical
Company began making telescopic sights in 1971 in Colorado.

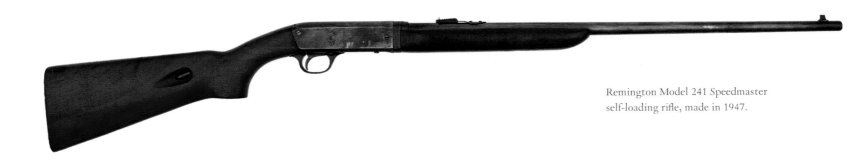

Remington Model 241 Speedmaster
self-loading rifle, made in 1947.

UBP/2017/3

REMINGTON MODEL 241 SPEEDMASTER SELF-LOADING
RIFLE, MADE IN 1947
Overall length: 104.5 cm
Barrel length: 58.5 cm

DESCRIPTION
On the side of the breech:

THE SPEEDMASTER
REG. U.S. PAT. OFF. MODEL 241
Remington REG US PAT. OFF. 96534

On the side of the barrel: .22 LONG RIFLE ONLY SMOKELESS-GREASED K S.S (Then jar
mark). Fed by a 10-round tube of .22 in Long Rifle cartridges in the stock.

COMMENT
Based on the John Browning designed .22 in Model 24 rifle, the Model 241 was re-engineered
by Crawford Loomis, a Remington engineer, in early 1935. None the less royalties still had to
be paid to Browning's company. Remington records show that they were made from 1935 until
about 1951. The Remington date code shows this rifle was made in May 1947.

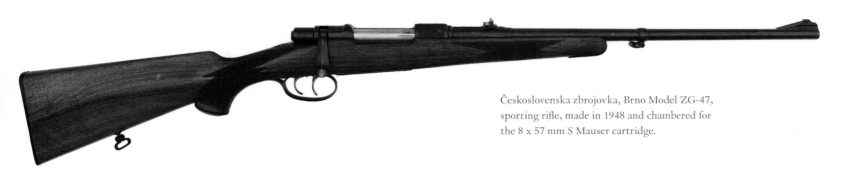

Československa zbrojovka, Brno Model ZG-47, sporting rifle, made in 1948 and chambered for the 8 x 57 mm S Mauser cartridge.

UBP/2017/6

BOLT-ACTION SPORTING RIFLE IN ORIGINAL CASE WITHOUT TRADE LABEL OR FITTINGS, MADE IN 1948.
Overall length: 105 cm
Barrel length: 54.25 cm

DESCRIPTION
On the left side of the barrel: 'Made in Czechoslovakia 7.9 18500.' Obscured stamp under crown '48' (for 1948). Crowned rampant lion? Inscribed is '48 Československa zbrojovka, Brno.' On top of barrel: Letter 'Z' within circles and '8 x 57 S'.

COMMENT
Zbrojovka, Brno a.s. was founded in 1918 after the First World War using the redundant Austro-Hungarian artillery workshops as a Czechoslovak state-owned firearms factory. The factory also made tools, telegraph and telephone components and railway equipment. In time the Austrian Mannlicher rifle, which was assembled here, was replaced by the German Mauser. By the late 1920s Zbrojovka, Brno became one of the largest producers of rifles in the world, a subsidiary of Česká zbrojovka a.s. Uherský Brod, which had more than seventy different production lines. Tractors and motorcycles were made here, Remington typewriters were made under licence in the 1930s, aircraft engines, bicycles and tools were manufactured. Sporting guns was only a small part of the production at this site. This is the Model ZG-47, made in 1948 and chambered for the 8 x 57 mm S Mauser cartridge, one of the more popular European sporting cartridges. Built with a large ring Mauser 98 action with a 23½ in barrel and walnut stock. They were exported between 1956 and 1962 approximately.

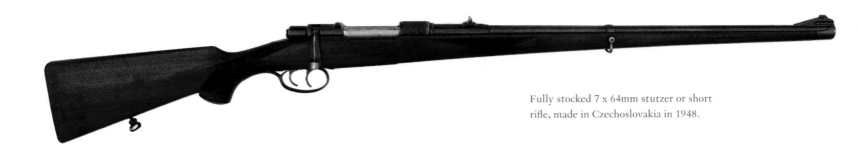

Fully stocked 7 x 64mm stutzer or short
rifle, made in Czechoslovakia in 1948.

UBP/2017/8

**FULLY STOCKED 7 X 64 MM STUTZER OR SHORT RIFLE, MADE IN 1948.
SPORTING RIFLE IN CASE WITHOUT TRADE LABEL OR FITTINGS.**
Overall length: 113 cm
Barrel length: 62.5 cm

DESCRIPTION
On the left side of the barrel: 'Made in Czechoslovakia 7' followed by two overlapping circles.
21261 Obscured stamp under crown: 48. Crowned rampant lion? 48. Zbrojovka Brno, Nar.
Podnik On top of barrel: Letter 'Z' within circles. '7 x 64'. Set trigger.

COMMENT
The letter Z on the barrel is for Zbrojovka, Brno a.s. See UBP/2017/6. With ammunition: 10
Original-Brenneke Hochleistungspatronen 7 x 64 Normalisert. Für alles Schalenwild. (For all
hoofed game.)

# 10 Original-Brenneke Hochleistungspatronen

# 7 x 64

## NORMALISIERT

Erosionssicher
quecksilber- und rostfrei
Für alles Schalenwild
mit

# Brenneke Torpedo-Ideal-Geschoß

Hersteller:

## INDUSTRIE-WERKE KARLSRUHE
Aktiengesellschaft
KARLSRUHE

Made in Germany

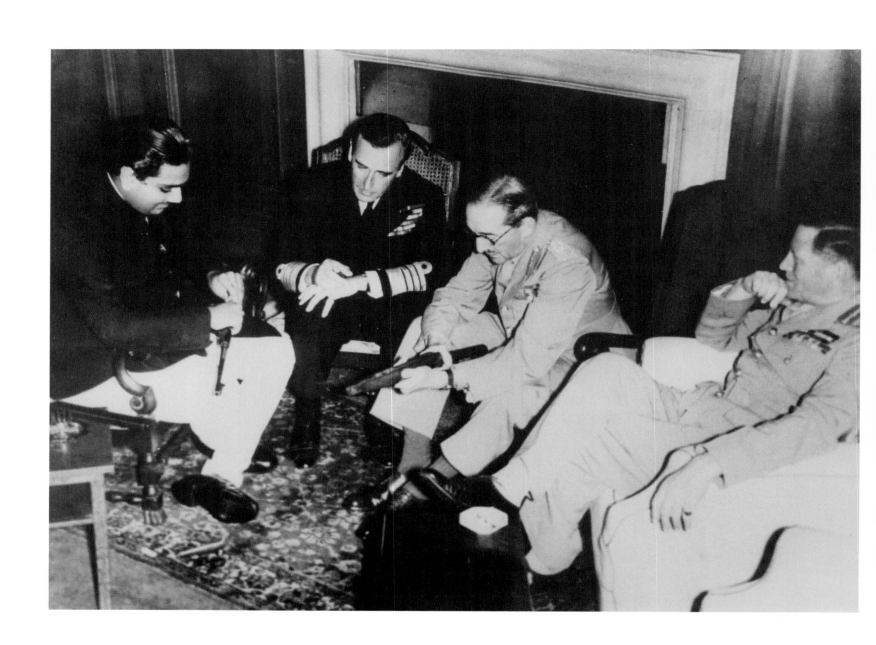

# 9 EXPERIMENTAL GUNS MADE IN MEHRANGARH UNDER THE DIRECTION OF MAHARAJA HANWANT SINGHJI

As a small boy, Yuvraj Hanwant Singhji (1923–52) was fascinated by science and technology with a particular interest in studying and making small arms. At the age of thirteen his father decided to send him to Mayo College at Ajmer, the Eton of India. A contemporary asked what he planned to take with him? 'A couple of cars, a few horses, some guns and of course my servants.' In the October-November 1939 edition of *Science and Mechanics* he published an article on 'Small Calibre Rifle Shooting'. With his father's support he created a large metals workshop in Mehrangarh Fort where he made experimental sub-machine guns, and designed swords and kukris with alloy hilts.[1] In 1942, aged nineteen, he made a version of a 1918 Thompson sub-machine gun, which was quieter and lighter in weight than the original, fired a similar number of bullets and was comfortable to operate. His interests were wide and the guns he collected very varied included a number of flare pistols.

Yuvraj Hanwant Singhji was also very interested in aviation. His father Maharaja Umaid Singhji was a far-sighted and progressive man who had built a landing strip in 1924 and established the Jodhpur Flying Club in 1931. In less than ten years Umaid Singhji put Jodhpur at the centre of civil aviation in India. Hanwant Singhji qualified as a pilot; flying was something he excelled at, and he strongly supported the club. For this and his work with the Indian Air Force at Jodhpur he was made an Honorary Group Captain. In 1943 he married Maharani Krishna Kumari Ba Sahiba of Drangadhra, by whom he had a son, Gaj Singh Rathore, the present maharaja. He was a man of many talents, a world polo champion and also a brilliant magician. In 1948 he gave a performance at the Piccadilly Theatre, London and on the strength of it was invited to become a member of the celebrated Magic Circle. He was once asked what he would do when he ceased to be maharaja? 'I can earn my livelihood through aviation, or as a performing magician or as a firearms manufacturer' was the confident response. In 1945 he sent a .9 mm carbine to the officer commanding the Government of India arms factory at Isapur. This was admired but he also made suggestions regarding improvements to the .303 rifle used by Indian forces. These ideas were endorsed and alterations made to the rifle.

He invented a camera gun with a rifle stock on which telescopic sights and a camera were mounted. This gave him great accuracy when photographing animals at a distance of up to half a mile. He may have learnt of camera guns from the air force which used a modified Lewis gun to take training photos in the First World War and subsequently.

FACING PAGE:
Yuvraj Hanwant Singhji shows his firearms inventions to Admiral Lord Louis Mountbatten, the Viceroy, Field Marshal Lord Allanbrooke, Chief of the Imperial General Staff and Field Marshall Sir Claude Auchinleck, Commander-in-Chief of the Indian Army at the latter's official residence in Delhi in 1944. His Highness Maharaja Gaj Singhji II of Jodhpur-Marwar.

Hanwant Singhji, like his father, was a very modern, progressive and energetic individual whose intelligent interest in science and technology resulted in Jodhpur having one of the first radio stations in princely India. His desire for his people to be at the forefront in technical knowledge led to the establishment of an Engineering College for which he quietly gave land and buildings.

Hanwant Singhji's father, Umaid Singhji, ADC to the Prince of Wales, later King Edward VIII, had strong links with the British Royal Family, was a highly decorated military man and supported the British Raj. Hanwant was aware that the old order was changing and his inclinations, like many of his contemporaries, were anti-British. By day he attended the Council of Ministers but at night he was believed to be active distributing anti-British posters. His father died suddenly aged fifty-three on 9 June 1947 and on the 21st he formally became Maharaja. The declaration of Indian independence was less than two months away and he faced hugely important decisions regarding the future of the state his family had ruled for centuries. He was young, headstrong, emotional and proud and it took the combined efforts of his mother the Rajmata, Mountbatten and Vallabhbhai Patel to persuade him to support a united India. Once he took the decision to abandon the position that his forbears had held since the eighth century he determined to be the most progressive maharaja in India, announcing that: 'privileges are only a paltry make believe if not a fool's paradise. Shorn of old feudal and autocratic character, a prince in free India should now rise to the level of the Common Man.' On 15 August Lord Mountbatten declared the Partition of India. The Princes by Treaty retained their palaces, lands and wealth but lost their political power: as compensation they each received an annual privy purse from the new Indian government.

In March 1949 the maharaja was a passenger in a small plane travelling from Delhi to Jaipur to inaugurate the newly created state of Rajasthan. Accompanying him was Vallabhbhai Patel, the Indian National Congress leader. The plane developed engine trouble over the Aravalli Mountains and an emergency landing was the only option. The pilot was paralysed by the situation and his responsibility for two celebrities so Hanwant Singhji took the controls and landed the plane safely on the riverbed at Shahpura.

In 1951 Prime Minister Nehru called the first Indian General Election, announcing that if any maharaja stood for election they would lose their privy purse. Rathores are not slow to accept a challenge and Maharaja Hanwant Singhji gave up his privy purse and founded his own political party. He campaigned with typical energy, piloting himself and his wife about Rajasthan in his own Beechcraft Bonanza. His workload was so great that he had little time for sleep and resorted to Dexadrine to keep going. Dexadrine like Benzadrine was routinely prescribed by RAF doctors to bomber crews during and after the Second World War.[2] It is a stimulant that assists people to stay awake and stay focused on an activity. On 26 January 1952, for reasons that are unknown, his plane flew too low and hit power cables, crashing and killing both the maharaja and his wife. Hanwant Singhji's party won the election by a landslide taking thirty-one of thirty-five seats. He was only twenty-eight.

.22 pencil pistol made for Yuvraj
Hanwant Singhji in his workshop
in Mehrangarh Fort. The design is
based on the SOE pistol used for
clandestine operations during the
Second World War. The pencil is
engraved: Gun Shop Jodhpur 1948
Length: 7 in
Copyright Royal Armouries,
Leeds, no. X11.11823.

## .22 PENCIL GUN MADE IN MEHRANGARH

In 1940 Winston Churchill created the Special Operations Executive and told it to 'Set
Europe ablaze'. During the Second World War the SOE carried out sabotage, assassination and
reconnaissance in enemy-occupied Europe and south-east Asia. This single-shot pencil pistol
copies similar SOE clandestine weapons. It was designed to escape notice during a cursory
search and used a .22 short cartridge.

The maharaja made pencil guns in his workshop and gave some to friends. A letter of 18 June
1942 shows the Jodhpur Comptroller of Household sending the Maharaj Kumar Sahib of Bundi
a 'breech-loading gun and two pencil pistols'.[3] The Maharaja had one these 'pens' in his pocket
when he went to a meeting in Delhi. V. P. Menon,[4] Secretary to the Home Minister K. C. Pant,
had led the maharaja to believe that the viceroy, Lord Louis Mountbatten, was expecting him.
The maharaja became extremely irritated at being kept waiting and finally, when admitted to
Menon's office, pulled out the pistol and in mock anger threatened to shoot him. Mountbatten
walked in on this scene. The maharaja explained that he was showing his new invention to Mr
Menon and gave Mountbatten the pistol as a gift.[5]

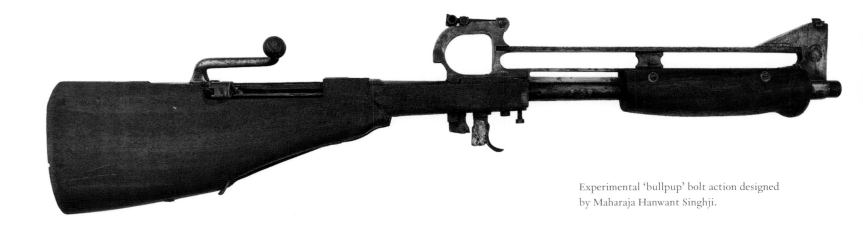

Experimental 'bullpup' bolt action designed
by Maharaja Hanwant Singhji.

ARM/76/365

## EXPERIMENTAL 'BULLPUP' BOLT-ACTION .22 CARBINE
Overall length: 74.5 cm

### DESCRIPTION
The unvarnished Indian stock and adapted gun parts indicates experimental work by Yuvraj
Hanwant Singhji in his workshop in Mehrangarh. The modified bolt has a worn crowned 'V'.
The same mark is on the barrel near the breech together with number 249 twice (the last
number obscured by the stock); and the local chiselled mark 'NP'. Next NITRO PROVE, below
which is a number, the first character obscured, probably G5303222. On the left side of the
barrel are a Birmingham proof mark and a crowned GR.
Because of the straight line of the barrel and stock the gun has a raised rail (like a Weaver
rail) to take sights. The back-sight, calibrated for 25 to 200 yards, and bolt are taken from a
Lee–Enfield. A locally made spring catch attached to the stock secured the magazine, which
is missing, as is the wooden pistol grip behind the trigger (though there is a recess cut in the
underside of the stock to take this). The stock has a carved wooden cheek pad, indicative of
civilian work. The screws before the trigger are for a trigger-guard.

### COMMENT
Towards the end of the Second World War Britain began developing a new cartridge and rifle.
Experience had shown that while the .303 cartridge and Lee-Enfield was designed for combat at
six hundred to eight hundred yards distance most infantry actions took place at three hundred
to four hundred yards.[7] The other British Army requirement was for a weapon with greater
accuracy and range than current sub-machine guns, giving the possibility of a less powerful,
lighter bullet to the .303 which would enable the infantryman to carry more ammunition,
necessary when equipped with an automatic weapon. Shorter weapons had the advantage of
being lighter and were more practical in jungle warfare, leading in 1943 to the Lee–Enfield No.
5 Mk1 'Jungle Carbine', manufactured from 1944 until 1947. This gun was the starting point
for Hanwant Singhji's bullpup[6] experiments, modifying the Indian army Lee–Enfield. The first
appearance of the bullpup was the Thorneycroft bolt-action carbine of 1901, followed by the
French semi-automatic rifle developed by Lieutenant Colonel Faucon in 1918 but the system
remained largely ignored.

A 1944 photograph shows the twenty-one-year-old Hanwant Singhji in Delhi discussing his experimental guns with Admiral Lord Louis Mountbatten, the Viceroy, Field Marshal Lord Alanbrooke, Chief of the Imperial General Staff and Field Marshal Sir Claude Auchinleck, Commander-in-Chief of the Indian Army. They would have informed him of British trials of two bullpup configuration experimental rifles in .280 calibre and 7 mm. EM-1 was not considered successful and was scrapped in 1947 in favour of concentrating on EM-2, indebted to the excellent German Heckler & Koch G43 system. EM-2 was the first bullpup to be adopted by a national army. It was an excellent rifle, issued in 1951 as Rifle No. 9 Mk 1 or the Janson Rifle, named after the Polish designer[8] working at the Royal Small Arms Factory. Replacing the bolt-action Lee–Enfield by an automatic weapon with a twenty-round magazine, gave a huge increase in firepower, the first British Army assault weapon.

During the war each Allied nation used a different calibre weapon and after the war efforts were made to standardise ammunition size with the Americans in NATO. The Americans did not like the British .280 cartridge considering it underpowered and adopted the T65. Although British technical experts advised Churchill against the American choice he accepted the American T65 round in the interests of standardisation among the Western allies. Britain abandoned the Janson rifle in 1952, when NATO adopted the 7.62-mm rifle cartridge as standard, and adopted the Belgian-designed 7.62-mm L1A1 self-loading rifle as the Janson was incapable of using the new NATO cartridge. In time the US accepted that the T65 was overpowered and finally in 1964 they adopted the M16 rifle and the 5.56 x 45 mm cartridge.

The date when Hanwant Singhji created his bullpup design is not known or whether it predated the British EM-1 and EM-2. France began experimenting with bullpup designs between 1946 and 1950 during the First Indochina War but budgets were limited and the priority was to modify existing arms. The French strategy in Vietnam was to create well-defended bases supplied by air, nicknamed le hérisson (hedgehog), which invited attack. French troops faced waves of Viet Minh attackers, sometimes with odds of 15 to 1 as General Giap sought political results on the battlefield by swamping the defenders without regard to normal military considerations of casualties.

A new automatic infantry weapon for the French Army became urgent and the Famas project began in 1967, leading to the introduction in 1978 of the Fusil d'Assaut de la Manufacture d'Armes de Saint-Étienne 5.56 Modele F1, or FAMAS F1. It was noteworthy for its rate of fire, 900–1,000 rounds per minute. However the Famas was preceded by another iconic bullpup, the Steyr AUG, adopted by the Austrian Army among others. Both guns in appearance closely resemble Hanwant Singhji's gun though the Famas action, using a lever-delayed blowback system and plastics, shows how far from his original bolt-action concept automatic weapons had evolved. It is worth noting that the Lee–Enfield no 5 Mk1 bolt-action 'jungle carbine' was popular and used successfully in the Malayan Emergency (1948–1960). Seeking a short, automatic assault rifle the Australians developed the bullpup KAL1 general-purpose infantry rifle in the 1970s before adopting the Steyr. The British Army finally acquired the SA80 (L85A1) which entered service in 1985 and was made until 1988 at the Royal Small Arms Factory at Enfield Lock though the mechanism of the SA80 is entirely different from that of the EM-2.

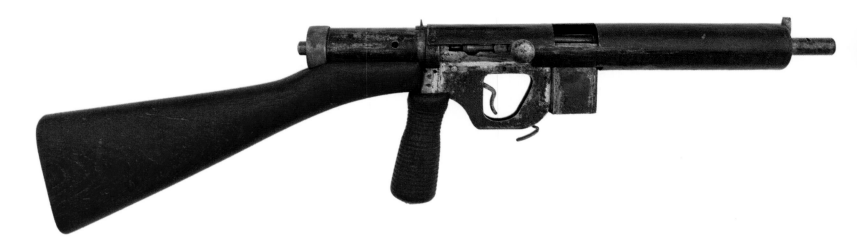

FRM343

**SUB-MACHINE GUN, 9 MM, MADE IN THE MEHRANGARH WORKSHOP**
The parts combine copies of a Thompson rear grip and a Thompson magazine, in this case reversed with the seam facing forwards.

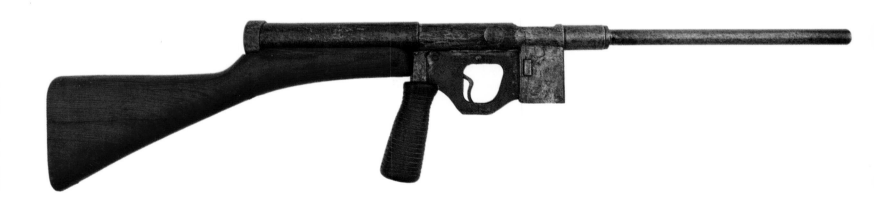

FRM346

**SUB-MACHINE GUN FROM THE MEHRANGARH WORKSHOP**
This 9 mm sub-machine gun is a simple blowback design that resembles the British Sten gun of the Second World War, but in this case with the magazine housing in the vertical position.

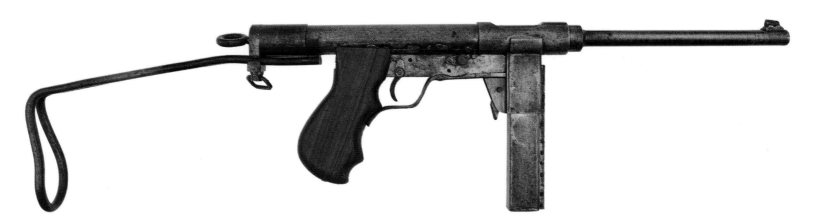

FRM97-327

SUB-MACHINE GUN, MADE IN THE MEHRANGARH WORKSHOP.
Similar to the previous example, this 9 mm sub-machine gun differs in design terms in having no barrel shroud and a longer return spring tube.

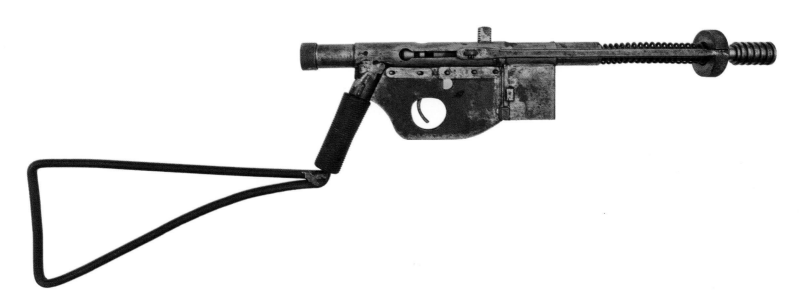

FRM97-337

SUB-MACHINE GUN, MADE IN THE MEHRANGARH WORKSHOP
This is an unusual, innovative 9-mm sub-machine gun design, anticipating features found on much more modern guns; the return spring is moved from the rear of the gun, in this case being wrapped around the barrel. The forward cocking spring in front of the bolt has been described by an expert as 'a perfect concept', making possible a more compact gun. Practically, with the high rate of fire of a sub-machine gun the spring would heat up and lose much of its elasticity. Making a gun more compact is best illustrated by the Israeli Uzi of the 1960s.

NO NUMBER

## WALKING STICK COMPENDIUM
Jodhpur
c.1930s
Overall length: 90 cm

### DESCRIPTION

The main section of the stick is steel wrapped in crocodile leather; round the top is a broad gold band fashioned as a belt and buckle and engraved 'Made in Jodhpur by Chunilal and Sons.' The handle made of machined gilt silver has a lioness-head top whose jaws open to reveal a rabbit. A watch is inset on the back of the handle, signed Otis. The handle and a tube of steel pulls out of the sheath like a swordstick and indeed the point, 10 cm of double-edged steel, remains. This can be removed as can the tubular section above it with a screw cap, a 7.25 cm long whisky flask. The central section of the 'stick' opens revealing a man's compendium: a miniature portrait of H. H. Maharaja Umaid Singhji that flips open at the push of a button revealing a storage cavity suitable for pills. Held in place by spring clips are four cheroots, a silver lighter, penknife and a combination propelling pencil and pen with gold clip, the top inset with mother-of-pearl, the nib inscribed: 'Waterman's Ideal, New York 2'. A customised travelling case protects the silver head and a woven cloth covers the remainder.

### COMMENT

This exquisite stick was probably designed by Yuvraj Hanwant Singhji as a present for his father, Maharaja Umaid Singhji. There are additional surprises to be found in the handle where knurled rings to twist and push studs that no longer function invite the question 'What else might a maharaja require in such a stick?' A British dealer had a fine related tulwar in a metal scabbard inscribed 'Chunilal and Sons'. The scabbard hinges along its length to reveal the 'sword' lacked a blade, instead containing a smoker's compendium, made for Maharaja Umaid Singhji, a heavy smoker. The dealer removed the metal hilt 'fit for a king' and sold it to another dealer who sold it to a second, very well-known London dealer who advertised it in the firm's glossy catalogue as eighteenth century. Because of the unusually wide scabbard container the languets were set abnormally wide on the hilt, which should have alerted all concerned that the hilt was not made for its newly inserted sword blade.

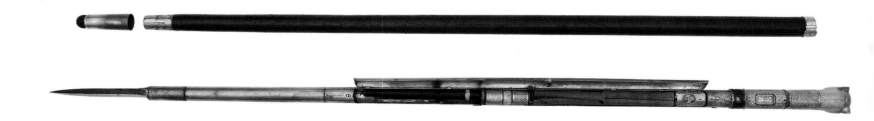

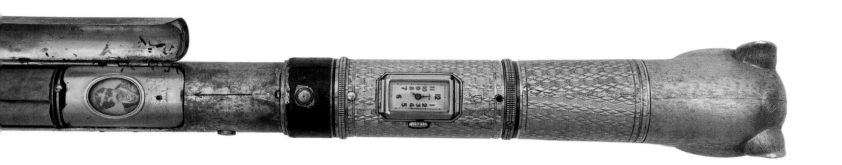

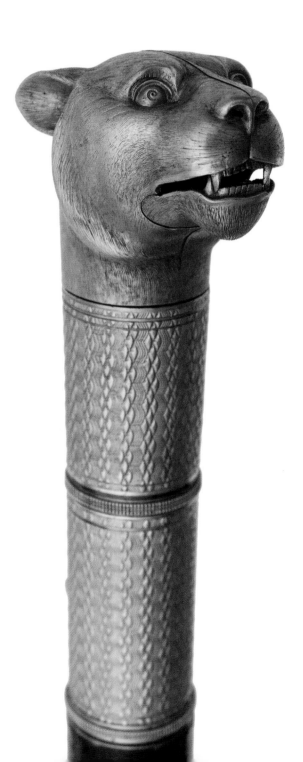

THE FOLLOWING WALKING STICK GUNS ARE IN A PRIVATE
COLLECTION. ALL ARE UNSIGNED AND IT IS NOT KNOWN
WHICH IF ANY WERE MADE IN JODHPUR.

PRIVATE COLLECTION

Walking stick gun with silver handle, 1930s. The gun is cocked by pulling out the ring at the
elbow. There is a sliding bar safety catch which can be pushed under the button trigger. The
grip hinges, revealing a bullet compartment.

Overall length: 91cm

PRIVATE COLLECTION

Walking stick gun with horn handle, 1930s. The gun is cocked by pulling out the ring at the
elbow. There is no safety catch on the trigger, a button set in the horn. The stick's metal ferrule
pulls off before the gun is fired. It has two silver bands, the lower marking the end of the
chamber. This design is reminiscent of the classic Belgian Dumonthier patent cane guns.

Overall length: 85.5 cm

PRIVATE COLLECTION

Walking stick gun with silver handle, 1930s. The gun is cocked by pulling out the ring at the elbow. There is a safety catch on the trigger. The handle has a key fitting on top but the component part, a detachable butt, is missing. The ferrule is removed before firing and acts as an extractor to remove spent cartridges. The gun is unsigned but resembles those firing centre-rim cartridges made in Saint-Etienne by Manufacture Stéphanoise d'Armes.

Overall length: 90 cm

PRIVATE COLLECTION

All-metal 1930s walking stick gun with horn handle, chambered for .410 shotgun cartridges. The gun is cocked by opening and closing the breech and then making a half turn of the barrel, which allows the sprung trigger to drop down through a slot. The trigger has no safety. The metal ferrule (in this instance missing) is removed before the gun is fired and is generally designed to extract spent cartridges. The cane's design is similar to those sold by the Birmingham gunmaker Parker Hale Ltd. An identical gun, also unmarked, was published by Owen.[9]

Overall length: 87 cm (89.5 cm with the missing tip).

# APPENDICES

## A NOTE BY THE LATE CLAUDE BLAIR FSA REGARDING TROMBA

Claude Blair (1922–2010) was the leading scholar on European metalwork of his generation, with a particular interest in arms including armour and guns. He worked at the Royal Armouries at the Tower of London from 1951–56 among a particularly able group of arms experts before moving to the Victoria and Albert Museum where he became Keeper of Metalwork. Under his stewardship arms were intelligently displayed didactically to show their evolution but also their decoration in its widest sense as an important element of the arts. In 1982 the museum forced the retirement of seven keepers as an economy, one of the most self-destructive moves ever to befall a great museum, and Claude's public career ended. He remained the dominant figure, continued to write, and was President of the Meyrick Society and the Arms and Armour Society, an exacting scholar ever ready to help younger arms enthusiasts. Many years ago at a Meyrick Society meeting I argued the case with Claude for the fire-lance (or *huo ch'iang*) being the origin of handguns in Europe. He did not agree, maintaining the Eurocentric view. Some time later he kindly sent me a note based on research in progress that he had written on tromba. I consider the text supports the case I make regarding the birth of handguns. As far as I know the text was a work in progress and never published and is probably still in his uncatalogued papers which are now in the Wallace Collection.

Blair wrote, the word tromba had a number of forms, in Italy was known as a *tromba da fuoco*. The usual English form of this was *tombe*, which, according to the *O.E.D.* is rare. The normal English term for the device was *trunk*. These must have been popular weapons since 269 are listed in the Inventory. A number of trunks are illustrated and described by Richard Wright in his manuscript *Treatise Concerning Gunnery and Fireworks* of 1563. These show that, in its simplest form, the trunk was, in effect, a large cylindrical Roman candle – according to Wright 20in. long, 10in. in circumference, and 12 'in the mouthe' – on the end of a long staff. A more complex form illustrated by Wright was the cross trunk, which had a main container as described above, and two others set at right angles one on each side.

Biringuccio's long account of trunks, under the name of fire tubes, is worth quoting in preference to Wright's, since it is much more detailed, and also explains their use. He starts:

> Fire tubes are commonly made in order to frighten horses or to harm enemy soldiers, but although fire issues from them, they do not cause much damage because they cannot be used at a distance. If you wish to use them, you are not able to approach close to the enemy, for if there is anyone who is afraid, he does not let you approach nor does he come near you until he sees that they have finished burning. Thus, in short, the assault with this is one that is seen beforehand, and for which there is always time to decide on some action in defence. It is indeed true that they are beautiful things to see and when the name tubes of fire is heard it terrifies those who do not have a defence ready. When four, six, or indeed ten or twelve of these are put in the hands of as many courageous and united men, they are surely good in forcing passage on a guarded bridge, or in entering or holding a gate, road, or other narrow place. They serve also for setting fire to dwellings or the enemy's supplies, carts, bridges, and all those things in the service of the enemy that are easily set on fire. They would also serve well to lay waste a land. Above all, they are good in naval battles.
>
> Some are also made to not only to vomit fire, but to shoot certain balls which ignite when they issue and burst in the air. I once made some of these like a gun, which I caused to shoot stone balls able to break any good thick wooden gate, and they served me admirably for the purpose that I made them for.

He continues with a detailed account of the manufacture of a trunk. The tubes are normally made of wood – though iron or sheet copper could be used – reinforced with a binding of iron wire, 'or a thin reinforced string'. If 'made of sheet [copper] it is strengthened with…bands of iron'. A cheap version can be made of several thicknesses of glued paper reinforced with a binding of iron wire. His description of the filling is as follows:

> Of whatever you have made this tube or may wish to, it is filled in this way, unless indeed you wish to fill it with a single composition: First put four dita of good gunpowder in the bottom, and then put in a little ball made of tow or of cloth rags and filled inside with good fine powder. The ball has one or two little holes and it is covered with pine resin, sulphur and some powder. Then above this put four dita of coarse powder composed of Grecian pitch, crushed glass, coarse common salt, roughly crushed saltpetre, and sawdust of dry elm or ground iron scale, and press it in well with a ramrod. On top of this, then put two dita of fine gunpowder and press it; on this put another ball made in the same way. Thus, four dita at a time, proceed to fill the whole inside of your tube up to the mouth. When it has been thus filled, it is covered with a little tallow, or with a plug of cork or paper so that the powder may not run out when it is handled. When these tubes have been made in this way, they are put on the end of a pike or other long pole and fastened with two nails at the foot. Then, when you wish to use them, fire is applied through the mouth with a fuse or a little gunpowder.

One trunk in the Inventory requires special mention. The relevant entry (11399) is among those under the general heading 'Stuff in Tholde Juelhous at Westminster':

> Item one Truncke to shoot in covered with blacke Leather.

An identical entry appears in the 1542 Westminster Inventory, together with another:

> Item oone Trunke to showte in painted grene tipped with metall gilt at both the endes (A marginal note records that it was sent to King Edward in 1548).

The locution 'shoot in' appears to have been the equivalent of the modern 'shoot with': for instance, a Statute of 1536 relating to the administration of Calais and its Pale includes a provision for encouraging soldiers 'to lerne the feate of shotyng in a gonne'. There can be no doubt, therefore, that the trunk, despite its unlikely location, was of the type discussed in this entry. One wonders if it was used to give firework displays for the entertainment of the young Edward.

## SELECTED ENTRIES FROM THE INVENTORIES OF THE MEHRANGARH SILEKHANA

Several of Mehrangarh's arms inventories have been found in recent years. Together with references taken from bahi these show how arms were acquired, altered and the Marwari terms used in the armoury. Many of the words are either technical or regional and no longer in use, their meaning lost. They do not appear in dictionaries. Elderly Rajputs were consulted as were scholars in Jodhpur. Some meanings can be rediscovered from their context or guessed at from Sanskrit. The author would like to thank all who contributed and would be pleased to hear from anyone able to assist the debate.

1843 Inventory. Futkar bahi no. 4, in the Rajasthan State Archive, Bikaner.
1843–60 Inventory. Garh Jodhpur re *Silehkhana* re Mojudayat (physical verification) ri Bahi vs 1900–1917.
1909–45 *Silekhana* dalki ri bahi (found in 2013).

1935 Eii. San. Mahekama Shree *Silekhana* Talke Register Patte Wala Kothar Chautha Chowk Maynla ree Hajri ro. (1935) Articles Present in the Chautha Chowk Kothar of *Silekhana* Department.[1]

VS 1830/1773 AD. *Mulmchi*[2] Sukhram and *mulmchi* Tulsidas were employed to add gold and silver work on the guns; *mulmchi Chitardar* applied gold and silver work to swords and guns.

'Shree'
Account of items present in the Jodhpur *Silekhana*
VS 1900–1917/1843–60 AD

Inventory Page 3
Pertaining to deposits made as gifts:

1. Gift from Rathore Ranjit Singh, son of Shivnath Singh of Kuchaman. One gun, *lamchar*, a combination of *pathari* (flintlock) and *todadar* (matchlock).
2. *Sahibzada* of Sindh gifted: one gun, *saskanee kothi ree kaagnee* (rabbit-gun), gold-covered muzzle, shisham stock, silver wires wound around the muzzle, a meshed silver *kadee* (suspension ring), one *bandh* (barrel band), two silver corners (on the butt), two inlaid flowers on the stock, silver butt-plate.

Inventory Page 8
Accounts of the month of *Bhadwa*
Lal Nathmal's son arrived from Delhi and gave a gun to the maharaja. 'One gun, double barrel, old totadar (*topidar*, a percussion gun) with a new stock.' [There is a case to accompany this gun, which indicates it is European.][3]

Inventory Page 11
In the month of *Asaadh*
Gift from Lavaar Muhta of Sai. One *saskanee* (rabbit-gun), suspension ring, the *pechari* (?) of the suspension ring is closed. Silver side-plate.

Inventory Page 16
Accounts of the *Silekhana* in the month of *Saawan*. VS 1902/1845 AD
Four guns gifted by Mulo, a lohar bechaar (a combined blacksmith and trader) of Ahmadnagar.
Chiselled shikar work on the barrel (a series of animals chiselled in relief). Crocodile head muzzle (*mori*). Iron side-plates on the stock, brass butt-plate, two suspension rings not closed.
The second gun has *belboota*-pattern chiselled work on the barrel, straight stock, brass side-plates and suspension rings.
Vertical shikari work[4] on the barrel, brass side-plates and suspension rings.
*Belboota* work on the barrel, iron side-plates, brass suspension rings.

Inventory Page 19
In the month of *Migsar*, Surajmal Khinchi brought back from Kotah a gun with *belboota*-pattern chiselled on the barrel. Iron side-plates, brass barrel bands closed. (This suggests the gun had been sent to Kotah to have the barrel decorated with a chiselled creeper pattern. Kotah was noted for such work.)
Gift from a blacksmith from Ahmadnagar in the month of *Saawan* (from the treasury), Mulmo work on the barrel, silver side-plates closed, *Dhamkapti Sudha Mulmadar*, this gun was dispatched after reworking.

In 1844 the East India Company authorised Maharaja Takhat Singh 'to commission a supply of fusils direct from England'.[5] In VS 1906/1849 AD Lohar Pira was employed to repair 'English guns', and an Afghan, Wilayti Abdul, supplied barrels. The British suffered the disastrous retreat from Kabul in 1842 when many sporting guns owned by British officers passed to new Afghan owners. One wonders about the fate of the previous owner of the barrels supplied by Abdul.

Inventory Page 21

Accounts of *Silekhana* VS 1903/1846 AD

In the month of *Kaati*, seven guns were deposited by Pawar Nahar Karan who arrived from Ahmadnagar. (Pawar is a surname used by various people including Marathas claiming Rajput origin, as here.)

One gun with gold-covered barrel, the stock with iron side-plates plated with gold, a silver side-plate on the *daglee* (the wooden block behind the breech), silver butt-plate, nine *lagar bandhs* (barrel bands) made of silver.

One gun with Ahmedabadi breech, gold on the muzzle, brass side-plates, brass barrel bands.

Four guns with straight stocks.

One gun with straight stock, with *pechari* work.

Inventory Page 24

Deposits made in the month of *Fagann*:

One gun gifted by *Sahibzada* of Sindh, *saskanee* (rabbit-gun), crocodile-head muzzle with ruby eyes, *mulmadar* gold work on the breech and muzzle, *mulma* work on the suspension rings, emerald on the trigger, five loose silver *bandhs*.

*Dhamkapti sudha*, two silver suspension rings, silver side-plate on the daglee (wooden block behind the breech. Stock made of kaag wood, two silver flowers, iron *khaleel*, silver *saaklee*, silver *chaapda*.

11 such guns.

Inventory Page 35

From Grant Sahib, political agent to Jodhpur state, one double-barrel matchlock.

*Sahibzada* of Sindh gifted one gun to the maharaja when he returned to Jodhpur from Sindh where he had gone to get married.

One rabbit-gun, Turkish barrel with jewel-studded breech, gold-covered muzzle, gold-covered *deedwaan* (sight?), gold-covered *chadiya petch* (some specific kind of screw?), without gold trigger, silver *makhi* (small decorative recesses with silvered surface in the steel barrel).

Inventory Page 48

In the month of *Bhadarwa*:

One gun bestowed on Rathore Shivnath Singh, son of Bakhtawar Singh of Asop.

One rabbit-gun (*saskanee*), the muzzle like a hornbell (*dhatura*) flower, snake screw. This gun was made at the expense of the treasury, *mulma* work/gold-covered muzzle and breech, corners on the butt, two flowers on the butt-plate, one barrel band, four small flowers, one sea-shell, one flower vase, two small flowers, silver *cheemti khaleel saaklee*, silver *daglee*, *mulma* work on *kalwaad* (?), seven barrel bands, wavy light [wood grain] stock.

Inventory Page 53

Accounts of the *Silekhana* VS 1906/1849 AD

Gifts deposited in the month of *Sawan*:

One gun gifted by Umkaran Shobhawat. Blunderbuss from Amber, iron side-plates. This gun was returned to Umkaran

Shobhawat by the maharaja. In return for this, the maharaja gave another gun to a person named Mala Borana.

Description – one gun, Amber make, chiselled iron side-plates, ivory-work on the *daglee* (the wooden block behind the breech), two ducks depicted on the stock (probably inlaid ivory, the common Jaipur form), gold-covered muzzle, on the 'tilak'[6] of the breech, gold covering on the *kalgaj* (?), silver *khaleel*, tweezers (*chimti*) and chain (*sakli*); and silver flower vase, *mulma* work on the barrel bands.

Gift from Gambhir Singh Ranawat, one gun with snake screw, Jodhpur make, silver side-plates, silver *chimti*, *khaleel*, *sakli*, silver suspension rings, gold-covered breech and muzzle.

Inventory Page 59

Flintlock tamancha (pistol), carved ivory tiger face on the stock, eight (plaited) silver wires attach the *khaleel*.

Inventory Page 64

Guns deposited by Nahar Karan Pawar and taken from the sons (sahib?) of (some) Ratnawat ji.

One single-barrel matchlock (*shermaar* – lion-killer), elongated cartridge, the sight (*deedwaan*) located at the muzzle, range 1,200 English yards.

Double-barrel matchlock, *shermaar*, elongated cartridge, the sight (*nazar*) of *deedwaan* located at the muzzle, range 1,200 English yards.[7]

Inventory Page 67

In the month of *Asaadh* three rabbit-guns were purchased from a merchant named Narottam.

Gun, *chapdar patharkala* (flintlock), gold-decorated tiger head muzzle and gold-decorated breech, turquoises set in the eyes and ears of the tiger, three silver barrel bands, two silver suspension rings, shisham stock, two silver corners, two silver flowers, silver *palkhi* and silver *kunthi* (?), silver *khaleel*, silver butt-plate, silver *kangani* (?) gold covering on the *mogra* (baluster) at the end of the ramrod, priced at Rs 150.

Gun, *chapdar patharkala* (flintlock), gilding on muzzle and stock, four silver barrel bands, two silver suspension rings, shisham stock, two silver corners, two silver flowers, silver *palkhi*, silver side-plate, an iron *chaap* (possibly compartment on the butt-plate?), priced Rs 80/-.

Gun, screwed breech plug, gilt muzzle, breech and ramrod, priced Rs 80/-.

Inventory Page 70

Saskani or light gun with golden side-plates, golden *chimti*, from Kanpur, (formerly Cawnpore, a city in Uttar Pradesh), silver *khaleel*, and chain, six silver barrel bands, two suspension rings, silver flower vase, golden rings on the stock, gilt muzzle, breech and *mogra* (ramrod baluster). The gun was given by Devi Singh Rathore.

Inventory Page 84

In the month of Vaishakh at Nagore dera (camp).

Gun gifted to the Sahibzada of Sindh, single barrel *shermaar* (for killing lions and tigers), elongated cartridge, imported from Europe, gun case, one *baroodani* (powder flask).

Inventory Page 91

In the month of *Kaati*, the following guns were sent by Jodhpur Maharaja to Maharaja Ram Singh of Kotah.

Gun, Delhi make, tiger face muzzle, gilt muzzle and breech, silver side-plates, five barrel bands, two silver suspension rings, silver *khaleel*, *chimti* and *saakli* or chain. Silver *Chapdas* (?), silver flower vase, ivory-work on the *daglee*, gilt ramrod.

Gun, Delhi make, chiselled barrel, gilt muzzle and breech.

Inventory Page 94

Accounts of the *Silekhana* vs 1911/1854 AD in the month of *Saawan*, pertaining to gifts from blacksmith/merchant from Ahmadnagar.

Two guns of Ahmadnagar make, straight stock, pathardar (flintlock), each barrel with eight barrel bands and four suspension rings.

In the month of *Bhadarwa* gifts were made by Tanwar Pratap Singh and Pancholi Dhanrup on their arrival from Kotah at camp Balsamand.

One gun, breech made of *kedi* (a type of local steel), bajra work on the barrel, gilt muzzle and breech, eight silver barrel bands, gilt ramrod baluster, silver *khaleel* and chain, thick stock.

Inventory Page 99

One rabbit-gun, taarkashi (?) gold work on the muzzle and breech, golden ramrod, gifted by Ahmadnagar blacksmith. This gun was repaired and a new shisham stock added. Iron *chimti*, *khaleel* and flower vase, silver chain to the *khaleel*.

Inventory Page 109

One gun bought by sepoy Karachi Khan,[8] Bhadani (?) *saskanee* (rabbit-gun), flintlock without breech screw, gilt muzzle and breech, priced at Rs 150, this gun was taken by Kiladar[9] Anar Singh.

Inventory Page 111

Accounts of the *Silekhana* vs 1913/1856 AD.
Pertaining to gifts made in the month of *Asoj*.

Gift by Nemo, blacksmith of Kuchaman.
One gun, *todadar* (matchlock), small ramrod, wooden stock.
Special English guns bought by Captain Durgaprasad.

Inventory Page 148

One *tamancha* (pistol) belonging to the Maharaj Jaswant Singh.

Inventory Page 160

The following arms were taken away by Maharaj Kumar Pratap Singh [a son of Maharaja Takhat Singh]: two tamanchas (pistols), these were returned inlaid with gold wire.

Inventory Page 137

78 guns.
Nagore make, breech screw, *Sagwaan* wood stock, iron side-plates.
Breech screw, *Sudho* (?) Intact stock, side-plate.
Nagore make, intact stock, side-plate.
Nagore make, mouth of the gun made at Kuchaman, Intact stock, side-plate.
Jodhpur make, breech screw, intact stock, side-plate.

Inventory Page 132

Jodhpur make, Nagpetch (?). Snake screw breech, intact stock, side-plate.
Rup Nagar make, intact stock, side-plate.

Plain gun Nagore make, intact stock, side-plate.

Plain gun Nagore make, intact stock, side-plate.

Plain gun Nagore make, intact stock, side-plate.

Straight stock fixed at Kuchaman, breech screw, intact stock, side-plate.

Plain gun Lahore make, intact stock, side-plate.

Rup Nagar make, breech screw, intact stock, side-plate.

Rup Nagar make, chiselled barrel, intact stock, side-plate.

Plain gun Jalore make, broken stock, intact side-plate.

Plain gun Nagore make, intact stock and side-plate.

Straight flintlock, intact stock and side-plate.

Straight flintlock, intact stock and side-plate.

Straight plain gun, intact stock and side-plate.

Chiselled barrel from Rup Nagar, intact stock and side-plate.

Small plain gun, intact stock and side-plate.

Plain gun, muzzle damaged. Intact stock and side-plate.

Plain gun of Rup Nagar, intact stock and side-plate.

Plain Nagore make, intact stock and side-plate.

Inventory Page 133

Blunderbuss from Rup Nagar, damaged barrel covered with brass, straight stock.

Straight LADI (?) beloved gun. Intact stock and side-plate.

Plain Nagore, intact stock and side-plate.

Burst Kuchaman barrel, intact stock and side-plate.

Inventory Page 134

Plain Nagore gun, intact stock and side-plate.

Burst Nagore barrel, intact stock and side-plate.

Plain Kuchaman, intact stock and side-plate.

*Dhamako pathadar* (flintlock) blunderbuss, Kuchaman barrel, Da'udi[10] breech screw, intact stock and side-plate.

Plain gun, intact stock and side-plate.

Chiselled barrel from Rupnagar, intact stock and side-plate.

Nagore make, breech screw, intact stock and side-plate.

Nagore plain gun, intact stock and side-plate.

Ahmedabad blunderbuss, intact stock and side-plate.

Ahmedabad make, breech screw, intact stock and side-plate.

Kuchaman make, breech screw, intact stock and side-plate.

Plain gun, intact stock and side-plate.

Small plain gun, intact stock and side-plate.

Plain gun, intact stock.

Double barrel English percussion rifle (*topidar*).

Inventory Page 135

Jewel studded breech of *Narwar*, gold covered muzzle with rhinoceros head, gold covered ramrod.

*Mulma* gold work on special Amber breech, intact stock and side-plate, ivory work on stock.

Amber make, Da'udi screw (?), gold covered muzzle and breech, straight stock and side-plates, silver *khaleel*, *chimti* and

chain, ivory work on *khaleel*.

Jewel studded breech, gold covered muzzle, intact stock and side-plate.

Snake screw barrel, straight silver stock, silver flower vase depicted on the side-plate.

Inventory Page 136

Light gun, jewel studded, gold covered muzzle, intact stock and side-plate, silver *Dhamkapti* (?), silver chain on *khaleel*, two silver suspension rings.

Light gun with snake-screw breech, silver covered muzzle, intact stock and side-plate.

Blunderbuss of Ahmedabad make, gold covered muzzle and breech, a golden creeper carved all the way till the *langar* (?),[11] gold on a corner of the butt-plate.

Jodhpur make, snake screw barrel, *sabach* (a type of wood?) stock and screws in side-plates.

Delhi make, screwed barrel, intact stock and side-plate, gilt muzzle, two silver suspension rings.

Delhi make, screwed barrel, gold covered muzzle, intact stock and side-plate, one *dhamkapti* (?), eight silver suspension rings.

Plain gun of Kuchaman make, intact stock and side-plate.

Delhi make, chiselled barrel, intact stock and side-plate.

Plain straight gun, intact stock and side-plate.

Plain gun of Nagore make, intact stock and side-plate.

Burst barrel, made in Nagore, intact stock and side-plate.

Inventory Page 137

Barrel made in Rup Nagar, chiselled, side-plates on stock.

Straight (*Seedhan*?) plain gun, intact stock and side-plate.

Plain gun of Nagore make, intact stock and side-plate.

Rup Nagar make, burst muzzle, intact stock and side-plate.

Plain gun of Khurrampur make, intact stock and side-plate.

Plain gun of Nagore make, intact stock and side-plate.

Inventory Page 138

Plain gun, intact stock and side-plate.

Plain gun, intact stock and side-plate.

Plain gun of Nagore make, intact stock and side-plate.

Nagore make, straight stock, three brass barrel bands.

Plain gun, intact stock and side-plate, three brass barrel bands.

Plain gun of Nagore make, intact stock and side-plate.

Plain gun of Rup Nagar make, intact stock and side-plate, brass barrel bands.

Khurrampur make, screwed breech, intact stock and side-plate.

Plain gun, intact stock and side-plate, seven brass barrel bands.

Plain gun of Kuchaman make, intact stock and side-plate.

Plain gun, intact stock and side-plate.

Plain gun, intact stock and side-plate.

Old gun of Rup Nagar make, plain stock.

In VS 1914/1857 AD Gujdhar, an expert at cleaning and washing guns was employed. He used *janathi* cloth and white *lattha* cloth (a coarse cloth) purchased from a trader named Kesar.

In vs 1906 & 1912/1849 & 1855 AD. Gulab, a trader (*vyapari*) supplied large and small size lead shot.[12]

Inventory Pages 155–56
Accounts of the *Silekhana* in vs 1915/1858 AD.
In the month of *Asoj*, Brahman Lakshmandas brought a *khalita* (a letter in a wallet) to Jodhpur from the Maharao of Kotah (Ram Singhji II) who gifted two guns.

One blunderbuss, Bundi make, chiselled muzzle and breech, covered with *mulma* gold work, image of the mother goddess in *charbhuja* on the breech and also a figure of *Bhaironji*,[13] side-plates on the stock, silver creepers on the *daglee*, silver flower vase, silver *khaleel*, silver suspension rings, two silver side-plates, a silver peacock on one side and silver creeper on the other side, two pigeons depicted on the stock along with two dots, silver flowers, silver side-plates, gold covered ramrod, an image of a lion imprinted on *makhmal* (silk velvet) and an image of a lioness engraved on deer horn.

Inventory Page 163
Accounts of *Silekhana* in vs 1916/1859 AD.
In the month of *Saawan* four English rifles imported from the west were deposited in the *silekhana* at the cantonment/camp with a paper describing the guns in detail.

Two double barrel rifles, brass match, priced Rupees 1470. Two gun cases with all required items. Each gun case was priced at Rupees 735.
Rupees 105, *mulma* gold work done on items in the gun case. Rupees 52 charged for the same.
Rupees 42, gun cases covered by *makhmal* cloth, Rupees 21 for the same for each case.
Rupees 10, gun cases covered with leather. Rupees 5 for each case.
Rupees 22, for extra items.
Each gun in the gun case had gold work on *chaap* (?), *eda* (?), *palkhi* (?) and ramrod (*gaj*) baluster.

Inventory Page 185
In the month of *Migsar* vs 1917/1860 AD.
On the Eleventh *sudi*, an English matchlock was purchased from Nazar Iliyas Baksh priced (…) [sic] silver *susi* (?) on the shisham stock, brass *pola* (?) on the ramrod baluster. This gun was deposited in the *silekhana*.

Inventory Page 190
In the month of *Fagann* Paliwal Shivnarayan arrived at the royal palace here from Jaipur carrying a gift from Maharaja Ram Singh of Jaipur (r.1835–80 AD). This gun was deposited:

One gun, breech made at Amber, gold covered muzzle, gold creeper chiselled on the barrel, iron side-plates (decorated) with gold lines on the stock, iron *khaleel* with gold chain, two gilt iron suspension rings, the gun covered with a special *makhmal* (silk velvet) cloth, a plain mould for casting bullets, *kalavantu* (?) work on the muzzle.

From the Shikarkhana miscellaneous files it is possible to see what guns the Maharaja Umaid Singh was using and his frequent requests for ammunition to be sent shows how much he used them. None of the gun numbers listed below are in the 1935 Inventory.

B182/ 5342. To James Purdey, London. Urgent cable. Please despatch immediately by return four foresights for the .450 rifle No 22983 with metal points not ivory. Comptroller Household, Jodhpur. On 7/12/26 Purdey's supplied the sights and a sketch giving instructions as to their adjustment. (This gun is no longer in the Jodhpur Armoury).

257/7907. 25/8/30 Telegram to Manton and Co., Kashmir Gate, Delhi. Please send immediately:

50 12 bore Manton's Contractile ball smokeless cartridges.

100 12 bore 3" cartridges loaded with No 1 Shots 3" case

50 12 bore 3" long cartridges loaded with L. G. shots

and also send your latest fishing catalogue.

18/9/30 S. B. .22 bore Winchester Target Model Rifle, no. 13059 returned from Manton after repairs.

26th Aug. 1930. A .350 bore DB, H' less Ejector Rigby rifle in W. C. Case was sent to Manton and Co – 'The ejector of this rifle does not work'. Clearly a favourite of Umaid Singh who asked for its return at 'an early date'.

16th Sept. 30. Manton [telegraphic address 'Rifling'] to Comptroller of Household. 'Your DB Rifle No. 6955 by Alex. Henry is now ready after necessary repairs…'

(Note: Alex Henry rifle no.6955 was sold at James Julia's in the USA – lot. 2384 March 2016).

30/9/31 Please supply 500 long and 500 short cartridges for .22 bore Winchester rifle.

13/10/30 Please supply immediately 150 copper point and fifty solid cartridges for Holland and Holland's .375 DB barrel. Order for 200 more on 17/11/30

18/11/30 send 1000 short and 500 long cartridges for .22 Winchester rifle.

19/12/30 send 600 twelve bore long cartridges – wire size of shot – 300 of size 4 and 300 of size 5

6/1/31 send 150 cartridges for .375 DB Holland rifle

26th Feb 1931 Purchase of .38 Colt auto pistol no. 7608 from Manton and Co.

.22 bore FSA air rifle no. 39827

Ditto No. 34984

One Crosman air rifle no. C9667[14]

The maharaja was generous in granting permission for people to shoot 'blackbuck and chink' as the files show. Other files relate payments of *bhatta* and railway fares for staff engaged in shikar.

B280/8667 deals with a case of illegal sambhar shooting within the reserve forest in Sojat Pargana in the spring of 1936. Under section 2 of the Marwar Shooting rules of 1921, the shooting of sambhar in all parts of the state was strictly prohibited except with the written permission of the maharaja. This case also involved a breach of the Marwar Forest Act of 1934.

# GLOSSARY

*Aftabi* (Persian). A style of goldwork where the subject, usually a flower head, is outlined by a dark ground like a shadow where the gold is cut away exposing the base steel or iron.

*Agadi tilak* or *tilak* for short (Marwari). These terms appear to mean 'screw breech plug', a Bohemian fifteenth-century invention, adopted by the Turks who had captured both European gunmakers and European guns. The Portuguese found the Goan armourers already making screw in breech plugs when they captured the main town in 1510, having Turkish and European guns on which to model Goan products. The Portuguese took these guns to their colonies in south-east Asia and the Far East where the screw breech plug was adopted by local gunmakers in Japan in 1547, who took it to China in 1548 and Korea in 1595. In the rest of India and Persia this construction appears to have been ignored. One would have expected the Mughal court to have adopted this design but there is no evidence that it did. Had it done so the technique would have spread to their Indian allies. In the 1856 Mehrangarh Inventory there are references to guns with screw breech plugs made in Nagore, Jodhpur, Kuchaman, Rup Nagar and Amedabad. There is also a blunderbuss with a breech screw and the Jodhpur armourers note that a Sindhi gun does not have one, presumably mentioned because they thought it should. It appears that in the first half of the nineteenth century this method of construction was adopted by craftsmen across India and the fact that this detail is mentioned so often in 1856 suggests that the technique had caught the attention of the workers in the armoury and was comparatively novel. Prior to the introduction of the screw breech plug the practice was to either have the breech end with a flat plate, or by hammering in a metal plug which was usually welded to the barrel. See *kalgaj*.

*Ahsham*. Includes all soldiers connected to the Mughal army who were not handpicked by the emperor as his elite (*ahadi*s), *mansabdar*s or their entourage (*tabinan*). The Emperor Akbar's 12,000 matchlock men would be listed under this title as were armed police, artillery personnel, artificers and court attendants.[1] The common feature in the *Ahsham* is direct payment by the imperial court. As the southern Italian traveller Gemmelli Careri (1651–1725) observed in his book *Giro Del Mondo*, in 1699: 'I cannot account for the prodigious amount of infantry with which some people swell the armies of the great Mogol, otherwise than by supposing that with the fighting men they confound servants, sutlers, tradesmen, and all those who belong to bazars or markets who accompany the troops.'[2]

*Al-bunduq al-rasas* (Arabic). A common name for a gun; *rasas* means 'lead'.

*Arabas* (India). A kind of arquebus.[3]

*Arghun*. India, a corruption of English 'organ', commonly thirty-six gun barrels, mounted on a cart, linked by a loose gunpowder train to fire simultaneously. This Chinese invention was adopted in Europe in the fourteenth century and was known as a ribauldequin. Leonardo da Vinci drew designs of them in his *Codex Atlanticus* in the late fifteenth century. Abu'l Fazl credits the Mughal Emperor Akbar with the invention of joining seventeen gun barrels together so that they could be fired with a single match[4] but Fathullah Shirazi[5] may have seen a fourteen-barrel 'organ' in Goa.[6] A letter from an officer in De Boigne's camp dated 1790 describes how a fellow officer was severely wounded by Jodhpur troops during the battle of Merta by a 'weapon called an organ, which is composed of about thirty-six gun barrels so joined as to fire at once'.[7] Known to Rajputs as a *shatghri*, this is still at Mehrangarh.

*Bacamarte* (Portuguese) A blunderbuss.

*Badalaya* (Marwari). Literally 'cloudy'. Watered-steel pattern found in Rajasthan.

*Bail-buta* (Hindi). *Belboota*. Scroll and flower design. *Bel* is Hindi for 'Arabian jasmine'.

*Bajra* work (Marwari). Ring-matted decorative finish found on barrels. *Bajra* means 'millet'. See Bij (below) for a finer form of stipple.

*Banat*. A fairly coarse red baize or broadcloth used for gun-bags. The other cloth used is *logi*.

*Bandh* (Marwari). Singular and plural. Metal barrel bands. Otherwise *tenes*, origin unknown. Sinew whipping is the traditional method of securing the barrel. The 1843 inventory indicates whether *bandh*s are 'open' or 'closed'; some are complete circular bands, others half-bands that bestride the barrel above the stock with raised edges to keep the whipping together as it passes over the half-band. In Europe these are referred to as 'saddles'. In India metal barrel bands become more common in the eighteenth century. Many Takhat Singh *bandh*s have similar silver designs that appear later than the guns themselves, as though all were added at the same time in the late nineteenth century — possibly before the guns were sent for exhibition in Delhi. Ranjit Singh's Punjab has a distinctive slender brass *bandh*. The big game hunter Gerald Burrard wrote in 1920 in *Notes on Sporting Rifles for Use in India and Elsewhere* that sling swivels rattle noisily and strongly recommended rawhide.

*Bandro pani pina* (Marathi). Serpentine. 'Monkey drinking water' (see Cooper). In Marwar it is a *ghora*, a horse that drinks from the *makhi*, a *makhi* being a 'hole', here meaning the lock pan.

*Banduk* (Marwari, Urdu, Hindi) (Arabic *bunduk*, archaic Anglo-Indian *bundook*). The word is usually qualified by adding a second word which indicates the place of manufacture as in '*bundook* Sindhari', or the mechanism such as *bundook topidar*, *bundook toredar*, *bundook singhaj*, *bundook kartusi*. In Sri Lanka, the word '*bondikula*' is used.

*Banduk doraha*. Double-barrel gun. *Do* means 'two' and *raha* means 'way' or 'path', hence double-barrel.

*Banduk dubandi*. The two-band Enfield.

*Banduk saskani* (Sindhi). *Saskani* means rabbit. A small bore Sindhi rabbit-gun, normally 25-bore. Also *saskanee*.

*Banduk tibandi* (Marwari). Three-band Enfield (*ti* means 'three').

*Barak*. Gold foil.

*Baroodani* (Marwari). Barudani. A powder flask.

*Barq-andaz* (Persian). Matchlockmen.

*Beg*. A Turco-Mongol military title, a high status warrior.

*Berços* (Portuguese). Small breech-loading European cannon invented in the fourteenth century, sometimes mounted on a swivel. The open breech had a pre-loaded chamber that looks like a tankard placed in it and a wedge was hammered behind it to ensure the chamber fitted tightly against the barrel. Ignition was via a touch hole on the chamber. Barros wrote that the King of Cambay had pairs of berços mounted in 'castles' on steel armoured elephants, each with four men.[8] The 1525 list of artillery in Portuguese India mentions that many chambers are wasted due to humidity.[9]

*Bhadaka* (Mewar). A small firecracker for driving cattle. Small stones, potash and gunpowder were placed within a paper and sealing wax cover. These exploded when thrown at the feet of cattle.

*Bharmar*. Matchlock and flintlock combined in one gun. Hindi *bhar*, 'heavy' and *mar*, hitting. An example is listed in the Mehrangarh armoury.[10] Baden-Powell (vol.II, div.III) suggests the bharmar was invented in Ranjit Singh's time by a Hindustani named Mirza Bharmar but he was not above embroidering a story. It was believed to carry further and more accurately than a conventional matchlock or flintlock and was therefore preferred. In 1827, Dr Murray recorded a Gurkha regiment armed with this weapon.[11] Four battalions of Gurkhas were recruited by the East India Company in 1815 under the treaty of Sauguli from the defeated and disbanded Nepali army. Egerton described *Banduk doraha*, 'Two guns, one completely enclosed within the other. The outer gun is a flintlock, the inner one a percussion lock.'[12]

*Bij* (Marwari). Seed. The fine stipple finish on a gun barrel as distinct from the larger bajra finish.

*Bisen* (Japanese). The plug that protrudes from the breech of a Japanese matchlock barrel.

*Bokemar* (North India). A small blunderbuss flintlock carbine.

*Bunduk Masaladar* (Punjabi). Sikh percussion gun, the system gradually adopted by the Sikh army after 1825 though irregular troops continued to use the matchlock until mid-century. General Allard imported two million caps from France in 1836.[13]

*Bunduk-i chakmaki* (Persian). Flintlock gun. The Sikhs referred to this gun using the Persian or else called it *banduk du kala*.[14] See Ottoman *çakmakli tufek*.

*Campo*. (Hindu *kampu*, the u is long) Taken from the Portuguese word 'campo', literally a 'camp' but specifically applied to military brigades under European leadership in service of the Marathas.

*Chand-mari* (Mewari). Shooting at a target (like the moon) on a range.

*Chap. Chanp* (Marwari). The metal side-plates of a gun applied to the stock.

*Charra. Charre* (Urdu). Shot (pellets).

*Charredar banduk* (Urdu). Shotgun.

*Cheel*. A red kite, symbol of the Rathores of Marwar.

*Cheepiya*. Literally 'tweezers'. The 'V' that grips the match on the arm of a matchlock.

*Chhadee*. Ramrod.

*Chimti* (Marwari). Tweezers of the type found on the *sakli* (chain) attached to the stock of a matchlock near the breech.

*Chitara* (Marwari). A painter, also a man creating fine inlay in iron such as pictures or inscriptions. The 1843 arms inventory refers to fine gold flowers as 'chitara work'.

*Chokri* Cross-hatching.

*Da'ud* is Arabic for David; in the *Qur'an dawud*, a reference to King David (also of the Old Testament). The Arabs use Da'udi or Dawudi to mean mail shirts which God instructed King David to make. (Qur'an XXXIV, 10 F.; XXI, 78). In Jodhpur *Da'udi pecha* probably means Arab rifling. Akbar ordered '50 large mortars and 500 Da'udi cannons'.[15] The meaning is unclear but *da'udi* suggests 'of the Arabs', a broad description of something from the Near East.

*Daglee* (Marwari). The wooden block behind the breech.

*Damanak*. A shorter than usual matchlock with a length of one and a quarter yards invented by the Mughal Emperor Akbar. The more usual length in his reign was two yards.[16]

*Dana* (Marwari). Lead shot.

*Darogha*. A superintendent or senior administrator.

*Daru* (Persian). Gunpowder, medicine. Gunpowder was thought to have medicinal qualities. The earliest Arabic word for gunpowder, *dawa*, means 'remedy'. Afghanistan and India took the term *daru* from Persian but also adopted the word *barut* or *barud* for gunpowder. *Darukhana* or *barutkhana* both mean gunpowder store; *daru che baste*, bags of gunpowder (Maratha eighteenth century).

*Da'udi / Dawudi / Duru'i dawudiya* (Arabic and Persian). Mail. A reference to the *Qur'an* (34:8) where Dawud (the biblical King David) made the first mail shirt: 'On David We bestowed Our favours. We said: Mountains and you birds, echo his songs of praise. We made hard iron pliant to Him, saying: make coats of mail and measure their links with care. Do what is right: I am watching over all your actions.'

*Deg, deg-i buzurg*. A mortar.

*Dhamako; dhamaka* (Marwari). A blunderbuss. *Dhamaka*, Hindi for 'explosion' or 'bang'; 'to make a loud noise'. The word is used in Hindi, Rajasthani and Gujarati.

*Dilkhush*. 'Heart's desire' or 'Happy Heart', a common north Indian name for a fine gun. Another gun name in the Mehrangarh Inventory is '*ladi*' meaning 'beloved'.

*Drillings* (German for 'triplet'). A combination gun with three barrels, usually one rifled and the other two smoothbore, arranged in an over-and-under configuration. There was also the vierling, German for quadruplet, with four barrels. The advantage of having a gun capable of shooting a wide variety of game made these combination guns particularly

popular with gamekeepers. Usually there are two triggers and a selector allowing the user the choice as to which barrel to fire. They break at the breech and commonly use a rimmed cartridge because it is easier to extract.

*Durbin*. Field glasses.

*Edo* (Marwari). Heel-plate on a gun stock. *Edi* in Marwari means a 'heel'. The term is used in the 1935 Inventory to describe S. W. Silver's rubber recoil pad.

*EIG*. Stamp on a gun; East India Government.

*Eknali, donali* (Marwari). Single/double barrel.

*Espingarda* (Portuguese). A gun.

*Espingarda de mecha* (Portuguese). A matchlock gun.

*Falcaõ* (Portuguese). Literally 'falcon'. An early breech-loading cannon. Correia suggests they often fired grape-shot.

*Farzul* (Sikh). Touch hole on a musket; nineteenth century.

*Fatila* (Persian). A match for a matchlock.

*Fei-huo-ch'iang* (Chinese). A 'flying fire lance', a rocket.[17]

*Firangi* means foreign and is applied to people and a variety of cannon, guns and edged weapons.[18] Babur applies the name to cannon, indicating how 'foreign' the technology was to him.[19] Irving gives a later use of the word 'Firangi', the name in the Deccan for a swivel gun.

*Fofalia* (Hindi). Silver (also bubbles).

*Folangji* (Chinese). Bronze and iron muzzle-loading cannon with a calibre of about 40 mm, used by Chinese frontier troops in the sixteenth century. Folangji from 'farangi' or 'franks' – in this instance Portuguese who supplied these guns. They were mounted in special battle carts drawn by mules.[20]

*Fuladi* (Indo-Persian). Watered-steel.

*Fuldi* or *fulri* (Marwari). A washer, a design.

*Gaddi*. Throne.

*Gaj* (Marwari). Ramrod. The baluster end of the ramrod is a *mogra* or 'bud', also the name of the lotus 'bud' that projects above the talwar disk pommel where it symbolises the goddess.

*Gajnal* (Persian and Hindi). A small swivel gun, from *gaj*, 'elephant' and *nal*, 'tube' or 'gun barrel'. It appears that they were carried in pairs per elephant and were swivel guns. Sometimes called a *hathnal*, which has the same translation, *A'in-i Akbari*. Also *kajnal* – 'A small cannon carried on an elephant', Steingass, *Persian-English Dictionary*, p.1017. In transliteration 'k' and 'g' in Persian are interchangeable as in, for example, the verb 'gashodan' which is often rendered as 'kashodan'.

*Galangeh-dan* (Persian). The cocking lever on a gun.

*Ganga-Jumna*. Rajputs write Ganga-Jumni, Jumni being feminine in Marwari. Two contrasted metals, usually brass with steel, as in links of mail, or brass and copper but in the Jodhpur arms inventory also contrasting gold and silver. The name describes the coming together of the two goddesses who symbolise the Ganges and the Jumna at Allahabad, called by Hindus *Prayag*, the yellow Ganges mingling with the dark blue Jumna. In early India water was one of the five elements (*tattvas*), together with fire, earth, space and wind. The meeting point of two rivers is invariably regarded by Hindus as a sacred and auspicious place or *sangam*. It is also a *tirtha*, a crossing point between the mundane and spirit worlds.

*Gaz* (Urdu). Cleaning rod.

*Ghoda* (Marwari). Match holder on a gun, also a horse. The term reflects the travel of the match arm.

*Gholihas*. Pincers.

*Ghor-dahan* (Persian). A *jezail* made at Lahore in the mid-eighteenth century. Irvine suggests it had a flared muzzle.[21]

*Ghora* (Marwari). Trigger.

*Gingall / jingall*. Heavy wall gun served by two or three men. Fitzclarence wrote in 1819: 'They use long heavy wall pieces called gingalls, which send a ball of two or more ounces to a very considerable distance.' Sources suggest a range of a mile. A light artillery piece of about an inch calibre though with considerable variety, the barrel supported by a tripod. Known in Sri Lanka in two forms, firstly as *kodi tuvakku*, 'grasshopper gun', because of the appearance of the two legs of the rest and the long tiller-like stock; and a larger, heavier version on wheels, the *kala tuvakku*. An ornate, bell-mouthed, 39-inch barrel *kala tuvakku* dated 1745, made for the king, is in the Rijks Museum, Amsterdam. Similar guns were used in Burma, sometimes mounted on a carriage. See Chinese *tyfu* – Elgood, 1995.

*Goli* (Marwari). A ball or bullet.

*Gupti bundook*. John Day of Barnstaple, England developed the first percussion cap mechanism for a walking-stick gun in 1823, a product that appealed to the county landowner out for a stroll and to the poacher; popular in Britain and India. The nawab of Ahmedpur, Bahawalpur owned one c.1850:

> Amongst other little curiosities of art, he displayed, with some pride, a gun that could, at any moment, be converted into a walking stick. This ingenious weapon had been constructed by artisans residing in Ahmedpore. The gun was his constant companion, and how it was that no accident ever occurred, appears most wonderful; for not content with loading it to the muzzle, the Nawab called my attention to the fact that it was always on full cock ready for use.[22]

Single-shot, European-style walking-stick guns were made in Monghyr in India in the nineteenth century. Indian sticks often have concealed blades that have to be removed with the ferule before the gun can be fired. The development of pin-fire, rim-fire and centre-fire cartridges made stick-gun design infinitely easier. By 1900, a hundred patents relating to these cane guns had been filed and a further fifty by 1935.[23] In London Thomas Bland and Son advertised a stick gun in Walsh's *The Modern Sportsman's Gun & Rifle* in 1882: 'The Collector's Gun, a miniature breechloader for naturalists' use, in .360 and .410 bores. Price ten guineas'. The naturalists mentioned in advertisements for stick guns were interested in ornithology and across the world they shot and preserved species of birds, their collecting often supported by the Natural History Department of the British Museum. The birds' skins were preserved in drawers. Stick guns often fired a .410 shotgun cartridge and could be carried discreetly when a conventional gun might cause problems.

*Hawadar* (Marwari). An airgun.

*Hawai* (Persian). A rocket. Iqtidar Alam Khan suggests the earliest contemporary mention of a hawai for military purposes is by the ruler of Malwa, mentioned in the *Ma'asir-i Mahmud Shahi*, compiled 1467–8 AD.[24]

*Hiddah*. A powder flask attributed to Udaipur. Wallace Collection Catalogue, 1914 no.2245.

*Hinawaju* (Japanese). Matchlock.

*Hor* (Marwari). Gunpowder.

*Huka* (Maratha). 'A shell'. A gunpowder container. See the early eighteenth-century *Ajnapatra* by Ramacandrapant Amatya.

*Huo ch'iang* (Chinese). A flamethrower and proto-gun; a tube containing an inflammable mixture mounted on a spear. Invented by the Chinese and later adopted by the Mongols and Christian Europe.

*Huo pao* (Chinese). An incendiary arrow with an attached glass container that shattered on impact, containing an inflammatory substance.

*Jagir*. An estate or land holding.

*Jal, jali* (Marwari). A net or lattice pattern. Also the perforated stone lattices used for palaces.

*Jamagi* (Persian). A match for a matchlock gun. The Persian word *falitah*, *palita* in Hindi was also used.[25]

*Janbiyya* (Arabic). *Jambiyya* (Persian). Jamb means side. A dagger with a crooked double-edged blade with a median ridge.

*Jambur* (Marathi). A field gun. In the eighteenth century associated with the use of grapeshot.[26]

*Jamki* (Mewari). A match for a matchlock gun.

*Jezail* (Urdu). A matchlock gun. The Afghans talk of 'black guns'.

*Jinsi*. A mercenary brigade of infantry with supporting field artillery, for hire in north India.[27]

*Jujarba* (Rajasthani). Camel gun or swivel, mounted on the saddle. Alwar Government Museum has large, brass-mounted examples as well as steel ones with internally fitted hammers for percussion caps based on Henry Nock, William Jover and John Green's patent no.1095 1775. Military units with swivel-gun mounted camels were inspected by the Prince of Wales during his tour of India in 1875–6.

*Kadiya, kadiya fibadi* (Marwari). Pronounced 'kari'. Sling swivel.

*Kaitoke*. 'A very long and heavy matchlock'; used in the eighteenth century by South India troops, referred to as Karnataki by the Mughals, by which they meant southerners in general rather than the modern region. 'Kaitoke' is a phonetic rendering of the French word *cailletoque*.

*Kalgaj* (Marwari). A welded or pinned breech plug.

*Kalindar jadea* (Marwari). Inlaid brass 'cobra scales' on a gun barrel. See FRM/76/241

*Kan* (Marwari). Gunpowder pan on a matchlock – also an ear.

*Kandha* (Marwari). 'Shoulder'; stock of a gun. Normally written '*kundo*' in the Jodhpur Inventory.

*Kanti* (Marwari). *Kant* (Hindi) 'neck', pertaining to the neck, a necklace or the locket or upper suspension band on a Rajput scabbard. In Marathi, *kanthi* means a necklace. The decorative ring three-quarters of the way up the grip of a talwar towards the *katori* or pommel disc. In the Jodhpur Armoury Inventory the ring of metal in the middle of the butt of a Sindhi gun where the wood is at its most reduced.

*Karabin* (from French). Blunderbuss. Ranjit Singh's Sikh cavalry, trained by the French officer Jean-François Allard, used a gun of this type. See also *sher-bachha*. North India and Afghanistan.

*Karol*. A heavy carbine used by Haidar Ali's cavalry.[28]

*Kartus* (Rajasthani, Hindi, Urdu). Cartridge.

*Kartus*i. A cartridge gun.

*Kazan* (Persian). A copper alloy mortar used by the Timurid forces in Khurasan at the end of the fifteenth century. It was usually extremely heavy, difficult to move, and fired stones. The *Baburnama* mentions kazan cast by Ustad 'Ali-Quli at Agra in 1526. Because of the difficulty of casting large objects most Indian cannon were made like those of the Turks, in two pieces, subsequently joined, the powder chamber (*daru-khana*) and the stone chamber (*tash-awi*), the former having a thicker wall.

*Kedi* (Marwari). Country or local steel.

*Khaleel* (Arabic). Literally 'my friend'. The implements found on the end of the chain (*sakli*) attached to the stock of a matchlock near the pan. These assist the owner of the gun to keep the vent open and the match trimmed and the powder in the pan.

*Kharita-ha* (Persian). Gunpowder pouches.

*Khatka* (Marwari). Trigger.

*Khodva* (Marwari). Incised pattern.

*Kholia* (Marwari). A gun cover. Mughal miniatures show guns being carried by a *mirdaha* or 'gunbearer' in a red cloth bag made of *banat* or 'broadcloth' with drawstring mouth. A common Hindi/ Marwari/ Punjabi word for a matchlock or gun is *banduk*, hence '*banduki*s', orderlies who carry the *banduk*. Fryer, travelling in India in 1672–81, describes how the Indians 'Cloath the Gun with Scarlet that has made any notable Breach, Slain any great soldier, or done any extraordinary Feat'.[29] In nineteenth-century Sindh the matchlock was generally carried with 'a red cloth cover'.[30] Tailored red gun covers with ivory caps over the muzzles of all the guns carried by infantry can be seen in a Jodhpur painting of c.1810, *Nath Dignitaries in Procession*.[31]

*Khoti* (Marwari). Breech.

*Khotun* (Chinese). Early gun made from iron or bronze.

*Khudma* (Marwari). An inscription.

*Khurampur*. Town in Uttar Pradesh making guns.

*Kirniyan* (Marwari). A bullet mould.

*Kisa'i kamar* (Persian). A belt worn at the waist carrying all the requisites of a hunter or musketeer. Steingass, *Persian-English Dictionary*, p.1069.

*Knoxform*. Or Nock form, as its invention is sometimes attributed to the Nock family of gunmakers. The flat area adjacent to the receiver ring found on many nineteenth- and twentieth-century barrels. It simplifies the correct positioning of the barrel wrench when the barrel is removed.

*Koitha* (Mewari). Caterpillar cocoon used as wad when loading a toredar. Before boar-hunting at Devgarh in Rajasthan, Bhils would be sent into the jungle to bring back branches covered in these ball shaped cocoons. The Rawat says he has drawers full in his armoury dating from when they were used.

*Koragokiya* (Marwari). A curved cartridge box, worn on a waistbelt to hold handmade matchlock cartridges. In nineteenth-century Jaipur Armoury list.

*Korbandi*. Work, any decorative border, similar to Hindi *kinari* work.

*Kothi* (Marwari). A store. The 'store' for gunpowder or breech.

*Kothi bundh* (Marwari). The astragal at the breech marking the limit of the breech or powder chamber, which has a thicker barrel wall.

*Kuchaman*. A gunmaking town in Nagaur District, Rajasthan.

*Kundan* (Urdu). 'Finest', 'purest'. An Indian jewellers' technique for setting stones in gold that relies on the malleability of pure gold.

*Kundha* (Marwari). Butt.

*Lamchar* (Marwari). Literally 'big and long'. The local Jodhpur name for a tall matchlock gun.

*Langar*. In Farsi and Urdu a cable or rope. An astragal, the reinforcing ring on a cannon or gun barrel. On some matchlocks the astragal is given a rope appearance.

*Languets* (from old French). The metal 'tongues' projecting from the hilt of a sword or dagger on either side of the blade. Their function is to grip the scabbard to prevent the weapon from falling out.

*Lashkar*. A town in Gwalior. The Royal Armouries Leeds own a matchlock made there.

*Luleh* (Persian). A gun barrel.

*Madafi* (pl. *midfa'*) (Arabic). Mamluk firearm, mid-fourteenth century onwards.

*Makara* (Sanskrit). Gharial, the Indian river crocodile (*Gavialis gangeticus*) with long, upturned snout. Also a mythical composite animal used as an ornament from Mauryan times, usually with a crocodile's body, pig's eyes and ears and often an elephant's trunk. Makara often decorate matchlock muzzles.

*Makhi* (Marwari). The front- and rear-sight on a gun. Possibly originally the hole in the rear-sight and by extension the sights.

*Manpur*. A town in Gaya District, north-eastern India, manufacturing wooden railway sleepers. A matchlock with teak stock inlaid with ivory attributed to Manpur is in the Jaipur Armoury.[32]

*Manton and Co*. London gunmakers. Frederick Manton established a Calcutta office c.1825. The company still exists. See Blackmore, 1986, pp.137–8 for this English gunmaking family.

*Masha* (Persian). Trigger. The word is used in the *A'in-i Akbari*.

*Metris tüfengi* (Turkish). A trench gun.

*Minai* (Persian). Enamel; *minakari*, enamel work.

*Miquelet*. The distinctive early seventeenth-century Spanish snaplock, called the *llave española* in the seventeenth and eighteenth centuries, is known today as the miquelet lock. It is characterised by a horizontal sear passing through the lock-plate, which serves to maintain the base of the cock in the armed position. A similar functioning sear is found on wheel-locks. The second feature that is universal on miquelet locks and flintlocks other than the snaphaunce is the combined L-shaped one-piece battery and pan cover. The large external spring is a common feature of these locks.

*Mori* (Marwari). Muzzle

*Mugger*. Crocodile. A crocodile-head design is common on gun muzzles. Boileau was given a Sindhi gun with such a barrel by the Khan of 'Ahmudpoor'.

*Mulama* (Indo-Persian). Fire gilding.

*Mulma*. Fire gilding.

*Mulmchi* (Marwari). Community of goldsmiths specialising in fine gold work.

*Murassa*. Decorative treatment of metal, for example of a sword hilt using gold, silver, diamonds and other gems. S.A.A. Bilgrami In Hindi *talwar par jarau kam*, work of decoration: murassagari, the work done by a murassagar.

*Naal* (Marwari). Barrel of a gun.

*Naga*. In Rajasthan this may refer to the indigenous inhabitants of the region; but is also the name given to ascetics of the Dadupanthi sect whose headquarters is in Jaipur. Both groups were militant and served as mercenaries. The former were noted for being armed with the traditional six-foot cane bow and the latter for using the *pata* or gauntlet sword, but both groups used firearms.

*Nal* (Marwari). A ramrod; *nali* (Hindi rod).

*Nala* (Urdu). Barrel of a gun. *Do nale wala / dunali* – double barrelled.

*Nalikayudham* (Sanskrit). An unknown weapon with a 'fire wick' (*analavarti*) mentioned in the *Sahityaratnakara*. In Sanskrit *nalika* means a 'pipe' and *ayudham* means 'war' or 'battle'. (Persian *nal*, a 'pipe' or 'tube' also meant a 'barrel' in Akbar's time. Steingass.)

*Narnal* (Persian?). 'Guns which a single man may carry are called narnals.' Abu'l Fazl in his chapter on matchlocks in the *A'in-i Akbari*, Blochmann, 1988, Delhi reprint, vol.I, p.119. Cited by Irvine but apparently not mentioned in other Mughal manuscripts.

*Narwar*. A town and fort in Madhya Pradesh, a Rajput state captured by the Mughals in the sixteenth century and by Scindia in the nineteenth. Mail and guns were made there. See matchlock, Royal Armouries, Leeds, XXVIF. 126/XV.6 bearing the date VS 1786.

*Niaoqiang* (Chinese). A snap matchlock modelled on those brought to East Asia by the Portuguese in the sixteenth century.

*Paik.* 'Soldier', a foot soldier. The term refers to troops of varying competence in Ottoman Turkey, the Delhi Sultanate or among the Ahom of Assam for example; most were armed with the bow, in time replaced by guns.

*Paltan* (India). Battalion, subdivided into squadrons (*nishans*). The paltans took their names from their leaders[33] and varied greatly in size.

*Pat* (Mewari). A side-plate on the stock of a matchlock.

*Patasudi* (Marwari). Overlaid with silver or silver gilt.

*Patharidar, pathadar, patharkala.* Flintlock.

*Patilha* (Portuguese). Miquelet lock.

*Pavise.* A very large European shield used from the late fourteenth century to the early sixteenth century to protect archers and crossbowmen, particularly when conducting a siege. The lower end of it rested on the ground and the pavise was supported by a prop.

*Paya* (Marwari). Serpentine on a matchlock. The S-shaped lever that pivots on an early gun stock bringing the slow match to the touch hole to ignite the charge. The date when this was adopted is disputed. It is said to be first depicted in China in 1411 AD.[34] Blackmore shows the earliest illustration of such a mechanism in a European painting dated 1411[35] and another painting in Breslau dated 1468.[36] Both have the serpentine mounted in the centre of the stock igniting a cannon-barrel touch hole and show a lever trigger that clearly owes its origin to the crossbow. A matchlock example is illustrated in the *Codex Germanicus* 597 dated 1475. Blair points to the *Codex Monacensis* 222 of Munich c.1500, which illustrates matchlocks with serpentines but no trigger, with two extant early matchlocks in the Basle Historical Museum.[37] He writes:

> When pressure is applied to the head of a rod attached to a trip lever, the later disengages and the serpentine, no longer held back, falls towards the pan…with this system the serpentine was lowered by means of its own weight assisted by a spring. These snapping matchlocks were popular for only a brief period in Europe during the early sixteenth century but they served as a model for the matchlocks made in Japan until about 1850.[38]

During the sixteenth century the modern-style trigger was invented where a sear mechanism controlled the movement of the serpentine. The Indian matchlock owes its design to Nuremberg matchlocks of the fifteenth and early sixteenth century.

*Pechdar* (Marwari). 'coiled'. '[Gun] barrels are called *pechdar* when plain or simply twisted'.[39] Also a visual term referring to decoration on arms. '*Pechari* of a suspension ring' in the Jodhpur Inventory possibly refers to twisted or plaited wire. *Pecha* (Marwari) describes types of rifling, qualified by the proceeding word.

   *Da'udi pecha.* See Da'udi.

   *Ada pecha.* Precise meaning unknown.

   *Naga pecha.* 'Coiled snake'. The Inventory often refers to Jodhpur made naga pecha.

   *Moliya pecha.* Precise meaning unknown.

*Pestanak* (Persian). Nipple on a percussion gun.

*Pišt'ala.* Czech meaning 'whistle'; it was also the Hussite name for a short early gun mounted on a pole, so named because it resembled the musical instrument. The Vlachs, traditionally pastoral nomads in the Balkans, make a musical instrument out of redundant gun barrels to play their haunting music. From the fourteenth century till now, Slovakian shepherd culture has the *rifová pišt'ala* whistle, without individual finger holes, the instrument blown through the ignition vent at one end of the barrel while the muzzle end is cupped with the right hand.

*Pitl* (Marwari). Brass.

*Piyadagam* (Arabic and Persian). Foot soldiers. The term is used by Abu'l Fazl to refer to foot soldiers assigned to nobles paid a salary by the Imperial Government. Also included under this title were simple retainers such as clerks, gatekeepers, guards, slaves, palanquin bearers, messengers etc. The same word means a pawn in chess, indicating the lowly rank. Infantry held a very inferior status and received very little pay.

*Qur khalq* (Persian). Powderhorn.

*Rafal* (Marwari, Urdu). Rifle.

*Raghogarh*. Town and fort in Madya Pradesh making guns, also known as Khichiwara.

*Rānnchangi* (Rajasthani). Long, heavy matchlock used for war.[40] *Rann* means 'battle' and *changi* 'convenient'.

*Ranjakdan* or *ranj-dan* (Mysore). Priming flask made of antelope horn. Codrington Collection 1850, cited Egerton 1880, cat. no. 591T. Vogel, 1909, p.38 gives *rinjak*, a priming horn with ivory makara head, probably an editing error for 'ranjak'.

*Rohida*. *Tecomella undulata*, the most common wood in the Thar Desert, known as Marwar teak, used to make gunstocks.[41]

*Roopnagar*. A village in Mewar with fortifications, built to control a pass crossing the Aravalli Mountains c.1772 by Thakur Veeramdeo. It is a jagir of the Solakis, one of the thirty-two great families of Mewar. The Jodhpur Armoury lists guns from Roopnagar.

*Rore* (Hindi). A ramrod.

*Rumiyandar*. Turkish gun. The *Jahangirnama* describes the emperor giving a gift 'of a Rumi gun of my own',[42] in 1615, which confirms Mughal belief in the superiority of Ottoman guns.

*Sakli* (Marwari). A chain fixed to the side of a matchlock: with a pricker, *chimti* and detachable pan cover. The Inventory calls this ensemble *khaleel*.

*Sangin* (Persian). Bayonet – 'a little spear'. They are shown in Marwar paintings of c.1770 and 1790 attached to matchlocks.[43]

*Sanjali* (South India). 'A gun for two men'. See *Hobson-Jobson* under Sarboji citing *Account of the Maravas* from the Mackenzie MSS. A local name for a gingall.

*Sanyanqiang* (三眼鎗). Or 'three eyed gun' mounted on a pole, a direct descendant of the early fire-lance, in use in the Ming army. The three barrels were wrapped in an iron sleeve and were ignited by handheld match. The design was carried by Ming armies to other countries. For a Cambodian example see Stone, Fig. 353, p.281.[44]

*Schiopetti* (Italian). A late fifteenth-century handgun.

*Secling currie*. Indian army term derived from British army 'sling carry'. See *kadiya*.

*Seedam kundo* (Marwari). Inventory term – 'straight stock' on a matchlock, a direct translation, seemingly the conventional early Rajput matchlock stock. The description becomes necessary due to the increased numbers of curved Sindhi, central Indian, Afghan and European stocks.

*Seep kuppi*. Mother-of-pearl powder flask, Jaipur.

*Shahin*. A culverin, a small swivel gun or light cannon. The word in Arabic means a falcon and may be a direct translation of the Spanish 'falcone' or 'falconet'.[45] It appears to be a small culverin in which category there are numerous names that may have had minor differences, particularly on a regional basis, such as the zamburak. It is a mistake to equate the size or weight of Middle Eastern and European cannon bearing the same name. In the Philippines a modified form of cannon, possibly derived from the falcon, is called the lantaka. In Brunei this is the bedil; and in Malaysia and Indonesia, the lela.[46] In Malaya there is the meriam kechil or small cannon.[47]

*Shakh-i-tufang* (Persian). The rest attached to the muzzle end of a matchlock, invariably two curved tines or prongs. The shape suggests these were originally antelope horns (the early Tibetan name for this rest was 'gun horn' or muzzle horn) but surviving Indian examples are wood and metal. There is a fine two-prong seventeenth-century example in the Al Sabah Collection.[48] Examples are shown in *Jahangir Shooting at the head of Malik Ambar*, c.1616, Chester Beatty Collection, Dublin, MS 7, No.15; and *Shah Jahan Standing on the Globe*, c.1630 by Payag, Chester Beatty Collection, Dublin, MS 7, No.28.

Irvine gives sih-payah, 'three footed' meaning 'tripods',[49] giving a literary source but the author knows of none surviving. The sih-payah is a free-standing tripod unattached to the gun, used to support the end of the very long and heavy early Indian matchlock. See page 254.

*Shankal* (Marwari). Chain.

*Shatghri* (Marwari and Rajasthani). Elsewhere in India *arghun*. Commonly thirty-six gun barrels mounted on a cart, linked by a loose gunpowder train to fire simultaneously.

*Shuturnal* (Persian), *Shawahi* (Arabic). A light cannon mounted on a swivel, carried and used on a camel by a single man, *shutur* being Persian for a camel. Ayalon gives Mamluk examples. The concept may have evolved from the European heavy arquebus à croc, mounted on a cart, which carried a ball of about three and a half ounces (100 g). In the sixteenth century the Mughals had small cannon mounted on elephants, mentioned in the *Ain-i Akbari* as *gajnal* and *hathnal*, *gaj* and *hathi* both meaning elephant and *nal* meaning a tube or barrel.[50] Manucci reports that at the battle of Samugarh in 1658, Prince Dara Shukoh's army had 500 elephants with howdahs containing two gunners, each using a *Shuturnal*.[51] Elsewhere he says they fired balls of three to four ounces. The Emperor Aurangzeb had two or three hundred according to the French traveller Bernier who saw them during his visit from 1658 to 1664.

Swivel cannon called 'slings' in England were fairly common in the second half of the sixteenth century and throughout the seventeenth century.[52] Colombari claims that the Afghans of Qandahar first fixed a light swivel cannon to the camel saddle prior to 1722 when they used them for the invasion of Persia. An Ottoman camel gun (though not mounted on a swivel) is illustrated by Marsigli in *Stato Militare dell'Imperio Ottomano*, published in 1732 though he visited Turkey years earlier. 'Abd Allah Pasha Chataji, Governor of Damascus, is credited with introducing them into Syria in the late 1750s to guard the Meccan pilgrims from attacks by the bedu. Sindia's army had them in 1828. See *Shuturnal*; *Zamburak*; and *Shahin*.

*Sher-bacha*, *Sher-bachcha* (Persian). Literally 'tiger cub', an allusion to the fierce properties of a blunderbuss pistol introduced into Persia and northern India in the eighteenth century. The *Akbar-ul-Muhabbat* describes 10,000 men in Ahmad Shah Abdali's army in 1760 armed with sher-bachas of Kabul.[53] Richard Barter, an officer with the 75th Gordon Highlanders, describes Kashmiri troops on the ridge during the siege of Delhi in 1857:

> Many were armed with a curious kind of flintlock brass barrelled weapon with a bell muzzle like a blunderbuss; this was called a shere butcha, literally a lion's whelp; it was fired with the stock under the right arm, by which it was kept close to the side, and the man when firing it slewed himself about under the impression that by that means he distributed the slugs and pieces of old iron with which it is crammed, in the same way that water can be thrown round with a sweep of a garden watering pot.[54]

*Shikar*. Hunting. *Shikari*. Hunter.

*Shikari* (pronounced seekari in Marwari). Hunting gun barrel chiselled with animals in high relief.

*Shisham* (Marwari). *Dalbergia sisso*, a deciduous tree found in the subcontinent and southern Iran. It is particularly common in the Punjab and is imported into Rajasthan. It is commonly known as Indian rosewood and is used for furniture, building (being resistant to white ants) and gunstocks.

*Shishana*, pl. *shishane* (Turkish / Persian). Šišana (Bosnian, Serbia). *Shishané* (Bulgarian). A long gun with a hexagonal wooden butt and a heavy barrel, a stock form used by Ottoman troops, particularly the Janissaries, from the fifteenth century. The Persians adopted the shishana based on Ottoman examples after their defeat at the battle of Chaldiran in AH 920/1514 AD.[55] The gun with minor variations was made and used from the Caucasus and Persia through Anatolia to the

Western Balkans and was carried further afield by troops and levies of the Ottoman army including India (see *lamchar*).

*Shist* (Persian). A gun sight.

*Sindhi stock*. The distinctive wide, thin, hooked gun butt found in Sindh is often inaccurately referred to as an Afghan stock. Sindh was part of the Durrani Afghan Empire in the second half of the eighteenth century but the stock is specifically Sindhi. In Baluchistan a rather less extreme curve is found and in Afghanistan a more slender stock of totally different form is used. The British army invaded Afghanistan via Sindh in the 1840s, which may account for this confusion.

*Sona chadhiyo*. Gold covered, leaf, gold wash.

*Stumpwork*. An embroidery technique where stitched details are raised using layers of textile under the surface to create a three-dimensional effect.

*Sung hoà mai* (Cochinchina). Matchlock musket with Indo-Portuguese lock. Surviving cheek guns date from the eighteenth-century onwards and are long, about 50 inches but the type presumably evolved in tandem with the Malay and Sri Lankan cheek gun with considerable borrowing from the Portuguese. The locks are usually brass but the best examples are silver. Dekker reports finding bamboo used as a spring in a Malay gun.[56]

*Susan patta / sosan patta* (Persian and Urdu). A sword with a forward curved blade. *Sausan* (Arabic) means 'lily or iris' and *patta* means blade, a reference to the sword-shaped leaf of the Indian iris or Sausan lily. There are numerous susan patta with 3–4-inch wide blades in Rajput collections.

*Syahtaav* (Marwari). Black metal, i.e. heat-coloured.

*Tamancha / Tapancha* (Persian). Literally a 'blow or slap'. A pistol, either European or locally made copy. Thevenot (p.61) describes the occasional pistol in use in Delhi in 1666. During the second half of the seventeenth century their use became increasingly common. In the nineteenth century the Sikh ruler Ranjit Singh imported 500 pairs of *tapancha* from Europe and on another occasion purchased 500 from the British Indian Government.[57]

*Tamanchewali* (Marwari). Combination sabre and pistol.

*Tamcha* (Marwari). A pistol.

*Tanisa* (Marwari). Inlay, from the Persian *tahnishan*.

*Tarkash* (tir-kash). (Persian) or *terkesh*. In Hindi *tarkas*. A quiver. A maker of quivers is tarkash-duz. The British Library has an eighteenth- or nineteenth-century version of the *A'in-i Akbari* (OR 11629, 32V and 33), which omitted the term, the word 'zazi' being substituted.

*Tarkasi* (Marwari). Gold or silver decoration, a reference to the extravagant embroidery on the red or blue velvet covers found on the best quivers.

*Tel* (Urdu). Oil.

*Tilak* (Hindi). The inset gold mark inlaid above the breach on good-quality Persian and Sindhi gun barrels. It bears an Islamic religious invocation or the maker's name.

*Toda-dar banduk*. Gond matchlock gun.

*Top* (Turkish). Cannon.

*Topidar*. Percussion-cap gun, named after the hat-like percussion cap, *topi* meaning a 'hat'.

*Tora* (Hindi). A match for a gun; sometimes an air root such as those found on the banyan tree,[58] suitably impregnated to make it smoulder.

*Toradar*. An Indian matchlock.

*Tosh dans*. Postans (p.126) refers to 'the embroideries of his many coloured tosh dans, (powder flasks, pouches, etc.), of Rahimdad the Brahooe, the Brohi tribe who were Baluch'. Sikhs refer to toshadan, a pouch.

*Tsuba*. The disc guard on Japanese swords.

*Tüfenk*, *tüfeng*, *tüfek* (Turkish). Originally the word for a blowpipe used to kill small birds; from the mid fifteenth century a general term for a gun, arquebus or later musket.

*Fitilli tüfenk* (Turkish). Matchlock musket.

*Tufenk-i firang*. A European gun.

*VOC* (Dutch). The Vereenigde Oost-Indische Compagnie (Dutch East India Company).

*Watered-steel*. Watered steel is a catch-all term covering two distinct steels, pattern-welded damascus and wootz damascus, both of which seem to have been invented circa 500 AD. In appearance they are similar comprising light swirling patterns on a dark grey or black background. Bogus watered steel is also common, created using acid etching.

Pattern-welded damascus is created by forge welding alternate sheets of high- and low-carbon steel and then folding this to maximise the number of layers. By contrast wootz is the Indian name for a steel produced in India and exported in the form of small cakes. Blades using this steel were made in many places in Asia and in the Near and Middle East but Europeans in the sixteenth century associated it with Damascus. Wootz blades have a unique metallurgical microstructure that varies depending on heat treatment by the smith who can control the mixture of bands of cementite and pearlite so that etching and polishing the blade produces complex irregular linear patterns. This prestigious metal was also used for gun barrels.

*Yuvraj*. Prince.

*Zamburak* / *zanburak* (Arabic, Turkish and Persian). Originally a crossbow. Subsequently a small cannon carried on the back of a camel.[59] *Zanbur* is a 'bee' and *ak* is the diminutive, a joke relating to the sound of the missile and its sting. The bore is usually about one and a half inches.

*Zar buland* (Persian). *Zar* means 'gold'. True inlay, but where the inlaid material stands proud of the host metal.[60] *Buland* means 'high' or 'raised'. This inlay is frequently carved or incised. Lucknow was famous for this work. In Damascus today the Arabs use the word *tasmeek* or *tanzeel* for this inlay process as opposed to the cross-hatched surface with applied wire decoration called *takfeet* or *tajfeef*.

*Zarb-zan*. A light artillery piece or large bore gun used by Babur in India. Either the type of gun changes over time or the term is used inaccurately for a heavier gun.

*Zarnishan* (Persian). True inlay that finishes flush with the host metal surface, also transliterated as *tehnishan* or *tahnishan*. Steingass, *Persian-English Dictionary*, gives *teh* or *tah* as meaning 'the bottom, deep, inner part' and *nishandan*, the Persian verb, 'to place one thing upon another'. *Tahnishan* means 'sitting below' and also specifically 'inlaid iron with gold'. The Wallace Collection's *Oriental Arms Catalogue* wrongly gives *zarnashah*.

*Zazi* (Indo-Persian). A quiver. See *Tarkash*.

# ENDNOTES

## CHAPTER 1

1. See Partington, 1960, pp.212–14.
2. See Lallanji, 1962, p.524.
3. Needham, 1986, vol.V, pt.7, The mid-ninth century Taoist text *Zhenyuan miaodao yaolue* mentions an explosive powder.
4. Realgar is an arsenic sulphide mineral used by Chinese alchemists. Its brilliant red colour made it appear appropriate for the 'fire drug' though in fact it is extremely toxic.
5. The matter is considered in Needham, vol.V, pt.4.
6. Needham, 1986, vol.V, pt.7, p.342. This influential manuscript, with a preface by the Emperor Renzong, describes a variety of weapons including incendiary gunpowder weapons and noxious smoke.
7. See Jixing Pan, 1996, p.27.
8. Needham, 1986, vol.V, pt.7, pp.171–8.
9. Needham, 1986, p.225: Jixing Pan, 1996, p.27.
10. See Franke, 1994.
11. Franke, 1994, pp.263–4.
12. Kautila is the traditional author. Like most early Indian documents the text is composite and in the form known to us was probably compiled between the second century BC and third century AD. For centuries the text was widely read, seemingly known to the Mongols.
13. Barthold, 1955, p.414.
14. See p.16 Metropolitan Museum of Art, NY (20.120.246).
15. In 1368 the Chinese Ming overthrew the Mongol Yuan.
16. The Il-Khanids were a Mongol dynasty established in 1256 by Hulagu, a grandson of Genghis Khan, who ruled much of western Asia including Persia, Iraq, the Caucasus and Anatolia on behalf of the Great Khan. Ilkhanate rulers converted to Islam from 1295.
17. Hulagu and his successors attempted unsuccessfully to form an alliance with Christian Europe against the Mamluks. In the thirteenth century Mongol culture was in vogue in Europe and many children in Italy were named after Ilkhanate Mongol rulers. Friendly relations facilitated exchange between China and Europe.
18. See al-Hassan and Hill, 1986, p.118.
19. In the Oriental Institute, St. Petersburg. See Partington, 1960, p.207. Needham suggests a date of 1320 AD for this manuscript being unaware that it is dated. However it is likely that Furusiya manuscripts were copied and the original may well be as old as he suggests.
20. The author drew attention to this possibility in 1995, p.20.
21. Now in the Musée Guimet, Paris.
22. See Khan, Iqtidar Alam, 2004, p.200.
23. The Chinese for a ship is *chuan*. The seventeenth-century English word 'junk' comes from the Portuguese '*junco*', from the Javanese or Malay '*jong*'.
24. Needham, 1986, p.259.
25. Needham, 1986, suggests that the Chinese used early gunpowder as a fuse to ignite Greek fire in 919 AD.
26. Ayalon, 1956, p.15.
27. Ayalon, 1956, pp.9–11.
28. Length 100 cm; weight 108.5 kg.
29. The cannon, 34 cms (13.4 inches) long, is in the Heilongjiang Provincial Museum, Harbin.
30. Yang Hong, 1992, p.288, fig.380. The cannon is in the Historical Museum of China.
31. For example, when the Muslims sacked Baghdad they spared the Christian community.
32. See Partington, 1960, pp.201–4. This late thirteenth century manuscript is believed to have been written in Spain.
33. Albert of Cologne, c.1200–1280, Dominican friar and bishop, known in his lifetime as Doctor Universalis.
34. Roger Bacon, 1219/20–1292, Franciscan friar.
35. William found a very cosmopolitan community with town quarters for Muslim and Chinese craftsmen, a French silversmith and a French woman from Lorraine who cooked him Easter dinner. Prior to William of Rubruck there were European missions to the Mongols in 1245 and 1249.
36. Berthold is said to have been a German Cistercian monk who lived in the fourteenth century. See Kramer, 2001.
37. Hoffmeyer, 1972, p.217.
38. *Zanbūrak* originally meant a crossbow but the word later referred to a gun. In both cases the sound of the missile suggested the name.
39. See Elgood, 1995, p.20.
40. DeVries, 1990, p.824.
41. LaRocca, 2006, p.198.
42. Fitzclarence, 1819, p.256. Francis Drake wrote to the Council of War in London in 1588, the year of the Armada: 'forgett not 500 Musketts and at least 1000 arrows for them'. These were metal arrows called sprites with great penetrative power, used against musket proof areas of ships. (See Blackmore, 1965, p.12). During the Vietnam War the Americans used 12-bore combat shotguns with cartridges containing 20 steel flechettes each.
43. OED: 'A short, heavy, square-headed arrow or bolt formerly used with the crossbow or arbalast'. The word comes from French, at that time dominant in northern Europe in the development of gunpowder weapons.
44. See DeVries, 1998, p.390.
45. See Elgood, 1995, p.21. Advice on how to fire these arrows (*garros*) from a bombard is given in *Das Feuerwerkbuch* c.1400. See Kramer, 2001, p.57.
46. See Blair, vol.16, 2004.
47. *Huolongjing*, an early Ming Dynasty (1368–1683) military text, has information on gunpowder weapons. A second and third volume of this work published in 1632 describes guns and cannons. When the Manchu Qing dynasty replaced the Ming they banned these books because the text referred to 'northern barbarians'.
48. Cited by Reinaud and Favé, 1849, pp.307–8; Partington, 1960, p.250.
49. Andrade, 2016, p.76.
50. See Blair, p.320 below.
51. Ayalon, 1988, p.254.
52. See Appendix I for an unpublished note on Tromba sent to the author by the late Claude Blair. There are many drawings of

European knights using this weapon. The Sienese Biringuccio in his *De la Pirotechnia*, the first European book on metallurgy, printed in 1540, illustrates a number of spears and lances with attached fire tubes with the caption 'Modo di fare le trombe di fuoco, per tirar pietre'. Tirar pietre – to fire stones. Also 'Modo di far palle di metallo, che si spezzano'. See *Delle Palle Di Metal*, vol.10, pp.328–34.

53. See Hoff, 1969, p.8.

54. Historisches Museum, Berne, nr. 2193.

55. See Hoff, 1969, p.9.

56. A ribauldequin was a fourteenth- and fifteenth-century multi-barrel volley gun, a series of iron gun barrels mounted on a frame that usually had wheels. King Edward III of England, whose ribauldequin had twelve barrels, first used them in 1339 in France. Later given the European name 'organ' after the musical instrument it resembled, this weapon continued in use in India into the nineteenth century. See Arghun in the Glossary.

57. Cf. Johannis Villani Florentini, *Historia Universalis a condita Florentia usque ad annum MCCCXLVIII*, in Muratori, Rerum Italicarum Scriptores, xiii (Mediolani, 1728), col.947.

58. Arab, Indian and European scholars have tended to look favourably on evidence that enables them to advance national claims.

59. Needham, 1986, Appendix B, p.582 provides a good example of this in his discussion of the changing meaning of the Arabic word *midfa'* which describes part of a naphtha projector in 1206, subsequently the tube of a fire-lance and finally the cylinder of early firearms, a meaning it has to the present day. Zaytseva, 2018, p.48 mentions a *midfa'* that shot incendiary arrows, used against ships. The Arabic ms. is dated 1474.

60. Sherwani, 1953, p.93.

61. Stein, 1982, p.119. Unfortunately he provides no reference. See Khan, 2004, appendix B, for a discussion of the *Tarikh-i Ferishta*.

62. Irwin, 2004, p.121.

63. Khan, 2004, p.18.

64. Manucci, London 1707, p.346.

65. Translation by Digby, 1971, p.80. *Ra'd andazan* are later translated as cannoneers.

66. See Alexandrescu-Dersca, 1977, p.73.

67. Le Strange, 1928, p.288.

68. The meaning of this word is unknown – possibly a mistaken transcription for Albanies or Albanians, noted metalworkers?

69. Estrada, 1999.

70. As late as the Korean and Vietnam War, Asiatic armies relied on mass attack rather than advanced military technology.

71. Wittek, 1955, p.143.

72. Risso, 1995, p.24.

73. The *Yuanshi* was much criticised for its inaccuracies by Imperial Chinese scholars and modern scholars too.

74. Sun, 2010, p.65.

75. Literally 'Great Viet', the name by which Vietnam was known from 1054–1400 and from 1428–1804.

76. See Peter Dekker for example. Overall length: 30.5 cm, barrel length: 11 cm, bore: 13 mm, weight: 1,588 grams. Dekker says these were used in China until the Warlord period (1916–28) by which time some were being made to take percussion caps. There is a small example in the Royal Armouries, Leeds – three wrapped barrels with three touch holes and a socket to take the pole handle.

77. Ming Shilu, quoted by G. Wade in 'The Ming Shi-lu (Veritable Records of the Ming Dynasty) as a source for South-east Asian History – Fourteen to Seventeenth Centuries', Ph.D diss., University of Hong Kong, 1994, vol.1, p.349.

78. *Khâm Định Việt Sử Thông Giám Cương Mục*, (The Imperially Ordered Annotated Text Completely Reflecting the History of Viet), 1884, vol.1, p.735.

79. Anh, Nguyễn Thế, 2003, pp.95–6.

80. Sun, 2010, p.66. The connection between Chinese gunpowder technology and state formation in fifteenth-century maritime south-east Asian states, especially Java, should be investigated further.

81. Conti, 1858, p.31.

82. See Chase, 2003.

83. Sun, 2003, pp.498–9.

84. See Sun, 2003, p.501.

85. Wade, 2010, p.62.

86. See Risso, p.49.

87. Sun, 2010, p.57.

88. Gode, 1953, p.6.

89. Partington, 1960, p.222 gives the original: 'e hũa espingarda a qual hia tirando amte nos' from the anonymous *Roteiro da Viagem*, discovered in Oporto in 1838.

90. Correa, 1869, p.160.

91. The author was handed a flail to use on his Tuscan farm in the early 1970s.

92. Corning is a method of creating regular granulation at the optimum diameter for the gunpowder to burn quickly, which governs the velocity of the bullet.

93. The Han Chinese used cart defences very successfully against the northern barbarian Xiongnu at the battle of Mobei in 119 BC.

94. Marinus Barletius, c.1450–c.1512–13, considered the first Albanian historian, famous for his biography of Skanderbeg, the Albanian national hero.

95. Parker, 1988, pp.9–17 writes that Venice was the first Italian state to replace its bowmen with 'musketeers' in 1490.

96. These wagon walls became obsolete in the early sixteenth century with improvements in battlefield artillery which smashed them to pieces.

97. Blair, Peterson, ed., 1964, p.157.

98. Rainer Daenhardt to the author.

99. Some British navy ships still had cannon with a touch hole as late as the Napoleonic Wars though a flint mechanism was replacing these. Standard practice for navy gunners was to prime the touch hole and then put their hand over the vent until ready to fire to prevent the fine powder blowing away. Early hand-cannon users must have done the same thing.

100. See Elgood, 1995, p.36.

101. For a long time Portuguese ships reaching India did not exceed 500 tons and the caravelas rarely reached 150 tons. Barker, 1996, p.54.

102. Correa, 1869, p.277.

103. Correa, 1869, p.368. See also p.226, n.1 for a discussion of *camaras* or *mascolos*, Portuguese for the chambers used in breech-loaders. It was common to have a spare ready loaded. Later the Portuguese in Lisbon invented the *parafuso*, a screw breech cannon, mentioned by Diego Ufano, *Treatise on Artillery*, Brussels, 1617, p.15.

104. Sunna means 'path'. Muslims follow the example set by the Prophet as well as his teaching.

105. Ayalon, 1975, p.33.

106. See Nicolle, 2011, who concludes that lead bullets and powder horns excavated in the Damascus citadel cannot be attributed with certainty either to the Mamluk garrison or their Ottoman successors. See pp.195–238.

107. Jacques Coeur, c.1395–1456

108. See Ashtor, 1983, p.349.

109. Ayalon, 1975, p.36.

110. See Elgood, 2009.

111. The Venetians were keen to arm the Mamluks who were at war with the Portuguese in the Indian Ocean. The Portuguese had taken control of the Venetian spice trade that followed the Red Sea and Egypt route, diverting it round Africa to Portuguese markets.

112. Ayalon, 1975, p.38.

113. Elgood, 1994, p.59.

114. For example the Jodhpur Lancers at Haifa in 2018 contemptuously ignored the Turkish artillery and machine guns, their apparently suicidal charge capturing 17 pieces of artillery, 11 machine guns and 1,350 German and Turkish prisoners. Their losses were 8 dead and 34 wounded; 60 horses were killed and a further 83 wounded. Liddell Hart reports Field Marshal Haig asserting emphatically in 1925 that the aeroplane and the tank could only be accessories to man and horse on the battlefield, a remark so foolish as to be scarcely credible. Lloyd George, the British prime minister, described Haig as 'Brilliant, to the top of his [riding] boots' but lacked the political power to remove him from the command of British Forces in France because Haig represented in all respects the epitome of the military man in the eyes of British society. European cavalry regiments were bitterly resistant to mechanisation up to the Second World War, resulting in Polish cavalry gallantly charging German tanks in 1940.

115. DeVries, 1998, p.130, n.9 citing three secondary sources.

116. Naus, a three- or four-masted ocean-going carrack, a European sailing ship with a high aftcastle and sterncastle that evolved in the fourteenth and fifteenth centuries. They were superseded by galleons in the seventeenth century.

117. Marine excavations in 2016 recovered ordnance including three thin copper alloy tubes c.750 mm long, probably gun barrels. For a full account of the Sodrés shipwreck see Mearns, Parham and Frohlich, 2016.

118. Afonso de Albuquerque, vol.3, p.128. Lassen, 1962, vol.IV, p.541. Portuguese sources give various figures all pointing to the fact that there were several thousand guns in Malacca.

119. Excavation of a late fifteenth-century junk, the *Lena*, wrecked east of Busuanga in the Philippines, yielded bronze cannon. See Crick, 2001.

120. Albuquerque, vol.3, p.128.

121. Sun, 2010, citing Sudjoko.

122. Note the sixteenth-century writer Ibn Zunbul al-Mahalli's use of the word 'Al-Bunduqiyya' meaning a gun. For centuries the Arabs named their arms descriptively, often after where the gun was made; and Al-Bunduqiyya is the Arabic for Venice. However bunduq is also the name for a nut and the pellet used with an Arab pellet bow.

123. Pires, 1515, p.269.

124. Rumi Khan was commandant of the Sultan of Gujarat's artillery and in 1533 was obliged to burst his two large guns named Leyla and Majnun when the sultan was defeated by Humayun, so as to prevent their capture. Rumi Khan then entered Humayun's service. He is later described as 'an engineer'. He directed the Mughal artillery at the siege of the fort at Chunar and when it surrendered ordered that both hands should be cut off the 300 captured enemy artillerymen. Soon after Rumi Khan died of poison given to him by jealous Mughal courtiers. See Stewart, 1832, pp.4, 9–11.

125. Dames, *Barbosa*, 1918, p.118. Barbosa died in 1521.

126. Sewell, (nd), p.277ff.

127. Sewell, p.335.

128. Reis, 1899, p.30.

129. See Needham 1986, p.442.

130. *Tuzak-i Jahangiri*, p.332.

131. Inalcik 1975, p.196.

132. See Petrović, 1975, p.176.

133. Andrade, 2016, p.169. The Japanese independently adopted volley fire in the late sixteenth century. However Sun, 2003, p.500, says that Ming troops used volley fire against the war elephants of Maw Shan at Nanjian in Yunnan in 1388.

134. Gabriel de Luetz, Baron d'Aramont, was French Ambassador to the court of Suleiman the Magnificent in Istanbul from 1546 to 1553. In 1547 he accompanied and advised the Sultan during the Ottoman–Safavid War of 1532–55 and in 1551 he joined the Ottoman fleet at the siege of Tripoli with two galleys and a galliot. The following year he persuaded Suleiman to send a joint French and Turkish fleet against the Holy Roman Emperor Charles V. This fleet devastated twelve to fifteen miles of Calabrian coastline round Rhegium. See Jean Chesneau, *Le Voyage de Monsieur d'Aramon dans le Levant*, Paris 1547.

135. Both woodcuts can be seen in Elgood, 1995, p.35.

136. See Ágoston, 2005, p.93, n.128.

137. See Ágoston, 2005, p.89.

138. Ágoston, 2008, p.9.

139. Sultan Selim's diplomatic gift established an enduring military relationship between the Ottomans and Mughals. See Farooqi, Naimur Rahman, *Mughal-Ottoman Relations: a study of political and diplomatic relations between Mughal India and the Ottoman Empire, 1556–1748*. Delhi, Idarah-i Adabiyat-i Delli, 1989.

140. The Egyptian historian Iyas, who died in 1522 AD, gives this figure.

141. An Asian people more receptive to firearms than the Persians were the Uighurs of eastern Sinkiang, Muslims on the Chinese border, who shared Turkic language and cultural values with the Ottomans, received guns from them, and fought Chinese armies in the early sixteenth century. See Inalcik, 1975, pp.202, 208–9.

142. Ismail's son Shah Tamasp subsequently used cannon on the battlefield.

143. See Bacqué-Grammont, 1987.

144. Iqtidar Alam Khan inexplicably translates 'Ustad' as 'engineer'. It means 'Master', for example in the Sufi hierarchy, but used here meaning master craftsman, the top rank in the Islamic Guild system. 'Ali Quli was a Shi'ite from Persia.

145. Thackston 1996, p.323.

146. Beveridge ed., *Baburnama,* 1979, p.564.

147. Beveridge ed., *Baburnama*, p.550. Nineteenth-century translators like de Courteille and Erskine give 'araba' meaning cart as a gun carriage; 'afut' in Persian.

148. For the Chinese use of these carts see Folangji in the Glossary.

149. Thackston, 1996, p.384.
150. Beveridge, *Baburnama*, 1979, p.635.
151. Beveridge, *Baburnama*, 1979, p.628.
152. Beveridge, *Baburnama*, 1979, p.617.

## CHAPTER 2

1. Daehnhardt, 1994, p.39.
2. There are six Persian matchlocks in the Armeria del Palazzo Ducale in Venice, presented to Doge Marino Grimani by a Persian ambassador in 1602 that are distinguishable from Ottoman matchlocks solely by their applied Persian style decoration and the fact that they are made of cherry wood rather than the usual Cilician walnut. See Franzoi, 1990, Tav.30, scheda 433.
3. Daehnhardt, p.39.
4. Daenhardt is the authority on this development.
5. Correia, b.1492 or 1496, arrived Portuguese India c.1512–14, secretary to Albuquerque, died in Goa c.1563.
6. Albuquerque, 1 December 1513, cited by Daehnhardt, 1994, p.39.
7. Sen (ed.), 1971, p.66.
8. Abu'l Fazl, *A'in*, p.120.
9. This cannon, 17ft 2in long and weighing 6 tons 16 cwt (6,909 kg), also bears the maker's name, Mohammed ibn Hamza. Sister cannon by this maker include the famous Nilam Top, now in Uparcot Fort, Junagadh, Gujarat. Nilam Top was taken to Junagadh from Diu where the Ottomans and Gujaratis had used it in their siege of the Portuguese in 1538.
10. Reid, 1993, p.147.
11. Inalcik, 1975, p.206.
12. A wish list included 100 gunners, 'half German the rest Portuguese, and more skilled in that office than those that came in past years. Also required were: 'nails, studs for armours, crossbows and threads for cords, Biscayan iron, breastplates, helmets and hilted swords, iron for arrows that they make here cheaper and better, Biscayan spears and very good pikes and very good lances, and they should not be as are wont to come, that are rotten and wasted.' Barker, 1996, p.71.
13. No. S.981. See Schuckelt, 2010, p.79.
14. For example de Campos (1940) suggests that Siamese success against Lan Na c.1520 was significantly assisted by gifts of Portuguese firearms. These would have been superior to Lan Na's Chinese-made guns, which Sun reports had been adopted well before the mid-fifteenth century. Similarly, in 1635–6 the first ruler of unified Bhutan was given matchlocks, cannon and gunpowder by a Portuguese emissary. See LaRocca, 2006, p.200.
15. Khan, 2004, p.118, n.27. Akbar had problems moving heavy cannon to his campaigns in the Deccan and Goan artillery were conveniently located.
16. I am very grateful to Guy Wilson for his advice on this matter and see his Oman 2013 publication.
17. Japanese gunmaking was a hereditary occupation. For example seventeen generations of Sakai gunmakers in Inoue Kanemon's family worked from the sixteenth to the late nineteenth century.
18. Hyeok Kweon Kang told the author he has seen screw breeches on early Korean guns.
19. Codex icon. 222, Munich State Library.
20. See Gaibi, 1978, illus. 25 who attributed them to Brescia, first half of the sixteenth century. Three conjoined barrels of a matchlock pistol are in the Ashmolean Museum, Oxford, first catalogued in 1685. See Wilson 1983, pp.197–99: Spenser 2019. The fact that these barrels have tube sights, which do not appear much before 1525, suggests these barrels date from the second quarter of the sixteenth century at the earliest.
21. Germanisches Nationalmuseum, Nüremberg, No. W 1980.
22. Maihaugen Museum, Lillehammer, Norway.
23. See Franzoi, 1990, Tav. 46, p.62.
24. Maharaja Sawai Man Singh II Museum, Jaipur MJM80. 716. See Elgood, 2015, pp.246–9 where this pistol is discussed.
25. Blackmore, 1965, no.550 described it as eighteenth century (Royal Scottish Museum, Edinburgh no. 1956.612) but it has probably been restocked. He also published (no.551) another seventeenth-century three-barrel gun relating to the revolving cylinder guns that date from the seventeenth century. (Royal Armouries no. XXVI-70F).
26. The Anselmo mechanism is the first flintlock, invented in Portugal in the first half of the sixteenth century. See Daehnhardt, 1994.
27. Blackmore, 1965, no.552. The barrels bear the crest of the Tokugawa family. The inscription indicates that the gun was owned by an officer named Slichezalman (probably the Dutch name Slijkerman). Made by Umetada Muneshige of Machi', a late seventeenth-century craftsman.
28. I am indebted to Hyeok Hweon Kang for assistance with this, which partially features in Needham.
29. See Elgood, vol.II, 2017, p.970.
30. Khan, 2004, p.136: 'The Nature of Handguns in Mughal India; sixteenth and seventeenth centuries'. Proceedings of the Indian History Congress, 52nd session, New Delhi 1992 is adamant that this describes a wheel-lock mechanism. Irfan Habib's 'Akbar and Technology' in *Akbar and His India* (1997) claimed recent research 'has narrowed the choice to the wheel-lock fairly closely; but positive proof is yet to come'. Iqtidar Alam Khan wrote in 2004 in his note 33: 'I had identified the handgun in question as a flintlock, which was a slip. In the light of Jaroslav Lugs' detailed research (*Firearms Past and Present*, vol.I, p.25) it is obvious that at the time of the compilation of *A'in-i Akbari* (1594), the flintlock had not appeared even in Europe. As already noticed, it first appeared in Europe only in the beginning of the seventeenth century.' These authors are clearly unaware of the Anselmo lock, described by Daehnhardt, p.53, as 'the first of the flintlock mechanisms, invented in Portugal and used since the the first half of the 16th century.' The term 'flintlock' first occurs in 1683.
31. Daehnhardt, 1977, p.2; 1981, p.11.
32. Barbosa 1, p.110.
33. See Fernao De Queyroz, *The Temporal and Spiritual Conquest of Ceylon*, Father S. G. Perera (trans.), Colombo, 1930.
34. Diogo do Couto, 1919, p.72.
35. Chester Beatty, 7B 28.
36. State Hermitage, St Petersburg. Length of barrel 37.2 in; Cal. 0.71 ins. (2) Army Museum, Paris (No. M. 1067). Barrel 32.6 in; cal. 0.55 in.
37. See Daehnhardt, 1997, pp.22 and 23.
38. Acc. 379.
39. For barrels of this type see Elgood, 2009.
40. It bears the painted reference number FRM -96-2008.

41. Wallace Collection Catalogue – Oriental Arms and Armour 1964, OA 2022.

42. The gun is illustrated in Blackmore, 1965, no.555.

43. My thanks to Lenny Lantsman for the photographs.

44. Czerny's, 25 and 26 February 2012, p.165, no.580. My thanks to Peter Dekker, Mandarin Mansion, for details of another four-shot revolving cylinder matchlock gun. Overall length 132 cm, barrel length 86 cm, calibre 11.5 mm, weight 3,230 grams.

45. The author wishes to thank the two owners for making photos available and for their valuable discoveries and conclusions. These guns pose many questions and we do not agree on all points. The views expressed here are those of the author.

46. I am grateful to Lenny Lantsman for identifying the wood.

47. Which they called Tourane, 'mouth of the (Han) river'.

48. Zhao, 1941, pp.7b–8a.

49. Tenure, 1623–26. Prior to 1623 Macau was ruled by captain-majors.

50. Boxer.

51. The German artillerymen working in Lisbon in the first half of the sixteenth century established the Brotherhood of Saint Bartholomeus and built their own church. The patron saint of gunners and anyone else dealing with gunpowder is Saint Barbara, because of her association with lightning, which killed her father after he had executed her for becoming a Christian. Spanish Santabárbara, Italian Santa Barbara and French Sainte-Barbe all signify the powder magazine of a ship or fortress because these places invariably had a devotional protective statue of the saint.

52. See Boxer, 1938.

53. Father Fernandes describes the embassy in a long letter to his provincial superior dated 6 July 1622, written in Cochin-China. B. V. Pires SJ, citing Ajuda Library in Lisbon, 'Jesuits in Asia' collection, file 49-IV-7, folios 347–350.

54. Li Tana, 1998, p.44. In 1643 three Dutch warships allied with the Trinh were defeated by Nguyen galleys, which sank one and killed the captain of another.

55. For da Cruz see Adrien Launay, *Histoire de la mission de Cochinchine 1658–1823, Documents historiques*, vol.1, Paris 1923, p.16.

56. A letter written by Mgr. Francois Pallu (1626–1684) to Propaganda Fide, dated 28 November 1682, refers to him as a Portuguese Canarin. *Hobson-Jobson*, 1903, p.154, describes 'Canarin' as a person from Canara but says the Portuguese apply the term to the Konkani people of Goa.

57. Andaya, 2008, p.383.

58. Borri, 1633, p.64.

59. Tavernier, the French traveller in India in the mid-seventeenth century, noted the excellence of Tonkin and Thai gunpowder. In 1695 Thomas Bowyear met Cochinese officials seeking a trade agreement for the East India Company at Faifó and discovered that an important corollary to this agreement was to supply cannon to the Nguyen. He also noted that Chinese vessels brought saltpetre from Ning-Po and Batavia and lead from Siam. See Boyear's 'Narrative' in Alistair Lamb, *The Manderin Road to Old Hue: Narratives of Anglo-Vietnamese Diplomacy from the 17th Century to the Eve of the French Conquest*, Archon Books, 1970, p.53

60. Clemente da Cruz owned the church of Our Lady of Conception in Tu Due. See Benjamim Videira Pires, SJ, D. João V's Diplomatic Mission to Cochin-China.

61. Rhodes, 1681, p.162.

62. Borri, 1633, p.63.

63. Analysis of a bronze Bocarro gun of 1640 shows 87 per cent copper, 9.2 per cent tin, 1.7 per cent lead, 1.4 per cent iron, 0.08 per cent antimony and 0.01 per cent zinc. Allen, 1978, p.52.

64. The Duke of Wellington used Macau cannon at the siege of Badajos in Spain in 1812.

65. These cannon were recovered by divers in 1978.

66. Pieris, 1920, p.101.

67. Reid, 1994, p.279.

68. For an example made by R. Steadman see Cowan's Auctions, 9 December 2018, lot 11.

69. Lê Quý Đôn, Lê Quý Đôn Toàn. (Lê Quý Đôn's Complete Works), Tập. I: Phủ Biên Tạp Lục (Frontier Chronicles) Hà Nội: Khoa Học Xã Hội, (Social Science Publishing House), 1977, pp.328–329. See also Nguyễn Thế Anh, 2003, p.96.

70. See Volkov 2013, pp.31–71.

71. The Cross of Avis can be found on a sixteenth-century Portuguese powder-flask, stamped on blades and elsewhere and served as an ownership mark of the Order. The cross also occurs fairly frequently on tsuba, for example; one is in a private American collection and another in the Daehnhardt collection and elsewhere. Japanese sword collectors refer to these as *nanban tsubas*, a category that unlike all other types of tsuba cannot be related to any Japanese school where the founders, craftsmen and designs are well known. The *nanban* group has no known history within Japan and were arguably not primarily made for export to the Japanese market that had traditions and higher standards. They were also probably made in more than one place. To take a single instance, one of many, the Nguyen imported a large quantity of Japanese sword blades that required guards and may have ordered local Vietnamese craftsmen to make tsubas for these. The Cross of Avis suggests they were made somewhere where the Portuguese had an influence.

72. There is a cannon in the British Royal Armouries inscribed: DA CIDADE DE DEOS DA CHINA (the city of the name of God, i.e. Macau). It bears the name of the cannon founder: MANOEL TAVARES BOCARRO AFES A. 1627; and the name S. Tilafoco (St. Ildefonso?). Below the first reinforce are the arms of Portugal and the cross symbol of the Order of Christ, a detail that occurs on other Macau guns. (See Blackmore, 1976, p.141, no.180.) It also occurs as part of the armorial bearing over the inner gate of the Macau fort of Nossa Senhora do Monte, built between 1517 and 1526 for the Jesuits. (Graça, 1984, p.58, pl.1A.) There is no doubt that the Order used the cross as a symbol of ownership: but the symbol was also adopted as an entirely non-specific decorative motif by local craftsmen across the whole of Asia.

73. For the type see Blackmore, 1965, no.57.

74. See Hoff, 1978, p.229.

75. T. Lefer made a breech-loading system in 1668.

76. My thanks to Hyeok Hweon Kang for this information.

77. See Hoff, 1978, p.222 ff.

78. Windsor. Royal Collection Trust RCIN 90672. Carleton House 3011, Laking 413.

79. John Hayward, a reliable scholar, gives the name as Chalenbron.

80. Born Koningsbergen, c.1740; died Batavia 1796. Soldier in the East India Company army in 1767; in 1773 he became a surgeon; in 1777 made ensign and fort surveyor. Later lieutenant colonel and director

of fortifications. RKD Netherland Institute for Art History.

81. See Elgood, 1995, pp.158 and 160. Jean Bouillet came from a well-known family of Liegois arms makers. In 1752 he made a rifle, which he presented to Louis XV. The king passed this gun to the Dey of Algiers who asked that the maker be sent to him but instead Jean's eldest son Claude went to seek his fortune, aged twenty-two. Claude was assassinated in Algiers in 1758 on the orders of the Dey because he refused to convert to Islam.

82. Yazdani, 2014, p.102.

83. Gulfishan Khan, 1993, p.297. This author remarks of eighteenth-century Indian visitors to Britain that: 'The existing varieties of glassware, paintings, guns, pistols, swords, knives and scissors were nothing but a source of bewilderment for our observers'. (p.358).

84. The Keladi ruler Veerabhadra Nayaka, 1629–45 AD, established a fort on the road from Shimoga to Chitradoorga, which he called Bedanur and made his capital. In 1639 AD Basappa Nayaka renamed it Chennagiri in memory of his mother the rani. In 1763, Haidar Ali captured the fort and renamed it Haidar Nagar and made it his capital. The town is now called Hulilkere.

85. Stronge, 2009, p.13. In the Wallace Collection there is an eighteenth-century south Indian talwar with a single-edged, pattern-welded blade stamped at the forte 'Hyder Nager' (Haidar Nagar) in Western script, suggesting the blade was made by or under European supervision.

86. Yazdani, 2014, n.121.

87. Yazdani, 2014, p.107.

88. Yazdani, 2014, p.105. See also Hosain, 1940.

89. Antony Cribb Ltd. Arms and Armour Auctions. 26 March 2019, lot 1.

90. Sridharan 2002, p.146.

91. '[Tipu's] workmen cast guns of a wonderful description, lion-mouthed; also, muskets with two or three barrels, scissors, penknives, clocks, daggers called sufdara…' *Neshani Hyduri*, Mir Hussain Ali Khan Kirmani, p.135.

92. Wigington, 1992, pp.45–8.

93. Royal Collection Trust RCIN 90673. Carleton House 540, Laking 430. Publ. Blackmore, 1968, p.57; mistakenly catalogued as '1802 AD' and therefore assumed by him not to have been made for Tipu who was killed in 1799.

94. Royal Armouries, Leeds, no.XXVI-102.

95. Lyon and Turnbull, Edinburgh, April 2010, lot 41; 54 ins; 137 cms overall.

96. Now a protected monument.

97. For Martin's career as a gunmaker see Blackmore, 1989: Elgood 1995, p.158ff.

98. See Blackmore, 1989, p.6.

99. In the age of mercenaries such transfers were common. Kirkpatrick 1811, *Tipu's Letters* XLII, p.56, mentions nine Frenchmen and their captain who have embraced Islam and have requested to join the Ahmedies, Tipu's corps of converts. Another letter (p.12) mentions a prisoner 'to be converted to Islam' and 'paid to teach mortar practice'.

100. Moldave, 1971, p.155.

101. Royal Armouries, Leeds, no. XXVII.2.

102. Colt, 1855, p.4.

103. Richardson, 2007, p.25, who notes that Colt referred to the Tower of London gun in his London lecture in 1851.

104. Formerly Rotunda Museum, Woolwich, now in the Royal Armouries, Leeds, XII, 1078. See Rimer, 2001, p.28. See also Rockstuhl, 198, CXIV, no. 3, a Mousquet à mèche à huit coups.

105. Bequest of Elizabeth Hart Jarvis Colt, 1905, 1022. Colt's collection of firearms was donated to the Wadsworth Atheneum in 1905.

106. Blackmore, 1965, no.554.

107. Now in the Hofjagd-und Leibrüstkammer, Vienna, inv.no.D486.

108. Hawkins, 2001, p.126.

109. Egerton, 1968, p.111, no.426. Length 5 ft 6 ins; barrel 3 ft 6 ins.

110. Gardner, 1895, p.148. She also noted: 'Several brass helmets and cuirasses have the Imperial French eagle embossed in front. They are said to have belonged to one of General Ventura's regiments, and were probably bought cheap after the downfall of the First Empire.

## CHAPTER 3

1. Ayalon, 1956, p.67.
2. Khan, 2004, p.129.
3. Stewart, 1832, p.18.
4. Saxena, p.197 and p.264.
5. See Seyller, 2002, p.98, no. 27.
6. Abu'l Fazl, *A'in-i Akbari*, vol. I, p.83.
7. Barua, 2005, pp.33–4.
8. Saxena, 1989, p.342.
9. Born AH 1006/1597–8 AD, better known by his poetic name Bihishti Herawi.
10. Beveridge, *Akbarnama*, vol.II, p.327
11. Beveridge, *A'in-i Akbari*, vol.I, p.116.
12. Beveridge, *A'in-i Akbari*, vol.I. p.119.
13. Beveridge, *A'in-i Akbari*, vol.I. p.119.
14. Beveridge, *A'in-i Akbari*, vol.I, p.120.
15. Beveridge, *A'in-i Akbari*, vol.I, p.120.
16. Beveridge, *A'in-i Akbari*, vol.I, p.83
17. Correia-Affonso, 1980, p.22.
18. Monserrate, 1922, p.201.
19. Vambéry, trans. 1899, p.69 ff. See Inalcik, 1975, p.209.
20. Abu'l Fazl, *A'in-i Akbari*, vol.I, p.120.
21. Abu'l Fazl, *A'in-i Akbari*, vol.I, p.121.
22. Abu'l Fazl, *A'in-i Akbari*, vol.I, 37, p.120.
23. Abu'l Faz, *Akbarnama* (1989), vol.2, p.472.
24. Farvardin is the first month of the solar Hijri calender, 31 days, usually beginning on 21 March.
25. Thackston, *Jahangirnama*, p.44.
26. See Abu'l Fazl, *A'in-i Akbari*, vol.I, p.123.
27. Thackston, *Jahangirnama*, p.44.
28. See Egerton in the Bibliography.
29. Beveridge, *Baburnama*, 1979, p.628.
30. Saxena, 1989, p.198.
31. The author cannot point to any cannon made by the Rajputs. See Elgood, 2017, p.58.
32. Egerton, 1968, p.61, n.1.
33. For Jodhpur swords see Elgood, 2017.
34. Koch, 2001, p.40.
35. Vanjula has a useful role in Ayurvedic medicine.
36. For this design see FRM41, 232; and 249.
37. Beach and Koch, 1997, p.38, folio 51a.
38. Lach, 1970, vol.II, p.111.

39. Beach and Koch, 1997, p.59, folio 117a.

40. Kolff, 1990.

41. See Khan, 2002, p.148.

42. Lavin, 1965, p.158ff.

43. See Elgood, 2009, p.75. Occasionally one finds Balkan *yataghans* in India with Rajput hilts though these short blades cannot have greatly appealed as weapons to Rajput warriors. See Elgood, 2009, p.150.

44. See Elgood, 2009, p.190.

45. See Elgood, 2009, p.205.

46. Irving, 1903, reprinted 1962, p.106. Khan, 2004, p.144 disputes this and other historians have entered the dispute. Irvine was an ICS official who worked in India between 1863 and 1889.

47. Among Asian nomads the recurved bow was a symbol of royalty. The monk William of Rubruk (1220–93) reached the court of Mangu Khan where the Great Khan sent the French King Louis the Holy a bow with two silver arrows, inviting him to become his vassal.

48. Eleven-year-old Guru Har Gobind was instructed by his father to change the Sikh movement from a purely spiritual one to one also militant. He therefore made much of arms symbols at his enthronement, putting on two swords, representing spiritual and temporal authority.

49. Tod, *Annals*, 2010, vol.I, p.248.

50. See Elgood, 1995, p.163ff.

51. Fitzclarence, 1819, p.273.

52. Tone, 1796.

53. Fitzclarence, 1819, p.256.

54. Sikhs did not have the long martial tradition of the kshatriyas and adopted firearms without the reservations of the Rajputs. The excellence of their matchlocks and their adeptness with them passed into an Indian nineteenth-century proverb: 'the Maratha spear, the Afghan sword, the Sikh matchlock and the English cannon'.

55. Tod, vol.I, p.512.

56. Tod, *Annals*, 2010, vol.2, p.126.

57. Egerton, 1968, p.58.

58. Peabody, 2006, p.136ff.

59. Princep, 1820, pp.31–2.

60. The Japanese almost totally ignored the miquelet and flintlock though a few examples exist. There are Japanese netsuke flintlock tinderlighters from the Edo period, for example Bonhams, London, 25 July 2012, lot 10.

61. Khan, 2004, p.195.

## CHAPTER 4

1. Abu'l Fazl, *A'in*, vol.I, p.120.

2. Thackston, 1999, Appendix A.

3. *Akbarnama*, vol.III, p.1254.

4. Thackston, *Jahangirnama*, p.39.

5. A modern copy is in the Museo Nationale di Artiglieria, Torino. Similar stands can be seen in a Chinese illustration of an early seventeenth century battle between Manchu and Ming forces. See Needham, 1986, p.404.

6. See Boccia, 1978, illus. 13–14.

7. Beveridge, *A'in-i Akbari*, vol.I, p.121.

8. Lake, 1825, p.70, note.

9. Saxe, Maurice, Count de, Book I, 1759, p.38.

10. See Thomas Del Mar Ltd. Antique Arms, *Armour & Militaria*, London, 7 December 2011, lot 351.

11. See Elgood, 1995, p.6, 'An officer with a matchlock', signed Tirayya, Collection Frits Lugt, Institut Neerlandais, Paris.

12. Beach and Koch, 1997, p.52, folio 98b.

13. See Elgood, 2017, vol.I, ch.8.

14. See Elgood, 2017, vol.I, p.474.

15. Egerton, 1968, p.46.

16. San Diego Museum, Accession no. 1990. 1008.

17. See Welch, 1963, p.145, no.72. The length is the same as FRM/76/40.

18. Beach and Koch, 1997, p.85, folio 165a.

19. Elgood, 2017, vol.II, p.912.

20. See Elgood, 2013, p.262, no.186. The barrel may be considerably older than the stock.

21. Fiegiel, 1991, p.137. His collection formed in Jaipur has other barrels from this group.

22. Egerton, 1896, 1968 ed., p.118, no.552.

23. The Talpurs are a Baluch tribe that ruled Sindh in the late eighteenth and nineteenth centuries – see page 152.

24. In Europe and America barrels with this raised rib are referred to as 'hogs back'.

25. Henley, 1883, Plate XLI.

26. See Fiegiel, 1991, p.112, Fig. 45b for a discussion of this pattern. He shows a number of examples.

27. For an explanation of this symbol see FRM846.

28. One silver side-plate on the butt is a modern renewal, c.2016.

29. See ARM/76/846 for a discussion of Matsya's presence here.

30. Royal Armouries, Leeds, XXVIF.42.

31. The month is divided into bright and dark halves as the moon waxes and wanes.

32. The author was having dinner in a house in Jodhpur when the meal was interrupted by a cobra entering the kitchen. My host's son calmly reached for his mobile phone and called the snake remover who he had listed and booked him for the following day. The snake meanwhile disappeared and dinner continued without any concern.

33. Sagwan, the Rajput name for teak.

34. See Welch, 1963, p.173, no.71.

35. The same reference number occurs on the revolving cylinder gun sold by Peter Dekker of Mandarin Mansion. There are a number of instances of such duplication in the Jodhpur Armoury.

36. Sindh, one of many variants, was declared the official spelling in 1990, replacing the colonial Sind.

37. Telangana is a state in south India with Hyderabad Deccan as its capital. It was famous for its mercenaries who had a reputation as matchlockmen.

38. Lord, Report No. XI, p.67. He gives a detailed account of the Sindhi cannon and says the Mirs when hunting sometimes have an escort of 600 men.

39. Leech, 1839, p.67.

40. Leech, 1839, p.67.

41. Leech, 1839, p.70.

42. Leech, 1839, p.67.

43. Leech, 1839, p.67.

44. See Missilier and Ricketts, 1988, illustration p.131 for the distinction between Sindhi matchlocks with Multan (no. 219) and Persian/Hyderabadi (no. 220) enamel. Multan enamel is found on silver and Persian/Hyderabadi enamel is usually on gold.

45. Postans, 'Miscellaneous Information'. See Hughes Thomas, ed., *Selections from the Records of the Bombay Government*, No. XVII, New Series, 1855.

46. Postans, 1841, p.92.

47. Pottinger, 1816, pp.235–6.

48. Moorcroft, 1841, p.195.

49. Postans, 1843, p.103.

50. See Wallace Collection no. 2055.

51. Postans, 1843, p.4.

52. Von Orlich, 1845, Vol.1, p.97. For East India Company exports of rifles to Sindh see Harding 1997, vol.II, p.558.

53. Boileau, 1837, p.67.

54. Boileau, 1837, p.176. When Charles Masson had an audience with the Nawab in 1826 he found him 'seated cross legged, on a carpet, reclining on a pillow, his left arm resting on a black shield'. The pose was a traditional one for rulers at that time but the nawab was anxious to give this a modern touch. 'Before him was lying a double-barrelled fowling-piece, and on each side of him European sabres.' These he showed to Masson explaining how he obtained them, a considerable coup. Masson, 1842, p.15.

55. See illustration, Elgood, 1995, p.86.

56. Gordon, Reports, 1841–2, p.348 ff. Gordon reports that small quantities of gunpowder were also imported from Muscat.

57. See Markovits, 2000, p.39ff.

58. Formerly Amarkot.

59. Falzon, 2004, p.132.

60. Postans, 1843, p.102ff.

61. See Crill, p.124, centre plate.

62. Egerton, 1968, p.110, no.420 and plate IV.

63. Markovits, 2000, p.116.

64. Markovits, 2000, p.118.

65. Victoria and Albert Museum, London: IS. 143&A-1890.

66. See Elgood, 1995, p.168 no.114.

67. Burnes, 1831, p.86.

68. See Alexander, 1992, p.202.

69. See Loukonine and Ivanov, 1996, p.233, no.272. Inv. no.OR-274.

70. A Sindhi talwar with both their names on the blade was sold at Sotheby's *Arts of the Islamic World* 2015, lot 351, demonstrating that arms passed from father to son.

71. His memorial is in Birmingham Cathedral.

72. See Askari, 1999, p.62, fig.59.

73. See Elgood, 1995, p.86 for examples of these barrels.

74. For an example see Elgood, 1994, pp.38–9, third gun from the left.

75. Elgood, 1994, p.38.

76. See Gaibi, 1978, illus.5, lower two barrels.

77. See Egerton, 1896, reprinted 1968, p.110, no.420; Jackson and Jaffer, eds., 2009, p.57.

78. See Elgood, 2015, pp.258–9.

79. A *schioppo da caccia* or Italian flintlock hunting rifle made by Peter the Fortunate Cominazzi, born c.1670, with two-stage barrel; the upper section with broad concave fluting weighs a mere 2.5 kg. See Gaibi, 1978, illus. 181–2.

80. See Schuckelt, 2010, p.69, no.45.

81. Elgood, 2017, vol.I, ch.8 discusses this style.

82. See Elgood, 2017, ch.8 plate 8.3.

83. Pelly, *Brief Notes*, 1854. He described the Mir as 'Robust and an excellent sportsman'.

84. Valle, II, p.371.

85. Fawcett, I, p.172. The ms. gives 'bacquemarde', from Portuguese 'bacamarte', a blunderbuss.

86. Fryer, 1992, vol.II, p.26.

87. Irvine, p.112.

88. Painted by Miskina and Bhura, V&A IS.2: 74–1896.

89. See Khan, 2002, p.148.

90. Harding, 1999, vol.4, p.518.

91. Harding, 1999, vol.4, p.518.

92. Myatt, 1970, p.140.

93. Dallas, 2014, p.56. This rifle is in the Holland & Holland collection.

94. Heer, 1979, vol.1, p.137; Bailey and Nie, *English Gunmakers*.

95. Private letter, SOE Advisor to MOD Pattern Room, 11 September 1991, pp.8–9.

96. Heer, 1979, vol.II, p.1192.

97. Støckel.

98. See Christies, 2001, p.218.

99. (Inv. No. XII.3527). For another see *Fine Antique Arms*, Bonhams, London, 27 November 2019, lot 334.

100. Peterson, 1964, p.329.

101. See Thomas Del Mar, Antique Arms, London, 10 July 2019, lot 341.

102. See Brower, 1996.

103. Later named Dalhousie Square, now Benoy-Badal-Dinesh Bagh, generally abbreviated as B. B. D. Bagh, named after three freedom fighters who shot dead the British Inspector General of Prisons in 1930.

104. Blackmore, 1986, p.62.

105. For a cased pair of Cooper's Patent percussion pistols made in the 1850s by Thomson, Calcutta and retailed by R. B. Rodda see 'The Richard Garrett Collection', Bonhams, London, 28 November 2018, lot 256. In the late nineteenth century W & C. Scott and Son of Birmingham made guns for Rodda.

106. Wilhelm, 1882–1951, eldest son of Kaiser Wilhelm II.

107. Private communication: John W. Brunner to Mark Murray-Flutter.

108. See Carr, 1969; Brower Jr., 1996 and 2008.

109. Rudolf (ed.), 2000, p.151.

110. See Stepan, 2012.

111. In the 1990s, the 'bicycle era', Quackenbush made the .22 'Quackenbush Bicycle Rifle' with a skeleton stock which was usually carried strapped to the crossbar.

112. John Atkins, *Airgunner Magazine*, April 1985 discusses Bussey's air guns; with further articles by Trevor Adams and John Griffiths. See also *Journal of the Arms and Armour Society*, Sept. 1997. Extract by Howard Blackmore.

113. See Dee: https://www.jimmiedeesairguns.com/

114. See Michael Wessel, 'Theodor Bergmann's 150th Birthday': Stadt Gaggenau, ed., Stadtarchiv Gaggenau, May 2000: and The Eisenwerke Gaggenau 'MF' (1878 to 1900), Michael Flürscheim, https://www.jimmiedeesairguns.com/ for further information on the 'MF' and on Theodore Bergmann's gun developments after 1884.

115. See Bruce, 2008; Hillier,1996.

## CHAPTER 5

1. Baden Powell, 1889, vol.II, div.III.
2. Fane, 1842, vol.1, p.75. Frederick Manton opened an office in Calcutta c.1825.
3. See William Greener, 1835, ch.XI, p.51. Swaff iron was made from waste found in the gunsmiths' workshops, which was sold for beer money and converted into quality iron bars.
4. *Barut-sanj* (Persian), *deredza* or *kantar-ćila* (Turkish) – a gunpowder measure usually inlaid with gold or silver flowers. *Krćmar* gives *teredza* (Bosnian) – tubular metal powder measure with plunger to provide measured levels. Bosnia. *Wazna-i barut* (Arabic) – tubular powder measure; *wazna* means weight or measure in Arabic, Persian, Urdu and Hindi.
5. Rifleman Harris of the 95th, a Light Infantry Regiment, describes this problem in 1808 during the Peninsula War. The obscurity was much greater in a regiment formed in square firing by rank. 'I myself was very soon so hotly engaged, loading and firing away, enveloped in the smoke I created, and the cloud which hung about me from the continued fire of my comrades, that I could see nothing for a few minutes but the red flash of my own piece amongst the white vapour clinging to my very clothes. This has often seemed to me the greatest drawback upon our present system of fighting; for while in such a state, on a calm day, until some friendly breeze of wind clears the space around, a soldier knows no more of his position and what is about to happen in his front, or what has happened (even amongst his own companions) than the very dead lying around.' Hibbert, 1970, p.26. In the right weather conditions this 'fog of war' made it possible for regiments to march in close formation up to enemy infantry relatively unscathed and attack through the enemy gun smoke with the bayonet. The last word on massed European infantry volleys in the age of the flintlock can be left to the very experienced Maurice, Compte de Saxe (1696–1750), Marshal of France: 'The effects of gunpowder in engagements are become lefs dreadful, and fewer lives are loft by it, than is generally imagined. I have feen whole volleys fired, without even killing four men; and fhall appeal to the experience of all mankind, if any fingle difcharge was ever fo violent, as to difable an enemy from advancing afterwards, to take ample revenge, by pouring in his fire, and at the fame inftant rufhing in with fixed bayonets. It is by this method only that numbers are to be deftroyed, and victories obtained'.
6. All Purdey guns are recorded in their Dimensions Books.
7. Patent no.3223 of 1875.
8. To this day Purdey makes 'damascus' guns using a Swedish steel alloy.
9. Barrels continued to be made in this manner until the twentieth century, ignoring the fluid pressed steel process invented by Sir Joseph Whitworth in the late 1870s.

## CHAPTER 6

1. Thorn, 1818.
2. See Gardner, 1895.
3. Baden-Powell became a national hero in Britain in 1900 due to his successful defence of Mafeking in the South African War. His book *Aids to Scouting*, written as a military manual in 1899, became popular among adolescents leading to the creation of the Boy Scout movement.

4. Williamson, 1808, vol.I, p.76.
5. Gardner, 1895, p.324.
6. Gardner, 1895, p.325.
7. Wart, 1926, p.106ff.
8. Ellison, 1925, p.193.
9. Beach and Koch, 1997, p.76ff. Folio 135b.
10. Thackston, *Jahangirnama*, p.219.
11. Thackston, 1999, p.174.
12. Thackston, *Jahangirnama*, p.44.
13. A kos is about two and a half miles.
14. Thackston, *Jahangirnama*, p.126.
15. Bernier, 1981, p.378.
16. Beach and Koch, 1997, p.110, folio 220b.
17. Blane, 1788, p.2. His account describes the princely hunting party of 20,000 very well.
18. For a portrait of Asaf-ud-Daula with a brace of European pistols thrust in his sash c.1784–6 by Johann Zoffany see Llewellyn-Jones, 2008, p.31.
19. Blane, 1788, p 5.
20. Johnson, 1827, p.160.
21. For a superb pair of John Manton silver-mounted flintlock pistols with gold inlaid decoration, made in 1793 and inscribed 'Wazir al-Mamalik Asaf al-Dawlah Yahya Khan Bahadur' in gold naskh, see *Fine Antique Arms*, Bonhams, London, 27 November 2019, lot 519.
22. The Probyns were Birmingham barrel-makers. John Probyn of Birmingham and London was gunmaker to the Prince of Wales in the period 1770–1800.
23. See Johnson, 1822, pp.169–79
24. In modern times this scale was reduced. A Hyderabadi told the author that when Mir Barkat Ali Khan Mukarram Jah Asaf Jah VIII, Nizam of Hyderabad, went hunting post 1967 he was generally accompanied by about a hundred vehicles.
25. Johnson, op. cit.
26. Jacquemont, letter, 17 March 1830, p.79.
27. Johnson, 1827, p.1.
28. Nilgai, nilgau or 'blue bull', *Boselaphus tragocamelus*, the largest Asian antelope, common in central and northern India.
29. Wart, 1926, p.75.
30. Iran's Department of the Environment is working with Panthera, the Wildlife Conservation Society, and the UN Development Programme to conserve their remaining cheetahs.
31. Turley, 1926, p.71.
32. Gerard, 1904, p.4.
33. Later Acts include the Wild Birds and Animals Protection Act, 1912, Forest Acts, 1927 and 1950, and the Wild Life Protection Act No. 53, 1972.
34. Larking (1842–1910) joined the army after Cambridge. He was Equerry to the Duke of Cambridge and Gentleman Usher to both Queen Victoria and King Edward VII.
35. Business manager.
36. Colonel Larking, 1888, p.94ff.
37. Larking, 1888, p.98.
38. Thevenot, ch. XXII, p.57.
39. Johnson, 1827, p.4.
40. Williamson, vol.I, p.211.
41. Burton, 1928, p.89.

42. James, 1854, vol.II, p.38.

43. James, 1854, vol.II, p.203.

44. Gilmour, p.309.

45. Gardner, 1895, p.147. *Baboo* (Bengali), *babu* (Hindi), means father, originally a term of respect for a distinguished person. However, as Anglo-Indian it came to be used disparagingly to describe a class of Indian clerks who wrote English. Mrs Gardner's amusing story reflects British prejudice against educated Indians, by this date a growing political threat to Imperial supremacy.

46. Adams, 1899, p,168.

47. Gerard, 1904, p.31.

48. Sir Montagu Gerard, 1904, p.14.

49. Corbett, 1946, p.43.

50. Gerard, Aflalo ed., 1904, p.14.

51. The present Maharaja of Jodhpur told the author that the only time he was out on foot after a tiger he saw it going away at some distance and thought the idea of shooting at it under such conditions repugnant.

52. The .500 Jeffrey was introduced to bring firepower comparable to the .505 Gibbs into a standard-sized 1898 Mauser action such as the 8x57 and 7x57, as opposed to the over-sized magnum actions used by the Gibbs and 416 Rigby. To shoehorn a large round into the 98 action required a rebated rim. When introduced the .500 Jeffery was technically rated the most powerful rifle cartridge although in reality not quite up to the performance of the .505 Gibb. The .505 Gibbs with greater capacity can be loaded far in excess of the .500 Jeffery today. Both were perfect for large game when introduced.

53. Dumdum bullets such as the hollow-point bullet and the soft-point bullet were designed to expand on impact, increasing in diameter to limit penetration and/or produce a larger diameter wound for faster incapacitation. They were used for hunting and by some police departments, but are prohibited for use in war.

54. Gerard, Aflalo ed., 1904, p.14.

55. Ellison, 1925, p.182.

56. A. A. Dunbar-Brander, 30 August 1923.

57. Captain H. E. Gregory-Smith, 22 November 1923.

58. See Ellison, p.185.

59. Hamadrayad, a king cobra.

60. In the early 1880s damascus barrels began to be superseded by steel that took rifling much better than steel and iron ribbon twist.

61. For the official account of the visit see Ellison, 1925.

62. Woodruff, 1954, p.65.

63. Alfred Comyn Lyall (1835–1911). After Eton and Haileybury he joined the ICS in 1856. The following year he was Assistant Magistrate at Bulandshahr in the North-West Provinces when the revolt broke out. His house was burnt down and he only just escaped alive, having his horse shot under him. He then saw action with the Khaki Risala. His rise in the ICS was rapid. In 1874 he became the Governor General's agent in Rajputana, subsequently Lieutenant Governor of North-West Provinces and Chief Commissioner of Oudh. He later founded the University of Allahabad and was its first chancellor. In 1902 he was made a member of the Privy Council. He was a brilliant, pragmatic administrator, far less regarded as an historian and poet. He died when visiting Tennyson at his home on the Isle of Wight.

64. A small town in Rajasthan is named after Mr Irons though Ironpura is spelt Arenpura. My thanks to Rawat Veerbhadr Singhji of Devgarh for the story.

65. Numberless file produced by the librarian Mahendra Singh Tanwar.

66. The Gujarat High Court prohibited the use of live decoys within the state in 2000.

67. Correspondence relating permission of shikar, 1938–40 is in Mehrangarh, file B280/8662.

68. Elliot, 1973, p.108.

69. The lions attract so many tourists that neighbouring regions now want some transferred to their forests so that they too can benefit from this lucrative business.

70. Elsewhere in India the cost of compensating shepherds for the odd animal killed by leopards is far outweighed by the financial benefits to the local economy of eco-tourism. However, problems develop where the leopards lose their fear of man through familiarity due to their living in close proximity.

71. MacKenzie, 1988, p.298.

72. MacKenzie, 1988, p.300.

73. The Charans were poets who held a privileged and protected position at Rajput courts where one of their roles was to adjudicate on the correct Rajput code of behaviour or Rajput dharma.

74. Keshari is both the colour saffron and the spice. The most important colour in Hinduism, hence its presence on the Maratha Jari Patka flag and the Indian national flag, as well as being the background colour of the Nishan Sahib, the Sikh flag on which is displayed a blue khanda. Saffron is associated with sacrifice, religious abstinence and salvation. Warriors committed to conquer or die in battle and sannyasin renouncing the world put on clothes of this colour. Turmeric produces the same colour and is used in the same manner.

75. Johar is when a Rajput commits himself to die in battle, putting on the saffron clothes of the sannyasin who has renounced life.

76. Elgood, 2017, vol.I, p.41.

77. See the *Hindu*, 9 October 2016.

78. B290/9109 12 October 1933.

79. Elliot, 1973, p.215.

80. From 1892 when he was ten years old Maharaja Jai Singhji ruled Alwar, a state of 3,213 square miles, initially under the control of a regent. He was the best tiger shot and polo player of his day, considered brilliant but fey. The story of his feeling slighted by a Rolls-Royce salesman in London, buying fifteen cars and converting them into dustcarts in Alwar is well known. He built a castle, Sariska Palace as a shikar lodge, had a particular liking for Westley Richards' rifles, and is reputed to have used young children as bait for tigers when hunting. The viceroy finally forced him into exile in 1933, which he endured with great dignity. His body was brought home after death to the acclaim of his people.

81. *National Geographic Traveller India*, 10 December 2015.

## CHAPTER 8

1. The cricketing term 'leg glance' describes when a fast bowler aims at the batsman's legs as a form of intimidation and the batsman responds by positioning his bat vertically so the ball glances off it and is carried by its own pace behind the batsman.

2. Polish people will remember him for establishing a camp in his State for Polish Refugee children brought out of the USSR

in 1942. The Jamsaheb Digvijay Singh Jadeja School in Warsaw commemorates this and in 2016 the Polish Parliament passed a special resolution honouring him for his work saving Polish children during the Second World War.

## CHAPTER 9

1. 'From Officer-in-Charge, State Armoury, Jodhpur to Comptroller of Household, Jodhpur, 10th 9. 48. Supply of Khukaries. Mistri Chandmal was asked to prepare 10,000 Khukaries by your office. He has yet supplied 4400 khukaries to us and payment in full of the above quantity has been made. Now as the khukaries has been disapproved by His Highness the Maharaja Sahib Bahadur, the order for the supply of remaining khukaries may be stopped. He was asked verbally by me on 18.8.48 and I agreed to purchase 1300 khukaries which Mr Chandmal reported to be in stock to cover the advance already given him. So in these circumstances no more Khukaries will be accepted by this department.'
2. RAF escape kits included Dexadrine and it is to this day sometimes taken by university students cramming for exams.
3. Household File B297/9364, Mehrangarh Fort.
4. V. P. Menon, the son of a Kerala schoolmaster, rose in the Indian Civil Service through hard work and ability to become the highest Indian government officer in British India, political adviser to the Viceroy, Lord Louis Mountbatten. He is considered one of the architects of the Partition of India.
5. Menon inflated this incident, suggesting that he was seriously threatened (see Menon, 1956 and 1968). Mountbatten confirmed the present account when he met the present Maharaja, Gaj Singhji, at King Birendra's coronation in Nepal in 1975. After Mountbatten's death the pistol was offered for sale at Holts, 24 June 2010, lot 999. The Maharaja left a bid for his father's pistol but a private collector outbid him. He wrote a letter to the collector explaining the gun's history and this, together with the pistol, is now in the Royal Armouries, Leeds. My thanks to Mark Murray-Flutter, Royal Armouries, for showing it to me.
6. Bullpup – where the action and magazine is behind the trigger. This enables the barrel to be the normal length but the gun to be shorter improving manoeuvrability and reducing weight.
7. The Lee–Enfield Mark 1 was introduced in 1895 and with modifications remained the front line British Army rifle until 1957. It was extremely accurate. The Mark 4 was issued to the British army in 1939. Holland & Holland converted some 12,000 for sniping, the No 4, Mk1T. Converted to NATO 7.62 calibre round, the L42A1 were used as sniper rifles by Royal Marines in the 1982 Falklands War and the Gulf War. The Canadian Rangers were still using the .303 Lee–Enfield in 2016.
8. Kazimierz Januszewski became a British citizen, changing his name to Stefan Janson.
9. Owen, 1995, pp.16–17.

## APPENDICES

1. The gun descriptions are so inadequate that the author has not included a translation.
2. *Mulmchi* specialise in fine gold work. See Elgood, 2017, vol.1, p.156.

3. Bernier (1981, p.254) wrote of mid-seventeenth-century Delhi: 'Sometimes they imitate so perfectly articles of European manufacture that the difference between the original and copy can hardly be discerned. Among other things the Indians make excellent muskets and fowling pieces…'
4. The chiselled images of animals and plants can run along the barrel or appear as framed vertical pictures from the muzzle to the breech.
5. Harding, 1999, vol.IV, p.586.
6. A tilak is the red-paste dot worn on the forehead to denote caste, status or as an ornament. When arms are worshipped they are decorated with red kumkum dots, which are left on the weapon. Alternatively, on the breech on good quality Persian and Sindhi gun barrels there is often an inset gold mark which usually bears an Islamic inscription, either religious, or the maker's name. This might be described by a Hindu as a tilak. The sense is of something gold covered, which indicates the inset gold stamp.
7. Also see footnotes in Elgood, 2017, vol.I, p.160.
8. Karachi is the principal port of Sindh.
9. Kiladar – the fort commander.
10. See Glossary, Pechdar.
11. *Langar* in Persian and Urdu is a cable or rope. In this instance the gold creeper decoration probably ended at the raised 'cable' or 'rope' that is found on all matchlocks marking the point where the enlarged breech chamber ends and the barrel begins.
12. Clothe Store Daily Accounts.
13. Bhairon is a field spirit, the village counterpart of Bhairava, 'terrifying', an aspect of the god Shiva.
14. Crosman Corporation, a leading maker of airguns, was founded in 1923 in Rochester, New York.

## GLOSSARY

1. Irvine, 1962, p.160.
2. Careri, vol.III, p.244.
3. Tod, *Annals and Antiquities of Rajasthan*, 1839, reprinted 2010, vol.I, p.220.
4. Abu'l Fazl, *A'in*, p.119.
5. See Bag, 2005, p.431–6.
6. Now in the Lisbon Military Museum. See Daehnhardt, 1994, p.44 for an illustration.
7. Compton, p.61.
8. Barros, *Décadas*, IV.6.4.
9. See Barker, 1996, p.71.
10. Another from Bundelkhand, central India, is illustrated in Elgood, 1995, p.176, no.122.
11. See Bajwa, 1964, p.235.
12. Egerton, p.145, No.801.
13. Bajwa, 1964.
14. Baden-Powell, 1889, vol II, div.III.
15. Khan, 2004, p.114.
16. Abu'l Fazl, *A'in-i Akbari*, vol.I, p.83.
17. Jixing Pan, 1996, p.27.
18. See Elgood, 2017.
19. Khan, 1999, p.63.
20. Kahn, Harold L., Monarchy in the Emperor's Eyes, pp.139–140.
21. Irvine, 1962, p.111.

22. James, 1854, Vol. I, p.88.

23. Dike, 1983, p.325.

24. Khan, 2004, p.29.

25. The nineteenth-century traveller Alexander Burnes was with a group of merchants in Afghanistan when they were confronted on the road at dusk by what appeared to be bandits behind a line of matchlocks, their fuses burning. A tea merchant in Burnes's party 'busied himself tearing up rags, rubbing them with gunpowder, and lighting them' to give the impression they too had guns though in fact they had only one. The two groups carefully circled round, avoiding each other. Only later did Burnes discover that both parties were merchants using the same stratagem to avoid what they feared were robbers.

26. Cooper, 2005, p.338.

27. See Kolff, 1990.

28. Egerton, p.585.

29. Fryer, vol. II, 1992, p.72.

30. Postans, 1843, p.104.

31. See Crill, p.124, fig.97.

32. See Welch, 1963, p.173, no.71.

33. British infantry regiments were similarly known by their colonel's name until 1751 when this system was replaced by regimental numbers.

34. Needham, 1986, p.425, citing Blackmore, 1965, p.9.

35. Codex MS. 3069, Austrian National Library, Vienna.

36. Vignette from a Froissart ms., Breslau City Library. See Blackmore, 1965, p.9.

37. Basle Historical Museum, Inv. Nos. 1905, 1498 & 1498a respectively. The Daenhardt Collection has examples.

38. Blair, 'Matchlock', in Peterson, ed., 1964, p.199.

39. Egerton, 1968, p.61, n. 1.

40. See V. S. Srivastava, 1960–1, nos. 619–20 BM.

41. See Elgood, 2017, vol.1, p.160

42. Thackston, p.174.

43. Daljeet, Cimino, and Ducrot, 2009, p.97, MA 10.

44. My thanks to G. Wilson for drawing this to my attention.

45. Birds are commonly invoked as the name for a gun, for example in about 1550 AD the Italian word 'moschetto' gives us the musket; while the Dutch 'snaphaan' or German 'schnapphahn' referring to the action of the lock like a pecking hen are the source of the English 'snaphaunce'; and the simile continues when the refined mechanism is referred to as a 'cock'.

46. See Peralta, 1998, for a survey of the lantaka collection at the Philippines National Museum. My thanks to Jan Piet Puype for bringing this to my attention.

47. See Sanders, 1982.

48. LNS 186 M. Keene and Kaoukji, 2001, p.92.

49. Irvine, 1962, p.104.

50. But note that the word *gajnal* is also used to mean a crowsbeak axe in Hindi.

51. Manucci, *Storia do Mogor*, vol. I, p.254.

52. Guy Wilson comment to the author.

53. Irvine, 1962, p.112.

54. Barter, 1984, p.43.

55. See Elgood, 1995, for an account.

56. Personal communication to the author.

57. See Lentz and Lowry, 1989, cat. no.31.

58. The banyan tree, *Ficus benghalensis*, produces figs that are eaten by birds. The seed passes through the bird and germinates high on the tree producing roots that grow downwards until they reach the ground where they turn into multiple tree trunks. One unusually large banyan tree was reported to have had a circumference of 2,000 feet.

59. See Colombari, 1853.

60. Watt, 1903, p.47.

# BIBLIOGRAPHY

Adams, A., *The Western Rajputana States*, Bombay, 1899. Reprinted Vintage Books, 1990.

Aflalo, F. G. (ed.), *The Sportsman's Book for India*, London, H. Marshall & Son, 1904. (RAL)

Ágoston, Gábor, *Guns for the Sultan: Military Power and the Weapons Industry in the Ottoman Empire*, CUP, 2008.

Akehurst, Richard, *Game Guns and Rifles: From Percussion to Hammerless Ejector in Britain*, London, G Bell & Sons, 1969.

Albuquerque, Braz de, *The Commentaries of the Great Alfonso Dalboquerque*, trans. W. de Gray Birch, 3 vols, London, Hakluyt Society, 1880.

Alexander, David, *The Arts of War*. The Nasser D. Khalili Collection of Islamic Art. The Nour Foundation, Azimuth Editions and OUP, Vol. XXI, 1992.

Alexandrescu-Dersca, M. M., *La campagne de Timour en Anatolie (1402)*, London, Variorum Reprints, 1977.

Al-Hassan, Ahmad Yusuf, 'A Note on Gunpowder and Cannon in Arabic Culture', Proc. XVI Internat. Congress Hist. of Science, Bucharest, 1981, Vol.1, p.51.

———'Potassium Nitrate in Arabic and Latin Sources', *History of Science and Technology in Islam*, 2001.

Al-Hassan, A. Y. and Hill, D. R., *Islamic Technology*, CUP, 1986.

Alikberov, A. and Rezvan, E. 'Ibn Abi Khazzam and his Kitab al-makhzun: the Mamluk military manual', *Manuscripta Orientalia*, 1, no. 1 (1995), pp.21–8.

Allen, G & D., *The Guns of Sacramento*, London, Robin Garton Ltd., 1978.

Ambekar, A. S., Pande, R. & Garge, T.M., *Cannon from the Western Coast of India*, Fundacao Oriente, 2013.

Andaya, L. Y., 'Interactions with the Outside World and Adaptation in Southeast Asian Society, 1500–1800', *Cambridge History of Southeast Asia*, ed., N. Tarling, vol. I, *From Early Times to c.1800*, CUP, 2008, pp.345–402.

Andrade, Tonio, *The Gunpowder Age: China, Military Innovation, and the Rise of the West in World History*, Princeton University Press, 2016.

Anh, Nguyễn Thế, *Ambivalence and Ambiguity: Traditional Vietnam's Incorporation of External Cultural and Technical Contributions*, East Asian Science, Technology and Medicine 21, 2003, pp.94–113.

Anon. *Official Report of the Calcutta International Exhibition, 1883–84*, 2 vols. Calcutta, Bengal Secretariat Press, 1885.

Archer, M., Rowell, C., Skelton, R. et al., *Treasures from India: The Clive Collection at Powis Castle*, The National Trust, 1987.

Ashtor, Eliyahu, *Levant Trade in the Later Middle Ages*, Princeton, 1983.

Askari, Nasreen, *Treasures of the Talpurs: Collections from the Courts of Sindh*, Karachi, Mohatta Palace Museum, 1999.

Ayalon, D., *Gunpowder and Firearms in the Mamluk Kingdom*, London, Vallentine Mitchell, 1956.

———'Barud', *Encyclopaedia of Islam* (E.I.2), Leiden, Brill, 1960.

———'A Reply to Professor J. R. Partington', ARAB, 1963, 10, 64.

———'The Impact of Firearms on the Muslim World', Princeton Middle East Papers 20, Princeton, 1975, pp.32–43, reprinted in Ayalon, *Islam and the Abode of War*, Variorum, 1994.

———'Islam versus Christian Europe: the case of the Holy Land', *Pillars of Smoke and Fire*, ed., M. Sharon, Johannesburg: Southern Book, 1988, pp.247–56, reprinted in Ayalon, *Islam and the Abode of War*, Variorum, 1994.

Bacqué-Grammont, Jean-Louis, 'Les Ottomans, Les Safavides et leurs voisins' in *L'Histoire des relations internationals dans l'Orient Islamique de 1514 á 1524*, Netherlands Historisch-Archaeologisch Instituut Te Istanbul, 1987.

Baden-Powell, R. S. S., *Pig sticking or Hog hunting*, London, Harrison and Sons, 1889.

Bag, A. K., 'Śukranīti on Guns, Cannon and Gunpowder', *Indian Journal of History of Science*, 40.4, 2005, pp.657–62.

———'Fathullah Shirazi: Cannon, Multi-barrel Gun and Yarghu', *Indian Journal of History of Science*, 40.3, 2005, pp.431–35.

Bajwa, Fauja Singh, *Military System of the Sikhs during the Period 1799–1849*, Delhi, Motilal Banarsidass, 1964.

Baker, Sir Samuel, *The Rifle and Hound in Ceylon*, London, 1854, reprinted New Delhi, 1999.

Barker, Richard, 'A Gun-List from Portuguese India, 1525', *Journal of the Ordnance Society* 8, 1996, pp.53–71.

Barter, Richard, *The Siege of Delhi*, London, Folio Society, 1984.

Barthold, W., *Turkestan Down to the Mongol Invasion*, second ed., London, 1955.

Barua, Pradeep, *The State at War in South Asia*, University of Nebraska Press, 2005.

Bernier, F., *Travels in the Mughal Empire*, Edinburgh, 1981.

Beveridge, A. (trans. and ed.), *Baburnama*, New Delhi, Oriental Books, 1979.

Beveridge, H. (trans. and ed.), *The Akbar nama of Abu-l-fazl*, New Delhi, 1989.

Blackmore, H. L., *Guns and Rifles of the World*, London, 1965.

———*Royal Sporting Guns at Windsor*, London, HMSO, 1968.

————*The Armouries of the Tower of London*, The Ordnance, London HMSO, 1976.

————*A Dictionary of London Gunmakers*, 1350–1850, Phaidon, Christies, 1986.

————'General Claude Martin, Master Gunmaker' in *Arms Collecting*, vol.27, no.1, February 1989.

Blair, Claude, 'The Milemete Guns', *Journal of the Ordnance Society*, vol.16, 2004.

Blane, William, *An Account of the Hunting Excursions of Asop Ul Doulah, Vifier of the Mogul Empire and Nabob of Oude. Bt William Blane, Efq: Who attended in thefe Excurfions in the Years 1785 and 1786*, London, 1788.

Boileau, A. H. E., *Personal Narrative of a Tour through the Western States of Rajwara 1835; comprising Beekaner, Jesulmer, and Jodhpoor, with the Passage of the Great Desert, and a Brief Visit to the Indus and Buhawulpoor*, Calcutta, 1837.

Borri, Christoforo, *Cochinchina*, translated into English from Borri's presentation to the pope by Robert Ashley, London 1633. (Ms. held by Cornell University)

Boxer, C. R., 'Portuguese Military Expeditions in aid of the Mings against the Manchus, 1621-1647', *T'ien hsia Monthly*, 7.1, pp.24–50 (August 1938).

Brower, Bailey, Jr., 'Savage Pistols: The Birth of the .45 and the Savage Automatic Pistols', *American Society of Arms Collecting*, 1996, pp.1–10.

————Brower, Bailey Jr., *Savage Pistols*, Stackpole Books, 2008.

Brown, Nigel, *London Gunmakers*, Christies Books, 1998.

Bruce, Gordon, *Webley Air Pistols: Their History and Development*, London, Robert Hale Ltd, 2008.

Burgess, Captain F. F. R., *Sporting Fire-Arms for Bush and Jungle: Hints to intending Griffs and Colonists on the Purchase, Care, and Use of Fire-arms, with useful Notes on Sporting Rifles, &c.*, London, W.H. Allen & Co., 1884.

Burke, W. S., *The Indian Field Shikar Book.* fourth ed., Calcutta, The Indian Field Office, 1908.

Burnes, J., *A Narrative of a Visit to the Court of Sindh*, Edinburgh, J. Stark, 1831.

Burrard, Maj. Sir Gerald, *Notes on Sporting Rifles*, London, Edward Arnold, 1920 and 1958.

Burton, R. F., *Sindh, and the Races that inhabit the Valley of the Indus*, London, 1851, reprinted AES, Delhi, 1992.

Burton, R. G., *Sport and Wild Life in the Deccan*, London, Seeley Service & Company Ltd, 1928.

Careri, Gemelli, *Voyage autour du Monde*, 6 vols., Paris, 1726.

Carr, James R., *Savage Automatic Pistols*, Privately printed, 1969.

Chandra, Satish, 'The Eighteenth Century in India: Its Economy and the Role of the Marathas, the Jats, the Sikhs and the Afghans', *Essays on Medieval Indian History*, OUP, 2005, pp.71–127.

Chase, Kenneth, *Firearms: A Global History to 1700*, Cambridge University Press, 2003.

Colombari, F., 'Les Zamboureks.-Artillerie de campagne a dromedaire, employee dans l'armee persane', *Le Spectateur Militaire*, II serie, V, pp.265–96; pp.397–427; pp.541–57; pp.661–3, Paris, 1853.

Colt, Col. Samuel, On the application of machinery to the manufacture of rotating chambered-breech firearms, and their peculiarities. Excerpt Minutes of Proceedings of the Institute of Civil Engineers, Vol. XI. London, William Clowes and Sons, 1855.

Conti, N., *The Travels of Nicolo Conti, in the East, in the Early Part of the Fifteenth Century*, trans. J. Winter Jones, London, Hakluyt Society, 1858.

Cooper, Randolf G. S., *The Anglo-Maratha Campaigns and the Contest for India. The Struggle for Control of the South Asia Military Economy*, Cambridge University Press, 2005.

Cooper, Randolf G. S., and Wagle, N. K., 'Maratha Artillery: from Dabhoi to Assaye', *Journal of the Ordnance Society*, 7, 1995.

Corbett, Jim, *Man-Eaters of Kumaon*, OUP, 1946.

Correa, Gaspar, *The Three Voyages of Vasco da Gama, and his Viceroyalty. From the Lendas da India of Gaspar Correa, accompanied by original documents (translated from the Portuguese, with notes and an introduction by the Hon. Henry E. J. Stanley*, London, Hakluyt Society, 1869.

Correia-Afonso, John (ed. and trans.), *Letters from the Mughal Court: The First Jesuit Mission to Akbar* (1580–83), Bombay, 1980.

Daehnhardt, Rainer, *First Steps towards an Introduction into the Study of Early Gunmaking in the Portuguese World, 1450–1650*, American Society of Arms Collectors, no.37, 1977, pp.1–8.

————'Portuguese Antique Weapons', *Atlantis*, vol.1, no.1, Lisbon, February 1981, pp.10–13.

————*Os Descobrimentos Portugueses e a Expansao Maritima, Exposicao, Palacio do Correio- Velho*, Lisbon, 1983.

————*Espingarda Feiticeira. A Introducao da Arma de Fogo pelos Portugueses no Extremo-Oriente*, Texto Editora, 1994.

————*First steps towards an introduction into the study of Early Gunmaking in the Portuguese World, 1450–1650* [Parallel Portuguese and English texts] Boletin da Sociedade Portuguesa de Armas Antiqas, Vol.I, No.I, Julho de 1997, pp.5–30.

Daljeet Singh, Cimino, R., and Ducrot, V., *Four Centuries of Rajput Painting. Mewar, Marwar and Dhundhar*, Indian Miniatures from the Collection of Isabella and Vicky Ducrot, Milan, Skira, 2009,

Dallas, Donald, *Purdey, Gun and Rifle Maker: The Definitive History*, Shrewsbury, Quiller Publishing Ltd., 2000.

————*The British Sporting Gun and Rifle*, Pursuit of Perfection 1850–1900, Shrewsbury, Quiller Publishing Ltd., 2008.

————*Holland & Holland 'The Royal' Gunmaker*, Shrewsbury, Quiller Publishing, 2014.

Dames, Mansel Longworth, *The Book of Duarte Barbosa: An Account of the Countries bordering on the Indian Ocean and their Inhabitants*, London, Hakluyt Society, 1918.

De Campos, Joaquim. 'Early Portuguese Accounts of Thailand', *Journal of the Siam Society*, 32 (1940), pp.1–27.

DeVries, Kelly, 'A 1445 Reference to Shipboard Artillery', *Technology and Culture*, 31 (1990), pp.818–29.

_____'Gunpowder Weaponry and the rise of the Early Modern State', *War in History* 5, 1998, pp.127–45, reprinted in De Vries, *Guns and Men in Medieval Europe, 1200–1500*, Variorum, 1994.

_____'The Effectiveness of Fifteenth-Century Shipboard Artillery', *The Mariner's Mirror*, 84 (1998), pp.389–99.

Digby, Simon, *War-Horse and Elephant in the Delhi Sultanate*, Oxford, Orient Monographs, 1971.

Dike, Catherine, *Firearms Curiosa: From Gun to Gadget*, Paris, Les Éditions de l'Amateur, 1983.

Diogo do Couto, 'Asia, Decada IV' (trans D. Ferguson), *Journal of the Royal Asiatic Society* (Ceylon Branch) 20 (1909).

Divyabhanusinh, *The End of a Trail: The Cheetah in India*, OUP, 1999.

Egerton, W., *Indian and Oriental Armour*, 1896, facsimile edition, London, Arms and Armour Press, 1968.

Elgood, Robert, *The Arms and Armour of Arabia in the 18th, 19th and 20th Centuries*, London, Scolar Press, 1994.

———*Firearms of the Islamic World in the Tareq Rajab Museum, Kuwait*, London, I.B.Tauris, 1995.

———*Hindu Arms and Ritual*, Eburon, Delft, 2004.

———'Mughal Arms and the Indian Court Tradition', Jewelled Arts of Mughal India. Papers of the Conference held jointly by the British Museum and the Society of Jewellery Historians at the British Museum, London, 2001, Chadour-Sampson and Israel (eds.), *Jewellery Studies*, vol. 10, 2004, pp. 76–99.

———Introductory essay to *Indian Art at Marlborough House*. With the original introduction by G. Birdwood, London 1898: and *Arms and Armour at Sandringham. The Indian Collection presented by the Princes, Chiefs and Nobles of India to H.M. King Edward VII when Prince of Wales on the occasion of his visit to India 1875–6*. London, 1910. Two volumes republished in facsimile editions with additional colour photos. Ken Trotman Books, 2008.

———*The Arms of Greece and Her Balkan neighbours in the Ottoman Period*, London, Athens, 2009.

———*Arms and Armour at the Jaipur Court*, The Royal Collection, New Delhi, Niyogi Books, 2015.

———*Rajput Arms and Armour. The Rathores and their Armoury at Jodhpur Fort*, New Delhi, Niyogi Books, 2017.

Elliott, J. G., *Field Sports in India 1800–1947*, London, Gentry Books Ltd, 1973.

Ellison, Bernard C., *H.R.H. The Prince of Wales's Sport in India*, London, William Heinemann, 1925.

Estrada, Francisco López, ed., *La embajada a Tamorlán*, Madrid: Castalia, 1999.

Falzon, Mark-Anthony, *Cosmopolitan Connections: The Sindhi Diaspora, 1860–2000*, Leiden, Brill, 2004.

Fane, H. E., *Five years in India*, 2 Vols., London, Henry Colburn, 1842.

Fawcett, Lady (trans.) and Fawcett, Charles (ed.), *The Travels of the Abbé Carre in India and the Near East, 1672–1674*, 3 vols., London, Hakluyt Society, 1947–8.

Figiel, Leo S., *On Damascus Steel*, New York, Atlantis Arts Press, 1991.

Fitzclarence, G. A. F., *Journal of a Route Across India, 1817–1818*, 4 vols., London, John Murray, 1819.

Franke, Herbert, 'The Chin Dynasty', *The Cambridge History of China: Volume 6, Alien Regimes and Border States, 710–1368*, Twitchett, D. C., Franke, H., Fairbank, J.K., Cambridge University Press, 1994.

Franzoi, Umberto, *L'Armeria Del Palazzo Ducale A Venezia*, Canova, 1990.

Fryer, John, *A New Account of East India and Persia, being Nine Years' Travels, 1672–1681*, William Crooke (ed.), London, Hakluyt Society, reprinted 1992, vol.II, p.72.

Gaibi, Agostino, *Armi da Fuoco Italiane*, Bramante Editrice, 1978.

Gardner, Mrs Alan, *Rifle and Spear with the Rajpoots: being the Narrative of a Winter's Travel and Sport in Northern India*, London, Chatto and Windus, 1895.

Gerard, Lieut.-Gen. Sir Montagu, 'The Tiger, Panther and Bear' in Aflalo (ed.), The Sportsman's Book for India, 1904.

Giản, Phan Thanh (ed). *Khâm Định Việt Sử Thông Giám Cương Mục*, (The Imperially Ordered Annotated Text Completely Reflecting the History of Viet), 1884.

Gilmour, David, *The Ruling Caste. Imperial Lives in the Victorian Raj*, London, John Murray, 2005.

Glasfurd, Captain A.I.R., *Rifle and Romance in the Indian Jungle*, London, 1905.

Gode, P. K., 'The History of Fireworks in India between A.D. 1400 A.D. And 1900', no. 17, Bangalore, Indian Institute of World Culture, 1953, pp.1–26.

Gommans, Jos, 'Indian Warfare and Afghan Innovation during the Eighteenth Century', *Studies in History*, 11, 1995.

———*Mughal Warfare: Indian Frontiers and High Roads to Empire, 1500–1700*, London and New York, Routledge, 2002.

Gordon, M. F., Reports on the Trade of Sonmeeanee, the seaport of Lus. Submitted to Government in 1841 and 1842. Selections from the Records of the Bombay Government. No. XVII, - New Series, Hughes Thomas, ed., Bombay, 1855.

Graça, Jorge, *The Fortifications of Macao*, Director of Tourism, Macao, second ed., 1984.

Greener, William, *The Gun; or, a treatise on the various descriptions of small firearms*, London, Longman, 1838.

Gunn, Hugh, 'The sportsman as empire builder', in John Ross and

Hugh Gunn (eds.), *The Book of the Red Deer and Empire Big Game*, London, 1925.

Harding, D. F., *Smallarms of the East India Company 1600–1856*, 4 vols., Foresight Books, 1999.

Hawkins, Peter, 'Fine Antique Firearms from the W. Keith Neal Collection', Christies London, 25 October 2001.

Heer, Eugene, *Der Neue Støckel: Internationales Lexikon der Büchsenmacher, Feuerwaffenfabrikanten und Armbrustmacher von 1400 bis 1900*, Zwei Bände, insgesamt 1486 S. Schwäbisch Hall, 1979.

Hendley, Thomas H., *Memorials of the Jaypore Exhibition*, Vol.II, Industrial Art, 1883.

Hibbert, Christopher (ed.), *Recollections of Rifleman Harris*, London, Military Book Society, 1970.

Hillier, Dennis E., *The Collector's Guide to Airpistols*, third ed., 1996.

Hoff, Arne, *Feuerwaffen, Ein waffenhistorisches Handbuch*, 2 vols., Braunschweig, Klinkhardt and Biermann, 1969.

Hoff, Arne, *Dutch Firearms*, Walter A. Stryker (ed.), Sotheby Parke Bernet, 1978.

Hoffmeyer, Ada Bruhn de, *Arms and Armour in Spain*, Instituto do Estudios sombre Armas Antiguas, Consejo Superior de Investigaciones Cientificas, Madrid, 1972.

Holt, Richard, *Sport and the British: A Modern History*, OUP, 1990.

Hosain, M. Hidayat, 'The Library of Tipu Sultan', *Islamic Culture*, 14:3 (1940): pp.139–67.

Hughes, Julie E., *Animal Kingdoms: Hunting, the Environment and Power in the Indian Princely States*, Harvard University Press, 2013.

Inalcik, Halil, 'The socio-political effects of the diffusion of fire-arms in the Middle East', *War, Technology and Society in the Middle East*, eds., V. J. Parry and M. E. Yapp, London, OUP, 1975, pp.195–218.

Irvine, William, *Army of the Indian Moghuls*, Delhi, Eurasia Publishing House, 1962.

Irwin, Robert, 'Gunpowder and Firearms in the Mamluk Sultanate Reconsidered', in *The Mamluks in Egyptian and Syrian Politics and Society*, ed. Winter, M. and Levanoni, A. Leiden, Brill, 2004, pp.117–39.

Jackson, A., Jaffer, A., Ahlawat, D. eds., *Maharaja: The Splendour of India's Royal Courts*, Lustre Press and Roli Books, 2009.

Jacquemont, Victor, *Letters from India 1829–1832*, trans. and introd. C. A. Philips, London, Macmillan, 1936.

Jaikishan, S., 'Forge Welded Iron Cannon in Medieval Deccan Forts', VII- BUMA Proceedings, Nara, Japan, 2013.

James, Hugo, *A Volunteer's Scramble through Scinde, The Punjab, Hindostan and the Himalayah Mountains*, 2 vols., London, W. Thacker and Co., 1854.

Jixing Pan, 'The Origin of Rockets in China', *Gunpowder: The International Technology*, Brenda Buchanan (ed.), Bath University Press, 1996.

Johnson, Daniel, *Sketches of Indian Field Sports as followed by the Natives of India*, London, Robert Jennings, 1822, reprinted 1827.

Kahn, Harold L., *Monarchy in the Emperor's Eyes: Image and Reality in the Ch'ien-lung Reign*, Harvard University Press, 1971.

Keene, Manuel and Kaoukji, Salam, *Treasury of the World: Jewelled Arts of India in the Age of the Mughals*, Thames and Hudson, 2001.

Khan, Gulfishan, 'Indian Muslim Perceptions of the West during the Eighteenth Century', D.Phil. Thesis submitted for the Faculty of Modern History, University of Oxford, 1993. Bodleian Library, 1994.

Khan, Iqbal Ghani, tr., 'The Awadh Scientific Renaissance and the Role of the French: c.1750–1820', *Indian Journal of History of Science*, 38 (2003), pp.273–301.

Khan, Iqtidar Alam, 'The Role of Mongols in the Introduction of Gunpowder and Firearms in South Asia', *Gunpowder: The History of an International Technology*, Brenda J. Buchanan (ed.), Bath University Press, 1996.

———'Firearms in Central Asia during the Fifteenth Century: and the Origins and Nature of Firearms brought by Babur', Proceedings of the Indian History Congress, 56th Session (Calcutta 1995), Calcutta, 1996.

———'The Indian Response to Firearms (1300–1750)', Presidential address, Proceedings of the Indian History Congress, 39th Session, Bangalore, 1997.

———'Nature of Gunpowder Artillery in India during the sixteenth century – a Reappraisal of the Impact of European Gunnery', *Journal of the Royal Asiatic Society*, London third series, vol.9, pt.1, April 1999.

———*Gunpowder and Firearms: Warfare in Medieval India*, OUP, New Delhi, 2004.

Kirkpatrick, William (ed.), *Select Letters of Tippoo Sultan to Various Public Functionaries*, London, Black, Parry, and Kingsbury, 1811.

Knight, Ian, *Marching to the Drums*, London and Pennsylvania, Greenhill Books, 2000.

Koch, Ebba, 'Mughal Art and Imperial Ideology', *Collected Essays*, OUP, 2001.

Kolff, Dirk H.A., *Naukar, Rajput and Sepoy: The Ethnohistory of the Military Labour Market in Hindustan, 1450–1850*, CUP, 1990.

———'The Rajput of Ancient and Medieval North India', *Folk, Faith and Feudalism: Rajasthan Studies*, ed., N. K. Singhi and Rajendra Joshi, Rawat Publications, Jaipur and New Delhi, 1995, pp.257–95.

Kramer, G. W. (ed.), *Das Feuerwerkbuch*, MS 362 dated 1432, Library of the University of Freiburg, trans. Klaus Leibnitz, The Arms and Armour Society, Vol. XVII, No. 1, March 2001.

Lach, Donald F., *Asia in the Making of Europe*, Vol.II, University of Chicago Press, 1970.

Lake, Edward, *Sieges of the Madras Army, in 1817, 1819*, 4 vols, London, Kingsbury, Parbury, and Allen, 1825.

Laking, G. F., *Oriental Arms and Armour*, Wallace Collection Catalogues, 1914, revised by N. Norman, 1964.

Lallanji, Gopal, 'The Śukranīti – a Nineteenth Century Text', Bulletin of the School of Oriental and African Studies, University of London, Vol.25, No.1/3, 1962, pp.524–56.

Larking, Col. Cuthbert, *Bandobast and Khabar: Reminiscences of India*, London, 1888.

LaRocca, Donald J., *Warriors of the Himalayas: Rediscovering the Arms and Armour of Tibet*, Metropolitan Museum and Yale University Press, 2006.

Lassen, Christian, *Indische Altertumskunde*, vols. I–IV, Bonn/Leipzig, H. B. König, 1847–62.

Lavin, James D., *A History of Spanish Firearms*, London, Herbert Jenkins, 1965.

Leech, Lieutenant R., 'Report on the Sindhian, Khelat and Daoodputr Armies', Reports and Papers, Political, Geographical, and Commercial, submitted to Government by Sir Alexander Burnes, Lieutenant Leech, Doctor Lord and Lieutenant Wood, Employed on Missions in the Years 1835-36-37, in Scinde, Affghanisthan and Adjacent Countries. Printed by Order of Government, Calcutta. No. XI, 1839.

Lentz, Thomas W. and Lowry, Glenn D., *Timur and the Princely Vision: Persian Art and Culture in the Fifteenth Century*, Los Angeles County Museum of Art, Smithsonian Institution Press, Washington, 1989.

Le Strange, Guy, trans., *Ruy González de Clavijo: Embassy to Tamerlane, 1403–1406*, New York, Routledge, 1928.

Lewis, Bernard, 'Egypt and Syria', *The Cambridge History of Islam*, Vol.I, 1970.

Ling, Wang, 'On the invention and use of gunpowder and firearms in China', *Isis*, 37 (3/4), 1947, pp.160–178.

Li Tana, Nguyen, *Cochinchina: Southern Vietnam in the Seventeenth and Eighteenth Centuries*, SEAP, Cornell, 1998.

Llewellyn-Jones, R., 'Portraits of the Nawabs': *Portraits in Princely India, 1700–1947*, ed., Rosie Llewellyn-Jones, Marg, 2008, pp.30–44.

Loukonine, Vladimir and Ivanov, Anatoli, *Persian Art*, London, Book Sales, 2003.

Lu, Gwei-Djen, 'The Oldest Representation of a Bombard', *Technology and Culture*, 29: 1988, pp.594–605.

Mackenzie, John, *The Empire of Nature: Hunting, Conservation and British Imperialism*, London, Gentry Books, 1973.

Markovits, Claude, *The Global World of Indian Merchants, 1750–1947: Traders of Sind from Bukhara to Panama*, CUP, 2009.

Masson, Charles, *Narrative of Various Journeys in Balochistan, Afghanistan, and the Punjab; including a residence in those countries from 1826 to 1838*, 3 vols. London, R. Bentley, 1842.

Mayatt, F., *The March to Magdala: The Abyssinian War 1868*, London, Leo Cooper, 1970.

Mearns, David, Parham, David and Frohlich, Bruno, 'A Portuguese East Indiaman from the 1502–1503 Fleet of Vasco da Gama off Hallaniyah Island, Oman: an interim report', *International Journal of Nautical Archaeology*, vol. 45, Issue 2, September 2016, pp.331–50.

Menon, V. P., *The Story of the Integration of the Indian States*, Delhi, Orient Longmans, 1956.

———*The Transfer of Power in India*, Delhi, Orient Longmans, 1968.

Minorsky, V., *Persia in A.D. 1478–1490*, London, Royal Asiatic Society, 1957.

Missilier, Philippe and Ricketts, Howard, *Splendeur Des Armes Orientales*, Paris, Acte-Expo, 1988.

Modave, Compte de., *Voyage en Inde du Compte de Modave 1773–1776*, ed. Jean Deloche, Paris, 1971.

Monserrate, Anthony, *Commentary on his Journey to the Court of Akbar*, J.S. Hoyland (trans) and S.N. Banerjee (ann.), *OUP, 1922*.

Moorcroft, William and Trebeck, George, *Travels in the Himalayan Provinces of Hindustan and the Punjab*, 2 vols. London, John Murray, 1841.

Navarrete, Domingo Fernández, *Tratados Historicos, Politicos, Ethicos, y Religiosos de la Monarchia de China*, Madrid, Imprenta Real, 1676.

Needham, Joseph et al., *Science and Civilization in China*, Vol. V, pt. 7, Military Technology – The Gunpowder Epic, Cambridge, 1986.

Nicolle, David, *Late Mamluk Military Equipment*, Travaux et Études de la Mission Archéologique Syro-Française Citadelle de Damas (1999–2006), volume III, Damascus, Presses de l'IFPO, 2011.

Olival, Fernanda, 'An Elite? The Meaning of Knighthood in the Portuguese Military Orders of the Seventeenth and Eighteenth centuries', *Mediterranean Studies*, vol.15, (2006), pp.117–26.

Oppert, G., *On the Weapons, Army Organisation and Political Maxims of the Ancient Hindus with Special Reference to Gunpowder and Firearms*, Madras, Higginbotham and Co., 1880.

Owen, Clifford, 'The Walking-stick Gun', *Classic Arms and Militaria*, March 1995, pp.16–17.

Park, Hyunhee, *Mapping the Chinese and Islamic Worlds: Cross-Cultural Exchange in Pre-Modern Asia*, CUP, 2012.

Parker, Geoffrey, *The Military Revolution: Military Innovation and the Rise of the West, 1500–1800*, CUP, 1988.

Partington, J. R., *A History of Greek Fire and Gunpowder*, Cambridge, W. Heffer and Sons, 1960.

Peabody, Norbert, *Hindu Kingship and Polity in Precolonial India*, CUP, 2006.

Pelly, Lewis, *Brief Notes relative to The Khyrpoor State in Upper Sind.* Submitted to the Government on the 22 May 1854. Selections from the Records of the Bombay Government, No. XVII, New Series, Hughes Thomas, ed., Bombay, 1855.

Peterson, H. L. (ed.), *Encyclopaedia of Firearms*, London, The Connoisseur, 1964.

Petrović, Djurdjica, 'Fire-arms in the Balkans on the eve of and after the Ottoman Conquests of the fourteenth and fifteenth centuries', V. J. Parry and M. E. Yapp (eds.), *War, Society and Technology in the Middle East*, OUP, 1975.

Pieris, J. F., *Ceylon and the Portuguese, 1505–1658*, American Ceylon Mission Press, Tellippalai, 1920.

Pires, Benjamim Videira, João V's Diplomatic Mission to Cochin-China, Revue of Culture, no. 111/12, Instituto Cultural de Macao, (nd).

Pires, Tomé, *The Suma Oriental of Tomé Pires, 1515*, trans. Armando Cortesão, London, Hakluyt Society, 1944.

Postans, Marianne, *Travels, Tales and Encounters in Sindh and Balochistan 1840–1843*, OUP, 2003.

Postans, Thomas, 'Miscellaneous Information', Selections from the Records of the Bombay Government, No. XVII, New Series, Hughes Thomas, ed., Bombay 1855.

——— *Personal observations on Sindh; the manners and customs of its inhabitants; and its productive capabilities*, London, Longman and Co., 1843.

Princep, Henry T., *A Narrative of the Political and Military Transactions of British India under the Administration of the Marquess of Hastings, 1813–1818*, London, John Murray, 1820.

Rattray, James, *Scenery, Inhabitants & Costumes, of Afghaunistaun from drawings made on the spot by James Rattray*, London, Day and Son, 1847.

Reid, Anthony, *South-east Asia in the Age of Commerce 1450–1680*, Vol. II, Expansion and Crisis, Yale University Press, 1993.

———'Early South-east Asian categorizations of Europeans', ed., Stuart B. Schwartz, *Implicit Understandings: Observing, Reporting and Reflecting on the Encounters between Europeans and Other Peoples in the Early Modern Era*, CUP, 1994, pp.268–95.

———*Europe and Southeast Asia: The Military Balance*, Townsville, James Cook University of North Queensland, Australia, 1982.

Reinaud, J.T. and Favé, I., 'Du feu grégeois, des feux de guerre, et des origins de la poudre à cannon chez les Arabes, les Persans et les Chinois', *Journal Asiatique*, 4e série, XIV, pp.257–327.

Rhodes, Alexander de., *Divers voyages de la Chine et autre royaumes de l'Orient: avec la retour del'autheur en Europe, par la Perse et l'Arménie / le tout divisé en trois parties*, Paris, S. Cramoisy, 1681.

Rice, William, *Tiger Shooting in India – Rajpootana 1850–1854*, London, Smith, Elder and Co., 1857.

Rimer, Graeme, *Wheel-lock Firearms of the Royal Armouries*, Leeds, Royal Armouries Museum, 2001.

Risso, Patricia, *Merchants and Faith: Muslim Commerce and Culture in the Indian Ocean*, Westview Press, 1995.

Rockstuhl, A., *Musee des armes rares ancienes orientales de sa majeste l'empereur de toutes les Russies*, St Petersburg 1835–53. Repr. 1981, Graf Klenau, Darmstadt.

Rudolf, S. H., Rudolf L. I., Kanota, Man Singh eds. and coms., *Reversing the Gaze. Amar Singh's Diary, A Colonial Subject's Narrative of Imperial India*, Boulder, Colorado, Westview Press, 2002.

Sanders, J. W., 'Swivel Guns of Southeast Asia', *Gun Digest*, 36th Edition, Northfield, DBI Books, Inc., 1982.

Sanderson, G. P., *Thirteen Years Among the Wild Beasts of India*, Edinburgh, John Murray,1878.

Saxe, Maurice, Count de, *Reveries or Memoirs Concerning the Art of War*, Edinburgh, Sands, Donaldson, Murray, and Cochran,1759.

Saxena, R. K., *The Army of the Rajputs*, Udaipur, Saroj Prakashan, 1989.

Schuckelt, Holger, *Die Türckische Cammer*, Sammlung orientalischer Kunst in der kurfürstlich-sächsischen Rüstkammer, Dresden, 2010.

Sen, Surendranath (ed.), *The Indian Travels of Thevenot and Careri*, Records Series, National Archives of India, New Delhi, 1949 and 1971.

Sewell, Robert, (trans)., *Vijayanagar, Chronicles of Domingos Paes and Fernão Nuniz*, New Delhi, Asian Education Services, 1991.

Seyller, John, *The Adventures of Hamza*, Freer Gallery of Art and Arthur Sackler Gallery, Smithsonian Institution, Washington and Azimuth Editions, 2002.

Shakespear, Major H., *The Wild Sports of India*, London, Smith, Elder and Co., 1862.

Spencer, Michael. 'The Ashmolean Matchlock Revolver Revisited', *Journal of Arms and Armour Society*, vol. XXIII, No.1, 2019.

Sridharan, M. P., 'Tipu's Drive towards Modernisation: French Evidence from the 1780s', Irfan Habib (ed.), *Confronting Colonialism: Resistance and Modernisation under Haidar Ali and Tipu Sultan*, Anthem Press, London, 2002, pp.143–7.

Stein, Burton, 'Vijayanagara c.1350–1564', *The Cambridge Economic History of India*, vol.I: 1200–c.1750, Tapan Raychaudhuri and Irfan Habib (eds.), CUP and Orient Longman, 1982.

Stepan, Steven, *SS Walther PP/PPK: Identification and Documents*, Private publication, 2012.

Stewart, Charles, *The Tezkereh Al Vakiat: Or, Private Memoirs of the Moghul Emperor Humayun*. Written by Jouher and translated by Charles Stewart. Oriental Translation Fund, London, 1832.

Stone, George Cameron, *A Glossary of the Construction, Decoration and Use of Arms and Armor in All Countries and in All Times*, New York, Jack Brussel, 1934, 1961 ed.

Stronge, Susan, *Tipu's Tigers*, V&A, 2009.

Subramanyam, S., 'The Kagemusha effect: The Portuguese, firearms and the state in early modern south India', *Moyen Orient et Océan Indien*, 4 (1987).

———'Warfare and state finance in Wodeyar Mysore, 1724–25: A missionary perspective', *Indian Economic and Social History Review*, 26 (1989).

Sudjoko, *Ancient Indonesian Technology: Ship Building and Firearms Production around the Sixteenth Century*, Jakarta, Proyek Penelitian Purbakala, 1981.

Sun Laichen, 'Military Technology Transfers from Ming China and the Emergence of Northern Mainland Southeast Asia (c.1390–1527)', *Journal of Southeast Asian Studies*, vol.34, no.3, (2003), pp.495–517.

———'Gunpowder Technology and Commerce in East and Southeast Asia: Towards Defining an "Age of Gunpowder" in Asia, c.1368–

1683', in *The Proceedings of the Northeast Asia in Maritime Perspective: A Dialogue with Southeast Asia Workshop*, Okinawa, Japan, 29–30 October 2004. Osaka: Osaka University, 2004, pp.174–88.

———'Assessing the Ming Role in China's Southern Expansion', Wade, Geoff and Sun Laichen (eds.), *Southeast Asia in the Fifteenth Century*, The China Factor, NUS Press, 2010, pp.44–83.

Thackston, Wheeler H. (trans., ed. and annotated), *The Baburnama*, New York and Oxford, OUP, 1996.

——— *The Jahangirnama: Memoirs of Jahangir, Emperor of India* (trans), New York and Oxford, OUP, 1999.

Thackston, Wheeler H; Beach, Milo Cleveland; and Koch, Ebba, *King of the World: The Padshahnama*, An Imperial Mughal Manuscript from the Royal Library, Windsor Castle, Azimuth Editions and Sackler Gallery, 1997.

Thevenot – see Sen.

Thorn, Major William, *Memoir of the War in India Conducted by General Lord Lake, Commander-in-Chief, and Major-General Sir Arthur Wellesley, Duke of Wellington: from its Commencement in 1803, to its Termination in 1806, on the Banks of the Hyphasis*, London, T. Egerton, 1818.

Tieh-han, Chao, *Huo Yao de Faming* (The Invention of Gunpowder), Collected Papers on History and Art of China (First Collection), 4. National Historical Museum Taipei Taiwan, Republic of China.

Tittman, W., 'Die Eltzer Büchsenpfeile von 1331/3' [The gun arrows of Eltz of 1331/3], Waffen- und Kostümkunde Heft 1 und 2, Göttingen, 1995.

Tod, James, *Annals and Antiquities of Rajasthan*, vols 1 & 2, London, 1829–32, repr. 3 vols, Delhi, Motilal Banarsidass Publishers, 2010.

Tone, William Henry, *A Letter on Maratta People*, Bombay, 1796.

Truesdell, S. R., *The Rifle, its Development for Big-Game Hunting*, Safari Press Inc., 1992.

Tulloch, Col. Maurice, *The All-in-One Shikar Book: An Everyday Guide to Field Sports in India*, Bombay, Nd.

Turley, Charles, *With the Prince Round the Empire*, London, Methuen, 1926.

Turnbull, Steven, *The Mongols*, Oxford, Osprey Publishing, 1980.

Volkov, Alexei, 'Evangelization, Politics and Technology Transfer in 17th Century Cochin-China: The Case of João Da Cruz', *Europe and China: Science and Arts in the 17th and 18th Centuries*, ed., Luís Saraiva, Singapore, 2013, pp.31–71.

Valle, Pietro della, *The Travels of Pietro della Valle in India*, E. Grey (ed.), London, Hakluyt Society, 1892.

Vambéry, A. (trans.), *The Travels and Adventures of the Turkish Admiral Sidi Ali Reïs in India, Afghanistan, Central Asia, and Persia. During the Years 1553–56*, London, Luzac and Co., 1899.

Van Wart, R. B., *The Life of Lieut. General H. H. Sir Pratap Singh*, OUP, 1926.

Wade, Geoff and Sun Laichen (eds.), *Southeast Asia in the Fifteenth Century: The China Factor*, NUS Press, 2010.

Wakeman, Frederic E., *The Great Enterprise: The Manchu Reconstruction of Imperial Order in Seventeenth-century China*, Vol.I, University of California, 2008.

Welch, C., *The Art of Mughal India: Paintings and Precious Objects*, New York, Asia Society and Harry N. Abrams, Inc., 1963.

Wigington, Robin, *The Firearms of Tipu Sultan 1783–1799*, John Taylor Book Ventures, Hatfield, 1992.

Williamson, Capt. Thomas, *Oriental Field Sports*, London, E. Orme and B. Crosby, 1808.

Wills, John E., *Pepper, Guns and Parleys: The Dutch East India Company and China 1622–1681*, CUP, 1974.

Wilson, Guy, in Arthur MacGregor (ed.), *Tradescant's Rarities*, Oxford, OUP, 1983, pp.197–9.

———'The Adoption of the Snap Matchlock in the East: Tangled Webs and Cautionary Tales'. The Proceedings of the Icomam Conference. Nizwa, Sultanate of Oman, October 2012, pp.10–27.

———'Some Important Snap Matchlock Guns', *Arms Collecting*, vol. 26, no 1.

———'Handguns: Scope and importance of the assemblage' in Alexandra Hildred (ed.), *Weapons of Warre: The Armaments of the Mary Rose: The Archaeology of the Mary Rose, Volume 3, Parts 3 and 4*, Portsmouth, England, 2012.

Wittek, P., 'The Earliest References to the use of Firearms by the Ottomans', Appendix II in D. Ayalon, *Gunpowder and Firearms in the Mamluk Kingdom*, London, Vallentine Mitchell, 1956.

Woodruff, Philip, *The Men Who Ruled India: The Guardians*, London, Jonathan Cape, 1954.

Yang Hong, *Weapons in Ancient China*, New York and Beijing, Science Press, 1992.

Yazdani, Kaveh, 'Haidar 'Ali and Tipu Sultan: Mysore's Eighteenth-century Rulers in Transition'. Itinerario, vol. 38, issue 2. Published online: 26 September 2014, pp.101–20. DOI: https://doi.org/10.1017/S0165115314000370

Yule, Henry, and Burnell, A. C., *Hobson-Jobson: A Glossary of Colloquial Anglo-Indian Words and Phrases, and of Kindred Terms, Etymological, Historical, Geographical and Discursive*, ed., William Crooke, New Delhi, Asian Educational Services, 1995.

Zhao, Shizhen, *Shen qi pu*, Xuanlan tang jushi, Minguo 30, 1941.

# INDEX

Note: Italicized page locators denote images.

pig-sticking, 251–4, 260, 262, 275
Pinto, Fernão Mendes, 49, 57
Pires, Tomé, 38
Pistols, 52, 61, 64, 80, 155–6, 219, 224, 226,
   228–30, 232, 236–41, 258–9, 311; air
   242, 244; Baby Browning self-loading,
   238; Bussey Air, *241*; Chalembrom, 63,
   *246*; Colt Model 1903, 230; Colt self-
   loading, *226–7, 231, 233;* European
   and American, *225;* four-barrel pistol or
   *tapancha*, 52, 341; Haenel Air, *245;* of
   Jaipur, 54; Lignose self-loading, *236;* Luger
   P08 self-loading, *239;* Mauser, 228, 235;
   Parabellum Automatic, 239;  pencil pistol,
   *311;* .22 Walther Model PP self-loading,
   *240;* revolving three-barrel, *51;* self-
   loading Mauser, *234–5;* self-loading target,
   *237–8;* semi-automatic, 237, 239; six-shot
   wheellock revolving, *64;* Webley Junior Air,
   *244;* of Yuvraj Hanwant Singh, *308*
Poivre, Pierre, 59
Poole, Moses, 219
Porter, Parry W., 219
Portuguese, 31, 34–8, 48–9, 51–4, 57,
   59–60, 67, 74, 188; invasion, 38; overseas
   possessions, 51; patilha lock, 65; vessels of,
   35, 37
Pottinger, 155–6
powder flasks, *193–8;* in silver, *202;* Sirohi, *204*
Powell, William 216
Prataparudradeva, and gunpowder formulae, 32
Prince of Wales, 254, 261–2, 268, 272, 310
Purdey: guns and rifles, 155; James, 249,
   272, 295

**Q**

Quackenbush, 241
Qufei, Zhou, 30

**R**

Rajasthan, map of, *13, 15*
Rajputs, 38, 40–1, 67–8, 71, 73, 75, 78, 83,
   152, 157, 272, 275
Rao Raja, 274
Rathore, Jaimal, 71
Rathores, 68, 73, 78, 310
Raymond, Michel Joachim Marie as Musa Ram
   and Rahim, 63
Reading, Lord, 271
Reis, Sidi Ali, 38
Remington 303–4; typewriters, 305
revolver: carbine, *223–4;* Deane Adams, 223;
   Nuremburg eight–shot, *52*
revolving: barrels, European system of, 52;
   cylinder guns, 43, 51–4, 65; matchlocks,
   47, 55, 57, 60; guns, history of, 47–65;

Japanese gun, 52
Rice, Lieutenant, 52
Richards, Westley, 234, 297
rifles, 155–6, 210–11, 215, 217, 219, 249,
   269–70, 272–3, 275, 283, 285, 297, 300–
   1, 303–5, 309, 312–13; air, 241; breech-
   loading centre-fire, *215–16;* double-barrel,
   248–9, 272; KAL1 313; Lancaster Sporting
   Percussion, *222;* makers of, 270; Purdeys,
   284; Remington Model self-loading, *304;*
   Sindh Percussion, *169*
Roberts, General, 253
Rodda, R.B., 228, 264
Rohillas, 80, 152, 264; defeat of, 81
Rouse, W., 65
Royal Armouries, 23, 47, 62–4, 220
Royal hammerless ejector, 290, 292
Royal Small Arms Factory, 313
Rumi, Amir Mustafa Khan, 38, 40–1

**S**

Safar, Khwaja, 38
Safavi, Shah Ismail, 40
Saltpetre *under* gunpowder, 19
Sangster, George Col., 80
Sani, Abdullah, 68
Sarajevo, 77
Sardarsamand Farm, *266–7*
Savage Arms Company, (Savage Repeating
   Arms Company), New York, 232
Savage, Arthur, 232
Schmeisser, Hugo, 245
Scindia, Maharaja, 271
Scindiah, 81
Scott, William, and patent of Crystal
   Indicator, 249
Scythian invasions, 78
Second World War, 230, 240, 242, 244,
   310–11, 314
sea routes, 30, 73
Selim, Ottoman Sultans, 36, 49
*Seyahatname,* 77
Shah Jahan, 38, 54, 68, 73–4, *76*–7, 181, 255
Shah, Ali Adil, 48, 53
Shah, Nusrat, 41
*Shen qi pu,* 38, 52
Sheridan, General, 241
Shikarkhana, 274
Shirazi, Fath Allah, 53, 155–6
shot gun, 269–70; Police, *217*
shotgun: Birmingham breech-loading db
   shotgun, *288;* Breech-loading Shotgun,
   *289;* Holland & Holland, *290–3;* J. Purdey
   & Sons Hammerless Ejector, *296;* Purdey
   Hammerless Ejector, *294–5*
Shuja-ud-daula, Nawab, 63

*Shuturnal* (swivel gun), 102–6, 340
Sigismund, 32–3
*siham khita'iyya,* 19
silversmiths, 29, 65; Edward Bate as, 65
Sindh: army of, 152; artillery of, 156; butt
   reduction in guns of, 157; court guns,
   155; divisions of, 176; *Jezails,* 152, 156–8;
   matchlock, 155; merchants, 156, 158
Singh Jaloda, Bhanwar, *85–6*
Singh Kesrisinghot, Kamr Fateh, *122*
Singh, Ajit Maharaja, 77
Singh, Amar, 251
Singh, Bhoor, *85, 87*
Singh, Bhupinder of Patiala, Maharaja, 295
Singh, Gaj Maharaja, 254, 279
Singh, Ganga of Bikaner, Maharaja, 235, 275
Singh, Hanwant, 309–10, 312–13
Singh, Hari Maharaja, 301
Singh, Hari of Chandawal, *113*
Singh, Jaswant, 222
Singh, Laxman Sir, 275, 278
Singh, Maharana Amar II, *75*
Singh, Maharana Hamir, 71
Singh, of Patiakot, *113*
Singh, Pratap Sir, 225, 235, 253–4, 260–1, 295
Singh, Pushpendra, 254
Singh, Raj Kumar Devi, 278
Singh, Sangram, as Rana Sanga, 40
Singh, Takhat Maharaja, 176, 222, 260, 295
Singh, Thakur Mangal, 273
Singh, Umaid of Jodhpur Maharaja, 229,
   235, 278–9, 281, *282, 284, 286,* 295,
   309–10, 316
Singh, Yuvraj Hanwant, 238, 245, 298, 301,
   309–10, 316
Singh, Yuvraj Shivraj, 230
Singh, Zalim, 81
Siyar, Farrukh Emperor, Indra Kunwar
   married to, 77
Skanderbeg, 34
Skinner, James, 251, 258
snap matchlocks, 34, 51, 53; mechanism of, 47;
   Portuguese, 51
Snider, Jacob, 213
Snider–Enfield, 213, 297
Sodré brothers, 37
Sodré, Vicente, 37
Souza, Faria, y 35
Spain, 24, 39, 59
sporting gun, 305; Bolt-Action *300;* By E. J.
   Churchill, *298–9;* Three-Barrel German
   'Drilling', *302*
Sporting Rifle: Bolt-Action, *305;* Remington
   Model With Telescopic Sight, *303;* Short
   Rifle, *306;* Westley Richards Model, *297*
sports, 253–5, 259, 262, 264, 267, 269, 272